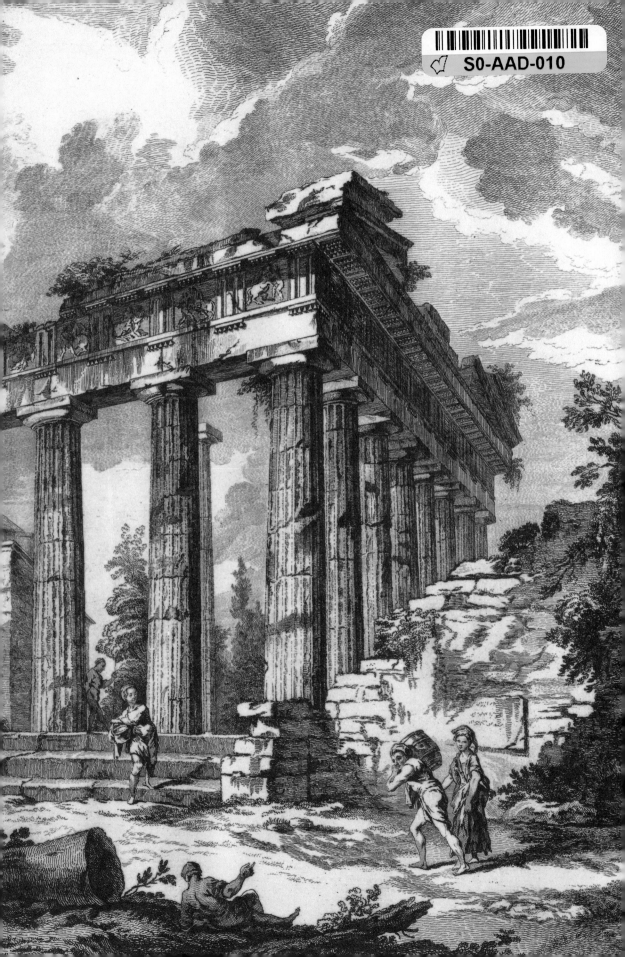

The Ruins of the
Most Beautiful Monuments
of Greece

Published by the Getty Research Institute

Julien-David

Le Roy

The Ruins of the Most Beautiful Monuments of Greece

Introduction by Robin Middleton
Translation by David Britt

Texts & Documents

Translation of Julien-David Le Roy, *Les ruines des plus beaux monuments de la Grece,*
considérées du côté de l'histoire et du côté de l'architecture, 2d ed., 2 vols. (Paris: Imprimerie
de Louis-François Delatour, 1770)

Published by the Getty Research Institute, Los Angeles
Getty Publications
1200 Getty Center Drive, Suite 500
Los Angeles, CA 90049-1682
www.getty.edu
© 2004 The J. Paul Getty Trust
Printed in Canada

08 07 06 05 04 5 4 3 2 1

Cover: Julien-David Le Roy, *Les ruines . . . ,* vol. 1, pl. 30 (detail). See page 344
Frontispiece: Julien-David Le Roy, *Les ruines . . . ,* vol. 1, pl. 4 (detail). See page 249

Library of Congress Cataloging-in-Publication Data
Le Roy, David, 1724?–1803.
 [Ruines des plus beaux monuments de la Grece. English]
 The ruins of the most beautiful monuments of Greece / Julien-David Le Roy ;
introduction by Robin Middleton ; translation by David Britt.
 p. cm. — (Texts & documents)
Includes bibliographical references and index.
 ISBN 0-89236-669-9 (pbk.)
 1. Architecture — Greece. 2. Architecture, Ancient — Greece. [1. Greece — Antiquities.]
I. Title. II. Series.
 NA270.L413 2004
 722′.8′0938 — dc21
 2003011119

Contents

Foreword

Julien-David Le Roy's *The Ruins of the Most Beautiful Monuments of Greece* (1758; 2d ed., 1770) forms part of a trilogy of books relating to the eighteenth-century Graeco-Roman debate translated and published in the Getty Research Institute's Texts & Documents series. It accompanies Johann Joachim Winckelmann's masterpiece, *History of the Art of Antiquity* (1764), and Giovanni Battista Piranesi's three-part polemic, *Observations on the Letter of Monsieur Mariette* (1765). Together, these works decisively changed the course of Western art and architecture.

By the time Piranesi rose to defend the genius of ancient Roman architecture against the distinctive Greek forms depicted by Le Roy and the superiority of early Greek art argued by Winckelmann, in many respects the matter had already been decided. European artists were in a state of rapture over Greece, a Graecomania owing everything to the easing of diplomatic relations with the Ottoman Empire in the 1740s. This had allowed the slight opening of the road to Athens, which had been more or less closed to Europeans for centuries, save for a few years of Venetian rule in the seventeenth century. The Englishmen James Stuart and Nicholas Revett were among the first to avail themselves of this possibility, with their well-publicized trip to Attica, where they conducted an impressive survey of Greek architecture. When Stuart left Athens toward the end of 1753, Le Roy, then a *pensionnaire* at the Académie de France à Rome, was only beginning to make preparations for his trip. He did not actually begin measuring and sketching the buildings of Athens until the first months of 1755. But Stuart and Revett's delay in publishing their findings created a window of opportunity, and Le Roy responded. Assisted by the comte de Caylus and several skilled artists and engravers, the young French architect rushed his sketches and observations into print. In 1758 the Western world was presented for the first time with striking images of works such as the Parthenon and the Erechtheion. Overnight, Greece became the rage.

The greatly expanded, second edition of the *Ruins*, which appeared in 1770, is much more than an annotated archaeological survey, however — as Robin Middleton's wide-ranging introduction makes clear. Reflecting Le Roy's historiographic considerations of the 1760s, his developing fascination with the perceptual and psychological effects of experiencing a building, and his varied response to Winckelmann's insights and Stuart's harsh critiques, *Ruins* rises to the level of a historical and aesthetic tour de force. It is in fact one of the great books of the eighteenth century.

—Harry F. Mallgrave

Acknowledgments

I am indebted to a great many people for help in editing this translation and writing the introduction. The librarians of the Avery Architectural and Fine Arts Library and the staff of the Interlibrary Loan Division of Butler Library, both at Columbia University, were unfailingly helpful. I used the Bibliothek Werner Oechslin at Einsiedeln, Switzerland, for a short stint, to considerable profit. Gerald Beasley, Jean-François Bédard, Vittoria di Palma, Joseph Disponzio, Philippe Duboy, John Harris, Clemente Marconi, Nicholas Savage, and Richard Wittman all provided essential information or procured texts or illustrations when I was in need of them. Samuel Gilbert made the first skirmishes at analyzing the composition of the texts that make up the second edition of Le Roy's folio. C. Drew Armstrong, Barry Bergdoll, Richard Brilliant, John Goodman, and Mary McLeod all read the draft of the introduction and offered advice and criticism, to much of which I responded. Clemente Marconi and C. Drew Armstrong read the final version and provided further information and clear-cut recommendations—Clemente Marconi substituting good references to the architecture of ancient Greece for altogether inadequate, not to say foolish, ones; C. Drew Armstrong trying to restrain and temper my endless excurses. The typing was done with great efficiency by John Harwood. Finally, I wish to express my gratitude to Michelle Bonnice, the editor, who has worked with dedication and goodwill (and good humor) to make this book as sound and reliable as possible. To all of these, and others unnamed, I am extremely grateful, for without their help I would certainly not have been able to bring the work to a conclusion.

The introduction is dedicated to Billy Walton, who died during the writing.

—Robin Middleton

Introduction

Robin Middleton

In Quest of an Architecture

Julien-David Le Roy's *Les ruines des plus beaux monuments de la Grece* has long been disparaged in favor of James Stuart and Nicholas Revett's *The Antiquities of Athens* (1762–1816), and this from the start. Reviewing the first volume of the *Antiquities* in April 1763, the *Monthly Review* judged that

> Mr. Le Roy's work, it is true, is greatly superior in point of scenery; his views are beautifully picturesque; the drawings executed with taste, and the engraving masterly. In this respect, the present work is most defective; the general views are stiff, and indifferently designed: Mr. Stuart, indeed, seems to apologize for this....
>
> In the capital and most essential parts of this undertaking, however, our English Artists indisputably bear away the palm. In the preservation of the due proportions in the architectural parts of the work, Le Roy can hardly be named in the comparison; his shameful negligence in taking his measures, or carelessness in laying them down, being evident on sight, to those who have any knowledge of architecture.[1]

This rude assessment is accepted still, and not, one must admit, without some justice. But the harsh verdict fails in its understanding of Le Roy's aims and his achievement. The *Ruines*, both in the first edition of 1758 and even more in the second of 1770, marked the emergence of a new sensibility in the grasp of architectural experience, as we shall find.

The *Ruines* and the *Antiquities* must needs first be considered together, however.[2] Le Roy was probably inspired to publish the buildings of Greece by Stuart and Revett's book proposals, which were circulating and widely discussed, especially in Italy, from 1749 onward. The first full account of their intentions was apparently included in a letter, dated 6 January 1749, sent by Revett to his father, but this letter is lost and known only from a summary that appeared in 1816 in the fourth volume of the *Antiquities*. Stuart published an account of their initial proposal, which he dated to 1748, in a lengthy footnote to the preface to the first volume of the *Antiquities*, issued in December 1762, but he was then intent to show that Le Roy had usurped their scheme. Thomas Hollis, an antiquarian from Dorset, wrote a long and circumstantial letter from Venice, dated 26 February 1751, in which he described Stuart and Revett's proposal to his friend, John Ward, professor at Gresham College in London, in a way that shows that a three-volume work had by then

been planned in some detail.[3] In any case, there is little doubt that Stuart and Revett had been toying with the Grecian enterprise since spring 1748, when they conceived the project, together with the painter Gavin Hamilton, while on a walking tour to Naples.

The idea of traveling to the Levant was taken up by a surprising number of gentlemen around this time. James Caulfeild, first earl of Charlemont, was organizing an expedition to Greece and Asia Minor in Rome in winter 1748.[4] He hoped to take Giovanni Battista Borra as his draftsman, but Borra changed his mind at the last minute. When Charlemont embarked from Livorno in April 1749 he was without a draftsman, and only in Malta did he manage to persuade Richard Dalton, an artist and dealer then traveling in Italy and the nearby islands, to accompany him to the east. Robert Wood and James Dawkins, who had been to Greece in 1742 and in 1743, were in Rome in winter 1749, together with James Bouverie and their draftsman, none other than Borra, planning a wondrously well-organized expedition to the Levant that would embark from Naples in May 1750.[5] They gave both advice and support to Stuart and Revett. By March 1750 the latter two had moved to Venice, hoping to find berths on one of the ships plying the currant trade with Zante (Zákinthos), off the west coast of Greece, but they missed them—or so Stuart later claimed. They seem to have been waiting for more subscriptions to come in. They journeyed to the Istrian Peninsula to measure the temples at Pola (Pula) that Andrea Palladio, Sebastiano Serlio, and Scipione Maffei had studied earlier.[6] Returning to Venice in November 1750, they drew up a revised proposal—probably that reported by Hollis—taking advice from Charlemont and Dalton, by then back from their expedition. Stuart and Revett sailed from Venice on 19 January 1751. They would reach Athens on 18 March, where they were joined two months later by Wood and Dawkins (and presumably Borra, but Bouverie had died in Turkey, at Magnesia ad Maeandrum), then returning from the Levant.

In Athens Stuart and Revett realized that their proposal would have to be redrawn yet again. A new version was printed in London in 1752, but no copy survives; the proposal published by Stuart in 1762 in the first volume of the *Antiquities* may represent this variant. Initially unable to gain access to the Acropolis, they began their survey with buildings in the town—the Tower of the Winds (also known as the Horologion of Andronicus Cyrrhestes) and the choragic Monument of Lysikrates (also known as the Lantern of Demosthenes)—where they were free to scramble and climb. They even persuaded the chief of the dervishes, who were using the Tower of the Winds as a *tekke* (sanctuary), to permit extensive excavation of the soil concealing the lower part of the building outside as well as removal of the wooden floor, concealing even more dirt, within. Only in summer 1753, after two years in Athens, were Stuart and Revett allowed to busy themselves measuring the buildings on the Acropolis. A local rebellion caused more difficulties and danger. Stuart caused even further difficulties by knocking down the British consul—a Greek—and being obliged to travel to Constantinople to present his case to the British

ambassador. Stuart departed from Athens on 20 September 1753, leaving Revett to continue with the work. But in January 1754 Revett too left, to join Stuart in northern Greece, at Thessaloníki. Plague broke out in Athens, and they decided to avoid further risk and return forthwith to England. They were back in London in summer 1754, intending to publish the Tower of the Winds and Monument of Lysikrates in their first volume and to take up their work in Athens at a later date. Some plates were engraved in that same year and soon after circulated both in England and on the Continent to encourage subscribers. But though there were prints, there was no text. This was Stuart's responsibility. He was notoriously dilatory and was, in any case, already embarked on an architectural career. Not much had been done when Le Roy's book was published in August 1758.

Julien-David Le Roy (1724–1803) was the third of the four sons of the famous clockmaker to the French king, Julien Le Roy.[7] Le Roy studied architecture first at the École des arts of Jacques-François Blondel, later with Philippe de La Guépière and Jean-Laurent Legeay. He completed his studies at the Académie royale d'architecture under Denis Jossenay and Louis-Adam Loriot, winning second prize in the Grand Prix de Rome d'Architecture competition of 1749 (registered as a pupil of Philippe Le Dreux) with a design entitled *Un temple de la paix, isolé, dans le goust des temples antiques* (A temple of peace, freestanding, in the style of the ancient temples), the elevation and section drawings of which survive at the École nationale supérieure des beaux-arts in Paris (figs. 1, 2).[8] In the following year, at the age of twenty-six, Le Roy won the prize with a design for an orangery; Pierre-Louis Moreau-Desproux and Charles de Wailly were the runners-up on this occasion. Though the *brevet* (certificate) confirming the award was to be issued only on 22 October 1751, Le Roy reached Rome much earlier, on 28 June,[9] missing Abel-François Poisson de Vandières (marquis de Marigny as of 4 September 1754) — the future directeur-général des bâtiments, jardins, arts, académies et manufactures du roi — and his entourage by a few months, though Jérôme-Charles Bellicard, winner of the Grand Prix in 1747, who had been a late addition to that company, had returned to Rome by June 1751. Another young *pensionnaire* at the Académie de France à Rome, Charles-Louis Clérisseau, who had arrived in June 1749, was established there, and others were soon to join them, including François-Dominique Barreau de Chefdeville in October 1751 and Marie-Joseph Peyre in May 1753. Peyre, like Le Roy, had been a pupil at Blondel's École des arts, as had another young architect, an Englishman, William Chambers, who had arrived in Rome in December 1750 to spend much of the next four years there.[10] Though Chambers was to emerge as a staunch opponent of *goût grec* — which he termed *gusto greco* — he remained throughout his life closely attached to Le Roy. Le Roy not only subscribed to the publication of Chambers's *Treatise on Civil Architecture* (1759) but also was introduced into the newly formed Royal Academy of Arts and liberally entertained by Chambers when he visited London in 1769.

Le Roy's activities in Rome between July 1751 and April 1754 are none

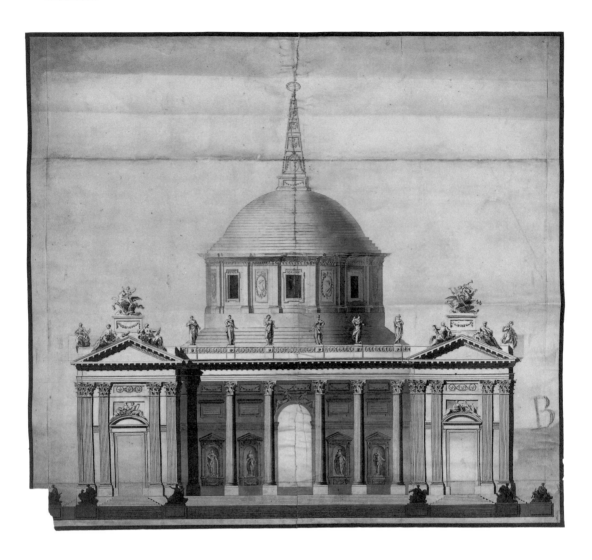

Fig. 1. Julien-David Le Roy
Entry for the Grand Prix de Rome d'Architecture: *Un
temple de la paix, isolé, dans le goust des temples antiques*
(elevation), 1749, drawing
Paris, École Nationale Supérieure des Beaux-Arts

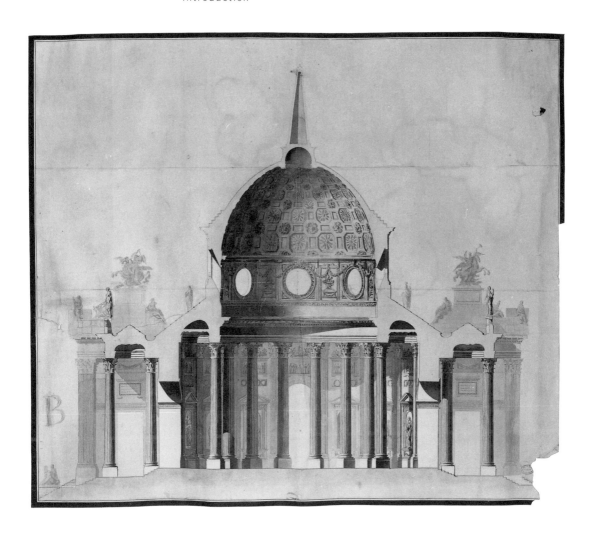

Fig. 2. Julien-David Le Roy
Entry for the Grand Prix de Rome d'Architecture: *Un
temple de la paix, isolé, dans le goust des temples antiques*
(section), 1749, drawing
Paris, École Nationale Supérieure des Beaux-Arts

too well documented. From remarks in the *Ruines* it is clear that he looked intelligently at church buildings. He was struck in particular by the arrangement of the drum and the dome in Cardinal Guillaume d'Estouteville's church of Sant'Agostino. Designed by Jacopo da Pietrasanta and completed between 1479 and 1483, this dome was the first, Le Roy thought, to be supported on transverse arches and pendentives. It was being rebuilt by Luigi Vanvitelli when Le Roy returned to Rome in 1755, prompting him to describe it later as destroyed.[11] From the correspondence between Charles Natoire, director of the Académie de France à Rome, and, Vandières, who had assumed the post of directeur-général des bâtiments du roi in November 1751, it is evident that Le Roy was both something of a rebel (he was, for instance, closely involved with Clérisseau in the student revolt against the *pensionnaires* having to submit Easter communion certificates as proof of religious orthodoxy)[12] and somewhat high-minded.

Le Roy informed Natoire of his intention to travel to Greece in February 1754, only after he had formulated his plans and ensured considerable support. He later claimed that he had conceived the project in 1753. Even if he had been unaware before then of the several expeditions planned for the Levant—which is altogether unlikely—he could hardly have failed to see a copy of Stuart and Revett's first printed proposal of 1752 (issued by Samuel Ball) or the extensive summary of it published in the *Journal britannique* of January–February 1753. Moreover, the first fruits of this wave of exploration were already in evidence. Though Charlemont seems not to have contemplated a publication, remaining in Italy for another three years after his return from Asia Minor, Dalton traveled straightaway to England and by April 1751 had issued twenty-one prints of plans, views, and details of the Parthenon (fig. 3), Erechtheion (fig. 4), Hephaisteion, Monument of Lysikrates, and Tower of the Winds, to be followed in February 1752 by twenty assorted views of Etna in Sicily, Pompey's Pillar at Alexandria, and other sites in Egypt and Greece, and also Constantinople.[13] Though another set of prints depicting life in Egypt was added in 1781, the complete work was never issued. What had appeared was judged by Robert Adam in Rome in 1756 to be "so infamously stupid and ill done that it quite knocked him on the head and entitled him to the name of Dulton which is generally given him."[14]

Wood and Dawkins's *The Ruins of Palmyra, Otherwise Tedmor, in the Desart* (1753), issued in London in both English and French, had a far different reception. It brought instant acclaim to the authors and set new standards of classical scholarship and accuracy of representation for such works—though they had spent no more than five full days at the site. "[T]he principle merit of works of this kind," Wood opened his preface, "is truth." And it was at once apparent that the previous exemplar of archaeological exactitude, Antoine Babuty Desgodets's sumptuous *Les édifices antiques de Rome, dessinés et mesurés trés exactement* (1682), had been quite overtaken. The English had snatched the laurels from the French. By the time Louis Jean Marie de Bourbon, duc de Penthièvre, presented a copy of the *Ruins of Palmyra*

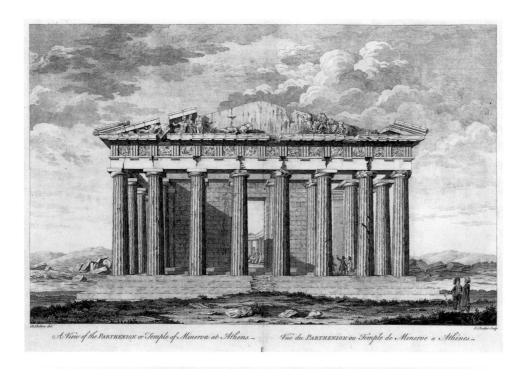

A View of the PARTHENION or Temple of Minerva at Athens. — Vûe du PARTHENION ou Temple de Minerve a Athènes. —

The Principal Parts of the Temple of Erictheus, in Large — Les principales Parties du Temple D'Eriethée en Grand

Fig. 3. Edward Rooker, after Richard Dalton
A View of the Parthenion or Temple of Minerva at Athens, 1751, engraving
Los Angeles, Getty Research Institute

Fig. 4. Richard Dalton
The Principal Parts of the Temple of Erictheus, in Large, 1751, engraving
Los Angeles, Getty Research Institute

(originally intended for the pope, but he already had one) to the students of the Académie de France à Rome in December 1754, it was already well known in Italy.

"I believe this student has further developed his talents," Natoire wrote to Vandières on 27 February 1754, when informing him of Le Roy's newly revealed plans. "I would simply have preferred that he had been a little more sociable with me, more communicative and less moody; I have seldom seen him since the Clérisseau affair, even though he was my student in Paris and I always considered his family to be very respectable people. I find that certain of these gentlemen, once they have been in Rome for some time, acquire a ridiculous way of thinking as a result of their arrogance."[15] Le Roy seems to have had little humility in soliciting support. He had by then induced François-Claude de Montboissier, abbé de Canillac, and François-Charles Le Clerc de La Bruère, two of the French chargés d'affaires in Rome, to persuade Antonio Donà, the Venetian ambassador to the Sublime Porte, to allow him to travel in his suite. He had already obtained letters of introduction to the French ambassador in Constantinople, Roland Puchot, comte Des Alleurs, and his wife, Federica Costanza de' Principi Lubomirski, not only from the abbé de Canillac but also from Paris, from Marie-Louise Jablonowska, princesse de Talmont, and Louis-Philogène Brulart de Sillery, marquis de Puisieux, the French minister of foreign affairs from 1747 to 1751. Le Roy picked up yet another letter of introduction in Venice, from François-Joachim de Pierre de Bernis, the French ambassador there from September 1752 to September 1753. All these grandees were to be proudly listed in the preface to the *Ruines* of 1758, though their names were omitted from the *Ruines* of 1770.

When Le Roy departed from the Académie de France à Rome, then in the Palazzo Mancini, in April 1754, Natoire was well pleased to be rid of him. "I am not sorry," he wrote to Vandières on 23 April, "that this *pensionnaire* is no longer at the academy; his haughty temperament and his less than docile character set a bad example for his fellow students. Had it not been for him, the Easter affair would not have been so acrimonious."[16] Le Roy reached Venice on 15 April; and by 5 May he was embarked on the ambassador's ship, the *Saint Charles*, an eighty-gun boat, which first moved to the Istrian coast to arm. Le Roy took advantage of the delay to travel to Pola, together with marchese (Giambattista?) Spolverini of Verona and Priuli, a grandee of Venice (there had been three doges in his family), to draw the remains of the temples there, as Stuart and Revett had done earlier. The *Saint Charles* then sailed down the Adriatic Sea to Corfu, where the party stayed a fortnight, and thence to Zante—sadly without catching even a glimpse of Homer's Ithaca, set between Leucadia (Levkás) and Cephalonia. By 23 June they were passing the Strophades—the two small islands where Virgil sited the Harpies—and proceeding swiftly round Taenarum (Cape Matapan or Ákra Taínaron), past Cythera (Kíthira)—"an arid, desert island, unworthy to be, as the poets called it, the haunt of the goddess of beauty" (p. 238).[17] Scarcely a day later they anchored off the ancient ruins at Sunium (Cape Colonna or Ákra Soúnion).

They expected to be at the island of Tenedos (Bozcaada), just south of the Dardanelles, two days later, and in Constantinople soon after. But the wind turned, and they had to seek shelter on the east coast of Attica, landing at Thorikos, where they found ruins that Le Roy drew after clearing the site with the help of the ambassador's Slavonian soldiers.

It took three weeks to get to Tenedos where, Venetian boats not being permitted to enter the Sea of Marmara, they had to transship to a Turkish galley. Contrary winds continued to delay their journey, and it was only on 13 September, fifty-two days after they had sighted Sunium, that they reached their destination. "Constantinople has the air of being the capital of the whole world," Le Roy judged on first sight, though once ashore he found the city less agreeable. But the Venetian ambassador took him to an audience with Sultan Mahmud I. "I shall not speak," Le Roy wrote, "of all the diamonds, all the rubies, all the pearls on the throne or of the carpets woven with gold and silk that cover the paving of the hall and its vestibules" (p. 242).[18] Three months were spent in Constantinople, during which period the sultan died, providing occasion for Le Roy to witness yet more pomp. From there he sailed back through the Dardanelles and south along the Turkish coast to Smyrna (İzmir) and thence westward to the Cyclades, to Mykonos and to Delos, where he measured and drew the ruins. He landed at Porto Raphti on the east coast of Attica (where Stuart and Revett had gone to meet Wood and Dawkins in May 1751) and finally reached Athens at the beginning of February 1755, a year after Revett's departure.

Le Roy at once presented himself to the French consul, Etienne Léoson,[19] with whom he was invited to stay and through whom he obtained all the permits needed to draw and set up ladders and scaffolds, even on the Acropolis, though he was asked to give warning when he climbed the Parthenon, so that the women walking in the streets might be advised to keep their distance and their cover. Léoson also provided a janissary to accompany Le Roy during his stay. Le Roy at once began work on the buildings of the Acropolis, then moved on to those of the town below. He traveled thence to Sunium and to Piraeus, where he surveyed the harbors. His work in Athens more or less complete, he left for Sparta, via Eleusis, Corinth, and Napoli di Romania (Návplion), traveling with two janissaries, a muleteer, and a servant. At Corinth he drew the temple, at Sparta he surveyed the site, as Michel Fourmont and his nephew Claude-Louis had done twenty-five years before. Le Roy returned to Athens from the Peloponnese via Lessa—which Pausanias (*Description of Greece* 2.25.10–2.26.1) said marked the junction between the territories of Árgos and Epidauros—and then Corinth. After three more weeks in Athens, he took a boat at the end of April from Oropos (Skála Oropoú), on the Southern Gulf of Euboea, for Italy. He had been in Greece somewhat less than three months.

By June 1755 Le Roy was in Bologna, where he was enrolled as a member of the Accademia Clementino; by July he was back in Rome. On 30 July, Natoire informed Marigny of Le Roy's return, remarking "full of conceit about his new veneer, [he] showed a few studies of that country, as if he were

bestowing a special favor."[20] During this sojourn Le Roy encountered Peyre once again, and no doubt Moreau-Desproux, de Wailly, and Louis-François Trouard, all of whom had arrived in November 1754. Clérisseau was also back, serving as drawing instructor to Robert Adam, so Le Roy is likely to have met Adam, though there is no mention in Adam's letters of either Le Roy or his drawings from Athens. He is likely as well to have seen Nicolas Henri Jardin's drawings for his initial design for a great domed building for the Frederikskirke in Copenhagen, then on display at the Académie de France à Rome.[21] At this time Le Roy drew the capitals and fragments then in the nave of San Pietro in Vincoli and on the steps of Santa Trinità dei Monti — architectural elements to be incorporated into the *Ruines* and incorporated already, one might note, in the second volume of Richard Pococke's *A Description of the East and Some Other Countries* (1743–45). Le Roy might also have traveled then to Naples and Paestum (Pesto) — if he had not already done so, as he intended, before his hasty departure for Venice in 1754.[22] But Le Roy was eager to return to Paris. Before the month was out he had set off, without paying his respects to Natoire, for which he was to be severely reprimanded by Marigny. Le Roy's immediate concern was to stake a claim as the first to publish the monuments of Athens in full. His spur was the comte de Caylus.

Anne-Claude-Philippe de Tubières, comte de Caylus, had long been a fervent admirer of classical antiquity, that of Greece in particular.[23] As a young man he had set out in 1716 in search of the site of Troy and had spent almost a year wandering in Asia Minor, visiting the Artemision at Ephesus, but returning home, recalled by his mother, before exploring Athens itself — though he did reach Piraeus, the great harbor complex of Athens. His inspiration, as for so many early-eighteenth-century travelers, was probably the painter Cornelis de Bruyn's *Reizen door de vermaardste deelen van Klein Asia, die eylanden Scio, Rhodus, Cyprus, Metelino, Stanchio, etc., mitsgaders de voornaamste steden van Aegypten, Syrien en Palestina* (1698), which was translated into French in 1700 as *Voyage au Levant*. One cannot be sure when Caylus first encountered Le Roy, but he was certainly in contact with Le Roy while the latter was in Constantinople, requesting that Le Roy survey the harbors of Piraeus.[24] On 7 April 1755, before leaving Athens, Le Roy wrote to confirm that he had completed the task, though most of his letter to Caylus was given over to an account of his journey to Sparta, later to be incorporated in the *Ruines*. He noted, at the end, "Foreigners who travel here are indebted to Messieurs Stuart and Revett. They have revealed treasures hidden underground or in thick walls in Athens, and I have no doubt that their work is very precise and very beautiful."[25]

Whether Caylus spurred and underwrote Le Roy's expedition is not clear. Le Roy credited his father with all such support. Notwithstanding, Caylus was eager always both to assist young artists and to assert French authority in matters archaeological. For instance, he thought at the end of 1755 to further the publication of the drawings of Paestum that Jacques-Germain Soufflot and Gabriel-Pierre-Martin Dumont had made in June 1750 but was warned

off by Jean-Jacques Barthélemy lest he appear to act dishonorably with respect to conte Felice Gazzola (who had in fact learned of the matter through a letter from Le Roy passed on by Caylus to Barthélemy and thus to Gazzola). Gazzola had long been known to be working on a publication and had generously shared his knowledge with all and sundry, Soufflot included. When Soufflot's drawings were published by Dumont in 1764, Caylus was appalled at the lack of a proper introduction and wrote to Paolo Maria Paciaudi, an antiquarian and Caylus's agent in Rome, asking that he supply one for any future edition.[26] Nothing came of this; Caylus died the following year.

There can be no doubt, however, that once Le Roy returned to Paris, Caylus took a very active interest in his book. The testimony of Charles-Nicolas II Cochin is unequivocal. He wrote in his *Mémoires,*

> Monsieur Le Roy, an architect-*pensionnaire* of the king, had the opportunity to travel to Greece. He sketched the antiquities he found there, but his drawings were so crude that when we saw them in Paris, we had trouble imagining anyone could get anything out of them. Monsieur de Caylus, a warm admirer of Greece as well as Egypt, had them redone by Le Lorrain, who, though a very mediocre and unsuccessful painter despite his fine natural abilities, nevertheless drew in an agreeable and tasteful manner. He succeeded in making the drawings that were engraved; thereby one can judge their degree of fidelity and how reliable the details of that work are.
>
> The plates were to be engraved; that expense was beyond the means of Monsieur Le Roy, unless they could be done very cheaply; nevertheless, there was a desire to have them engraved well. No better choice could have been made than that made by Monsieur de Caylus when he turned to Monsieur Le Bas; but he had also to use all his persuasive eloquence to convince Le Bas to engrave them for half what the job was worth, by making him anticipate yet more recompense if the book was a success. The book sold well, but no bonus was forthcoming — something that Monsieur Le Bas, who can count perfectly well and is hardly indifferent to his own interests, has always complained about.[27]

Jacques-Philippe Le Bas was at the time accounted the finest engraver in France for views. Louis-Joseph Le Lorrain, a painter and printmaker, had made a name for himself while a student in Rome with his designs for the annual Festa della Chinea of 1745, 1746, and 1747; these drawings were engraved in the elegant, elegiac style he cultivated, establishing a new fashion in design, known as *goût grec,* which was advanced after Le Lorrain's return to Paris by Caylus, on whose recommendation Le Lorrain designed a suite of furniture for Ange Laurent La Live de Jully, master of ceremonies at court. Executed in ebony-veneered oak with heavy gilt bronze mounts, this suite *à la grecque* consisting of a clock (the works were by Le Roy's father) with a combined cabinet and writing table (1756–58; Chantilly, Musée Condé) was at once acclaimed as of authentic Greek inspiration.[28] In fact, there is nothing Greek about the furniture, even though Le Lorrain must have had the

drawings Le Roy made in Greece to hand. One of Le Lorrain's drawings, *La vue du temple de Jupiter Olympien à Athènes* — no doubt Le Roy's ruins in the bazaar, now identified as Hadrian's Library — was later in La Live de Jully's collection.[29] Concerning Le Roy's text, Caylus no doubt took part in its organization, but Camille Falconet, doctor to the king, owner of one of the largest private libraries in Paris (about forty thousand volumes), and a member of the Académie royale des inscriptions et belles-lettres, seems to have been called upon for authentic scholarship. "Immersed in that ocean of literature," Falconet's obituarist wrote in 1762, "he knew all of it perfectly well."[30] Both Falconet and Le Bas were thanked by Le Roy in the preface to the *Ruines* of 1758.

All concerned must have worked very hard. Less than six months after Le Roy's return from Athens, Barthélemy, then in Rome, was apprised of the intended publication. "Accept my compliments upon the work of Mr. Le Roy," he wrote on 10 December 1755 to Caylus,

> I long as much as you for its appearance; but I could wish, that you would let the English work [by Stuart and Revett] appear first. Is it not probable, that many persons might have seen better than one? These English are not those of Palmyra, but another company of travelers, who resided a long time in Athens, and whose work will soon be out. I have heard it very well spoken of by men who could not be prejudiced; and if it should chance to be better than Mr. Le Roy's, that lofty nation would exult. You know the force of this objection, and I submit it to your judgment.[31]

Ten days later he wrote again to report that he had actually seen the prints that Stuart and Revett were circulating: "I have seen the first proofs of the ruins of Athens by the English. They appear to be very well executed, and confirm me in the sentiment, which I imparted to you formerly."[32] But the pressure on Le Roy to publish seems to have remained intense, and by March 1756, his proposal had been issued (see this volume, pp. 518–21).

Le Roy thought to divide his book into two parts. The first, preceded by an essay on the history of architecture in general, was to provide a survey of the classical architecture of Greece, illustrated by plans of the Acropolis, the town and ports of Athens, and the plain of Sparta and by twenty-five views of buildings in their settings. The second, preceded by an essay on the principles of architecture, was to analyze the evolution, in three phases, of the Doric order, with comparative studies of the Tuscan order in Rome, followed by accounts of the Ionic, Caryatid, and Corinthian orders, illustrated by thirty-two plates of plans, elevations, and details of selected buildings. Stuart and Revett, in their earliest proposal, had thought to divide their work into three volumes, the first illustrated by views of buildings, the second by measured drawings, the last by sculptures and reliefs. Only after they reached Athens did they recognize the need to reshape their proposal, deciding then to devote each volume to a different group of buildings — views and measured drawings to be intermingled — the first to be given over to those on the Acropolis, the second to

those of the town of Athens, the last to those of Eleusis, Megara, and Sunium. Le Roy's arrangement was thus closer to their initial proposal, though he aimed rather more than they did to instruct. Like them he was in no doubt that the source of architectural excellence lay in Greece, not in Rome and still less in the architecture of the Renaissance, but he made clear from the start that he was not providing a survey of Greek architecture. He aimed at selectivity — "Not everything will be described in detail," he wrote of the buildings to be included, "because it seems there are only two reasons that would make necessary the rendering of the details — first, that they are sufficiently beautiful to be imitated by artists; second, that they might serve the history of art. The elements of architecture that fulfill these aims of curiosity and use will be discussed at length and in detail; the others will not be considered at such length."[33] To be issued before the end of the year, the book was available at fifty-four livres to subscribers, seventy-two livres after publication.

The proposal was at once summarized and trumpeted in *L'année littéraire, Journal des sçavans, Journal encyclopédique,* and *Mémoires de Trévoux* — in the first at greatest length, in the last with the best informed comment.[34] "The comte de Caylus and Monsieur [Pierre-Jean] Mariette," the editors noted, "have taken a strong interest in this enterprise, which they are overseeing as enthusiasts and connoisseurs: that is enough to speed up the subscription, the purpose of which is merely to defray the principal costs, since the work is to be a monument of glory for France, not a matter of private interest for the artist and those who wish to support him."[35]

In the event, the *Ruines* was not issued until nearly two years later, in August 1758, though much as planned in its arrangement. The volume was divided into two parts and opened with a dedication to Marigny, a preface in which Le Roy thanked those who had assisted him in his enterprise (though, notably, not Caylus), and a discourse on the history of architecture. The first part continued with an account of the journey from Venice to Athens, via Constantinople, including descriptions of the temples at Pola and Thorikos. A very brief history of Athens prefaced the account of the buildings of the Acropolis — the Parthenon (called the Temple of Minerva in Le Roy's text), Erechtheion, Propylaia, the Odeion of Herodes Atticus (identified by Le Roy as the Theater of Bacchus, now called the Theater of Dionysos and placed farther to the east on the southern slope of the Acropolis), and the choragic Monument of Thrasyllus. Next came the history of the buildings of the town of Athens: Hadrian's Library (Le Roy's "ruins in the bazaar," which he identified as the Temple of Jupiter Olympius) and the Tower of the Winds, both north of the Acropolis, near the Roman Agora; the Hephaisteion (called the Temple of Theseus by Le Roy), northwest of the Acropolis, in the Greek Agora; the Pnyx (identified by Le Roy as the Odeion of Pericles, now placed next to the Theater of Dionysos), west of the Acropolis; the Monument of Lysikrates, east of the Acropolis; and two buildings erected under the Romans: the Doric portico of the Roman Agora (described by Le Roy as a temple to Augustus, now identified as the Gate of Athena Archegetis), and the Monument of

Philopappos, on the Mouseion hill, southwest of the Acropolis. Next came Le Roy's observations on the Temple of Minerva Sunias at Sunium and the harbors of Athens. Accounts of the buildings of Athens concluded with four of the buildings in the Hadrianic suburb to the east of the Acropolis—the Arch of Hadrian, the so-called Columns of Hadrian (identified by Le Roy as Hadrian's Pantheon, now known as the Temple of Zeus Olympios), the Stadium of Herodes Atticus, and the Roman cistern (*dexamenē*) at the foot of Mount Lykabettos. These were followed by an account of Le Roy's journey to Sparta, via Corinth; a dissertation on the Greek foot that he had read to the Académie royale des sciences on 31 August 1757; and two pages of inscriptions.

The second part was prefaced by a discourse on the principles of architecture, followed by sections on Doric in its first state (the temple at Thorikos, the Temple of Apollo at Delos, and the temple at Corinth) considered in relation to the Tuscan order; Doric in its second state (the Parthenon, and the Propylaia); Doric in its third state (the Doric portico, now known as the Gate of Athena Archegetis, but identified by Le Roy as a temple to Augustus); the Ionic and Caryatid orders (the Erechtheion); and the Corinthian order (Hadrian's Library, Le Roy's ruins in the bazaar, there identified as the Temple of Jupiter Olympius; and the Temple of Zeus Olympios, the so-called Columns of Hadrian, identified by Le Roy as Hadrian's Pantheon). To end there were remarks on a group of circular buildings (the Monument of Lysikrates, and the Tower of the Winds), some assorted buildings (the temples at Pola, and the Arch of Hadrian), and various fragments (capitals from Delos and Rome).

The work was announced at once in the *Journal encyclopédique* and enthusiastically reviewed in *L'année littéraire, Mémoires de Trévoux*, and *Mercure de France*—in the last, it was, in addition, summarized in four issues from December 1758 to March 1759.[36] The reviewers all accepted without demur Le Roy's premise that the art of architecture had been perfected first in Greece. "Whatever role is granted to the Egyptians in the arts of Greece," the *Mémoires de Trévoux* opined, "one must nonetheless recognize that architecture is, strictly speaking, Greek in origin—that is, in terms of beautiful forms and exact proportions, the Greeks outstrip Egypt, the Greeks are the founders in this domain."[37]

The book was a triumph, even by the standards set by Wood and Dawkins, who had themselves furthered their reputation only a few months earlier in issuing the second of their books, *The Ruins of Balbec, Otherwise Heliopolis, in Coelosyria* (1757). "Hence you will find this collection," *L'année littéraire* wrote of Le Roy's book, "not only as interesting and accurate as *The Ruins of Palmyra* and [*The Ruins*] *of Balbec*, which I recommended to you, but also more knowledgeable, tasteful, well organized, and lucid. Monsieur Le Roy combines proficiency in his art with knowledge of mathematics, history, literature, and so on, and his work sets the tone for the English enterprise to follow."[38] The *Mercure de France* summarized Le Roy's achievement even more expansively: "The historical part is treated with the learning of a scholar

and the taste of a man of letters. The part on art leaves nothing to be desired, either from the observer or from the draftsman. The details are marvelously clear; the engraving is of a beauty worthy of the drawings. Monsieur Le Roy has forever saved from the ravages of time the mutilated but precious relics of Greece, now half deserted and half barbaric."[39]

In November 1758, as these assessments began to appear, Jacques-François Blondel reviewed a copy of the book, presented to him by Le Roy, for the members of the Académie royale d'architecture, once again with the highest approbation. His report prompted Le Roy's election, forthwith, to the academy—much to Marigny's satisfaction.[40] No less approving were the reviews that appeared in learned magazines published in Leipzig in the two years following.[41] Johann Joachim Winckelmann, not altogether surprisingly, struck the first critical note, mild enough; writing to Barthélemy in September 1760, he remarked that Le Roy should have included the temples at Paestum and Cora (Cori a Valle) in the third phase of Doric.[42] Even in England the book was received with real interest. The main distributor of Wood and Dawkins's books, Andrew Millar, announced in the *Public Advertiser* of 1 May 1759 that he had the *Ruines* for sale; by the month following another publisher in London, Robert Sayer, had for sale a plagiarized version, entitled *Ruins of Athens, with Remains and Other Valuable Antiquities in Greece,* for one pound ten shillings, half the price of the French original. This version—for which Le Roy's plates were combined, rearranged, and entirely re-engraved, his text much reduced and crudely translated, with the history of Athens taken from George Wheler's *A Journey into Greece* (1682)—was condemned in the *Critical Review* of July 1759. The public was advised "that Le Roy's plans are far from being correct; that his imagination in some places has run riot; that, in others, his drawings are faulty, his proportions false."[43] Buyers were advised to wait for a work drawn on the spot by an English artist. Another rip-off was attempted in the *Royal Magazine; or, Gentleman's Monthly Companion* of 1760, in the form of a summary of Le Roy's descriptions, illustrated by three plates, each combining, willy-nilly, two of Le Roy's images.[44] But four years later, in 1764, Millar was still anxious to get hold of copies of the *Ruines.* He asked David Hume, then in Paris, to procure a copy for Wood and noted that Wood was willing to exchange up to forty copies of *The Ruins of Balbec* for an equal number of Le Roy's book, if Le Roy and his publisher were amenable.[45]

The publication of Le Roy's volume galvanized Stuart, but though his text was more or less complete by the end of 1758, he decided to revise it yet again to call attention to Le Roy's mistakes. Revett was by then quite exasperated by the delays; he sold his interest in the undertaking to Stuart, who set to work at once to expose their rival. The first volume of *The Antiquities of Athens*— containing no more than the Doric portico (the Gate of Athena Archegetis, thought by Jacob Spon and George Wheler and subsequent visitors to have been part of a temple to Rome and Augustus, though correctly identified by Stuart as a gateway and not a part of a temple), the Ionic temple by the Ilissos

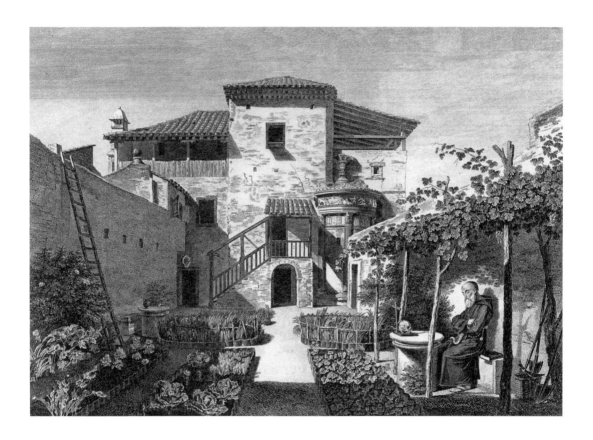

Fig. 5. Anthony Walker
A View of the Choragic Monument of Lysicrates in Its Present Condition, Taken from the
Farther End of the Garden Belonging to the Hospitium of the Capuchins
From James Stuart and Nicholas Revett, *The Antiquities of Athens* (London: printed by
John Haberkorn, 1762–1816), vol. 1, chap. 4, pl. I

(the Temple of Diana Agrotera, overlooked, to all intents, by Le Roy), Tower of the Winds, Monument of Lysikrates (fig. 5), and Hadrian's Library (identified by Jacques-Paul Babin, Spon and Wheler, and Le Roy, though not Stuart, as the Temple of Jupiter Olympius)—was to be published only in December 1762.[46] Dedicated to the king, its measured drawings and details were magnificently done, the text sharp and to the point. All too often, however, Stuart's point was to disparage Le Roy, and his obsession undermined the value of his own work. At the end of each chapter, Stuart painstakingly itemized Le Roy's misunderstandings and faults. He railed against Le Roy for publishing inscriptions and even descriptions taken from Spon and Wheler rather than from direct observation, for myriad inaccuracies of measurement and representation, for failing to recognize the dedication on the Monument of Lysikrates, for overlooking the temple by the Ilissos, and so on, reaching a crescendo of vituperation (nine closely printed pages) over the ruins in the bazaar (Hadrian's Library), which Stuart had come to realize were certainly not the Temple of Jupiter Olympius, though what they might be he would not venture. Le Roy, at any rate, was more inaccurate in his surmise and in his drawings in this instance, Stuart stressed, than in all others. Le Roy had sketched a temple in the center of the stoa where there was no vestige of one. "If it appears of any importance to the study of architecture," Stuart concluded,

> and to the reputation of ancient Greece, that these errors be detected, and that the false opinions concerning these Athenian antiquities, after having subsisted so long, be at length confuted, it must appear still of greater consequence, that the negligences of Mons. Le Roy should not escape our notice; the study of architecture which he professes, the critical knowledge which he affects to display in that art, the appearance of precision in his measures, and the pompous circumstances of his publication, give an air of authenticity to his errors, which seems perfectly calculated to impose them on us for so many accurate truths. The strictures therefore which in the course of our work have been so freely bestowed on his performance, will not, we imagine, surprise any of our readers.[47]

The appearance of the first volume of the *Antiquities* in December 1762 must have been something of an embarrassment to Le Roy, especially as just the month before Marigny had appointed Le Roy historiographer to the Académie royale d'architecture and assistant and successor to Blondel as professor of architecture.[48] The world of scholars and connoisseurs was abuzz with the attack. Most acknowledged that in terms of accuracy Stuart and Revett's work was far superior. Nonetheless, as Winckelmann would remark to Henry Fuseli in a letter dated 22 September 1764, their volume offered only the minor buildings of Athens and inflated their presentation out of all proportion. "Monstrum horrendum ingens, cui lumen adem[p]tum" (a monster awful, shapeless, bereft of light), he rudely remembered Virgil's description of the Cyclops Polyphemus.[49] But not until 1767 did Le Roy make a public response, in his *Observations sur les édifices des anciens peuples*, which was

published together with another study designed to bolster his scholarly status, "Dissertation sur la longueur de la carrière d'Olympie," read earlier in the year to the Académie royale des inscriptions et belles-lettres.

In the "Reflexions préliminaires" of the *Observations*, Le Roy wrote scathingly of Sayer's plagiarism, in particular, the English publisher's amalgamation of views, often unrelated, on one plate. The whole operation, he suggested, seemed expressly designed to undermine his own. But his main concern was with Stuart. He doubted, whatever Stuart's protestations, that Stuart's prime motivation was the defense of truth, for if that were so, Le Roy pointed out, how could Stuart have announced a book that he was not in a position to produce, not yet having measured even half the monuments of Athens? Le Roy himself had not promised a full survey, as the very title of his work made clear; nor, as his prospectus made clear, had he undertaken to illustrate the buildings in equal detail, but rather in accord with their historical interest or usefulness as exemplars. He wanted no superfluity of moldings and cornices, and whatever license he might have taken with the views, he had aimed to convey the essential effect of each building on the onlooker. "This entails," Le Roy averred, "introducing into the souls of those who see the image all the admiration that would strike them upon seeing the building itself"[50]—and also introducing, on occasion, as with the Albanians he had shown dancing in the street alongside the Monument of Lysikrates (see vol. 1, pl. 10), something of the continuities of history, for could not their dance be construed as a distant memory of that invented by Theseus, the dancers' handkerchief as a representation of the thread of Ariadne?[51] In any case, Le Roy had no doubts about whose views were better. But his sharpest riposte concerned the divergence of aims. Stuart thought that the only point was accuracy; Le Roy was intent on understanding the nature of Greek architecture. "I had very different ideas as to my journey," he wrote, "and I was certainly not in Greece simply to observe the relationship of the buildings and their parts to the divisions of our foot.... It was principally to understand the relationship of the monuments of Greece to one another, and to those of the peoples who preceded or followed them in a knowledge of the arts, and to those described by Vitruvius, that I measured them."[52]

While yet in Athens, it is important to note, Le Roy had managed to correct his first measurement of the Parthenon frieze, increasing it by two inches, to ninety-five feet six inches. He had done this by procuring a ruler from Canivet, a leading instrument maker in Paris who was soon to be appointed instrument maker to the Académie royale des sciences. The post had been left vacant in 1756 by the death of Canivet's uncle, Claude Langlois, who in 1735 had made the two new *toise* standards taken to Peru and Lapland on expeditions sponsored by the academy. In 1766 Canivet would make eighty copies of Langlois's Peru *toise*, also known as the *toise de l'Académie*, to be distributed to the provincial *parlements* of France in an effort to standardize measures.[53] Notwithstanding his lifelong obsession with measuring, Le Roy's claim about

his attitude toward measurement was no more than a statement of fact, nicely summarizing the difference between French and English attitudes to the study of the architecture of the past—the French, if they admired it, sought to capture the spirit of that architecture, the better to infuse it into their own tradition; the English sought a model to adopt or adapt.

But most of Le Roy's response to Stuart focused on the real subject of their dispute—the ruins in the bazaar. Given the emphasis on history in the first edition of the *Ruines*, it is not surprising that Le Roy sought in the *Observations* to consider the matter from a historical point of view. He thus began by declaring himself concerned not with the endless minutiae of history but rather with those undertakings and events that conferred real distinction on architecture. Some things scarcely mattered; others, seemingly secondary, were of the highest import, such as the forms of the stones erected by the Phoenicians on the graves of their heroes, or the idea of the primitive hut as described by Vitruvius, or the enclosing court that Agrus and Agronerus had first erected around it.[54] These were primal forms. In time, the Phoenician stones became obelisks, then pyramids, which gave rise to the oldest known pyramidal building in history, the eight-tiered ziggurat of the Babylonian Temple of Belus (the Tower of Babel of the Temple of Marduk, or the Etemenanki of the Esagila), which like the primitive hut was set, according to Herodotus (*History* 1.181), in a square court. These forms were taken up by the legendary ruler Sesostris after his return from Babylonia to Egypt,[55] where, to commemorate his conquests, he erected temples dedicated to the local deity in the principal cities. Each of these new temples consisted of a series of colonnaded courts separated by giant doorways. The greatest of these temples, that to the goddess Bubastis (Artemis) in the city Bubastis (Tall Bastah, near modern Az-Zaqāzīq, in the eastern Nile delta), was described by Herodotus (*History* 2.137–38) as a vast square enclosure sheltering a sacred wood with a tiered temple in the middle. Le Roy confidently assumed that the temple at Bubastis was adorned both inside and out with colonnades, though these features were not specified by Herodotus. This temple gave rise in turn to the Tabernacle of the Israelites, which was singular only in that it had five columns on the front facade—an irregularity found, Le Roy wrongly believed, only in three other temples, all of "the greatest antiquity,"[56] one in Egypt, one on the island Aegina, and the last at Paestum. The Tabernacle's surrounding court was lined with columns, ten on the shorter sides, twenty on the flanks, with piers behind to create a peristyle, cloth or skins suspended in between to serve as curtains that could be closed or opened as desired.[57]

And so to the Temple of Jupiter Olympius at Athens, described both by Pausanias (*Description of Greece* 1.18.6–9) and, according to Le Roy, by Thucydides (*History of the Peloponnesian War* 2.15.4). Le Roy narrated the complex history of the building of this temple, not altogether inaccurately, though without compunction he endowed it with the sacred wood and the colonnaded court that he had conjectured for the temple at Bubastis and the

colonnaded court he had described for the Tabernacle. The historical pedigree of the temple thus established, he turned to its siting. As in the *Ruines*, Le Roy relied in the *Observations* largely on Pausanias's description of the buildings of Athens in order to locate the temple, attempting at considerable length to determine the exact route the Greek geographer took through the city in the middle of the second century. But nothing was certain.[58] Le Roy was prepared to concede that he might have been incorrect in identifying the ruins in the bazaar as the Temple of Jupiter Olympius, but if it was not to be sited there, where else could it have stood? For the ruins known as the Columns of Hadrian identified by Stuart—correctly, as it turned out—as the Temple of Jupiter Olympius could not possibly be regarded as such, Le Roy argued, because Vitruvius (*De architectura* 2.8) had described the temple as having two rows of eight columns in the front and no more than seventeen columns on each side. Le Roy had located and measured the seventeen columns extant at the site and had drawn a temple with three rows of ten columns at the front and rear and two rows of twenty on each side. As this corresponded with some of the details of the description of Hadrian's Pantheon in Pausanias (*Description of Greece* 1.18.9), Le Roy saw no alternative but to identify the Columns of Hadrian as Hadrian's Pantheon, and he forcefully reiterated his earlier claim that they were not the remains of the Temple of Jupiter Olympius.

The second edition of the *Ruines,* of 1770 (though Le Roy was able to send copies to Chambers in November 1769), provided a final riposte to Stuart. The material of the first edition was thoroughly rearranged. The division between history, illustrated by views, and theory, illustrated by measured drawings, remained. The essays on history and theory, greatly extended, were set, as before, at the head of each of the two volumes that now made up the *Ruines,* but the monuments themselves were divided between the volumes, and in each volume the monuments were considered in terms of history (part 1) and theory (part 2). The first volume included the chief buildings of the Acropolis—the Parthenon, Erechtheion, and Propylaia—and those of its surrounds that were considered to have been built before the end of the age of Pericles (late fifth century B.C.)—the Theater of Dionysos, Hephaisteion, Odeion of Pericles, and Monument of Lysikrates. These were analyzed in the theoretical section of the book under the heads of Doric in its first and second states (the Parthenon, and the Propylaia), the Ionic (the Erechtheion), Caryatid (the Erechtheion), and Corinthian orders (a page on the Monument of Lysikrates). The second volume covered post-Periclean buildings—the Monument of Thrasyllus, Tower of the Winds, Doric portico (now identified by Le Roy as part of a temple to Minerva and Augustus), Monument of Philopappos, ruins in the bazaar (now identified by Le Roy as a temple to Juno Lucina), Arch of Hadrian, Columns of Hadrian (identified still as Hadrian's Pantheon), Stadium of Herodes Atticus, and the remains of the Roman cistern. These were dealt with, as before, in two parts, as history, with views, and as theory, with measured drawings. But the balance of the second volume was none too satis-

factory. Far too much of Le Roy's text was devoted to the matter of Pausanias's route through Athens and to the ongoing arguments with Stuart — for whatever Le Roy's conclusions, the identity of two major ruins (the Columns of Hadrian, and the ruins in the bazaar) remained in doubt. The unevenness of the second volume was furthered by the inclusion in it of the journey to Sparta via Corinth, which meant that the Doric of the temple at Corinth, though early, had to be considered in the theoretical part of this volume along with an odd assortment of much later buildings. The ostensible purpose of all this juggling, Le Roy declared in his preface, was "to make clear the difference between the buildings erected by a free people...and those produced by the same people when, under the yoke of Rome, they had lost part of their former pride and genius" (p. 205).[59] But the more vital aim, one might judge, was to embarrass Stuart and to relegate, as far as might be, to the very end of the first volume, and better still to the age of decline of the second volume, the two monuments that Stuart and Revett had measured with such painstaking care and had illustrated so beautifully in the only volume of their work to have appeared — the Monument of Lysikrates, and the Tower of the Winds. To cast the Tower of the Winds even further into obscurity, Le Roy's two plates of its plans, section, and elevation — revealed by Stuart to be altogether inadequate — were omitted from the second edition of the *Ruines*, the only plates to be removed.

For the rest, the *Ruines* was greatly enlarged. The text increased by as much as one-third, mainly through the absorption of the two short books that Le Roy had written in the interval between the two editions: *Histoire de la disposition et des formes différentes que les chrétiens ont données à leurs temples depuis le règne de Constantin le Grand, jusqu'à nous* (1764), published to coincide with the laying of the foundation stone of Soufflot's Sainte-Geneviève (now the Panthéon); and *Observations sur les édifices des anciens peuples, précédées de Réflexions préliminaires sur la critique des Ruines de la Grece, publiée dans un ouvrage anglois, intitulé Les antiquités d'Athènes, et suivies de Recherches sur les mesures anciennes* (1767). Three-quarters of the *Histoire* was included in the essays on history and theory in the *Ruines*. The substance, if not always the exact text, of about one-third of the "Reflexions préliminaires" of the *Observations* was incorporated into the new preface, though no more than one-tenth of the main text, but as the *Observations* constituted Le Roy's first response to Stuart, most of the information it contained served as the basis for his further reply. The "Recherches sur les mesures anciennes," the essay on Greek stadia concluding the *Observations*, was taken in full.

Much of the added matter, however, was in the form of footnotes. Le Roy was determined to display himself a scholar this time around. Lengthy quotations in Greek and Latin were added. Variations in the translation of Vitruvius's *De architectura* were discussed to tedium, Claude Perrault's rendering into French, first published in 1673, being pitted against marchese Berardo Galiani's Italian version, which had appeared in 1758, with Le Roy often

offering translations of his own. Sources throughout were cited with a new precision—passing references to works by Antonio Labacco and Sebastiano Serlio in the first edition, for instance, are pinpointed in the second. "What will particularly distinguish this edition from its predecessor," Le Roy noted in the preface, "is the wealth of quotations that I have added" (p. 206).[60]

Of the hundred-odd pages of text in the first edition, no more than about twelve were omitted, among them the two-page dedication to Marigny and the three pages of the preface largely given over to Le Roy's acknowledgments. Much of the text was rewritten, as might be imagined, in response to Stuart, but so also were the accounts of the Parthenon and the Erechtheion, which remained an enigma to the end, as Le Roy could not comprehend the architecture or decide whether the ruins on the Acropolis to the north of the Parthenon were the "combined temples of Minerva Polias and Pandrosos" or the "double temple" of Erechtheus (p. 253).[61]

The sixty plates of the first edition (four maps, twenty-four views, and thirty-two measured drawings) were reused for the second edition (minus the two plates of the Tower of the Winds) but were, of necessity, rearranged and renumbered. Captions on four were altered in response to the dispute with Stuart, but only two were adjusted internally: the dimensioning at the base of the column of the Doric portico was reduced by two inches (Le Roy noted the faultiness of his ruler), and the three porticoes that had been shown on the plan of the "temple enclosure" in the bazaar were reduced to one. Three plates were added: a revised version of the comparative diagram of temples and churches that had illustrated the *Histoire* (see vol. 1, pl. 1); an enlarged version of the plans of stadia that had been included in the *Observations* as an illustration to "Recherches sur les mesures anciennes" (see vol. 2, pl. 15); and a new assemblage of plans and elevations of temple fronts and circular or octagonal buildings (see vol. 2, pl. 25), which included the Tower of the Winds, in miniature. Costs of engraving were, clearly, being kept to a minimum. The paper of the second edition, one might note, was considerably less costly than that of the first.

The problem of the Temple of Jupiter Olympius, more correctly the Temple of Zeus Olympios, was not to be resolved until many years later. Stuart had not himself measured the so-called Columns of Hadrian, but he had in his possession Revett's drawings, done after Stuart's departure from Athens, and these, like Le Roy's, indicated a temple with twenty columns on the flanks. Studying William Newton's English translation of 1771 of the first five books of Vitruvius,[62] Stuart found that he, following Galiani's Latin and Italian edition of 1758, had introduced an ampersand into the text that allowed the octastyle temple at Athens and the Temple of Zeus Olympios to be regarded as two different buildings, the latter a decastyle. This offered Stuart a way out of the impasse and almost confirmed his identification—though not quite, for if the temple were indeed a true decastyle, it should have twenty-one columns on the flanks. Stuart, unabashed, added a row of columns in red chalk to Revett's drawings. This was a matter with which later editors of *The*

Antiquities of Athens had to contend—the second volume was issued only in 1790, two years after Stuart's death, and the third did not appear until 1794. Only in 1884, when the site was excavated by the architect Francis Cranmer Penrose, was the Temple of Zeus Olympios found to be an octastyle with twenty columns on its flanks—something altogether exceptional.[63]

Stuart and Revett's and Le Roy's surveys are marked by other divergences, but only one—related to the matter of measurements, yet quite distinct—need be noted here. The reader will have remarked already that Stuart and Revett offered the *antiquities,* Le Roy the *ruins.* Stuart and Revett presented their views as the start in a process of reconstructing each building, in the form of finely finished measured drawings; Le Roy grouped his views together as part of the process of history. Stuart and Revett saw in the picturesque remains evidence of a glory that had passed, where Le Roy, one might hazard, found objects of wonder and beauty. Ruins revealed the poetry of architecture to Le Roy.

Ruins have not always been admired, of course. In classical times they were thought of as evidence of a fallen grandeur. In the Middle Ages the ruins of Rome were referred to, if at all, in much the same way as those of Troy or Carthage (the most often noted of antique sites), in terms of moral opprobrium. They were lessons to the decline of human achievement and the folly of human pride. Petrarch was among the first to look upon them with respect, most movingly in his letter to Giovanni Colonna, of 1341 or 1342, recalling their wanderings in the ruins of Rome,[64] and he was followed by the humanist scholars and artists of the Renaissance, who inspected the remains of antiquity to learn of the forms and the rules of classical architecture. Ruins were recast as objects that spoke of the splendor of the past and from which one might learn, but they were probably not much appreciated as things of beauty in themselves. Not until the end of the fifteenth century were their artistic possibilities to be exploited, in an illustration in the *Hypnerotomachia Poliphili* (Dream of Poliphilo), printed in Venice in 1499. As an indication of how differently ruins were viewed, even then, by Italians and Frenchmen, one might note that when a French edition of the work was published in 1546, the informally composed Italian woodcut was replaced with a more formally composed French image.[65] Even the poet Joachim du Bellay, though greatly moved by the ruins of ancient Rome, and intent in *Les antiquités de Rome* (1556) to conjure the same emotions they had aroused in him for his countrymen, found no charm in the spectacle of their decay. Maerten van Heemskerck's sketchbooks of 1532 and 1536 bear witness nonetheless to the thoroughness and painstaking care with which the ruins of Rome were being observed in the sixteenth century.[66] The recently discovered *Fantastic Landscape with Ruins (Tempus Edax Rerum)* by Hermannus Posthumus, also of 1536, demonstrates just how intriguing a painter could find those remnants of the past.[67] In 1575 Etienne Du Pérac, an architect, published a book on the ruins of Rome, *I vestigi dell'antichità di Roma,* showing them both in their ruined state and imaginatively restored, but his enthusiasms were none too

widely shared. When Michel de Montaigne visited Rome in 1580, he declared himself disgusted by the ruins; they were to him unworthy of their original grandeur. Many others thought as he did.

The evocative magic of the ruins was to be celebrated only in the following century, first in the paintings of French artists such as Nicolas Poussin, Jean Lemaire, and Claude Lorrain, and soon after by artists from Holland and Flanders who adapted their native topographical traditions to the landscape of Rome. Pietro Santo Bartoli, Domenico de Rossi, and other engravers published an array of books on the ruins of Rome in the late seventeenth century. Desgodets famously recorded the buildings of classical Rome, restored, in his *Les édifices antiques de Rome* (1682), the spur to almost all the archaeological surveys of the following century. Attitudes were clearly being reconsidered and thought out anew. Ruins were providing lessons for architects as never before; they were also being rediscovered and clearly seen and understood as mnemonic symbols.

By the middle of the eighteenth century a new note had been struck, something quite without precedent. A fragment was upheld as more wonderful by far than the original entire. Describing the single standing column of the Temple of Peace (the Basilica of Maxentius, in the Roman Forum)—by then adorning the piazza outside Santa Maria Maggiore—Charles de Brosses wrote, "I cannot tell you what that temple was, but only that that isolated column is the most beautiful thing in architecture in the whole world, and that seeing it gives me as much and perhaps more satisfaction than the view of any complete building, ancient or modern, by presenting to me the idea of the highest degree of perfection art has ever achieved."[68] This undated letter was probably written soon after 1750. De Brosses's letters circulated freely among his friends in the decades before his death in 1777, but they were published only in 1799, at the behest of the historian Antoine Sérieys, as *Lettres historiques et critiques sur l'Italie*. While a student in Rome in the 1750s, Le Roy might well have been privy to de Brosses's new viewpoint. And Chambers, with whom Le Roy was in close contact, early gave imaginative architectural expression to this attitude: in 1751, after hearing of the death of his patron, Frederick, Prince of Wales, Chambers composed a design for a mausoleum in his honor, a grand domed and colonnaded affair; the following year, while yet in Rome, he drew a section of the prince's mausoleum in ruins. Even earlier, in 1748, one might note, the French designer Gilles-Marie Oppenord had engraved a design for a new building—a grotto and salon—for Clemens August, elector of Cologne, in the form of a ruin, and this was published about 1750 in the so-called Grand Oppenord.[69] But exercises of this sort, though later quite common, were still unusual.

The next twist in the reaction to ruins occurred some twenty years later. They were viewed, quite suddenly, not only as symbols of the past but also as uneasy portents of the future. Reviewing one of Hubert Robert's compositions, *Ruine d'un arc de triomphe, et autres monuments*, at the Salon of 1767, Denis Diderot wrote,

The effect of these compositions, good or bad, is to leave you in a state of sweet melancholy. Our glance lingers over the debris of a triumphal arch, a portico, a pyramid, a temple, a palace, and we retreat into ourselves; we contemplate the ravages of time, and in our imagination we scatter the rubble of the very buildings in which we live over the ground; in that moment solitude and silence prevail around us, we are the sole survivors of an entire nation that is no more. Such is the first tenet of the poetics of ruins.[70]

Within a few years, or perhaps in that very year, René Louis, marquis de Girardin, erected the Temple of Modern Philosophy overlooking the lake at Ermenonville—a ruin it would seem, similar to the temple at Tivoli, but in fact a building yet incomplete, its six standing columns dedicated to René Descartes, Isaac Newton, Montesquieu, Voltaire, Jean-Jacques Rousseau, and William Penn, with additional columns lying on the ground, one inscribed "Qui l'achevera?" (Who will finish this?).

The challenging issue of ruins, fragments, and unformed architecture is key to understanding not only the form of Le Roy's great folio but also his theories of architecture. His book, in contrast to that of Stuart and Revett, can be seen as a reflection of newly emerging attitudes to ruins. This introduction could, indeed, have been written around that theme—a subject so vast and so enthralling that I have determined to resist its lure, lest it get quite out of hand. I offer no more than this summary and turn instead to a survey of some of the less frequently studied cultural forces that affected the making of *Les ruines des plus beaux monuments de la Grece.*

The Early Exploration of Greece

The inspiration and even the form of Le Roy's *Ruines* was greatly influenced by Stuart and Revett's *Antiquities,* but there were other motivating forces, more determining yet. Ultimately, rivalries, whether personal or national, were of little account in relation to the very real desire to unravel the mysteries of Greek architecture. For Le Roy and his contemporaries, classical Greek architecture was understood almost entirely on the basis of the writings of the first-century B.C. Roman architect Vitruvius. According to the fourth book of his *De architectura,* the beginnings of Doric were discernable in the Temple of Hera, near Árgos, though the rules of harmony were as yet unformulated. These were to evolve only in the Athenian colonies in Ionia, but once established they provided the model for all proper architecture. There was no question but that true architecture had emerged and reached its fulfillment in Greece or in Greek lands. All this was readily accepted by Renaissance commentators on Vitruvius, but it remained no more than a literary trope, for there was no real knowledge of the architecture of Greece.[71] Athens and the mainland of Greece were visited twice by the great Italian traveler Ciriaco d'Ancona, in 1436 and 1444; but though he eagerly inspected the antiquities and recorded what he saw in notes and drawings, he could evoke no more than the crudest approximation of the originals. Nonetheless, his drawing of

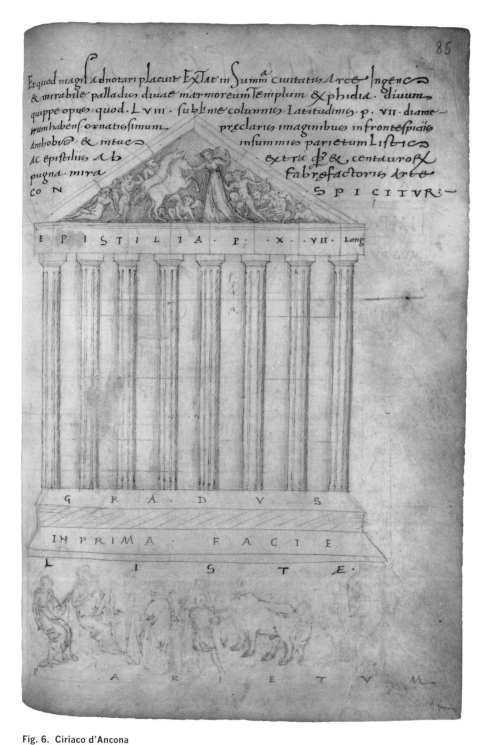

Fig. 6. Ciriaco d'Ancona
West facade of the Parthenon, ca. 1435, MS Hamilton 254, fol. 85r
Berlin, Staatsbibliothek zu Berlin, Handschriftenabteilung

the west front of the Parthenon (fig. 6) shows the Doric columns fluted and without bases, as described by Vitruvius—marks of authenticity lost when the drawing was copied some sixty years later by Giuliano da Sangallo.[72] For almost two centuries these two drawings remained the only images of the Parthenon available to architects in Europe, and Le Roy was sufficiently curious to view Sangallo's manuscript, then in the Barberini library in Rome.

After the fall of Constantinople in 1453 and the Turkish conquest of Greece a few years later, Athens, and the Acropolis in particular, became virtually inaccessible to foreigners. For inspiration and examples from the classical past, the architects of the Renaissance thus relied on Roman ruins, which, though regarded as mere imitations of the Greek originals, were readily visible throughout Europe, and most particularly in Rome. The rich vocabulary of sixteenth- and seventeenth-century architecture was developed without reference to the actual architecture of Greece; over time, the glories of Rome were accepted by many as the real source of inspiration for contemporary architecture and extolled as such. In his *Cours d'architecture* (1691), Charles-Augustin d'Aviler expressed the common belief that "Rome...still contains that which is most precious and from which the best principles of this art have been drawn, since it is difficult to believe that the Greeks, who invented the orders, elevated them to the same level of perfection as the Romans."[73]

But this was a pragmatic stance. Connoisseurs and theorists who aimed to purify architecture were all too willing to reject the richness of Roman form. Most notable among these was Roland Fréart, sieur de Chambray, author of the *Parallèle de l'architecture antique avec la moderne* (1650), which was translated into English in 1664 by none other than John Evelyn. Fréart, together with his brothers Jean and Paul, and their cousin François Sublet de Noyers, who was surintendant des bâtiments du roi from 1638 to 1643, concerted to institute a state-supported policy of renewed classicism in France. In 1640 they succeeded in bringing Nicolas Poussin back from Rome to Paris, where he worked for two years on a set of friezelike, severely classical designs for the Grande galerie of the Palais du Louvre, but when Sublet de Noyers was dismissed in 1643, they lost their base in official power. The *Parallèle* thus became their chief instrument of propaganda. Fréart was intent to do away with all Roman and Renaissance elaboration. He upheld the Greek orders alone.

I willingly communicate the thoughts which I have had of separating in two branches the *five Orders of Architecture*, and forming a *body* a part of the *Three* which are deriv'd to us from the *Greeks*; to wit, the *Dorique, Ionique*, and the *Corinthian*, which one may with reason call the very flower and perfection of the *Orders*; since they not onely contain whatsoever is excellent, but likewise all that is necessary of *Architecture*; there being but three manners of *Building*, the *Solid*, the *Mean*, and the *Delicate*; all of them accurately express'd in these three *Orders here*, that have therefore no need of the other two (*Tuscan*, and *Composita*) which being purely of *Latine* extraction, and but forrainers in respect to *them*, seem as it were of another *species*; so as being mingl'd, they do never well together.[74]

But determined though he might be to revert to the Greek orders alone, Fréart knew nothing of authentic Greek architecture. His baseless Doric was that of the Theater of Marcellus, in Rome, a Tuscan order.

Even Claude Perrault, who abjured all blind adoration of the ancients (the Greeks), unwaveringly accepted the Vitruvian position in *Les dix livres d'architecture de Vitruve* (1673), his translation of *De architectura*. Following an illustration in Serlio's *Il terzo libro, de la antiquita* (1540), Perrault showed the Doric order fluted and without a base, though he was not prepared to recommend its use in this form for other than theatrical sets or ephemeral displays. Subsequently, in his *Ordonnance des cinq espèces de colonnes selon la méthode des anciens* (1683), Perrault stressed even more forcefully his determination to reject all later accretions and distortions and to revert to the simplicity of the Grecian originals—but, like Fréart, he was without any real knowledge of that architecture, and he was, moreover, willing and even eager to accommodate to his contemporaries' architectural practices. More radical in his respect for the originals was Perrault's follower, the Cistercian abbé Jean-Louis de Cordemoy. In his *Nouveau traité de toute l'architecture* (1706), Cordemoy not only discounted the Roman orders, upholding the three Greek orders alone, with even simpler proportions than usual, but also envisaged, in his later letters defending his ideas, the general use of the baseless Doric.

Such severity cannot have been too seriously intended, however. The position maintained by theorists in France in the early years of the eighteenth century was rather more flexible, that of Fréart and Perrault. Even Cordemoy's strongest critic, Amédée-François Frézier, declared in his *Dissertation sur les ordres d'architecture* (1738), "for the finest models of architecture, we are beholden, first to the Greeks, and then to the Romans, who imitated them."[75] Similar sentiments were expressed in the same years by Jacques-François Blondel, Le Roy's master. But disparagement of the Roman achievement had already emerged, as we shall see, in the writings of Nicolas Gedoyn and of Caylus. A stand dismissive of the arts of Rome is perhaps something of a surprise when firsthand acquaintance with the arts of Greece was so restricted. Literature and philosophy were within the grasp of most readers, pottery and vases were to be seen in a handful of curiosity cabinets, including Caylus's own, but very few works of sculpture in the collections of the rulers of Europe could be claimed, with any confidence, to be the work of Greek artists, while the great monuments of Greek architecture had been viewed by only a handful of travelers, not one of them an architect, and no adequate records were available.

Yet knowledge of Greek art was being accumulated, extremely slowly. After the French king Frances I signed a trade treaty with the Ottoman sultan Süleyman I in 1536, diplomats, merchants, missionaries and even adventurers were able to enter the lands of the Levant.[76] The focus of their attention was Constantinople, however, and those with antiquarian interests concentrated on the acquisition of manuscripts and coins, sculpture and reliefs, and perhaps the recording of inscriptions, not on architecture. A succession of French

ambassadors to the Sublime Porte — Jean Hurault, seigneur de Boistaillé; François Savary, comte de Brèves; and Achille de Harlay de Sancy — set the tone by acquiring manuscripts for their own collections, and soon they were being required to buy on behalf of the king. But only in the reign of Louis XIV did such acquisition become systematic: Cardinal Jules Mazarin and the French chancellor Pierre Séguier initiated a policy of actively pursuing antiquities and manuscripts — mainly for themselves though, rather than the king — largely through the offices of the ambassador Jean de La Haye, but also through the appointment of special agents, notably the Cypriot priest Athanasius Rhetor. Between 1643 and 1663, the latter purchased over three hundred manuscripts, mostly from the monastic community at Mount Athos, in Greece. This policy, as might be imagined, was taken up and greatly furthered by Jean-Baptiste Colbert, who not only coerced on the king's behalf successive ambassadors and the growing number of French consuls scattered throughout the Levant but also recruited and instructed a succession of agents on his own account. Notable among these representatives were de Monceaux and Laisné, about whom almost nothing is known except that between 1667 and 1675 they journeyed, together and separately, to the Levant on behalf of the Bibliothèque du roi; Johann Michael Wansleben, son of a Lutheran pastor, who had entered the Dominican order in Rome and later moved to the Levant (1671–76); Antoine Galland, the orientalist who was to become famous for *Les mille et une nuits: Contes arabes* (1704–17), who traveled three times to the east (1670–75, 1676, 1679–89); and Pierre Besnier, a Jesuit, who took rather too active an interest in diplomatic affairs and was quickly recalled (1679). Charles Perrault, brother of Claude and Colbert's right-hand man from 1663 to 1683, was in charge of all these agents. They were given detailed instructions concerning the manuscripts they were to seek — sometimes information about specific manuscripts in specific monasteries — and general guidance as to medals and coins, but they were also advised to travel with Pausanias to hand and to make sketches and measurements of the significant monuments they encountered. Wansleben was directed to visit Baalbek. His instructions, dated 17 March 1671, give evidence of a real interest in architecture:

> He will observe and describe as accurately as he can the principal palaces and buildings, both ancient and modern, located in the places he will pass through, and he will try to deduce and reconstitute the plans and sections of those that are in ruins; and, if he cannot do all the buildings completely, he will at least do the principal parts that have remained, such as columns, capitals, cornices, and so forth; and, as for the modern ones, in describing them he will indicate the principal functions of each of their parts.[77]

Whatever their instructions, none of these agents was equipped to record architecture with any degree of finesse, and all knew only too well that what mattered most were the manuscripts. De Monceaux in fact visited Baalbek and made a tolerable survey of the temples there that was to serve as the basis

for a sheaf of engravings by Jean Marot, issued around 1670 and perhaps used by the Perrault brothers as a justification for their design for the projected reconstruction of Sainte-Geneviève, Paris, of soon after. Laisné stopped at Ankara on his way to Persia and made some notes and a crude sketch of the *cella* (body) of the Temple of Augustus there that would serve as the basis of some learned comment in Claude Perrault's Vitruvius, but that was all.[78] These men revealed nothing of the art and architecture of Greece.

This last was to be the particular province of Charles-François Olier, marquis de Nointel, who was dispatched as ambassador to Constantinople in August 1670, to renew France's trade treaties with the Sublime Porte. He was accompanied by Galland, then on the first of his journeys, who was charged to take attestations from the elders of the Greek church in relation to the religious dispute with the Jansenist Antoine Arnauld.[79] Nointel adopted a high and arrogant manner, which served him well. By September 1673, agreements seemed to have been reached with the Ottoman ruler, so the ambassador set out to visit Egypt, taking a considerable and costly train, about forty in all, including Galland; a French gentleman, Antoine Des Barres, and an Italian one, Cornelio Magni, both of whom were later to publish books relating to their trip; and two artists in Nointel's employ, Rombaut Fayd'herbe, a Fleming, and Jacques Carrey, of Troyes, a pupil of Charles Lebrun. They visited Delos, a long description of which is to be found in Galland's journal. On Naxos, in December 1673, Fayd'herbe died. While Nointel was in Jerusalem, the Ottoman grand vizier recalled him to Constantinople. Nointel was prepared to relinquish Egypt, but he determined to visit Athens on his way back. He reached Piraeus on 14 November 1674 and departed thirty-four or thirty-five days later. Two weeks of this period were spent in Boeotia, though he was mainly in Athens, where unlike de Monceaux and Laisné, as he noted in his dispatch of 17 December 1674, he was allowed free access to the Acropolis. The upper part of the south wing of the Propylaia was occupied by the aga, while his harem was in the Erechtheion. Nointel saw these edifices but made no observations. The Temple of Athena Nike was intact (in 1686 it would be dismantled and its stones used to strengthen the fortifications; it was to be rebuilt only in 1836). It too was left unrecorded. Nointel focused his attention on the Parthenon, on its sculpture in particular. The building was then largely intact. The *cella* had been converted into a church in the fifth century, and an apse constructed at the east end, occasioning the collapse of the central portion of the pediment. The rest of the sculpture in the pediments was untouched, as were the friezes, apart from six slots for windows. The metopes on the north, west, and east sides had been systematically defaced; those on the south survived still. For two weeks Nointel's artist, almost certainly Jacques Carrey, worked with a rare intensity to record the sculpture in the pediments (fig. 7) and the friezes, as well as the metopes extant on the south side. Not all his drawings survive, but the thirty-five that do provide an unparalleled archaeological survey of the Parthenon's classical sculpture. Nointel was systematic and comprehensive in his aims. He noted of the drawings in his dispatch, "I

am persuaded that they will be particularly well received in that, in addition to their accuracy, they are also commendable for their rarity, which makes them unique."[80] The representation of the capitals and columns under the pediments, as of the so-called Columns of Hadrian and other ruins in Athens sketched by Carrey, is altogether inept, however, and no measured drawings were made. By 21 February 1675 Nointel was back in Constantinople, and it was there, one must assume, that the vast panorama of himself and his retinue seen against the background of Athens (fig. 8) was painted. The trade treaty was successfully concluded, but the merchants of Marseille, who were expected to pay for the embassy, balked at the cost. Nointel was recalled in 1677. He retreated upon his return to his château at Bercy, intending to write an account of his journey, but it was never forthcoming.

However, one of Nointel's train, the abbé Pecoil, meeting in Constantinople a Jesuit missionary, Jacques-Paul Babin,[81] who had five times traveled to Athens, encouraged him to record something of the state of that town. From Smyrna, Babin sent some notes to Pecoil, returned by then to Lyon. These notes Pecoil passed on to a local doctor and antiquarian, Jacob Spon, who edited, enlarged, and finally published them in 1674 as *Relation de l'état présent de la ville d'Athènes*. Spon was so stirred by Babin's report that he decided to embark on a voyage of exploration of his own. In Rome he encountered George Wheler, from Oxford, an enthusiastic botanist and fellow Protestant. They decided to travel to Greece together, Wheler giving some financial aid to Spon. By the time they embarked from Venice on 20 June 1675, they had been joined by two more Englishmen, Sir Giles Eastcourt and the mathematician Francis Vernon, a friend of the Italian ambassador to the Sublime Porte, on whose ship they all traveled. The party split up at Zante, Eastcourt and Vernon moving via Patras to the Gulf of Corinth, Domvrena, and Athens, Spon and Wheler continuing on to Constantinople. Eastcourt and Vernon spent no more than a week in Athens before going to the Peloponnese and then north again via Patras to Lepanto (Návpaktos), where Eastcourt died. Vernon traveled on to Delphi and then back to Athens, where two months were spent, in part, in measuring the Parthenon. He decided then to make for Persia (Iran). By the new year he was in Smyrna, from which he wrote a short but extremely judicious account of his observations on Greece, published on 24 April 1676 in the *Philosophical Transactions* of the Royal Society of London. He saw at once that the Hephaisteion was "much less" than the Parthenon, which he judged the equivalent, at least, of the most esteemed building to have survived from antiquity, the Pantheon in Rome—"The Temple of Minerva is as entire as the Rotunda. I was three times at it, and took all the dimensions, with what exactness I could." The Erechtheion, he thought, "most fine, and all the ornaments most accurately engraven," the Monument of Lysikrates "neat architecture."[82] Within a year Vernon was dead, killed outside Ispahan (Eşfahān, Iran) in a dispute over his knife. Spon and Wheler, meanwhile, had reached Constantinople, where they were received by Nointel, shown all his drawings, and allowed to copy his

Fig. 7. Attributed to Jacques Carrey
Left half of the west pediment of the Parthenon, 1674,
drawing
Paris, Bibliothèque Nationale de France

Fig. 8. Attributed to Jacques Carrey
The Marquis de Nointel's Arrival at Athens, 1675, oil
Athens, National Art Gallery and Alexandros Soutzos
Museum

inscriptions. They traveled thence to Smyrna, where they were welcomed by the fifty-odd English residents there, and then to Ephesus. At the end of November 1675, they sailed from Smyrna to Zante and from there, by the same route as Eastcourt and Vernon, to Athens, which they reached finally at the end of January 1676. They spent almost a month in Athens, making excursions to Eleusis and Corinth. They set out then for Mount Athos, but finding their way blocked by snow, they separated, Spon making his way back to Zante and Venice, and thus to Lyon, where he published his *Voyage d'Italie, de Dalmatie, de Grece et du Levant* in 1678, Wheler returning to England via Athens, reaching home in November 1676, some months later than Spon. In 1682 he published *A Journey into Greece*, in part no more than a translation of Spon's work, to which was added some comment and observations of his own on plants. Spon's book was published in German in 1681; it was abridged and translated into Italian by Casimiro Freschot in 1688.[83]

Spon's book was surprisingly comprehensive and precise but, inevitably, descriptive rather than interpretative. He knew what to aim for — "We hastened to go to see the large mosque, which had once been the Temple of Minerva, and was the largest building on the citadel. The sight of it roused a certain awe in us, and we stood considering it for a long time, without tiring our eyes."[84] A long, factual account follows, providing little enough to inspire, though Spon did note that "The Order is Doric, and the columns are fluted and stand without base."[85] And that was how it was illustrated in a miserable engraving (fig. 9) that was to serve as the standard image of the Parthenon for over sixty years. He also illustrated the Doric portico, Hephaisteion, Tower of the Winds, and Monument of Lysikrates, in which the Capuchins had installed their library in 1669. These monks had drawn up a plan of Athens between 1669 and 1671, which had served as a guide to Spon.

A fictitious account of a journey to Greece, *Athènes ancienne et nouvelle* (1675), based on Capuchin missionaries' maps and notes, had followed Spon's publication of Babin's notes on Athens. This composition was by Georges Guillet de Saint-Georges, writing under the name La Guilletière. The book was extraordinarily successful, running to at least four printings in the first year, and an English translation in the year following. Spon himself had received a copy in Venice, on his way to Greece, but detected its falsity soon enough. He engaged in a lively controversy on his return, abetted by Galland, thus ensuring considerable publicity for Spon's own work. Des Barres published *L'estat present de l'archipel* in Paris in 1678, and Magni issued *Relazione della città d'Athene, colle provincie dell'Attica, Focia, Beozia, e Negroponte* in Parma in 1688, but these were racy, unreliable journals of their travels while in Nointel's entourage, intended to excite, not to inform.

By then the form of the Acropolis had been changed irrevocably. When the sultan's armies failed to capture Vienna in 1683, the Austrians and Venetians formed an alliance intending to recover some parts of the Ottoman Empire. A motley expeditionary force made up of mercenaries, under the command of Francesco Morosini, a Venetian, took control of the Peloponnese almost at

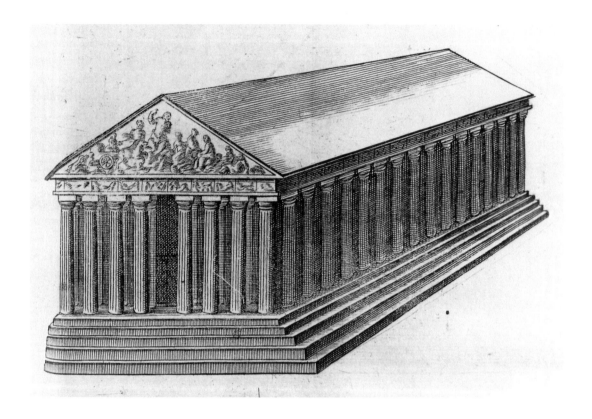

Fig. 9. The Parthenon
From Jacob Spon, *Voyage d'Italie, de Dalmatie, de Grèce et du Levant, fait és années 1675 et 1676* (Lyon: Antoine Cellier le fils, 1678), vol. 2, facing p. 188

once, but not until summer 1687 did they move on Athens. The Turkish forces abandoned the lower areas of the town, moving to the Acropolis. For eight days Morosini directed his mortars and canons against them, then on the evening of 26 September a shell landed on the roof of the Parthenon, in which gunpowder had been stored. The explosion that followed ripped the center of the structure apart; the fire that burned for two days after compounded the damage, as did Morosini's attempt, after the surrender, to remove the horses from the center of the west pediment, which resulted in their utter destruction.[86] When the Turks recaptured the town in 1688 they erected a small mosque in the center of the Parthenon, and thus it remained until the removals of Thomas Bruce, seventh earl of Elgin, in 1802.

French agents continued to be sent out to scour the east in Louis XIV's last years, most notably Paul Lucas, a goldsmith's son from Rouen, who had served in the Venetian army besieging Turkish-held Chalkis, in Euboea, in 1688. He thus was familiar with the Levant before he set out in 1700 on the first of his three celebrated journeys of exploration, commemorated in his three books, *Voyage du sieur Paul Lucas au Levant* (1704); *Voyage du sieur Paul Lucas fait par ordre du roy dans la Grèce, l'Asie Mineure, la Macédoine et l'Afrique* (1712); and *Troisième voyage du sieur Paul Lucas, fait en 1714 etc. par ordre de Louis XIV dans la Turquie, l'Asie, la Sourie, la Palestine, la Haute et la Basse Egypte* (1719). These accounts yielded no new evidence for an assessment of the architecture of Greece, however. Nor did the journeys of the two orientalists, François Sévin and Michel Fourmont, who were carefully instructed by Jean-Paul Bignon, known as the abbé Bignon, librarian to the king from 1719 to 1741, as to the manuscripts and books they should seek out. Sévin spent most of the year 1729 and the first four months of that following trying in vain to discover whether any of the books of the Byzantine emperors remained in the sultan's libraries, a failure offset by the purchase of about four hundred oriental and twenty-five Greek manuscripts, including a magnificent copy of Strabo's *Geography*.

Michel Fourmont and his nephew Claude-Louis made for the Peloponnese, hoping to find remnants of the Byzantine emperors' libraries in the monasteries on the peninsula. Through most of 1729 and on to the middle of 1730 they crisscrossed the land, driven by hints of treasures and fears of plague, but there were virtually no manuscripts to be found. The elder Fourmont concentrated on inscriptions. In Athens alone he recorded four hundred that Spon and Wheler had missed. By the time he reached Sparta he was in a frenzy of accumulation. He had fifty or more workmen tearing down walls and remains, searching for antique fragments with inscriptions, which he would record and then destroy, it was later rumored, lest anyone else should profit from his labors. "For more than a month, though ill," he wrote to Bignon on 20 April 1730 from Sparta, "I've been working with thirty laborers on the complete destruction of Sparta; there is not a day when I don't find something, and some have yielded me as many as twenty inscriptions." He continued,

If I could have made of Tegea and Antigonia, of Nemea and one or two other cities what I have made of Hermione, Troezen, and Sparta, there would be no need to send anyone to this land; there would be nothing left. I was unable to unearth the relics from the former cities because of the plague; otherwise, they would be totally destroyed. These destructions were, lacking books, the only means to bring renown to a journey that has caused such a stir.[87]

He was on his way to Olympia when he was recalled. He took back records of twenty-six hundred inscriptions and three hundred bas-reliefs, but they were not to be published, though they were carefully cataloged by his nephew, who would travel to the east again, to Egypt, in 1747. Sévin and Michel Fourmont were both members of the Académie royale des inscriptions et belles-lettres, and an account of their mission was read to the members on 14 November 1730 and published in 1733 in the academy's *Mémoires*. Caylus was in contact with Sévin while the latter was still in Constantinople[88] and no doubt continued the connection on his return to Paris, but other than the plans of Athens and Sparta the Fourmonts had drawn up, there was not much of use from either Sévin or the Fourmonts that could have been transmitted to Le Roy. The Fourmonts did measure the temple platform at Sunium, inspect the ruins of the two temples on Aegina, and explore the remains of Mycenae, remarking the Lion Gate and the tomb of Agamemnon, but their energies were not diverted to architecture.

Various other French agents had been active in the east earlier, in the second half of the seventeenth century and the early years of the eighteenth century—Laurent d'Arvieux, who first traveled to the Levant in 1653; Jean de Thévenot, who made the journey initially in 1655; and Joseph Pitton de Tournefort, the great botanist, there from 1700 to 1702, each of whom wrote books on their travels. Other travelers from Europe had visited Athens even before, as carefully recorded by Léon, marquis de Laborde, in his *Athènes aux XVe, XVIe et XVIIe siècles* (1854). Nonetheless, when the great Benedictine historian Bernard de Montfaucon began publication in 1719 of his suffocating compendium of knowledge on classical antiquities, *L'antiquité expliquée et représentée en figures,* in ten folio volumes, with five more to follow, he was able to illustrate the monuments of Athens—indeed of all Greece—with no more than copies of Spon's miserable woodcuts of the Hephaisteion and the Parthenon, along with engravings of figures from two of the Parthenon's metopes based on the drawings done for Nointel[89] (almost the only eighteenth-century response, one might note, to that extraordinary repository; Caylus searched for the drawings in 1764, but they were to be rediscovered only in the 1780s by the architect Léon Dufourny). The temples at Baalbek were fully illustrated, on the basis of Marot's engravings;[90] though thought to be Greek, these temples were rich and elaborate Roman works, readily assimilable to the tastes of the times. Montfaucon had thought to travel to the east in 1701, when on a literary voyage in Italy, but had changed his mind. Later he was involved in the writing of instructions for Bignon's

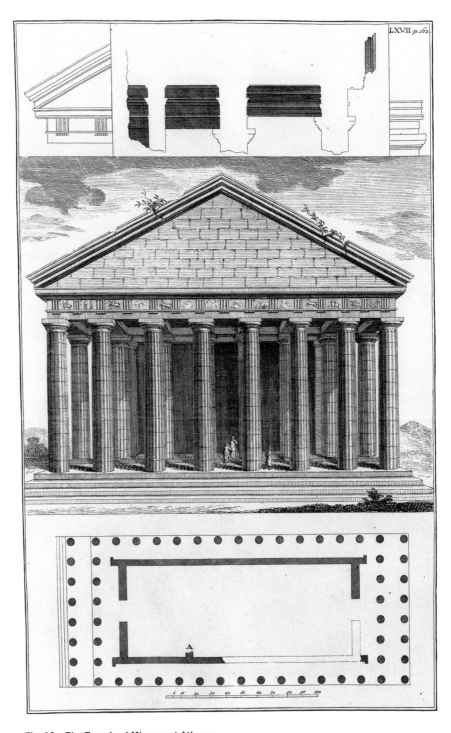

Fig. 10. *The Temple of Minerva at Athens*
From Richard Pococke, *A Description of the East and Some Other
Countries* (London: printed for the author, by W. Bowyer, 1743–45),
vol. 2, pt. 2, pl. LXVII

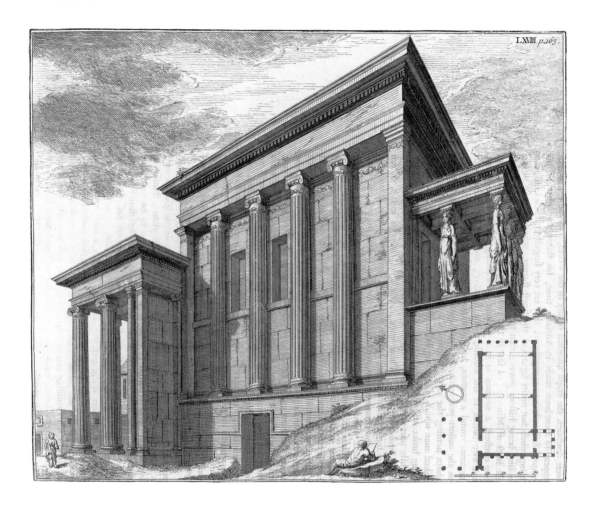

Fig. 11. *The Temple Erechtheion at Athens*
From Richard Pococke, *A Description of the East and Some Other
Countries* (London: printed for the author, by W. Bowyer, 1743–45),
vol. 2, pt. 2, pl. LXVIII

agents, laying stress, of course, on the acquisition of manuscripts and coins, though he did suggest that Olympia might repay a visit. In any case, however strongly he or others believed in the primacy, even the perfection of Greek architecture, clearly it had not yet captured the imagination of the scholars and adventurers of Europe. It could not command attention. It could not, in effect, even be seen. And this was evidently still the case two decades later, when the first measured drawings of the Parthenon were published in the third volume of Pococke's *A Description of the East and Some Other Countries* (1743–45; French translation, 1772–73).

Pococke was a great traveler;[91] he toured Europe with his cousin Jeremiah Milles, later dean of Exeter, between 1733 and 1736, then decided to go east. He landed in Alexandria on 29 September 1737, searched for the site of Memphis, visited Lake Moeris (Lake Qarun or Birket Qārūn), and explored the Nile as far as Philae (here he passed his Danish counterpart, Frederik Ludvig Norden, in the night, unremarked). From Egypt he went to Jerusalem, Syria (visiting Baalbek), Cyprus, and Greece, returning to Sicily in November 1740, and thence through Italy, Switzerland, and Germany to reach England in 1742. By the next year the first volume of his book, on Egypt, had been published in London. The second volume, in two parts, was issued in 1745. All the buildings of Athens that Le Roy was to include were described and illustrated in the latter. Though the elevation of the Parthenon was hideously distorted (fig. 10), the perspective of the Erechtheion ungainly, its capitals quite false (fig. 11), Pococke's illustrations of these, and other, famous buildings of Athens were the best available until Dalton's twenty-one engravings of the same buildings were offered in 1751. Whatever Adam's opinion of Dalton's representations, they were far closer to the form and spirit of the originals than anything else to be seen, and Le Roy was clearly responsive to them. He was to illustrate one of the capitals of the Erechtheion in a half drawing, in the manner of Dalton (see fig. 4). Nonetheless, there was little of authenticity in Dalton's images, nothing of the sculptural splendor of Doric. An appreciation of Doric was to emerge, albeit slowly, from a glimmering but growing understanding of the Greece of antiquity.

Coming to Terms with Homer

Marseille might have been founded by Greeks, Charlemagne might have induced scholars of Greek to travel from Ireland to France, but by the end of the fifteenth century there was little enough of Greek culture in France—some esteem for Aristotle, or rather pseudo-Aristotle, apart.[92] The sixteenth century marked a change. The first books to be printed in Greek appeared in the early years of the century, scholars were invited from Italy to teach Greek in the schools, and by 1521 the first Greek grammar to be written by a Frenchman, *Grammatica isagogica* by Jean Chéradame, had been published. By 1530 Jehan Samxon's *Les Iliades de Homère* had appeared. This version of the *Iliad* was something of a hybrid, however; it was set in Gothic typeface, illustrated with woodblocks of knights in medieval armor, and translated

from the Latin. This last was to remain a limiting condition in Greek studies in France throughout the sixteenth and seventeenth centuries and even beyond. The language of education was Latin. Montaigne knew only Latin, not French, up to his seventh year. Instruction at schools and at the Collège de France was in Latin, and students were expected to respond and converse in Latin. Greek works were, almost without exception, translated into French, if at all, from Latin. Yet knowledge of Greek language and literature was greatly advanced in these years, in particular at the Collège de France, sustained by the learning and enthusiasm of classical scholars such as Petrus Ramus and Guillaume Budé, librarian to the king from 1522 to 1540. The best translator to emerge was Jacques Amyot, admired especially for his folio edition of Plutarch's *Lives*, done direct from the Greek and published in 1559. Others soon translated the key works of Aristotle, Herodotus, Hesiod, Plato, and Thucydides, for this upsurge of learning was to be sustained and diffused throughout France through the medium of books. The greatest propagators of the classics were the Estiennes, a French family of bookdealers and printers, starting with Henri, who began as early as 1502 with an abridgement of Aristotle's *Ethics* in Latin and was to be abetted by his sons François, Robert, and Charles, and, eventually, by Robert's son, another Henri. By 1588 they had published both of Homer's epics in Greek and Latin en face; in addition, Hugues Salel and Amadis Jamyn, beginning in 1542, had rendered the *Iliad* part by part into French, and their work had been published, together with Jacques Peletier's older translations of the first two cantos of the *Odyssey*, in 1577. This interest in Homer survived into the early years of the seventeenth century. Salomon Certon published a French translation of the *Odyssey*, in alexandrines, in 1604, and the *Iliad* in 1615. The year before, François Du Souhait had offered the latter in prose, and this version, unlike Certon's, was to be reprinted no fewer than five times before 1634. An *Odyssey*, translated, it was claimed from the Greek, by Claude Boitel appeared in 1617, to be reprinted twice before 1638. Between 1622 and 1624 the Estiennes' Greek and Latin version was twice reprinted, but after 1617 there were no new translations of Homer's great works, in full, before the end of the century, when, in 1681, La Valterie published translations of the *Iliad* and the *Odyssey*, both reprinted in 1699 and 1709.

This might be thought a rich enough harvest of Homer, but the translations were clumsy and leaden, events and descriptions were transposed into contemporary terms with little attempt to represent or understand the world of Homer. There was labored scholarship, of a kind, in the commentaries offered, but it was largely inaccurate. In other countries of Europe, in Holland and Switzerland, but especially in England, there is evidence of a more eager attack by translators and scholars on the world of the ancient Greeks, a certain liveliness of approach and a sharpness of comment, notably in the Cambridge edition of the *Iliad* and the *Odyssey*, in Greek, of 1689.

The leaden translations of Homer in France ensured that they were not much read for pleasure; for sheer storytelling, there were available later, more

popular accounts of the wars of Troy, such as Dictys Cretensis's *De bello Trojano* and Dares Phrygius's *De excidio Trojae historiae*. But the *Iliad* and the *Odyssey* did begin to provide a repertoire of the principal postures and responses of the cultivated world that gradually came to sustain the literary and cultural landscape of France—one sailed a wine dark sea, one steered a course between Scylla and Charybdis, one's faithful dog recognized one's homecoming even if one's wife did not. The travails of Odysseus were depicted in tapestries, paintings, and prints thoughout the seventeenth century, though nothing rivaled in scale or in wonder the Château de Fontainebleau's great Galerie d'Ulysse, painted in the middle years of sixteenth century by Francesco Primaticcio and his pupils.[93] Most such works were the outcome not of a reading of Homer entire but rather of Homer as presented in the schools, where his works served to introduce the classics and to provide models and precepts, notions of courage and endurance, boldness and daring. The publication of Homer in the seventeenth century was made up principally of issues of single cantos, sometimes two, occasionally four, never more, issued year after year, clearly labeled "ad usum studiosae juventatis" (for the use of the young student). Homer served largely as an instrument of basic instruction. As might be imagined, the *Iliad*, with its wars and passions, was always more popular than the *Odyssey*. But Homer was never to rise to the stature of Virgil in general esteem; he seemed far too unruly, even uncouth, with no more than occasional flashes of genius.

Henri IV read Greek (though he read Plutarch in Amyot's translation) and was pleased to accept the dedication of Certon's translation of the *Odyssey*. His son Louis XIII likewise studied Greek seriously and was to publish a translation of his own, *Préceptes d'Agapétus à Justinien*, in 1612, but Louis XIV had no interest in Greek and achieved no proficiency, nor indeed did his son, the Grand Dauphin, though tutored by Jacques-Bénigne Bossuet (a great admirer of Homer), or even his son, the duc de Bourgogne, tutored by François de Salignac de la Mothe-Fénelon (an even more fervent adherent of Homer). This slackening of royal interest is a reflection of the decline in Greek studies in the seventeenth century. The statutes that were promulgated for the university in 1600 under Henri IV's direction required that the students have some knowledge of Homer, Hesiod, Theocritus, Plato, and other Greek works, and in the schools of philosophy Aristotle remained pre-eminent (until dethroned in the later years of the century by Descartes), but these authors continued to be studied in translations from the Latin and to be analyzed in Latin. As the century progressed, less and less time was devoted to these works in the original, other than for medical or theological studies. No professors of any real ability in Greek instruction were to emerge before the eighteenth century.

There were, of course, centers of learning where Greek was cultivated: the Jesuit Collège de Quimper, the Jesuit Collège de Clermont, and, especially, the school at the Jansenist Port-Royal des Champs, where Claude Lancelot initiated the instruction of Greek in French. This might be judged as no more than

a part of the breakup of the culture of Latinity throughout Europe, pursued as an active policy by Louis XIV and Colbert in their drive not only to unify France by the imposition of a standard language—the great project of the Académie française was the compilation of the official French dictionary—but also to make French the language of European diplomacy, reflecting France's cultural and political dominance. Whether or not Lancelot was inspired by such aims, which is doubtful, his initiative and state policy compounded to enable Greek studies to be separated from the study of Latin. This change of vision was slow to achieve focus, but the implications were profound, even from the start. Athens was to be clearly distinguished from Rome.

The greatest of Lancelot's pupils, Jean-Baptiste Racine, not only read Greek from his earliest youth but also grasped with unusual clarity the symbolic and mythical force of the Greek poets. At the age of twenty-two he wrote "Remarques sur l'Odyssée" (first published in 1825) in which he analyzed at some length and with vivid delight the way in which Homer combined the matter-of-fact description of the objects and events of everyday life with the noblest of aspirations and ideals, even if these be failing.[94] And in the astringent plays of his later years he demonstrated how closely he could identify with the world of the Greek poets and tragedians; he recognized unflinchingly its unique dignity. The Greeks had for him attained to the summit of the human spirit. In the preface to *Iphigénie* he expressed the hope that the response of audiences to his borrowings from Homer and Euripides might show that the taste of Paris was as one with that of Athens, that reason and good sense were shared through the ages.

Racine's world was a closed and confined one. His joy in the Greek spirit was by no means generally shared. Other writers, such as Jean de La Fontaine, might have prized Homer above all other poets. Other critics, such as the austere ecclesiastic Claude Fleury—remembered by literary historians, if at all, for his *Traité du choix et de la méthode des études* (1686), but author also of a youthful study, "Remarques sur Homère" (1665), first published in 1970—might have tried to appreciate, despite the confusion and irregularities of Homer's style, a grand design and nobility of concept in his epics—and in this Fleury is of particular note for his association of Homer with architecture: "One can excuse what at first appears shocking in it," he wrote of the *Iliad*,

> and forgive it on the grounds of its great age and his boldness in being the first to undertake, at least as far as we know, a work of that nature, just as one would not cease to hold in esteem an ancient building that had no ornaments or the stones of which were rude, provided that the mass as a whole had a regular and beautiful form, that the site was well laid out, and that it was well suited to the uses for which it had been designed. But, in examining somewhat more closely the so-called defects of Homer, we find that most of them are either matters of no import or perfections.[95]

Such individuals remained rare indeed, however. When the *querelle des anciens et des modernes* erupted in the final years of the seventeenth century — another reflection of the policy of French cultural superiority — the reputation of Homer, along with that of all the other Greek poets, was severely battered. His works were seen as crudely composed, his style as rough and irregular. His gods were all too easily ridiculed. Though some of the surpassing heroes of literature that Charles Perrault proposed instead — Jean Louis Guez de Balzac, François de Malherbe, and Vincent Voiture — make for a somewhat ludicrous array, Perrault's chief opponent, the poet and critic Nicolas Boileau-Despréaux, was so inhibited by the rules of decorum and convention that he could make no proper riposte or defense. Homer and the Greeks, it was all too readily accepted, could not really stand up to the moderns — though, it is important to note, Sophocles was translated into French for the first time in just these years, with André Dacier's *L'Oedipe et l'Electre de Sophocle* appearing in 1692. However, it was not a more authentic experience of the literature of ancient Greece itself that opened it up to general responsiveness but a pastiche concocted by Fénelon, *Les aventures de Télémaque*. It was this amalgam of Homer, Virgil, and Sophocles that would provide an altogether new and popular entrance to the potent originals.

Fénelon had been appointed tutor to the duc de Bourgogne, Louis XIV's grandson, in August 1689, and in the following month Fleury was appointed to assist him. The tutors had much in common in their high moral probings. Fleury had published *Les moeurs des Israelites* in 1681, *Les moeurs des chrestiens* in 1682; Fénelon had written "Réfutation du système du père Malebranche sur la nature et la grâce" in 1687. They shared also a knowledge of Greek and a deep fondness for Homer. Like Fleury, Fénelon had involved himself early with Homer and had even begun a translation of the *Odyssey* for the prince. In 1694 he took this up once again, composing a manual of moral and political instruction for his young charge in the form of a tale of adventure, ostensibly a continuation of the fourth book of the *Odyssey*, recounting the travels of Telemachus in search of his father, Odysseus. Accompanied by the goddess Minerva, in the guise of the old Ithacan Mentor (a play on sexual ambivalence that runs throughout), Telemachus lands on Ogygie, the isle of Calypso, soon after his father's departure. Calypso is overjoyed by this instant replacement of the object of her affections and promises Telemachus immortality if he will remain with her. This is the first of his temptations.

Calypso's isle serves as the base for the first six of the eighteen chapters of Fénelon's book. Telemachus begins as a young man full of faults and passions but is slowly transformed by experience. To ward off Calypso, and also to establish his manhood, Telemachus recounts his travels to Sicily, Egypt, Tyre, Cyprus, and Crete, where he has observed different forms of rule, different religions and customs. He is tempted by demons of desire when he falls in love with Eucharis, one of Calypso's maidens, rousing his hostess's jealousy and

wrath and imperiling his quest. Mentor gets them off the isle, onto a passing boat, but they are not ready to return to Ithaca, as there is still too much to be learned. The captain tells them of Boetica, a rustic paradise where the nomads have neither houses nor much in the way of possessions but live in a state of frugal bliss. Next Telemachus and Mentor are thrown up once again on Crete, where they become involved with wars and disputes and the reorganization and rebuilding of the state of Salenta and the transformation of its ruler, Idomeneus. Telemachus's courage and wisdom, perseverance and tolerance are then put to the test. He descends alone into the underworld to obtain news of Odysseus and there meets an array of good and bad rulers who rouse in him deep pity. Upon his return he is tempted by demons of ambition when he is offered a crown, along with a sensible, though loving, marriage to Idomeneus's daughter. The amorous intrigues are as involved as the negotiations of state. Eventually Telemachus returns to Ithaca, a man, wiser and better, and a wiser and better man, it is suggested, than Odysseus, though the end of the tale is left up in the air.

The tale was not intended for publication, though more than Fénelon's pupil saw it in manuscript, a copy of which passed from Fénelon's secretary to a printer in Paris, who published the work in April 1699 under the cumbersome title *Suite du quatrième livre de l'Odyssée d'Homère; ou, Les avantures de Télémaque fils d'Ulysse*. Fénelon promptly expressed his dismay, for unquestionably the work was a veiled attack on the policies of Louis XIV and Madame de Maintenon, with whom Fénelon was already in dispute on religious matters, which no doubt had occasioned his appointment as archbishop of Cambrai in February 1695, to secure his distance from the court. Scandal made for instant success. The response was electric; six hundred copies of the first printing are said to have been sold in one day. The privilege to publish was withdrawn, and Fénelon ordered to remain in his diocese. But by autumn 1699, a new edition, tidied up it would seem by Fénelon himself and more briskly titled *Les avantures de Télémaque*, had been published in the Netherlands. Swiftly it became the most successful novel of the new century, appearing in sixteen editions before the year was out, published in every year thereafter, often in more than one edition, right through the the Terror, excepting only the years 1747 and 1789. The first edition in English appeared in 1700, and the work soon became, paradoxically enough, the standard text for English schoolboys learning French. Over eight hundred editions and translations can be identified, but no doubt there were other pirated editions, and the work inspired countless imitations, parodies, and interpretative parallels, from allusive responses such as Charles-Louis de Secondat, baron de Montesquieu's *Le temple de Gnide* (1725) and Voltaire's *Candide; ou, L'optimisme* (1759) to such overt representations as Bignon's *Les avantures d'Abdalla, fils d'Hanif* (1712), *Les voyages de Cyrus* (1727) by Fénelon's disciple Andrew Michael Ramsay, or Jean Terrasson's *Sethos: Histoire ou vie tireé des monumens anecdotes de l'ancienne Egypte* (1731)—the latter so inspiring to both Wolfgang Amadeus Mozart and Claude-Nicolas Ledoux—

and more, on to Louis Aragon's forthright rewriting, *Les aventures de Télémaque* (1922), in which the episode on Calypso's isle is retold in raw sexual terms: Telemachus, a virgin, keeping lovemaking at bay with his story-telling but seduced soon enough by Eucharis; the aged Mentor enthralling Calypso with his sexual prowess; both Telemachus and Mentor ending up dead. In Fénelon's original, though there was much of amorous encounter, the book was safe enough to be put into anyone's hands — though not in the judg-ment of Fénelon's Jansenist antagonists.

Fénelon was undisturbed by the perceived impropriety of projecting Chris-tian values in the guise of ancient mythology. He saw the antique world of Homer as closer to nature, and the heroes, whatever their failings, as aiming always at virtue and nobility. This easy assimilation of the pagan realm marks his thinking from his earliest days. In 1675, at age twenty-four, he wrote a well-known letter in which he described his desire to become a missionary in the Levant:

> I feel myself transported to those beautiful places and among those precious ruins, to recover, along with the most curious monuments, *the very spirit* of antiquity. I seek out the Areopagus where Saint Paul announced the unknown God to the world's sages; but since the profane follows the sacred, I have no compunction about descending to the Piraeus where Socrates drew up the plan for his republic. I climb to the double summit of Mount Parnassus. I gather the laurels of Delphi and experience the delights of the Vale of Tempe.[96]

In the guise of Minerva, Venus, and Cupid he could deal with matters of religion, life and death, love and desire. He could condemn war, fulminate against luxury and all excess. His ideal society — no more than an ideal, as he freely admitted — is presented in the description of Boetica, an archaic realm peopled by nomads who have no need of houses, no possessions other than their animals and the practical objects they make themselves. This is a pre-figuration of the world celebrated by Rousseau and by the Physiocrats. Féne-lon hated cities and towns. Nonetheless his work later offers a more viable utopia in the form of Salenta's capital, largely remade under the direction of Minerva-as-Mentor. Only the temples are ornamented; the houses are sensi-bly organized, nicely spaced out, well built, plain, simple and clean: "Mentor, like a skillful gardener who cuts back the useless wood from his fruit trees, thus attempted to cut away the useless ostentation that was corrupting morals. He returned all things to a noble and frugal simplicity."[97] The vision through-out is that of Poussin, rather than any more authentic recreation of antiquity. The straightforward architecture serves always to teach a lesson, often more than one. When Telemachus and Mentor first land on Calypso's isle, they are taken to her grotto, where "Telemachus was surprised to see, in its rustically simple appearance, everything that can charm the eyes. There was neither gold nor silver nor marble nor columns nor paintings nor statues; this grotto was carved into the rock, vaulted with rocks and shells, adorned with a young

vine that spread its flexible branches equally in all directions."[98] This opens out to a mass of plants and flowers and to views of the hill and the sea. Clichés abound. A fire is lit, and robes are laid out for Telemachus, one of fine white wool, another of purple fringed with gold. This last is not to be read simply as a symbol of luxury and ostentation; it can also be taken as a sign of proper authority. Telemachus has not yet earned this. Mentor advises him to put on the white robes.

The rocks and shells and the clinging vine are an intimation, almost, of the rococo style to which the austere aesthetic of ancient Greece was later to be so strongly opposed, by Caylus among others. Architecture, as a rule of a practical and simple kind, is a recurring theme throughout Fénelon's writings. It appears thus in tales such as "Les aventures d'Aristonoüs" (1699)[99] or in fundamental texts of theology such as the *Demonstration de l'existence de Dieu* (1712).[100] More than once in Fénelon's work, architecture serves as a marker for the proof of God—a clock proves the existence of the clockmaker, a well-designed house proves the existence of the architect, the wonder of the universe proves the existence of God.[101] In the second of his *Dialogues sur l'éloquence*, perhaps written as early as 1679, though published only in 1718, Fénelon upheld the noble simplicity of Greek architecture, as opposed to the complexity and intricate detail of Gothic: "Greek architecture is much more simple, it allows only majestic and natural ornaments; one sees nothing but the great, the proportionate, the correctly placed."[102] He took up this comparison again, at far greater length, adding a thrust at the moderns, in his famous *Lettre à l'académie* of 1714, which he revised at the request of André Dacier and which was published in 1716, posthumously, as *Réflexions sur la grammaire, la rhétorique, la poétique et l'histoire; ou, Mémoire sur les travaux de l'Académie française à M. Dacier:*

> It is natural that the moderns, who have great elegance and ingenious devices, flatter themselves that they have surpassed the ancients, who had only simple nature. But I ask for leave to make a kind of apologia; the inventors of what is called Gothic architecture, and which, they say, is that of the Arabs, undoubtedly believed they had surpassed the Greek architects. A Greek edifice has no ornament other than that serving to adorn the work; the elements needed to support it or to enclose it, such as the columns and the cornice, achieve their grace solely by their proportions. Everything is simple, everything is measured, everything is reduced to its function. Neither boldness nor caprice imposes on the eye. The proportions are so correct that nothing looks too big, though it might be. Everything is restricted to satisfying true reason: in contrast, the Gothic architect erects on very slender pillars an immense vault that rises to the clouds. One thinks everything is going to fall, but everything lasts for many centuries. Everywhere there are windows, rose windows, and spires. The stone seems to be cut up like cardboard. There are openings everywhere, everything is in the air. Is it not natural that the first Gothic architects flattered themselves that by their vain refinement, they had surpassed Greek simplicity?[103]

In these same pages Fénelon sums up the greatness of Homer thus: "He painted with naïveté, grace, force, majesty, passion. What more can one want?"[104]

Fénelon's *Les avantures de Télémaque* opened responsiveness to the world of Homer, but the writings of Homer were to be rendered beguiling and familiar throughout France by another scholar, Anne Dacier.[105] Born in Saumur in 1651, she was the daughter of Tannegui Le Fèvre, an early enthusiast of Greek who had taught himself the language and established himself as an earnest scholar of antiquity in general, and of Homer in particular, with the publication of *Les poètes grecs* (1664). He, in turn, instructed his children in Greek; his son had read the *Iliad* twice by the age of fourteen, claimed Le Fèvre, but only when she was twenty-one did he begin the classical education of his daughter. She took up Greek and Latin with rare aptitude. After her father's death in 1672, she moved to Paris to work with his close friend Pierre-Daniel Huet, another dedicated scholar who would soon publish *De optimo genere interpretandi* (1680), one of the fullest and most intelligent texts to appear on the aims and methods of translation—a subject of special import in the years of the political promotion of French as the cultural language of Europe. Huet's advice was sensible and practical and was taken to heart by Anne Le Fèvre. She helped him with his translations. She also published an annotated edition of Dictys Cretensis's *De bello Trojano* and Dares Phrygius's *De excidio Trojae historiae* in 1680. But already she had embarked on translations of her own—Kallimachos's works were issued in Latin in 1675, the poems of Sappho and the *Anacreontea* in French in 1681, with more to follow. In 1683 she married André Dacier, later a member of both the Académie française and the Académie royale des inscriptions et belles-lettres, whom she had already encountered in Saumur as a pupil of her father.[106] She worked with him on translations, in particular on his rendering into French of Plutarch's *Lives*, which began appearing in 1695, but she was soon publishing again on her own account, producing not only translations but also studies such as the *Philosophie de Platon* (1699), in which she sought to demonstrate Pythagoras's and Plato's borrowings from the Bible.

Her great achievement though was her translation of Homer into French. *L'Iliade d'Homère* appeared in 1711, *L'Odyssée d'Homère* between 1708 and 1716. These were aimed unashamedly at the widest possible audience. The prose was clear and easy, and the translation not altogether faithful to the original, for Dacier was intent to avoid coarseness and violence. She was less prudish than her predecessors, but she avoided bodily descriptions as best she could. Inevitably she imposed contemporary mores and beliefs on her characters. Undeniably she softened Homer. She flinched from his energy. As Voltaire was to remark, "Anyone who has read only Madame Dacier has not read Homer."[107] Voltaire, however, could not read Greek. Dacier managed nonetheless to conjure up an archaic world of directness and simplicity, peopled by heroes of independence and spirit.

The publication of the *Iliad* catapulted her to fame. Dacier became a

celebrity, the first fashionable translator ever, courted in the salons, the talk also, altogether surprisingly, of the cafés and the boulevards, for in the early months of 1715 there was a final bright flaring of the quarrel of the ancients and the moderns, the quarrel of Homer. This was provoked by the publication in Amsterdam, in 1714, of *L'Iliade, poëme avec un discours sur Homère,* by the dramatist Antoine Houdar de La Motte.[108] This version of the *Iliad* comprised La Motte's previously published translation of the first book, which had appeared in 1701 with a dedication to the duc de Bourgogne; free translations of the second, third, and fourth books (from the Latin, as he too did not read Greek) accompanied by adaptations of his own; and even freer interpretations and amalgamations of the remaining twenty books. In his preface, La Motte made clear that there might be something of greatness in Homer but it was almost a matter of chance, for the original was in most respects coarse, lacking in proper morality, clumsy, and repetitive. La Motte offered a contemporary variant all his own of the ancient work — as he had happily acknowledged in letters exchanged on the subject, in 1713 and 1714, with Fénelon.[109]

Dacier, correctly, regarded the publication as a personal challenge. Though she had not directed her translation of the *Iliad* to scholars, and though she had nowhere brashly displayed her erudition, it was clear from the notes she had offered that she was very well versed indeed in classical literature and commentaries. She now emerged as the pedant. Her reply to La Motte, *Des causes de la corruption du goust* (1714), issued in Paris in February 1715, answered his attack point by point but scarcely rose to a proper defense of Homer. La Motte replied at once, with verve, issuing *Réflexions sur la critique* in parts, as a series of broadsides. Others entered the fray: the Oratorian Jean-François de Pons with *Lettre à Monsieur *** sur l'Iliade de Monsieur de La Motte* (1714), which acknowledged that Madame Dacier's elegant translation had nothing of the force and confusion of Homer; the Jesuit Claude Buffier with *Homère en arbitrage* (1715), a silly attempt to satisfy all sides; Terrasson with *Dissertation critique sur l'Iliade de Homère* (1715), a sternly rational analysis of Homer's work by an expert in Greek, inevitably to its detriment (though Terrasson saw at once that Dacier's Homer was grounded in Fénelon); Boscheron with the publication of *Conjectures académiques; ou, Dissertation sur l'Iliade* (1715), a long-suppressed manuscript completed before 1664 by François Hédelin, abbé d'Aubignac, isolating some felicities in the assemblage represented by Homer but adding little to the controversy; and Jean Boivin and Etienne Fourmont, two members of the Académie royale des inscriptions et belles-lettres. Jean Boivin,[110] professor of Greek at the Collège Royal and garde des manuscrits at the Bibliothèque du roi, was a fervent supporter of Homer (despite having learned Greek the hard way, by being locked up by his elder brother each day until he translated a set number of lines). He had put forward a proposal in 1708 to the Académie royale des inscriptions et médailles to publish an authoritative edition of Homer in Greek and Latin, nothing of the sort, he considered, having yet emerged in France, but he could not find a publisher even later, despite the support of the

abbé Bignon of the Bibliothèque du roi. Boivin's *Apologie d'Homère et bouclier d'Achille* (1715) was a polite but firm response to La Motte that included an analysis of Achilles' shield, with an engraving by Charles-Nicolas I Cochin (fig. 12), after a drawing by Nicolas Vleughels, designed to prove that all the scenes described by Homer (*Iliad* 18.475–615) could fit on such an object. Writing voluminously and not always to the point, Étienne Fourmont—newly promoted professor of Arabic at the Collège de France, member of the Académie royale des inscriptions et belles-lettres in succession to Galland, and the elder brother of Michel Fourmont, who was to be dispatched to Sparta by Bignon—though a savant of the most austere sort, embracing not only Greek and Arabic but also Chinese,[111] offered in his *Examen pacifique de la querelle de Madame Dacier et de Monsieur de La Motte sur Homère* (1716) a surprisingly sharp appraisal of Homer as the greatest of all possible poets (surpassing, he believed, even Fénelon). Homer's work, Fourmont argued, was to be judged not in terms of what it represented of current morality but rather in terms of what it represented of the creative spirit. This was a note struck for the future.

Another late contribution to the controversy was *Apologie d'Homère, où l'on explique le véritable dessein de son Iliade et sa théomythologie* (1716), by another Jesuit, Jean Hardouin, who argued that the gods in Homer represented Earth, the Sun, the Moon, and the planets. This work elicited yet another pedantic response from Dacier, *Homère défendu contre l'Apologie du R. P. Hardouin* (1716). Other pamphlets, other articles were published. Learned journals and newspapers encouraged the debate. It was taken up in the theater: Pierre Marivaux offered *L'Homère travesti; ou, L'Iliade en vers burlesque* in 1716, and strolling players poked fun at the argument. While it lasted, the quarrel of Homer was a cause célèbre, an entertainment for all. And then it was over. Dacier and La Motte were reconciled at a dinner on 5 April 1716.

To all appearances, the moderns had won the battle of Homer. In the terms advanced by the ancients, those of rational analysis and academic rules, Homer could not be defended. The moderns were more confident and livelier in their thrusts. Homer could be parodied all too easily. Dacier, an ancient by inclination, herself considered that her vital contribution to Homer studies was to have imposed order on the great epics, and this vision of order was undoubtedly one of the reasons her versions were so popular. When Alexander Pope published an English translation of the *Iliad* starting in 1715, his work, like Dacier's, was not that of Homer. He had grasped the sinewy force of the original and described its poetry, in his preface, as that of a "wild paradise" (rendered in the French edition of Pope's preface, issued between 1718 and 1719, as "paradis brut"). Dacier could see nothing of the sort. In the preface to the second edition of her translation, issued in 1719, she rejected the notion brusquely. Having rendered Pope's simile as "jardin brut"—she readily admitted to not understanding English very well—Dacier wrote of Homer's work, "It is the most regular and symmetrical garden ever. Monsieur le Nostre, who was the best in the world at his art, never observed a

Fig. 12. Charles-Nicolas I Cochin, after Nicolas Vleughels
Bouclier d'Achille, tel qu'il est dècrit dans Homere, Iliade, L. 18ᵉ
From Jean Boivin, *Apologie d'Homere, et bouclier d'Achille*
(Paris: François Jouenne, 1715), facing p. 1

more perfect and admirable symmetry in his gardens than that which Homer observed in his poetry."[112]

Dacier imposed a grand design on Homer, one readily acceptable to her contemporaries. Her translations were reprinted again and again until 1826. There were many who still regarded Homer as uncouth and slightly ridiculous, but Dacier had provided the means of seeing him whole. She had rendered him consistent and coherent, simple and powerful, and had provided thus a framework of thought to approach the world of antiquity entire.[113]

Coming to Terms with Feeling

Though Madame Dacier might seem to have ordered Homer, there was more at stake than a call to order. The acceptance of Homer was equally part of a new responsiveness to natural feeling and passion, and no single individual set the tone and style for this new sensibility more effectively—it is not altogether surprising to find—than Fénelon.

To the ancients, Fénelon seemed the equal of Homer; to the moderns, he had surpassed Homer, particularly in the matter of morality. Either way, he won. Fénelon himself, as we have seen, found the moderns too ingenious, too clever. He was by inclination an ancient. He believed in the privileges of birth, in an aristocratic caste (in reformed Salenta, the ranks of the citizens are distinguished by seven types of dress), in social structures and traditions rooted in the past, and he proclaimed above all the return to an order than had been eroded by luxury and war, by neglect of the ideals of family and nation, by an absence of the love of God—"l'amour pur." His rustic ideal was no more than an earlier manifestation, simpler and more direct, and thus closer to nature, of this structure of order. Again and again, he argued calmly and in rational terms for the reinstatement of a life of sobriety, piety, and authentic wellbeing. Yet he knew well enough that the human spirit could not be controlled by reason alone; there was, as he explained in *Traité de l'existence de Dieu* (1713), another reason, that of the self, which may be wayward and uncertain but must, if there were to be any recovery of order, be impelled by a deep and instinctual desire for order's attainment. Individual feeling thus became the determinant of all true action as well as the ultimate guarantee of all true order.[114]

Individual feeling and passion, individual perception and vision had long been features at odds with the rules of classical literary composition so thoughtfully and painstakingly established in the early seventeenth century.[115] Even before the publication in 1674 of *Le traité du sublime; ou, Du merveilleux dans le discours,* Boileau's translation of a treatise attributed to Longinus, those most rigorous of critics, Dominique Bouhours and René Rapin, as Théodore Litman has shown, had read the work, no doubt in Tannegui Le Fèvre's Latin translation of 1663, and were grappling with the very real difficulties it raised for those intent to set literary standards amenable to rule alone. They were determined to explain genius itself. Bouhours was a fervent upholder of common sense and clarity, simplicity and sobriety—

style, he thought, should be "a pure, clean water, that has no taste at all."[116] Nonetheless, in his *Les entretiens d'Ariste et d'Eugène* (1671), one of those popular seventeenth-century theoretical texts presented, in the Socratic manner, in the form of a dialogue, he felt impelled to accept and consider the effect of sheer inspiration. "Genius," he acknowledged, "is independent of chance and fortune; it is a gift from heaven in which the earth plays no part at all; it is the je ne sais quoi of the divine."[117] This marks the entry into French literary criticism of the tormenting concept of the inexpressible "je ne sais quoi." But Bouhours, though he recognized it, and recognized it as an aspect of "le style sublime," was no more able to explain and define it than his successors, who worried at it at length. Bouhours could simply describe its impact.

Rapin, though often considered far more dogmatic a classicist than Bouhours, tackled the issue head on. In his two most famous critical works, *Réflexions sur l'usage de l'éloquence de ce temps* (1671) and *Réflexions sur la Poétique d'Arioste et sur les ouvrages des poètes anciens et modernes* (1674) — the latter published the same year as Boileau's *Le traité du sublime* — Rapin showed himself both fully familiar with Longinus and essentially in accord with the idea that great literature required genius and inspiration rather than rules, for though literature must stimulate the mind, it must, even more, touch the spirit: "But just as judgment without genius is cold and listless," he argued, "genius without judgment is extravagant and blind."[118] His thought evolved rapidly over the years; at first he preferred Cicero to Demosthenes, Virgil to Homer, but he came soon enough to esteem Homer above all other ancient authors — "He was the only one who found the secret of combining purity of style with all the loftiness and grandeur of which heroic poetry is capable."[119] In *Les comparaisons des grands hommes de l'antiquité qui ont le plus excellé dans les belles-lettres* (1684), he was yet more expansive and circumstantial: "I would have no trouble agreeing, first, that Homer has a much vaster plan and a more noble manner than Virgil, that he has a greater breadth of character, that he has a grander air and a more sublime je ne sais quoi, that he describes things much better; that even his images are more accomplished."[120] Rapin's unembarrassed acceptance of Homer was perhaps made easier in that none of the moderns, who kept to the rules, could be compared to him; Rapin dismissed them all.

With the publication of Boileau's translation of Longinus in 1674, the sublime emerged as a major element in literature, whether ancient or modern. Boileau's rendering was of the freest kind. He aimed, he said, to provide no more than a useful introduction to the subject. Though he skirmished more than once with definitions, he relied rather on examples — supremely on one adduced by Longinus himself: "God said, 'Let there be light,' and there was light."[121] But Boileau did make clear the distinction between a "sublime style" and the "sublime" itself. "One must know," he wrote, "that, by sublime, Longinus did not mean what orators call the sublime style, but rather the extraordinary and wondrous thing that strikes you in discourse and that

makes a work sweep you away, enrapture you, transport you. The sublime style relies merely on lofty words."[122] Bold and enterprising though Boileau might have seemed in thus broaching the sublime, he hedged his bets, publishing his influential *L'art poétique* (1674), a didactic treatise setting forth the rules for the composition of poetry in the classical tradition, in the same year as his translation of Longinus. The sublime could not, he stressed, be explained; it could only be felt, and felt by those of refined sensibility alone.

Pierre-Daniel Huet, bishop of Avranches, with whom Anne Le Fèvre worked after her father's death, was outraged that words from Genesis should be subject to literary analysis. Huet responded to Boileau in his *Demonstratio Evangelica ad Serenissimum Delphinum* (1679) by defining four categories of the sublime, not one of which could encompass the *Fiat lux* of Genesis. Bouhours and Rapin likewise felt bound to respond to Boileau. In *La manière de bien penser dans les ouvrages de l'esprit* (1687), another set of dialogues, on this occasion between one Eudoxe and one Philanthe, Bouhours tried yet again to reconcile the sublime with the rules, in particular the rules relating to fine and delicate writing. Bouhours liked the light and witty poems of Voiture. Eudoxe, Bouhours's protagonist, preferred Virgil to Homer. In effect, Bouhours favored a subverted and sapped sublime.

Rapin, as aggressive and audacious as ever, made no mention of Boileau in *Du grand ou du sublime dans les moeurs et dans les différentes conditions des hommes* (1686), and with intent, for Boileau had offered the sublime as no more than an artistic concept, whereas for Rapin it had become a moral issue: "the idea of the sublime is always so linked with literature that one finds it difficult to shift it elsewhere. But since all things can contain something of the great and the wondrous, I decided that one might be able also to conceive of the sublime in that way: this led me to imagine it in all life's different conditions. Each of these conditions is capable of assuming a degree of perfection that can inspire in its realm the same admiration that literature can inspire in its own."[123] He was categoric that this sublime was not to be accommodated to any system of rules: "it is an idea of perfection above all ideas and in a lofty place of excellence, about which art and nature know nothing because it stands above their rules."[124] The sublime, for Rapin, partook of the divine.

The reaction of those thinkers who had adopted a Cartesian mode of reasoning—which played no part in the system of thought and structures of rule that classicists had formulated in the early years of the seventeenth century—can be readily imagined. The moderns would have no truck with the sublime, it being to all accounts inexplicable. The quarrel of the ancients and the moderns could thus be (and indeed has been) construed as a debate as to the nature and the value of the sublime. But even before that battle was joined in 1687, after the delivery of Charles Perrault's poem "Le siècle de Louis le Grand" before the Académie française on 27 January, the flurry of terms that had been invoked to denote the sublime—"je ne sais quoi," "génie," "feu divin," "enthousiasme," "passion"—was rudely rejected in the name of rationalism by Charles de Marguetel de Saint-Denis, seigneur de

Saint-Évremond, an exile in London from 1661 until his death in 1703, but for an interval in the Netherlands (1665–70), and thus something of an onlooker to the French literary debate, and one subject, moreover, to English influence. He offered no comprehensive work of analysis or criticism, but in occasional papers and articles he made clear his pragmatic attitude toward the authors of classical antiquity and his belief that what was required was a literature reflecting the advances in knowledge, philosophy, and morality of the present. He liked best the French classical tragedies of Pierre Corneille. "One must love the rule," he wrote in "De la comédie anglaise" (1677), "to avoid confusion; one must love good sense, which tempers the ardor of a fired imagination." "But," he continued, "one must remove from rule all trouble-some constraint and banish a punctilious reason that, through too great an attachment to exactitude, leaves nothing free and natural."[125] He too would have no truck with the sublime.

Nonetheless Saint-Évremond served to introduce into the arguments over the sublime the concepts of vastness and terror that were to assume such significance in the development of romanticism during the second half of the eighteenth century. About 1681 he would address "Dissertation sur le mot vaste" to the Académie française. Occasioned by a dispute in which he was engaged with Hortense Mancini, duchesse de Mazarin, as to the precise meaning of *vaste,* he wrote, spurred by his distaste for the sublime,

> The vast and the frightful are closely related, vast things belong to what astonishes us, they do not belong to those things that make an agreeable impression on us.... Vast gardens cannot provide the pleasures that come from art, nor the graces that nature may give. Vast forests frighten us, our faculty of sight wanders and loses focus when we look at vast countrysides. Rivers of a reasonable size allow us to see pleasant banks and imperceptibly inspire us with the gentleness of their peaceful course. Overly wide rivers, overflowing banks, and floods displease us with their turmoil, and our eyes cannot bear their vast expanse.[126]

Longinus himself had invoked the awe aroused by the sight of great rivers and views from mountain peaks as examples of the sublime, but such references were not to be taken as positive features of the sublime before 1757, when Edmund Burke published *A Philosophical Enquiry into the Origin of Our Ideas of the Sublime and Beautiful.* Vastness and terror then became experiences to relish, albeit from a position of safety.

Once the battle between the ancients and the moderns was fully engaged with the appearance of the first volume of Charles Perrault's *Parallèle des anciens et des modernes, en ce qui regarde les arts et les sciences* (1688), yet another critical harangue against Boileau couched in the form of a dialogue, it became apparent that the issue of the sublime was the real bugbear of the new rationalists. It seemed to the moderns a spur to incomprehension and illusion. Moreover, it was quite simply old-fashioned. What else could it be when Homer himself was to be regarded as little more than a representative of the

world in its early formation? "I have no difficulty in acknowledging," Perrault wrote in the second volume of the *Parallèle* (1690), "that, however great the genius he received from nature, for he is perhaps the most expansive and the finest mind that ever was, he nevertheless committed a very great number of errors, which the poets who followed him, though inferior in the power of their genius, corrected in themselves over time."[127] There was no doubt in Perrault's mind that the literature of the seventeenth century far surpassed that of the poets of antiquity: "They spoke naturally, tenderly, passionately, but they did not speak with the refined, delicate, and witty tone found in the works of Voiture, [Jean-François] Sarasin, [Isaac de] Benserade, and a hundred others."[128] Perrault's tastes were other than that of the wild and the rugged. Like Saint-Évremond he recoiled from the untrammeled grandeur of nature. "That wild nature," he warned, "would spoil everything if we allowed it; it would fill every path with weeds and brambles, every fountain and canal with reeds and silt; hence gardeners do nothing but battle it constantly."[129]

One begins to comprehend something of Perrault's real fear for a loss of civility in the face of emerging tastes for the force and irregularity of Homer or the chasms and mountain peaks of Switzerland. He is unlikely to have experienced the rapt absorption that Thomas Burnet, a fellow of Christ's College, felt for the Alps and Apennines when he traveled to Italy in 1671 and recorded, greatly elaborated, in 1681 in his *Telluris Theoria Sacra:...de Diluvio et Paradiso*, rendered three years later into English as *The Theory of the Earth:...concerning the Deluge, and concerning Paradise*. Burnet viewed the earth itself as a vast and wild ruin, a broken hulk left by the Deluge.[130] Joseph Addison discovered Burnet's work in his youth, and traveling near Mont Cenis in 1702, he could write of "the Alps, which are broken into so many steeps and precipices, that they fill the mind with an agreeable kind of horror."[131] In France, however, the raw splendor of the mountains was not to be fully embraced until 1761, with Rousseau's *Lettres de deux amans, habitans d'une petite ville au pied des Alpes*—known to modern readers as *La nouvelle Héloïse*.[132]

The quarrel of the ancients and the moderns has been often enough recounted; little by way of summary is needed here. The first nine of Boileau's *Réflexions critiques sur quelques passages de Longin*, an extended response to Perrault's earlier writings, were included, immediately following the *Traité du sublime*, in the edition of 1694 of his *Oeuvres diverses*. Perrault and Boileau were then uneasily reconciled, on 30 August 1694, in a gathering at the Académie française; but they continued to spar. The fourth and last volume of Perrault's *Parallèle* was published in 1697. The *Réflexions* were again included in Boileau's *Oeuvres diverses* of 1701, in which he added a paragraph at the end of the preface to the *Traité du sublime* offering, quite unexpectedly, a new and instantly acclaimed exemplar of the sublime from modern literature: the elder Horatius's famous reply, in act 3 of Pierre Corneille's *Horace*, after being told that the third of his sons had fled once the two others had been slain, bringing, Horatius judged, everlasting shame on the family

name; upon being asked, "Que vouliez-vous qu'il fît contre trois?" (What would you have him do against three?), he answered, "Qu'il mourût" (That he die).[133] Boileau had too keen a taste for turns of speech to deny the attainments of his contemporaries. Ultimately he was more interested in the sublime than the felicities of Homer even. He adduced Homer a hundred times and more in his writings, most often in the *Traité du sublime* and the *Réflexions*, but he had little enough to say as to the nature of Homer's distinction. Simply to name Homer, along with Virgil, seemed to Boileau to suffice. Homer's epithets and images Boileau thought the best part of him.[134] Perrault's praise of Homer, he noted—and he quoted the phrase from the second volume of the *Parallèle* earlier referred to—was patently false. "One might say," he wrote, "that forced praise of this sort is like the flowers with which one crowns a victim before sacrificing him."[135] The last three of his *Réflexions*, aimed at Huet and La Motte rather than Perrault and written after 1710, were to be published only after Boileau's death, in the *Oeuvres complètes* of 1713.

Perrault was firmly convinced that the world of the seventeenth century was more enlightened and more advanced than that of antiquity, but his writings reveal a complacency of spirit, a smallness of mind, no breadth of understanding. The figure to emerge as the towering defender of the moderns was Bernard Le Bovier de Fontenelle, a mathematician and physicist, permanent secretary (*secrétaire perpétuel*) of the Académie royale des sciences, and the author of a spate of clear-cut works designed to make comprehensible the intricacies of science. He was an arrant Cartesian. The workings of nature he saw as no more than a play of physical forces—"a game of ropes, pulleys, and levers."[136] Reason, he believed, must be employed to eliminate outmoded beliefs and prejudices. Nonetheless, he saw clearly enough that the sciences and the arts were different, that an increase in knowledge must lead, inevitably, to an increase in understanding in the sciences, whereas in the arts knowledge was not the issue, so that themes might be taken up and explored to perfection only to be replaced in time by others. The literature and poetry of the past served merely to perpetuate error, however, and the source of this error was human passion and sentiment. Poetry should be the result of controlled endeavor, not of mysterious inspiration and inexplicable insight. All flights of the imagination were suspect. The sublime was irrational and dangerous. Yet in a memorable passage in "Sur la poésie en général," of about 1678, his thoughts rose majestically above all the bluster and the posturing of his companions, to set forth the notion of a modern sublime, one based on reason and science: "Above the most noble or acute images capable of representing the feelings and the passions, there are still other, more spiritual images, located in a region into which the human mind launches itself only with difficulty; these are the images of the universal order of the cosmos, space, time, spirits, the divine; they are metaphysical, and their mere name announces the high rank they hold."[137]

Though the science and reason of the moderns might seem to have risen finally in triumph, the new sensibility to be explored in the years that fol-

lowed was based on the notions of the older sublime of the direct representation of fine ideals and morals that the ancients had steadfastly fought to uphold, whatever their doubts and misgivings; and it was, as already remarked, Fénelon, that ancient by inclination, who first demonstrated clearly, without fuss and argument, that the whole encumbering system of rules that both ancients and moderns had accepted was well-nigh irrelevant in the face of the outpourings of the true human spirit. In his *Dialogues sur l'éloquence,* Fénelon upheld an art that no longer imitated nature but rather re-created its spirit as faithfully as possible. Nature herself, he argued, was neither ordered nor regular, art therefore might be rough and with unpredictable sallies, provided always that it be truthful. Words and figures, expressions and gestures were to be conditioned by no more than the need to provide an honest and direct representation of fine ideas and morals. The concept of the sublime was integral to this pattern of thinking, and Fénelon referred again and again to Longinus in his *Dialogues sur l'éloquence.* Homer too loomed large in the discussion, though it was the Bible, inevitably, that became the model for an art of direct impact.

Such themes were even more fully explored, and to greater resulting effect, in Fénelon's *Lettre à l'académie.* The analysis there was largely concerned with literature, and it was in the detailed criticism of authors and texts that Fénelon made most apparent the nature of his beliefs, his likes and dislikes. Demosthenes replaced Cicero as the orator to be preferred. "He thunders, he fulminates," Fénelon wrote. "It is a torrent that sweeps everything away. We cannot criticize him because we are captivated. We think about the things he is saying and not about his words."[138] So determined was Fénelon to do away with needless rules that he rejected even the need for verse and rhyme in poetry—at one here, surprisingly, with that zealous upholder of rules, Fontenelle's faithful disciple, La Motte. "The Book of Job," Fénelon decreed, "is a poem full of the boldest and the most majestic figures.... All Scripture is full of poetry in the very places where no trace of versification is to be found."[139] The tone and outlook is strikingly different from all those cited earlier. His *Lettre* served to establish new forms of criticsm in which feeling rather than rational analysis played the prime role in the assessment of literature. This feeling, he believed, should spring naturally from a well of inner goodness, though he was not altogether hopeful. "I want a sublime," he wrote, "so familiar, so sweet, and so simple that everyone will at first be tempted to believe he could have found it without difficulty, even though few are capable of finding it."[140]

The claims of the natural response to critical esteem had already been staked out in the world of painting. In 1708 the connoisseur and amateur artist Roger de Piles had published a small manual, *Cours de peinture par principes,*[141] in which he carefully analyzed the relative merits of drawing and color, the elements of composition, the effects of chiaruscuro, matters such as invention and expression, and other established aspects of fine painting. But he also insisted that the deciding factor in the assessment of each work of art

was the impact it made at first sight—in the "clin d'oeil" in which one took in the whole at a glance. An entire section of his treatise was given over to "The effect of the whole together; where I shall occasionally speak of harmony and enthusiasm."[142] The quality of enthusiasm, not surprisingly, was defined entirely in terms of the sublime. "Enthusiasm," de Piles explained, "is a transport of the mind, which makes us conceive things after a sublime, surprising, and probable manner."[143] The origin of this concept can be discerned even earlier, in 1686, in Rapin's *Du grand ou du sublime*. There, in dealing with the notion of a sublime of which one was not fully aware, Rapin wrote, "there is a hidden sublime that reveals itself to the heart on its own, independent of words, when it says more than the terms and expressions signify; like the works of that painter, which suggested that there was more to understand than they expressed"[144]—a reference, as he noted, to Pliny the Elder's discussion of paintings or portrait busts of great men, specifically Homer, fabricated to match an established image (*Naturalis historia* 35.10).

The great work of criticism that compounded most of the discussion summarized here on poetry and verse, tragedy and comedy, with a great deal more on painting and music was the *Réflexions critiques sur la poésie et sur la peinture*, published anonymously in 1719, three years after Fénelon's letter to the Académie française.[145] The author was Jean-Baptiste Dubos, who had spent the first years of the century in London, in the circle of John Locke, by whom he was greatly influenced. Dubos's work finally brought an end to the bickerings of the ancients and the moderns, for he upheld, unequivocally, the role of passion and feeling in fixing the quality of any work of art. "The heart," he wrote, "is agitated of itself, by a motion previous to all deliberation, when the object presented is really affecting; whether this object has received its being from nature, or from an imitation made by art. Our heart is made and organized for this very purpose: Its operation therefore runs before our reasoning, as the action of the eye and ear precedes it in their sensations."[146] Or, more pithily, "Do we ever reason, in order to know whether a ragoo be good or bad"[147] (just as Fénelon had remarked in a letter of May 1714, "I state my taste for the record—like a man at a meal who simply says he likes one ragout better than another").[148] Dubos could encompass Homer and Fénelon, Perrault and Fontenelle, and point out the particular merits of each. He could even concede that the great discoveries of the modern era—which he listed as knowledge of the weight of Earth's atmosphere and the invention of the compass, the printing press, and the telescope—might stir new responses. But, he warned, old scientific books become obsolete, whereas antique literature does not. Homer retained his wonder. The Bible was even better. The established rules might have their merit in ordering "le feu" or "le fureur poëtique," "le génie" or "l'enthousiasme divin," but in the end they could provide no more than useful guidance. "Those beauties in which its [literature's] greatest merit consists, are better felt than found out by rule and compass."[149] But Dubos was equally convinced that it was not only individual response but also a long-standing tradition of acceptance that established the

ultimate merit of a work of art. A public reaction was needed—though it must needs be that of an informed public. "In fine," he wrote, "in things which belong to the jurisdiction of the sense, such as the merit of a poem; the emotion of all men who have and still do read it, as well as their veneration for the work, amount to as strong a proof as a demonstration in geometry."[150]

There is not much of architecture in Dubos's voluminous study, but when he broached it, it was on exactly the same terms as the other arts: "the mind resigns itself without any wandering, to whatever moves it. A person skilled in architecture does not examine a pillar or inspect into a particular part of a palace, 'till after having given a glance [*coup d'oeil*] over the whole pile of building, and settled in his imagination a distinct idea of the edifice."[151] Dubos far preferred Latin to French. He read Aristotle in Latin. He knew little Greek, though he berated Perrault for his lack of knowledge of Greek. He was nonetheless taken up at once as the spokesman for the new sensibility of sentiment. His book ran to nine editions in France in the eighteenth century; it was translated into six other languages. The year after its publication, he was elected to the Académie française, and three years later he replaced André Dacier as its permanent secretary.

By the third decade of the eighteenth century, Fénelon's pastiche, Anne Dacier's decorous versions of Homer, and Dubos's handbook on the new sensibility had together suffused the cultural landscape of France, irrevocably transforming the image of Greek antiquity and providing a framework for approaching it. *Télémaque* had been apostrophized as having "a pure and sublime je ne sais quoi."[152] Montesquieu could note, "The divine work of this century, *Télémaque,* in which Homer seems to breathe again, is incontrovertible proof of the excellence of that ancient poet."[153] What had seemed gross and shapeless in Homer had been given an order of its own, what had seemed uncouth and barbarous had become an expression of energy and genius. Homer and ancient Greece had even been given a moral sanctity. The critical stance, even the critical vocabulary that Winckelmann later to advance in formulating his theory on the rise and decline of Greek art was in place. But before any comprehensive view of that kind could be articulated, something of the reality of the art of ancient Greece had needs be established. The first view was put together tentatively, piecemeal and usually inaccurately and more often that not in illusory fashion, by the members of the Académie royale des inscriptions et belles-lettres, many of whom we have already encountered.

Constructing an Image of Greek Antiquity

The informal gathering of scholars versed in history and antiquity assembled together as the "petite Académie" in 1663 by Colbert was directed to write the official history of Louis XIV's reign and to ensure that the French monarch was properly glorified in all works of art and in all inscriptions that adorned his structures. This body was first given official standing in 1701, when it was designated the Académie royale des inscriptions et médailles, but

only in 1716, after the death of Louis XIV, was it relieved of its tiresome official duties and established as a cultural institution, the Académie royale des inscriptions et belles-lettres.[154] The men directly responsible for this transformation were Louis Phélypeaux, comte de Pontchartrain, chancellor from 1699 to 1714; his son Jérôme Phélypeaux, comte de Pontchartrain; and his son Jean-Frédéric Phélypeaux, comte de Maurepas; together with the abbé Bignon and his brother's son Armand-Jérôme Bignon.[155] The first three administered the king's household, including royal patronage of the cultural and scientific establishment, in succession, from 1690 to 1775; while the last two in effect ruled the king's library, almost in succession, from 1719 to 1772,[156] controlling much of the cultural activity in eighteenth-century France, including the *Journal des sçavans*.

In point of fact, the abbé Bignon's control of cultural activities began even earlier. In 1684 his uncle, the chancellor to be, Pontchartrain, hoped that the abbé, then twenty-two years of age, might be appointed the king's librarian, in succession to three earlier Bignons. The position was given instead, nominally at first, to Camille Le Tellier de Louvois, then nine years of age, at the behest of his father, François Michel Le Tellier, marquis de Louvois, who from the death of Colbert in 1683 until his own death in 1691 was the most powerful of Louis XIV's ministers. However, Pontchartrain was able to ensure the abbé Bignon's nomination to the Académie royale des sciences in 1691; to the Académie royale des inscriptions et belles-lettres in 1692 (which he at once reformed and of which he took control with Claude Gros de Boze, garde des médailles du Cabinet du roi, who became the permanent secretary of this academy in 1706); and to the Académie française in 1693 (where his controlling hand was firmly rebuffed). In 1701 the abbé was made conseiller d'État d'Église, a position normally reserved for the highest ranking clergy. His control of the world of books began in 1699, when he was given the direction de la librairie, which meant that he headed the administration in charge of the censorship and circulation of books throughout France. There he worked hand in glove with Marc-René de Voyer de Paulmy, marquis d'Argenson, Louis XIV's famous lieutenant of police. In 1701 the abbé was put in control of the *Journal des sçavans*, though he lost this position, along with the direction de la librairie in 1714, when chancellor Pontchartrain resigned; however he regained his control of the journal in 1723 and remained its editor until 1739. His eventual appointment as bibliothècaire du roi, in September 1719, was at the behest of his cousin, Maurepas, as were his appointments, in 1720, as garde du cabinet of the king's personal libraries at Versailles and at Fontainebleau. The abbé Bignon's installation as king's librarian marked the beginning of the period of the greatest and most spectacular expansion of the Bibliothèque du roi.

Though Sévin and Michel Fourmont were sent out to the Levant under his auspices, the abbé Bignon does not seem to have instigated any policies focused on the study of Greek art as such. This new endeavor was furthered within the Académie royale des inscriptions et belles-lettres by others, includ-

ing Claude-François Fraguier,[157] a royal censor and close companion to Bignon. He had probed the history of antique painting as early as 1709 but soon shifted to working with Pierre-Jean Burette, another censor and another of the abbé's scholars at the king's library, on reconstructing the music of ancient Greece.[158] By the 1730s, Burette felt sufficiently confident in his understanding to assure the academicians that the music of antiquity was better than that of the present. Classical painting and sculpture were brought before the academy in the ensuing years by Nicolas Gedoyn,[159] a canon at Sainte-Chapelle, whose translation *Pausanias; ou, Voyage historique de la Grèce* (1731) accompanied Le Roy on his travels. In October 1725, Gedoyn tried to conjure up for the members of the academy the appearance of one of Polygnotus of Thasos's two famous paintings in the Lesche (clubhouse) of the Knidians at Delphi on the basis of no more than Pausanias's *Description of Greece* (10.25–31).[160] Some seven years later, he gave a paper on the works of the sculptor Pheidias.[161] These were, inevitably, insubstantial pieces, but in 1736 he offered a paper of sharper interest, pertinent to the polemics of the preceding years, in which he discussed "Whether the ancients were more knowledgeable than the moderns, and how one can assess the merits of the one and the other."[162] His position was much the same as that of Fénelon, to whom he referred more than once, and also of Dubos. The literature of antiquity, whether Greek or Roman, was far preferable to that of the modern age. Corneille, Molière, Racine, and Philippe Quinault could be compared only to their embarrassment to Homer, Virgil, Demosthenes, and Cicero. The music of antiquity was likewise better than that of the present. Though Gedoyn allowed that "as for the speculative sciences, that is another thing entirely,"[163] where he thought his contemporaries excelled was in the richness and complexity of their knowledge and understanding, and in their morality. Plato himself could not stand comparison: "As for his morals, are they comparable to those of *Télémaque,* by the illustrious archbishop of Cambrai, Monsieur de Fénelon? If that book had been written in Greece, and if it were two thousand years old, we would regard it as a masterpiece of antiquity."[164] In assessing the fine arts, Gedoyn made harder, clear-cut distinctions, censuring the Romans unconditionally. Their achievements, he made plain, owed everything to those of the Greeks:

> As for the fine arts such as architecture, painting, and sculpture, one must admit that these were the weak spot of the Romans. In vain they decorated Rome with the masterpieces of Greece, that is, with the most beautiful statues and the most excellent paintings in all the world, for they were never able to approach those great models. Vitruvius had profound insight into the science of proportions and architecture, but he had more theory than practice. The Greeks, who had sharp and refined minds, were well suited for it; the Romans were not.[165]

When this assessment was republished in 1745, the year after Gedoyn's death, in his *Oeuvres diverses,* a further sentence had been added, just before the

last, giving evidence of yet other emerging sensibilities: "I would be happy to believe," Gedoyn wrote, "that to excel in these arts, it is not enough to form oneself on the originals—one must also capture the true, the natural; even that is not enough, one must capture nature itself."[166]

Other upholders of the Greek cause may be adduced—Nicolas Fréret,[167] for example, who from 1736 onward was drafting a new chronology and analysis of Greek history; or Claude Sallier,[168] a remarkable linguist and fervent admirer of Plato who worked with Sévin at the Bibliothèque du roi, and who presented an early paper on the issue of perspective in antique painting and sculpture, and another, unusually levelheaded one in March 1756 on the terms employed in Homer for the tools and materials of construction and the elements of buildings. However, the most conspicuous and effective spokesman, by far, was the comte de Caylus.

The scion of an old and distinguished family, Caylus was intended by his mother, a woman of mettle and close companion to Madame de Maintenon, for a military career, but he resigned his commission soon enough and set off in 1714, at the age of twenty-two, for Italy (to avoid, it is said, his mother's plans for his marriage), where he stayed a year, traveling as far south as Sicily and Malta. Eight months after his return to Paris, he set off on a longer and more adventurous expedition, to the Levant, in the company of the new ambassador to the Sublime Porte, Jean Louis d'Usson, marquis de Bonac, with whom he embarked from Toulon in July 1716.[169] He took advantage of a stopover in Smyrna to visit the ruins of the Artemision at Ephesus. From Constantinople he traveled northwest to the province of Adrianople (Edirne) and also southwest to the Troad, searching for the site of Troy, but his mother called him home before he was able to explore Athens. He was back in France by February 1717. Settling in Paris in 1719, he took up a social life, becoming friendly with Pierre Crozat, whose exceptional collection of old master drawings he began to engrave; with Pierre-Jean Mariette,[170] another celebrated if far less wealthy collector of drawings and prints; and also with Maurepas, already, in 1718, at the age of seventeen, secrétaire d'État de la Maison de la roi and secrétaire d'État de la Marine, though it was only in 1723 that he was able to take up these charges, who was to be the staunchest of Caylus's friends through life and, even after, executor of his will.[171] Some of Caylus's circle were to gather later at the Monday salons of Marie-Thérèse Rodet Geoffrin.[172] Her Wednesday salons were reserved for the philosophes, all of whom, to a man, loathed Caylus—whether for his frivolity (he wrote hundreds of extremely lightweight, sometimes altogether lewd occasional pieces) or for his obsessive antiquarianism. He is said to have been the butt of Diderot's "L'antico-manie,"[173] though this was concerned largely with the craze for classical literature. He was possibly known as "la Czarine de Paris,"[174] for he and his close friend Antonio Conti, a radical thinker from Venice settled in Paris from 1718 to 1726, who was soon to serve as his mentor, were conspicuous members of a gay group, the Académie de ces messieurs,[175] which was attached to the salon of Anne Charlotte Crussol, duchesse d'Aiguillon. This group centered

about Maurepas and, in addition to Caylus, Conti, and Montesquieu, its members included René-Louis de Voyer de Paulmy, marquis d'Argenson; the sculptor Edmé Bouchardon; the novelist Claude Prosper Jolyot de Crébillon; and, on occasion, Voltaire. Together they published *Recueil de ces messieurs* (1745), a collection of racy short stories that Jean Le Rond d'Alembert judged to be "crap rather than a debauchery of the mind."[176]

When Caylus's mother died in 1729 he moved to a house of his own, alongside the Tuileries, and there he began to install an ever-expanding collection of antiquities and miscellaneous objects. He collected almost without discrimination, buying from here, there, and everywhere (Maurepas was very useful in expediting his purchases), though the bulk came from Italy, through the agency of Paciaudi, to whom Barthélemy had introduced him in 1756. Caylus filled his house three times over, donating each collection in turn to the king. After his death in 1765 his obituarist, Charles Le Beau, declared,

> Nothing antique was indifferent to him; from the gods to reptiles, from the richest metals and the most beautiful marbles to fragments of glass and terra-cotta jars, everything found a place in his collection. The entrance hall to his house announced ancient Egypt: you were welcomed into it by a beautiful Egyptian statue, five *pieds* five *pounces* tall. The staircase was covered with medallions and with curiosities from China and America. In the antique room, you found yourself surrounded by gods, priests, magistrates — Egyptian, Etruscan, Greek, Roman, in whose midst a few Gallic figures seemed ashamed to reveal themselves.[177]

The vast assemblage was recorded in the seven volumes of the *Recueil d'antiquités égyptiennes, étrusques, grecques et romaines* (the word *gauloises* was added to the title after the second volume) issued from 1752 to 1767. This work featured over eight hundred closely packed plates, a handful engraved by Bouchardon and Louis-Claude Vassé, some by other artists, most by Caylus himself. There was little system in the arrangement, other than that provided by the categories of the title; items were simply added to the catalog, almost, it seems, as they were acquired.

Though the short introduction in each volume revealed something of Caylus's concerns, these were more effectively outlined in the papers he presented at the Académie royale de peinture et de sculpture, of which he became an honorary member in November 1731 with the support of Charles-Antoine Coypel. Caylus presented his first paper there in 1732, but the session was so poorly attended that he withdrew, offended, to take up an active role only after 1747, when Coypel became director; then Caylus became very active, instituting prizes and presenting a succession of *mémoires*, at least eighteen on the lives of French painters and sculptors, others on matters of taste in painting, composition and color. His "Discours sur l'harmonie et sur la couleur," read in November 1747 and again in June 1762, indicates a ready grasp of new aesthetic theories springing from the writings of Locke and those of Étienne Bonnet de Condillac, Locke's leading advocate in France. "It is

certain," Caylus wrote, "that *we have no innate ideas,* and that the gifts of nature consist only in a greater aptitude, in a predisposition of fibers more sensitive in one area than in another to receiving an impression and making it germinate."[178]

His interests in antiquity were to be focussed rather at the Académie royale des inscriptions et belles-lettres, to which he was elected in February 1742. He presented about sixty papers there over the years, once again on a wide range of subjects. Those on the arts of Greece were clearly inspired by Gedoyn. In June 1747 Caylus read "De l'amour des beaux-arts, et de l'extrême considération que le Grecs avoient pour ceux qui les cultivoient avec succés," based entirely on literary sources, in which he ended with a thrust, now familiar, at the Romans: "Moreover, Gentlemen, I will not speak to you of the Romans. We know they had little taste for the arts; they liked them only for appearance and magnificence, following the tastes of others; they had more than one Mummius."[179] Lucius Mummius was the Roman consul who stripped and destroyed Corinth in 146 B.C. In March 1756, Caylus attempted ambitious reconstructions of the shields of Achilles, Herakles, and Aeneas based on the descriptions in Homer (*Iliad* 18.475–615), Hesiod (*Shield of Herakles* 139–302), and Virgil (*Aeneid* 8.611–832). Achilles' shield was illustrated by a copy of the drawing Vleughels had prepared for Boivin's *Apologie d'Homere, et bouclier d'Achille,* and the shields of Herakles and Aeneas were drawn under Caylus's own direction by Le Lorrain;[180] all three drawings were eventually engraved and published in the academy's *Histoire* (figs. 13–15).[181] Caylus did not hesitate to judge Homer's the best; the others he thought less well composed and overly detailed. The year following, in 1757, he tackled the reconstruction of Polygnotus's two paintings at Delphi—one depicting the embarcation of the Greeks after the fall of Troy, the other Odysseus's descent into the Underworld—once more with drawings prepared by Le Lorrain that were engraved and published in the academy's *Histoire* (figs. 16, 17).[182] As before, Caylus made bold to criticize the compositions as if he had the originals to hand, even comparing his reconstructions with the paintings of Paolo Veronese. These exercises must be seen as part of Caylus's attempt to encourage painters to take up subjects from antique texts, a project that provoked several sarcastic chapters in Gotthold Ephraim Lessing's *Laokoon* (1766), not, as one might suppose, because such exercises in reconstruction could be thought to be fatuous in themselves but because Caylus was judged to be failing in poetic imagining.[183]

The most famous of Caylus's attempts to resurrect the arts of Greece was the result of years of experimentation with the encaustic process, based on Pliny the Elder's account (*Naturalis historia* 35.39), in collaboration with the physician Michel Joseph Majault. Their "Mémoire sur la peinture à l'encaustique et sur la peinture à la cire" was presented to the Académie royale des inscriptions et belles-lettres in its first form on 15 November 1754 and in its final form in July 1755. By then, Caylus was able to show a painting, *Tête de Minerve casquée* by Joseph Marie Vien (fig. 18), executed in the revived wax

Fig. 13. Martin Marvye, after Nicolas Vleughels
Bouclier d'Achille, Homere, Liv. XVIII
From Anne-Claude-Philippe de Tubières, comte de Caylus, "Des boucliers d'Achille,
d'Hercule et d'Énée; suivant les descriptions d'Homère, d'Hésiode et de Virgile,"
Histoire de l'Académie royale des inscriptions et belles-lettres . . . 27 (1761): Histoire,
after p. 20, pl. I

Pl.II.Hist.de L'Acad.des Bell.Lettr.T.XXVII, pag. 21.

Bouclier d'Hercule,
Tel qu'il est décrit dans le fragment d'Hésiode

Dessiné et gravé par le Lorrain

Fig. 14. Louis-Joseph Le Lorrain
Bouclier d'Hercule, tel qu'il est décrit dans le fragment d'Hésiode
From Anne-Claude-Philippe de Tubières, comte de Caylus, "Des boucliers d'Achille,
d'Hercule et d'Énée; suivant les descriptions d'Homère, d'Hésiode et de Virgile,"
Histoire de l'Académie royale des inscriptions et belles-lettres... 27 (1761): *Histoire,* after
p. 20, pl. II

Fig. 15. Louis-Joseph Le Lorrain
Bouclier d'Enée, tel qu'il est décrit le 8e livre de Virgile
From Anne-Claude-Philippe de Tubières, comte de Caylus, "Des boucliers d'Achille, d'Hercule et d'Énée; suivant les descriptions d'Homère, d'Hésiode et de Virgile," *Histoire de l'Académie royale des inscriptions et belles-lettres . . .* 27 (1761): *Histoire,* after p. 20, pl. III

Fig. 16. Louis-Joseph Le Lorrain
Premier tableau: L'embarquement des Grecs après la prise de Troye
From Anne-Claude-Philippe de Tubières, comte de Caylus, "Description de deux tableaux de Polygnote, donnée par Pausanias," *Histoire de l'Académie royale des inscriptions et belles-lettres* . . . 27 (1761): *Histoire,* after p. 34, pl. I

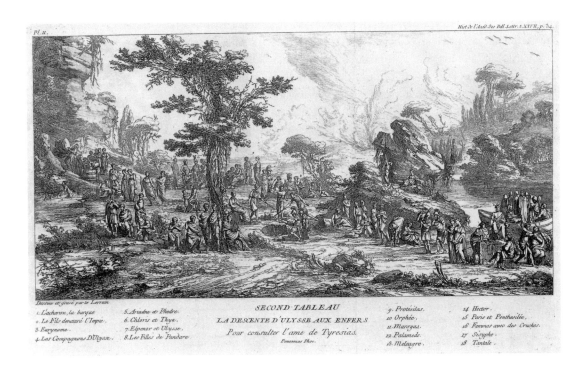

Fig. 17. Louis-Joseph Le Lorrain
Second tableau: La descente d'Ulysse aux enfers pour consulter l'ame de Tyresias
From Anne-Claude-Philippe de Tubières, comte de Caylus, "Description de deux tableaux de Polygnote, donnée par Pausanias," *Histoire de l'Académie royale des inscriptions et belles-lettres . . .* 27 (1761): *Histoire,* after p. 34, pl. II

process. Vien's painting was exhibited at Madame Geoffrin's salon and at the Salon itself in 1755 and was bought by La Live de Jully for the considerable sum of twelve hundred livres. [184] Caylus and Majault's essay provoked Diderot's bitter attack, *L'histoire et le secret de la peinture en cire,* issued in April 1755, in which he accused them of having plagiarized the discoveries of the painter Jean-Jacques Bachelier.

Though such writings caused great stir, the paper most pertinent to Caylus's engagement with the arts of ancient Greece was "De l'architecture ancienne," read on 17 January 1749.[185] Like much of Caylus's writing, it is unstructured and rambling, but from the plethora of references—Herodotus, Pausanias, and Strabo from antiquity; John Durant Breval, John Chardin, de Bruyn, Thomas Dempster, Antonio Francesco Gori, Norden, and Spon and Wheler among the moderns (only later was Pococke introduced to Caylus by Barthélemy)—there emerges a history of the formation of a magnificent architecture in Egypt, which gave rise in turn to Solomon's temple in Jerusalem and to the glories of Persepolis in Persia, and also to the distinctive architecture of the Etruscans. According to Caylus, the architecture of Egypt had its effect also on that of the Greeks, but Greek sensibility raised the arts of both sculpture and architecture to a new distinction: "they took both [arts] to the ultimate degree of the sublime through the taste, delicacy, feeling, and lightness they added to them."[186] Surprisingly Caylus thought the Greeks' highest achievement might not be the Parthenon (restored by Hadrian, according to Spon) but rather the Hephaisteion, "built to the same proportions."[187] In any case, the greatest period of Greek architecture was, without demur, the age of Pericles, and the Romans represented a great falling off. "One can say, with confidence," Caylus wrote, "that the Romans, in the place and situation of the Greeks, would not have left behind even the slightest of monuments or made a single step toward the culture and the progress of the arts; it seems, in short, that they worked in that area, or rather instituted work, only according to the ideas of others."[188]

Caylus contended firmly that as architecture was not an art of imitation, its distinction was greater than that of the other arts, achieved by a slow process of the refinement of forms, and here the Greeks had triumphed. "If we set aside the totality of a piece of architecture, which indicates its intended purpose and suitably informs the beholder as to its purpose," he wrote,

> the most beautiful column is a cylinder, a tree, a ninepin, what have you—I say this not for the vulgar but for an infinity of those most vocal in judgment—whereas in fact, in its proportions, its swelling, its tapering, its base, and its capital, all of which appear absolutely arbitrary, and no doubt were for a long time, that column, I say, is for a man gifted with genius and filled with knowledge and a feeling for the arts one of the most beautiful of creations. To be brought to its perfection, then, architecture did not require a genius different from that of the other arts, since it is everywhere the same, but a finer sense, inasmuch as its expression emanates uniquely and absolutely from the mind, from a correct balance and the purest of taste.[189]

Fig. 18. Joseph Marie Vien
Minerva, ca. 1754–55, oil and wax on canvas
Saint Petersburg, State Hermitage Museum

But though architecture might require a rare refinement of spirit, it was also an art grounded in common sense and a firmness of appearance, to be apprehended at first glance—and here Caylus invoked the east front of the Louvre. It was based, he believed, on the example of Greek architecture: "To take one example of that truth, Monsieur [Claude] Perrault's facade, which one sees with renewed admiration each day, and which is executed according to the principles and fine points invented by the Greeks, is as perfect and as pleasing as it is because it strikes both at first glance and upon reflection, while presenting us with only a single order in which we delight without distraction."[190] Opinions of this sort were to emerge also in the writings of Le Roy.

Caylus presented many more *mémoires* touching on the arts of ancient Greece. Among those directly concerned with architecture was "Dissertation sur le tombeau de Mausole" of August 1753,[191] which once again presented an image of a full restoration, this one drawn by Ennemond Alexandre Petitot, engraved by Bellicard (fig. 19), and based not only on the celebrated description in Pliny the Elder's *Naturalis historia* (36.4.30–32) but also on recent drawings, albeit of the Medracen, the tomb of a Numidian king, standing to the south of Constantine, Algeria, which had been carefully recorded in 1725 by Jean-André Peyssonnel, a doctor and naturalist sent by Maurepas and the abbé Bignon to explore the Barbary Coast. Peyssonnel was established on Guadaloupe from 1727 until his death in 1759, but his drawings were in Paris and readily available to Caylus through Maurepas. There were well over one hundred drawings in all, mostly of Roman monuments on the north coast of Africa, that Caylus considered worthy of publication, though he made no effort to ensure this. Bellicard's engraving of the Medracen, an edifice Caylus thought of as Greek, was published in 1759 in the academy's *Mémoires* (fig. 20).[192] In 1762 Caylus conjured up the funeral pyre designed for Hephaestion, Alexander the Great's intimate friend, and Alexander's own funeral chariot (fig. 21), both based on Diodorus Siculus's history (*Library of History* 17.115, 18.26–28).[193] But these representations were no more revealing of real understanding of the arts of ancient Greece than those enumerated earlier.

The members of the Académie royale des inscriptions et belles-lettres carefully cultivated an image of themselves as interpreters of antiquity, and not only in their gatherings at the Louvre but also in the small dinner parties that Gros de Boze, the academy's permanent secretary, held on Tuesday and Wednesday evenings. They considered themselves an exclusive and extremely learned circle, and they were undoubtedly dedicated and serious. But the only really significant contributions to knowledge to emerge from their deliberations were those of Barthélemy, who from his arrival in Paris in 1744 worked with Gros de Boze and who was to succeed him as royal numismatist in 1754. Barthélemy laid down a proper basis for the classification of coins with his "Essai d'une paléographie numismatique," presented in January 1750. His first revelation was the decipherment of the Palmyrene alphabet, based on an inscription published the year before by Wood and Dawkins— "Réflexions sur l'alphabet et sur la langue dont on se servait autrefois à

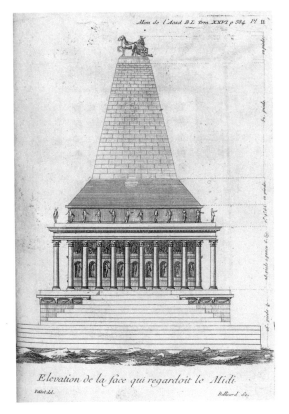

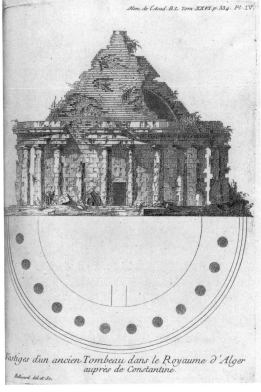

Fig. 19. Jérôme-Charles Bellicard, after Ennemond Alexandre Petitot
Elevation de la face qui regardoit le midi
From Anne-Claude-Philippe de Tubières, comte de Caylus, "Dissertation sur le tombeau de Mausole," *Histoire de l'Académie royale des inscriptions et belles-lettres . . .* 26 (1759): *Mémoires,* after p. 334, pl. II

Fig. 20. Jérôme-Charles Bellicard
Vestiges d'un ancien tombeau dans le royaume d'Alger, auprès de Constantine
From Anne-Claude-Philippe de Tubières, comte de Caylus, "Dissertation sur le tombeau de Mausole," *Histoire de l'Académie royale des inscriptions et belles-lettres . . .* 26 (1759): *Mémoires,* after p. 334, pl. IV

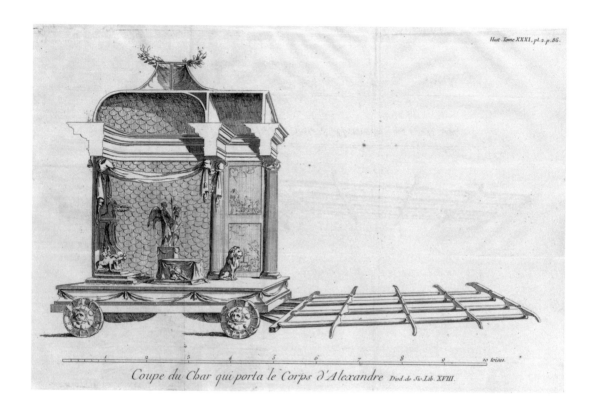

Fig. 21. *Coupe du char qui porta le corps d'Alexandre*
From Anne-Claude-Philippe de Tubières, comte de Caylus,
"Sur le char qui porta le corps d'Alexandre," *Histoire de
l'Académie royale des inscriptions et belles-lettres . . .* 31
(1768): *Histoire,* after p. 86, pl. ɪɪ

Palmyre," presented on 12 February 1754. Barthélemy's second and far more important decipherment was that of the Phoenician alphabet — "Reflexions sur quelques monuments phéneciens, et sur les alphabets qui en résultent," read on 12 April 1758.[194] Neither Caylus nor any of the other academicians could provide revelations of this kind. All in all, Diderot's very public disdain for Caylus is easy to understand. Diderot scorned the obsessive accumulation of bric-a-brac, the gathering of undifferentiated information. To him, Caylus's relentless activity was without discrimination, and when Caylus died, Diderot wrote a rude epitaph to be set under the urn containing his remains: "Ci-gît un antiquaire acariâtre et brusque: / Ah! qu'il est bien logé dans cette cruche étrusque!" (Here lies an antiquarian bitter and brusque: / Ah! How well he is lodged in this jug *étrusque!*).[195]

Clearly, there was something risible about Caylus's obsessions. Even his friends Barthélemy and Paciaudi sniggered at his inability to decipher inscriptions (he had no Greek, no more than a smattering of Latin), but underlying his endeavors was an altogether original understanding of the role of such activities. In his short preface to the fifth volume, of 1762, of his *Recueil d'antiquités,* he responded with some dignity to the jibes to which he had been subjected. He himself, he wrote, would smile at someone interested in broken pots if there were no more to it, but the careful inspection of all surviving evidence from the past, even the rubbish, he claimed, could serve to provide knowledge of cultures and societies long forgotten, and knowledge not only of their material world but also of their spiritual state. The process was painstaking and slow, the antiquarian's lot was not always rewarding — "he will decipher only with difficulty a few atoms in the immensity of the void"[196] — yet it was necessary if men were to understand one another. Caylus wrote thus little more than thirty years after Michel Fourmont had laid waste the antiquities of Sparta.

Nonetheless Caylus mistrusted all attempts at systematizing and theory. When Paciaudi introduced him to Francesco de Ficoroni's *Gemmae Antique Litteratae, Aliaequae Rariores* (1757), Caylus replied, on 20 November 1763, "There is no general thesis on monuments, and a shot at random can contradict the propositions of all the antiquarians, present, past, and future."[197] He had nothing to say of Winckelmann's *Geschichte der Kunst des Alterthums,* published in 1764. The book was to be translated into French two years later, but Caylus died without having read it — he seems not to have read German. Though Caylus thought Winckelmann too heavy, and Winckelmann thought Caylus too lightweight, Winckelmann was generous — and quite early — in assessing Caylus's contribution. "He has the honor," he wrote to Ludovico Bianconi on 22 July 1758, "of being the first to have set out to study the essence of the style of the art of classical civilizations. But to wish to do so in Paris is an endeavor above all expectation."[198]

Caylus's more ephemeral contribution to Greek tastes was his advocacy of the *goût grec,* already alluded to, now seen as part of a general stirring of

interest in antiquity. This classicizing style coincided with the return of Le Roy to Paris with firsthand evidence of the general appearance and details of the ancient remains of Athens, though such details were in fact to play no part in the fashion: the motifs taken up by Le Lorrain for La Live de Jully's furniture and in the handful of interiors that followed were the key pattern and the Vitruvian scroll. Not until de Wailly introduced the authentic Ionic of the Erechtheion into the portico of the house he erected for Marc-René, marquis de Voyer d'Argenson, in the Palais-Royal in Paris between 1762 and 1770, and Jean-Denis Antoine used something of the same kind for the south facade of the Château d'Herces in Eure-et-Loir a few years later, was the impact of Le Roy's recording made evident. However, there can be little doubt that his expedition and his findings were regarded as grist for the new fashion, and the one full-scale restoration study offered in Le Roy's book, the view of the Propylaia (see vol. 1, pl. 26), may be seen as the climax to Caylus's sustained fabrication of a lofty image for the arts of ancient Greece. The extent to which the image of the Propylaia was fabricated may be judged from Le Roy's in situ view (see vol. 1, pl. 6) or from the more accurate one taken in 1765 by the English painter William Pars (London, British Museum).[199] Likewise, Cochin's *Mémoires* made clear the extent to which the *néo-grec* revival was a return to the weight and grandeur of Louis XIV's reign rather than a reference to any notion of Greek antiquity:

Finally everyone returned, or rather worked to return, to the path of good taste of the previous century. And since in Paris everything must have a nickname, this was called architecture *à la grecque*, and soon even braid and ribbons were being made *à la grecque;* it remained good taste only in the hands of a small number of people and became a folly in the hands of the others.

Our old architects, who had never been outside Paris, wanted to show they could also cope with the *goût grec;* it was the same with apprentices and even the master masons. All those good people misplaced antique details, deformed them, decorated the corbels of the transepts with very heavy guilloche, and committed a thousand other blunders. The painter Le Lorrain provided very clumsy drawings for the ornaments in the apartment of Monsieur de la Live, a rich art lover who produced scrawls from time to time. They made quite a stir, particularly since Monsieur de Caylus praised them enthusiastically; that is how garlands came to take the form of coiled well-ropes, and jars, formerly used to contain liqueurs, were transformed into windup clocks. These beautiful inventions were imitated by every ignoramus and flooded Paris with the craze *à la grecque*. It followed from there what always will, given that the number of good things will always be very small in any style and that ignorance will always find a way to blight architecture; but, though many bad things are still being made, they are at least closer to good taste than to the bad taste that preceded them, and anyone with natural taste will be closer to the path leading to the good than previously, provided that this taste does not become (through the mistakes of those who parody it) so degraded that no one can bear it any longer.[200]

An essential element in the elevation of the Greeks was the disparagement of the Romans' achievement. Gedoyn's dismissal was published first, in the *Histoire* of the Academie royale des inscriptions et belles-lettres in 1740; Caylus's did not appear until 1754,[201] but Caylus had by then sharpened his views on the Etruscans' position in the history of art and architecture. The propaganda of the Accademia etrusca had wrought its effect.[202] The society had emerged, fully fledged almost, in 1726 with the completion of the publication in Florence, for political aims, of Thomas Dempster's early-seventeenth-century manuscript *De Etruria regali*. Known at first as the Società erudita degli occulti, it was transformed into the Accademia etrusca delle antichità ed inscrizioni and established in Cortona. Its members, Marcello Venuti and Antonio Francesco Gori foremost among them, feverishly scoured the surrounding countryside in search of Etruscan remains. They set up a museum as well and published their findings not only in the *Saggi di dissertazioni accademiche pubblicamente lette nella nobile Accademia etrusca dell'antichissima città di Cortona,* initiated in 1735, but also in a spate of pamphlets and books published from as early as 1727 until the early 1750s, when their interests turned suddenly to botany. By 1754 the Accademia etrusca had ceased to study the Etruscans.

In the first volume, of 1752, of his *Recueil d'antiquités,* Caylus summarized the revisionist history of the arts. "These were formed in Egypt with a real grandeur of character; from there they moved to Etruria, where they acquired some detail, but at the expense of the grandeur; to be transported to Greece, where knowledge combined with the most noble elegance brought them to their highest perfection; after which, in the end, to Rome, where, continuing to shine only with the aid of foreigners, after struggling for some time against barbarism, they were buried in the debris of the empire."[203] The preface to the section on Greek antiquities in this same volume recapitulated this history, but laid even greater emphasis on the supreme excellence of the Greeks:

> The Greeks distanced themselves from the taste for the grand and prodigious, whose example had been provided by the Egyptians. They reduced the masses to add elegance and refinement to the detail. They added to these beautiful features of the art the grace and knowledgeable freedom that can be achieved only at a level of superiority rarely granted by nature, but which was fairly commonly to be found in Greece over the course of some centuries. Finally, the Greeks brought to perfection those arts whose aim is to please through the imitation of nature. Their works bring focus to so many aspects in which they excelled that the study of them goes hand in hand, as it were, with the study of nature.[204]

No more than one of the objects offered as representative of Greek art in this volume of the *Recueil d'antiquités* would now be accepted as such. But Caylus's beliefs were widely shared in France. They were, inevitably, paralleled in the *Recueil de pierres gravées antiques* (1732–37), published by

Caylus's friend Pierre-Jean Mariette, who is usually considered to have written the preface to the first volume, which begins, "I will not attempt here to write the history of engraved stones; we know that, like all the fine arts, they come from the Egyptians, that from there they were passed to the Greeks, who took this art to its highest degree of perfection: the Romans in the end adopted them from these last; but the Greeks always remained superior in taste and workmanship."[205] By 1750, when the revised and more famous edition of this work was published, the history offered was more complex. The Etruscans, Mariette believed, had learned the arts directly from the Egyptians and the Phoenicians: "the beginning of the arts was no different in Greece from what it had been in Etruria. It was once again the Egyptians who placed the instruments of art in the hands of the Greeks."[206] The Romans, he thought, had found their first inspiration in the arts of the Etruscans only to be overtaken in time by the example of the Greeks. Marc-Antoine Laugier advanced this notion in his *Essai sur l'architecture* (1753), and Le Roy accepted such ideas without demur. But in Italy they provoked an angry rebuttal.

Giovanni Battista Piranesi's celebrated attack on Le Roy and Mariette has often been recounted, most notably by Rudolf Wittkower in the *Journal of the Warburg Institute* in 1938, and requires no more than the briefest outline here.[207] Piranesi was in a buoyant and combative mood in the late 1750s. He had invested his wife's dowry in copper plates and obtained papal permission to import two hundred bales of paper, tax exempt, and had issued the four volumes of the magnificent *Antichità romane* in May 1756. Charlemont's reluctance to pay, as agreed, for the dedication plates of these folios goaded Piranesi into a fury. In February 1758 he published his unanswered letters to Charlemont, together with small-scale replicas of the dedication plates, now defaced and gouged, as *Lettere di giustificazione scritte a Milord Charlemont e à di lui agenti di Roma*. Piranesi required a great deal of further support from the Vatican to avoid a term in prison. He remained, however, in mettlesome mood. In 1761 he issued the lengthiest of his polemical works, *Della magnificenza ed architecttura de' romani*, ninety-eight pages of text in Latin, the same in Italian, and thirty-eight plates directed against both a pamphlet published anonymously in London in 1755 and Le Roy's *Ruines* of 1758. The pamphlet, *The Investigator, Number 332*, was the work of the painter Allan Ramsay, who had arrived in Rome, on his second visit, in February 1755 and had formed a circle of friends with Wood, Adam, Peter Grant (the Scottish Catholic agent in Rome who had tried to intercede between Charlemont and Piranesi in their dispute), and Piranesi himself. Ramsay left Rome in May 1757, and Piranesi may well not have known that Ramsay was the author of the provoking pamphlet; he referred to its author throughout as "l'Investigatore." The pamphlet was in the form of a dialogue between Colonel Freeman and Lord Modish, with occasional reference to Lady Modish and her sister Lady Harriot, and its principal theme was that there could be no absolute standard of taste, that in the end taste was a matter of individual preference. Ramsay was clearly in agreement here with his friend and compatriot Hume,

with whose essay "Of the Standard of Taste," of 1755, Ramsey was familiar even before it was published in 1757 in Hume's *Four Dissertations*. Ramsay ranged over a number of issues, such as the neglect of Gothic architecture and the creative genius of the Greeks as opposed to the Romans, who were skilled only in the arts of war before they conquered and plundered Greece (as Horace himself had described). Ramsay also thundered against the medieval church for its suppression of free inquiry and its restriction of the arts.

Piranesi condemned this attack as blasphemous, but the real thrust of his response was a defense of the artistic achievements of the Romans—namely, they had founded their civilization on that of the Etruscans, whose simple style was to be preferred by far to the overdecorated style of the Greeks. He cited surviving Etruscan roads, aqueducts, and sewers, in particular the Cloaca Maxima, as examples of an appropriately functional architecture, concerned with majesty rather than show. He exposed flaws in Laugier's theory about the evolution from wooden to stone architecture by mocking the supposed timber origins of Greek temples. Evidently worried by the new interest in Greece that Le Roy's book had aroused, Piranesi was determined to denigrate Greek architecture in any way he could. And there were clearly others who felt as he did. He had been greatly abetted in mounting the scholarly apparatus to attack Le Roy.[208] There was a great deal of it, quite niggling, in *Della magnificenza*, for Piranesi was incensed by Le Roy's easy rejection of Rome in favor of Greece, by his disdain for the Tuscan and Composite orders. He pilloried Le Roy as best he could. In one notable engraving (fig. 22), Piranesi assembled a group of buildings illustrated by Le Roy, some in thin line drawings, with the Ionic capital of the Erechtheion conspicuous, and flanked this composite with an array of the more complex and varied Ionic capitals to be found in Rome (Piranesi, whatever claims he made for simplicity, favored a highly elaborated architecture). Inserted in the composition was *La Bocca della Verità* (Mouth of Truth), an ancient circular relief from Rome's Santa Maria in Cosmedin; this was said to bite off the hands of any who lied.

Piranesi's attack of 1761 was probably not directed against Ramsay and Le Roy alone, for though he made no mention of him, Winckelmann had already emerged as a conspicuous upholder of the glories of Greece. His *Gedanken über die Nachahmung der griechischen Wercke in der Mahlerey und Bildhauer-Kunst* had been published in Friedrichstadt in 1755, the year before his arrival in Rome, and in 1759 he had published an essay on the Greek temples of Sicily, *Anmerkungen über die Baukunst der alten Tempel zu Girgenti in Sicilien*, based on the drawings he commissioned from the architect Robert Mylne. Mariette's reply to Piranesi, published in the *Gazette littéraire de l'Europe* of 4 November 1764, likewise failed to mention Winckelmann, though it unquestionably reflects his influence. Mariette claimed that the Etruscans were no more than Greek colonists from whom the Romans might indeed have learned something, though it was evident that the Romans had simply plundered Greece (and he cited Mummius's actions at Corinth yet again) and debased its arts with a profusion of ornament and other disgusting

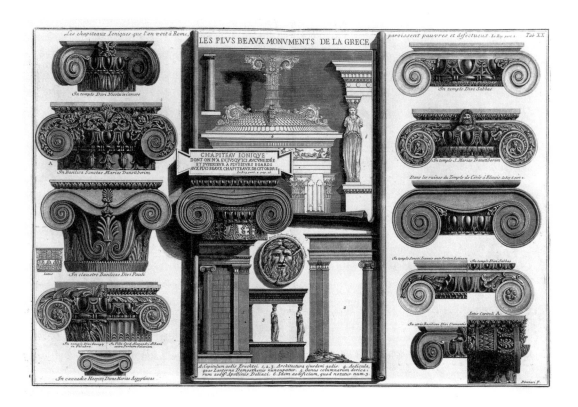

Fig. 22. Giovanni Battista Piranesi
Various Roman Ionic capitals compared with Greek
examples from Julien-David Le Roy's *Les ruines des plus
beaux monuments de la Grece* (1758)
From Giovanni Battista Piranesi, *Della magnificenza ed
architettura de' romani*...(Rome: n.p., 1761), pl. 20

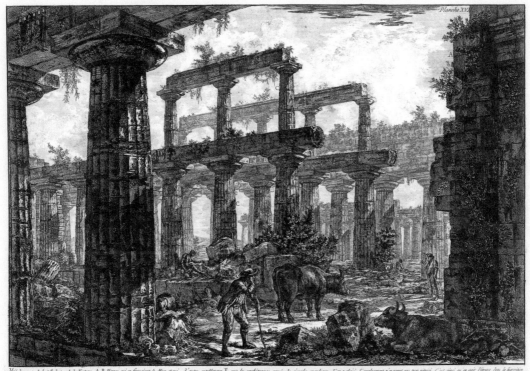

Fig. 23. Giovanni Battista Piranesi
Vuë des restes de la celle du temple de Neptune
From Giovanni Battista Piranesi and Francesco Piranesi, *Différentes vues de quelques restes de trois grands édifices qui subsistent encore dans le milieu de l'ancienne ville de Pesto, autrement Possidonia qui est situee dans la Lucanie* (Rome: n.p., 1778), pl. 17

liberties; they lost all sense of the essential "belle et noble simplicité" (beautiful and noble simplicity) of the Greeks—a catchphrase made famous by Winckelmann.

Within a year Piranesi had rushed his three-part response to Mariette into print: "Osservazioni di Gio. Battista Piranesi sopra la lettre de Monsieur Mariette," a defense of *Della magnificenza* that, with the help of additional ironical comment in the form of illustrations, contrasted Mariette's scholarly pedantry to the creative freedom of the architect; "Parere su l'architettura," a dialogue between Protopiro, a novice upholding a rational theory, and Didascolo, the true learner open to artistic adventure; and "Della introduzione e del progresso delle belle arti in Europa ne' tempi antichi," the opening salvo of a treatise, never to be completed, reiterating the superiority of Rome to Greece. By then Winckelmann's *Geschichte der Kunst des Alterthums* had been published in Dresden, but, in truth, Piranesi had lost any vital interest in the Graeco-Roman argument, believing that the artist should take inspiration from any source he liked and make of it something his own. He thus illustrated the *Osservazioni* with some of the most bizarre, oddly scaled, and overcrowded designs of the century. His final thrust at the antiquarians was *Diverse maniere d'adornare i cammini ed ogni altra parte degli edifizj* (1769). This folio comprised a short text, printed in Italian, English, and French, upholding Egyptian and Etruscan art (the text's tailpiece was a turd as a mound on an archaeological site) followed by sixty-six plates of altogether extraordinary designs, mostly for chimneypieces but also for furniture, clocks, and other miscellaneous items, with many details culled from Caylus's *Recueil d'antiquités*. Nonetheless, it was not Le Roy's *Ruines* or even Stuart and Revett's *Antiquities* that opened the eyes of Europe to the weight and true splendor of Greek architecture, but the last of Piranesi's works, the twenty staggering plates (two signed by his son Francesco) of the *Différentes vues de quelques restes de trois grands édifices qui subsistent encore dans le milieu de l'ancienne ville de Pesto, autrement Possidonia qui est situee dans la Lucanie,* issued in November 1778, within a few months of Piranesi's death. In the descriptive captions, in French, to the plates (fig. 23), he tacitly acknowledged the temples as Greek, but they were more beautiful by far, he explained, than those of Greece itself or even Sicily. They were on Italian soil.

Le Roy's Ruines *and Other Works*

Pococke and Dalton had provided crude images of the architecture of ancient Greece in the decade or so before the appearance of Le Roy's *Ruines* in 1758, but their works made little enough impact in eighteenth-century France. Nor indeed did Stuart and Revett's hard-edged measurements, whether in the first volume of 1762 or in the second and third of the 1790s, though their work was to be taken up seriously in the nineteenth century. Le Roy's, or rather Le Lorrain's, depictions of the monuments of ancient Greece provided the first altogether satisfying focus for those French enthusiasms and sensibilities that we have thus far explored—the desire to assimilate an ideal of the rude and

noble grandeur of Greece, to endow it with a moral dimension, and to give to it a form that could be admired and upheld. For twenty or thirty years, perhaps more, Le Roy's *Ruines* provided the requisite images for this ideal, to be overtaken, as we have seen, only by Piranesi's more robust and forceful sculptural representations of the temples at Paestum. But despite the very real success of Le Roy's book, whether in its 1758 or in its 1770 edition, the vital impact of the work was not its expression of an image of a Greek ideal but rather its unraveling of that ideal. Le Roy wanted no fixed ideal. Having made his voyage of discovery, having returned with his prize, he rejected from the start any attempt to hold the architecture of ancient Greece up as a model for emulation. He neither used his newfound knowledge to establish a canon for the proportioning of the Doric, the Ionic, or even the Corinthian order nor sought to purify the classical tradition with reference to the example of ancient Greece. As he had scornfully replied to Stuart, he had not traveled to Greece simply to measure the buildings. He was concerned rather to penetrate to the essential spirit that had conferred upon the architecture of ancient Greece its supreme distinction, the better to understand not only that architecture but also the very nature of all architecture that mattered.

His analysis of architecture in the *Ruines* of 1758, as previously indicated, was presented in two forms, a discourse on history, another on theory. These forms might be considered separate and distinct, even opposed, but they were no more than two facets of a single intellectual enterprise. The belief that emerged in the seventeenth century, more forcefully in France than anywhere else in Europe, that the entire universe, together with all understanding and experience, was susceptible to rational analysis, assessment, and systematic tabulation — most precisely in the language of mathematics — occasioned a profound change in response. All the mysteries of the cosmos were to be endowed with a new order. Time, for instance, was seen, as never before, as part of a progress toward perfection. The past was no longer to be regarded as a paradigm of order but rather as a succession of phases moving steadily from origins and primitive beginnings to some future utopia. The goal was perfection. Each phase was thus to be isolated and carefully assessed to determine its particular value in the train of events. The study of history became no more than an ordering device. Traditional knowledge and skills were, similarly, to be subjected to analysis and categorization that rendered them explicable and meaningful in intellectual and theoretical terms. The ends of historical study and theory were as one.

The seventeenth century saw the rise of academies and other institutes of learning, which became in time more and more specialized.[209] This was the world of Le Roy. His father, Julien, despite his mechanical innovations in the field of horology, was considered to be in commerce and an artisan and hence ineligible for election to the Académie royale des sciences, even after his appointment in 1739 as horloger ordinaire du roi. He thus took an active part in both the formation and the discussions of a mixed group of artists, artisans, and scientists who gathered informally at first and then at the

Petit Luxembourg after being formally constituted in 1728 as the Société des arts under the protection of Louis de Bourbon-Condé, comte de Clermont, later grand master of the Masonic Grande Loge de Paris.[210] For a time Julien Le Roy presided over the society, which included not only makers of watches and instruments such as Henry Sully, Pierre Gaudron, and Jacques Lemaire but also the composer Jean-Philippe Rameau and the architects Jean Aubert, Germain Boffrand, and Jean-Michel Chevotet. However, it was the prominent scientists among its members who threatened the prestige of the Académie royale des sciences: the astronomer Jean-Paul Grandjean de Fouchy; the physicist Jean-Antoine Nollet, later to become a minor celebrity for his public demonstrations of static electricity; the mathematician Jean-Paul de Gua de Malves; the naturalist Charles-Marie de La Condamine,[211] who traveled along the north coast of Africa and up to Constantinople in 1731 and 1732 and, more famously, joined the mission sent to equatorial Peru in 1735 to measure the length of a degree of the meridian in order to settle the dispute stirred by the theories of Isaac Newton as to the shape of Earth (was it a mandarin or a cucumber?); and the mathematician Alexis-Claude Clairaut, who traveled with the astronomer Pierre-Louis Moreau de Maupertuis[212] to Lapland in the following year, to the same end, earning them the nickname of Argonauts. Four of these five were to be elected to the Académie royale des sciences between 1729 and 1731 (Fouchy had to wait until 1741). The Société des arts had more or less been forced out of existence by the late 1730s, while Le Roy was still a child. His elder brother Pierre,[213] born in 1717, knew something of its struggle for survival, however. Pierre followed his father's profession, training with his father and with Sully, who had moved to Paris in 1712. Pierre first made a name for himself with a striking clock with a single cogwheel, but soon he was celebrated for producing the first effective French marine chronometer for determining longitudes, to be tested out on the Channel in May 1767, though Ferdinand Berthoud, a Swiss clockmaker settled in France (and formerly at Julien Le Roy's workshop), disputed both its priority and its effectiveness. Pierre was nonetheless awarded prizes for his marine clocks by the Académie royale des sciences in 1769 and 1773.

The next of Julien's sons, Jean-Baptiste, born in 1720, was admitted to the Académie royale des sciences in 1751, as adjoint géometre.[214] His principal field of inquiry was electricity. By 1753 he was in conflict with Nollet, defending the theories of Benjamin Franklin, with whom he became friendly. Nollet believed there were two separate streams of electric fluid, the one outflowing, the other inflowing. Franklin believed there was only one. Jean-Baptiste was the author of innumerable papers on the theory and practical application of electricity, in particular lightning rods, published for the most part in the *Histoire de l'Académie royale des sciences, avec les Mémoires de mathématique et de physique*. In 1773 he was made director of the Académie royale des sciences and also elected to both the Royal Society of London and the American Philosophical Society. Having defended Jean-Paul Marat's attacks against Newton's theories of color in 1779,[215] he felt sufficiently confident

after the Convention abolished all state-supported academies in 1793 to attempt to sustain something of the Académie royale des science's activity in the Société philomatique de Paris, but he met with little success. However, in 1795 he was made a member of the newly constituted Institut national des sciences et arts (now the Institut de France), in the Section des arts mécanique of the Classe des sciences mathématiques et physiques.

Le Roy's third and youngest brother, Charles,[216] born in 1726, was educated, as no doubt were his brothers, at the Collège des Quatre-Nations and the Collège de Harcourt. He began his medical studies in Paris but finished them in Montpellier, which he chose principally on account of his fragile health. He traveled to Italy in 1750, a year before Le Roy, venturing south to Naples where he investigated the asphyxiating gases in the Grotto del Cane and the phosphorescence of the Mediterranean Sea. He returned briefly to Paris, attending the sessions of the Académie royale des sciences, of which he was soon to be made a corresponding member, for by 1752 he was back in Montpellier, established first as a doctor and then, after 1759, as a professor of medicine as well. He lived in the south until 1777, when he returned to Paris, where he died of a duodenal ulcer or tumor in 1779. He was elected to the Société royale des sciences de Montpellier in 1751, but resigned in 1764, owing to a dispute, only to be readmitted in 1775. He was a member also of the Royal Society of London from 1770. He wrote a great deal, on sicknesses and fevers, on hearing and optics, on the workings of the eye in adjusting to distant objects (not altogether convincingly to his contemporaries); but his real contribution to science was his theory of evaporation, first outlined in 1751.[217] Most of those working on the subject had considered evaporation in mechanical terms, but all hypotheses were unprovable by the science of the day, unable as yet to see submicroscopic particles. Charles sought instead to explain evaporation by analogy; vapors, he thought, might act in relation to air as dissolved salts to water. And many phenomena could, indeed, be explained in such terms, though not the phenomenon of evaporation *in vacuo*. Notwithstanding, Charles's notion was extremely significant in changing the pattern of thinking relating to the problem, thus paving the way for the theories of the chemists Antoine-Laurent Lavoisier and John Dalton. Published in full in Diderot and d'Alembert's *Encyclopédie* in 1756, Charles's theory was at once taken up by Franklin and, in Scotland, by Henry Home, Lord Kames.

Most of the men whose names have occurred in the summary of the culture that occasioned Le Roy's *Ruines* offered here were members of more than one academy — most often the Académie française and the Académie royale des inscriptions et belles-lettres, sometimes the Académie des beaux-arts, though some, exceptionally, were members of three, even four of the great Parisian academies. The abbé Bignon and Fontenelle were members of the Académie royale des inscriptions et belles-lettres, Académie française, and Académie royale des sciences, this last the most prestigious of all. Bignon was, in addition, a member of the Académie royale de peinture et de sculpture.

These connections, as we shall see, mark precisely the nature of the interests that are to be followed through in Le Roy's studies. Le Roy himself, as already noted, had presented a paper to the Académie royale des sciences on 31 August 1757. But scientific thinking was in no great evidence in the 1758 edition of the *Ruines*.

Le Roy's historical discourse was no more than six pages long, compounded from authors ranging from Herodotus to Pococke but following in its general thrust the histories already outlined by Mariette, Gedoyn, and Caylus, uncomplicated as yet by the propaganda of the Accademia etrusca or by Barthélemy's interest in the Phoenicians. The focus of the discourse, as one might expect, was Greece. For Le Roy, as for Vitruvius, architecture emerged as an object of use. Men built huts for protection, as animals and birds built shelters and nests. This early history is unknowable. Architecture took form first in Egypt, where stone was substituted for wood as a means of support. These stones were, inevitably, of the larger sort. The Egyptians thus learned early to aim for the grand and stupendous in architecture. They allowed no time for refinement; instead they embarked with their rudely evolved range of forms and decoration on the construction of the largest of complexes. The Greeks, too, began with mere shelters, but they moved with more circumspection, learning from Egyptians who had ventured to Greece something of the art of construction and the possibility of an architecture of grandeur but devising for themselves the system of orders that was to confer distinction on their architecture — "they devised a regular system for this art, where the Egyptians seem to have followed no system at all."[218] There was no question in Le Roy's mind but that, whatever they might have learned from the Egyptians, the Greeks had invented architecture as such. The column was the key element in this development. What had begun as a mere support in a primitive hut was spaced out evenly to distribute the loads of larger buildings. This modular arrangement was then rhythmically adjusted to satisfy the eye, resulting in a coherent system of architecture. This system was confined at first to the interiors of temples, but so satisfying did the serried columns prove, that they were adopted for the exterior also, to envelop the whole. Colonnades and porticoes were adopted, eventually, for all kinds of architecture.

Le Roy accepted unquestioningly Vitruvius's account in book 4 of *De architectura* of the evolution of the Greek temple and its orders. After its early appearance in the southern Peloponnese at Árgos, the classical proportioning system was developed in the Greek colonies of Asia Minor. The Dorians adapted the proportions of a man to arrive at a column six diameters in height, a step that Le Roy adjudged "undoubtedly the greatest discovery ever made regarding the adornment of architecture, and it was the foundation and basis of all other discoveries of this kind."[219] The Doric was greatly refined in its transfer to mainland Greece, slowly attaining to perfection. The Ionic order soon developed in Ionia, and then the Caryatid order. Taking his cue from Vitruvius, Le Roy described precisely the perspectival adjustments that also evolved — the columns at the corners, seen against light, were strengthened; the

columns of the inner porch, seen against shadow, were slimmed down, so that all might appear equal—and he was the first to do so. The last of the great discoveries was the Corinthian order, and here, once again, Le Roy took up Vitruvius's account, including the tale of its invention by Kallimachos, "in short, the Greeks discovered all that is beautiful and ingenious in architecture."[220] When the Doric was transferred to Italy, it was impoverished, emerging there as the Tuscan order. The Romans, whatever they might have learned directly from the Egyptians of the art of construction, derived their architecture from Greece, whether in the crude form of the Tuscan column or through direct imitation. Once conquered, Greeks were employed by the Romans to build not only in Athens but also in Rome and throughout the empire. The three sites Le Roy named had all been the subject of recent publications: Cyzicus, on the Sea of Marmara, had been represented by no more than a map and inscriptions included in the second volume, of 1756, of Caylus's *Recueil d'antiquités,* the information supplied by Charles de Peyssonnel, consul in Smyrna and brother of the naturalist Jean-André Peyssonnel; but Baalbek and Palmyra had been illustrated very well in Wood and Dawkins's volumes of 1753 and 1757.[221] The Romans, Le Roy stressed, had invented nothing by way of form. They used only the rectangular and circular arrangements of the temples of the Greeks, and the one Roman creation, the Composite order, was no more than an imperfect mix of the Ionic and the Corinthian.

Even the next discovery of architectural significance, the integration of rectangular and circular temple forms, together with the introduction of domes, was owing entirely to Greeks—to Anthemios of Tralles and Isidorus of Miletus, the sixth-century architects who were responsible for Justinian I's Hagia Sophia. Justinian's jubilant cry, "I have surpassed thee, Solomon,"[222] was scarcely to be wondered at, but the achievement was not to be repeated until, five centuries later, the Venetians, having brought an architect from Constantinople, attempted something of the sort at the Basicila di San Marco in Venice. With the revival of the arts in the fifteenth century, however, Filippo Brunelleschi devised a double-skinned dome of considerable span that was built on an octagonal drum over the crossing of Florence's Duomo, Santa Maria del Fiore. This marked a change. Something similar, Le Roy thought, was attempted soon after by Domenico Bramante in planning a double-skinned dome for the Basilica di San Pietro in Vaticano (Saint Peter's). But the first dome to be supported on the four arches of a crossing, together with pendentives between, Le Roy claimed, was that of Sant'Agostino in Rome, built between 1479 and 1483. The *magister architector,* though not named by Le Roy, was Jacopo da Pietrasanta. This church Le Roy had measured for himself, before its rebuilding by Vanvitelli, and he considered that it had provided the model for Saint Peter's—"the masterpiece of the moderns of Europe and of the Christians."[223] It thus represented yet another moment of perfection in the evolutionary development of architecture.

In summarizing his history of building, Le Roy noted that the forms of roofs—flat in Egypt, low pitched in Greece, steeper in Rome and northern

Europe—were a direct response to climatic conditions, from which he concluded that different principles of architecture pertained in different countries, though there were some principles accepted by all, he cautioned, as he intended to demonstrate in his discourse on architectural theory.

The discourse on the principles of architecture required even less than the six pages allotted to history. The principles were sharply defined. Too few rules, Le Roy warned, led to capriciousness, too many could cramp the architectural imagination and reduce "this sublime art to a kind of craft, confined to the blind copying of a few ancient architects"—a warning that Piranesi was to traduce to considerable effect in his polemical "Parere su l'architettura."[224] The principles of architecture, said Le Roy, were to be divided into three classes: the first class comprised universally accepted principles, which thus may be considered axioms; the second, principles conventionally accepted by enlightened people; the last, principles accepted only by some people, determined by climate and geographical conditions, the materials available, power and customs, perhaps caprice itself (shades of Montesquieu's "Essai sur le goût," as we shall discover).

The axioms were obvious enough. A building must be well sited and soundly constructed, and its forms related to use. Supports must be vertical, beams and floors horizontal. The structure was thus to be orthogonal. Much in this category was subject to the laws of mechanics. The second class of principles was more problematic, relating largely to a sense of well-being and aesthetics. Le Roy made clear that though beauty related properly to the buildings in the classical tradition alone, ideas of nobility and grandeur derived from the Greeks by enlightened people could nonetheless not possibly be considered as axiomatic; after all, Gothic architecture had once been preferred to Greek architecture. But there was no doubt that the general acceptance of other facets of Greek culture—whether philosophy, literature, or poetry—had made the assimilation of the Greek criteria of beauty well-nigh axiomatic to the enlightened peoples of Europe, as the varied expressions of a culture related integrally. One could make no connection, for example, between the science of the Greeks and Chinese painting, while the Romans, deriving so much of their civility from the Greeks, had thus sustained a coherent system of understanding and discernment, eventually to be taken up throughout Europe. This wide acceptance of a culture emanating from Greece might be thought to render the related architectural criteria as well established as anything based on mere opinion could be, but the criteria must, nonetheless, Le Roy cautioned, be carefully analyzed to determine their validity.

The first in the second class of principles concerned the proportioning of the orders, that momentous discovery of the Greeks whereby the proportions of a man (Doric), a woman (Ionic), and a maiden (Corinthian) were transferred to built form. Though the basis for each order remained constant, proportions might vary considerably over time and across cultures, for individuals, though equally beautiful, might be very differently built. Thus the proportions admired at some period or in some country might be rejected in another.

Nothing was fixed. The second in this class of principles related directly to the first: the forms of a building must express the same characteristics as the chosen order, this consistency being a condition of architectural harmony. This principle might be considered a law of nature—almost—as large animals have large limbs, large trees have large branches (another knowing reference to Montesquieu's "Essai sur le goût"), and so on. The last of this class of principles emerged from the axiom of stability: the elements of a structure should be clearly expressed. This, however, was not straightforward. The Greeks had evolved their structures in wood and then transformed them into marble while retaining the early expressive forms of the architrave, the triglyph and metope, the mutule and modillion. All other applied details were to be rejected as bizarre, for they were not part of the system originally established in timber. Egyptian, Chinese, and Gothic details were all unacceptable.

The third class of principles, though even more variable, were concerned entirely with the matter of proportioning. As already indicated, nothing was fixed. Vitruvius could not be regarded as authoritative; he might have read some Greek treatises, but he had not inspected enough of their buildings. Moreover, no drawings recording his intentions had survived, and commentators had offered differing interpretations. Roman buildings could not serve as models, for there was no certainty that the Romans had adopted the best of the Greek forms—witness the Doric of the Theater of Marcellus, condemned even by Vitruvius. The new knowledge of the buildings of Greece itself might be thought to provide a proper basis for architectural imitation, but, Le Roy asked, "Are we to imitate them slavishly?"[225] His answer was no. Though many great ruins survived from the age of Pericles, there were not enough to establish fixed standards. The forms of the orders must needs be considered afresh, on the basis of all the accumulated knowledge. The matter was open.

Le Roy's division of architectural principles into three classes echoes the threefold division of visual beauty proposed by Yves-Marie André in the first chapter of his *Essai sur le beau* (1741)—first, essential beauty, concerned with order, symmetry, and balance; second, natural beauty, which is just that, concerned with the beauty of nature, colors, and so forth, to be judged by direct response ("obvious at a mere glance");[226] and third, arbitrary or artificial beauty, which is a matter of custom and taste, even fashion. André refers specifically to architecture to illustrate his concepts, but in this field he adduces no more than two categories. "The first are invariable, like the science that prescribes them,"[227] thus columns must needs be perpendicular, floors horizontal, and symmetry imposed. The second—"being based only on observations of the eye, which are always a little uncertain, or on often equivocal examples, are not entirely essential rules"[228]—are concerned largely with the proportioning of elements, altogether variable. Though there can be little doubt that Le Roy was familiar with André's short treatise, it is evident that he had considered the matter of architectural principles for himself, anew.

By 1764, when Le Roy published his next book, the *Histoire,* three-quarters of which was to be incorporated into the second edition of the *Ruines,* his understanding of architecture had been greatly enlarged. The *Histoire* was made up of four chapters, the first two recounting the same evolutionary history of church design offered in the *Ruines* (three pages were quoted direct), but the history was far more richly detailed. It made reference to Antonio Zatta's *L'augusta ducale basilica dell'evangelista San Marco nell'inclita dominante di Venezia colle notizie* (1761) for Venice's San Marco, to Bernardo Sansone Sgrilli's *Descrizione e studi dell'insigne fabbrica di S. Maria del Fiore* (1733) for Florence's Duomo, and to Filippo Buonanni's *Numismata summorum pontificum templi Vaticani fabricam* (1696) for Saint Peter's, with the addition of Sir Christopher Wren's Saint Paul's in London and Jules Hardouin Mansart's Dôme des Invalides in Paris, to demonstrate the way in which the piers of the crossing of these two churches had been successively reduced and opened up to cross views. There followed a remarkable chapter on the use of columnar arrangements and their resulting effects. In the concluding chapter, Le Roy presented three churches that he regarded as the culmination of the historical development he had charted: Mansart's royal chapel at Versailles, Pierre Contant d'Ivry's Madeleine, and Sainte-Geneviève, the last two still being built in Paris. This history was recorded in a single engraving (fig. 24) illustrating thirteen plans and four sections of the churches described, drawn more or less to the same scale, though the Madeleine was at a slightly larger scale and Sainte-Geneviève was largest of all, at once indicating Le Roy's preference, though he carefully avoided any other expression of it.

A comparative diagram of this sort was not altogether new to French architectural theory. The engineer Jacques Tarade had measured Saint Peter's in 1659 and published engravings of his drawings on sixteen plates,[229] including one with half-plans of Notre Dame in Paris and Saint Peter's drawn to the same scale and set against each other on a common axis (fig. 25); together with another engraved plate tabulating the dimensions of not only these two churches but also Strasbourg cathedral (fig. 26). Tarade aimed to make evident, at a glance, the grandeur of Saint Peter's. But his surprising unconcern at the clash of styles gives evidence of an unusual objectivity in the assessment of architectural form. As one of Sébastien Leprestre de Vauban's engineers, and one responsible chiefly for the construction of the fortified towns of Belfort, Neuf-Brisach, and Saverne, Tarade was familiar with standardized layouts, and not only of towns but also of individual buildings, for the French had taken over from their Spanish adversaries the practice of planning their barracks to standardized form, to be built of whatever materials were available. This marks an early acceptance of what was later to be termed a building type.

Tarade's book, *Desseins de toutes les parties de l'église de Saint Pierre de Rome,* was probably published first in the first decade of the eighteenth century. The enlarged edition, issued in 1713, offered twenty plates of Saint Peter's, the two plates comparing Notre Dame in Paris and Saint Peter's, and

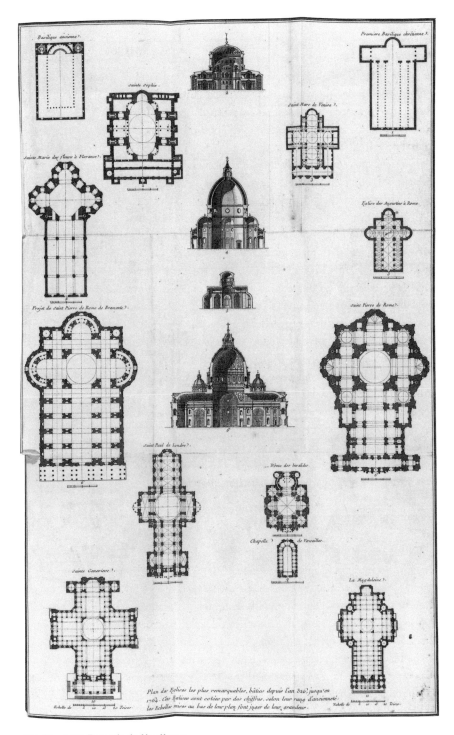

Fig. 24. Jean-François de Neufforge
Plan des eglises les plus remarquables, bâties depuis l'an 326 jusqu'en 1764
From Julien-David Le Roy, *Histoire de la disposition et des formes différentes que les chrétiens ont données à leurs temples, depuis le règne de Constantin le Grand, jusqu'à nous* (Paris: Desaint & Sallant, 1764), after p. 90

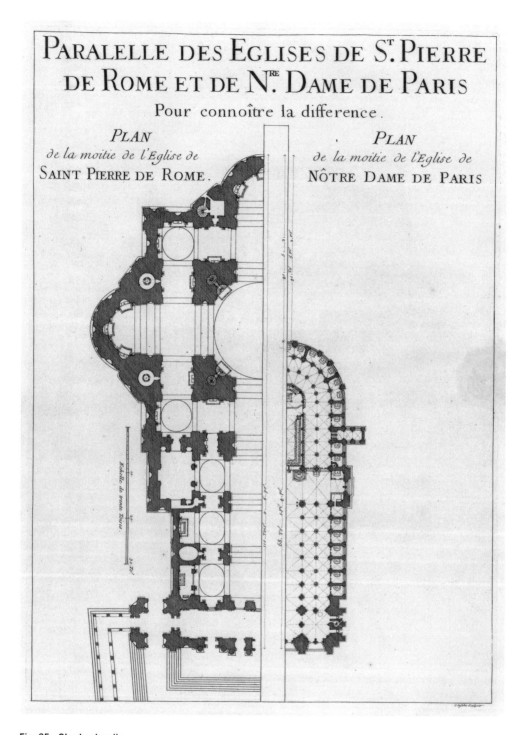

Fig. 25. Charles Inselin
Paralelle des eglises de St. Pierre de Rome et de Nre. Dame de Paris
From Jacques Tarade, *Desseins de touttes les parties de l'eglise de*
Saint Pierre de Rome (Paris: Jombert, 1713)

PARALELLE

DES MESURES ET DIMENTIONS

DES EGLISES DE SAINT PIERRE DE ROME,

DE NOSTRE DAME DE PARIS ET DE

LA CATHEDRALE DE STRASBOURG.

	SAINT PIERRE DE ROME	NOSTRE DAME DE PARIS	N.TRE DAME DE STRASBOURG
Longueur exterieure	110 to 0 m 6 po	68 1 4	54 5 0
Longueur Interieure	94 0 0	63 0 0	51 2 0
Largeur exterieure de la croisée de l'Eglise	77 0 0	28 0 0	35 0 0
Largeur interieure	70 0 0	25 0 0	24 1 0
Largeur interieure de la Nef	13 4 0	6 4 0	7 1 0
Largeur des 1ers Collateraux	5 3 0	2 2 0	5 0 0
Seconds Collateraux	4 3 0	2 3 0	3 4 0
3me partie pour les Chaples		2 4 0	0 0 0
Hauteur des Voultes sous la clef	24 0 0	16 0 5	16 2 0
Espaisseur des Voultes	0 3 6	0 3 0	0 3 0
Hauteur jusqu'au dessous de la boule qui est sous la croix	63 5 0	33 0 0	69 1 8
Le diametre de la boule	1 2 0	0 0 0	0 0 0
Hauteur de la Croix	2 1 0	0 0 0	2 0 8

Fig. 26. Charles Inselin
Paralelle des mesures et dimentions des eglises de Saint Pierre de Rome, de Nostre Dame de Paris et de la cathedrale de Strasbourg
From Jacques Tarade, *Desseins de toutttes les parties de l'eglise de Saint Pierre de Rome* (Paris: Jombert, 1713)

an additional comparative plate illustrating the plans and the west fronts of Notre Dame and Strasbourg cathedral. Juste-Aurèle Meissonnier took up the idea for his *Traité sur l'architecture universelle,* to be issued in four volumes, announced in 1748.[230] Two years later Meissonnier was dead, and only two plates and their preparatory drawings survive to give evidence of the nature of his enterprise. The buildings may well have been arranged on the plates not by Meissonnier but by his publisher, Gabriel Huquier, who issued them under the title *Parallèle général des edifices les plus considerables depuis les Egyptiens, les Grecs jusqu'à nos derniers modernes* some time between 1749 and 1761, most probably around 1757 (figs. 27, 28). Meissonnier seems to have been contemplating a history of architecture that included works of his own, in the manner of Johann Bernhard Fischer von Erlach's much acclaimed *Entwurff einer historistorischen Architektur.* First published in German and French, in 1721, this consisted largely of plates of architecture, ancient and modern, ranging from the Temple of Solomon and the Tower of Babel to a sheaf of Fischer von Erlach's own designs. He not only provided a historical survey but also presented an extraordinary range of styles, including Chinese and Persian buildings and Hagia Sophia. Though Fischer von Erlach's work might be regarded as the first comparative history of architecture, there was no structure to its arrangement.

Meissonnier's two plates were both less and more wide-ranging. The first comprises thirty structures, temples and churches for the most part, most drawn to the same scale, and presented in elevation, though a plan was provided for the Temple of Mars Ultor in the Forum Augustum and a section for the Temple of Minerva in the Forum Nervae and for Guarino Guarini's Cappela della Santa Sindone (Chapel of the Holy Shroud) of the Cattedrale di San Giovanni Battista in Turin. Other structures were the Egyptian obelisk erected on Saint Peter's piazza in 1585, temple forms derived from Vitruvius and Palladio, the Pantheon in Rome (with and without its portico), Saint Peter's (in both its early and final forms), a handful of Roman churches (Sant'Andrea della Valle, Sant'Agnese in Agone, Santa Maria della Pace, Sant'Ivo alla Sapienza), the Cattedrale di San Giovanni Battista in Turin, Saint Paul's in London, and Fischer von Erlach's Karlskirche in Vienna. Also included on the first plate were two Chinese pagodas, Hagia Sophia, and three Gothic structures: the cathedrals of Rouen and Strasbourg and Sint-Romboutstoren at Mechelen in Belgium. The second plate illustrated twelve buildings, all French, once again in elevation (though the royal chapel at Versailles was shown in two sections), beginning with Notre Dame in Paris, with most of the remainder dating from the seventeenth century, secular as well as ecclesiastical, to end with Meissonnier's own design for a palace and church for the Chevaliers du Saint Esprit, taking in the Hôtel de Conti, on the site of the Grands Augustins in Paris.

For his folio, *Détails des plus intéressantes parties d'architecture de la basilique de St. Pierre de Rome* (1763), Dumont, Soufflot's companion at Paestum, copied both Tarade's comparative plate of the plans of Notre Dame

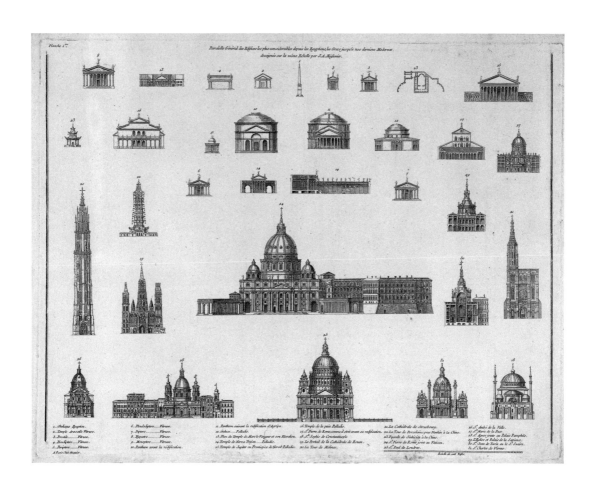

Fig. 27. After Juste-Aurèle Meissonnier
First plate of *Parallèle général des edifices les plus
considerables depuis les Egyptiens, les Grecs jusqu'à nos
derniers modernes*, ca. 1745–50, engraving
Montreal, Collection Centre Canadien
d'Architecture/Canadian Centre for Architecture

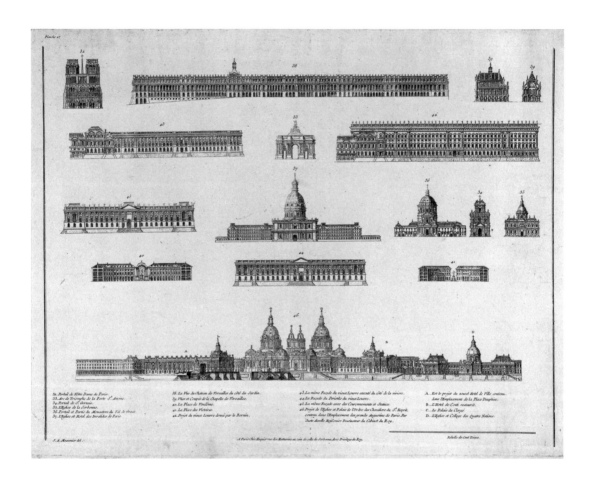

Fig. 28. After Juste-Aurèle Meissonnier
Second plate of *Parallèle général des edifices les plus
considerables depuis les Egyptiens, les Grecs jusqu'à nos
derniers modernes*, ca. 1745–50, engraving
Montreal, Collection Centre Canadien
d'Architecture/Canadian Centre for Architecture

in Paris and Saint Peter's (fig. 29) and his plate of engraved dimensions. Dumont, unabashed, also composed two further plates (figs. 30, 31), titled *Parallele de monumens sur une même echelle,* derived directly from Meissonnier. The first plate illustrated the Val-de-Grâce in Paris, Sant'Ivo alla Sapienza in Rome, Notre Dame in Paris, the Sindone chapel in Turin, the Invalides, Santa Maria della Pace, Sant'Andrea della Valle, and the church of the Sorbonne; the second plate was made up with Sant'Agnese in Agone, the Pantheon in Rome in its two variants, Saint Peter's, the Karlskirche, Saint Paul's in London, and Hagia Sophia. There is no obvious sequence or order in the arrangement. As the plates of Dumont's work were presented to the members of the Académie royale d'architecture on 5 July 1762, and a report made a month later, on 9 August, they were almost certainly known to Le Roy. Other such comparative plates appeared in France in the ensuing years, including a revised version of Le Roy's own plate in the *Ruines* of 1770, two plates of plans of theaters published in 1772 to illustrate Dumont's article on theaters for Diderot and d'Alembert's *Encyclopédie,* another comparative array of recent theater designs (fig. 32) in Victor Louis's *Salle de spectacle de Bordeaux* (1782), and a comparative study of porticoes prepared by Antoine-François Peyre, the son of Marie-Joseph, for the enlarged edition of 1795 of his father's *Oeuvres d'architecture.* But the idea was to be exploited fully only at the very end of the century, when Le Roy's pupil, Jean-Nicolas-Louis Durand, took it up as the basis for the plates of his celebrated *Recueil et parallèle des édifices de tout genre, anciens et modernes, remarquables par leur beauté, par leur grandeur ou par leur singularité, et dessinés sur une même échelle,* issued between 1799 and 1801.[231] Encompassing buildings of all styles, this work was intended to show not so much historical developments as the establishment of individual building types—or "genres," to use Durand's term.

Though the emphasis might have changed from Le Roy to Durand, it is clear that Le Roy's *Histoire* first settled the format for such comparative studies. But his *Histoire* was to be significant for quite different reasons, for in that work he established the vocabulary for dealing with the experience of architecture. Locke's notion of the way in which all knowledge of the world arises from the experience of the five senses, first put forward in *An Essay concerning Human Understanding* (1690), had long been familiar in France; the essay had run to seven French editions and printings by the time Le Roy wrote his *Histoire* (not counting four abridged versions). Locke's ideas had been developed and refined by his follower Condillac, particularly in his most significant work, *Traité des sensations* (1754), with its marvelous conceit of an inert statue slowly endowed with sensation and thus, in time, all the faculties of understanding. The impact of these works on the mediated relation between the senses and knowledge requires no analysis here, though their influence on Le Roy was paramount.

In the third chapter of his *Histoire,* Le Roy explored two visual phenomena: the effect of serried ranks of columns; and the apparent size of buildings,

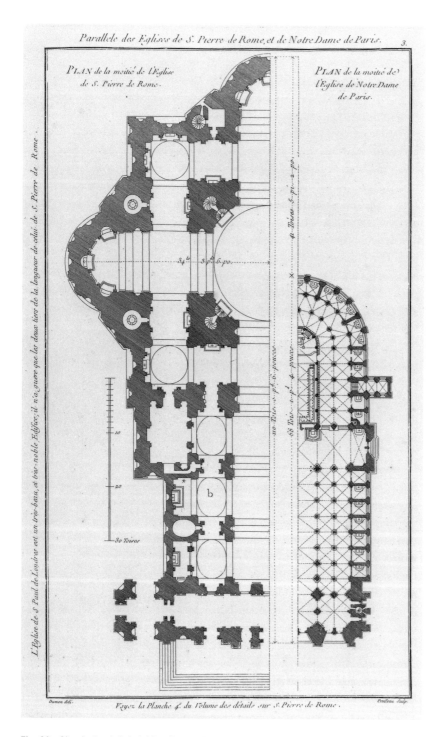

Fig. 29. Claude René Gabriel Poulleau, after Gabriel-Pierre-Martin Dumont

Parallele des eglises de S. Pierre de Rome, et de Notre Dame de Paris
From Gabriel-Pierre-Martin Dumont, *Détails des plus intéressantes parties d'architecture de la basilique de St. Pierre de Rome* (Paris: L'auteur & Madame Chereau, 1763)

Fig. 30. *Parallele de monumens sur une même echelle*
From Gabriel-Pierre-Martin Dumont, *Détails des plus intéressantes parties d'architecture de la basilique de St. Pierre de Rome* (Paris: L'auteur & Madame Chereau, 1763)

Parallele de Monumens sur une même Echelle

Fig. 31. **Parallele de monumens sur une même echelle**
From Gabriel-Pierre-Martin Dumont, *Détails des plus intéressantes parties d'architecture de la basilique de St. Pierre de Rome* (Paris: L'auteur & Madame Chereau, 1763)

Fig. 32. Michelinot
Plan sur la même echelle des théatres modernes les plus connus
From Victor Louis, *Salle de spectacle de Bordeaux* (Paris: L'auteur
& Esprit/Imprimerie de Cailleau, 1782), pl. XXII

in particular internally. He started with the premise that it was our visual responsiveness to the forms, proportions, and details of architecture that conditioned our vital estimation of it. Our feelings were stirred by what we saw. A wall, he said, might be articulated in two distinct ways: its surface might be divided with moldings and details, or it might be broken up with openings of different shapes and sizes. The end result of such operations, he suggested, might be a wall adorned with engaged columns and entablatures or simply an isolated range of columns and lintels. The last he thought far preferable to the first. Columns might have been evolved initially to act as supports, but it was evident from the extensive use made of them by both the Egyptians and the Greeks that they were endowed with a potent visual attraction, far more compelling than mere usefulness might account for. Colonnades invariably aroused notions of grandeur, stirring souls in much the same way as the vastness of the sky, the sea, or the earth. But size alone did not always stir the strongest of sensations. Sometimes the relationship of the parts of a building one to another was far more effective. The impression made by the Pantheon in Rome was in great measure owing to its size and scale, but even more important was the contrasting effect of the deeply shadowed forms of the portico followed by the great uncluttered interior, to be taken in at a glance, "un coup d'oeil." There was no doubt in Le Roy's mind that the portico of the Parthenon stirred the spirit more effectively than the facade of Saint Peter's, though the latter's columns might be larger. Without its portico, the Pantheon would indeed be less impressive. There had to be both balance and contrast in the elements of a composition, and the number of varied elements must be limited.

Like many other eighteenth century critics, Le Roy referred his reader to Montesquieu's article on *goût* that had been published in 1757 in the seventh volume of Diderot and d'Alembert's *Encyclopédie*. Montesquieu's "Essai sur le goût dans les choses de la nature et de l'art," right from the start, with its recognition of taste as natural and acquired, its division of taste into three kinds based on three sorts of pleasure, and its subsequent headings for order, symmetry, variety, contrast, surprise, progression, je ne sais quoi, and so on, indeed in the whole manner of its composition and expression,[232] lies at the root of Le Roy's own theoretical exposition, whether in its first form in the *Ruines* of 1758 or, more obviously, in his discussion in the *Histoire* of 1764. Here, in full, is the passage from Montesquieu's discussion of variety to which Le Roy refers:

> There are certain objects, which have the appearance of variety, without the reality; and others, that seem to be uniform, but are, in effect extremely diversified.
>
> The *Gothic* architecture appears extremely rich in point of variety, but it's ornaments fatigue the eye by their confusion and minuteness. Hence we cannot easily distinguish one from the other, nor fix our attention upon any one object, on account of the multitude that rush at once upon the sight; and thus it happens that this kind of architecture displeases in the very circumstances that were designed to render it agreeable.

A *Gothic* structure is to the eye what a riddle is to the understanding; in the contemplation of it's various parts and ornaments the mind perceives the same perplexity and confusion in it's ideas, that arise from reading an obscure poem.

The *Grecian* architecture, on the contrary, appears uniform; but as the nature, and the number also of it's divisions are precisely such as occupy the mind without fatiguing it, it has consequently that degree of *variety*, that is pleasing and delightful.

Greatness in the *whole* of any production requires of necessity the same quality in the parts. Gigantic bodies must have bulky members; large trees must have large branches, etc. Such is the nature of things.

The *Grecian* architecture, whose divisions are few, but grand and noble, seems formed after the model of the great and the sublime. The mind perceives a certain majesty which reigns through all it's productions.[233]

This passage reveals at once the extent to which Le Roy's discussion of form and formal effects is indebted to Montesquieu. Thus, Le Roy noted, painters preferred fewer rather than more figures in a composition, musicians and actors limited the length of their performances, knowing that only a restricted range of feelings should be aroused at any one time. Form and surface articulation in architecture was the equivalent of time in the theater: only so many responses should be stirred by a building, and such sensations should, as in a play or a poem, be sequential, the better to be savored separately. All too often in architecture, as sometimes in painting too, no more than a single effect was aimed at, thus limiting possibilities. Consider once again, Le Roy suggested, the two walls he had earlier evoked, first, the richly adorned wall with engaged columns and moldings standing alone, then the same wall with the colonnaded variant set in front of it. Far more agreeable sensations would be aroused by walking the length of the second arrangement than the first. There would be a constant number of forms involved but an unending variation in their relationships. And he pursued this comparison to even bolder effect. Imagine, he said, an arcade with a row of trees set against it; imagine the same arcade with the row of trees some distance in front of it. A walk alongside the second arrangement would present to the eye an ever-changing pattern of branches and trees, arches and broken views visible through them but without confusion. The forms would be limited in range, but a marvelous spectacle would result, animated by the movement of the stroller. The initial arrangement, whatever the movement, would remain more or less static, however richly decorated the wall might be. But not so Le Roy's ranks of trees and arches. He conjures here, one might suggest, the Homeric beginnings of architecture.

The example he chose to illustrate the transformation of this into contemporary architecture was Claude Perrault's colonnade on the east front of the Louvre—"the finest piece of architecture in Europe"[234]—contrasted, as might be expected, to Louis Le Vau's pilastered south front. For three pages and more Le Roy invoked the marvelous variety of effects experienced in viewing

Perrault's colonnade, first from afar, then on approaching, then walking alongside or under it, whether in bright sunlight or on a clouded day. New beauties were constantly to be revealed to the spectator. Colonnades were, for Le Roy, the summit of architectural achievement—an interactive architectural achievement.

> As we come closer, our view alters. The mass of the building as a whole escapes us, but we are compensated by our closeness to the columns; as we change position, we create changes of view that are more striking, more rapid, and more varied. But if we enter beneath the colonnade itself, an entirely new spectacle offers itself to our eyes: every step adds change and variety to the relation between the positions of the columns and the scene outside the colonnade, whether this be a landscape, or the picturesque disposition of the houses of a city, or the magnificence of an interior.[235]

Columnar interiors, as might be imagined, were extolled. And here once again Le Roy made bold to suggest that it was not the refinements of architectural form and detailing that mattered but rather the forms themselves and their relation one to another. "So universal is the beauty derived from such colonnades," he wrote, "that it would remain apparent even if their constituent pillars were not superb Corinthian columns but mere trunks of trees, cut off above the roots and below the springing of the boughs; or if they were copied from those of the Egyptians or the Chinese; or even if they represented no more than a confused cluster of diminutive Gothic shafts or the massive, square piers of our porticoes."[236] Though the interval and proportioning of these, he warned, might considerably change the effects.

Le Roy's second exploration of visual effects concerned the apparent size of interiors. Here he invoked the famous example of the boy, born blind, who had to learn painstakingly to comprehend depth and distance after an operation performed by William Cheselden restored his sight.[237] In making visual judgments, one can never be sure of reality, however carefully one might have learned. The Sun and the Moon, for example, seem larger when viewed on the horizon than when high in the sky. Objects look different when differently related to other objects, when patterned, or set in conjunction with others whose size is known. The size of an interior is even more difficult to assess. Guidelines based on observation might be formulated, but no rules. Hagia Sophia, the Pantheon, and Santa Maria degli Angeli in Rome all look larger than they are in actuality, Saint Peter's looks smaller—an issue Montesquieu also addressed in his essay on taste. The nave of Saint Peter's, Le Roy judged, was too high in relation to its width.[238] But such judgments might change over time, depending on the size of the piers and the openings into the aisles. Thus Gothic churches, though often inordinately high, do not always seem so, because the columns flanking the naves are relatively slender and the space (*le vuide*) of the aisles seems to open up between them. Likewise, in the royal chapel at Versailles, the upper part seems to expand outward but not the lower level. Once again, it was a matter of the columnar arrangements. And

these, as already indicated, Le Roy explored at length in his final chapter on the Versailles chapel and the projects for Sainte-Geneviève and the Madeleine in Paris.

There had been much propaganda in France, from the building of the Louvre colonnade onward, for the use of freestanding columns, the most celebrated advocates being Cordemoy, whose *Nouveau traité de toute l'architecture* was published in 1706, and his emulator Laugier, whose *Essai sur l'architecture* appeared in 1753.[239] These were regarded as tracts of a revolutionary kind, though they were firmly confined within the limits of the classical tradition. Both men, admittedly, had invoked the effects of Gothic cathedrals, but they had reinterpreted these entirely in classical terms — in terms, moreover, of the Greek orders alone. Notwithstanding, Laugier's celebrated description of the successive responses aroused on entering Notre Dame in Paris and then wandering down the length of its nave does represent a milestone in the sensationalist fervor for the direct experience of architecture.[240] He recorded his feelings plainly, uninhibited by convention. His description no doubt served as a liberating stimulus for Le Roy, but it was Le Roy's *Histoire* that enabled Laugier in turn to free himself, as never before, from the restraints of architectural custom and taste. In his *Observations sur l'architecture* (1765), Laugier thought to introduce soaring columns, quite unclassical in form and proportion, into the naves of new churches. "I imagine," he wrote, "a church in which all the columns were large palm tree trunks, the branches spreading right and left, the highest extending across all the curves of the vault, the effect quite surprising."[241] The columns were to be closely set, to intensify this effect. And he explored the Gothic analogy further in suggesting that something of the close-packed, awry arrangement of the columns in the apses and ambulatories of Gothic cathedrals might be conjured up — "Which would produce," he wrote, "a forest of columns in the apses, an effect quite magnificent and grand."[242] Elsewhere in the *Observations,* Laugier took up Le Roy's two themes — trees as the formal equivalent of columns, and the matter of apparent size — together. "Very closely spaced columns," he wrote, "increase the apparent size of a nave. They are like trees placed close to one another on both sides of a pathway."[243] And when he came to deal with the two great churches of Sainte-Geneviève and the Madeleine — he preferred the former unhesitatingly — he referred his readers directly to Le Roy.[244]

Laugier was not the only French critic to give a spur to Le Roy's new mode of analyzing architecture; that less famous, far more abrasive critic, Etienne La Font de Saint-Yenne, who had been writing and campaigning for years for the completion of the Louvre, provided Le Roy with an even more liberating exemplar of architectural responsiveness in the last of his studies of that great palace, a Dantesque excursus entitled *Le Génie du Louvre aux Champs-Élysées: Dialogue entre le Louvre, la ville de Paris, l'ombre de Colbert, et Perrault* (1756). Claude Perrault, addressing the Louvre on the state of architecture, dismisses current convention:

In our architects' discussions I saw only enslavement to blind routine and rules that one must dare to break again and again. But only genius enables one to recognize such occasions, and that requires a keenness of vision and a superior understanding of the effect of the whole, to be envisioned before construction, an understanding not provided by the science of optics, though absolutely necessary to any architect—since its rules are rendered useless by the infinite variety of positions of the eye of the beholder, positions that cannot be foreseen. There is yet more knowledge no less necessary to the great architect, especially for external facades that are well lit, that is, knowledge of chiaroscuro and the picturesque effects of lighting on the projections of masses and in their recesses. That is what gives movement to the parts of a large building and makes the eye of the beholder delight in a satisfaction that captivates it without knowing why. Large buildings in which such art is neglected always appear cold and flat, though overburdened with projections that have no positive effect. After all, it is taste alone, that gift of the gods so rare among men, and which each one nonetheless believes he possesses, which can determine most certainly such liberties, and which differs from genius (if by that term one means a rich and fertile inventiveness) in that taste can be acquired through the study of good works, whereas genius can never be acquired.[245]

There is more of this kind in La Font de Saint-Yenne, and there can be little doubt that it was absorbed to great effect by Le Roy.

Le Roy's critical stance is, in general terms, indebted to the writings of Dubos, though it might be more specifically related to landscape theory, or rather descriptions of landscapes. The most memorable was Jean-Denis Attiret's account, published in 1749, of the route through the emperor of China's Yuan Ming Yuan (Garden of perfect splendor), which drew the visitor from pavilion to pavilion, along zigzag paths and over bridges.[246] There is something of this also in Chambers's account of moving from scene to scene in other Chinese gardens—quite specifically not along avenues—in his *Designs of Chinese Buildings, Furniture, Dresses, Machines, and Utensils* (1757), a book published in both English and French, and well known to Le Roy. The formulation of theories of design in relation to such experience was to emerge only later, however, beginning in 1770 with Thomas Whately's *Observations on Modern Gardening*, translated in the following year into French, and swiftly followed by Claude-Henri Watelet's *Essai sur les jardins* (1774) and Jean-Marie Morel's *Théorie des jardins* (1776). In these works, movement was a prime consideration in the laying out of a landscape.

A more obvious spur to Le Roy's thinking might, perhaps, have been *A Philosophical Enquiry into the Origin of Our Ideas of the Sublime and Beautiful* (1757) by Edmund Burke, another follower of Locke. Burke was in contact with Chambers—publishing parts of *Designs of Chinese Buildings* in 1758 in the first volume of *The Annual Register*, Burke's yearly survey of world affairs, as support for his notion of terror as a basis of the sublime— but there is no reason to suppose that Chambers might have forwarded a copy of Burke's *A Philosophical Enquiry* to Le Roy or that Le Roy might have

understood it. Le Roy can have had no more than a rudimentary grasp of English; he corresponded with Chambers in French, and later, when required to render for presentation, in French, a paper by Benjamin Franklin, Le Roy had it translated, as he made clear. However, despite the unfolding of the Seven Years' War, begun in 1756, between England and France, Burke's book was reviewed promptly and at some length in the July 1757 issue of the *Journal encyclopédique,* published in Liège, Belgium. Much of the review was mere summary, but Burke was upheld as a navigator who had ventured into a new realm. "The author of this book," the reviewer concluded, "seems to me a man of genius; his ideas are new and bold; his style is vigorous and sharp."[247] This summary might well have been known to Le Roy. In any event, Burke's book made an impact in Paris early, though it was to be fully appreciated only after its translation into French in 1765.

Though Le Roy would have been inspired, indeed fascinated by Burke's book, he need not have known it. Burke's association of the immensity of the sea and the view from a mountaintop with the sublime, and Burke's reference to the blind boy Cheselden had operated upon, suggest that his work was known to Le Roy, but Le Roy could easily have come to such knowledge elsewhere. Cheselden described the boy to the Royal Society of London in 1728 and published a report in the *Philosophical Transactions* in the same year.[248] The problem that he seemed to resolve was introduced into philosophical discourse by Locke, in book 2, section 8, of the second edition, of 1694, of his *Essay concerning Human Understanding,* as a response to an objection to Locke's theories on sight made by William Molyneux, whence "Molyneux's Problem," a standard reference thereafter for this problem of vision. The question Molyneux posed to Locke was, would a man on first recovering his sight be able to name, just by looking at them, a cube and a sphere he had touched when blind? Molyneux and Locke agreed he would not. It seems not to have occurred to them to ask if he would be able to see the forms at all. Voltaire first gave prominence to the issue in France in his *Elémens de la philosophie de Newton, mis à la portée de tout le monde* of 1738, in which he explicitly linked Locke and Cheselden's boy. Condillac took up the matter in 1746 in his *Essai sur l'origine des connaissances humaines.* Diderot discussed it at length in his *Lettre sur les aveugles à l'usage de ceux qui voyent* of 1749; as did George-Louis Leclerc, comte de Buffon, in the same year in the first volume of the *Histoire naturelle, générale et particuliére.* The exemplar of the sea and the mountaintop can be traced back to Longinus himself, and it was freely invoked in all discussion on the sublime in France, whether in the seventeenth or eighteenth century. Le Roy's interest in the effects of the sublime and in the je ne sais quoi in architecture is an aspect of that long-standing discussion, already surveyed, in literary criticism. Burke would have served merely to reinforce ideas already familiar. Nonetheless, the freedom with which Le Roy applied them to architecture, ignoring all constraints of convention—and only six years after he had published a canonical survey of the architecture of ancient

Greece—was to devastating effect. The classical ideal was shattered. For Le Roy style itself had become a secondary consideration, as Laugier had at once realized.

Le Roy's *Histoire*—which ran to eighty-nine octavo pages but can be regarded as no more than an essay—made an immediate impact. It was written, as must already be apparent, as a justification for the two great columnar churches being erected in Paris, Soufflot's Sainte-Geneviève and Contant d'Ivry's Madeleine. In a cermony in the Abbaye Sainte-Geneviève after the laying of the foundation stone of the new church, on 6 September 1764, Le Roy presented a copy of the *Histoire* to the king, Louis XV, ensuring that it became an object of attention.[249] Its publication was announced in the *Catalogue hébdomadaire* on 15 September 1764 and again in the issue for 19 January 1765, in the *Gazette littéraire de l'Europe* on 26 September 1764, and in the *Journal oeconomique* in January 1765. Reviews appeared in October 1764 in the *Mémoires de Trévoux* and the *Mercure de France;* both were approving, the critic of the *Mercure* admiring in particular the clarity with which the course of history was presented in a diagram, but it was *L'année littéraire* of 1764 that bestowed the most fulsome praise.[250] The book was upheld not just as excellent and well written but as a product, almost, of genius—and the section most admired was that on colonnades: "the fact that the author casts a light of genius in this piece proves he has a deep understanding of all the arts, of their relationships, of their wholeness, of their outcome."[251] Long quotations from Le Roy were offered with no objections, no demur, only more praise. "Everything he tells us about peristyles betokens a superiority of insight into this art, which identifies the great master."[252] Le Roy's final chapter on Soufflot's and Contant d'Ivry's projects stirred like enthusiasm: "His critical comments are accompanied by that delicate respect owing to great men, whose faults one has the courage to reveal even while recognizing the supreme ascendancy of their genius. Monsieur Le Roy deserves the greatest praise, both in his capacity as an architect and in his capacity as a man of letters. This last piece combines profound knowledge of his art with a vigor and beauty of style."[253]

Le Roy's final publication before the *Ruines* of 1770 was the *Observations sur les édifices des anciens peuples.* The *Observations,* as already described, was largely a response to Robert Sayer's *The Ruins of Athens* and to Stuart's attack published in 1762 in the first volume of the *Antiquities.* Le Roy would incorporate much of the matter of the *Observations* into the second edition of the *Ruines,* in particular that relating to Pausanias's route through Athens, though not much was quoted directly. Some general remarks addressed to Stuart were to be included in the preface of 1770, and the historical excursus, already outlined, dealing with the emergence of generative architectural concepts that were to be developed and combined with others to provide the significant progression of architecture, including now the formal discoveries of the Phoenicians (as outlined in Eusebius's rendering of Sanchuniathon) predating those of the Egyptians and Greeks. This account was to be

absorbed into the "Essai sur l'histoire de l'architecture" of the *Ruines* of 1770. The *Observations*'s "Recherches sur les mesures anciennes," which included the dissertation on the Greek foot that had appeared in the first edition of the *Ruines*, was taken almost entire into the second edition, but with further reference to Barthélemy's analyses of Greek stadia, a subject long debated in the Académie royale des inscriptions et belles-lettres, beginning in 1723 with a paper by Nicolas Fréret.[254]

The *Observations* was announced in the *Catalogue hébdomadaire* in February 1768, *Mercure de France* in March 1768, and *Journal oeconomique* in January 1769, and it was reviewed between January and June 1768 in *L'année littéraire, L'avant coureur, Journal encyclopédique,* and *Journal des sçavans*.[255] Two of the reviewers, at least, muddled the work of Sayer with that of Stuart and Revett, but none thought Le Roy required any defense. He had gone to Athens, they noted, as he himself had made clear, not simply to measure the buildings but to understand their relationships, one to another and to those that came before and after. Not that the reviewers were uninterested in measurements. The dissertation on Greek stadia and the matter of the Greek foot excited them all. But what stirred their interest most was Le Roy's notion of the primitive forms that had given rise to the significant structures of antiquity. Le Roy was quoted at some length on this subject, and he could scarcely have wished for more favorable responses. "I will not expound further on this piece of writing," the reviewer for *L'année littéraire* wrote, "it is full of scholarly research, judicious observations, and enlightened analysis."[256] The reviewer for *L'avant coureur* concluded, "These different pieces make up a tract as interesting for its style as for the depth of its views and the soundness of its ideas."[257] "This entire piece," the reviewer for the *Journal encyclopédique* judged of the theory of forms, "as well as all the observations in this work do infinite honor to the author's talents, taste, and erudition."[258] The reviewer for the *Journal des sçavans* provided more by way of a factual summary of the work but was no less admiring, looking forward to further studies by Le Roy: "Occupied since his trip to Greece with his work on the ancients, with examining and comparing what they have to say about architecture, about the erection of large buildings, and so forth, he proposes in his next study to give us his reflections on this subject and its relation to their machines and their navy."[259] This critic knew what Le Roy was up to.

The reorganization of the first edition of the *Ruines* to create the second has already been summarily described (for a detailed list of where parts of the first edition, the *Histoire*, and the *Observations* appear in the second edition, see this volume, pp. 522–29). Though the revised *Ruines* was a scissors-and-paste operation, Le Roy multiplied the number of footnotes and greatly extended existing notes with scholarly quotations and references, and there was as well much rewriting, with new material introduced throughout. The cost of the new edition was higher, increased from seventy-two to ninety-six livres.

In the first part of the first volume, concerned with the history and description of the buildings of Athens to the end of the age of Pericles, there was no great change from the first edition. The account of the journey and the outline history of Athens was little altered; indeed it was still quite close to that provided by Spon and Wheler. In describing the Parthenon, the friezes and sculpture were addressed at greater length, however, and Pheidias given his due. The arrangement of the Erechtheion was likewise analyzed in more detail, though Le Roy still hestitated over its identity. The Theater of Dionysos, though mistakenly identified with the ruins of the Odeion of Herodes Atticus, was more fully described; as was the Hephaisteion, with particular reference to its metopes. The Monument of Lysikrates, in view of Stuart's jibes, had to be dealt with at greater length, though Le Roy made clear that it was so richly decorated that it might almost be thought to postdate Pericles. Even in this volume Le Roy felt impelled to stress the falling off of the later period. He wrote,

> Pericles had given the Athenians a taste for the arts; and this still struck a few sparks in the century after his death. But fate had a great revolution in store. Alexander transformed the face of Greece and of all the parts of Asia and Africa that he conquered; and the arts, which follow in the train of glory and enhance its luster, departed with him to Alexandria. Athens now declined from her former superiority to occupy the second rank among celebrated cities. Opulence replaced the noble simplicity, the masculine and majestic character, of the buildings of Pheidias, Iktinos, Kallikrates, and Mnesikles (p. 262).[260]

The section on Sunium and the ports of Athens was little altered, apart from some new information on the Temple of Minerva Sunias from Pausanias and on the Long Walls taken from Diodorus Siculus's history.

The second part of the first volume, largely concerned with the architectural orders, was extensively revised, with new translations and notes provided, though it was not much changed in its essentials. Perhaps the most notable changes were the removal of the Doric in its third state and the doubts Le Roy cast, as he had in describing the Erechtheion, on the caryatids as representative of the original form of that order. He also worried again that the richness of decoration of the Monument of Lysikrates was inconsistent with the vigor of the age of Pericles.

In the second volume, the description of Athens and its buildings in the post-Periclean era — the Monument of Thrasyllus, Tower of the Winds, the Doric portico, Monument of Philopappos, and the ruins in the bazaar, which Le Roy now identified as a temple to Juno Lucina — though much rewritten and incorporating a good deal of new political history was based largely on the first edition. The route taken by Pausanias was revised along the lines first sketched in the *Observations,* however, and Le Roy re-identified some of the buildings in response to Stuart's scathing attacks.

The account of the Hadrianic buildings to the east of the Acropolis was

likewise filled out with new historical information and rewritten, but on the whole it was derived from the first edition and the *Observations*. The Temple of Zeus Olympios was identified still as Hadrian's Pantheon. The account of the journey to Sparta was little changed. Some alterations were made to the analysis of the track at Olympia, and a new plate provided (see vol. 2, pl. 15), to take account of observations and discussions at the Académie royale des inscriptions et belles-lettres, notably those by Barthélemy.

The second part of the second volume, concerned with the forms and details of the Hadrianic architecture described in the first part of the volume, included the Doric temple at Corinth (somewhat misplaced); the Doric portico (the Gate of Athena Archegetis) to represent Doric in its third state; the temple at Pola, as an example of the Corinthian; together with the ruins in the bazaar (Hadrian's Library), Hadrian's Pantheon (the Temple of Zeus Olympios), and the Arch of Hadrian—this last considered quite tasteless. At the end, as before, was an analysis of the engaged columns of Delos, first noted by Michel Fourmont, and a compounded Corinthian capital lying against Santa Trinità dei Monti in Rome, first described and illustrated by Pococke. What is new to this portion of the *Ruines* is a commentary and the associated plate (see vol. 2, pl. 25). The plate appears at first glance to be another comparative history, illustrating eleven buildings, six rectangular, five circular, most shown in elevation, though the octagonal Tower of the Winds is shown also in two plans and section, the Monument of Lysikrates in section, and Vitruvius's round peripteral temple in plan. The first six elevations, based on Vitruvius's descriptions, depict the standard arrangement of columns in temple fronts, ranging from the two columns of the temple *in antis* to the two rows of ten columns in the hypaethral temple. These are designed to demonstrate just how changeable was the proportioning required to accommodate such variety, which was further increased by variants in the spacing of columns and the heights of stylobates. "It follows," Le Roy wrote, "that the ancient rectangular temples of any one type were far more varied in their forms and in the proportions of their facades than could ever have been supposed until we became familiar with the ruins of Greece, Magna Graecia, and various cities in Asia" (p. 490).[261]

In assembling images of the Tower of the Winds, the Monument of Lysikrates, the temple at Tivoli, and the monopteral and peripteral round temples described by Vitruvius, Le Roy had a differing aim. He thought to prove that the roofs of circular buildings were initially pyramidal and topped by a capital but had been slowly transformed into a low dome finished by a flower. He was clearly groping for a history of the development of the dome, but the result, as he must have realized, was inconclusive, lacking in both knowledge and reflection.

The vital changes that marked the second edition of the *Ruines* were those incorporated into the two introductory essays—the discourse on history in the first volume, the discourse on theory in the second. These are Le Roy's culminating statements. The new discourse on history does not, in fact,

contain much that is new: the essay of the first edition was skillfully inter-
woven with much from the *Histoire* and a section from the *Observations,*
and a new plate, revising the comparative history of 1764, was added (see
vol. 1, pl. 1). But the result is a history of ancient architecture more vital,
more dynamic than anything previously attempted. The structure of this dis-
course is provided by the notion of conceptual forms — one is tempted to say
Platonic forms, but they are not quite that — providing the basis for all signifi-
cant developments in architecture, a notion first outlined in his response to
Stuart in 1767. "The history of the arts," Le Roy begins, "offers us one spec-
tacle that deserves the attention of all who love to trace their progress —
namely, a view of how much the primitive original ideas of some creative
geniuses have influenced the various works subsequently made by men"
(p. 209).[262] Phoenician gravestones, he tells his readers, become obelisks,
heaped stones become pyramids, the primitive hut serves as the protype for
the temple. The new plate illustrating the historical evolution of sacred archi-
tecture now has three distinct lines of development: the Phoenicians, the
Egyptians, and Hebrews are in one track; the Greeks and Romans in another;
the Christians in a third. The aim, though unstated, was to separate the
Greeks from the Egyptians and to distinguish the Christians from all the rest.
However, the lines of development do follow on, one from another.
Continuities are indicated. The first column ends with a fake "Phoenician
temple" — in fact a Syrian tomb culled from Pococke[263] — creating a link to
the second column in which the Etruscans are subsumed (whatever the role
and position of the Etruscans in the ongoing arguments of scholars, all were
agreed that the Etruscans' script was based on that of the Phoenicians).
Similarly, the second column ends with the temples at Baalbek, in Syria, and
the third column starts, as might be expected, with the Christian catacombs,
but Christian catacombs in the Levant, in Egypt, derived once again from
Pococke. Much may be teased out from an analysis of the buildings illus-
trated, though it is scarcely necessary, for most of the examples had been cited
or illustrated by Le Roy in earlier works. His only surprise is the removal of
the two great Parisian churches, Sainte-Geneviève and the Madeleine, that he
had earlier considered to be the spearhead of the architectural renewal in
France. The third column ends with the royal chapel at Versailles. Durand, Le
Roy's most famous pupil, was later to disapprove strongly of domes on pen-
dentives set over crossings, considering them to be structurally unsound, the
occasion, perhaps, of Le Roy's removals. His attitude might have sprung from
Le Roy, as so many of Durand's ideas.

The accompanying text is built around the tripartite division of the plate.
Some of the text in the first section, relating to the Egyptians, is new, though
most is brought in from the *Observations;* the text of the second section, on
the Greeks and Romans, is taken over, almost unaltered, from the *Ruines* of
1758; the last section, on Christian churches, is derived in the main from the
Histoire — without the descriptions of Sainte-Geneviève and the Madeleine
but with a chunk on Hagia Sophia and the concluding paragraphs of the his-

torical essay of the *Ruines* of 1758. A few paragraphs and comments are added to reinforce the evolutionary theme and, to compensate for the loss of Sainte-Geneviève and the Madeleine, a new summary is given of the influence of Gothic construction on contemporary church architecture — "The vaults in the naves of their churches," he writes, taking on from his earlier account of Gothic architecture,

> are commonly somewhat lighter and somewhat taller than ours; and, having less thrust, they do not need such stout piers to sustain them. Thus, by following — in this respect alone — in the footsteps of the Goths, by searching for the strongest and at the same time lightest materials for the construction of vaults, and by placing extremely slender piers at the points where those vaults exert their greatest force, French architects might endeavor to make the interiors of their churches more unobstructed than was formerly thought possible, while gracing them with Greek orders used in the noblest and most comprehensive manner (p. 228).[264]

Le Roy was as uneasy as ever with Gothic, but he was intent on demonstrating a lack of prejudice in assessing something of its advantages. This was at one with his overall approach. He saw that the Gothic cathedral represented a peak of achievement in architecture, just as the Parthenon in Athens and the Pantheon in Rome had earlier and, he no doubt still hoped, the two great churches being built in Paris would prove — a synthesis of all that had gone before, another moment of supreme harmony in architecture. But he also saw that nothing could remain perfect, that each achievement was relative not only to geographical conditions but also to those of religion, politics, and society, all inevitably changing. The laws of structural stability alone seemed axiomatic.

Le Roy's history is erratic and partial, his ideas are not well worked out, but it is sustained by a conceptual thrust lacking in all other attempts of the time to compose a history of architecture. The most obvious example is the history provided the following year as an introduction to the first volume, of 1771, of the *Cours d'architecture; ou, Traité de la décoration, distribution et construction des bâtiments*, by Jacques-François Blondel, Le Roy's own superior. Blondel declared at the start, "this introduction will set forth the origin of architecture, its progress, and the revolutions that have taken place in it."[265] His aim was to discover the principles of architecture through a study of its history. Architecture, he argued, arose from the need for protection. The primitive hut provided the security for societies to form. Settlements led to the first town founded by Cain (Gen. 4:17) and thus to Babylon and Nineveh, though only when Egypt is reached was Blondel able to provide anything by way of hard evidence. His prime sources were Herodotus and Diodorus Siculus. But though the Egyptians built widely and on the grandest of scales, determining the forms of Greek architecture, they were never able to confer the highest distinction on their architecture. The Egyptians, Blondel wrote,

burning with the desire to immortalize themselves, and involved with problems of construction, had neglected all delicacy of execution and failed to appreciate the graces of art; the [Greeks] gave their creations the regularity, correctness, and refinement that satisfy the soul and that present an admirable composition to the eyes of the enlightened beholder. In a word, we may regard the Greeks as the creators of architecture proper and may consider them the first worthy of having imitators.[266]

Blondel in fact deals with the Greeks at less length than the Egyptians, but the highlights of Greek architecture are noticeably isolated—the Artemision at Ephesus; Pericles' Athens, with the focus on the Parthenon of Iktinos and Kallikrates (Le Roy is referred to here); the Hadrianic Temple of Zeus Olympios in Athens; and the Maussolleion in Halicarnassus. Blondel, it would seem, had been looking hard at Fischer von Erlach's *Entwurff einer historischen Architektur.* The Etruscans, like the Egyptians, had never given proper form to their architecture, Blondel declared, and the Romans had done little more than imitate the Greeks: "The Romans learned from the Greeks how to make their buildings regular, how to relate the plan and the ordering; they worked to surpass their masters, but they succeeded only in becoming their rivals."[267] Thus, after a survey, the highlights of which were the Pantheon in Rome, Hagia Sophia, the Pfalzkapelle in Aachen and other Carolingian works, and the great Gothic cathedrals, Blondel reached Saint Peter's—"The foundation of Saint Peter's basilica in Rome marked the renaissance of fine architecture."[268] (No mention is made of the Basicila di San Marco in Venice or of Florence's Duomo.) And thus onward to end not only with Sainte-Geneviève and the Madeleine but also with a host of smaller contemporary works by Nicolas Le Camus de Mézières, Moreau-Desproux, Antoine, and even Blondel's own additions to Metz. The architecture of the present was offered as continuous with that of the past.

There is a structure and a chronology to Blondel's history—architectural achievements are identified with societies and rulers and, wherever possible, with architects; dates are furnished as may be—but there is no sense of the forces, whether social or individual, that occasioned it all. No pattern of change is described. The account is additive, one building following the next, recounted briefly or at length, depending on the available information. Even the opinions offered scarcely provide a slant to the story. It makes for dull reading. Nonetheless, Blondel's history was the first attempt to provide a comprehensive account of the evolution of architecture, and in length and range it was far superior to Le Roy's. Le Roy, however, had a point of view, and that gave his work its edge.

Historical studies had, of course, been greatly advanced in France from the late seventeenth century onward,[269] but there was no obvious model for Le Roy's discourse on architecture. Bossuet's celebrated *Discours sur l'histoire universelle* (1681), which provided a solid base for much historical writing, had nothing in it on architecture, nothing much, for that matter, on ancient

Greece and Rome, no more than a handful of pages, for Bossuet was concerned with the Christian realm, from the Creation to the reign of Charlemagne. He stuck, moreover, to a chronology constrained by the Old Testament. Despite the difficulties and anomalies that this involved, all too soon apparent, even to Bossuet—he advised readers of the third edition of his *Discours* to use the chronology of the Septuagint, rather than the Vulgate, as it gave them an extra thousand years in which to accommodate the history of the world—the biblical chronology was staunchly upheld in Le Roy's time. It was maintained by Nicolas Lenglet Dufresnoy in his *Méthode pour étudier l'histoire,* from the two-volume first edition of 1715 right through to the revised fifteen-volume edition of 1772 (maps added from 1729 on); in Augustin Calmet's *Histoire universelle, sacrée et profane, depuis le commencement du monde jusqu'a nos jours* (1735–71); and in Jacques Hardion's *Histoire universelle sacrée et profane, composée par ordre de Mesdames de France* (1754–65). It was followed even in the outlines for a universal history sketched out around 1751 by the young and radical Anne-Robert-Jacques Turgot, who aimed to provide a blueprint for human progress. [270] And Blondel, even later, in the section on history in his *Cours d'architecture,* was invoking Isaac Newton's *Chronology of Ancient Kingdoms, Amended* (1728).

Voltaire was the first to pour scorn on Old Testament chronologies, in his *La philosophie de l'histoire* of 1765, but this work was not intended as a guide for students of ancient history. He introduced the Chinese and the Indians into general historical consideration, but he focused on the Jews. He regarded the golden ages of Greece and Rome as peaks of human achievement, but he had little enough to say about them. He wrote on their concepts of the soul, on sibyls and oracles. He ridiculed Huet's attempts, in the *Demonstratio Evangelica,* to identify the pagan gods with the prophets of the Jews, though intent himself to find traces of monotheism in all religions. Voltaire's work was, in effect, a deist tract. But it served to displace Bossuet's approach to the past.

Voltaire never worked out a theory of the forces determining human development. That was the achievement of Montesquieu—speculatively in *Considérations sur la grandeur et la décadence des Romains* (1734), resolutely and with passion in *L'esprit des loix* (1748). Montesquieu explored the nature and limits of power in the institution of social structures. He ranged on the grandest of scales. The sections of *L'esprit des loix* most often invoked by art historians are chapters 14 through 19, dealing with the relation of cultures to climate and geography. Montesquieu was deeply concerned with this issue. He began his analysis, as might be expected, with something of scientific precision. He thought to account for the differing natures of peoples with reference to the expansion and contraction of the fibers of the body and the rate of the flow of blood at different temperatures. People in cold climates were vigorous, he thought; those living in the warmth were langorous and timorous. And thus he continued, accounting for the various characteristics of races and peoples throughout history as well as for the forms of their social institutions.

Most of his analysis relates to climate alone. Only in chapter 18 is the quality of the soil considered: "The goodness of the land, in any country," Montesquieu wrote, "naturally establishes subjection and dependence. The husbandmen, who compose the principal part of the people, are not very jealous of their liberty; they are too busy and too intent on their own private affairs. A country which overflows with wealth is afraid of pillage; afraid of an army."[271] A monarchy, he judged, was thus more frequently to be found in a fruitful country, a republican government in one that was not so. The barrenness of the soil of Attica had produced the democracy of Athens. Montesquieu's comparative study of cultures was a critique of political absolutism. He was nowhere concerned with the things that people made or created. His short section on temples was included to prove merely that only people who lived in houses built temples.

Le Roy might have been stirred by Montesquieu's *L'esprit des loix*, but only in the most general terms. Far more pertinent to his investigations was Dubos's *Reflexions critiques sur la poèsie et sur la peinture* (1719). In this earlier work, as Montesquieu well knew, sections 13 to 20 — 165 of the 529 pages of the second volume — are given over to a consideration of the influence of climate and geography on artistic expression.[272] Like Montesquieu later, Dubos favored a scientific explanation; it was all a matter, he said, of the air that one breathed. "The air we breathe, communicates to the blood in our lungs the qualities with which it is impregnated."[273] Hence the differences that occur throughout history in artistic expression and in the achievements of the nations of the world. If the Romans and the Dutch might be judged to have declined in their artistic and other achievements, it was because their air had changed. The Romans had become prey to the waters stagnating in the ruins. The Dutch, he explained, had lost their forests. "I conclude therefore from what has been hitherto set forth," Dubos wrote, "that as the difference of the character of nations is attributed to the different qualities of the air of their respective countries; in like manner the changes which happen in the manners and genius of the inhabitants of a particular country, must be imputed to the alterations of the qualities of the air of that same country."[274]

Whatever the drawbacks of the compendious histories of Bossuet and his followers, they saw history as an evolutionary process. Bossuet had invoked the notion of "enchaînement" — now associated as a rule with the ideas of the liberal, progressive historians of the early nineteenth century — in describing the course of history, though for him the force behind it was, of course, God: "that long chain [*enchaînement*] of particular causes that make and unmake empires," he wrote, "depends on the secret ordering of divine Providence."[275] History was defined in the early editions of the popular *Dictionnaire de Trévoux* as the "a true narrative, connected and linked together [*enchaînée*], of several memorable events."[276] And one can find similar definitions in Lenglet Dufresnoy and Voltaire. But the histories offered in these books could not have been much use to Le Roy. Bossuet thought the Egyptians "a grave and serious nation,"[277] as did most of his successors. Lenglet Dufresnoy

digressed marginally on Egyptian architecture, but only to confirm French conventional wisdom, quoting still from Bossuet even in his revised edition of 1737: "everywhere architecture manifested the noble simplicity and the grandeur that fills the soul. Long galleries displayed sculptures, which Greece took as models. Thebes rivaled the most beautiful cities in the world."[278] Voltaire, unusually, was prepared to concede neither the antiquity nor the splendor of Egypt. He cast doubt on the veracity of Herodotus's descriptions of the works of Sesostris. "They knew the grand," he concluded reluctantly of the Egyptians, "but never the beautiful. They taught the early Greeks, but the Greeks were later their masters in everything."[279]

None of these authors disputed the supremacy of the Greeks, however. Comparing the Greeks with the Persians, Bossuet wrote, "But what Greece had that was greater was a firm and farsighted policy that knew when to retreat, to risk, and to defend what was necessary; and, still greater, a courage that love of freedom and of the nation made invincible."[280] Bossuet held the ancient Athenians in high esteem, though, to be fair, he thought the Romans their equal in their love of liberty. Lenglet Dufresnoy apostrophized Athens thus: "Athens, the inventor of the arts, the sciences, and the law; the seat of good manners and knowledge; the theater of merit and eloquence; the public school of all those who aspired to wisdom; more famous for the minds of its inhabitants than Rome became for its conquests, owed its beginnings to Egypt and to the person of Cecrops, a native of the city of Saïs in the Nile delta."[281] Voltaire could scarcely do better: "Fine architecture, perfected sculpture, painting, good music, true poetry, true eloquence, good history writing, and finally, philosophy itself, though unstructured and obscure, all came to nations only through the Greeks."[282] The Romans in particular, he confirmed, had got everything from the Greeks. Perfunctory comment of this sort, as already indicated, was commonplace in France but was of little real use in structuring an architectural history.

Only two surveys of architectural history had been attempted in France when Le Roy began writing: Jean-François Félibien's long and dense *Recueil historique de la vie et des ouvrages des plus célèbres architectes*, published in 1687 as a companion volume to his uncle André's more famous *Entretiens sur les vies et sur les ouvrages des plus excellens peintres anciens et modernes* (1666–88); and the short chapter on "Architecture" that Charles Rollin included in the section on Greece and Rome in the eleventh volume, of 1737, of the *Histoire ancienne des Egyptiens, des Carthaginois, des Assyriens, des Babyloniens, des Medes et des Perses, des Macedoniens, des Grecs*. Félibien began with the biblical Cain and moved forward to Arnolfo di Cambio, the thirteenth-century architect of Florence's Duomo. There is something of a chronological sequence in his account, but not much of method and nothing of purpose. He switches from Incan Cuzco to Renaissance Florence without pause or cause. Snippets of information are packed one against another to suffocating effect. Félibien is illuminating when dealing with Gothic architecture, and Athens does emerge, briefly, as the creation of Pericles, with Iktinos

and Kallikrates named as the designers of the "Temple of Minerva, called *Parthenon*, that is, the Temple of the Virgin"[283] (Félibien was uncertain as to whether it was Doric or Ionic) and Mnesikles as architect of the Propylaia. Le Roy could have learned little more from Félibien.

Rollin's chapter, by contrast, evidently provided a useful starting point. Architecture starts, in Rollin's account, with agriculture, with the building of simple huts that establish the forms of columns and lintels, which, in time, are made harmonious through proportioning (Saint Augustine of Hippo is referred to here). Great towns and buildings emerge, Babylon and Nineveh, the pyramids and temples of Egypt, the Labyrinth on Lake Moeris,[284] the Tabernacle of the Israelites, and Solomon's temple. Agrus and Agronerus, Sesostris, and others to be invoked by Le Roy are named. "Nevertheless," Rollin makes clear, "it is neither to Asia nor to Egypt that this art is indebted for the degree of perfection it achieved.... it is to Greece that one attributes if not its invention, then at least its perfection; and it is Greece that prescribed its rules and provided its models."[285] This is remarkably close to both Le Roy and Blondel. For Rollin, the great works of Athens are the port and the buildings of Pericles, already held up as exemplary in the third volume, of 1728, of Rollin's *De la manière d'enseigner et d'étudier les belles-lettres*. But the four principal temples of the Greeks are listed as the Temple of Diana at Ephesus (the Artemision), that of Apollo at Miletus (the Delphinion), that of Ceres and Proserpine at Eleusis (the temple in the Sanctuary of Demeter and Kore, thought by Rollin to be the work of Iktinos), and that of Jupiter Olympius (Temple of Zeus Olympios) at Athens. The Parthenon is not included. As always, the Roman contribution is disparaged, and their orders are dismissed as "very far from the degree of excellence of the other three."[286] Roland Fréart and Claude Perrault, Rollin proudly claimed, were his guides in such matters.

Lenglet Dufresnoy provided annotated bibliographies at the end of each section of his history; so useful were these bibliographies, updated in successive editions, that they were later published separately. For basic geographical information, he later recommended the maps of Jean-Baptiste Bourguignon d'Anville's *Géographie ancienne abrégée* (1768). For the history of ancient Egypt, he suggested Sir John Marsham's *Chronicus Canon Aegyptiacus, Ebraicus, Graecus et Disquisitiones* (1672) and Jacobus Perizonius's *Origines Babylonicae et Aegypticae* (1736), though, surprisingly, not Benoît de Maillet's *Description de l'Egypte* (1735); however, he thought best, by far, the accounts of Herodotus and Diodorus Siculus. Likewise, for the study of ancient Greece, he referred in passing to Temple Stanyan's *The Grecian History* (1707–39), translated by Diderot in 1743 as *Histoire de Grèce*,[287] and to Rollin's *Histoire ancienne*, but recommended Herodotus, Plutarch, and Thucydides for all serious study. He aimed at something of authenticity. "The first thing I have to do when starting to write with authority on history," he announced at the beginning of his study, "is to establish its truth and certainty, to show those who study it that, in taking it up, they are working on a real foundation, not only able to improve their minds but also suited to instruct them on the duties of

civic life, and even to strengthen their religious beliefs."[288] But though truth and certainty were to be the basis of history, the Bible was never to be doubted, by Lenglet Dufresnoy at least. Voltaire expressed himself more bluntly, opening the article on history he wrote and rewrote between 1755 and 1758 for Diderot and d'Alembert's *Encyclopédie,* "History is the narration of facts presented as true, in contrast to the fable, which is the narration of facts presented as false."[289] He despised Lenglet Dufresnoy.

Whether he referred to him or not, Le Roy seems to have operated along the lines suggested by Lenglet Dufresnoy, though not entirely: Le Roy preferred by far to rely on antique sources, but clearly he was familiar with Rollin; he, notably, added Pausanias to Lenglet Dufresnoy's authorities, but for sharp opinion — prejudice even — Le Roy relied on his mentors at the Académie royale des inscriptions et belles-lettres. The interpretation of history that he offered in his discourse was thus a compilation, but a compilation of his own, wayward and inconclusive, held together by a conviction that architecture springs from the embodiment of an idea that is slowly elaborated and given significant form. Thus begins a chain of development. The only precedent in architectural histories is, of course, Vitruvius's notion of the primitive hut, and this Le Roy seems to have reinterpreted anew, very imaginatively, to arrive at a whole range of primal concepts and forms, determining thus the course of architectural history. His performance was a tour de force.

To establish the sequence of development of the great temple precincts, Le Roy was forced to elaborate somewhat on Herodotus's descriptions — though for the temples themselves he kept remarkably close — and likewise in recounting Pausanias's and (he claimed) Thucydides' descriptions of the Temple of Zeus Olympios in Athens. In pursuing an idea, he was clearly prepared to give a twist to the truth. But the history of the buildings of Athens offered in the main text was as consistently reliable as his ancient sources allowed. Scarcely any precise dates are given — though the mythical king Cecrops's arrival in Athens from Egypt is firmly dated to 1582 B.C. In attempting to establish the sequence of architectural development, Le Roy set the buildings relative one to another in time,[290] resorting in part to stylistic criteria — the squatter a column, the earlier he judged it. He was wrong more than once, but he did better than might be expected.

Le Roy's discourse on history was highly provocative; his discourse on theory was an expansion of the very possibilities of experiencing architecture and a way of explaining that experience. He gave a new voice to feeling. The discourse of 1770 is almost three times as long as that of 1758, but only one section is new. The first page of the earlier essay — setting down the three categories into which architectural principles may be divided: universal axioms first, then principles accepted by all enlightened peoples, past or present, and lastly principles held by particular groups of people, relating to geographical and social conditions, even caprice — once again serves as the opening. The five remaining pages of the earlier essay, which analyze some of the principles of the last two categories, serve, as before, as the conclusion. In between, Le

Roy set the whole of the third chapter of the *Histoire* of 1764 — which explored visual responses to forms and the uncertainties of apprehension of internal volumes, whether from a fixed position or moving — followed by an entirely new section on visual illusions and distortions and the grounds of familiarity in molding our tastes. He goes far beyond Montesquieu here.

A lark in the sky, he begins, disappears from view before an eagle. But this is not just a matter of size; it relates also to shape, for larger dimensions, he observed, appear to diminish at a less rapid rate than smaller ones as an object recedes. Thus a man standing against the horizon seems both taller and more slender than he is in reality. Columns standing on a mountain top seem both taller and more slender from a distance than they seem close up. And he relates this optical phenomenon to another. A man appears slimmer when dressed in black than when wearing white, yet he does not seem shorter. Can this be, Le Roy hazards, because black is the most light-absorbent of colors, so that a black object quite close up begins to act like a distant object, the greater dimension diminishing less rapidly than the lesser one? Le Roy adduces no principles from these observations, indicating only that our responses to the size, distance, and color of forms are far more complex than might have been thought.

Le Roy then moves to taste. This, he asserts, is determined largely by our earliest experiences, by our earliest responses to people and places. Childhood memories give form to our sense of being. A black man from Guinea will always like best a black face and the fetishes of his upbringing; a Laplander or Chinese will likewise prefer the images he loved first. How then to find some universal ground for taste in the rich variety of the world offered by the spectacle of nature, he writes, echoing Noël Antoine Pluche's *La spectacle de la nature; ou, Entretiens sur les particularités de l'histoire naturelle, qui ont paru les plus propres à rendre les jeunes-gens curieux, et à leur former l'esprit* (1732–35), an eighteenth-century best-seller. Le Roy discerns two radically opposed principles in nature: a natural attraction to symmetry, another to striking contrast. The forms of animals, including those of man himself, determine our liking for symmetry; the star-scattered skies, the mountains and rivers, the trees, plants, and flowers, in all their infinite variety of color and shape, lie at the root of our fondness for contrast. The enlightened citizen, no less than the Hottentot, requires symmetry in the form of the human body and face. Everyone likes the symmetry of the birds and the fishes. What no one likes is an element of disparity in either of the opposed compositional types: the regularly ordered or the boldly picturesque. Instance, Le Roy says, our taste in clothes. We like best a neat symmetry, pockets and sleeves lined up, though in theatrical costumes or paintings we will accept a wild disorder of pleats and drapes; but the two modes cannot be combined. Similarly in gardens, there are those of the regular kind, admired by the French, and those mirroring the disorder of nature, preferred by the Chinese and the English. The moment of confusion occurs when some of the trees in an ordered avenue break the line or are unevenly spaced. The eye is offended, the soul is dis-

turbed. The intent is in doubt. These deeply grounded reactions, Le Roy insists, must needs be accepted as having the same certainty as the laws of mechanics. Look, he remarks, at the natural taste of the good workman in settling sizes and patterns. Thus, though ideas of beauty may differ in different parts of the world, there is a shared and basic responsiveness to forms throughout, deriving from man's initial response to nature. When the model is not provided by nature but invented by man, then notions of beauty are indeed variable, even in a single nation. Gothic might be preferred to Greek. Le Roy leaves the momentous implications of his claims unexplored; instead, fearing that perhaps he has overstepped the mark, he concludes, somewhat lamely, that once the hallmarks of the thought and arts of the enlightened nations of antiquity have been accepted by a people, there is no recourse but for them to accept those precepts from antiquity relating to architecture too.

The tenor of Le Roy's discussion, as well as his remarks on optical effects and patterns of response to differing modes of composition, once again suggests a reading of Burke's *A Philosophical Enquiry,* published, as noted already, in French in 1765. There is no reason to doubt that Le Roy was familiar with that work, but he made no reference to it and relied on it in no way. The two authors use references in altogether different ways—the starry skies are for Le Roy an exemplar of composition, for Burke they represent magnificence; habit for Le Roy is the grounding of taste, for Burke it is a promise of mediocrity and indifference. The catalyst for Le Roy's thinking was rather the French ferment, in particular, the concerns of the Académie royale des sciences. A glance at the *Histoire* and *Mémoires* recording the activities of the academy in the decades preceding the revised edition of the *Ruines* reveals an obsession with astronomical observation and with the distortions of vision to be taken into account when viewing phenomena.[291] The academicians seem, to a man, to have had access to a telescope. The versatile Pierre Bouguer, it is worth noting, broached two issues dear to Le Roy. His "Recherches sur la grandeur apparente des objets" of 1755[292] might have influenced Le Roy's comments in the *Histoire* of 1758, but Bouguer, as his posthumously published *Traité d'optique sur la gradation de la lumière* (1760) made clear, though as intensely involved as Le Roy with the myriad effects of light and the distortions and illusions of sight, was intent to analyze them in mathematical terms alone. However, his "Sur les principaux problèmes de la manoeuvre des vaisseaux" of 1754–55,[293] though also focused on mathematical vectors, was no doubt taken into account, along with Clairaut's reflections on this subject in 1760,[294] when Le Roy turned his attention to the movement of ships.

But it was the interest in sight taken by his brothers Jean-Baptiste and Charles that seems to have proved most provocative to Le Roy. Jean-Baptiste performed a celebrated experiment, published in 1784, in which he electrically stimulated the optic nerve of a man rendered blind by an illness, thus rousing up images in the mind, proving, to Cartesian delight, that it is the brain that sees, not the eye.[295] Charles, a corresponding member of the Académie royale des sciences, sent a paper from Montpellier in 1755, finally

published in 1761; his "Mémoire sur le méchanisme par lequel l'oeil s'acco-mode aux différentes distances des objets"[296] is mainly technical, elaborat-ing on a discredited belief of the mathematician Philippe de La Hire that no adjustment occurs in the lens itself when the eye focuses on objects at vary-ing distances. The eye, Charles thought, functioned as simply as a camera obscura. He confirmed this conviction, to his own satisfaction if not to that of all concerned, in a series of eight experiments involving strips of white paper pasted horizontally and vertically onto black cards. This research was appar-ently presented to the Académie royale des sciences in 1762 but published only in his collected papers of 1771.[297] Charles's stand was more rigid than one might expect in view of the imaginative approach he took to the problem of evaporation in the early 1750s. Le Roy seems to have been stimulated to reaction by his brothers' experiments: he stuck resolutely to a consideration of what he could see, to the impact of viewing on his mind and his senses, whether he could explain the effects fully or not. He steadily upheld the verac-ity of the senses. He championed the vital import of one's first responses to the world, further demonstrating his opposition to Descartes, for whom such learning must forever be in doubt. Le Roy had perhaps read Rousseau's account of childhood experience, *Emile*, issued in May 1762 (and burned in public the month after).

Le Roy's remarks on the relative nature of beauty and taste in the different regions of the world, though passing and swift, are deeply grounded in the emerging concept of a science of man. The differences between the peoples of Earth had long been a source of fascination. Christians liked to believe that everyone was descended from Noah; there was also a tradition that those descended from Noah's son Ham were black, as a result of the curse Noah put upon Ham's son: "Cursed be Canaan; a servant of servants shall he be unto his brethren" (Gen. 9:25). This notion was convenient for those who had black slaves, but there was, in fact, no mention of blackness in Genesis. Aristotle had thought exposure to the Sun's rays had made some people black. Jean Bodin's *Methodus ad Facilem Historiarum Cognitionem* (1566) rejected the notion that blackness was the result of a curse, but he elaborated to some length on the effects of climate on the physical makeup of man. People from the tropics were swarthy and densely black as a result of the Sun, at the poles they were tawny, in between they were graded from ruddy to white to yel-low and even, as they approached the tropics, to greenish — "when the yellow bile is mingled with the black," he declared, "they grow greenish."[298] Bodin devoted a whole chapter to the characteristics of people, but such characteris-tics, he thought, might change when men moved from one region to another.

Such beliefs were upheld in France into the eighteenth century and beyond. In 1737 Maupertuis and Clairaut had returned from their expedition to Lap-land with two young Lapp women, Christine and Ingueborde Plaiscom, of whom they grew quite fond.[299] Maurepas dispatched the women to a convent, lest any scandal ensue, but by then Maupertuis had become much interested in racial characteristics.[300] He published *Dissertation physique à l'occasion*

du nègre blanc in 1744, reporting on an albino who, he thought, confirmed the notion that blacks were once white. He enlarged on his theories in the following year in *Vénus physique.* There he described the wide range of the peoples of Earth, all too aware of the difficulties of accounting for such variety in terms of climate alone. He continued nonetheless to believe that all humans were of a single origin. The parallel beliefs published by Dubos in 1719 and by Montesquieu in 1748 have already been noted. But it was Buffon who most famously spoke on the subject in 1749 in "Variétés dans l'espèce humaine," the last chapter of the third volume of the *Histoire naturelle, générale et particulière.*[301] He too ranged far and wide, recording the colors, heights, shapes, and features of the peoples of Earth, starting his sweep in Lapland, moving across eastern Europe to China, then south to Malaysia and Australia and west, once again, through southern India to Arabia, Egypt, and North Africa. He started a second loop in Kashmir, went west to Europe, then crossed to Africa, moving south down the western coast and north up the eastern side. America he dealt with from north to south. Despite the evident impossibility of unifying this gallimaufry of beings, Buffon continued to believe that mankind was of common origin but had evolved differently in different parts of the world.

Voltaire scorned these notions. In 1765, in "Des différents races d'hommes," the second chapter of *La philosophie de l'histoire,* he declared the Genesis story to be absurd, the whole notion of a single source for the human race ridiculous: "Only a blind man could doubt that Whites, Negroes, Albinos, Hottentots, Laplanders, Chinese, and Americans are of entirely different race."[302] They were as different as apricots and pears, he had decided even earlier, in his *Traité de métaphysique* (1734–35).[303] And climate had nothing to do with it. Blacks do not become whites when they move to Europe—as most writers from Bodin to Buffon had thought possible.

The concepts of beauty upheld by these various peoples were likewise a matter of consideration, from the start. Jacques de Vitry, writing in the thirteenth century but published only in 1597, had declared, when considering the question of tolerance, "we consider the black Ethiopians ugly, but among them the blackest is judged the most beautiful."[304] In the eighteenth century, while discoursing on natural beauty in the first chapter of his *Essai sur le beau* (1741), André instanced the natural preference of blacks for those of their kind, described, he said, by Antoine-François Prévost in *Le pour et contre* in 1736. "There are black people and there are white people," André wrote, "and neither has ever failed to act according to their own interest and sense of pride. I have just read an account by a black man who, without hesitation, awards the palm of beauty to the color of his race."[305] Voltaire, as recorded in the hybrid *Dictionnaire philosophique* of the great Kehl edition of his works, under the heading "Monstre," wrote much the same thing: "The first Negro was however a monster for white women, and the first of our beauties was a monster in the eyes of Negroes."[306]

Le Roy's ready knowledge of such opinion, his glib reference to Laplanders,

Hottentots, and Nigerians, might have sprung direct from a reading of Maupertuis's *Vénus physique,* a short and provocative book. Most of the ready references are there, though not the Nigerians, but they might easily have been supplied from another short and spicy work, Charles de Brosses's *Du culte des dieux fétiches; ou, Parallèle de l'ancienne religion de l'Egypte avec la religion actuelle de Nigritie* (1760). Buffon has them all, however, and it is thus to Buffon that Le Roy's knowledge is most convincingly ascribed. Buffon, moreover, had chapters on hearing and sight in the same volume of the *Histoire naturelle* as his chapter dealing with race. In addition, Buffon's conviction that the finest forms of the human race had evolved between the fortieth and fiftieth parallel, roughly between Madrid and Paris, corresponds nicely, with some slight extension to the north and the south, to the zone of Le Roy's enlightened peoples of Earth. Not, of course, that Le Roy would have required confirmation for such a conviction.

The *Ruines* of 1770 prompted the usual notice in a wide range of journals.[307] The review in *L'avant coureur* of 11 December 1769 was short but to the point. Le Roy's alterations to the new edition were noted, with special reference to the essays on theory and history — "the author has enriched them with interesting observations, and with principles knowledgeably discussed, which lead to a theory equally simple, illuminating, and rich."[308] The views of the buildings were applauded as still "very picturesque and very satisfying."[309] The review published in the *Mercure de France* in January 1770 dealt with the book in much the same manner — the engravings illustrate "very picturesque and very satisfying parts of the most beautiful monuments remaining of the architecture of the Greeks, our masters in the fine arts"[310] — but was more sharply appreciative of the two essays:

Even more to advantage, he has determined the connection between the basic principles of Greek architecture and those, in this art, that have to do with the laws of mechanics, or that derive from the nature of our souls and our organs, and sometimes from the habits we evolve in seeing objects scattered over the surface of our globe: Monsieur Le Roy has aimed to examine these also in his two essays — one on the history of architecture, the other on the theory — that introduce the two volumes of this work. These essays are replete with new reflections on the arts in general and on architecture in particular. They are the reflections of an enlightened artist, of an intelligent observer, and of a man of taste.[311]

The *Journal encyclopédique,* as before, offered by far the longest assessment. Appearing in two parts in March 1770, the review noted the new arrangement of the work, the alterations and additions, referring only briefly to the dispute with Stuart that was the occasion for so many of Le Roy's changes, to conclude with a resounding encomium: "the wisdom Monsieur Le Roy infuses into his criticism of the travelers who preceded him to Greece, and with whom he does not always agree, as much honors his heart as his work does his mind and his zeal for the progress of the arts."[312] But it was the essay on theory that

stirred the most vital response. "One needs to copy," the critic wrote, "everything that Monsieur Le Roy says of the effects produced by peristyles; all his ideas, on this matter, ought to be engraved on the souls of artists."[313]

Le Roy lived another thirty-three years after the publication of the *Ruines* of 1770. Surprisingly little is known of his life. Mention is not often made of him in contemporary memoirs. The smattering of polite correspondence that survives consists of no more than fourteen letters or drafts of letters (three of which are duplicated) dating from 1769 to 1775, seven sent by Le Roy to William Chambers, seven by Chambers to Le Roy.[314] The first two letters, of 12 October and 26 November 1769, were written soon after Le Roy's autumn visit to London, where Chambers had entertained him and introduced him to the members of the Royal Academy of Arts and others—among them the painters Joshua Reynolds and Joseph Wilton; the author and lexicographer Giuseppe Marc'Antonio Baretti, who was to write the guide to Somerset House, Chambers's chief architectural work; Joseph Damer, Lord Milton, a client of Chambers; and a former pupil, Edward Stevens.[315] The second letter records that Le Roy sent Chambers copies of Laugier's *Observations* and a work on Gothic architecture—probably Louis Avril's *Temples anciens et modernes; ou, Observations historiques et critiques sur les plus célèbres monumens d'architecture greque et gothique* (1774), which contained much praise of Gothic and also much praise of Le Roy. He also sent copies then of the new edition of the *Ruines* not only to Chambers but also to Wood (who already owned the first edition and the *Observations*)[316] and someone he named as "Ouri" (in fact the pastelist William Hoare, of Bath, who wrote on 29 May 1770 to thank Chambers for sending the book on),[317] with yet a fourth volume for the Royal Academy of Arts, where the copy survives.

"The two essays on the history and the theory of architecture," Le Roy told Chambers,

> include things that you have already read, but they also contain other things that you do not know; and as they are on a matter that should interest you, I believe that you may take some pleasure in reading them. If you have the time, you might also want to read everything in the second volume relating to plate 25, and, finally, if you are curious about the main points of my reply to Stuart, you can read from page six to page twenty-three or twenty-four of the second volume [see pp. 395–423, this volume].[318]

There is no record of Chambers's reply. In a letter of 4 February 1770, addressed to Charlemont, Chambers took strongly against the *gusto greco* of Richard Chandler and Nicholas Revett's *Ionian Antiquities* (1769), complaining that their sponsor and publisher, the Society of Dilettanti, had acted with "a degree of madness in sending people abroad to fetch home such stuff. I am told this curious performance has cost the society near three thousand pounds; such a sum well applied would be of great use and advance the arts

considerably, but to expend so much in order to introduce a bad taste is abominable. However, not a word of this to any dilettanti living."[319] Chambers himself evidently conveyed nothing of this to Le Roy.

On 4 September 1772 Chambers sent copies of his *Dissertation sur le jardinage de l'orient* (1772) for Le Roy, Voyer d'Argenson, and the Académie royale d'architecture. He aimed to send eighty-two additional copies to be sold in Paris on his own behalf at three livres ten sols each. He had already, one might note, sent a copy direct to Voltaire on 3 July 1772, his covering letter in English.[320]

Soon Chambers and Le Roy were to be involved in an active exchange of books. Thomas Major, the British engraver who had trained with Le Bas,[321] took a consignment from Paris to London, acknowledged by Chambers on 18 September 1772, that included *Descrizione delle feste celebrate in Parma l'anno 1769*, composed largely of engravings after drawings by Petitot, and Contant d'Ivry's *Les oeuvres d'architecture* (1769), with which Chambers declared himself unhappy ("nullement content").[322] Le Roy suggested that Major might act as courier in an exchange of the *Ruines* for Revett's book (presumably the *Ionian Antiquities* rather than the *Antiquities of Athens*), but no more was to be heard of this. By 24 October 1772 Major was back in Paris, finally delivering the large consignment of Chambers's *Dissertation*. "I have received the box of your books in good condition," Le Roy wrote then. "Your book is extremely interesting to me, both on account of the large number of new ideas it contains, and for the poetic manner in which they are presented."[323] Le Roy read the work to Marie-Anne Le Page Fiquet, Madame Du Boccage, who liked it so much that he presented a copy forthwith, on Chambers's behalf. Another was set aside for Adrienne-Catherine de Noailles, comtesse de Tessé.[324]

The trade in books and other items—a jacket for Chambers, ribbons for Voyer d'Argenson, a basket of "palachine" (senna pods) for a relative of Le Roy, obtained by Chambers from Joseph Banks, the naturalist, and Daniel Carl Solander, the botanist—continued strong during the following years. On 14 May 1773, Chambers dispatched four copies of his *Plans, Elevations, Sections, and Perspective Views of the Gardens and Buildings at Kew* (1763), together with eighteen more copies of his *Dissertation* and no less than one hundred copies of the *Discours servant d'explication, par Tan Chet-Qua De Quang-Cheou-Fou* (1773), translated for Chambers by a Monsieur de la Rochette of Pimlico, London.[325] Chambers added a further two copies of the *Dissertation* printed in sepia, one for Le Roy, the other for Voyer d'Argenson. "Your reply to Tan Chetqua," Le Roy wrote on 15 July, "which I read with great eagerness, seemed to me quite ingenious. The portrait you draw of this extraordinary man is very agreeable, and I found parts in his discourse that were quite poetic and the comparisons sublime."[326] The translation he thought adequate, "though some expressions are not quite correct."[327] Le Roy requested further copies of the book on Kew and also Chambers's *A Treatise on Civil Architecture* (1759). These were not forthcoming.

Six months later, on 8 February 1774, Chambers sent in his reckoning of their account (together with some arch comment on the stair that de Wailly had built for Voyer d'Argenson at the Château des Ormes, near Tours, in place of a project to Chambers's design).[328] Le Roy, Chambers calculated, was 1,399 livres in his debt, including the 225 livres Chambers's had spent on purchases for Voyer d'Argenson. Chambers visited Paris in spring 1774[329] and no doubt stayed with Le Roy, as he had intended when planning a visit earlier. But the debt remained outstanding. Not until 20 July 1775 did Le Roy write to describe his difficulty in settling it. He offered to send (by Major once again) two fine drawings that Chambers had admired in Paris, as payment in part. "I am not too well off," he explained, "I receive small recompense from the king for my post, I am paid three years late, and I have found no other way to convert the extraordinary expenses that I am obliged to incur than to exchange whatever I can for money for anything not absolutely indispensable."[330] Le Roy also promised an account of the building of the Pont de Neuilly over the Seine by Jean-Rodolphe Perronet and an *éloge* of his own on Jacques-François Blondel. Only on 25 December 1775 was Le Roy able to settle the matter, sending Domenico Fontana's *Della trasportatione dell'obelisco vaticano* (1590), Carlo Fontana's *Il tempio vaticano e sua origine* (1694) and his *Utilissimo trattato dell'acque correnti* (1696), Cornelis Meijer's *L'arte di rendere i fiume navigabili* (1696), Jean Barbault's *Recueil de divers monumens anciens* (1770; a supplement to Barbault's *Les plus beaux monumens de Rome ancienne* of 1761), two books of engravings, *Le grand cabinet des tableaux de l'archiduc Léopold Guillaume... dessinés par David Teniers, dit le vieux* (1755) and the *Iconographie; ou, Vies des hommes illustres du XVIII^e siecle... avec les portraits peints par le fameux Antoine van Dyck* (1759), and a history in five volumes, René Aubert de Vertot's *Histoire des chevaliers hospitaliers de S. Jean de Jerusalem, appellez... aujourd'hui les chevaliers de Malthe* (1726). These books are still in the academy's library.[331] In addition, Le Roy sent four copies of the *Ruines*, to be sold. He allowed 178 livres in his billing for the two drawings, now dispatched. The *éloge* to Blondel was yet incomplete, though he had presented it the year before at the Académie royale d'architecture. No more of their correspondence survives, though Le Roy and Chambers evidently wrote to each other in later years.

Le Roy was a friend of Barthélemy, Buffon, and Franklin, and one might expect him to have frequented the first salon of Marie de Vichy-Chamrond, Madame du Deffand, the focus of their social activity and attended also by Jean-Baptiste Le Roy. But the only record of Le Roy's social activity in Paris is provided, once again, through English sources—the diaries of Samuel Johnson and Hester Lynch Thrale, who visited Paris together in October 1775. Baretti was there too, as Italian tutor to Mrs. Thrale's daughter. Le Roy dined with them a few nights after their arrival—"I fancy upon nearer acquaintance we shall find him very agreeable,"[332] Mrs. Thrale recorded on 4 October. He saw them again and again and dined with them often. But their entrée into Paris society was through Madame Du Boccage, whom they also

entertained frequently. Le Roy seems to have taken them on 11 October to see Etienne-Louis Boullée's Hôtels de Monville, on the rue d'Anjou-Saint-Honoré, described by Dr. Johnson as "furnished with effeminate and minute elegance" and by Mrs. Thrale as "contrived merely for the purposes of disgusting lewdness."[333] On 14 October, Le Roy took them to de Wailly's Hôtel de Voyer d'Argenson — "almost wainscotted with looking glasses, and covered with gold," Dr. Johnson noted; "all gold and glass," Mrs. Thrale wrote. They sneered at the books in the marquise's "boudoir or pouting room,"[334] which was promptly closed. Le Roy also introduced them to his brother Pierre, with whom they got on extremely well, talking of clocks and longitudes; "a good old Mechanick," Mrs. Thrale judged. When they left Paris on 1 November, Mrs. Thrale recorded, "The people who have pleased me best were I think all foreigners, except old Monsr. Le Roy the mechanist and his brother who has travelled into Greece, Asia, etc. and is a pleasing man enough and vastly friendly with his brother of whose machines he seems very proud and confident."[335]

Le Roy himself built nothing. He dedicated his later life to the Académie royale d'architecture and to his teaching there, and also to a final, odd and unexpected obsession with movement, with ships and their sails. Trained by members of the academy, sent to Italy under its auspices, and elected to the second class of that institution immediately upon the appearance of the *Ruines,* Le Roy remained an active member from 27 November 1758, when he first took his seat, to the academy's dissolution in 1793 — though he was not present at the last meeting on 5 August.[336] The academy, one might note, had continued to meet, seemingly unruffled by the events of the Revolution. The Bastille was stormed on 14 July 1789; the academy convened on 13 July to read Vitruvius and on 20 July to grant an extension to the Grand Prix candidates. Le Roy himself presented his designs for a *maison de plaisance* (country house) for the Russian minister of the admiralty on 22 July 1793 — nine days after the assassination of Jean-Paul Marat, five days after Charlotte Corday was guillotined on the place de la Révolution.

Le Roy was involved throughout with the everyday business of the Académie royale d'architecture. He reported, usually with others, on a wide range of manuscripts, *mémoires,* and publications submitted for approval, similarly on designs and inventions.[337] Not surprisingly he presented his own works to the academy and read chapters from them at meetings.[338] He acted as a liaison for foreign correspondents, notably Jardin and Chambers, whose elections he arranged on 29 March 1762.[339] He visited the sick members, and when they died gave the *éloge.*[340] Le Roy was a leading spokesman in the opposition to Marigny's arbitrary appointment of de Wailly to the first class of the academy in 1767; he was one of the four members chosen to present a petition to the king. Friedrich Melchior, Freiherr von Grimm, writing in his *Correspondance littéraire* on 15 July 1768, judged that it was on this account that the dramatist Michel-Jean Sedaine was chosen in that year to succeed the mathematician Charles-Étienne-Louis Camus as permanent secretary to the

academy, though Le Roy was the obvious choice. Le Roy was much disappointed. Grimm thought that Marigny might appease him with an appointment as "architect-in-charge of some royal building,"[341] but Le Roy's only application for such a position, for contrôleur of the Château de Saint-Germain-en-Laye, made on his behalf by his brother Jean-Baptiste in May 1766, had already been rejected by Marigny, who cited Le Roy's lack of practical experience.[342] Le Roy was to be promoted to the first class of the academy only in 1776, after Marigny's fall.

Inevitably, Le Roy devoted a great deal of time to the assessment of student drawings, particularly after November 1762, when he was appointed adjunct to the new professor, Jacques-François Blondel, and even more so once he succeeded Blondel in January 1774 (without an adjunct until Bellicard was appointed in 1781, to be succeeded by Mathurin Cherpitel in 1786). Not much is known about Le Roy's teaching activities. The minutes of the academy reveal that he taught on Mondays and Wednesdays from eleven to one o'clock, that his instruction included history, focusing on celebrated buildings, that he surveyed the treatises on the orders, dealing with proportions especially as well as other matters relating to theory and practice. He evidently composed a *cours d'architecture* for publication, a chapter of which, on planning and methods of lighting in antiquity, he read to the academy on 16 May 1791. No trace of this work survives. No more than twenty-two of the students he instructed in design have been identified; most are little known today, though they did include Pierre-Jules Delespine, Léon Dufourny, Durand, and Charles Percier.[343] Only two weeks after the sealing of the academies, the painter Jacques-Louis David, chief instrument of their closure but a friend to both Sedaine, the permanent secretary, and Le Roy, agreed that Le Roy might organize classes at his own quarters in the Louvre; thus the École d'architecture was formed, to sustain the academic tradition, with ateliers run by Le Roy and Antoine-Laurent-Thomas Vaudoyer, abetted by Louis-Pierre Baltard, Dufourny, Pierre-François-Léonard Fontaine, and Percier.[344] With the reorganization of the academies as the Institut national des sciences et arts in 1795, Le Roy's school was given official status as the École spéciale d'architecture, and money allocated for its operation. The Prix de Rome was reinstituted in 1797. But after Le Roy's death in 1803, the school lagged, though it was moved from the Louvre into the seat of the Institut national, the remodeled Collège des Quatre-Nations, and though it was taken over by Dufourny and Baltard in turn, and staunchly supported throughout by Vaudoyer. Nonetheless, it would serve as the basis for the École des beaux-arts, formed in 1816.

When he was appointed adjunct in 1762, Le Roy was nominated also as historiographer of the Académie royale d'architecture, in response to a proposal he had made earlier in the year that the papers read to the academy be published together with a historical introduction, along the lines of the *Histoire de l'Académie royale des sciences, avec les Mémoires de mathématique et de physique,* published from 1702 onward. This was a project to which Le Roy

Pl. I. Mem. Acad. des B. L. Tome XXXVIII. Pag. 596.

Fig. 1.

Fig. 2.

Fig. 3.

Fig. 4.

Fig. 5.

Fig. 6.

Cne Haussard Sculp.

Fig. 33. Catherine Haussard
The evolution from a log raft to an oared vessel
From Julien-David Le Roy, "Premier mémoire sur la marine anciens,"
Histoire de l'Académie royale des inscriptions et belles-lettres . . . 38 (1777):
Mémoires, after p. 596, pl. I

returned again and again, and it was invariably approved, though to no effect, for money was lacking. The furthest he got was a summary history, written with Sedaine, which was read to the members on 7 January 1772 to commemorate the centenary of the founding of the academy. In recording the changing enthusiasms of the academicians, he noted the twist that had occurred at the academy with the advent of Marigny and his circle: "it turned its attention to the kinds of buildings erected by the Goths, inferior in many respects to those of fine Greek architecture. It saw that they had perhaps been held in too much contempt with the revival of the arts, and it applied itself to understanding all the wonder and lightness of their construction." He also noted the expansion of interest in archaeology: "The journeys made to *Palmyra*, to *Baalbek*, those to *Greece, Paestum*, and *Dalmatia*, also became worthy of its notice."[345]

Le Roy was elected to the Academie royale des inscriptions et belles-lettres in 1770, and it was there, ten days after his election, on 23 February, that he presented the first of a series of papers that were to define the enthusiasms of his later years, "Mémoire sur la marine des anciens."[346] He read on four more occasions on this subject in the same year, analyzing the ancient vessels of the Phoenicians, the Egyptians, and the Greeks. These lectures were put together in three essays and published, together with four comparative plates showing an evolution from log rafts to oared vessels (fig. 33) to quinqueremes, in the *Mémoires* of the Academie royale des inscriptions et belles-lettres in 1777. In the same year he published a new essay exploring the lessons to be learned from antiquity for the design of modern ships, *La marine des anciens peuples, expliquée et considérée par rapport aux lumieres qu'on en peut tirer pour perfectionner la marine moderne*. He referred still to Homer's account of the construction of Odysseus's raft. By the mid-1780s, this interest in ships had become an obsession. He had experimented with the use of lateen sails on a bark at Rouen in August 1782 and in Paris in September of that year, and he was eager to publicize the results. He thought his newly rigged ships far easier to handle and more maneuverable than those in use. He was also experimenting with balloons to be hoisted by ships in distress. There followed a spate of *mémoires* and *lettres*—the latter part of an exchange with Franklin on the subject—looking back to precedents in maritime design as much as forward to the design of the ships of the future. Several of these papers were presented at the Académie royale des inscriptions et belles-lettres. By the middle of 1785 he had another boat on trial, the *Calypso*, no less—"mon yacht, mon petit vaisseau long" (my yacht, my little long vessel)[347]—though it was not, in fact, his. He was still looking at local precedents, but he had begun to range further afield, looking also at Indian dhows and Chinese junks—he referred to the thirteenth-century humanist Gian Francesco Poggio Bracciolini's *Historiae de varietate fortunae*[348] as published in 1723 for the former; he consulted Chambers on the latter in 1784 and 1785. Le Roy's aim was to design a boat of shallow draft with swiftly deployed lateen sails that might be used to navigate the channel ports and sail up the Seine to Paris. Paris, he thought, might thus become a major port, in particular, a major grain port. He was elected

to the Society of Antiquarians in London in March 1784. He joined the Académie royale de marine de Brest, in 1786. The next year he built, at Rouen, his first boat, the *Naupotame,* which he tried out on the channel and on which he sailed up the Seine to Paris, carrying a load of lead, dropping anchor, opposite the Louvre, on 16 October 1787.

"Seated at the base of his mast," Bon-Joseph Dacier recalled in Le Roy's obituary, "the new Argonaut, with his crew of only four men, tacked for several hours between the Pont-Neuf and the Pont-Royal, in the midst of a crowd of spectators attracted by the novelty of the spectacle; made tacks; let out and took in its sails several times, in order to convince even the most incredulous people of the safety and ease with which the *Naupotame* (that is the name he had given his vessel) could execute these different maneuvers."[349] The boat was thirty-six feet long at the water line, eight feet wide, and drew no more than three feet, fully loaded. It could carry 30 to 40 metric tons. It had been paid for by a group of subscribers, ranging from Louis XVI himself to an Englishman identified only as "K.," and including, among others, the archbishop of Sens, Paul d'Albert de Luynes; the governor of Provence, François-Henri, duc d'Harcourt; the directeur-général des bâtiments du roi, Charles-Claude Flahaut, comte d'Angiviller; and the structural engineer Jean-Rodolphe Perronet. Le Roy was in a state of high excitement. He projected a much larger boat, of 120 metric tons, the *Diligent,* which might sail to Boston and Martinique, to Pondicherry, and even to China. Le Roy opened a subscription of forty thousand livres. His enterprise was brought to a halt by the French Revolution. It would be satisfying to suggest that his designs foreshadowed those of the clipper ships of the nineteenth century, but this was not so. He was certainly working counter to the merchant ships on which he had sailed in his youth—the French merchant fleet that sailed from Marseille and Toulon to the Levant was all square-rigged, and only the largest of the vessels had a lateen sail or two[350]—but his inspiration was the caïques on which he had sailed along the coast of the Peloponnese, whose rigs were a survival from the merchantmen of ancient times.

After the Revolution, Le Roy served on the Société du point-central des arts et metiers, later the Commune des arts, which called successfully for the abolition of the Académie royale de peinture et de sculpture. He presented designs for a stupendous Théâtre des patriotes (earlier envisaged as a Théâtre du peuple), and he approved a project in June 1797 for the redesign of the supports of the dome of Sainte-Geneviève, by then renamed the Panthéon. He was made a member of the Institut national when it was formed in 1795. He pursued his plans to make Paris a major port, sitting on commissions reviewing proposals for linking the capital with the north via a system of canals—like his ships, part of an enterprise dating from the years preceding the Revolution—but nothing much came of this. Nor were the essays he published, taking up themes of the past such as the length of the stadia of Greece and the siting and buildings of Lake Moeris, of any vital interest. His teaching was his real contribution to knowledge in these years.[351] When he died on

Fig. 34. Antoine-Denis Chaudet
Bust of Julien-David Le Roy, 1803, terra-cotta
Paris, Musée du Louvre

29 January 1803, his students commemorated him in a medallion commissioned from Benjamin Duvivier.[352] A bust of Le Roy by Antoine-Denis Chaudet (fig. 34), a prolific sculptor of portrait busts that combine neoclassical austerity of format with vigor of characterization, was installed in the Salle du Laocoon of Napoléon Bonaparte's new Musée des antiques in the Louvre.

Matter and Movement

Maupertuis opened his *Système de la nature* (1751) with a crude summary of the contemporary understanding of the cosmos: "Some philosophers have believed that, with *matter* and *motion,* they could explain all nature."[353] But there was more to it, he stressed, than that. He referred, of course, to both Descartes's and Newton's cosmologies. Descartes maintained that matter existed within a plenum of particles stirred by the Sun's rotation into vortices that caused the rotation, in turn, of the planets and Earth. Newton believed that matter operated in a void and was moved by the forces of gravity, though he had no explanation for how gravity might work. He thought God responsible for that. There was indeed more to these constructs than this: the one based on a priori philosophical grounds, the other a system to be tested by observation and experiment. But whether one takes Descartes's *Discours de la méthode pour bien conduire sa raison, et chercher la verite dans les sciences* (1637) or Newton's *Philosophiae Naturalis Principia Mathematica* (1687) as the point of no return in an essential understanding and imaginative grasp of the cosmos, there can be no doubt that elements of belief that had sustained the societies of the West for centuries receded from consciousness in the late seventeenth century. Newton constructed both a new heaven and a new Earth.

Nonetheless, Cartesianism continued to color eighteenth-century French thinking, and more indelibly than might be expected.[354] No French editions of Descartes's *Meditationes de prima philosophia* (1641) were published between 1724 and 1824, but Fontenelle provided a bastion for Cartesian thinking at the Académie royale des sciences, of which he remained director until his death, at almost a hundred, in 1757. He delivered an *éloge* on Newton in 1728, but he used the occasion to uphold, yet again, Cartesian vortices against Newtonian attraction.[355] In the same year, Maupertuis traveled to England, meeting the disciples of Newton, becoming a member of the Royal Society of London, and returning a staunch supporter of the Newtonian system. He presented the paper "Sur les loix de l'attraction" at the Académie royale des sciences in 1732, but Fontenelle remained unmoved. To him Newton's beliefs smacked of alchemy.

The popular reception of Newton's ideas in France was to be ensured by Voltaire, who was stimulated by the enthusiasm of Maupertuis as well as by his own alliance with the philosopher and mathematician Gabrielle-Émilie Le Tonnelier de Breteuil, marquise du Châtelet. One of Voltaire's *Lettres philosophiques* (1734) opened up the subject with a study of Newtonian attraction—soon to become a cult word in France. In *Eléments de la philosophie de*

Newton (1738), he explained the remaining Newtonian concepts lucidly for the first time, to be readily grasped by all. Madame du Châtelet's translation of the *Principia Mathematica,* on which she worked continually between 1745 and her death in 1749, was to appear only in 1759. But by then the mechanist concept of the cosmos—the notion that everything in nature, whether organic or inorganic, could be explained in terms of the laws of matter and motion—was being seriously eroded, overlaid by a more dynamic concept of the world as a complex system, changeful, with a history of its own. The latter philosophy had as its inspiration Locke's belief that the observations made through our senses are the basis of all human knowledge. His disciple Condillac was the favorite of the *encyclopédistes.*

Maupertuis remained to the end a mechanist, and Buffon, when he began his *Histoire naturelle* in 1749, was intent too to explain nature with the precision and exactitude of a mathematician, though he found soon enough that the complexity and variety of the realm of nature could not be encompassed in mathematical terms—or even in descriptive terms; the project was still incomplete when Buffon died in 1788. Still, no one of the philosophical systems for ordering the universe reigned supreme in eighteenth-century France. Newtonianism was superseded by sensationalism for a time, but at the end of the century it was revealed intact, once again, in the *Traité de mécanique céleste* (1798–1827) by the mathematician Pierre-Simon, marquis de Laplace.

The Newtonian charting of the heavens served as a spur to the mapping of Earth.[356] The great undertaking in France was the creation of a reliable map of the realm. The astronomer and geodesist César-François Cassini de Thury was in charge of the triangulation of France as early as 1739, though the systematic survey began only in 1744, and the first section of the comprehensive topographical map of the country was issued only in 1750, not to be completed for another thirty-nine years.[357] There was much activity also on the part of the key ministries, whether for purposes of war or of trade, though they were disinclined to cooperate. The charting of France and its immediate neighbors by the Ministère de la guerre had begun early, with Vauban's appointment in 1655 as engineer to the king. Strategic sites and positions were charted piecemeal, and the maps deposited in the Dépôt des cartes et plans, also known as the Dépôt de la guerre.[358] The work continued into the following century, though after Louis XIV's death in 1715 there was little activity, excepting the ambitious survey of the Pyrénées by Roussel, chief engineer to the king in the ministry's mapping office from 1716 to 1719, and François de La Blottière, a maréchal de camp. Their survey was largely complete in 1719, but their eight charts were not finished before 1730 and their mapping was inexact, not being based on triangulation. In 1738 the ministre de la guerre, Marc Pierre, comte d'Argenson, would complain bitterly that no suitable maps of strategic areas in Flanders, Germany, Italy, or even Canada and Brazil, where mapping had been undertaken, were available at Fontainebleau for discussions with the king. Six years later, he attempted to unite at Versailles all the maps of the Dépôt des cartes et plans and the Dépôt des

fortifications, but soon enough the maps were again divided between Versailles and Paris. Mapmaking, moreover, declined between the end of the War of the Austrian Succession in 1748 and the start of the Seven Years' War in 1756. Only in 1761 were all the maps of the Ministère de la guerre gathered together in new quarters at Versailles.

The mapping enterprise of the Ministère de la marine ran parallel to that of the Ministère de la guerre. In the early 1700s, Jérôme Phélypeaux, comte de Pontchartrain, secrétaire d'État de la Marine from 1699 to 1715, promoted the mapping of parts of the coasts of France and also of French possessions in America.[359] A Dépôt des cartes et plans et journaux was set up in 1720, but not until 1750, when its direction was taken over by Roland-Michel Barrin, marquis de La Galissonière, a serving officer with the rank of rear admiral who had spent two and a half years as an interim governor of Canada, was any initiative taken by the head of the Dépôt des cartes. La Galissonière organized expeditions to Nova Scotia, to the Iberian peninsula, and to the Cape of Good Hope; and the Dépôt des cartes began, for the first time, to publish maritime charts. The plates of the *Neptune françois* (1693) were acquired, and a revised edition was issued in 1753. Joseph-Nicolas Delisle (or de l'Isle) was attached as astronomer, and his large collection of maps purchased. In 1756 the Dépôt des cartes promoted the publication of the *Hydrographie française*, a major advance on previous sea charts, incorporating the information that had been collected and collated from naval surveys and ships logs for over three decades.[360] For though there had been little enough initiative on the part of the early directors of the Dépôt des cartes, Maurepas, who served as secrétaire d'État de la Marine from 1723 to 1749, had been greatly interested in charting the coasts and the seas of the world on France's behalf.[361]

Maurepas's was a position of great power. Not only was he one of the four ministers of state, but as secrétaire d'État de la Maison du roi from 1715 to 1749 he was responsible also for the civil order of Paris, for the ecclesiastics, the police, the academies, the theaters, and so forth. He was thought by Jean-François Marmontel to be frivolous, like Caylus, but Maurepas had an extremely sharp mind and was able to understand issues with clarity and to act with determination.[362] He visited the ports of France in 1727 (none too willingly). He reformed the methods of shipbuilding and attached astronomers and cartographers to his ministry. He sent Peyssonnel and La Condamine to explore the coasts of the Mediterranean in furtherance of knowledge, Sévin and the Fourmonts to scour the Levant for antiquities and inscriptions. Henri-Louis Duhamel du Monceau, the botanist, and Buffon inspected timbers for shipbuilding on his behalf. There were many more. He had a sharp eye for new endeavors. Alerted by the work Luigi Ferdinando Marsili had done in the Golfe du Lion, off Marseille, and published in Marsili's *Histoire physique de la mer* (1725), Maurepas considered contour mapping the coasts of the Mediterranean in 1730. He also grasped at once the supreme importance of resolving the problem of determining the degrees of latitude. He promoted the expedition to the equator in Peru in 1735, and when it was realized that this

would not in itself resolve the issue of the shape of Earth, he straightaway sponsored a second expedition, which went to Lapland in 1736 — the meeting between Maurepas and Maupertuis to decide on this was arranged by Caylus. In 1781, in his *éloge* for Maurepas, the great Enlightenment reformer Jean-Antoine-Nicolas de Caritat, marquis de Condorcet, judged that Maurepas "knew how to make his ministry brilliant even in the midst of peace, by having the navy serve the progress of the sciences themselves, and the sciences the progress of the navy. Charged with the administration of the academies, he mustered all the authority necessary for the execution of his plans."[363] Condorcet noted as well that Maurepas had closed the gaming houses of Paris and had broken the coffee monopoly of the Compagnie des Indes, greatly reducing the price of coffee and making it a popular drink for the first time. In addition Maurepas stopped the company's trade in slaves and discontinued the use of galleys in the eastern Mediterranean.[364] All this activity was curtailed abruptly in 1749, when Maurepas was dismissed by the king, the outcome, it is sometimes said, of a witticism directed against Madame de Pompadour.[365] Exiled to his estate at Pontchartrain, Maurepas settled down to learn English.

The sécrétariat d'État des Affaires étrangères was less active than the war office or the navy in charting the world.[366] Only in 1772 did the head of the Dépôt des archives des affaires étrangères, Claude-Gérard Sémonin, persuade the minister in charge, Emmanuel-Armand de Richelieu, duc d'Aiguillon, to send Charles-Emile Gaulard de Saudray to Holland, Germany, and England to purchase a proper number of maps; he had assembled twenty-three hundred by 1774. In 1772 also, the ministry was offered what was then the greatest collection of maps in France: the well-nigh ten thousand maps massed by the cartographer Jean-Baptiste Bourguignon d'Anville.[367] Only in 1780 were the terms of the acquisition settled, and only after d'Anville's death in 1782 was the collection moved to the ministry's Dépôt des archives at Versailles, where it was carefully cataloged by Jean-Denis Barbié du Bocage, the one devoted pupil of this hard, self-centered, and ungenerous man.

D'Anville had been interested in geography from his early youth. By the age of twenty-two, he was geographer to the king, though, unlike his predecessors, such as Jean-Dominique Cassini and Guillaume Delisle, he was not trained as an astronomer. He was made a member of the Académie royale des inscriptions et belles-lettres in 1754, but only in 1773 was he admitted to the Académie royale des sciences. In preparing new maps, he minutely compared and analyzed existing ones; he read travelers' accounts and corresponded with diplomats, merchants, missionaries, and adventurers of all sorts, carefully assessing their information and adjusting accordingly. He slowly straightened out the terrible distortions that had resulted from Ptolemy's miscalculation of the longitude of the Mediterranean. "Almost all the ancient geographers," Dacier declared when d'Anville died in 1782, "had traveled and very often spoke of what they had seen. Monsieur d'Anville, in contrast, knew the world without having seen it; he never left Paris, so to speak, and had never traveled

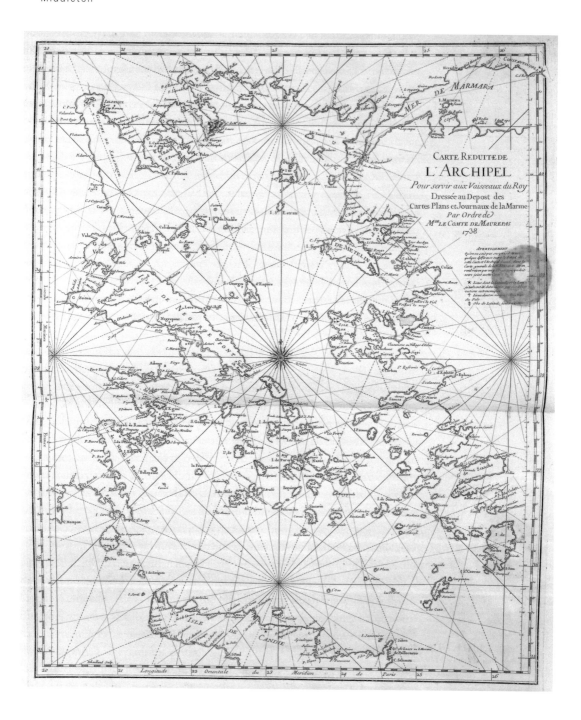

Fig. 35. Guillaume Dheulland
Carte reduite de l'archipel, pour servir aux vaisseaux du roy, dressée au Depost des cartes, plans et journaux de la marine, par ordre de Mgr. le comte de Maurepas, 1738
From Jacques Nicolas Bellin, *Recueil des cartes hydrographiques qui ont eté dressées au Depost des cartes et plans de la marine pour le service des vaisseaux du roy* ([Paris: Bellin, 1752]), after p. 6

more than forty leagues from it."[368] D'Anville nonetheless drew hundreds of maps judged more useful and accurate than those of his predecessors—Africa (1727), China (1735), Italy (1743), North America (1746), South America (1748), Africa revised (1749), North America revised (1750), Asia (1751), a general map of the world in two hemispheres (1761), and so on. He also published written commentaries on his maps. In 1740 he began to supply small-scale maps, ten in all, for the new editions of Rollin's *Histoire ancienne*. Thus when Le Roy went to Greece in 1754, there were available not only a map of the ancient world but also two new maps of its contemporary state—one issued by Jacques Nicolas Bellin[369] and F. Grognard (or Grongnard) in 1738 (fig. 35), the other issued by Grognard alone in 1745; both maps were sponsored by Maurepas and, fittingly, dedicated to him. D'Anville's map of Greece was issued only in 1756, after Le Roy's return, and his *Analyse de la carte intitulée "Les côtes de la Grèce et l'archipel"* followed in 1757. Nonetheless, it was to d'Anville's works that Le Roy was to refer in his later books, and d'Anville himself was to refer to Le Roy's calculation of the Greek foot in his *Traité des mesures itinéraires anciennes et modernes* of 1769 (the length of the frieze of the Parthenon cited then as 94 feet 10 inches).[370]

There were other surveyors and mapmakers of import in eighteenth-century France—among them Alexis-Hubert Jaillot, geographer to the king as of 1675; Jacques Cassini and his son César-François Cassini de Thury, who together accomplished the triangulation of France; Guillaume Delisle (or de l'Isle), made geographer to the king in 1718, and his son-in-law and successor, Philippe Buache; Pierre Moullart-Sanson, grandson of Nicolas Sanson d'Abbeville, the seventeenth-century founder of the French school of cartography; and, a bit later, Joseph Roux. Together with their lesser known contemporaries, these men contributed significant new knowledge to the charts of the lands and seas of Earth. They succeeded, moreover, in wresting the map trade from the Dutch, producing exquisitely embellished works based on scientific mapping from exact ground observation. Eighteenth-century French mapmakers not only imposed, in effect, a new order on the face of Earth but also opened up the world to travel and exploration as never before. One could move now with knowledge, positioned to chart ever more knowledge ever more accurately.

Though some of the practical advances that intersected with the activities of Le Roy, and also of his brothers, have been invoked here as results of the Cartesian and Newtonian triumph in giving new order to the world, they might equally be seen as fundamental to Locke's inducement to grasp the world through direct experience and personal contact with the objects about us. The succession of sensations thus aroused would, according to Locke, become the basis of knowledge and new trains of thought. Hence the sudden vogue for travel and movement in the eighteenth century. Hence the delight even in fantastical travel—whether in Fénelon's *Les aventures de Télémaque* (provided with maps in editions from 1717 on; fig. 36) or in another illusory but very different exploration of the realms of the antique Mediterranean,[371]

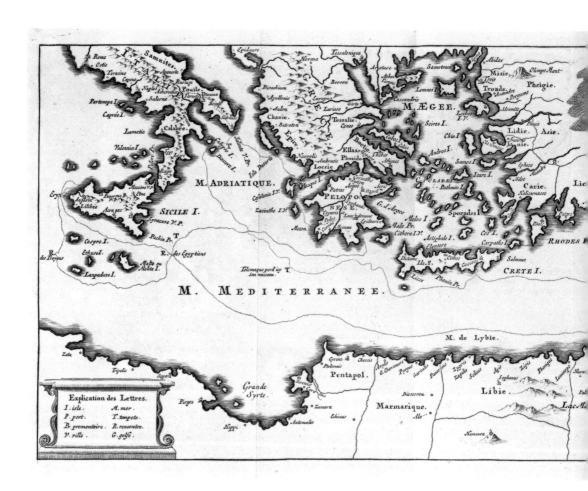

Fig. 36. Broen, after Rousset
Carte des voyages des Telemaque selon Monsr. Fenelon
From François de Salignac de la Mothe-Fénelon, *Les avantures de Telemaque, fils d'Ulysse*, new ed. (Amsterdam: J. Wetstein & G. Smith, & Zacharie Chatelain [etc.], 1734), after p. xxvi

Barthélemy's *Voyage du jeune Anacharsis en Grèce, dans le milieu du qua-trième siècle avant l'ère vulgaire* (to be given maps by d'Anville's only real pupil, Barbié du Bocage, with the plain of Sparta based on a map from Le Roy), issued in 1788. Read by Barthélemy's young charge, Marie-Gabriel-Auguste-Florent, comte de Choiseul-Gouffier, in its earliest drafts, it incited him to embark at Toulon in March 1776 for a three-year exploration of the Levant, resulting in the *Voyage pittoresque de la Grèce,* published between 1782 and 1824.[372] Choiseul-Gouffier's work represents the next stage of French exploration of the antique world — historical and anthropological rather than archaeological — but its connection to Le Roy's *Ruines* is at once evident. Both books explored realms of the mind that were slowly trans-formed into physical facts.

Maupertuis's crude summary of the philosophies of Descartes and Newton in terms of matter and movement might serve, almost, as a précis of Le Roy's theoretical achievement: he understood architecture as the unfolding of form through movement, he opened up awareness of the relation of form and space (*le vuide,* which makes him more a Newtonian than a Cartesian, though there can be little doubt that Locke was his true mentor). Though Le Roy was fas-cinated by figures and calculations, returning even in his last years to the conundrum of the Greek foot, he avoided as far as possible the application of mathematics in assessing the effects or the distinction of architecture. Measurements were no part of its quality. Even symmetry ceased to be an axiom for Le Roy. Claude Perrault clung to the orthogonal — or Cartesian — coordinate system of a fourfold displacement moving around a point (*axis mundi*) to produce perfect symmetries. But Perrault's absolutes of beauty did not hold sway over Le Roy. He might well have preferred symmetry, but he accepted that it, along with striking contrast, was no more than a composi-tional mode.

Paradoxically, the more rigid aspects of Le Roy's interests were those most conspicuously commemorated in the works of his most active follower, Jean-Nicolas-Louis Durand. Durand took up the idea of comparative plates for the most famous of his books, *Recueil et parallèle des édifices.* He included in it, as had Le Roy, buildings of all styles, whether Chinese or Gothic. He also included Le Roy's reconstruction of the Temple of Solomon, which he com-pared to that of the architect and cleric Juan Bautista Villalpando, but he recorded his debt to Le Roy even more obviously in the frontispiece to the *Recueil et parallèle des édifices* showing the restoration study of the Propylaia from the *Ruines* (see vol. 1, pl. 26). Durand liked best four-square symmetry — though, to be fair, he quoted Le Roy at length on the subject of Gothic archi-tecture and in intoning the effects of colonnades, whether made up of columns or trunks of trees, in the first volume, of 1813, of his *Nouveau précis des leçons d'architecture données à l'École imperiale polytechnique.*[373] Le Roy's lessons might indeed have been transmitted to future generations more effec-tively through Durand's quotation than through Le Roy's own publications —

the *Histoire*, though small, was not readily available; the *Ruines* of 1770, large and unwieldy, was not easily read.

Le Roy's restored Propylaia was a potent image. It inflected the forms of hundreds of designs, whether in France or the rest of Europe, for public buildings in the grand classical manner; it provided the underpinnings for a great many edifices that were actually built, beginning with the Cour du Mai of the Palais de Justice in Paris, largely designed around 1780 by Pierre Desmaisons, and encompassing others in England (Robert II Smirke's British Museum, London, 1823–47), Scotland (Thomas Hamilton's Royal High School on Carlton Hill, Edinburgh, 1825–29), and elsewhere. But Le Roy's real contribution to architecture was his attempt to describe it in terms of direct experience, to give it expression not as the outcome of measures and rules—both Laugier and Le Roy sought to establish principles, it might be remembered, not rules—but as a magical harmony seen in ever-changing light and in ever-changing vistas. In the published discourse on architecture of the eighteenth century, there is perhaps something of this in the *Elements of Criticism* (1762) of Henry Home, Lord Kames, or in the famous footnote on movement added by Robert Adam to the preface to the first folio, of 1773, of the first volume of *The Works in Architecture of Robert and James Adam,* but nothing as rewarding and deeply revealing as Le Roy's explorations. The pared-down forms of the late architecture of Boullée and Ledoux, it might be argued, were indebted to Le Roy. Boullée's thinking was certainly colored by Le Roy's writings: the rapturous analysis of *basiliques* or the *Métropole* in Boullée's *Architecture, essai sur l'art* (circa 1780–99; published posthumously) can be quoted almost at random to illustrate his debt to Le Roy. The whole is indeed a paraphrase of much of the *Histoire.* One excerpt must suffice here:

> By extending the sweep of an avenue so that its end is out of sight, the laws of optics and the effects of perspective give an impression of immensity; at each step, the objects appear in a new guise and our pleasure is renewed by a succession of different vistas. Finally, by some miracle which in fact is the result of our own movement but which we attribute to the objects around us, the latter seem to move with us, as if we had imparted Life to them.[374]

Others in France responded to other aspects of Le Roy's theories, particularly toward the end of the century, when historical investigations were being thoughtfully intermingled with myth. The so-called Baron d'Hancarville's inquiries into the origin and nature of art itself in the final two volumes, of 1776, of *Antiquités etrusques, grecques et romaines tirées dy cabinet de M. Hamilton,* and especially his theory of signs, owe much to Le Roy's discussion of the emergence of the architectural impulse in the mounds of stone of the Phoenicians and Egyptians.[375] So too does Jean-Louis Viel de Saint-Maux's attempt, in the sixth of his *Lettres sur l'architecture des anciens, et celle des modernes* (1787), to trace the origins of architecture to commemorative piles or other such assemblages of stone, though he was to scoff at Le Roy for not

going far enough in this respect.[376] Dufourny, as Le Roy's pupil and successor as professor of architecture, took up his ideas throughout his own lectures, but more determining by far was the influence exerted by Le Roy's analysis of the separate origins of Egyptian and Greek architecture on the young Antoine-Chrysostôme Quatremère de Quincy. The essay topic for the Prix Caylus of the Académie royale des inscriptions et belles-lettres of 1785 — no doubt set by Le Roy — was "Quel fut l'état de l'architecture chez les Egyptiens, et ce que les Grecs paroissent en avoir emprunté" (What was the state of architecture among the Egyptians, and what might the Greeks appear to have borrowed from them). Quatremère de Quincy's prize-winning essay, reworked as *De l'architecture égyptienne, considérée dans son origine, ses principes et son goût, et comparée sous les mêmes rapports à l'architecture grecque* (1803), established not only his whole understanding of the formation and distinction of Greek architecture but also that of most Frenchmen for decades to come.[377] Even so lively and radical a thinker as Hippolyte Fortoul unashamedly adhered to Le Roy's special pleading on the evolution of Egyptian and Greek architecture in his famous chapter, "De l'architecture curviligne," in the second volume, of 1842, of *De l'art en Allemagne.*[378]

Le Roy's *Histoire* was translated and published, together with a newly engraved comparative plate, in Leipzig in 1768, along with Laugier's *Observations sur l'architecture,* so the most illuminating of Le Roy's ideas were known in Germany. In England these same ideas were noted in the early 1770s by Chambers. "Variety in peristyles," he jotted down when preparing a set of lectures on architecture meant to rival the lectures on art Reynolds was delivering at the newly founded Royal Academy of Arts, "because the form changes as the spectator removes his Situation or as the sun encreases or diminishes the shadow."[379] The lectures were never delivered, but much of their content was to be integrated into Chambers's *Treatise on the Decorative Part of Civil Architecture* (1791), in which, however, no reference is made to Le Roy.

When Chambers's pupil John Soane began preparing his lectures for the Royal Academy of Arts, he started his translations from the French with Le Roy's *Ruines* of 1770, carefully rendering both the historical and theoretical discourses, entire, into English between 23 November and 3 December 1804.[380] He was clearly much intrigued by Le Roy's investigations. He had two copies of each edition of the *Ruines.* In the same year he was making his translations from Le Roy, Soane designed a colonnade of "mutilated trunks of ancient columns" leading from his house, Pitzhanger Manor, to the outbuildings in which he hoped to educate his sons to architecture. In his notes of 1807 for the Royal Academy lectures, he adapted Le Roy's ideas in dealing with the experience of Egyptian hypostyle halls: "the varied play of shadow in the different hours of the day: — these bodies at rest seem to move about the spectator as he advances in the enclosures, in proportion as he advances because the points of view change each moment — different emotions succeed and bring into his mind that trouble and uneasiness, whereof the priests knew

how to profit and make their fables and oracles believed."[381] Among the illustrations Soane had prepared for his lectures were a view of a man walking down an avenue of trees and, also in 1811, a comparative array of religious buildings. But when it came to lecturing, the only direct reference he made to Le Roy was in the eleventh lecture, first delivered in March 1815, in which he criticized Le Roy's work for its inaccuracies.

Le Roy's theories emerged from a culture in which science and art were still intermingled. Enmeshed right to the last, as we have seen, in calculations of the measures of antiquity, Le Roy invoked Homer throughout, and not just for information. His brother Pierre did likewise in the last of his works, a letter of 1785 addressed to Etienne-Claude, baron de Marivetz, a scientist—and one as obsessed as Le Roy with the problems of navigating the internal waterways of France.[382] In debating whether the Sun's rays could cause the planets to move, whether light was to be thought of as moving in great spirals or in straight lines, whether light rays were continuous or composed of separate particles, Pierre referred readily to Virgil and Tasso.[383]

Similarly, Le Roy took up the traditions of antique art and contemporary scientific experimentation in attempting to fashion a new understanding of architecture. Little in this new understanding was to be fixed, beyond the matter of structural stability. This tenet was to be the determining factor of built form, but it was to be not so much expressed as represented—a difference that is of significance. Architecture was to be a striking assemblage of forms in space, modulated and changing under the influence of light, color, and, especially, movement, designed to stir endless sensations. Le Roy sought to identify the je ne sais quoi of architecture. He did not succeed in defining the ineffable, of course, but for an architect who was raised to esteem the rules of the classical tradition and who was one of the first Europeans to inspect for himself the hallowed precincts of that architecture, his freedom from convention was astonishing. He opened up architecture to a new discourse of experience, a lesson that survived in the architectural memory through to the twentieth century. "Architecture," Le Corbusier declared famously in *Vers une architecture* (1923), "is the masterly, correct and magnificent play of masses brought together in light."[384] To which characterization he added in this same year, in designing the Maison La Roche in Paris, the concept of the "promenade architecturale." It would be pleasing to think that these notions had a direct link to Le Roy through the oral tradition of the French atelier. There is no record of Le Corbusier having studied either Le Roy's *Histoire* or the second edition of the *Ruines*—or even Durand's *Nouveau précis*—during his stint of reading at the Bibliothèque nationale de France in 1915. He did take notes on Kurt Cassirer's pioneering dissertation of 1909 on French architectural theory, but there is no mention therein of Le Roy. Nonetheless Le Corbusier was deeply responsive to the themes of Le Roy's teachings. He saw his Unité d'habitation in Marseille (1946–52)—a massive concrete apartment block—as set in the landscape of Homer.[385]

Notes

1. K–n–k, Review of *The Antiquities of Athens,* vol. 1, by James Stuart and Nicholas Revett, *Monthly Review; or, Literary Journal* (London), April 1763, 306–7.

2. The history of the publication of the *Ruines* and the *Antiquities* is contained in Dora Wiebenson, *Sources of Greek Revival Architecture* (London: A. Zwemmer, 1969); that of the *Antiquities* alone is described at greater length in the entry on Stuart and Revett in Eileen Harris and Nicholas Savage, *British Architectural Books and Writers, 1556–1785* (Cambridge: Cambridge Univ. Press, 1990), 439–50. The latter is reprinted in Robin Middleton et al., *British Books, Seventeenth through Nineteenth Centuries,* vol. 2 of *The Mark J. Millard Architectural Collection* (Washington, D.C.: National Gallery of Art, 1998), 302–11 (cat. no. 81).

3. Quoted in full in Wiebenson, *Sources of Greek Revival Architecture* (note 2), 76–82; from Henry Ellis, ed., *Original Letters of Eminent Literary Men of the Sixteenth, Seventeenth, and Eighteenth Centuries,* Camden Society Publications, no. 23 (London: printed for the Camden Society, by J. B. Nichols, 1843), 379–89 (letter 163; British Library, Add. MS 6210, fol. 96); see also 389–93 (letter 164, Thomas Hollis to John Ward, Genoa, 25 December 1752; British Library, Add. MS 6210, fol. 101), with further reference to Stuart and "Rivett" (p. 393).

4. Charlemont's expedition has been several times described, with varying emphases, first in Maurice James Craig, *The Volunteer Earl, Being the Life and Times of James Caulfeild, First Earl of Charlemont* (London: Cresset, 1948), 57–75; next in W. B. Stanford, "The Manuscripts of Lord Charlemont's Eastern Travels," *Proceedings of the Royal Irish Academy* 80, no. 5 (1980): 69–90; followed by W. B. Stanford and E. J. Finopoulos, eds., *The Travels of Lord Charlemont in Greece and Turkey, 1749* (London: Trigraph for the A. G. Leventis Foundation, 1984); and most recently in Cynthia O'Connor, *The Pleasing Hours: James Caulfeild, First Earl of Charlemont, 1728–99: Traveller, Connoisseur, and Patron of the Arts in Ireland* (Wilton, Cork, Ireland: Collins, 1999), 3–92.

5. On Wood and Dawkins's expedition to the Levant, see the entries on Robert Wood, with further references, in Middleton et al., *British Books* (note 2), 344–51 (cat. nos. 92, 93).

6. Raymond Chevallier, "La découverte des antiquités de Pola par les voyageurs du XIIe au XIXe siècle," in *Studi in memoria di Giuseppe Bovini* (Ravenna: Mario Lapucci, Edizione di Girasole, 1989), 147–59.

7. On Julien-David Le Roy, see Antoine Mongez, "Éloge de Le Roy prononcé à l'institut le 9 Pluviôse an XI," *Journal de Paris,* 12 Pluviôse an XI [1 February 1803], 834–35; Bon-Joseph Dacier, "Notice historique sur la vie et les ouvrages de M. Julien-David Leroy" (read 23 March 1804), *Histoire et mémoires de l'Institut royal de France, Classe d'histoire et de littérature ancienne* 1 (1815): 267–84; Joseph-Marie Quérard, *La France littéraire; ou, Dictionnaire bibliographique . . .* (Paris: Didot frères, 1827–39), 5:215–16; and Joseph Fr. Michaud, gen. ed., *Biographie universelle ancienne et moderne,* 2d ed. (Paris: L. Vivès, [1880]), 24:260–61.

Within the past twenty years, Chantal Grell has published an article on the buildings inspected by Le Roy in Greece and Fréderic Pousin no fewer than three articles and a book relating to Le Roy's representation of Greek architecture, but these are based on

no more than cursory research. Barry Bergdoll has set Le Roy neatly within the context of late-eighteenth-century architectural history in his *Léon Vaudoyer: Historicism in the Age of Industry* (New York: Architectural History Foundation, 1994) and again in his *European Architecture, 1750–1890* (Oxford: Oxford Univ. Press, 2000), but the only serious study of Le Roy to have been undertaken to date is that by C. Drew Armstrong, who has been working toward a doctoral dissertation under my supervision at Columbia University. The first results of his investigations have been presented in his "De la théorie des proportions à l'expérience des sensations: L' 'Essai sur la théorie de l'architecture' de Julien-David Le Roy, 1770" (paper presented at the symposium "Etienne-Louis Boullée (1728–1799): L'architecture régenerée par les lumières: La poésie et l'utopie de l'art," Centre Ledoux, Université de Paris I, 3 December 1999) and in his "Projets inédits pour une école de navigation à Malmaison, en l'an VIII," *Bulletin— Société des amis de Malmaison*, no. 34 (2000): 108–25. I should note that at the time of writing this introduction, I had no other access to his research; I thus look forward with high expectations to the forthcoming chapters of his dissertation, certain in the knowledge that his study will illuminate Le Roy and his works as never before.

8. Jean-Marie Pérouse de Montclos, *"Les Prix de Rome": Concours de l'Académie royale d'architecture au XVIIIᵉ siècle* (Paris: Berger-Levrault/École Nationale Supérieure des Beaux-Arts, 1984), 51.

9. Le Roy's activities in Rome are recorded in *Correspondance des directeurs de l'Académie de France à Rome avec les surintendants des bâtiments*, vol. 10, *1742–1753*, ed. Jules Guiffrey (Paris: Charavay frères, 1900); vol. 11, *1754–1763*, ed. Jules Guiffrey (Paris: Noël Charavay, 1901); vol. 18, *Table générale*, ed. Paul Cornu (Paris: Jean Schemit, 1912).

10. Janine Barrier, "Chambers in France and Italy," in John Harris and Michael Snodin, eds., *Sir William Chambers, Architect to George III*, exh. cat. (New Haven: Yale Univ. Press, 1997), 19–33.

11. Cesare De Seta, ed., *Luigi Vanvitelli* (Naples: Electa Napoli, 1988), 255–56, 257 (cat. no. 190); see also Julien-David Le Roy, *Histoire de la disposition et des formes différentes que les chrétiens ont données à leurs temples depuis le règne de Constantin le Grand, jusqu'à nous* (Paris: Desaint & Saillant, 1764), 28.

12. Clérisseau seems to have been involved with Jansenist politics, but there is no evidence that Le Roy was thus concerned; see Charles H. O'Brien, "New Light on the Mouton-Natoire Case (1768): Freedom of Conscience and the Role of the Jansenists," *A Journal of Church and State* 27, no. 1 (1985): 65–82, an article kindly brought to my attention by Richard Wittman.

13. Though Dalton's publication has been noted in studies on Charlemont (see, for example, the four works cited in note 4) and in Harris and Savage, *British Architectural Books* (note 2), 173–75, the exact composition of his successive sets of plates is not yet properly established. I have followed the dating on the plates in the complete copy of Dalton's work in Sir John Soane's Museum, London, where Dalton's drawings of Egypt are also to be found. Other drawings by Dalton are in the British Museum.

14. Cited in John Fleming, *Robert Adam and His Circle, in Edinburgh and Rome* (London: John Murray, 1962), 223.

15. *Correspondance des directeurs* (note 9), 11:15–16 (no. 5007):

Je crois que ce pensionnaire aura fai des prograis dans son talent. J'aurois seulement souhaitté qu'il eût été un peut plus liant avec moy, plus de confiance et moin d'humeur; depuis l'affaire de *Clérisseau*, je ne l'ay veu que rarement, malgré qu'à Paris il avoit été mon élèves et que j'ay toujour considéré sa famille comme de très honnettes gens. J'en vois de ses Msrs. plusieur qui, dès qu'ils ont été quelque tems à Rome, [de]viennent ridicule dans leurs façon de pencer, à force d'aitre orgueilleux.

16. *Correspondance des directeurs* (note 9), 11:23 (no. 5018): "Je ne suis pas fâché, que ce pensionnaire ne soit plus à l'Académie; son humeur haute et son caracterre peut docile donnoit un movais exemple parmy ses confrères. Sans luy, l'affaires des Pasques n'oroit pas été sy vive."

17. Julien-David Le Roy, *Les ruines des plus beaux monuments de la Grece, considérées du côté de l'histoire et du côté de l'architecture,* 2d ed. (Paris: Imprimerie de Louis-François Delatour, 1770), 1:3: "isle aride et déserte, peu digne du séjour qu'y saisoit, selon les Poetes, la Déesse de la beauté."

18. Le Roy, *Les ruines,* 1770 (note 17), 1:5: "Constantinople a l'air de la Capitale du Monde"; "Je ne parle pas de tous les diamants, de tous les rubis, de toutes les perles du trône, et des tapis filés d'or et soie qui couvrent le pavé de cette salle et celui de ses vestibules."

19. C. Drew Armstrong kindly informed me of the consul's first name; see Anne Mézin, *Les consuls de France au siècle des lumières (1715–1792)* (Paris: Ministère des Affaires Étrangères, Direction des Archives et de la Documentation, 1998).

20. *Correspondance des directeurs* (note 9), 11:503 (no. 5115 bis): "tout remply de ce nouveau vernis [il] a fait voir quelques études de ce pays comme par grâce particulière."

21. *Correspondance des directeurs* (note 9), 11:118 (no. 5138, 14 January 1756).

22. While visiting Paris in 1764, Thomas Major would study and copy one of Le Roy's drawings of the temples at Paestum for his own publication, *The Ruins of Paestum, Otherwise Posidonia, in Magna Graecia* (London: T. Major, 1768), though this was not used. On Major's publication, see Robin Middleton et al., *British Books* (note 2), 151–61 (cat. no. 41). Major's copy of Le Roy's plan of the Temple of Athena at Paestum is in Sir John Soane's Museum, London (drawer 60, set 1).

23. There has been no recent full-scale study of note on Caylus. The basic references are as follows: Jean-Jacques Barthélemy, *Voyage en Italie de M. l'abbé Barthélémy . . . imprimé sur ses lettres originales écrites au comte de Caylus, avec un appendice, où se trouvent des morceaux inédits de Winckelmann, Jacquier, Zarillo* (Paris: F. Buisson, an X [1801]; 2d ed., with a notice by Madame de Choiseul, Paris: F. Buisson, an X [1802]), which was translated as *Travels in Italy by the Late Abbé Barthelemy . . . in a Series of Letters Written to the Celebrated Count Caylus; with an Appendix, Containing Several Pieces Never Before Published by the Abbé Winkelman, Father Jacquier, the Abbé Zarillo, and Other Learned Men* (London: printed for G. & J. Robinson, by S. Hamilton, 1802); Charles Nisard, ed., *Correspondance inédite du comte de Caylus avec le P. Paciaudi, théatin (1757–1765), suivie de celles de l'abbé Barthélemy et de P. Mariette avec le même,* 2 vols. (Paris: Imprimerie Nationale, 1877); Charles Henry, ed., *Mémoires inédits de Charles-Nicolas Cochin sur le comte de Caylus, Bouchardon, les Slodtz* (Paris: Baur, 1880); Samuel Rocheblave, *Essai sur le comte de Caylus: L'homme,*

l'artiste, l'antiquaire (Paris: Libraire Hachette, 1889); Anne-Claude-Philippe de Tubières, comte de Caylus, *Vies d'artistes du XVIIIe, Discours sur la peinture et la sculpture, Salons de 1751 et de 1753, Lettre à Lagrenée,* ed. André-Jean-Charles Fontaine (Paris: Libraire Renouard, 1910), which has a good introduction and an excellent bibliography; A. N. Zadoks-Josephus Jitta, "De comte de Caylus als archeoloog," *Tijdschrift voor geschiedenis* 61 (1948): 290–97; Jean Seznec, "Le singe antiquaire," in idem, *Essais sur Diderot et l'antiquité* (Oxford: Clarendon, 1957), 79–96; Jacques Guillerme, "Caylus 'technologue': Note sur les commencements problématiques d'une discipline," *Revue de l'art* 60 (1983): 47–50; Krzysztof Pomian, "Maffei and Caylus," in idem, *Collectors and Curiosities: Paris and Venice, 1500–1800,* trans. Elizabeth Wiles-Portier (Cambridge: Polity, 1990), 169–84; Fabrice Denis, "Le comte de Caylus et l'antiquité" (Diss., Université de Paris-Sorbonne (Paris IV), 1994); Marc Fumaroli, "Le comte de Caylus et l'Académie des inscriptions" (read 3 March 1995), *Comptes rendus des séances—Académie des inscriptions et belles-lettres,* January–March 1995, 225–50; and Luca Giuliani, *Bilder nach Homer: Vom Nutzen und Nachteil der Lektüre für die Malerei* (Freiburg im Breisgau: Rombach, 1998).

24. François Sévin, *Lettres sur Constantinople…,* ed. Simon-Jacques Bourlet de Vauxcelles (Paris: Obré & Buisson, an X [1802]), 98–101 (letter 16, Le Roy to Caylus, 1 October 1754).

25. Sévin, *Lettres sur Constantinople* (note 24), 109 (letter 17, Le Roy to Caylus, 7 April 1755): "Les étrangers qui voyagent ici ont obligation à M.M. Stuard et Rivet. Ils ont découvert à Athènes des trésors cachés sous la terre ou dans d'épaisses murailles, et je ne doute point que leur ouvrage ne soit fort exact et fort beau." Le Roy's description relates directly to that in his *Les ruines des plus beaux monuments de la Grece…* (Paris: H. L. Guérin & L. F. Delatour, 1758), 1:44–48.

26. Barthélemy, *Travels in Italy* (note 23), 52–58 (letter 10, 20 December 1755) = Barthélemy, *Voyage en Italie,* 1801 (note 23), 54–61; and Nisard, ed., *Correspondance inédite du comte de Caylus* (note 23), 2:63–65 (letter 113, 24 December 1764); see also letters 114 (26 December 1764), 118 (10 February 1765), 119 (18 February 1765).

27. Henry, ed., *Mémoires inédits de Charles-Nicolas Cochin* (note 23), 78–79:

M. Le Roy, architecte pensionnaire du roy eut occasion de faire un voyage en Grèce; il y croqua les antiquités qu'il y trouva; mais ses desseins étoient si informes que, quand nous les vîmes à Paris, nous eûmes peine à croire qu'on en pût tirer quelque chose. M. de Caylus, chaud amateur de la Grèce ainsi que de l'Egipte, les fit redessiner par Le Lorrain qui, quoique peintre très-médiocre et manqué malgré les plus belles dispositions, néanmoins dessinoit agréablement et avec goust. Il vint à bout d'en tirer les desseins que l'on a gravés; on peut juger de là du degré de fidélité et combien on peut se rapporter aux details de cet ouvrage.

Il étoit question de faire graver les planches; c'étoit une dépense au-dessus des forces de M. Le Roy, à moins qu'on ne les fit à très grand marché; cependant on vouloit qu'elles fussent bien gravées. On ne pouvoit pas mieux choisir que le fit M. de Caylus en s'adressant à M. Le Bas; mais il fallut encore qu'il usast de toute son eloquence persuasive pour engager Le Bas à les graver pour la moitié moins qu'elles ne valoient, en lui faisant cependant entrevoir quelque dédommagement si le livre

réussissoit. Le livre s'est bien vendu, mais la gratification n'est pas venue. Aussi M. Le Bas, qui sçait très bien compter et qui n'est pas mal attaché à ses intérests s'en est-il toujours plaint.

28. On Le Lorrain, see Pierre Rosenberg, "Louis-Joseph Le Lorrain (1715–1719)," *Revue de l'art* 40–41 (1981): 173–202.

29. Pierre Remy, *Catalogue raisonée des tableaux*, in *Ange-Laurent de La Live de Jully: A Facsimile Reprint of the* Catalogue historique *(1764) and the* Catalogue raisonée des tableaux *(March 5, 1770)* (New York: Acanthus, 1988), lot 149. Cf. Le Roy, *Les ruines*, 1758 (note 25), vol. 1, pl. 10; and Le Roy, *Les ruines*, 1770 (note 17), vol. 2, pl. 6.

30. Charles Le Beau, "Éloge de M. Falconet" (read 1762), *Histoire de l'Académie royale des inscriptions et belles-lettres; avec les Mémoires de littérature tirez des registres de cette académie* 31 (1768): *Histoire*, 354: "Plongé dans cet océan de littéraire, il en connoissoit parfaitement toutes les parties." The title of this journal is hereafter abbreviated in these notes as *HistMemBL*.

31. Barthélemy, *Travels in Italy* (note 23), 47–48 (letter 8, 10 December 1755) = Barthélemy, *Voyage en Italie*, 1801 (note 23), 48–49:

> Je vous fais mon compliment sur l'ouvrage de M. Leroi; je désire comme vous qu'il paroisse; mais je souhaiterois que vous laissassiez passer d'abord celui des Anglais. Ne seroit-il pas possible que plusieurs personnes eussent mieux vu qu'une seule? Ces Anglais ne sont pas ceux de Palmyre: c'est une autre troupe qui a demeuré long-temps à Athènes, et dont l'ouvrage, dit-on, ne tardera pas à paroître: j'en ai entendu dire beaucoup de bien à des gens indifférens. Si par hasard il valoit mieux que celui de M. Leroi, cette nation avantageuse triompheroit. Vous connoissez mieux que moi la force de l'objection, et je la soumets à votre avis.

32. Barthélemy, *Travels in Italy* (note 23), 58 (letter 10, 20 December 1755) = Barthélemy, *Voyage en Italie*, 1801 (note 23), 60: "J'ai vu les premières épreuves des Ruines d'Athènes par les Anglais. Elles m'ont paru très-bien exécutées, et m'ont confirmé dans mon sentiment dont je vous ai fait part."

33. Julien-David Le Roy, Prospectus for *Les ruines des plus beaux monumens de la Grece*... (Paris: H. L. Guérin & L. F. Delatour, [before March 1756]): "On ne les détaillera pas également, parce qu'il semble qu'il n'y a que deux raisons, qui puissent rendre les détails nécessaires; la premiere, qu'ils soient assez beaux pour être imités par les Artistes; la seconde, qu'ils puissent servir à l'histoire de l'Art. Les membres d'Architecture qui auront rapport aux deux objets de curiosité ou d'utilité dont on vient de parler, seront développés fort en grand, les autres ne le seront pas avec la même étendue."

34. For a list of notices and reviews of Le Roy's works, see "Works by Le Roy," this volume, pp. 501–2. I am much indebted to Richard Wittman for providing most of the periodical references.

35. Unsigned summary of the prospectus for *Les ruines des plus beaux monumens de la Grece*, by Julien-David Le Roy, *Mémoires de Trévoux*, April 1756, 1137: "M. le Comte de Caylus et M. Mariette s'intéressent fort à cette entreprise, qu'ils y donnent le coup d'oeil d'amateurs et de connoisseurs: c'en est assez pour accelerer la souscription,

qui d'ailleurs n'a pour objet que de faire rentrer les frais principaux; l'ouvrage devant être un monument de gloire pour la Nation, non une affaire d'intérêt pour l'auteur et pour ceux qui veulent bien le seconder."

36. For complete citations, see this volume, p. 501. Wiebenson, *Sources* (note 2), 103 (no. 63), cites and quotes from a review in the *Journal des sçavans,* but I cannot locate this review in the Paris edition.

37. Unsigned review of *Les ruines des plus beaux monuments de la Grece,* by Julien-David Le Roy, *Mémoires de Trévoux,* October 1758, 2623: "Quelque part qu'on donne aux Egyptiens dans les arts de la Grèce, on n'en doit pas moins reconnoître que l'architecture est proprement Grecque d'origine; c'est-à-dire que, pour les belles formes et pour les proportions exactes, les Grecs l'emportent sur l'Egypte; que les Grecs sont fondateurs en ce genre."

38. Unsigned review of *Les ruines des plus beaux monuments de la Grece,* by Julien-David Le Roy, *L'année littéraire* (Amsterdam), November 1758, 122: "Ainsi vous trouverez dans ce Recueil, Monsieur, non-seulement autant d'interêt et d'exactitude que dans les *Ruines de Palmyre et de Balbec,* dont je vous ai fait l'éloge, mais encore plus de sçavoir, de goût, d'ordre et de clarté. M. *le Roy* aux lumières de son art joint les connoissances des Mathématiques, de l'Histoire, de la Littérature, etc., et son ouvrage peut donner le ton pour la suite à l'entreprise des Anglois."

39. Unsigned review of *Les ruines des plus beaux monuments de la Grece,* by Julien-David Le Roy, *Mercure de France,* November 1758, 192: "La partie historique est traitee avec les lumieres d'un sçavant, et le goût d'un homme de Lettres. La partie de l'art ne laisse rien à désirer, ni du côté de l'Observateur, ni du côté du Dessinateur. Les détails en sont d'une netteté merveilleuse; la gravure d'une beauté digne des desseins. M. le Roi a sauvé pour jamais des outrages du temps les restes mutilés, mais précieux, de cette Grèce, aujourd'hui moitié déserte, et moitié barbare."

40. See entries for 13, 20, and 27 November 1758 in Henry Lemonnier, ed., *Procès-verbaux de l'Académie royale d'architecture,* vol. 6, *1744–1758* (Paris: Édouard Champion, 1920), 334–37.

41. Unsigned review of *Les ruines des plus beaux monuments de la Grece,* by Julien-David Le Roy, *Bibliothek der schönen Wissenschaften und der freyen Künste 5,* no. 1 (1759): 181–85; and unsigned review of *Les ruines des plus beaux monuments de la Grece,* by Julien-David Le Roy, *Nova Acta Eruditorum,* April 1760, 193–211.

42. Johann Joachim Winckelmann, *Briefe,* ed. Walther Rehm and Hans Diepolder (Berlin: Walter De Gruyter, 1952–57), 2:101 (letter 374, Winckelmann to Barthélemy, 13 September 1760).

43. Unsigned review of *Ruins of Athens, with Remains and Other Valuable Antiquities in Greece,* by Julien-David Le Roy, *Critical Review,* July 1759, 81; see also Marcus Whiffen, "An English Le Roy," *Architectural Review,* August 1959, 119–20.

44. "The Modern Traveller," *Royal Magazine; or, Gentleman's Monthly Companion* 2 (1760): 364–67; 3 (1760): 95–96, 187–91, 245–48.

45. David Hume, *The Letters of David Hume,* ed. J. Y. T. Greig (Oxford: Clarendon, 1932), 1:466 n. 2. I am indebted to John Harris for this reference.

46. The first volume of *The Antiquities of Athens* is sometimes thought to have been issued in January 1763, but it seems to have been published rather in December

1762; see Horace Walpole, *Anecdotes of Painting in England (1760–1795); with Some Account of the Principal Artists; and Incidental Notes on Other Arts,* ed. Frederick W. Hilles and Philip B. Daghlian (New Haven: Yale Univ. Press, 1937), 109.

47. James Stuart and Nicholas Revett, *The Antiquities of Athens,* vol. 1 (London: printed by J. Haberkorn, 1762), 52.

48. See entry for 15 November 1762 in Henry Lemonnier, ed., *Procès-verbaux de l'Académie royale d'architecture,* vol. 7, *1759–1767* (Paris: Libraire Armand Colin, 1921), 120.

49. Winckelmann, *Briefe* (note 42), 3:57 (letter 673, Winckelmann to Henry Fuseli, 22 September 1764): "Monstrum horrendum ingens, cui lumen adem tum." Cf. Virgil, *Aeneid* 3.658: "Monstrum horrendum, informe, ingens, cui lumen ademptum," wonderfully rendered in John Dryden's seventeenth-century translation as "A monstrous bulk, deform'd, depriv'd of sight."

50. Julien-David Le Roy, "Reflexions préliminaires," in idem, *Observations sur les édifices des anciens peuples, précédées de Réflexions préliminaires sur la critique des Ruines de la Grèce, publiée dans un ouvrage anglois, intitulé Les antiquités d'Athènes, et suivies de Recherches sur les mesures anciennes* (Amsterdam: n.p., 1767), 11: "c'est de faire passer dans l'ame de ceux qui en verront l'image, toute l'admiration dont il est frappé à leur aspect."

51. Le Roy, "Reflexions préliminaires" (note 50), 14.

52. Le Roy, "Reflexions préliminaires" (note 50), 7–8: "j'ai eu dans mon voyage, des idées bien différentes, et je n'aurois assurément pas été en Grèce, simplement pour observer le rapport des Edifices et de leurs parties, avec les divisions de notre pied…. C'est principalement pour connoître le rapport des monumens des Grecs, entr'eux, avec ceux des Peuples qui les ont précédés ou suivis, dans la connoissance des Arts, avec ceux que décrit Vitruve, que je les ai mesurés."

53. Maurice Daumas, *Scientific Instruments of the Seventeenth and Eighteenth Centuries,* trans. and ed. Mary Holbrook (New York: Praeger, 1972), 260–61. A *toise* is a French lineal measure of 6 French feet, roughly equal to 6 feet 4¾ inches (U.S.) or 1.949 meters.

54. Neither Agrus nor Agronerus, it should be noted, is to be found in *Paulys Realencyclopädie der classischen Altertumswissenschaft;* Le Roy culled his information from the ancient writer Sanchuniathon (ca. 700–500 B.C.?)—or, more precisely, from the fragments of his work on Phoenician history preserved in the first book of Eusebius of Caesarea's *Praeparatio evangelica* (ca. 300–340).

55. It was partly the exploits of Sesostris III, partly those of his two predecessors of the same name (all of the Twelfth Dynasty), and also those of Ramses II (of the Nineteenth Dynasty) that came to figure in the legend of Sesostris that Herodotus recorded in his *History* (2.102–10).

56. Julien-David Le Roy, "Observations sur les édifices des anciens peuples," in idem, *Observations sur les édifices des anciens peuples, précédées de Réflexions préliminaires sur la critique des Ruines de la Grèce, publiée dans un ouvrage anglois, intitulé Les antiquités d'Athènes, et suivies de Recherches sur les mesures anciennes* (Amsterdam: n.p., 1767), 13: "on ne trouve cette irrégularité que dans trois Temples, qui tous paroissent être de la plus haute antiquité."

57. For the biblical description of the Tabernacle, see Exodus 26:1–27:8, 36:8–38, 38:9–21.

58. Well over a century later, after years of intensive activity on the part of archae-ologists and scholars, James George Frazer attempted to resolve the matter in his commentary on Pausanias's work; see James George Frazer, *Commentary on Book I,* vol. 2 of *Pausanias's Description of Greece,* ed. and trans. James George Frazer, 2d ed. (London: Macmillan, 1913). Frazer thought that Pausanias had entered Athens not from the south, as Le Roy as well as Stuart and Revett assumed, but from the north-west, through the Dipylon, Athens's main ceremonial gate; this might have been accepted in general, but there were still strong dissenters (pp. 42–45). Even then, Pausanias's route was extremely difficult to determine; no trace remains of most of the features he describes, many conspicuous features that remain are not mentioned in his description — for example, the Gate of Athena Archegetis, the Tower of the Winds, and the Arch of Hadrian (pp. 186–89). The exact form and purpose of the temple in the bazaar was still not settled, though Frazer thought it a Hadrianic library rather than a gymnasium, as some had proposed (pp. 184–85); Francis Cranmer Penrose had by then resolved the form and identity of the Temple of Zeus Olympios (pp. 178–81).

59. Le Roy, *Ruines,* 1770 (note 17), 1:iii: "de faire voir de la maniere la plus frap-pante, quelle est la différence qu'on observe entre les Edifices élevés par un peuple libre…et ceux qu'il exécuta quand, sous le joug de Romains, il eut perdu une partie de la fierté et du génie qui l'animoit."

60. Le Roy, *Ruines,* 1770 (note 17), 1:v: "ce qui distinguera particuliérement cette Edition de celle qui l'a précédée, c'est le grand nombre de citations dont je l'ai enrichie."

61. Le Roy, *Ruines,* 1770 (note 17), 1:11–12.

62. Vitruvius, *De architectura* 3.2.8. For the ampersand, see Vitruvius, *The Archi-tecture of M. Vitruvius Pollio,* trans. William Newton (London: J. Dodsley, 1771), 49 n. 22; and Vitruvius, *L'architettura di M. Vitruvio Pollione,* trans. Berardo Galiani (Naples: Stamperia Simoniana, 1758), 102 (bk. 3, chap. 1): "Hujus autem exemplar Rome non est, sed Athenis octastylos, & in templo Jovis Olympii."

63. Francis Cranmer Penrose, *An Investigation of the Principles of Athenian Architecture; or, The Results of a Survey Conducted Chiefly with Reference to the Optical Refinements Exhibited in the Construction of the Ancient Buildings at Athens,* new ed. (London: Macmillan, 1888), 74–88, pl. 40.

64. See Francesco Petrarca, *Rerum Familiarium Libri I–VIII,* trans. Aldo S. Bernardo (Albany: State Univ. of New York Press, 1975), 290–95 (*Fam.* VI, 2).

65. For the illustration of the "ruined and deserted temple" from the French edi-tion, published by Jacques Kerver, see *Hypnerotomachia Poliphili; ou, Le songe de Poliphile: Le plus beau livre du monde, Venise 1499/Paris 1546* (Auxerre, France: Bibliothèque Municipale d'Auxerre, 2000), 123. The engravings in the French edition are usually attributed to Jean Cousin. For the illustration in the Italian edition, see Francesco Colonna, *Hypnerotomachia Poliphili: The Strife of Love in a Dream,* trans. Joscelyn Godwin (London: Thames & Hudson, 1999), 238. The latter image is described in *The Dream of Poliphilus: Fac-similes of One Hundred and Sixty-eight Woodcuts in* Hypnerotomachia Poliphili *(Venice, 1499),* ed. J. W. Appell, new ed. (London: W. Griggs, 1893), 10 (no. 86), as "Poliphilus and Polia entering the ruins of

the Temple Polyandrion, in which the unfortunate lovers are buried. This is an ideal view of antique ruins, with lofty arches and columns. On the right hand side an obelisk is rising among luxuriant trees and bushes. A low wall in the foreground seems to belong to some ancient baths."

66. Christian Hülsen and Hermann Egger, eds., *Die römischen Skizzenbücher von Marten van Heemskerck im Königlichen Kupferstichkabinett zu Berlin*, 2 vols. (Berlin: J. Bard, 1913–16; reprint, Soest, Holland: Davaco, 1975).

67. Ruth Olitsky Rubinstein, "'Tempus Edax Rerum': A Newly Discovered Painting by Hermannus Posthumus," *Burlington Magazine*, July 1985, 425–33, figs. 2–10; and Henry A. Millon and Vittorio Magnano Lampugnani, eds., *The Renaissance from Brunelleschi to Michelangelo: The Representation of Architecture* (London: Thames & Hudson, 1994), 262–63, 433–34 (cat. no. 11 by Hubertus Günther).

68. Charles de Brosses, *Lettres d'Italie du président de Brosses,* ed. Frédéric d'Agay, new ed. (Paris: Mercure de France, 1986), 2:200 (letter 46): "Je ne puis vous dire ce qu'était ce temple; mais seulement que cette colonne isolée est la plus belle chose en architecture qui existe dans tout l'univers; qu'elle me donne autant et peut-être plus de satisfaction à la vue qu'aucun édifice complet, quel qu'il soit, ancien ou moderne, en me présentant l'idée du plus haut degré de perfection où l'art soit jamais parvenu."

69. Gilles-Marie Oppenord, *Oeuvres de Gilles Marie Oppenord...contenant différents fragments d'architecture, et d'ornements à l'usage des bâtiments sacrés, publics et particuliers, gravés par Gabriel Huquier* (Paris: Huquier, [1749–51]), pls. XCII, XCIII.

70. Denis Diderot, *Diderot on Art*, vol. 2, *The Salon of 1767*, ed. and trans. John Goodman (New Haven: Yale Univ. Press, 1995), 196–97 (no. 105); for the original, see Denis Diderot, *Salons*, vol. 3, *1767*, ed. Jean Seznec, 2d ed. (Oxford: Clarendon, 1983), 227 (no. 105):

> L'effet de ces compositions, bonnes ou mauvaises, c'est de vous laisser dans une douce mélancolie. Nous attachons nos regards sur les débris d'un arc de triomphe, d'un portique, d'une pyramide, d'un temple, d'un palais, et nous revenons sur nous-mêmes; nous anticipons sur les ravages du temps, et notre imagination disperse sur la terre les édifices mêmes que nous habitons; à l'instant la solitude et le silence règnent autour de nous, nous restons seuls de toute une nation qui n'est plus; et voilà la première ligne de la poétique des ruines.

Cited in Roland Mortier, *La poétique des ruines en France: Ses origines, ses variations, de la Renaissance à Victor Hugo* (Geneva: Librairie Droz, 1974), 93; this last work provided the basis for the summary offered here.

71. French attitudes to the Greek and Roman orders are briskly but most provocatively surveyed in Wolfgang Herrmann, *Laugier and Eighteenth Century French Theory* (London: A. Zwemmer, 1962), 25–27, which provided the basis for the account offered here.

72. On Ciriaco d'Ancona, see Gianfranco Paci and Sergio Sconocchia, eds., *Ciriaco d'Ancona e la cultura antiquaria dell'umanesimo: Atti del convegno internazionale di studio, Ancona, 6–9 febbraio 1992* (Reggio Emilia: Edizioni Diabasis, 1998). The drawing by Giuliano da Sangallo of the west front of the Parthenon is now in the Vatican library (Codex Barberinus Latinus 4424, fol. 28v), and the drawing by

Ciriaco d'Ancona from which Sangello's version was derived is in the Deutsche Staatsbibliothek, Berlin (MS Hamilton 254, fol. 85r); see Luigi Beschi, "I disegni ateniesi di Ciriaco: Analisi di una tradizione," in Gianfranco Paci and Sergio Sconocchia, eds., *Ciriaco d'Ancona e la cultura antiquaria dell'umanismo: Atti del convegno internazionale di studio, Ancona, 6–9 febbraio 1992* (Reggio Emilia: Edizioni Diabasis, 1998), 83–94; and Christian Hülsen, ed., *Il libro di Giuliano da Sangallo: Codice vaticano barberiniano latino 4424,* 2 vols. (Leipzig: O. Harrassowitz, 1910; reprint, Vatican City: Biblioteca Apostolica Vaticano, 1984).

73. Charles-Augustin d'Aviler, *Cours d'architecture qui comprend les ordres de Vignole...,* vol. 1 (Paris: Nicolas Langlois, 1691), "Preface," [fol. 4v]: "Rome...renferme encor ce qu'il y a de plus precieux, et d'où l'on a tiré les meilleurs principes de cet Art, estant difficile de croire que les Grecs qui ont inventé les Ordres les ayent portez à un pareil degré de perfection que les Romains."

74. Roland Fréart, sieur de Chambray, *A Parallel of the Antient Architecture with the Modern; in a Collection of Ten Principal Authors Who Have Written upon the Five Orders...,* trans. John Evelyn (London: printed by Tho. Roycroft, for John Place, 1664), 2.

75. Amédée François Frézier, *Dissertation sur les ordres d'architecture...* (Strasbourg: Jean-Daniel Doulsseker, 1738), 5: "nous devons les plus beaux modèles d'architecture, premièrement aux Grecs, et ensuite aux Romains, qui les ont imité."

76. The most comprehensive survey of travelers to Greek lands between 333 B.C. and A.D. 1821 is Kyriakos Simopoulos, *Xenoi taxidiotes sten Hellada,* 3 vols. in 4 (Athens: n.p., 1970–75), which is full of surprises; but the most useful studies on French exploration of the Levant are Léon, marquis de Laborde, *Athènes aux XVe, XVIe et XVIIe siècles,* 2 vols. (Paris: J. Renouard, 1854); and Henri Omont, *Missions archéologiques françaises en Orient aux XVIIe et XVIIIe siècles,* 2 vols. (Paris: Imprimerie Nationale, 1902). On Athens and the Acropolis in particular, see Léon, marquis de Laborde, *Le Parthénon: Documents pour servir à une restauration,* 2 vols. in 1 (Paris: Leleux, 1848); Henri Omont, *Athènes au XVIIe siècle: Dessins des sculptures du Parthénon, attribués à J. Carrey, et conservés à la Bibliothèque nationale, accompagnés de vues et plans d'Athènes et de l'Acropole* (Paris: E. Leroux, 1898); Albert Vandal, *L'odyssée d'un ambassadeur: Les voyages du marquis de Nointel, 1670–1680* (Paris: Plon-Nourrit, 1900); and Theodore Bowie and Diether Thimme, eds., *The Carrey Drawings of the Parthenon Sculptures* (Bloomington: Indiana Univ. Press, 1971)—this last a remake, as it were, of Omont's study of the Carrey drawings but with good and comprehensive illustrations and an up-to-date bibliography. For early recordings and the transformation of the Parthenon, see Panayotis Tournikiotis, gen. ed., *The Parthenon and Its Impact in Modern Times* (Athens: Melissa, 1994), esp. Manoles Korres, "The Parthenon from Antiquity to the Nineteenth Century," 137–61. For earlier travelers to the Levant, see Jean Ebersolt, *Constantinople byzantine et les voyageurs du Levant* (Paris: E. Leroux, 1918; reprint, London: Pindar, 1986).

77. Omont, *Missions* (note 76), 1:60:

> Il observera et fera des descriptions autant justes qu'il pourra des palais et bastiments principaux, tant antiques que modernes, scituez ez lieux où il passera, et

taschera de tirer et restablir les plans et les profiles de ceux qui sont ruinez; et, s'il ne le peut faire de tous les bastiments entiers, il le fera du moins des principales parties qui seront restées, comme des colonnes, des chapiteaux, des corniches, etc.; et, en ce qui concerne les modernes, en en faisant la description, il marquera les usages principaux de chacune de leurs parties.

78. On de Monceaux (or Desmonceaux) in Baalbek, see Paul Perdrizet, "Les dossiers de P. Mariette sur Ba'albek et Palmyre," *Revue des études anciennes*, 4th ser., 3 (1901): 228–31. For Laisné's sketch, see Omont, *Missions* (note 76), 1:47–49.

79. Antoine Galland, *Le journal d'Antoine Galland pendant son séjour à Constantinople (1672–1673)*, ed. Charles Schefer, 2 vols. in 1 (Paris: E. Leroux, 1881); and Omont, *Missions* (note 76), 1:175–221; see also Claude Gros de Boze, "Éloge de M. Galland" (read 1715), *HistMemBL* 3 (1746): *Histoire*, 325–30. Galland's description of Delos is often cited, but his was not the only seventeenth-century record of the ruins: Jacob Spon provided an account in his *Voyage d'Italie, de Dalmatie, de Grece, et du Levant, fait és années 1675 et 1676*, 3 vols. (Lyon: Antoine Cellier le fils, 1678), as did Olfert Dapper, *Naukeurige beschryving der eilanden, in de archipel der middelantsche zee, en ontrent dezelve, gelegen...* (Amsterdam: Voor Wolfgangh [etc.], 1688), which was translated into French as *Description exacte des isles de l'archipel, et de quelques autres adjacentes; dont les principales sont Chypre, Rhodes, Candie, Samos, Chio, Negrepont, Lemnos, Paros, Delos, Patmos, avec un grand nombre d'autres...* (Amsterdam: George Gallet, 1703). Dapper included a somewhat fantastical plate of the ruins (facing p. 368), but his description is careful. He records the plundering of the ruins in the seventeenth century.

80. Omont, *Missions* (note 76), 1:193: "Et je me persuade qu'elles seront d'autant mieux receues, qu'outre leur justesse, elles sont encore recommandables par leur rareté, qui les rend uniques."

81. On Babin, Spon, Wheler, and Vernon, see David Constantine, *Early Greek Travellers and the Hellenic Ideal* (Cambridge: Cambridge Univ. Press, 1984); and, more recently, on Spon, see Roland Étienne and Jean-Claude Mossière, eds., *Jacob Spon: Un humaniste lyonnais du XVIIème siècle*, exh. cat. (Paris: Diffusion de Boccard, 1993).

82. Francis Vernon, "Mr. Francis Vernon's Letter, Written to the Publisher Januar. 10th, 1676, Giving a Short Account of Some of His Observations in His Travels from Venice through Istria, Dalmatia, Greece, and the Archipelago, to Smyrna, Where This Letter Was Written," *Philosophical Transactions*, no. 124 (1676): 575–82 (quotations from pp. 577–79).

83. Jacob Spon, *Italiänische, dalmatische, griechische und orientalische Reise-Beschreibung*, trans. Jean Menudier (Nuremberg: in verlegung J. Hofmanns, gedruckt bey Andreas Knortzen, 1681); and Jacob Spon, *Viaggi de Mons. Spon per la Dalmazia, Grecia, e Levante*, trans. Casimiro Freschot (Bologna: per G. Monti, 1688).

84. Spon, *Voyage* (note 79), 2:142: "Nous nous hâtames d'aller voir la grande Mosquée, qui étoit autrefois le Temple de Minerve, comme la plus considerable piece de la Citadelle. Sa veuë nous imprima certain respect, et nous demeurâmes long-tems à le considerer, sans lasser nos yeux."

85. Spon, *Voyage* (note 79), 2:143: "L'Ordre est Dorique, et les colonnes sont canelées et sans base."

86. Twelve or more books were published in the seventeenth and early eighteenth centuries on Morosini's occupation of Athens and the Morea, where the Venetians held on, in parts, until 1716. The modern literature on this interlude is extensive, but see, in particular, Kenneth Meyer Setton, *Venice, Austria, and the Turks in the Seventeenth Century* (Philadelphia: American Philosophical Society, 1991); Sergio Perini, "Venezia e la guerra di Morea (1684–1699)," *Archivio veneto*, 5th ser., 153 (1999): 45–91; and Laura Marasso and Anastasia Stouraiti, eds., *Immagini dal mita: La conquista veneziana dell Morea (1684–1699)*, exh. cat. (Venice: Fondazione Scientifica Querini, 2001). The fortified sites and much of the land in the Morea was surveyed at the time, though no map of Sparta seems to have been attempted. Athens was mapped during the short occupation of the town, though none too accurately, providing a base for the later Capuchin plan. A detailed description of the monuments of Athens was drawn up in December 1687, though it was not to be published, nor were the drawings of the metopes of the Parthenon done by the engineer Laurent Gravier d'Ortières, now in the Staatsbibliothek in Munich and reproduced in Massimiliano Pavan, *L'avventura del Partenone, un monumento nella storia* (Florence: Sansoni, 1983). After his disastrous attempt to remove the pediment sculpture of the Parthenon, Morosini more or less gave up on archaeological looting; he took back to Venice three lion sculptures from Athens and the Piraeus, with another from Delos to follow a few years later, two of which survive at the gate of the Arsenal in Venice. On this, see Antonella Sacconi, *L'avventura archeologica di Francesco Morosini ad Atene (1687–1688)* (Rome: Giorgio Betschneider, 1991).

87. Omont, *Missions* (note 76), 1:616–17:

> Depuis plus d'un mois, quoyque malade, je travaille avec 30 ouvriers à l'entière destruction de Sparte; point de jour que je ne trouve quelque chose, il y en a eu qui m'ont produit jusqu'à 20 inscriptions. Si je pouvois faire de Tégée et d'Ἀντιγόνια, de Némée et d'une ou deux autres villes, ce que j'ay fait d'Hermione, de Troezène et de Sparte, il ne faudroit envoyer personne dans ce pays-cy; il n'y auroit plus rien. Je n'ay pu renverser les restes de ces premières, à cause de la peste, sans quoy elles seroient détruites totalement. Ces destructions étoient, faute de livres, le seul moyen de rendre illustre un voyage qui a fait tant de bruit.

88. Sévin, *Lettres sur Constantinople* (note 24).

89. Bernard de Montfaucon, *L'antiquité expliquée et représentée en figures*, vol. 3, *Les usages de la vie* (Paris: Florentin Delaulne [etc.], 1719), pt. 1, pl. 1, figs. 3 and 4.

90. On Marot's engravings, see André Mauban, *Jean Marot, architecte et graveur parisien* (Paris: Éditions d'Art & d'Histoire, 1944), 92.

91. Michael McCarthy, "'The Dullest Man That Ever Travelled'? A Re-assessment of Richard Pococke and of His Portrait by J.-E. Liotard," *Apollo*, May 1996, 25–29.

92. The pages that follow are based largely on the studies of Émile Egger, *L'hellénisme en France: Leçons sur l'influence des études grecques dans le développement de la langue et de la littérature françaises*, 2 vols. (Paris: Didier, 1869); Léon Boulvé, *De l'hellénisme chez Fénelon* (Paris: A. Fontemoing, 1897; reprint, Geneva: Slatkine Reprints, 1970); Albert Chérel, *Fénelon au XVIIIe siècle en France (1715–1820): Son presige, son influence* (Paris: Librairie Hachette, 1917); Maurice Badolle, *L'abbé Jean-*

Jacques Barthélemy (1716–1795) et l'hellénisme en France dans la seconde moitié du XVIIIe siècle (Paris: Presses Universitaires de France, 1926); and Alfred Lombard, *Fénelon et le retour à l'antique au XVIIIe siècle* (Neuchâtel: Secrétariat de Université de Neuchâtel, 1954). Information on Homer derives, in the main, from Noémi Hepp, *Homère en France au XVIIe siècle* (Paris: C. Klincksieck, 1968).

The literature on Fénelon is extensive, but the following have proved most useful: André Robinet, "Gloire et simplicité dans l'utopie Fénolienne," *Revue des sciences philosophiques et théologiques* 61 (1977): 69–82; James P. Gilroy, "Peace and the Pursuit of Happiness in the French Utopian Novel: Fénelon's *Télémaque* and Prévost's *Cleveland*," in Hadyn T. Mason, ed., *Studies on Voltaire and the Eighteenth Century,* vol. 176 (Oxford: Voltaire Foundation at the Taylor Institution, 1979), 169–87; Volker Kapp, *Télémaque de Fénelon: La signification d'une oeuvre littéraire à la fin du siècle classique* (Tübingen: Günter Narr, 1982); Philippe Bonolas, "Fénelon et le luxe dans le *Télémaque*," in Hadyn T. Mason, ed., *Studies on Voltaire and the Eighteenth Century,* vol. 249 (Oxford: Voltaire Foundation at the Taylor Institution, 1987), 81–90; Henk Hillenaar, "Fénelon ancien et moderne," in *Transactions of the Seventh International Congress on the Enlightenment,* Studies on Voltaire and the Eighteenth Century, vols. 263–65 (Oxford: Voltaire Foundation at the Taylor Institution, 1989), 1232–38; and Jean-Michel Racault, *L'utopie narrative en France et en Angleterre, 1675–1761,* Studies on Voltaire and the Eighteenth Century, vol. 280 (Oxford: Voltaire Foundation at the Taylor Institution, 1991), esp. 192–205. The edition of Fénelon's writings I have relied on is François de Salignac de la Mothe-Fénelon, *Oeuvres,* ed. Jacques Le Brun, 2 vols. (Paris: Gallimard, 1983–97).

93. Sylvie Béguin, Jean Guillaume, and Alain Roy, *La galerie d'Ulysse à Fontainebleau* (Paris: Presses Universitaires de France, 1985).

94. Roy C. Knight, *Racine et la Grèce* (Paris: Boivin, [1950]), esp. 178–94.

95. Claude Fleury, "Remarques sur Homère," in Noémi Hepp, *Deux amis d'Homère au XVIIe siècle: Textes inédits de Paul Pellisson et de Claude Fleury* (Paris: Éditions Klincksieck, 1970), 144–45:

on pourroit excuser ce qu'on y trouve d'abord de choquant et le pardonner à sa grande antiquité et à la hardiesse qu'il a eue d'entreprendre le premier, au moins que nous sachions, un ouvrage de cette nature. Comme on ne laisseroit pas d'estimer un bastiment antique qui n'auroit point d'ornemens et dont les pierres mesme seroient brutes pourveu que toutte la masse fust d'une forme reguliere et belle, que la place fust bien menagée et qu'il fust tres propre aux usages pour lesquels il auroit esté destiné. Mais en examinant un peu mieux ces pretendus defauts d'Homere, on trouve que la pluspart sont ou des choses indifferentes ou mesme des perfections.

96. François de Salignac de la Mothe-Fénelon, *Correspondance de Fénelon, archevêque de Cambrai, publiée pour la première fois sur les manuscrits originaux et la plupart inédits,* ed. Augustin Pierre Paul Caron (Paris: Ferra jeune [etc.], 1827–29), 2:291:

Je me sens transporté dans ces beaux lieux et parmi ces ruines précieuses, pour y recueillir, avec les plus curieux monumens, *l'esprit même* de l'antiquité. Je cherche

cet aréopage où saint Paul annonça aux sages du monde le Dieu inconnu. Mais le profane vient après le sacré, et je ne dédaigne par de descendre au Pirée, où Socrate fait le plan de sa république. Je monte au double sommet du Parnasse: je cueille les lauriers de Delphes, et je goûte les délices de Tempé.

97. François de Salignac de la Mothe-Fénelon, *Les aventures de Télémaque,* in idem, *Oeuvres,* ed. Jacques Le Brun (Paris: Gallimard, 1983–97), 2:161: "Mentor, semblable à un habile jardinier, qui retranche dans ses arbres fruitiers le bois inutile, tâchait ainsi de retrancher le faste inutile qui corrompait les moeurs. Il ramenait toutes choses à une noble et frugale simplicité."

98. Fénelon, *Les aventures* (note 97), 2:5: "Télémaque fut surpris de voir, avec une apparence de simplicité rustique, tout ce qui peut charmer les yeux. On n'y voyait ni or, ni argent, ni marbre, ni colonnes, ni tableaux, ni statues: cette grotte était taillée dans le roc, en voûte plein de rocailles et de coquilles; elle était tapissée d'une jeune vigne qui étendait ses branches souples également de tous côtés."

99. François de Salignac de la Mothe-Fénelon, *Fables et opuscules pédagogiques,* in idem, *Oeuvres,* ed. Jacques Le Brun (Paris: Gallimard, 1983–97), 1:253: "En s'avançant le long du fleuve, Sophronime aperçut une maison simple et médiocre, mais d'une architecture agréable, avec de justes proportions. Il n'y trouva ni marbre, ni or, ni argent, ni ivoire, ni meubles de pourpre: tout y était propre, et plein d'agrément et de commodité, sans magnificence" (Proceeding along the river, Sophronimus perceived a house simple and modest but architectually agreeable and properly proportioned. There he found neither marble nor gold nor silver nor ivory nor furnishings of purple: there everything was clean, utterly pleasant and cozy, without magnificence).

100. François de Salignac de la Mothe-Fénelon, *Démonstration de l'existence de Dieu,* in idem, *Oeuvres,* ed. Jacques Le Brun (Paris: Gallimard, 1983–97), 2:517, 522, 532, 575–77, 580, 590.

101. François de Salignac de la Mothe-Fénelon, *Lettres sur divers sujets concernant la religion et la métaphysique,* in idem, *Oeuvres,* ed. Jacques Le Brun (Paris: Gallimard, 1983–97), 2:800 (letter 5). See also François de Salignac de la Mothe-Fénelon, *Réfutation du système du père Malebranche sur la nature et la grâce,* in idem, *Oeuvres,* ed. Jacques Le Brun (Paris: Gallimard, 1983–97), 2:357–58; and Fénelon, *Démonstration* (note 100), 2:575–77.

102. François de Salignac de la Mothe-Fénelon, *Dialogues sur l'éloquence en général, et sur celle de la chaire en particulier,* in idem, *Oeuvres,* ed. Jacques Le Brun (Paris: Gallimard, 1983–97), 1:55: "L'architecture grecque est bien plus simple, elle n'admet que des ornements majestueux et naturels, on n'y voit rien que de grand, de proportionné, de mis en sa place."

103. François de Salignac de la Mothe-Fénelon, *Réflexions sur la grammaire, la rhétorique, la poétique et l'historie [Lettre à l'académie],* in idem, *Oeuvres,* ed. Jacques Le Brun (Paris: Gallimard, 1983–97), 2:1196–97:

> Il est naturel que les Modernes, qui ont beaucoup d'élégance et de tours ingénieux, se flattent de surpasser les Anciens, qui n'ont que la simple nature. Mais je demande la permission de faire ici une espèce d'apologue; les inventeurs de

l'architecture qu'on nomme gothique, et qui est, dit-on, celle des Arabes, crurent sans doute avoir surpassé les architectes grecs. Un édifice grec n'a aucun ornement, qui ne serve qu'à orner l'ouvrage; les pièces nécessaires pour le soutenir, ou pour le mettre à couvert, comme les colonnes, et la corniche, se tournent seulement en grâce par leurs proportions. Tout est simple, tout est mesuré, tout est borné à l'usage. On n'y voit, ni hardiesse, ni caprice, qui impose aux yeux. Les proportions sont si justes, que rien ne paraît fort grand, quoique tout le soit. Tout est borné à contenter la vraie raison: au contraire l'architecte gothique élève sur des piliers très minces une voûte immense, qui monte jusqu'aux nues. On croit que tout va tomber, mais tout dure pendant bien des siècles. Tout est plein de fenêtres, de roses et de pointes. La pierre semble découpée comme du carton. Tout est à jour, tout est en l'air. N'est-il pas naturel que les premiers architectes gothiques se soient flattés d'avoir surpassé par leur vain raffinement la simplicité grecque?

104. Fénelon, *Réflexions* (note 103), 2:1196: "Il a peint avec naïveté, grâce, force, majesté, passion. Que veut-on de plus?"

105. The fullest account of Anne Dacier and the quarrel relating to Homer is in Hepp, *Homère en France* (note 92), but see also Giovanni Saverio Santangelo, *Madame Dacier, una filologa nella "crisi" (1672–1720)* (Rome: Bulzoni, 1984).

106. Claude Gros de Boze, "Éloge de M. Dacier" (read 1723), *HistMemBL* 5 (1729): *Histoire*, 412–20; this *éloge* relates to both André and Anne Dacier.

107. Voltaire, *Essai sur la poésie épique* (1727); cited in Hepp, *Homère en France* (note 92), 660: "Qui n'a lu que Mme. Dacier n'a point lu Homère."

108. Paul Dupont, *Un poète-philosophe au commencement du dixhuitième siècle: Houdar de La Motte (1672–1731)* (Paris: Hachette, 1898); and François Moureau, "Les *Fables nouvelles* (1719) de La Motte, ou comment s'en débarrasser," *Le fablier* 2 (1990): 19–24.

109. François de Salignac de la Mothe-Fénelon, *Correspondance de Fénelon*, vol. 16, *Les dernières années, 1712–1715*, ed. Jean Orcibal, with Jacques Le Brun and Irénée Noye (Geneva: Droz, 1999), Fénelon to La Motte: 224 (no. 1727, 9 September 1713), 284 (no. 1762, 16 January 1714), 290–91 (no. 1765, 26 January 1714), 336–37 (no. 1805, 4 May 1714), 414–15 (no. 1923, 22 November 1714), 429 (no. 1943, n.d.); La Motte to Fénelon: 271 (no. 1753D, 14 December 1713), 299–300 (no. 1769B, 15 February 1714), 328–29 (no. 1793A, 15 April 1714), 428–29 (no. 1942A, 18 December 1714).

110. Claude Gros de Boze, "Éloge de M. Boivin le cadet" (read 1727), *HistMemBL* 7 (1733): *Histoire*, 376–85; Christophe Allard, "Deux Normands, membres de l'Académie des inscriptions au XVIIIe siècle: Louis et Jean Boivin: Deuxième partie, Jean Boivin de Villeneuve (1663–1726)," *Précis analytique des travaux de l'Académie des sciences, belles-lettres et arts de Rouen* 1888–89 (1890): 219–58; and François Martin, *Athenae Normannorum*, ed. V. Bourrienne and Tony Genty (Caen: L. Jouan, Librarie de la Société des Antiquaires de Normandie, 1901–2), 1:517–20. Also of interest is Jean Boivin, "Chronologie de l'Odyssée," *HistMemBL* 2 (1736): *Mémoires*, 361–72.

111. Nicolas Fréret, "Éloge de M. Fourmont l'aisne" (read 1746), *HistMemBL* 18 (1753): *Histoire*, 413–31.

112. Cited in Hepp, *Homère en France* (note 92), 643: "C'est le jardin le plus régulier et le plus symétrisé qu'il y ait jamais eu. M. le Nostre, qui était le premier homme du monde dans son art, n'a jamais observé dans ses jardins une symétrie plus parfaite ni plus admirable que celle qu'Homère a observée dans sa poésie." In the introduction in the first volume of her revised translation, Anne Dacier firmly denied any intent to imitate Fénelon's style; see Homer, *L'Odyssée d'Homère*, trans. Anne Dacier, new ed. (Amsterdam: Wetsteins & Smith, 1731), 1:cxxiii. Of *Télémaque* she wrote (pp. cxxi–cxxii),

Telemaque est un excellent ouvrage en son genre, et c'est un nouvel éloge pour Homere et un grand éloge, d'avoir M. de Cambrai pour imitateur, mais M. de Cambrai lui-même étoit bien éloigné d'avoir une idée si grande de son imitation, et il reconnoissoit la superiorité infinie de son original.

(*Telemachus* is an excellent work of its kind, and it is a new honor to Homer, and a great honor, to have Monsieur de Cambrai as an imitator, but Monsieur de Cambrai himself was far from having such a grand idea of his imitation, and he recognized the infinite superiority of his original.)

113. Françoise Létoublon and Catherine Volpilhac-Auger, eds., *Homère en France après la querelle, 1715–1900: Actes du colloque de Grenoble, 23–25 octobre 1995, Université Stendhal-Grenoble 3* (Paris: Champion, 1999).

114. Hillenaar, "Fenélon" (note 92).

115. The summary of the sublime in France that follows is largely based on the admirable analysis in Théodore A. Litman, *Le sublime en France (1660–1714)* (Paris: A. G. Nizet, 1971).

116. Cited in Litman, *Le sublime* (note 115), 18: "une eau pure et nette, qui n'a point de goût."

117. Cited in Litman, *Le sublime* (note 115), 24: "le génie … il est indépendant du hasard et de la fortune, c'est un don du ciel, où la terre n'a point de part; c'est je ne sais quoi de divin."

118. Cited in Litman, *Le sublime* (note 115), 44: "Mais comme le jugement sans génie est froid et languissant, le génie sans jugement est extravagant et aveugle."

119. Cited in Litman, *Le sublime* (note 115), 49: "Il est le seul qui ait trouvé ce secret de joindre à la pureté du style, toute l'élévation et toute la grandeur dont la poésie héroïque peut être capable."

120. Cited in Litman, *Le sublime* (note 115), 32: "je ne ferai point de difficulté de convenir d'abord qu'Homère a un plan bien plus vaste et de plus nobles manières que Virgile, qu'il a une plus grande étendue de caractère, qu'il a un air plus grand et je ne sais quoi de plus sublime, qu'il peint beaucoup mieux les choses; que ses images mêmes sont plus achevées."

121. Cited in Litman, *Le sublime* (note 115), 75: "Dieu dit: Que la lumière se fasse, et la lumière se fit."

122. Cited in Litman, *Le sublime* (note 115), 72: "Il faut donc savoir que, par sublime, Longin n'entend pas ce que les orateurs appellent le style sublime, mais cet extraordinaire et ce merveilleux qui frappe dans le discours, et qui fait qu'un ouvrage enlève, ravit, transporte. Le style sublime veut toujours de grands mots."

123. Cited in Litman, *Le sublime* (note 115), 122: "l'idée qu'on se forme du sublime est toujours tellement attachée au discours, qu'on a de la peine à le mettre ailleurs. Mais comme il peut y avoir du Grand et du Merveilleux en toutes choses, j'ai cru qu'on pourrait aussi y concevoir du Sublime: ce qui m'a donné lieu d'en imaginer dans les différents états de la vie. Chaque état pouvant être susceptible d'un degré de perfection capable d'inspirer la même admiration en son genre, que le discours dans le sien."

124. Cited in Litman, *Le sublime* (note 115), 124: "C'est une idée de perfection au-dessus de toutes les idées et dans une élévation d'excellence où l'art et la nature ne connaissent rien, parce qu'elle est au-dessus de leur règles."

125. Partly cited in Litman, *Le sublime* (note 115), 151; quoted from Charles de Marguetel de Saint-Denis, seigneur de Saint-Évremond, *Oeuvres en prose*, ed. René Ternois (Paris: Librairie Marcel Didier, 1962–69), 3:59–60: "Il faut aimer la regle pour éviter la confusion; il faut aimer le bon sens qui modere l'ardeur d'une imagination allumée; mais il faut ôter à la regle toute contrainte qui gesne, et bannir une raison scrupuleuse, qui par un trop grand attachement à la justesse, ne laisse rien de libre et de naturel."

126. Cited in Litman, *Le sublime* (note 115), 153; quoted from Saint-Évremond, *Oeuvres* (note 125), 3:380–81:

> Le vaste et l'affreux ont bien un grand rapport, les choses vastes conviennent avec ce qui nous étonne, elles ne conviennent point avec ce qui fait sur nous une impression agreable.... Des jardins vastes ne sçauroient avoir les agréments qui viennent de l'art, ni les graces que peut donner la nature. De vastes forests nous effrayent, la veuë se dissipe et se perd à regarder de vastes campagnes. Les rivieres d'une juste grandeur nous font voir des bords agreables et nous inspirent insensiblement la douceur de leur cours paisible. Les fleuves trop larges, les debordemens, les inondations, nous déplaisent par leur agitation, et nos yeux ne sçauroient souffrir leur vaste étenduë.

127. Cited in Litman, *Le sublime* (note 115), 162: "Je n'aurai pas de peine à faire voir que quelque grand génie qu'il ait reçu de la nature, car c'est peut-être le plus vaste et le plus bel esprit qui ait jamais été, il a néanmoins commis un très grand nombre de fautes, dont les poètes qui l'ont suivi quoiqu'inférieurs en force de génie se sont corrigés dans la suite des temps."

128. Cited in Litman, *Le sublime* (note 115), 168: "Ils /les Anciens/ en ont parlé naturellement, tendrement, passionnément, mais ils n'en ont point parlé avec cet air fin, délicat et spirituel qui se rencontre dans les ouvrages des Voiture, des Sarasin, des Benserade, et de cent autres encore."

129. Cited in Litman, *Le sublime* (note 115), 169: "Cette nature sauvage gâterait tout si on la laissait faire, elle remplirait toutes les allées d'herbes et de ronces, toutes les fontaines et les canaux de roseaux et de limon, aussi les jardiniers ne font-ils autre chose que de la combattre continuellement."

130. On the lure of mountains in general and on Thomas Burnet in particular, see Marjorie Hope Nicolson, *Mountain Gloom and Mountain Glory: The Development of the Aesthetics of the Infinite* (Ithaca: Cornell Univ. Press, 1959); for more on Burnet, see Ernest Lee Tuveson, *Millenium and Utopia: A Study in the Background of the Idea of Progress* (Berkeley: Univ. of California Press, 1949).

131. Joseph Addison, *Remarks on Several Parts of Italy, etc., in the Years 1701, 1702, 1703* (London: J. Tonson, 1705); cited in Gavin Rylands de Beer, *Early Travellers in the Alps* (London: Sidgwick & Jackson, 1930), 74.

132. On eighteenth-century French attitudes to the mountains, see Numa Broc, *Les montagnes vues par les géographes et les naturalistes de langue française au XVIII^e siècle: Contribution à l'histoire de la géographie* (Paris: Bibliothèque Nationale, 1969).

133. See Nicolas Boileau-Despréaux, *Oeuvres complètes*, ed. Françoise Escal, intro. Antoine Adam (Paris: Gallimard, 1966), which reprints the *Traité du sublime* of 1701. For the Corneille reference, see page 340 and the notes on page 1073 of this edition; the editor remarks that it is not, as Boileau recounts, one of the elder Horatius's daughters who asks the question, but a close friend, Julie.

134. On Homer's epithets, see Nicolas Boileau-Despréaux, *Réflexions critiques sur quelques passages du rheteur Longin où, par occasion, on répond à quelques objections de Monsieur P*** contre Homére et contre Pindare*, in idem, *Oeuvres complètes*, ed. Françoise Escal, intro. Antoine Adam (Paris: Gallimard, 1966), 536: "Tous les plus habiles Critiques avoüent que ces épithetes sont admirables dans Homere; et que c'est une des principles richesses de sa Poësie" (All the best critics agree that Homer's epithets are admirable and that they are one of the principal riches of his poetry). For the images, see Boileau, *Réflexions,* 519:

> Que c'est en cela qu'a principalement excellé Homere, dont non seulement toutes les comparaisons, mais tous les discours sont pleins d'images de la nature si vrayes et si variées, qu'estant toûjours le mesme, il est neanmoins toujours different; instruisant sans cesse le Lecteur, et lui faisant observer dans les objets mêmes, qu'il a tous les jours devant les yeux, des choses qu'il ne s'avisoit pas d'y remarquer.
>
> (Homer excelled principally in this: that not only all his comparisons but also all his descriptions were full of images from nature, so true and so varied that though always the same, they were equally always different, ceaselessly instructing the reader and making him recognize in the objects themselves that he had in front of his eyes every day, things that we never expect to see.)

135. Boileau, *Réflexions* (note 134), 538: "Mais on peut dire que ces loüanges forcées qu'il lui donne, sont comme les fleurs, dont il couronne la victime, qu'il va immoler."

136. Cited in Litman, *Le sublime* (note 115), 173: "un jeu de cordes, de poulies et de leviers."

137. Cited in Litman, *Le sublime* (note 115), 179–80: "Au-dessus des images, où les plus nobles, où les plus vives qui puissent représenter les sentiments et les passions, sont encore d'autres images plus spirituelles, placées dans une région où l'esprit humain ne se lance qu'avec peine; ce sont les images de l'ordre général de l'univers, de l'espace, du temps, des esprits, de la divinité; elles sont métaphysiques, et leur nom seul fait entendre le haut rang qu'elles tiennent."

138. Fénelon, *Réflexions* (note 103), 2:1152: "Il tonne, il foudroie. C'est un torrent qui entraîne tout. On ne peut le criticer, parce qu'on est saisi. On pense aux choses qu'il dit, et non à ses paroles."

139. Fénelon, *Réflexions* (note 103), 2:1155: "Le Livre de Job est un poème plein

des figures les plus hardies et les plus majestueuses.... Toute l'Écriture est pleine de poésie dans les endroits même où l'on ne trouve aucune trace de versification."

140. Fénelon, *Réflexions* (note 103), 2:1161: "Je veux un sublime si familier, si doux, et si simple, que chacun soit d'abord tenté de croire qu'il l'aurait trouvé sans peine, quoique peu d'hommes soient capables de le trouver."

141. Roger de Piles, *Cours de peinture par principes* (Paris: Jacques Estienne, 1708), translated as *The Principles of Painting...* (London: printed for J. Osborn, 1743). On de Piles, see Bernard Teyssèdre, *Roger de Piles et les débats sur le coloris au siècle de Louis XIV* (Paris: Bibliothèque des Arts, 1965); and Thomas Puttfarken, *Roger de Piles' Theory of Art* (New Haven: Yale Univ. Press, 1985).

142. De Piles, *Principles* (note 141), 64–75, 59 = de Piles, *Cours* (note 141), 104–21, 95: "L'effet du Tout-ensemble; où par occasion il est parlé de l'Harmonie et de l'Enthousiasme."

143. De Piles, *Principles* (note 141), 70 = de Piles, *Cours* (note 141), 114: "L'Enthousiasme est un transport de l'esprit qui fait penser les choses d'une maniere sublime, suprenante, et vraisemblable."

144. Cited in Litman, *Le sublime* (note 115), 127–28; quoted from René Rapin, *Les oeuvres du P. Rapin qui contiennent Les reflexions sur l'éloquence, la poétique, l'histoire et la philosophie*, rev. ed. (Amsterdam: Estienne Roger, 1709), 2:481: "il y a un Sublime caché qui se découvre au coeur par luy-même, indépendamment des paroles, lors qu'il en dit plus que les termes et les expressions n'en signifient; semblable aux ouvrages de ce Peintre, qui en donnoient plus à entendre qu'ils n'en exprimoient."

145. Jean-Baptiste Dubos, *Reflexions critiques sur la poésie et sur la peinture*, 2 vols. (Paris: Jean Mariette, 1719); the fifth edition was translated as Jean-Baptiste Dubos, *Critical Reflections on Poetry, Painting and Music, with an Inquiry into the Rise and Progress of the Theatrical Entertainments of the Ancients*, trans. Thomas Nugent, 3 vols. (London: printed for J. Nourse, 1748). On Dubos, see Alfred Lombard, *L'abbé Du Bos, un initiateur de la pensée moderne (1640–1742)* (Paris: Hachette, 1913; reprint, Geneva: Slatkine Reprints, 1969).

146. Dubos, *Critical Reflections* (note 145), 2:239–40 = Dubos, *Reflexions critiques* (note 145), 2:308: "Le coeur s'agite de lui même et par un mouvement qui precede toute deliberation, quand l'objet qu'on lui présente est réellement un objet touchant, soit que l'objet ait une existence réelle, soit qu'il soit un objet imité. Le coeur est fait, il est organisé pour cela. Son operation previent donc tous les raisonements, ainsi que l'opération de l'oeil et celle de l'oreille les devancent dans leurs sensations."

147. Dubos, *Critical Reflections* (note 145), 2:238 = Dubos, *Reflexions critiques* (note 145), 2:307: "Raisonne-t'on, pour sçavoir si le ragoût est bon ou s'il est mauvais."

148. Cited in Litman, *Le sublime* (note 115), 197; quoted from Arnaldo Pizzorusso, *La poetica di Fénelon* (Milan: Feltrinelli, 1959), 117: "je dis historiquement quel est mon goût, comme un homme, dans un repas, dit naïvement qu'il aime mieux un ragoût que l'autre."

149. Dubos, *Critical Reflections* (note 145), 2:365 = Dubos, *Reflexions critiques* (note 145), 2:470: "Les beautez qui en font le plus grand merite se sentent mieux

qu'elles ne se connoissent par la regle et par le compas." He noted also that if poets and painters lacked enthusiasm or divine inspiration, "les uns et les autres restent toute leur vie de vils ouvriers, et des manoeuvres, dont il faut payer les journées, mais qui ne meritent pas la consideration et les récompenses que les nations polies doivent aux Artisans illustres" (*Reflexions critiques,* 2:6) ("they must continue all their lives in the low rank of journeymen, who are paid for their daily hire, but are far from deserving the consideration and rewards which polite nations owe to illustrious artists") (*Critical Reflections,* 2:5). For a reference to Addison and Homer, see Dubos, *Reflexions critiques,* 2:528 = Dubos, *Critical Reflections,* 2:409. For the discussion of the great modern discoveries, see Dubos, *Reflexions critiques,* 2:430 = Dubos, *Critical Reflections,* 2:335.

150. Dubos, *Critical Reflections* (note 145), 2:365 = Dubos, *Reflexions critiques* (note 145), 2:471: "Enfin dans les choses qui sont du ressort du sentiment, comme le merite d'un Poeme, l'émotion de tous les hommes qui l'ont lû et qui le lisent, leur veneration pour l'ouvrage, sont ce qu'est une démonstration en Geometrie."

151. Dubos, *Critical Reflections* (note 145), 1:353 = Dubos, *Reflexions critiques* (note 145), 1:625: "Alors l'esprit se livre sans distraction à ce qui le touche. Un curieux d'Architecture n'examine une colonne et il ne s'arreste sur aucune partie d'un Palais qu'après avoir donné le *coup d'oeil* à toute la masse du bâtiment, qu'après avoir bien placé dans son imagination l'idée distincte de ce Palais."

152. Fénelon, *Les aventures* (note 97), 2:55: "je ne sais quoi de pur et de sublime."

153. Charles-Louis de Secondat, baron de Montesquieu, *Pensées et fragments inédits de Montesquieu* (Bordeaux: G. Gounouilhou, 1899–1901), 1:223 (no. 449): "L'ouvrage divin de ce siècle, *Télémaque,* dans lequel Homère semble respirer, est une preuve sans réplique de l'excellence de cet ancien poëte."

154. The basis for this account is Louis-Ferdinand-Alfred Maury, *Les académies d'autrefois,* vol. 2, *L'ancienne Académie des inscriptions et belles-lettres,* 2d ed. (Paris: Didier, 1864). The proceedings of the academy were published from 1729 onward, on the model of those of the Académie royale des sciences, under the title *Histoire de l'Académie royale des inscriptions et belles-lettres; avec les Mémoires de littérature tirez des registres de cette académie* (abbreviated in these notes as *HistMemBL*), issued in consecutively numbered volumes, not necessarily annually. The *Histoire,* which offered a summary of selected proceedings, and the *Mémoires,* which published papers read at the academy, were not always present in the same volume, and when the *Histoire* and *Mémoires* were issued together they were separately paginated. *Éloges* could appear in either section. Volumes 11 (1740), 22 (1755), 33 (1770), and 44 (1780) contain indexes.

155. On the Pontchartrains and the Bignons, see Simone Balayé, *La Bibliothèque nationale, des origines à 1800* (Geneva: Librairie Droz, 1988), esp. chap. 3, based on Françoise Blechet, "Recherches sur l'abbé Bignon (1662–1743), académicien et biblio-thécaire du roi, d'après sa correspondance" (Thèse, École nationale des Chartres, Paris, 1974). See also Françoise Blechet, "L'abbé Jean-Paul Bignon (1662–1743): Une république des lettres et des sciences" (Ph.D. diss., Université de Paris I Panthéon-Sorbonne, Paris, 1999).

156. Jérôme IV Bignon *dit* Bignon de Blanzy, the abbé Bignon's nephew and the

elder brother of Armand-Jérôme Bignon, held the post of librarian to the king from 1741 to 1743.

157. Claude Gros de Boze, "Éloge de M. l'abbé Fraguier" (read 1728), *HistMemBL* 7 (1733): *Histoire*, 394–99; see also, among the papers delivered by Fraguier, "De l'ancienneté de la peinture" (read 1709), *HistMemBL* 1 (1736): *Histoire*, 75–89; "Le caractére de Pindare" (read ca. 1709), *HistMemBL* 2 (1736): *Mémoires*, 33–45; "Discours sur la maniére dont Virgile a imité Homére" (read ca. 1709), *HistMemBL* 2 (1736): *Mémoires*, 141–60; and "Réflexions sur les dieux d'Homère" (read 18 June 1715), *HistMemBL* 3 (1746): *Mémoires*, 1–7. See also Augustin Simon Irailh, *Querelles littéraires; ou, Mémoires pour servir à l'histoire des révolutions de la république des lettres, depuis Homère jusqu'à nos jours* (Paris: Durand, 1761; reprint, Geneva: Slatkine Reprints, 1967), 2:301–2.

158. Nicolas Fréret, "Éloge de M. Burette" (read 1747), *HistMemBL* 21 (1754): *Histoire*, 217–33; and Pierre-Jean Burette, "Premier mémoire pour servir à l'histoire de la danse des anciens" and "Second mémoire pour servir à l'histoire de la danse des anciens," *HistMemBL* 1 (1736): *Mémoires*, 93–116, 117–35. See also Burette's "Examen d'un passage de Platon sur la musique," *HistMemBL* 3 (1746): *Histoire*, 111–22. For Burette's observations on various forms of music in antiquity, see *HistMemBL* 4 (1746): *Mémoires*, 116–31; 5 (1729): *Mémoires*, 133–99; 8 (1733): *Mémoires*, 1–96; 10 (1736): *Mémoires*, 111–310; 13 (1740): *Mémoires*, 173–316; 15 (1743): *Mémoires*, 293–394; 17 (1751): *Mémoires*, 61–126. The catalog of the Bibliothèque nationale notes the publication of a number of Burette's *mémoires* by A. Groppo in Venice: *Disserzione del disco* (1748); *Paragone dell'antica colla moderna musica* (1748); *Memorie per servire all storia degli atleti*, 2d ed. (1759); *Prima e seconda memoria per servire alla istoria del ballo degli antichi*, 3d ed. (1759).

159. Nicolas Fréret, "Éloge de M. l'abbé Gedoyn" (read 1744), *HistMemBL* 18 (1753): *Histoire*, 399–408.

160. Nicolas Gedoyn, "Description de deux tableaux de Polygnote, tirée de Pausanias" (read 13 October 1725), *HistMemBL* 6 (1729): *Mémoires*, 445–58.

161. Nicolas Gedoyn, "L'histoire de Phidias" (read 3 March 1733), *HistMemBL* 9 (1736): *Mémoires*, 189–99.

162. Nicolas Gedoyn, "Si les anciens ont esté plus sçavants que les modernes, et comment on peut apprécier le mérite des uns et des autres" (read 1736), *HistMemBL* 12 (1740): *Histoire*, 80–106.

163. Gedoyn, "Si les anciens" (note 162), 99: "pour les sciences spéculatives, c'est autre chose."

164. Gedoyn, "Si les anciens" (note 162), 83: "A l'égard de sa morale, est-elle comparable à celle du *Télémaque* de l'illustre Archevêque de Cambray, M. de Fenelon? Si cet ouvrage estoit écrit en Grec, et qu'il eût deux mille ans, nous le regarderions comme un chef-d'oeuvre de l'Antiquité."

165. Gedoyn, "Si les anciens" (note 162), 93:

A l'égard des beaux arts, tels que l'Architecture, la Peinture et la Sculpture, il faut convenir que ç'a esté l'endroit foible des Romains. Ils ont eu beau décorer Rome des chefs-d'oeuvres de la Grèce, c'est-à-dire, des plus belles statues et des plus excellens

tableaux qu'il y eût dans le monde, ils n'ont jamais pu approcher de ces grands modéles. Vitruve fut à la vérité profond dans la science des Proportions et de l'Architecture, mais il eut plus de théorie que de pratique. Les Grecs, qui avoient l'esprit vif et délicat, estoient propres pour cela; les Romains ne l'estoient pas.

In the preface to *Pausanias; ou, Voyage historique de la Grèce,* trans. Nicolas Gedoyn (Paris: Nyon, 1731), 1:x, Gedoyn stated, "il est certain que nous tenons des Grecs toutes ces belles connoissances, comme les Romains leur en avoient été redevables eux-mêmes" (it is certain that all that fine knowledge comes to us from the Greeks, since the Romans were themselves indebted to them). Gedoyn's was the first French translation of Pausanias's text.

166. Nicolas Gedoyn, "Des anciens et des modernes," in idem, *Oeuvres diverses* (Paris: Bure, 1745), 104–5: "Je croirois volontiers que pour exceller dans ces arts, il ne suffit pas de se former sur des originaux, il faut saisir le vrai, le naturel; ce n'est pas assez, il faut saisir la nature même." This collection also contains a short account of Gedoyn's life (pp. v–xvii).

167. Fréret succeeded Gros de Boze as permanent secretary in 1742, a position he used somewhat willfully until his death in 1749. See Nicolas Fréret, *Oeuvres complètes,* vol. 1, ed. Jacques-Joseph Champollion-Figeac (Paris: Firmin-Didot, 1825); Renée Simon, *Nicolas Fréret, académicien,* Studies on Voltaire and the Eighteenth Century, vol. 17 (Geneva: Institut & Musée Voltaire, 1961); and Chantal Grell and Catherine Volpilhac-Auger, eds., *Nicolas Fréret, légende et verité: Colloque des 18 et 19 octobre 1991, Clermont-Ferrand* (Oxford: Voltaire Foundation, 1994). Of particular interest for Le Roy were Fréret's two papers, "Essai sur les mesures longues des anciens" (read 1723), *HistMemBL* 24 (1756): *Mémoires,* 432–547; and "Observations sur le rapport des mesures greques et des mesures romaines" (read 1723), *HistMemBL* 24 (1756): *Mémoires,* 548–81. Le Roy's interest in Greek and Roman measures was not stirred and sustained by Fréret alone; the subject was first taken up at the Académie royale des inscriptions et belles-lettres by Louis-François-Joseph de La Barre—stirred in turn by Guillame de Lisle's "Justification des mesures des anciens en matiere de geographie" (read 11 April 1714), *Histoire de l'Académie royale des sciences; avec les Mémoires de mathématique et de physique* (1717): *Mémoires,* 175–85; and also by his "Determination geographique de la situation et de l'étendue des pays traversés par le jeune Cyrus, dans son expédition contre son frere Artazerxes, et par les dix mille Grecs dans leur retraite" (read 23 April 1721), *Histoire de l'Académie royale des sciences; avec les Mémoires de mathématique et de physique* (1723): *Mémoires,* 56–68. La Barre's "Essai sur les mesures géographiques des anciens" was published in *HistMemBL* 19 (1753): *Mémoires,* 512–76; interest was sustained by Louis Jouard de la Nauze, "Remarques sur quelques points de l'ancienne géographie" (read 31 January 1755, 16 August 1757), *HistMemBL* 28 (1761): *Mémoires,* 362–96; followed by Joseph-Balthasar Gibert, "Observations sur les mesures anciennes" (read 20 August 1756), *HistMemBL* 28 (1761): *Mémoires,* 212–24; and yet another paper by Louis Jouard de la Nauze, "Sur la mesure du stade employé par Hérodote" (read 1 August 1769), *HistMemBL* 36 (1774): *Histoire,* 86–99.

168. Charles Le Beau, "Éloge de M. l'abbé Sallier" (read 1761), *HistMemBL* 31

(1768): *Histoire*, 307–14. See also Claude Sallier, "Discours sur la perspective de l'ancienne peinture ou sculpture" (read 6 April 1728), *HistMemBL* 8 (1733): *Mémoires*, 97–107, which provides a response to Charles Perrault's claim that there was no perspective in antique painting; and Claude Sallier, "Remarques sur l'etat de l'architecture civile dans les temps d'Homère" (read 30 March 1756), *HistMemBL* 27 (1761): *Histoire*, 19–20. According to Hepp, *Homère en France* (note 92), 577 n. 234, the full text of this last work, "Réflexions sur quelques endroits d'Homère qui ont du raport avec l'architecture," is in the Cabinet des manuscrits, Bibliothèque nationale, Paris (Fonds fr. 12.893, fols. 65r–66r).

169. Caylus's journal for this trip was published in Paul-Émile Schazmann, "Voyage de Constantinople par le comte de Caylus," *Gazette des beaux-arts*, 6th ser., 19 (1938): 273–92; 20 (1938): 111–26, 309–22. See also Anne-Claude-Philippe de Tubières, comte de Caylus, *Voyage d'Italie, 1714–1715: Première édition du code autographe annotée et précédée d'un essai sur le comte de Caylus par Amilda-A. Pons* (Paris: Librairie Fischbacher, 1914); and Sévin, *Lettres sur Constantinople* (note 24), app. 1, 403–19. For additional sources on Caylus, see note 23.

170. Pierre-Jean Mariette, *Abécédario de P. J. Mariette et autres notes inédites de cet amateur sur les arts et les artistes...*, ed. Philippe de Chennevières and Anatole de Montaiglon, 6 vols. (Paris: J. B. Dumoulin, 1851–60); and *Le cabinet d'un grand amateur, P.-J. Mariette, 1694–1774, dessins du XV^e siècle au XVIII^e siècle* (Paris: Réunion des Musées Nationaux, 1967).

171. For sources on Maurepas, see note 361.

172. Pierre de Ségur, *Le royaume de la rue Saint-Honoré: Madame Geoffrin et sa fille* (Paris: Calmann-Lévy, 1897); and Marguerite Glotz and Madeleine Maire, *Salons du XVIII^e siècle* (Paris: Nouvelles Éditions Latines, 1949).

173. Maurice Tourneux, "Fragments inédits de Diderot," *Revue d'histoire littéraire de la France* 1 (1894): 173–74 (no. 8, "L'anticomanie"). The date of this work is uncertain.

174. Glotz and Maire, *Salons* (note 172), 129, identify Caylus as "la tsarine de Paris," while Rocheblave, *Essai sur le comte* (note 23), 61, identifies Madame Geoffrin as such. When Caylus himself uses the soubriquet, in a letter to Paciaudi of 5 June 1762, it is uncertain to whom he refers; his editor assumes that the phrase is meant to describe Madame Geoffrin, but the name might well have been transferred from the one to the other; see Nisard, ed., *Correspondance inédite du comte de Caylus* (note 23), 1:279.

175. One cannot be quite certain as to the nature of this group or indeed as to the nature of homoeroticism in eighteenth-century French society, the subject having been none too well studied. I have nonetheless retained the term *gay* to identify the group, this being the word used by Robert Shackleton in describing it in his *Montesquieu: A Critical Biography* (London: Oxford Univ. Press, 1961), 182–84. The group was earlier described by Louis-Simon Auger in his *Mélanges philosophiques et littéraires* (Paris: Ladvocat, 1828), 1:50–51, as "quelques jeunes gens, de familles nobles, amis des lettres qu'ils n'osoient cultiver ouvertement, mais partisans très déclarés du plaisir" (a few young people from noble families, friends of the letters, which they dared not cultivate openly, but certainly committed partisans of pleasure). Auger was director of the

Académie française under the Restoration. Alfred Maury repeats much the same information, referring the reader to Auger's *Mélanges;* see Alfred Maury, *Les académies* (note 154), 310 n. 2. After recounting the way in which Maurepas paid court to women, tirelessly, until they agreed to an engagement, whereupon he promptly withdrew, Jean-Nicolas, comte Dufort de Cheverny, hinted darkly at Maurepas's "little secret" in his *Mémoires sur les règnes de Louis XV et Louis XVI et sur la Révolution,* ed. Robert St. John de Crèvecoeur (Paris: E. Plon, Nourrit, 1886), 1:405: "on le savait fort galant, mais il paraissait assez clair qu'il bornait là tous ses empressements" (he was known to be very gallant, but it seemed clear enough that that was as far as his attentions went).

Jean-François Marmontel disliked Caylus and Maurepas equally and characterized both as frivolous. His celebrated disparagement of Caylus is perhaps worth quoting in full, as it is revealing of the way Caylus was viewed by the *philosophes;* see Jean-François Marmontel, *Mémoires,* ed. Jean-Pierre Guicciardi and Gilles Thierriat (Paris: Mercure de France, 1999), bk. 6, 205–6:

> Je ne saurais dire lequel de nous deux avait prévenu l'autre; mais à peine avais-je connu le caractère du personnage, que j'avais donné le soin d'examiner en quoi j'avais pu lui déplaire, mais je savais bien, moi, ce qui me déplaisait en lui. C'était l'importance qu'il se donnait pour le mérite le plus futile et le plus mince des talents; c'était la valeur qu'il attachait à ses recherches minutieuses, et à ses babioles antiques; c'était l'espèce de domination qu'il avait usurpée sur les artistes et dont il abusait en favorisant les talents médiocres qui lui faisaient la cour, et en déprimant ceux qui, plus fiers de leur force, n'allaient pas briguer son appui. C'était enfin une vanité très adroite et très raffinée, et un orgueil très apre et très impérieux, sous les formes brutes et simples dont il savait l'envelopper. Souple et soyeux avec les gens en place et de qui dépendaient les artists, il se donnait près de ceux-là un crédit dont ceux-ci redoutaient l'influence. Il accostait les gens instruits, se faisait composer par eux des mémoires sur les breloques que les brocanteurs lui vendaient; faisait un magnifique Recueil de ces fadaises, qu'il donnait pour antiques; proposait des prix sur Isis et Osiris, pour avoir l'air d'être lui-même initié dans leurs mystères, et, avec cette charlatanerie d'erudition, il se fourrait dans les Académies sans savoir ni grec ni latin. Il avait tant dit, tant fait dire par ses proneurs, qu'en architecture il était le restaurateur du *style simple,* des *formes simples,* du *beau simple,* que les ignorants le croyaient; et, par ses relations avec les *dilettanti,* il se faisait passer en Italie et dans tout l'Europe pour l'inspirateur des beaux-arts. J'avais donc pour lui cette espèce d'antipathie naturelle que les hommes simples et vrais ont toujours pour les charlatans.

This passage on Caylus was translated as follows in Jean-François Marmontel, *Memoirs of Marmontel, Written by Himself…,* 1st American ed. (Philadelphia: printed by Abel Dickinson for Brisban & Brannan, New York, 1807), 1:158:

> I cannot say which of the two had anticipated the other but I had scarcely known his character when I conceived as strong a dislike to him as ever he felt to me. I never gave myself the trouble of examining in what I could have displeased him. But

I well knew what displeased me in him. It was the importance he gave himself for the most futile merit, and the most trivial of talents; it was the value he attached to his minute researches, and to his antique gewgaws; it was the kind of sovereignty he had usurped over the artists, and which he abused, by favouring ordinary talents that paid their court to him, and by depressing those that, bolder in their force, did not go to solicit his support. It was, in short, a very adroit and very refined vanity, and the most bitter and imperious pride, under the rough and simple forms in which he had the art of enveloping it. Supple and pliant with the placemen on whom the artists depended, he obtained a credit for the former, whose influence was dreaded by the latter. He insinuated himself into the company of men of information, and persuaded them to write memorials on the toys he had bought at his brokers; he made a magnificent collection of this trumpery, which he called antique; he proposed prizes on Isis and Osiris, in order to have the air of being himself initiated in their mysteries; and with this charlatanism of erudition, he crept into the academies without knowing either Greek or Latin. He had so often said, he had so often published, by those whom he paid to praise him, that in architecture he was the restorer *of the simple style, of simple beauty, of beautiful simplicity,* that the ignorant believed it: and by his correspondance with the *Dilettanti,* he made himself pass in Italy and in all Europe for the inspirer of the fine arts. I felt for him, then, that species of natural antipathy that ingenuous and simple men always feel for imposters.

On Antonio Conti, see Nicola Badaloni, *Antonio Conti: Un abate libero pensatore tra Newton e Voltaire* (Milan: Feltrinelli, 1968); and *Dizionario biografico degli italiani,* s.v. "Conti, Antonio." For Conti's defense of Madame Dacier, see Françoise Waquet and Marc Fumaroli, "Un vénitien francophile," *Commentaire,* no. 61 (1993): 145; and Antonio Conti, "Lettre sur la querelle des anciens et des modernes," *Commentaire,* no. 61 (1993): 146–50.

176. Cited in Auger, *Mélanges* (note 175), 51: "une crapule plûtot qu'une débauche d'esprit."

177. Charles Le Beau, "Éloge de M. le comte de Caylus" (read 1766), *HistMemBL* 34 (1770): *Histoire,* 230–31:

Rien de ce qui étoit antique ne lui sembloit indifférent; depuis les dieux jusqu'aux reptiles, depuis les plus riches métaux et les plus beaux marbres jusqu'aux fragmens de verre et de vases de terre cuite, tout trouvoit place dans son cabinet. L'entrée de sa maison annonçoit l'ancienne Égypte: on y étoit reçu par une belle statue Égyptienne, de cinq pieds cinq pouces de proportion. L'escalier étoit tapissé de médaillons et de curiosités de la Chine et de l'Amérique. Dans l'appartement des Antiques, on se voyoit environné de Dieux, de Prêtres, de Magistrats Égyptiens, Étrusques, Grecs, Romains, entre lesquels quelques figures Gauloises sembloient honteuses de se montrer.

178. Cited in Rocheblave, *Essai sur le comte* (note 23), 177: "Il est certain que *nous n'avons aucunes idées innées,* et que les dons de la nature ne consistent qu'en une plus grande aptitude, en une disposition des fibres, plus propre dans un sujet que dans un autre à recevoir une impression et à la faire germer."

179. Anne-Claude-Philippe de Tubières, comte de Caylus, "De l'amour des beaux-arts, et de l'extrême considération que le Grecs avoient pour ceux qui les cultivoient avec succès" (read 27 June 1747), *HistMemBL* 21 (1754): *Mémoires,* 189–90: "Au reste, Messieurs, je ne vous parle point des Romains, nous savons qu'ils avoient peu de goût pour les arts; ils ne les ont aimés que par air et par magnificence, en suivant le goût d'autrui, ils ont eu plus d'un *Mummius.*"

180. Alexander Pope, taking up the idea from Boivin, included a plate of the shield of Achilles, engraved by Samuel Gribelin after the drawing by Nicolas Vleughels, in his translation of the Iliad; see Homer, *The Iliad of Homer,* trans. Alexander Pope (London: printed by W. Bowyer [etc.] for Bernard Linot, 1720–21), vol. 5, facing p. 1458.

181. Anne-Claude-Philippe de Tubières, comte de Caylus, "Des boucliers d'Achille, d'Hercule et d'Énée; suivant les descriptions d'Homère, d'Hésiode et de Virgile," *HistMemBL* 27 (1761): *Histoire,* 21–33. Another engraving after Vleughels's drawing of the shield of Achilles, this one signed "Benard Direx." (that is, "Robert Benard supervised"), would appear among the plates for the *Supplément à Encyclopédie* of Diderot and d'Alembert; see *Suite du recueil de planches, sur les sciences, les arts libéraux et les arts méchaniques, avec leur explication* (Paris: Panckoucke [et al.], 1777), s.v. "Antiquités diverses," pl. 3.

182. Anne-Claude-Philippe de Tubières, comte de Caylus, "Description de deux tableaux de Polygnote, donnée par Pausanias," *HistMemBL* 27 (1761): *Histoire,* 34–55. Caylus's reconstructions of Polygnotus's paintings might be compared with those of Professor C. Robert in James George Frazer, *Commentary on Books IX, X,* vol. 5 of *Pausanias's Description of Greece,* ed. and trans. James George Frazer, 2d ed. (London: Macmillan, 1913), 356–92, pls. facing pp. 360, 372.

183. For other works in which Caylus encouraged painters to turn to antique texts, see, for example, his *Nouveaux sujets de peinture et de sculpture* (Paris: Duchesne, 1755); *Tableaux tirés de l'Iliade, de l'Odyssée d'Homère, et de l'Énéide de Virgile, avec des observations générales sur le costume* (Paris: Tilliard, 1757); and *Histoire d'Hercule le Thébian, tirée de différents auteurs, à laquelle on a joint la description des tableaux qu'elles peut fournir* (Paris: Tillard, 1758). For Lessing's response, see Gotthold Ephraim Lessing, *Laokoon; oder, Über die Grenzen der Mahlerey und Poesie … mit beyläufigen Erläuterungen verschiedner Punkte der alten Kunstgeschichte: Erster Theil* (Berlin: bey Christian Friedrich Voss, 1766), chaps. 11–16.

184. Danielle Rice, *The Fire of the Ancients: The Encaustic Painting Revival, 1755 to 1812* (Ann Arbor: University Microfilms, 1979); and Thomas W. Gaehtgens and Jacques Lugand, *Joseph-Marie Vien, peintre du roi (1716–1809)* (Paris: Arthena, 1988), 151–52 (cat. I, no. 91).

185. Anne-Claude-Philippe de Tubières, comte de Caylus, "De l'architecture ancienne" (read 17 January 1749), *HistMemBL* 23 (1756): *Mémoires,* 286–319.

186. Caylus, "De l'architecture ancienne" (note 185), 300: "ils les ont conduits l'un et l'autre au dernier degré du sublime par le goût, la délicatesse, le sentiment et la légèreté qu'ils y ont ajoûtés."

187. Caylus, "De l'architecture ancienne" (note 185), 307: "bâti sur les mêmes proportions."

188. Caylus, "De l'architecture ancienne" (note 185), 317: "on peut dire, avec

assurance, que les Romains, à la place et dans la situation des Grecs, n'auroient ni laissé le moindre monument, ni fait un pas pour la culture et le progrès des arts; il semble en un mot qu'ils n'ont travaillé ou plustôt fait travailler en ce genre, que par l'idée d'autrui."

189. Caylus, "De l'architecture ancienne" (note 185), 287–88:

> sans parler de la totalité d'un morceau d'Architecture qui indique sa destination et qui prévient le spectateur convenablement à son objet, la plus belle colonne est un cylindre, un arbre, une quille, que sais-je, je ne dis pas pour le vulgaire, mais pour une infinité de gens qui sont même les plus forts en décisions, tandis que dans sa proportion, son renflement, sa diminution, sa base et son chapiteau, toutes choses qui paroissent absolument arbitraires, et qui l'ont été sans doute pendant long-temps, cette colonne, dis-je, est une des plus belles productions pour un homme doué de génie et rempli des connoissances et du sentiment des arts. L'Architecture a donc eu besoin, non d'un génie différent des autres arts, car il est par-tout le même, mais d'un sentiment plus fin pour être conduite à sa perfection, d'autant que son expression est uniquement et absolument émanée de l'esprit, de la justesse des rap-ports et du goût le plus pur.

190. Caylus, "De l'architecture ancienne" (note 185), 290: "Pour donner un exemple de cette vérité, la façade de M. Perrault que l'on voit tous les jours avec une nouvelle admiration, et qui est exécutée selon les principes et les finesses inventées par les Grecs, n'est aussi parfaite et ne nous plaît autant que parce qu'elle flatte et le premier coup d'oeil et celui de réflexion, en ne nous présentant qu'un seul ordre dont on jouit sans aucune distraction."

191. Anne-Claude-Philippe de Tubières, comte de Caylus, "Dissertation sur le tombeau de Mausole" (read August 1753), *HistMemBL* 26 (1759): *Mémoires*, 321–34.

192. The Medracen (ca. 200–150 B.C.) near Batna and the so-called tomb of the Christian woman (ca. 100–50 B.C.) near Tipasa—two great circular mausoleums with stepped pyramidal roofs, both located in Algeria—are often confused. There is no doubt, however, about the source of Caylus's illustration. Thomas Shaw, chaplain of the English factory in Algiers from 1720 to 1732, had included a crude diagram of "The sepulchre of the Christian woman" in his *Travels, or Observations Relating to Several Parts of Barbary and the Levant* (Oxford: printed at the Theatre, 1738), 45; the French translation of Shaw's book, *Voyages de Monsr. Shaw, M.D., dans plusieurs provinces de la Barbarie et du Levant* . . . (The Hague: J. Neaulme, 1743), was known to Caylus. Shaw visited the "Medrashem" and described it (Shaw, *Travels*, 110), but he made no drawings of this monument. Jean-André Peyssonnel, a doctor from Marseille, had already been sent by Maurepas to explore North Africa and Egypt, how-ever, and he visited the "Métacasem" and made measured drawings of it in 1725. By the following year he was back in France. Bignon asked Adrien de Jussieu to prepare a report on Peyssonnel's findings for Maurepas; some of Peyssonnel's letters and a few copies of his drawings have survived among the Jussieu papers at Aix-en-Provence. But far too little is known, as yet, of Peyssonnel and his brother, Charles, who was consul at Smyrna from 1747 to 1756. Charles-Marie de La Condamine explored the Barbary Coast in 1731, also under Maurepas's auspices, but he seems to have con-tributed nothing to Caylus's knowledge.

Caylus remarks on Peyssonnel's drawings of North Africa in his *Recueil d'antiqui-tés égyptiennes, étrusques, grecques, romaines et gauloises* (Paris: Desaint & Saillant, 1752–67), 3:217. For Peyssonnel's travels, see Adolphe Dureau de La Malle, *Peyssonnel et Desfontaines: Voyages dans les régences de Tunis et d'Alger,* 2 vols. (Paris: Librairie de Gide, 1838), later issued as Jean-André Peyssonnel, *Voyage dans les régences de Tunis et d'Algérie,* ed. Lucette Valensi (Paris: Éditions La Découverte, 1987); Auguste Rampal, "Une relation inédite du voyage en Barbarie du médecin naturaliste marseillais Peyssonnel," *Bulletin de géographie historique et descriptive* 22 (1907): 317–40 (Rampal was working toward a book on the Peyssonnels but seems to have published nothing further on the subject); and Charles Monchicourt, "Le voyageur Peyssonnel de Kai-rouan au Kef et a Dougga (août 1724)," *Revue tunisienne,* no. 23 (1916): 266–77. See also Numa Broc, *La géographie des philosophes, géographes et voyageurs français au XVIIIe siècle* (Paris: Éditions Ophrys, 1974), esp. "Du Levant et la Barbarie," 50–63; and Paul Masson, *Histoire des établissements et du commerce français dans l'Afrique barbaresque (1560–1793) (Algérie, Tunisie, Tripolitaine, Maroc)* (Paris: Hachette, 1903). For references on La Condamine, see note 211.

193. Anne-Claude-Philippe de Tubières, comte de Caylus, "Sur le bûcher d'Éphes-tion," *HistMemBL* 31 (1768): *Histoire,* 76–85; and Anne-Claude-Philippe de Tubières, comte de Caylus, "Sur le char qui porta le corps d'Alexandre," *HistMemBL* 31 (1768): *Histoire,* 86–98.

194. Jean-Jacques Barthélemy, "Essai d'une paléographie numismatique" (read 20 January 1750), *HistMemBL* 24 (1756): *Mémoires,* 30–48; Jean-Jacques Barthélemy, "Réflexions sur l'alphabet et sur la langue dont on se servoit autrefois à Palmyre" (read 12 February 1754), *HistMemBL* 26 (1759): *Mémoires,* 577–97; and Jean-Jacques Barthélemy, "Réflexions sur quelques monumens phéniciens, et sur les alphabets qui en résultent" (read 12 April 1758), *HistMemBL* 30 (1764): *Mémoires,* 405–27.

195. Cited in Rocheblave, *Essai sur le comte* (note 23), 70 n. 1.

196. Caylus, *Recueil d'antiquités* (note 192), 5:xiv: "il ne démêlera qu'avec peine quelques atômes dans l'immensité du vuide."

197. Cited in Rocheblave, *Essai sur le comte* (note 23), 331: "Il n'y a pas de thèse générale sur les monuments, et un coup de pied donné au hasard est capable de démen-tir les propositions de tous les antiquaires présents, passés et futurs." Rocheblave dis-cusses this comment with reference to Winckelmann, but it is clear from Nisard, ed., *Correspondance inédite du comte de Caylus* (note 23), 1:380, 380 n. 1, that the com-ment does not relate directly to the writings of Winckelmann.

198. Translated into French in Rocheblave, *Essai sur le comte* (note 23), 355: "On ne peut lui contester le mérite d'avoir défini le premier le goût des peuples anciens. Mais ce project était bien difficile à suivre à Paris"; for the original, see Winckelmann, *Briefe* (note 42), 1:394 (letter 224, Winckelmann to L. Bianconi, 22 July 1758): "Lui è il primo a cui tocca la gloria d'esserisi incaminato per entrare nella sostanza dello stile dell'Arte de' Popoli antichi. Ma volerlo fare a Parigi è un impegno assai più superiore dell'assunto."

199. Michael McCarthy, "The Image of Greek Architecture, 1748–1768," in Philippe Boutry et al., eds., *La Grecia antica: Mito e simbolo per l'età della grande rivoluzione: Genesi e crisi di un modello nella cultura del Settecento* (Milan: Guerini, 1991), 159–70.

200. Henry, ed., *Mémoires inédits de Charles-Nicolas Cochin* (note 23), 142–43:

Enfin, tout le monde se remit, ou tâcha de se remettre sur la voye du bon goust du siècle précédent. Et comme il faut que tout soit tourné en soubriquet à Paris, on appella cela de l'architecture à la grecque et bientôt on fit jusqu'à des galons et des rubans à la grecque; il ne resta bon goust qu'entre les mains d'un petit nombre de personnes et devint une folie entre les mains des autres.

Nos architectes anciens qui n'avoient pas sorti de Paris voulurent faire voir qu'ils feroient bien aussi dans ce goust grec; il en fut de même des commençans et même des maîtres maçons. Tous ces honnêtes gens déplacèrent les ornemens antiques, les dénaturèrent, décorèrent de guillochis bien lourds les appuis des croisées et commirent mille autres bevües. Le Lorrain peintre, donna des desseins bien lourds pour tous les ornemens de l'appartement de M. de la Live, amateur riche et qui dessinailloit un peu. Ils firent d'autant plus de bruit que M. de Caylus les loua avec enthousiasme; de là nous vinrent les guirlandes en forme de corde à puits, les vases, dont l'usage ancien étoit de contenir des liqueurs, devenus pendules à heures tournantes, belles inventions qui furent imitées par tous les ignorans et qui inondè-rent Paris de drogues à la grecque. Il s'en suivit ce qui sera toujours, c'est que le nombre de bonnes choses sera toujours très-petit dans quelque goust que ce soit et que l'ignorance trouvera toujours le moyen de dominer dans l'architecture; mais, quoiqu'il se fasse toujours de bien mauvaises choses, elles sont du moins plus approchantes du bon que le mauvais goust qui les a précédées et que quiconque aura du goust naturel, sera moins éloigné de la voye qui conduit au bon qu'on ne l'étoit cy-devant, si touttefois ce goust ne devient (par la faute de ceux qui en font la parodie), si décrié qu'on ne puisse plus le souffrir.

201. Gedoyn, "Si les anciens" (note 162); and Caylus, "De l'amour des beaux-arts" (note 179).

202. Paola Barocchi and Daniela Gallo, eds., *L'Accademia etrusca* (Milan: Electa, 1985).

203. Caylus, *Recueil d'antiquités* (note 192), 1:ix–x: "On les voit formés en Egypte avec tout le caractère de la grandeur; de-là passer en Etrurie, où ils acquièrent des par-ties de détail, mais aux dépens de cette même grandeur; être ensuite transportés en Grèce où le sçavoir joint à la plus noble élégance, les a conduits à leur plus grande perfection; à Rome enfin, où sans briller autrement que par des secours étrangers, après avoir lutté quelque temps contre la Barbarie, ils s'ensevelissent dans les débris de l'Empire."

204. Caylus, *Recueil d'antiquités* (note 192), 1:119:

Les Grecs se sont écartés du goût pour le grand et le prodigieux, dont les Egyptiens leur avoient donné l'exemple. Ils ont diminué les masses, pour ajouter de l'élégance et de l'agrément dans les détails. Ils ont joint à ces belles parties de l'art les graces et les licences sçavantes auxquelles on ne peut arriver que par un dégré de supériorité que la nature accorde rarement, mais qui se rencontroit assez communément dans la Grèce pendant la durée de quelques siécles. Enfin, les Grecs ont conduit à leur perfection les Arts dont l'objet est de plaire par l'imitation de la nature. Leurs

ouvrages réunissent tant de parties où ils ont excellé, que leur étude marche, pour ainsi dire, de pair avec celle de la nature.

205. [Michel Philippe Lévesque de Gravelle,] *Recueil de pierres gravées antiques* (Paris: Imprimerie de P. J. Mariette, 1732–37), 1:i: "Je n'entreprendrai point de faire ici l'Histoire des Pierres gravées; on sçait que de même que tous les beaux Arts, elles viennent des Egyptiens, que de-là elles sont passées aux Grecs, qui ont porté ce travail à son plus haut degré de perfection: les Romains enfin les ont prises de ces derniers; mais les Grecs ont toujours conservé sur eux la supriorité du goût et de l'execution." For sources on Mariette, see note 170.

206. Pierre-Jean Mariette, *Traité des pierres gravées* (Paris: De l'imprimerie de l'auteur, 1750), 1:11: "Le commencement des Arts ne fut point différent en Grèce de ce qu'il avoit été en Etrurie. Ce furent encore les Egyptiens qui mirent les instrumens des Arts entre les mains des Grecs."

207. The canonical account of Piranesi's attack is Rudolf Wittkower, "Piranesi's *Parere su l'architettura*," *Journal of the Warburg Institute* 2 (1938–39): 147–58. Though the quarrel has been recounted often enough since in books and articles on Piranesi, sometimes with useful additions, the only really useful extensions to Wittkower's account are provided by the modern facsimile edition, Giovanni Battista Piranesi, *The Polemical Works, Rome 1757, 1761, 1765, 1769*, ed. John Wilton-Ely (Farnborough, England: Gregg, 1972); the recently published translation, Giovanni Battista Piranesi, *Observations on the Letter of Monsieur Mariette; with Opinions on Architecture, and a Preface to a New Treatise on the Introduction and Progress of the Fine Arts in Europe in Ancient Times*, intro. John Wilton-Ely, trans. Caroline Beamish and David Britt (Los Angeles: Getty Research Institute, 2002); and the writings of Alastair Smart, in particular, *Allan Ramsay: Painter, Essayist, and Man of Enlightenment* (New Haven: Yale Univ. Press, 1992), 115–48. On Piranesi's borrowings from Caylus, see Roberta Battaglia, "Le *Diverse maniere d'adornare i cammini* . . . di Giovanni Battista Piranesi: Gusto e cultura antiquaria," *Saggi e memorie di storia dell'arte* 19 (1994): 193–273.

208. Piranesi, *Observations* (note 207), 16–17; and Giovanni Lodovico Bianconi, "Elogio storico del cavaliere Giambattista Piranesi," *Antologia romana*, no. 34 (1779): 274. Bianconi's obituary for Piranesi, in which he refers to Piranesi's scholarly collaborators, has been reprinted as "L'*Elogio* di Bianconi," *Grafica grafica* 2 (1976): 127–35.

209. The dominant academy in France during the first half of the eighteenth century was the Académie royale des sciences; the first comprehensive account of its organization and activities was Joseph Bertrand, *L'Académie des sciences et les académiciens de 1666 à 1793* (Paris: J. Hetzel, 1869), superceded by Roger Hahn, *The Anatomy of a Scientific Institution: The Paris Academy of Sciences, 1666–1803* (Berkeley: Univ. of California Press, 1971), revised and enlarged in its French edition, *L'anatomie d'une institution scientifique: L'Académie des sciences de Paris, 1666–1803* (Brussels: Éditions des Archives Contemporaines, 1993). For more on the activities and interactions of the academy's members, see Elisabeth Badinter, *Les passions intellectuelles*, vol. 1, *Désirs de gloire, 1735–1751* (Paris: Fayard, 1999). The scientific experimentation of the eighteenth century was summarized at the end of the century in Étienne-Claude,

baron de Marivetz, and Louis-Jacques Goussier, *Physique du monde*, 5 vols. in 8 (Paris: Quillau, 1780–87), the French counterpart, as it were, to Joseph Priestley, *The History and Present State of Discoveries Relating to Vision, Light, and Colours,* 2 vols. (London: printed for J. Johnson, 1772); for a somewhat damning assessment of one aspect of the activity heralded in these two books, that on optics, see Peter Anton Pav, *Eighteenth-Century Optics: The Age of Unenlightenment* (Ann Arbor: University Microfilms, 1970). The sharpest and most lucid modern summary of eighteenth-century scientific achievement is Charles Coulston Gillispie, *The Edge of Objectivity: An Essay in the History of Scientific Ideas* (Princeton: Princeton Univ. Press, 1960), though — Descartes, Newton, and Locke apart — very few of the names to be encountered in this introduction find mention there. The standard account of eighteenth-century technical achievements is Abraham Wolf, *A History of Science, Technology, and Philosophy in the Eighteenth Century* (New York: Macmillan, 1939).

210. The fullest account of the Société des arts is Roger Hahn, "The Application of Science to Society: The Societies of Arts," in *Transactions of the First International Congress on the Enlightenment,* Studies on Voltaire and the Eighteenth Century, vols. 24–27 (Geneva: Institut & Musée Voltaire, 1963), 829–36, though Hahn has more to say in his *The Anatomy of a Scientific Institution* (note 209), 108–10. See also Louis de Bourbon-Condé, comte de Clermont, *Le comte de Clermont, sa cour et ses maîtresses: Lettres familières, recherches et documents inédits,* ed. Jules Cousin (Paris: Académie des Bibliophiles, 1867), 1:108–10; Daumas, *Scientific Instruments* (note 53), 307; and Badinter, *Les passions intellectuelles* (note 209), 62–63.

211. La Condamine was a man of extraordinary boldness and brilliance, about whom much has been written. The neatest summary of his career is in Badinter, *Les passions intellectuelles* (note 209), 60–63; the basic text is Jean-Antoine-Nicolas de Caritat, marquis de Condorcet, "Éloge de La Condamine," in idem, *Oeuvres complètes de Condorcet* (Paris: Henrichs [etc.], 1804), 2:185–256. La Condamine's travels in North Africa have not been fully researched; his papers relating to these in the Bibliothèque nationale (MS Fr. 11333) have been published in part in H. Begouen, "La Condamine, Tunis, le Bardo, Carthage," *Revue tunisienne,* no. 17 (1898): 71–94; Marcel Emerit, "Le voyage de La Condamine à Alger (1731)," *Revue africaine* 98 (1954): 354–81; and Paul-Emile Schazmann, "Une mission de M. de La Condamine aux Échelles de Barbarie," *La revue maritime,* n.s., no. 205 (1937): 29–63. See also the account of La Condamine's secretary: Jean-Baptiste Tollot, *Nouveau voyage fait au Levant ès années 1731 et 1732...*(Paris: André Cailleau, 1742). All these sources are cited in Broc, *La géographie des philosophes* (note 192). Not altogether surprisingly, La Condamine viewed his adventure in terms of Telemachus's. La Condamine's return from Peru is detailed in his *Voyage sur l'Amazone,* ed. Hélène Minguet (Paris: F. Maspero, 1981); and in A. McConnell, "La Condamine's Scientific Journey down the River Amazon, 1743–1744," *Annals of Science* 48, no. 1 (1991): 1–19.

212. For sources on Maupertuis, see note 300.

213. On Pierre Le Roy, see Quérard, *La France littéraire* (note 7), 5:215; and Michaud, gen. ed., *Biographie universelle* (note 7), 24:259–60. Most studies on navigation, scientific instruments, and clockmaking in the eighteenth century deal with the problem of determining longitude at sea. British and American authors tend to award

the honors for the resolution of this problem to John Harrison (though he did not quite resolve it, and his recognition was delayed); French authors opt for Pierre Le Roy (though his instruments were rather too delicate for practical purposes) or Ferdinand Berthoud. In her extremely useful study, *The Haven-Finding Art: A History of Navigation from Odysseus to Captain Cook*, rev. ed. (London: Hollis & Carter, 1971), Eva Germaine Rimington Taylor endorses Pierre Le Roy as the hero. A recent assessment of the issue, with good illustrations of the instruments involved, is provided by Catherine Cardinal, "Ferdinand Berthaud and Pierre Le Roy: Judgement in the Twentieth Century of a Quarrel Dating from the Eighteenth Century," in William J. H. Andrewes, ed., *The Quest for Longitude: The Proceedings of the Longitude Symposium, Harvard University, Cambridge, Massachusetts, November 4–6, 1993* (Cambridge: Collection of Historical Scientific Instruments, Harvard University, 1996), 282–92. In the same volume, see Anthony G. Randall, "The Timekeeper That Won the Longitude Prize," 236–54, on John Harrison.

214. On Jean-Baptiste Le Roy, see Quérard, *La France littéraire* (note 7), 5:217; and Charles Coulston Gillispie, ed.-in-chief, *Dictionary of Scientific Biography* (New York: Scribner, 1980), 8:258–59.

215. On Marat's opposition to Newton's theories, see Marivetz and Goussier, *Physique du monde* (note 209), vol. 3, pt. 2, 440; see also Pav, *Eighteenth-Century Optics* (note 209), 148–57; and Hahn, *The Anatomy of a Scientific Institution* (note 209), 150–51, 266–67.

216. On Charles Le Roy, see Quérard, *La France littéraire* (note 7), 5:216–17; Michaud, gen. ed., *Biographie universelle* (note 7), 24:260; and Gillispie, ed.-in-chief, *Dictionary of Scientific Biography* (note 214), 3:255–56; see also Louis Dulieu, "Un parisien, professeur à l'Université de médecine de Montpellier: Charles Le Roy (1726–1779)," *Revue d'histoire des sciences et leurs applications* 6, no. 1 (1953): 50–59.

217. Charles Le Roy, "Mémoire sur l'élévation et la suspension de l'eau dans l'air, et sur la rosée" (read 1751), *Histoire de l'Académie royale des sciences; avec les Mémoires de mathématique et de physique* (1755): *Mémoires*, 481–518. The title of this journal is hereafter abbreviated in these notes as *HistMemSci*.

218. Le Roy, *Les ruines*, 1758 (note 25), 1:x: "ils ont formé un système régulier sur cet Art, au lieu qu'il ne paroît pas que les Egyptiens en ayent suivi aucun."

219. Le Roy, *Les ruines*, 1758 (note 25), 1:xi: "Ce premier pas est sans doute la plus grande découverte qui ait été faite en Architecture en ce qui regarde la décoration, et il est le fondement et la base de toutes les autres découvertes de ce genre."

220. Le Roy, *Les ruines*, 1758 (note 25), 1:xii: "Enfin les Grecs parvinrent à trouver dans l'Architecture tout ce qui y a été découvert de beau et d'ingénieux."

221. For the surviving correspondence of Caylus and Charles de Peyssonnel, between 1747 and 1763, see Sévin, *Lettres sur Constantinople* (note 24), 54–97 (letters 7–15).

222. "Anonymi narratio de aedificatione templi S. Sophiae," in Theodorus Preger, ed., *Scriptores Originum Constantinopolitanarum* (Leipzig: B. G. Teubner, 1901–7), 1:105 (27.4–5): ἐνίχησά σε, Σολομών. Preger dates this work to the mid-ninth century; see Theodorus Preger, "Die Erzählung vom Bau der Hagia Sophia," *Byzantinische*

Zeitschrift 10 (1901): 455–76; and Hans-Georg Beck, *Geschichte der byzantinischen Volksliteratur*, Handbuch der Altertumswissenschaft, 12. Abt., 2. T., 3. Bd. (Munich: C. H. Beck, 1971), 202.

223. Le Roy, *Les ruines*, 1758 (note 25), 1:xiv: "le chef-d'oeuvre des Modernes de l'Europe et des Chrétiens."

224. Le Roy, *Les ruines*, 1758 (note 25), 2:i: "cet Art sublime une espece de métier où chacun ne feroit que copier, sans choix, ce qui a été fait par quelques Architectes anciens"; and Piranesi, *Observations* (note 207), 111.

225. Le Roy, *Les ruines*, 1758 (note 25), 2:v: "devons nous les imiter servilement?"

226. Yves-Marie André, *Essai sur le beau, où l'on examine en quoi consiste précisément le beau dans le physique, dans le moral, dans les ouvrages d'esprit, et dans la musique* (Paris: Hippolyte-Louis & Jacques Guerin, 1741); quoted from Yves-Marie André, *Essai sur le beau par le père André J....; avec un Discours preliminaire, et des Réflexions sur le goût par M. Formey* (Amsterdam: J. H. Schneider, 1767), 8: "cela est donc évident par le seul coup d'oeil sur la nature."

227. André, *Essai sur le beau*, 1767 (note 226), 15: "les premières sont invariables, comme la science qui les prescrit."

228. André, *Essai sur le beau*, 1767 (note 226), 15: "n'étant fondées que sur des observations à l'oeil toujours un peu incertaines, ou sur des exemples souvent équivoques, ne sont pas des règles tout-à-fait indispensables."

229. André Mauban, *Jean Marot, architecte et graveur parisien* (Paris: Éditions d'Art & d'Histoire, 1944), 63–64, 216. Mauban's tabulation of the plates in the two editions of Tarade's work he examined does not correspond to that of copies in the Avery Architectural and Fine Arts Library of Columbia University, New York; the Bibliothek Werner Oechslin, Einsiedeln, Switzerland; or the Getty Research Institute, Los Angeles.

230. The plates prepared for Meissonnier's publication and their relationship to others of the sort has been discussed in detail in Peter Fuhring, *Juste-Aurèle Meissonnier, un génie du rococo, 1695–1750* (Turin: Umberto Allemandi, 1999), 1:44–45, 48; 2:181–84, 251, 252–55, 298–99, 376–79.

231. Werner Szambien, *Jean-Nicolas-Louis Durand, 1760–1834: De l'imitation à la norme* (Paris: Picard, 1984), esp. 27–30. Durand was to be translated soon enough into Italian, but Le Roy's comparative method had already been taken up in Italy, notably in Girolamo Masi, *Teoria e pratica di architettura civile per istruzione della gioventù specialmente romana* (Rome: Antonio Fulgoni, 1788), pls. V, IX.

232. Shackleton, *Montesquieu* (note 175), 60, 388; see also Robert Shackleton, "Montesquieu et les beaux-arts," in *Les langues et littératures modernes dans leurs relations avec les beaux-arts: Florence, 27–31 mars 1951* (Florence: Valmartina, 1955), 249–53.

233. "Mr. De Montesquieu's *Essay on Taste*," in Alexander Gerard, *An Essay on Taste; with Three Dissertations on the Same Subject, by Mr. De Voltaire, Mr. D'Alembert, Mr. De Montesquieu* (London: printed for A. Millar, A. Kincaide, and J. Bell, 1759), 276–77 = Charles-Louis de Secondat, baron de Montesquieu, *Essai sur le goût*, ed. Charles-Jacques Beyer (Geneva: Librairie Droz, 1967), 73:

Il y a des choses qui paroissent variées et ne le sont point, d'autres qui paroissent uniformes et sont très-variées.

L'architecture gothique paroît très-variée, mais la confusion des ornemens fatigue par leur petitesse; ce qui fait qu'il n'y en a aucun que nous puissions distinguer d'un autre, et leur nombre fait qu'il n'y en a aucun sur lequel l'oeil puisse s'arrêter: de manière qu'elle déplaît par les endroits même qu'on a choisis pour la rendre agréable.

Un bâtiment d'ordre gothique est une espece d'énigme pour l'oeil qui le voit, et l'âme est embarrassée, comme quand on lui presente un poème obscur.

L'architecture grecque, au contraire, paroît uniforme; mais comme elle a les divisions qu'il faut et autant qu'il en faut pour que l'âme voye précisément ce qu'elle peut voir sans se fatiguer, mais qu'elle en voye assez pour s'occuper; elle a cette variété qui fait regarder avec plaisir.

Il faut que les grandes choses ayent de grandes parties; les grands hommes ont de grands bras, les grands arbres de grands branches, et les grandes montagnes sont composées d'autres montagnes qui sont au-dessus et au-dessous; c'est la nature des choses qui fait cela.

L'architecture grecque qui a peu de divisions et de grandes divisions, imite les grandes choses; l'âme sent une certaine majesté qui y regne par-tout.

234. Le Roy, *Histoire* (note 11), 59: "le plus beau morceau d'Architecture de l'Europe."

235. Le Roy, *Histoire* (note 11), 62:

Lorsque nous nous en approchons, un spectacle different nous affecte; l'ensemble de la masse nous échappe, mais la proximité où nous sommes des colonnes nous en dédommage; et les changemens que le spectateur observe dans les tableaux qu'il est le maitre de se créer en changeant de lieu, sont plus frappans, plus rapides et plus varies. Mais si le spectateur entre sous le peristyle même, un spectacle tout nouveau s'offre à ses regards, à chaque pas qu'il fait, la situation des colonnes avec les objets qu'il découvre en dehors du peristyle varie, soit que ce qu'il découvre soit un paisage, ou la disposition pitoresque des maisons d'une Ville, ou la magnificence d'un intérieur.

236. Le Roy, *Histoire* (note 11), 63: "la beauté qui résulte de ces peristyles est si générale, qu'elle se feroit encore sentir, si les pilliers qui les forment, au lieu d'offrir au Spectateur de superbes colonnes Corinthiennes, ne lui présentoient que des troncs d'arbres coupés à leurs racines, et à la naissance de leurs branches, si ces colonnes étoient imitées d'après celles des Egyptiens ou des Chinois, si ces pilliers ne représentoient même, que les amas confus de petites colonnes gotiques, ou les soutiens massifs et quarrés de nos portiques."

237. Le Roy, *Histoire* (note 11), 64–65; and William Cheselden, "An Account of Some Observations Made by a Young Gentleman, Who Was Born Blind, or Lost His Sight So Early, That He Had No Remembrance of Ever Having Seen, and Was Couch'd between 13 and 14 Years of Age," *Philosophical Transactions*, no. 402 (1728): 447–50.

238. Charles-Nicolas II Cochin was to pursue this discussion in the following year

in his *Oeuvres diverses; ou, Recueil de quelques pièces concernant les arts* (Paris: Ch. Ant. Jombert père, 1771), 2:76.

239. On the issue of freestanding columns, see Robin Middleton, "The Abbé de Cordemoy and the Graeco-Gothic Ideal: A Prelude to Romantic-Classicism," *Journal of the Warburg and Courtauld Institutes* 25 (1962): 278–320; 26 (1963): 90–123; and Herrmann, *Laugier* (note 71), 109–117.

240. Marc-Antoine Laugier, *Essai sur l'architecture,* rev. ed. (Paris: Duchesne, 1755), 174–75 = Marc-Antoine Laugier, *An Essay on Architecture,* trans. Wolfgang Herrmann and Anni Herrmann (Los Angeles: Hennessey & Ingalls, 1977), 101–2.

241. Marc-Antoine Laugier, *Observations sur l'architecture* (The Hague: Desaint, 1765; reprint, Geneva: Minkoff Reprint, 1972), 117: "J'imagine qu'une Eglise dont toutes les colonnes seroient de gros troncs de palmier, qui étendroient leurs branches à droit et à gauche, et qui porteroient les plus hautes sur tous les contours de la voute, seroit un effet surprenant."

242. Laugier, *Observations* (note 241), 105: "ce qui produit dans ces ronds-points une forêt de colonnes dont l'effet est très-magnifique et très-grand."

243. Laugier, *Observations* (note 241), 54: "Les colonnes très-serrées augmentent la capacité apparente d'un vaisseau. Il en est d'elles comme des arbres mis fort près l'un de l'autre, aux deux côtés d'une allée."

244. Laugier, *Observations* (note 241), 183.

245. Etienne La Font de Saint-Yenne, *Oeuvre critique,* ed. Étienne Jollet (Paris: École Nationale Supérieure des Beaux-Arts, 2001), 359–60:

Je ne trouvais dans les discours de nos Architectes que des esclaves d'une routine aveugle et des règles qu'il faut oser franchir en plusieurs occasions. Mais c'est le génie seul qui les fait apercevoir ces occasions, qui demandent une sagacité de vue et une intelligence supérieure des effets de l'ensemble qu'il faut prévoir avant l'exécution, intelligence que ne donne point la science de l'optique, quoique absolument nécessaire à tout Architecte, ses règles devenant inutiles par la variété infinie des positions où se trouve l'oeil du spectateur et qu'elles ne sauraient prévoir. Il est encore une autre connaissance qui n'est pas moins nécessaire au grand Architecte, surtout dans les façades extérieures et qui sont si fort éclairées. C'est celle du clair-obscur et des effets pittoresques des lumières dans les saillies des masses et dans les renforcements. C'est elle qui donne le mouvement aux parties d'un grand édifice et fait jouir l'oeil du spectateur d'une satisfaction qui le ravit sans en savoir la cause. Les grands édifices, où cet art est ignoré, paraissent toujours froids ou plats quoique surchargés de saillies qui n'ont aucun heureux effet. Après tout, c'est uniquement le goût, ce don des Dieux si rare chez les hommes et que cependant chacun croit posséder, qui décide le plus sûrement de ces hardiesses et qui diffère du génie (si l'on entend par ce terme une riche et féconde invention) en ce que le goût peut acquérir par des méditations sur les ouvrages excellents et qui le génie ne s'acquiert jamais.

246. Jean-Denis Attiret, "Les jardins chinois," in Charles Le Gobien et al., eds., *Lettres édifiantes et curieuses ecrites des missions etrangeres par quelques missionnaires de la Compagnie de Jesus* (Paris: Nicolas le Clerc [etc.], 1703–76), 27:411–29.

247. Unsigned review of *A Philosophical Enquiry into the Origin of Our Ideas of*

the Sublime and Beautiful by Edmund Burke, *Journal encyclopédique,* 1 July 1757, 17: "L'Auteur de cet Ouvrage nous paroît homme de génie; ses idées sont neuves et hardies; son style est mâle et concis."

248. Cheselden, "An Account" (note 237); and Michael J. Morgan, *Molyneux's Question: Vision, Touch, and the Philosophy of Perception* (Cambridge: Cambridge Univ. Press, 1977).

249. "Art. VI, Cérémonies publiques," *Mercure de France,* October 1764, vol. 1, 211–12.

250. For the periodical reviews, see this volume, p. 502.

251. "Lettre V: *Histoire de la disposition et des formes différentes des temples, etc.,*" *L'année littéraire* 6 (1764): 118: "Que l'auteur répand les lumières du génie dans ce morceau qui prouve qu'il a une idée approfondie de tous les Arts, de leur liaison, de leur ensemble, de leur résultat!"

252. "Lettre V" (note 251), 121: "Tout ce qu'il nous dit sur les Péristiles annonce une supériorité de lumières dans cet Art qui décèle le grand maître."

253. "Lettre V" (note 251), 122: "Ses réfléxions critiques sont accompagnées de cette circonspection délicate que l'on doit aux grands hommes, dont on a le courage d'éclairer les défauts en reconnoissant le suprême ascendant de leur génie. M. *Le Roy* merite les plus grands éloges, et à titre d'Architecte et à titre d'homme de Lettres. Ce dernier morceau aux profondes connoissances de son art réunit la force et la beauté du style."

254. Fréret presented his paper over five sessions in January and February 1723, and it was later rewritten for posthumous publication in the academy's *Mémoires* by Fréret's disciple, Jean-Pierre de Bougainville; see Fréret, "Essai sur les mesures longues" (note 167).

255. For periodical reviews, see this volume, p. 502.

256. "Lettre IX: *Observations sur les edifices des anciens peuples, etc.,…,*" *L'année littéraire* 1 (1768): 203: "Je ne m'étendrai pas davantage sur cet écrit; il est rempli de recherches sçavantes, d'observations judicieuses et d'une critique éclairée."

257. Unsigned review of *Observations sur les edifices des anciens peuples…,* by Julien-David Le Roy, *L'avant coureur,* 8 February 1768, 84: "Ces différens morceaux forment une brochure aussi intéressante par le style que par la profondeur des vues, et la solidité des idées."

258. Unsigned review of *Observations sur les edifices des anciens peuples…,* by Julien-David Le Roy, *Journal encyclopédique,* April 1768, 86: "Tout ce morceau, ainsi que toutes les observations qu'on lit dans cet ouvrage, font un honneur infini aux talens, au goût et à l'érudition de l'auteur."

259. Unsigned review of *Observations sur les edifices des anciens peuples…,* by Julien-David Le Roy, *Journal des sçavans* (Paris) 2 (1768): 437: "Occupé depuis son Voyage de la Grèce à travailler sur les Anciens, à les examiner et à les comparer ensemble dans ce qu'ils disent de l'Architecture, de la construction des grands édifices, etc. il se propose dans la suite de nous donner ses réflexions sur ce sujet et sur ce qui concerne leur méchanique et leur marine."

260. Le Roy, *Ruines,* 1770 (note 17), 1:17:

Le goust que Périclès avoit donné aux Athéniens pour les arts, jeta encore quelques étincelles un siecle après sa mort; mais la grande révolution qu'ils devoient subir arriva: Alexandre changea la face de la Grece, et des parties de l'Asie et de l'Afrique, qu'il conquit; et les arts qui suivent la gloire et qui l'accroissent, allerent sur ses pas illustrer Alexandrie. Athenes alors déchue de la supériorité qu'elle avoit eue, ne tint plus que la seconde rang entre les villes célebres; la richesse dans les édifices succéda à la noble simplicité et au caractere mâle et majestueux qui régnoit dans ceux que Phidias, Ictines, Callicrates et Mnésiclès éleverent auparavant.

261. Le Roy, *Ruines*, 1770 (note 17), 2:49: "Il résulte donc de ce que nous venons de rapporter, que les Temples quarrés des Anciens de la même espece, étoient bien plus variés dans les masses et dans les proportions de leurs façades, qu'on ne pouvoit le penser, avant de connoître les ruines de la Grece, de la grande Grece, et de différentes villes de l'Asie."

262. Le Roy, *Ruines*, 1770 (note 17), 1:vii: "Un spectacle que nous offre l'Histoire des Arts, bien digne de piquer la curiosité de ceux qui aiment à en suivre les progrès, est de voir combien les idées primitives et originales de quelques génies créateurs ont influé sur les divers ouvrages, que les hommes ont faits dans la suite."

263. Pococke made no claims for a Phoenician provenance for the building represented in his drawing, describing the building merely as one of a number of rock-cut sepulchres at the site of Kuph in the region of Aleppo, Syria; see Richard Pococke, *A Description of the East and Some Other Countries*, vol. 2, pt. 1, *Observations on Palaestine or the Holy Land, Syria, Mesopotamia, Cyprus, and Candia* (London: printed for the author, by W. Bowyer, 1745), 147, pl. 24E.

264. Le Roy, *Ruines*, 1770 (note 17), 1:xxiii:

Les voûtes des nefs de leurs Eglises sont en général bien plus légeres et bien plus élevées que les nôtres; et ayant moins de poussée, elles n'exigent pas des piliers aussi forts pour les soutenir. C'est donc en marchant, à cet égard seul, sur les traces des Goths, c'est en faisant les recherches les plus étendues sur les matieres les plus résistantes, et en même temps les plus légeres avec lesquelles on peut construire des voûtes; c'est en ne distribuant que quelques massifs fort petits aux endroits où ces voûtes font les plus grands efforts, que les Architectes François s'efforcent de donner aux Eglises qu'ils bâtissent, un dégagement dont on ne croyoit pas qu'elles fussent susceptibles, en les décorant avec des Ordres Grecs, employés de la maniere la plus noble et la plus générale.

265. Jacques-François Blondel, *Cours d'architecture; ou, Traité de la décoration, distribution et construction des bâtiments; contenant les leçons données en 1750, et les années suivantes* (Paris: Desaint [etc.], 1771–77), 1:xix: "Cette introduction fera connoître l'origine, les progrès et les révolutions arrivées dans l'Architecture."

266. Blondel, *Cours* (note 265), 1:28: "ceux-là brûlant du desir de s'immortaliser, occupés d'ailleurs des difficultés de la main d'oeuvre, avoient négligé les finesses de l'exécution et méconnu les grâces de l'art; les autres donnerent à leurs productions cette régularité, cette correction, cette justesse qui satisfait l'âme, et présente un concert

admirable aux yeux du spectateur éclairé. En un mot, on peut regarder les Grecs comme les créateurs de l'Architecture proprement dite, et les considérer comme les premiers qui ayent été dignes d'avoir des imitateurs."

267. Blondel, *Cours* (note 265), 1:44–45: "Les Romains apprirent des Grecs à rendre leurs édifices réguliers, à y joindre la disposition et l'ordonnance: ils mirent tout en oeuvre pour surpasser leurs maîtres, mais ils ne parvinrent qu'à devenir leurs rivaux."

268. Blondel, *Cours* (note 265), 1:84: "La fondation de la Basilique de S. Pierre de Rome fut l'époque de la renaissance de la belle Architecture."

269. See J.H. Brumfitt, "Introduction," in Voltaire, *La philosophie de l'historie,* ed. J.H. Brumfitt, 2d ed., rev., vol. 59 of *Les oeuvres complètes de Voltaire = The Complete Works of Voltaire* (Geneva: Institut & Musée Voltaire, 1969), 13–80; and Chantal Grell, *L'histoire entre érudition et philosophie: Étude sur la connaissance historique à l'âge des lumières* (Paris: Presses Universitaires de France, 1993).

270. Anne-Robert-Jacques Turgot, baron de l'Aulne, "Plan de deux discours sur l'Histoire universelle (a)," in idem, *Oeuvres de Turgot et documents le concernant, avec biographie et notes,* ed. Gustave Schelle (Paris: Librairie Félix Alcan, 1913–23), 1:275–323.

271. Charles-Louis de Secondat, baron de Montesquieu, *The Spirit of the Laws,* trans. Thomas Nugent (New York: Hafner, 1949), bk. 18, chap. 1, 271 = Charles-Louis de Secondat, baron de Montesquieu, *L'esprit des loix,* in idem, *Oeuvres complètes,* ed. Roger Caillois (Paris: Gallimard, 1949–51), 2:531: "La bonté des terres d'un pays y établit naturellement la dépendance. Les gens de la campagne, qui y font la principale partie du peuple, ne sont pas si jaloux de leur liberté; ils sont trop occupés et trop pleins de leurs affaires particulières. Une campagne qui regorge de biens craint le pillage, elle craint une armée."

272. Montesquieu knew of Dubos's book early; he corresponded with Jean-Jacques Bel of Bordeaux on the subject in September 1726 and first formulated his ideas on taste then, to be taken up later in his "Essai sur le goût," which was begun about 1730 and, left unfinished at the time of Montesquieu's death in 1755, published posthumously in 1757 in Denis Diderot and Jean Le Rond d'Alembert, eds., *Encyclopédie; ou, Dictionnaire raisonné des sciences, des arts et des métiers ... par une société de gens de lettres* (Paris: Briasson, 1751–80), s.v. "goût." For the relationship between Montesquieu's work and that of Dubos, see Armin Hajman Koller, *The Abbé Du Bos — His Advocacy of the Theory of Climate; a Precursor of Johann Gottfried Herder* (Champaign, Ill.: Garrard, 1937); Warren Everett Gates, *Montesquieu and the Abbé Du Bos: Their Literary Relationship* (Ann Arbor: University Microfilms, 1958); and Shackleton, *Montesquieu* (note 175), 60.

273. Dubos, *Critical Reflections* (note 145), 2:178–79 = Dubos, *Reflexions critiques* (note 145), 2:228: "L'air que nous respirons communique au sang dans nostre poumon les qualités dont il est empraint."

274. Dubos, *Critical Reflections* (note 145), 2:224 = Dubos, *Reflexions critiques* (note 145), 2:287–88: "Je conclus donc de tout ce que je viens d'exposer, qu'ainsi qu'on attribuë la difference du caractere des nations aux differentes qualités de l'air de leurs pays, il faut attribuer de même aux changemens qui surviennent dans l'air d'un certain pays les variations qui arrivent dans les moeurs et dans le genie de ses habitants."

275. Jacques Bénigne Bossuet, *Discours sur l'histoire universelle à monseigneur le dauphin; pour expliquer la suite de la religion et les changemens des empires: Première partie, Depuis le commencement du monde jusqu'à l'empire de Charlemagne* (Paris: Sebastian Mabre-Cramoisy, 1681), 557; as quoted in Brumfitt, "Introduction" (note 269), 33: "Ce long enchaînement des causes particulières qui font et défont les empires, dépend des ordres secrets de la divine Providence."

276. Antoine Furetière, ed., *Dictionaire universel, contenant generalement tous les mots françois tant vieux que modernes, et les termes de toutes les sciences et des arts…* (The Hague: Arnout & Renier Leers, 1690), s.v. "Histoire": "HISTOIRE, à l'égard des actions, se dit de cette narration veritable suivie et enchaînée de plusiers évenemens mémorables." This definition appears in the first edition, of 1704, of the so-called *Dictionnaire de Trévoux,* which was nearly a reprint of Furetière's work; the seventh and final edition of the *Dictionnaire de Trévoux* appeared in 1771.

277. Bossuet, *Discours* (note 275), 443; as quoted in Brumfitt, "Introduction" (note 269), 63: "une nation grave et sérieuse."

278. Nicolas Lenglet Dufresnoy, *Méthode pour étudier l'histoire…,* new ed. (Amsterdam: aux depens de la Compagnie, 1737), 2:131: "l'architecture y montroit partout cette noble simplicité, et cette grandeur qui remplit l'esprit. De longues galeries y étaloient des sculptures, que la Grèce prenoit pour modèles. Thèbes le pouvoit disputer aux plus belles villes de l'Univers."

279. Voltaire, *La philosophie de l'historie,* ed. J. H. Brumfitt, 2d ed., rev., vol. 59 of *Les oeuvres complètes de Voltaire = The Complete Works of Voltaire* (Geneva: Institut & Musée Voltaire, 1969), 165: "Ils connurent le grand, et jamais le beau. Ils enseignèrent les premiers Grecs, mais ensuite les Grecs furent leurs maîtres en tout quand ils eurent bâti Alexandrie."

280. Bossuet, *Discours* (note 275), 485–84: "Mais ce que la Grece avoit de plus grand estoit une politique ferme et prévoyante, qui sçavoit abandonner, hasarder et defendre ce qu'il falloit; et ce qui est plus grand encore, un courage que l'amour de la liberté et celuy de la patrie rendoit invincible."

281. Nicolas Lenglet Dufresnoy, *Méthode pour étudier l'histoire avec un catalogue des principaux historiens…,* ed. Étienne François Drouet (Paris: Debure pere & N. M. Tilliard, 1772), 4:95: "Athènes, l'inventrice des arts, des sciences et des loix, le siége de la politesse et du savoir, le théâtre de la valeur et de l'éloquence, l'école publique de tous ceux qui ont aspiré à la sagesse; plus fameuse par l'esprit de ses habitans, que Rome ne l'est devenue par ses conquêtes, doit ses commencemens à l'Egypte et à la personne de Cécrops, originaire de la ville de Saïs dans le Delta." The legendary half-man, half-snake Cecrops is said to have been the first ruler of Athens.

282. Voltaire, *La philosophie* (note 279), 175: "La belle architecture, la sculpture perfectionnée, la peinture, la bonne musique, la vraie poésie, la vraie éloquence, la manière de bien écrire l'histoire, enfin, la philosophie même, quoiqu'informe et obscure, tout cela ne parvint aux nations que par les Grecs."

283. Jean-Francois Félibien, *Recueil historique de la vie et des ouvrages des plus celebres architectes* (Paris: Veuve de Sebastien Mabre-Cramoisy, 1687), 30–31: "Temple de Minerve appelé *Parthenone,* c'est à dire, le Temple de la *Vierge.*"

284. The missiting of the Labyrinth on Lake Moeris and their conjunction with the

Egyptian city of Thebes derives from Benoît de Maillet, *Description de l'Egypte, contenant plusieurs remarques curieuses sur la géographie ancienne et moderne de ce païs, sur ces monumens anciens, sur les moeurs...*, ed. Jean-Baptiste Le Mascrier (Paris: Louis Genneau & Jacques Rollin fils, 1735), esp. 266, 285–86, 300, map facing p. 1. Though Maillet was French consul in Cairo for sixteen years, beginning in 1692, he seems to have ventured no farther south than Al Fayyum. He was, however, one of the first writers to appreciate the Islamic architecture of Cairo. Lake Moeris was taken up at the Académie royale des inscriptions et belles-lettres by Joesph-Balthasar Gibert, "Dissertation sur le lac de Moeris" (read 19 November 1754), *HistMemBL* 28 (1761): *Mémoires*, 225–45 (with a map). For the French exploration of Egypt, see Jean-Marie Carré, *Voyageurs et écrivains français en Egypte*, 2d ed., 2 vols. (Cairo: Imprimerie de l'Institut Français d'Archéologie Orientale, 1956).

285. Charles Rollin, *Histoire ancienne des Egyptiens, des Carthaginois,..., des Grecs* (Paris: Veuve Estienne, 1740–51), 5:565: "Cependant ce n'est ni à l'Asie ni à l'Egypte que cet art est redevable de ce degré de perfection où il est parvenu.... c'est à la Grèce qu'on en attribue, sinon l'invention, du moins la perfection; et que c'est elle qui en a prescrit les règles, et fourni les modèles." On Rollin, see Louis Henri Ferté, *Rollin, sa vie, ses oeuvres et l'université de son temps* (Paris: Libraire Hachette, 1902), who on page 313 cites a similar phrase from Rollin's *Traité des études:* "C'est en Grèce... que se sont formés toutes les sciences, tous les arts, et que la plupart se sont perfectionnés" (It was in Greece that all the sciences, all the arts, were formed, and for the most part perfected); I have been unable to locate this phrase in the *Traité*.

286. Rollin, *Histoire* (note 285), 5:567: "bien éloignés du prix et de l'excellence des trois autres." Rollin's book was re-edited or revised nine times in Paris during the course of the eighteenth century, twice in The Hague, twice in Amsterdam. It was translated into English twice, in 1759 and in 1768, and into Italian in 1776.

287. Before the translation of Stanyan's history there was little available in France by way of a history of Greece, though Antoine Pagi had written a provocative "Discours sur l'histoire grecque" as an introduction to his *Histoire de Cyrus le jeune, et de la retraite des dix mille...* (Paris: Didot, 1736). Pagi recounts that he was inspired to learn Greek by reading Homer—"Je ne pus voir la nature si vive, si noble, si féconde dans Homère, sans être saisi d'admiration" (I could not see nature so alive, so noble, so fertile in Homer without being struck with admiration) (p. viii)—and determined to find out all he could on the Greeks who had brought so many arts to a state of perfection, but the more he read, the more complex the history, or rather the lack of it, became. He decided to write one of his own, reducing the history of Greece to the history of Athens alone: "Je m'aperçus d'abord que ce n'étoit point précisément l'Histoire d'un Peuple ou d'une Nation que j'avois à écrire, mais l'Histoire de l'*Esprit Humain*, dont on voit à Athenes la naîssance, le progrès, la perfection, et pour ne rien cacher, la décadence et la froide vieillesse" (I realized, first, that it was not exactly the history of a people or a nation that I had to write, but the history of the *human spirit,* whose birth, progress, perfection, and, to deny nothing, decadence and frigid old age can be seen in Athens) (p. xi). The history of Greece begins, effectively, when people gather in villages and towns for protection. Theseus abolished all distinctions: "Il réduisit son peuple à l'*égalité*" (He reduced his people to *equality*) (p. xv). The names of the early kings are

thus unimportant. The people together made the decisions. The people might have admired Pericles and Alcibiades, but they treated them as equals. Plato, of course, did not approve of such easy familiarity; he preferred hierarchy. Athens, however, owed its glory to the laws of Solon, rather than to any military victory: "La plupart des Villes de la Grèce, de la Côte Asiatique, les Romains mêmes, s'empressèrent de copier un si beau Gouvernement" (Most of the cities of Greece, of the Asiatic coast, and even the Romans, were eager to copy so fine a government) (pp. xxi–xxii). The very achievements of Athens, however, made the Lacedaemonians jealous. They were an austere race, aiming for virtue alone, without luxury or spectacle. Inevitably, they opposed the Athenians. And they beat them. This rivalry enabled Thebes to emerge in Boeotia, but its glory was eclipsed in turn by Philip II of Macedonia. His son, Alexander the Great, considered that the prince of Athens should be the prince of the world, and he aimed for that. There was a late flowering of the arts in Athens, but "Les Arts panchoient vers leur déclin, à-mesure qu'on en fixoit mieux les règles. La décadence des Moeurs entraîna celle des Esprits; on n'eut plus de pensées sublimes, dès-qu'on manqua par les sentimens. Et voilà la grande cause de la chute du Sublime que cherchoit Longin, et non le changement du Gouvernement" (The arts tended to decline, as the rules became better fixed. The decadence of morals led to that of minds; as soon as feelings slackened, no one had sublime thoughts anymore. And that is the main cause of the fall from the sublime that Longinus held dear, and not the change of government) (p. xxix). Athens, in the end, was conquered by Rome. Pagi's history, echoing so many of the themes explored in this introduction, was more widely known than one might expect. Antoine-François Prévost devoted seventeen pages to a summary of it in *Le pour et contre*, no. 106 (1736): 3–20.

Even in the decades after the appearance in 1743 of Diderot's translation of Stanyan, there was little enough on the history of Greece published in France. In 1749 Gabriel Bonnot, abbé de Mably, published *Observations sur les grecs* (Geneva: Compagnie des Libraires, 1749), later republished, in greatly revised form, as *Observations sur l'histoire de la Grèce; ou, Des causes de la prospérité et des malheurs des Grecs* (Geneva: Compagnie des Libraires, 1766). He admired Sparta rather than Athens, but was none too complimentary about either. There was little more until the 1780s, when two multivolume works, both titled *Histoire générale et particulière de la Grèce* appeared, one published by Louis Cousin-Despréaux, between 1780 and 1789, the other by Jean B. Claude Izouard, known as Delisle de Sales, in 1783. Neither work was of any distinction. The critical stance of these works was maintained in Cornelis de Pauw's *Recherches philosophiques sur les grecs* (Berlin: G. J. Decker, 1788), who wrote, "il faut renoncer à jamais au préjugé où sont encore aujourd'hui de prétendus Savans, qui s'imaginent sérieusement qu'Athènes étoit la plus superbe ville de l'univers" (one must give up for all time the prejudice still upheld by so-called scholars, who seriously imagine that Athens was the finest city in the world) (p. 55). The aristocrats, Pauw noted, lived outside the town, which was largely made up of hovels. Pericles squandered too much money on gold and ivory, encouraging too many artists and craftsmen to settle in the town (p. 65). Of the great architecture, Pauw had nothing to say.

288. Rollin, *Histoire* (note 285), 1:6: "La premiere chose que je dois faire en commençant d'écrire dogmatiquement sur l'histoire est d'en établir la vérité et la certitude,

pour faire voir à ceux qui l'étudient, qu'en s'y appliquant ils travaillent sur un fond réel; capable non-seulement de perfectionner l'esprit; mais propre encore à les instruire de tous les devoirs de la vie civile, et à les affermir même dans les maximes de la religion."

289. Voltaire, *Articles pour l'Encyclopédie*, ed. Theodore E. Braun et al., in idem, *Les oeuvres complètes de Voltaire = The Complete Works of Voltaire*, vol. 33, *Oeuvres alphabétiques*, ed. Jeroom Vercruysse (Oxford: Voltaire Foundation, 1987), 164: "HISTOIRE, s. f. c'est le récit des faits donnés pour vrais; au contraire de la fable, qui est le récit des faits donnés pour faux."

290. Chantal Grell, "J.-D. Le Roy et l'histoire de l'architecture grecque," in Yannis Tsiomis, ed., *Athènes, ville capitale*, vol. 2 of *Athènes, affaire européenne* (Athens: Ministère de la Culture, Caisse des Fonds Archaeologique, 1985), 86–89.

291. See, for example, "Sur le diamètre apparent du soleil" (1752), *HistMemSci* (1756): *Histoire*, 95–103; "Sur le diamètre apparent du soleil" (1755), *HistMemSci* (1761): *Histoire*, 93–103; and "Mémoire sur le diamètre apparent du soleil et sur la grandeur réelle" (1760), *HistMemSci* (1766): *Histoire*, 120–24.

292. Pierre Bouguer, "Recherches sur la grandeur apparente des objets" (read January 1755), *HistMemSci* (1761): *Mémoires*, 99–112.

293. Pierre Bouguer, "Solutions des principaux problèmes de la manoeuvre des vaisseaux" (read 1754), *HistMemSci* (1759): *Mémoires*, 342–68; and Pierre Bouguer, "Second mémoire sur les principaux problèmes de la manoeuvre des vaisseaux" (read 26 July 1755), *HistMemSci* (1761): *Mémoires*, 355–69.

294. Alexis-Claude Clairaut, "Nouvelle solution de quelques problèmes sur la manoeuvre des vaisseaux" (read 26 March 1760), *HistMemSci* (1766): *Mémoires*, 171–78.

295. Marivetz and Goussier, *Physique du monde* (note 209), 4:539–40, "Expérience de M. le Roi, de l'Académie royale des sciences," reported by Bonnet.

296. Charles Le Roy, "Mémoire sur le méchanisme par lequel l'oeil s'accomode aux différentes distances des objets" (read 1755), *HistMemSci* (1761): *Mémoires*, 594–602; reprinted in Charles Le Roy, *Mélanges de physique et de médecine* (Paris: P. G. Cavelier, 1771), 99–122.

297. There is no record of this paper in the *Histoire* or the *Mémoires* published by the Académie royale des sciences; see Charles Le Roy, "Second mémoire sur la vision, considérée relativement aux différentes distances des objets," in idem, *Mélanges de physique et de médecine* (Paris: P. G. Cavelier, 1771), 123–50. Charles apparently carried his somewhat individual experimental approach into his medical practice: Dufort de Cheverny reported that he administered opium to his mother-in-law, much to her physician's surprise and to her detriment; see Dufort de Cheverny, *Mémoires* (note 175), 1:414.

298. Jean Bodin, *Method for the Easy Comprehension of History*, trans. Beatrice Reynolds (New York: Columbia Univ. Press, 1945), 89.

299. Badinter, *Les passions intellectuelles* (note 209), 132.

300. On Maupertuis, see Laurent Angliviel de La Beaumelle, *Vie de Maupertuis...*, ed. Maurice Angliviel (Paris: Ledoyen, 1856); and Pierre-Louis Moreau de Maupertuis, *Oeuvres*, new ed., 4 vols. (Lyon: n.p., 1768; Hildesheim: Georg Olms, 1965–74). On Maupertuis's interest in reproduction and race, see Bentley Glass, "Maupertuis and the Beginnings of Genetics," *Quarterly Review of Biology* 22, no. 3 (1947): 196–210; and

Emile Guyénot, *Les sciences de la vie aux XVIIᵉ et XVIIIᵉ siècles: L'idée d'évolution* (Paris: A. Michel, 1941).

301. On Buffon, see Jacques Roger, *Buffon, un philosophe au Jardin du roi* (Paris: Fayard, 1989), translated as *Buffon, a Life in Natural History*, trans. Sarah Lucille Bonnefoi, ed. L. Pearce Williams (Ithaca: Cornell Univ. Press, 1997); see also Jacques Roger, *Les sciences de la vie dans la pensée française du XVIIIᵉ siècle: La génération des animaux de Descartes à l'Encyclopédie*, 2d ed. (Paris: Armand Colin, 1971). The easiest approach to Buffon's compendious writings is *Oeuvres philosophiques de Buffon*, ed. Jean Piveteau, with Maurice Fréchet and Charles Bruneau (Paris: Presses Universitaires de France, 1954). For a summary of Buffon's achievement, see Otis Fellows, "Buffon's Place in the Enlightenment," in *Transactions of the First International Congress on the Enlightenment*, Studies on Voltaire and the Eighteenth Century, vols. 24–27 (Geneva: Institut & Musée Voltaire, 1963), 603–29. For Buffon's "Variétés dans l'espèce humaine," see *Oeuvres philosophiques de Buffon*, 312–13.

302. Voltaire, *La philosophie* (note 279), 92: "Il n'est permis qu'à un aveugle de douter que les Blancs, les Nègres, les Albinos, les Hottentots, les Lapons, les Chinois, les Américains, soient des races entièrement différentes."

303. Voltaire, *Traité de métaphysique*, ed. W. H. Barber, in idem, *Les oeuvres complètes de Voltaire = The Complete Works of Voltaire*, vol. 14, *1734–1735*, eds. Ulla Kölving, Andrew Brown, and Janet Godden (Oxford: Voltaire Foundation, 1989), 423:

> Il me semble alors que je suis assez bien fondé à croire qu'il en est des hommes comme des arbres; que les poiriers, les sapins, les chênes et les abricotiers ne viennent point d'un même arbre, et que les blancs barbus, les nègres portant laine, les jaunes portant crins, et les hommes sans barbe ne viennent pas du même homme.
>
> (It seems to me, then, that I have solid grounds for believing that what is true of trees is also true of men; that pear trees, pines, oaks, and apricot trees do not come from the same tree, and that white men with beards, black men sprouting wool, yellow men with pigtails, and beardless men do not all come from the same man.)

Traité de métaphysique, written about 1734 or 1735, was first published in 1784 in volume 32 of *Oeuvres complètes de Voltaire*, ed. Pierre Augustin Caron de Beaumarchais; Jean-Antoine-Nicolas de Caritat, marquis de Condorcet; and Jacques Joseph Marie Decroix ([Kehl, Germany]: Imprimerie de la Société Littéraire-Typographique, 1784–89).

304. Jacques de Vitry, *Libri duo, quorum prior orientalis, sive Hierosolymitanae, alter, occidentalis historiae nomine inscribitur* (Douai, France: Balthazaris Belleri, 1597; reprint, Farnborough, England: Gregg, 1971), 216: "Nos autem nigros Aethiopes turpes reputamus: inter ipsos auté qui nigrior est, pulchrior ab ipsis iudicatur."

305. André, *Essai sur le beau*, 1767 (note 226), 9: "Il y a des Peuples noirs, et il y en a de blancs, et chacun n'a point manqué de prendre parti selon les intérêts de son amour-propre. Je viens de lire le discours d'un Nègre, qui donne sans façon la palme de la beauté au teint de sa nation." No doubt the account André references is in one of the three volumes of *Pour et contre* for 1736, as André indicates, but I have been unable to find it. In volume 6, of 1735, following an account of the Peru expedition, a story is recounted, from some unspecified writer, of a viceroy who developed a passion for a local woman, opposed both by her father and by the elders of the tribe: "il n'explique

point si la fille étoit Chrétienne, mais il assûre que c'étoit une beauté des plus noires, et il prend occasion de cet exemple pour vanter les charmes des Belles de cette couleur" (he does not explain whether the girl was Christian, but he is sure that this was one of the blackest beauties, and he takes occasion of this example to praise the charms of beauties of this color); see *Pour et contre* 6, no. 77 (1735): 35. In this same volume, Prévost summarized a tract, encouraging sedition, by a freed slave in Jamaica, though he suspects the author to be a Cuban or a native of Santo Domingo: "Quel avantage," the author writes of the oppressors, "croyent-ils tirer de leur fade et dégoutante blancheur, sur la couleur noble et majestueuse que nous avons reçûë de la nature? Si la délicatesse est une mérite, nous avons la peau aussi douce que leur velours. Est-il question des qualitez vraiment viriles? Considérez vos tailles; et vos forces. En quoi vous surpassent-ils?" (What advantage do they think to draw from their insipid and disgusting whiteness, on the noble and majestic color that we have received from nature? If delicacy is a merit, we have skin as soft as their velvet. Is it a question of truly virile qualities? Consider your size; and your strength. In what do they surpass you?)— apparently in no more than wiles and industriousness; see *Pour et contre* 6, no. 90 (1735): 343.

306. Voltaire, *Dictionnaire philosophique*, vols. 47–55 of *Oeuvres complètes de Voltaire*, ed. Pierre Augustin Caron de Beaumarchais; Jean-Antoine-Nicolas de Caritat, marquis de Condorcet; and Jacques Joseph Marie Decroix ([Kehl, Germany]: Imprimerie de la Société Littéraire-Typographique, 1784–89), 53:500: "Le premier nègre pourtant, fut un monstre pour les femmes blanches, et la première de nos beautés fut un monstre aux yeux des Nègres." This version of the *Dictionnaire philosophique* is an amalgam, created by the editors of the Kehl edition, of *Dictionnaire philosophique portatif* (1764), *Questions sur l'Encyclopédie* (1770–72), *Lettres philosophiques* (1733), and other miscellaneous materials, published and unpublished; see Theodore Besterman, *Voltaire* (London: Longmans, 1969), 435.

307. Copies were available by the end of November 1769. For a list of the notices and reviews, see this volume, p. 502.

308. Unsigned review of *Les ruines des plus beaux monuments de la Grece*, 2d ed., by Julien-David Le Roy, *L'avant coureur*, 11 December 1769, 786: "l'Auteur les a enrichis d'observations intéressantes, et de principes sçavamment discutés qui conduisent à une théorie également simple, lumineuse et féconde."

309. Unsigned review, *L'avant coureur* (note 308), 787: "très-pittoresque et très-satisfaisantes."

310. Unsigned review of *Les ruines des plus beaux monuments de la Grece*, 2d ed., by Julien-David Le Roy, *Mercure de France*, January 1770, vol. 1, 177: "des pieces très-pittoresques et très-satisfaisantes des plus beaux monumens qui nous restent de l'architecture des Grecs, nos maîtres dans les beaux arts."

311. Unsigned review, *Mercure de France* (note 310), 177–78:

Quoi de plus avantageux encore que de déterminer la liaison qu'ont les principes qui font la base de l'architecture grecque avec ceux qui, dans cet art, tiennent aux loix de la méchanique, ou qui dépendent de la nature de notre ame et de nos organes, et souvent de l'habitude que nous contractons en voyant les objets

répandus le plus généralement sur la surface de notre globe? C'est aussi ce que M. le Roi s'est proposé d'examiner dans ses deux essais, l'un sur l'histoire, l'autre sur la théorie de l'architecture, qui sont à la tête de chacun des volumes de cet ouvrage. Ces discours sont remplis de nouvelles réflexions sur les arts en général et sur l'architecture en particulier. Ces réflexions sont celles d'un artiste éclairé, d'un observateur intelligent et d'un homme de goût.

312. Unsigned review of *Les ruines des plus beaux monuments de la Grece* (1770), by Julien-David Le Roy, *Journal encyclopédique*, March 1770, 367: "La sagesse que M. Le Roi met dans la critique à l'égard des voyageurs qui l'avoient précédé en Grèce, et avec lesquels il ne se trouve pas toujours d'accord, fait autant l'éloge de son coeur, que son ouvrage en fait à son esprit et à son zèle pour les progrès des arts."

313. Unsigned review, *Journal encyclopédique* (note 312), 355: "Il faudroit copier tout ce que M. L. R. dit des effets que produisent les péristyles; tous ses principes pris dans la matière, devroient être gravés dans l'ame des Artistes."

314. Royal Institute of British Architects (RIBA), Chambers Letters, CHA.2/1–77: 27 (Le Roy to Chambers, 12 October 1769), 30 (L to C, 26 November 1769), 66 (L to C, 20 July 1775), 67 (L to C, 24 December 1775); all these letters are originals.

British Library (BL), Letter-books of Sir William Chambers, vol. 1 (Add. MS 41133): 83 (Chambers to Le Roy, 10? September 1772), 85 (C to L, 18 September 1772), 89b (C to L, before or on 27 November 1772), 110 (C to L, on or after 27 August 1773), 122b (C to L, 8 February 1774); vol. 2 (Add. MS 41134): 7b (C to L, 18 September 1772; copy of letter 85 in vol. 1), 8b (L to C, 24 October 1774), 11b (L to C, 16 December 1772), 15 (C to L, 5 January 1773), 24 (C to L, 14 May 1773), 29 (L to C, 15 July 1773), 36b (C to L; copy of letter 110 in vol. 1); vol. 3 (Add. MS 41135): 73b (L to C, 20 July 1775; copy of RIBA CHA.2/1–77: 66).

315. On 27 August 1773, Chambers wrote a letter of recommendation for Stevens to Le Roy (BL Add. MS 41133: 110); later, on 8 February 1774, he thanked Le Roy for the kindness shown to Stevens in Paris, in particular introducing him to Soufflot (BL Add. MS 41133: 122b). Stevens and his wife traveled on to Italy, reaching Florence in January 1774; they moved thence to Rome and Naples and back to Rome, where Stevens died on 27 June 1775, aged no more than thirty-one.

316. *A Catalogue of the Valuable Library of Robert Wood, Esq.;…which Will Begin to Be Sold by Auction, by S. Baker and G. Leigh, Booksellers,… on Wednesday, April 22, 1772, and to Continue the Three Following Days*, lots 219, 575, 576.

317. RIBA CHA.2/1–77: 36 (Hoare to Chambers, 29 May 1770).

318. RIBA CHA.2/1–77: 30 (Le Roy to Chambers, 26 November 1769):

Les deux essais sur l'histoire et sur la théorie de l'architecture contiennent des choses que vous avez déja lues, mais ils en contiennent d'autres que vous ne connaitre pas: et comme ils roulent sur une matière qui doit vous interesser, je crois que vous pouvez prendre quelque plaisir à les lire. Si vous avez du loisir vous pourrez encore lire tout ce qui a rapport dans le second volume à la XXV planche, et enfin si vous êtes curieuse de connaître les articles essentiels de ma reponse à Stuart vous pouvez lire dans le second volume depuis le page 6 jusqu'à la 23, ou 24ème.

319. James Caulfeild, first earl of Charlemont, *The Manuscripts and Corres-pondence of James, First Earl of Charlemont*, vol. 1, *Lord Charlemont's Memoirs of His Political Life, 1755–1783; Correspondence, 1745–1783,* ed. John Thomas Gilbert, Historical Manuscripts Commission, Report, 12th, Appendix, Part 10 (London: printed for H. M. Stationery Office, by Eyre & Spottiswoode, 1891), 1:298 (letter 106). I am indebted to John Harris for finding for me the source of this quotation.

320. BL Add. MS 41134: 1 (Chambers to Voltaire, 3 July 1772); for Chambers's remarks on Voltaire's response, see BL Add. MS 41135: 85 (Chambers to Le Roy, 18 September 1772).

321. On Thomas Major, see note 22.

322. BL Add. MS 41133: 85 (Chambers to Le Roy, 18 September 1772).

323. BL Add. MS 41134: 8b (Le Roy to Chambers, 24 October 1772): "J'ai recu la caisse de vos livres en tres bon etat. Votre livre m'a paru infiniment interessant, soit par la grand nombre d'idées neuves qu'il contient, soit par la manière poetique avec laquelle elles sont presentées."

324. The comtesse de Tessé laid out a picturesque garden in these years at her Château de Chaville, perhaps to the design of Boullée; see Jean-Marie Pérouse de Montclos, *Etienne-Louis Boullée,* rev. ed. (Paris: Flammarion, 1994), 219–20 (cat. no. 16).

325. Monsieur de la Rochette wrote to Chambers on 29 July 1772, to assure Chambers that he owed nothing for the translation of the book (RIBA CHA.2/1–77: 39). Chambers inquired of Le Roy his opinion of the translation on 14 May 1773 (BL Add. MS 41134: 24).

326. BL Add. MS 41134: 29 (Le Roy to Chambers, 15 July 1773): "Votre reponse de Tan Chetqua que j'ai lue avec empressement m'a paru tout a fait ingenieuse. Le portrait que vous faites de cet homme extraordinaire est tres plaisant, et j'ai trouvé dans son discours des morceaux tres poetiques et des comparaisons sublimes."

327. BL Add. MS 41134: 29 (Le Roy to Chambers, 15 July 1773): "quelques expressions qui ne sont pas assez nobles."

328. BL Add. MS 41133: 122b (Chambers to Le Roy, 8 February 1774). Chambers intended, he informed Le Roy, to inspect the stair at the Château des Ormes, which de Wailly had just completed, on his way to Paris. He himself had done a design for the stair two years before, but, Chambers noted, "celui la quoique fort leger ne se pouvoit pas suspendre en l'air comme le tombeau de Mahomet, de Waillie aura apparament rencheri sur ma construction ou inventé une nouvelle de sa façon dont les architectes jusqu'a present n'ont eu aucune idée" (that one, though very light, could not float in the air like Muhammad's tomb; de Wailly has apparently improved on my structure or invented a new one of his own of which architects up to now had no idea). On the stair, see John Harris, "Sir William Chambers and His Parisian Album," *Architectural History* 6 (1963): 54–90; and Monique Mosser and Daniel Rabreau, eds., *Charles de Wailly: Peintre architecte dans l'Europe des lumières,* exh. cat. (Paris: Caisse Nationale des Monuments Historiques & des Sites, 1979), 43–44.

329. Harris, "Sir William Chambers" (note 328); and Barrier, "Chambers in France and Italy" (note 10); see also note 331.

330. RIBA CHA.2/1–77: 66 (Le Roy to Chambers, 20 July 1775): "je ne suis pas

riche de mon bien, je ne recois pas de forts appointemens du Roi, pour ma place et on ne me les paye qu'après trois années, et je n'ai trouvé d'autre moyen de supleer aux petites depenses extraordinaires que je suis oblige de faire, qu'en echangeant autant que je le puis pour de l'argent tout ce qui ne m'est pas d'une nécessité indispensable."

331. Despite the scrappy nature of Le Roy's list, there is little doubt as to the titles of the books and the dates of the editions, as Chambers was paid for all of them in December 1775, by the Royal Academy of Arts, of which he was treasurer. The volume of works by David Teniers the Elder, it should be noted, was not listed separately by Le Roy; it seems to have been lumped together with the volume of Anthony van Dyck's portraits: the price of this last was higher than most of the other books listed, and the two books were listed and charged as one item by Chambers; the two books were, in addition, issued by the same publisher, Arkstée and Merkus. Chambers was paid on 21 May 1774 for the books he had purchased while in Paris, indicating that his visit was a month or two earlier than is usually thought; see Royal Academy of Arts, RA Archives, "Cash Book 1769–1795," 409. I am greatly indebted to Nicholas Savage, librarian to the Royal Academy of Arts, for helping to identify the books and for inspecting the accounts.

332. Hester Lynch Piozzi and Samuel Johnson, *The French Journals of Mrs. Thrale and Doctor Johnson,* ed. Moses Tyson and Henry Guppy (Manchester: Manchester Univ. Press, 1932), 99.

333. Piozzi and Johnson, *The French Journals* (note 332), 169, 113.

334. Piozzi and Johnson, *The French Journals* (note 332), 172, 116. For a brief history of the Hôtel de Voyer d'Argenson, see Mosser and Rabreau, eds., *Charles de Wailly* (note 328), 44–45.

335. Piozzi and Johnson, *The French Journals* (note 332), 149.

336. On Le Roy's academic activity, see Henry Lemonnier, ed., *Procès-verbaux de l'Académie royale d'architecture, 1671–1793,* 10 vols. (Paris: Jean Schemit [etc.], 1911–29). The index in volume 10 is extremely useful, albeit incomplete and not altogether accurate.

337. Le Roy reported to the Académie royale d'architecture on the following manuscripts, publications, design projects, and inventions:

1760	Jérôme Beausire's papers, left behind on his departure for Santo Domingo
	designs for a hospital at Montpellier, one by Jean-Antoine Giral, the other by an architect surnamed Carcenac
1762	the manuscript of Nicolas-Marie Potain's treatise on construction (now at the Centre canadien d'architecture, Montreal; see Robin Middleton, "Architects as Engineers: The Iron Reinforcements of Entablatures in Eighteenth-Century France," *AA Files,* no. 9 [1985]: 54–64)
	Gabriel-Pierre-Martin Dumont's engravings of Saint Peter's
1763	designs for French orders by Gimaray and by Charles Dupuis
1764	the design of Pierre-Louis Moreau-Desproux's grilles for the court of the Palais-Royal, Paris
	proposals for Saint Sulpice
	rules and set-squares of iron by Sr. Boussard
	a ventilation system by Ennemond Alexandre Petitot

1765 Pierre Patte's *Monuments érigés en France à la gloire de Louis XV*
 the sixth part of Jean-François de Neufforge's *Livre d'architecture*
 Laurent Desboeuf's *Mémoire contenant des observations sur la nouvelle
 église de Sainte-Geneviève* (judged "indécente, peu refléchie et remplie
 de faussetés")
 mills powered by the tide for grinding corn and cutting timber invented by
 Sr. Macary of Rochefort
1766 a system for bending glass by N. Bernières
1767 the second edition of Nicolas-Marie Potain's *Traité des ordres d'architecture*
1768 Jean-François-Thérèse Chalgrin's plans for Église Saint-Philippe-du-Roule
1770 a proposed spire for the Mainz cathedral
1771 Tommaso Temanza's *Vita di Vincenzio Scamozzi*
 a *mémoire* by Count Carl Johan Cronstedt on Swedish stores
1772 "Architecture raisonné dans sa théorie," a manuscript by Nicolas Maillier
 (now at the Avery Architectural and Fine Arts Library of Columbia
 University, New York)
 Nicolas Fourneau's *L'art du trait du charpenterie*
1774 a *mémoire* by Nicolas-Marie Potain on the instruction of students
1779 Jean Antoine's *Traité d'architecture; ou, Proportions des trois ordres grecs*
 the plates for the second edition of Antoine Babuty Desgodets's *Les
 édifices antiques de Rome*
1780 the plates for Jacques Gondoin's *Description des écoles de chirurgie*
1781 a fire hydrant by the garden designer Thomas Blaikie
 a pump by Sr. Charpentier
1785 "Antiquities de Nîmes," a manuscript by François Franque
 designs for the choir of the Laon cathedral
 designs for baths at Bagnères-de-Luchon
1787 an iron bridge

338. At the Académie royale d'architecture, Le Roy read from the *Ruines* on
18 June and 13 August 1759 (on the Propylaia and the ruins at Thorikos, the Doric and
Tuscan orders, and the proportioning of pediments) and on 4 February 1760 (on the
Parthenon and, in particular, on the design of its mutules). He read from the *Histoire*
on 13 and 20 August 1764 (the first chapter) and from the *Observations* on 25 April
and 2 and 9 May 1768 (on the generative forms of antique architecture, on Solomon's
temple, and his own response to the works of Sayer and Stuart). The second edition
of the *Ruines* was presented on 20 November 1769, and the discourse on theory was
read on 23 July 1770. A copy of the revised *Ruines* was given as a student prize in
February 1782. *La marine des anciens peuples* (1777) was given on 11 August 1777;
and *Nouvelles recherches sur les vaisseaux longs des anciens* (1786) on 12 June 1786.
Le Roy also presented works by his brother Jean-Baptiste—on 3 February 1784, he pre-
sented Jean-Baptiste's joint report on Joseph Michel and Jacques Etienne Montgolfier's
hot-air balloon, which had been prepared for the Académie royale des sciences in 1783;
and on 14 April 1788, he presented his brother's design for an ideal hospital, drawn up
by the architect Charles-François Viel de Saint-Maux, dismissed by Jean-Sylvain Bailly's

select committee on hospital designs (the design was presented to the Académie royale des sciences in April 1788). Jean-Baptiste's rival, Jacques Tenon, the famous surgeon, who wanted no ideal solutions but rather designs tailored to particular needs, quickly tendered his *Mémoires sur les hôpitaux de Paris* on 1 September 1788, and the members of the academy were pleased to accept it. On this project, see Louis S. Greenbaum, "Tempest in the Academy: Jean-Baptiste Le Roy, the Paris Academy of Sciences, and the Project for a New Hôtel-Dieu," *Archives internationales d'histoire des sciences* 24 (1974): 122–40; see also Robin Middleton "Sickness, Madness, and Crime as the Grounds of Form," *AA Files*, no. 24 (1992): 18–20.

339. Jardin's designs for the Frederikskirke in Copenhagen were shown to the Académie royale d'architecture in January 1763. Chambers's *Treatise on Civil Architecture* was presented to the academy on 30 July 1759, three months after its publication, and a translation of part of its preface, done at the behest of Le Roy, was read by Le Roy even before Chambers was elected in 1762. Chambers's *Dissertation on Oriental Gardening* was presented on 16 November 1772, and its preface read on 1 December 1772.

340. Le Roy presented an *éloge* for Antoine-Mathurin Le Carpentier in 1773, Jacques-François Blondel in 1774, Louis de Règemort in 1775, Charles Lécuyer and Jacques-Germain Soufflot in 1780, Pierre Contant-d'Ivry in 1781, and Ange-Jacques Gabriel, somewhat tardily, in 1791.

341. Friedrich Melchior, Freiherr von Grimm, and Denis Diderot, *Correspondance littéraire, philosophique et critique, adressée à un souverain d'Allemagne: Première partie, depuis 1753 jusqu'en 1769* (Paris: F. Buisson, 1813), 5:479: "contrôle de bâtimens de quelque maison royale." Dufort de Cheverny, a close friend of Sedaine, was ill-disposed to Marigny, stating "Très-égoïste, brutal et d'une grande présomption, il faisait les honneurs de sa naissance tant qu'on voulait, pourvu qu'on fût convaincu qu'il valait beaucoup par son mérite" (Very egotistical, brutal, and of great presumption, he carried out the duties required of his birth as long as needed, provided people believed that he was to be esteemed for his merit); see Dufort de Cheverny, *Mémoires* (note 175), 1:116. Dufort de Cheverny was opposed to Marigny in particular because he wished to purchase the Château de Cheverny, but he was mindful also of his rudeness to Sedaine; see Dufort de Cheverny, *Mémoires* (note 175), 1:362–63:

> Marigny, directeur général des bâtiments, avec de l'esprit, était l'homme de France le moins sociable; il était despote comme un petit roi de Maroc. Il s'était attaché exclusivement le fameux Cochin, graveur; et l'Académie d'architecture était menée par eux, si j'ose le dire, avec une baguette de fer.
>
> Le corps des architectes, arrivés à l'Académie par leur talent, n'était pas ce qu'il y avait de plus facile à réduire. Marigny s'aperçut bientôt d'une roideur, d'une opposition à l'autorité, dans tout ce qu'il voulait faire décider. Cette lutte durait depuis deux ans, lorsque le secrétaire perpétuel de l'Académie d'architecture vint à mourir. Cette place était à la nomination du directeur; elle valait un logement au vieux Louvre, dix-huit cents livres de gages et des jetons à chaque séance. Il calcula que s'il la donnait à un architecte, il mettait dans le corps une autorité de plus contre lui. N'ayant jamais connu Sedaine que par ses pièces, il prit des informations

sur son caractère, l'envoya chercher, et lui dit que le Roi l'avait nommé à la place de secrétaire. Sedaine veut le remercier, il l'arrête, avec sa franchise qui tenait de la rusticité: "Si j'avais cru trouver un homme plus fait pour cette place, vous ne l'auriez pas. Il me fallait quelqu'un qui tînt à la littérature et à l'architecture, pour ôter toute plainte sur ce que je ne choisissais pas dans l'Académie. Il me fallait un homme étranger à toutes querelles. Sous tous ces rapports, vous êtes celui qui convient à cette place; ainsi je ne vous demande aucune reconnaissance."

(Marigny, directeur général des bâtiments, a man of wit, was the least sociable in France; he was as despotic as a little king of Morocco. He liked only the famous Cochin the engraver; and together they controlled the Académie royale d'architecture with, if I may say so, an iron rod.

That body of architects, having attained to the academy by virtue of their talent, was not easy to impose upon. Marigny soon noticed an inflexibility, an opposition to authority, in everything he wanted decided. The struggle had continued for two years when the permanent secretary of the Académie royale d'architecture died. The position was the appointment of the director; it included lodgings in the old Louvre, a salary of eighteen hundred francs, and a fee for each session. He calculated that if he gave it to an architect, he would be providing one more voice in that body against him. Knowing Sedaine only through his plays, he found out about his character, sent for him, and told him that the king had named him to the position of secretary. Sedaine tried to thank him, but he stopped him with a frankness approaching rudeness: "If I had thought to find a man better suited for the position, you would not have it. I needed someone who knew about literature and architecture, so as to avoid all complaints that I had not chosen from within the academy. I needed a man who was not involved in any disputes. In all these respects, you are the one best suited for that position; thus I require no gratitude from you.")

For Sedaine's friendship with David, see Dufort de Cheverny, *Mémoires* (note 175), 2:19. On Sedaine, see Mark Ledbury, *Sedaine, Greuze, and the Boundaries of Genre,* Studies on Voltaire and the Eighteenth Century, vol. 380 (Oxford: Voltaire Foundation, 2000).

342. Armstrong, "De la théorie des proportions" (note 7), n. 31.

343. The other pupils were Pierre-Théodore Bienaimé; Paul-Antoine Bouchu; Bourgeot or Bourgeau; Jean Denis; Jean-Louis Faure; Garret; Jean-Baptiste-Philippe Harou-Romain; Jean Houet or Houette; Jean-Baptiste-Philibert Moitte; Jean-Marc Montémont or Montament; Jean-Baptiste Parison; Pierre Reufflet or Rufflet; Ritter; Jean-Jacques Tardieu; Jean-François Thomas; Topin; Pierre-Jean-Baptiste Vanday; and Fédor Ivanovitch Volkov.

344. On the continuation of Le Roy's teaching enterprise, see Richard Chafee, "The Teaching of Architecture at the Ecole des Beaux-Arts," in Arthur Drexler, ed., *The Architecture of the Ecole des Beaux-Art,* exh. cat. (New York: Museum of Modern Art, 1977), 65–77; Barry Bergdoll, *Léon Vaudoyer: Historicism in the Age of History* (Cambridge: MIT Press, 1994), 35–38; and, at greater length and with the emphasis on Jean Rondelet's transformations, Barbara Shapiro Comte, "The Architect's Working Drawings in Context: Paris, 1791–1875" (Ph.D. diss., Harvard University, 1999), 363–99.

345. See entry for 7 January 1772 in Henry Lemonnier, ed., *Procès-verbaux de l'Académie royale d'architecture*, vol. 8, *1768–1779* (Paris: Libraire Armand Colin, 1924), 118: "elle tourna ses regards sur ces espèces de monumens élevez par les Gots, inférieurs à beaucoup d'égards à ceux de la belle architecture grecque. Elle vit qu'ils avoient été peut être trop méprisez à la Renaissance des arts, et elle s'appliqua à pénétrer tout le merveilleux et toute la légèreté de leur construction. Les voyages faits à *Palmire*, à *Balbec*, ceux de la *Grèce*, de *Pestum*, de la *Dalmatie* devinrent aussi l'objet de ses remarques."

346. For Le Roy's late publications, see this volume, pp. 503–6.

347. Julien-David Le Roy, *Nouvelles recherches sur le vaisseau long des anciens, sur les voiles latines, et sur les moyens de dimnuer les dangers qui courent les navigateurs … servant de suite à l'ouvrage qui a pour titre Les navires des anciens, etc.* (Paris: n.p., 1786), 38.

348. For a modern critical edition, in Latin and Italian, see Poggio Bracciolini, *De varietate fortunae,* ed. Outi Merisalo (Helsinki: Suomalainen Tiedeakatemia, 1993).

349. Dacier, "Notice historique sur … Le Roy" (note 7), 281:

Assis au pied de son mât, le nouvel argonaute, avec son équipage composé seulement de quatre hommes, louvoya pendant plusieurs heures entre le Pont-neuf et le Pont-royal, au milieu d'une foule de spectateurs attirés par la nouveauté du spectacle, courut des bordées, fit déployer et carguer alternativement et plusieurs fois ses voiles, afin de convaincre les plus incrédules de la sûreté et de la facilité avec lesquelles le *naupotame* (c'est le nom qu'il avoit donné à son vaisseau) pouvoit exécuter ces différentes manoeuvres.

350. Charles Carrière, *Négociants marseillais au XVIIᵉ siècle: Contribution à l'étude des économies maritimes* (Marseille: Institut Historique de Provence, 1973), 594.

351. For Le Roy's influence on Durand, see Szambien, *Jean-Nicolas-Louis Durand* (note 231), 22–31, 59.

352. One example of this medallion is held by the École nationale supérieure des beaux-arts, Paris.

353. Pierre-Louis Moreau de Maupertuis, *Système de la nature*, in idem, *Oeuvres* (Hildesheim: Georg Olms, 1965–74), 2:139: "Quelques Philosophes ont cru qu'avec la *matiere* et le *mouvement* ils pouvoient expliquer toute la Nature."

354. Georges Gusdorf, *Les principes de la pensée aux siècles des lumières* (Paris: Payot, 1971), 151–212.

355. Pierre Brunet, *L'introduction des théories de Newton en France au XVIIIᵉ siècle* (Paris: Albert Blanchard, 1931), 1:149–52.

356. See, in general, Sergio Moravia, "Philosophie et géographie à la fin du XVIIIᵉ siècle," in *Transactions of the Second International Congress on the Enlightenment*, Studies on Voltaire and the Eighteenth Century, vols. 55–58 (Geneva: Institut & Musée Voltaire, 1967), 937–1011; and, more specifically, Broc, *La géographie des philosophes* (note 192).

357. Henri-Marie-Auguste Berthaut, *La carte de France, 1750–1898: Étude historique*, 2 vols. (Paris: Imprimerie du Service Géographique, 1898–99).

358. Henri-Marie-Auguste Berthaut, *Les ingénieurs géographes militaires*,

1624–1831: *Étude historique*, vol. 1, *Les ingénieurs géographes des camps et armées; La révolution; Le consulat* (Paris: Imprimerie du Service Géographique, 1902).

359. Charles Frostin, "Les Pontchartrain et la pénétration commerciale en Amérique espagnole (1690–1715)," *Revue historique* (Paris), April–June 1971, 307–36.

360. James Pritchard, *Louis XV's Navy, 1748–1762: A Study of Organization and Administration* (Kingston, Ontario, Canada: McGill-Queen's Univ. Press, 1987); and Michel Vergé-Franceschi, *La marine française au XVIIIᵉ siècle: Guerres, administration, exploration* (Paris: SEDES, 1996).

361. Maurepas succeeded his father as sécretaire d'État de la Marine in 1718, when no more than seventeen, but his functions were exercised by his cousin and father-in-law, Louis Phélypeaux, marquis de La Vrillière. Only in 1723 was Maurepas able to take up his position, though only after his father-in-law died in 1725 did he take control.

There is no adequate study of Maurepas, though the most recent is the fullest: André Picciola, *Le comte de Maurepas: Versailles et l'Europe à la fin de l'ancien régime* (Paris: Perrin, 1999); see also John C. Rule, "Jean-Fréderic Phélypeaux, comte de Pontchartrain et Maurepas: Réflections on His Life and Papers," *Louisiana History* 6 (1965): 365–77; Roland Lamontage, *Ministère de la marine, Amérique et Canada, d'après les documents Maurepas* (Montreal: Éditions Leméac, 1966); and Maurice Filion, *Maurepas, ministre de Louis XV, 1715–1749* (Montreal: Éditions Leméac, 1967). The best contemporaneous estimate is Jean-Antoine-Nicolas de Caritat, marquis de Condorcet, "Éloge de M. le comte de Maurepas," in idem, *Oeuvres complètes de Condorcet* (Paris: Henrichs [etc.], 1804), 2:159–204.

362. Marmontel disliked Maurepas as much as he did Caylus, but he writes of Maurepas only after Maurepas's recall, in 1774, by the newly crowned Louis XVI; see Marmontel, *Mémoires* (note 175), bk. 12, 364:

> Son ancien ministère n'avait été marqué que par le dépérissement de la marine militaire; mais comme la timide politique du cardinal de Fleury avait frappé de paralysie cette partie de nos forces, la négligence de Maurepas avait pu être commandée, et dans une place fictive, dispensé d'être homme d'État, il n'avait eu à déployer que ses qualités naturelles, les agréments d'un homme du monde et les talents d'un homme de cour. Superficiel et incapable d'une application sérieuse et profonde, mais doué d'une facilité de perception et d'intelligence qui démêlait dans un instant le noeud le plus compliqué d'une affaire, il suppléait dans les conseils par l'habitude et la dextérité à ce qui lui manquait d'étude et de méditation.

For this passage in English, see Marmontel, *Memoirs* (note 175), 2:87:

> His former ministry had only been marked by the decay of the navy; but as the timid policy of Cardinal Fleury had palsied that part of our forces, Maurepas might have been commanded to act as he did; and in a nominal place, dispensed with as a statesman, he had had nothing to display but his natural qualities, the inviting ease of a man of the world, and the talents of a courtier. Superficial, and incapable of any serious and profound application, but endowed with a facility of perception and intelligence that unravelled in an instant the most complicated business, he supplied in the council, by habit and dexterity, what he wanted in study in meditation.

There is a great deal more of this kind, including Maurepas's dismissal of Sartines, the Paris chief of police; see Marmontel, *Memoirs* (note 175), 2:99–105.

363. Condorcet, "Éloge de M. le comte de Maurepas" (note 361), 2:166: "sut rendre son ministère brillant au milieu même de la paix, en faisant servir la marine aux progrès même des sciences, et les sciences aux progrès de la marine. Chargé de l'administration des académies, il réunissait toute l'autorité nécessaire pour l'exécution de ses projets."

364. On Maurepas's promotion of trade, in the Mediterranean in particular, see Marcel Emerit, "L'essai d'une marine marchande barbaresque au XVIIIᵉ siècle," *Les cahiers de Tunisie: Revue des sciences humaines* 3 (1955): 363–70; and Paul Butel, *L'economie française au XVIIIᵉ siècle* (Paris: SEDES, 1993), 25–26, 98–100. On these events more generally, see Carrière, *Négociants marseillais* (note 350); Katsumi Fukasawa, *Toileries et commerce du Levant, d'Alep à Marseille* (Paris: Éditions du C.N.R.S., 1987); and Philippe Haudrère, *La Compagnie française des Indes au XVIIIᵉ siècle, 1719–1795* (Paris: Librairie de l'Inde, 1989).

365. This is recounted at length in the apocryphal *Mémoires du comte de Maurepas, ministre de la marine*, comp. Sallé, ed. Jean-Louis Giraud Soulavie (Paris: Buisson, 1792), 4:264–69.

366. Jean-Pierre Samoyault, *Les bureaux du secréteriat d'État des Affaires étrangères sous Louis XV: Administration, personnel* (Paris: Éditions A. Pedone, 1971), 152–54, 287, 305–6.

367. Jean-Antoine-Nicolas de Caritat, marquis de Condorcet, "Éloge de M. d'Anville," in idem, *Oeuvres complètes de Condorcet* (Paris: Henrichs [etc.], 1804), 2:248–64; and Bon-Joseph Dacier, "Éloge de M. d'Anville" (read 1782 or 1783), *HistMemBL* 45 (1793): *Histoire*, 160–74; the latter was printed separately, with a full "Catalogue des cartes gravés d'après les dessins de M. d'Anville" and a "Catalogue des ouvrages imprimés de M. d'Anville," in *Notice des ouvrages de M. d'Anville* (Paris: Fuchs, an X [1802]). See also Paul Poindron, "Les cartes géographiques du Ministère des affaires étrangères (1780–1789): Jean-Denis Barbié du Bocage et la collection d'Anville," *Sources: Études, recherches, informations, chronique des bibliothèques nationales de France* 1 (1943): 46–72.

368. Dacier, "Éloge de M. d'Anville" (note 367), 171: "Les anciens Géographes avoient presque tous voyagé, et parloient très-souvent de ce qu'ils avoient vu. M. D'Anville au contraire connoissoit la terre sans l'avoir vue; il n'étoit, pour ainsi dire, jamais sorti de Paris, et ne s'en étoit pas éloigné de plus de quarante lieues."

369. On Bellin, see Jean-Marc Garant, "Jacques-Nicolas Bellin (1703–1772), cartographe, hydrographe, ingénieur du Ministère de la marine: Sa vie, son oeuvre, sa valeur historique" (master's thesis, Université de Montréal, 1973). For an illustrated survey of maps of Greece, see Christos G. Zacharakis, *A Catalogue of Printed Maps of Greece, 1477–1880* (Nicosia, Cyprus: A. G. Leventis Foundation, 1982); for the maps by Grognard and Bellin, see Zacharakis, *A Catalogue*, cat. nos. 159, 160, 984, 985; pls. 23, 166.

370. Jean-Baptiste Bourguignon d'Anville, *Traité des mesures itinéraires anciennes et modernes* (Paris: Imprimerie Royale, 1769), 15.

371. On the innumerable imitations or derivatives of Fénelon's *Télémaque*, see

Chérel, *Fénelon au XVIIIᵉ siècle* (note 92); see also Geoffroy Atkinson, *The Extraordinary Voyage in French Literature from 1700 to 1720* (Paris: É. Champion, 1922).

372. On Barthélemy and his influence, see Badolle, *L'abbé Jean-Jacques Barthélemy* (note 92); for a summary account of Choiseul-Gouffier's *Voyage pittoresque de la Grèce*, see Adolf K. Placzek, gen. ed., *Avery's Choice: Five Centuries of Great Architectural Books: One Hundred Years of an Architectural Library, 1890–1990* (New York: G. K. Hall, 1997), 96–98 (entry no. 131 by Robin Middleton). Suggestive of the changed tastes of the late eighteenth century is the exchange between Madame du Deffand and Barthélemy on the subject of *Télémaque*: "Je me viens d'imposer la contraite de relire *Télémaque*," she wrote on 23 October 1771. "Il est ennuyeux à la mort. Ce n'est pas du véritable bon temps du siècle de Louis XIV. Il avoisinait celui de Fontenelle et de Lamotte. Son style est long, lâche; il vise à une certaine onction qui n'a point de chaleur. Toujours des préceptes, des descriptions, point de sentiments, point de mouvement, point de passion" (I have just forced myself to reread *Télémaque*. It is deadly dull. It is not really from the good part of the century of Louis XIV. It was close to the time of Fontenelle and Lamotte. Its style is long-winded, slack; it tends toward a certain unctuousness without warmth. Always precepts, descriptions, no feelings, no movement, no passion); to which the abbé replied four days later, "Il est diffus à la vérité, un peu monotone et trop chargé de descriptions, mais il est plein d'une grande morale" (In reality, it is diffuse, a bit monotonous, and too laden with descriptions, but it has great morality); cited in Chérel, *Fénelon au XVIIIᵉ siècle* (note 92), 445.

373. Jean-Nicolas-Louis Durand, *Nouveau précis des leçons d'architecture données à l'Ecole imperiale polytechnique* (Paris: L'auteur, 1813–17), 1:70.

374. Helen Rosenau, *Boullée and Visionary Architecture: Including Boullée's "Architecture, Essay on Art"* (London: Academy Editions, 1976), 91; for the original, see Étienne-Louis Boullée, *L'architecte visionnaire et néoclassique*, ed. Jean-Marie Pérouse de Montclos, 2d ed. (Paris: Hermann, 1993), 82 (90r):

En prolongeant l'étendue des allées de sorte que leur fin échappe à nos regards, les lois de l'optique et les effets de la perspective nous offrent le tableau de l'immensité; à chaque pas, les objets se présentent sous de nouveaux aspects renouvellent nos plaisirs par des tableaux successivement variés. Enfin, par un heureux prestige qui est causé par l'effet de nos mouvements et que nous attribuons aux objets, il semble que ceux-ci marchent avec nous et que nous leur ayons communiqué la vie.

375. Pierre-François Hugues, called Baron d'Hancarville, *Antiquités étrusques, grecques et romaines tirées du cabinet de M. Hamilton* (Naples: [Imprimé par F. Morelli], 1766–[76]), esp. vol. 3, chaps. 1–4.

376. Jean-Louis Viel de Saint-Maux, *Lettres sur l'architecture des anciens et celle des modernes* (Paris: n.p., 1787; reprint, Geneva: Minkoff Reprint, 1974), 17. This work is often attributed to Charles-François Viel de Saint-Maux, but it is probably by Jean-Louis.

377. Sylvia Lavin, *Quatremère de Quincy and the Invention of a Modern Language of Architecture* (Cambridge: MIT Press, 1992).

378. Robin Middleton, "The Rationalist Interpretations of Classicism of Leonce Reynaud and Viollet-le-Duc," *AA Files*, no. 11 (1986): 40–42.

379. MS CHA/2/30, Royal Academy, London; cited by David Watkin, *Sir John Soane: Enlightenment Thought and the Royal Academy Lectures* (Cambridge: Cambridge Univ. Press, 1996), 37.

380. Watkin, *Sir John Soane* (note 379), 104–11.

381. Soane Case no. 161, p. 67, 1807, Sir John Soane's Museum, London. I am indebted to Edward Wendt for this quotation.

382. For Marivetz's proposal for a system of navigable waterways covering France entire, see Etienne-Claude, baron de Marivetz, and Louis-Jacques Goussier, *Système général, physique et économique des navigations naturelles et artificielles de l'intérieur de la France et de leur coordonnation avec les routes de terre* (Paris: n.p., 1788).

383. Pierre Le Roy, *Lettre à M. le baron de Marivets, contenant diverses recherches sur la nature, les propriétés et la propagation de la lumière, sur la cause de la rotation des planètes; sur la durée du jour, de l'année, etc.* (London: Lamy, 1785), 28, 48.

384. Le Corbusier, *Towards a New Architecture*, trans. Frederick Etchells (London: John Rodker, 1927; reprint, London: Architectural Press, 1970), 31.

385. I am much indebted to Philippe Duboy for detailed advice on Le Corbusier's reading, in particular the study of Kurt Cassirer's "Die äesthetischen Hauptbegriffe der französischen Architektur-Theoretiker von 1650–1780" (Ph.D. diss., Friedrich-Wilhelms-Universität zu Berlin, 1909), which does, surprisingly, include Cordemoy. Le Corbusier also consulted a number of the books listed in Jacques-François Blondel's *Discours sur la nécessité de l'étude de l'architecture* (Paris: C.-A. Jombert, 1754), but that was published too early to include Le Roy's works. For Le Corbusier's remarks on Homer, see Le Corbusier, *The Marseilles Block*, trans. Geoffrey Sainsbury (London: Harvill, 1953), 8.

The Ruins of the
Most Beautiful Monuments
of Greece, Historically
and Architecturally Considered

Volume One

Which Contains the Ruins of Those Monuments Erected by the Athenians before the End of the Age of Pericles

With an Essay on the History of Architecture, and a Dissertation on the Length of the Greek Foot

Preface

The writings of the ancients, their medals, their statues, their engraved gems, their inscriptions — those treasures that we have rescued from the clutches of barbarism are not the only monuments that can tell us of the power, the genius, and the taste of the most famous peoples of antiquity and of the interactions they had with one another. The ruins of a few celebrated cities have cast fresh light on that interesting part of history; and it is undoubtedly due to the light cast by the ancient buildings of Greece that I now enjoy the honor of presenting their precious remains to the public for a second time.

I shall not speak here of the measures that I took to travel in Greece in safety and with profit; those I described in the first edition of this work. Instead I shall do no more than explain the differences between this edition and its predecessor. In this second edition, I have arranged the buildings under discussion so that the first volume contains those erected by the Athenians before the end of the age of Pericles and the second volume those built after that time. I have in mind to demonstrate the effect produced in Greece by the conquests of Alexander [the Great] and to make clear the difference between the buildings erected by a free people, when in their power and their brilliance they gave laws to other peoples, and those produced by the same people when, under the yoke of Rome, they had lost part of their former pride and genius.

In following this new plan, I have maintained a division of another kind established in my first edition: that between the different categories of knowledge to which the ancient ruins may be related. In each volume I have discussed the monuments separately in relation to history and in relation to architecture. This gives me a twofold advantage: with the architectural details separated from the historical part, the history will be less protracted; and with the architectural details collected in a part directly relevant to the principles of that art — united, as it were, by a single point of view — comparisons will be more readily drawn and understood.

In writing the history of these monuments, I accordingly report what their inscriptions or the ancient authors tell us of the famous men for whom they were built, of the deities to whom they were dedicated, and of the different times in which they were begun, completed, ruined, or reconstructed. To avoid the monotony attendant on the successive description of too many

buildings, I intersperse with them some details of my travels; I break off from discussing the buildings themselves to describe the places in which they stand. In the first volume, this gives me occasion to make some remarks on the origins of Athens, on the successive additions that it received under Theseus and Themistocles, on the construction of the harbors of the city, and, in general, on the various changes that befell it between its founding and the end of the age of Pericles.

In the second volume, I briefly describe the state of Athens under the successors to Alexander; I speak of the calamities Athens suffered under [Lucius Cornelius] Sulla [Felix], of the disgraces it endured and the favors it received under the Roman emperors, until the time when Hadrian took such delight in its enlargement and improvement. After a word on Athens's present state, I pass next to the description of the antiquities of Corinth and of Sparta.

In the second part of each volume of this work, I have collected the plans, elevations, and sections of the monuments, with all their measurements. I remark there not only on the sundry points of interest that one notices and that convey to us the progress of architecture in Greece but also on the relations that their main dimensions, in whole and in part, bear to one another and to Roman monuments. Finally, as these Greek monuments cast light on a number of obscure passages in Vitruvius that I consider to have been misread even by Monsieur [Claude] Perrault, I have felt it incumbent on me to elucidate these and to restore them to their true meaning.

Important though I consider the study of the monuments of Greece from the two points of view mentioned above, I find it no less important to reveal the relationships they have with the peoples that came before or after them in the knowledge of the arts, and also the connection between the principles that are the basis of Greek architecture and those principles, inherent in that art, that derive from the laws of mechanics, that are determined by the nature of our own minds and our organs or by the habits that we acquire in looking at the objects commonly seen on the face of the globe. This topic I examine in the two essays, one on the history and the other on the theory of architecture, that stand at the head of the two volumes of this work. The range that I have given these two bits so far exceeds their original measure that I believe I am authorized to call them essays. Finally, in this second edition, I have added an inquiry into the dimensions of the course at Olympia and into the comparative dimensions of the most celebrated stadia in Greece; though I have already published this in another work,[1] it seems to be necessary here.

As for the additions to the body of the work itself, these are very considerable, as will be seen; but what will particularly distinguish this edition from its predecessor is the wealth of quotations that I have added. Not only have I been at pains to transcribe these accurately but also, to enable the reader to form a candid opinion of my views, I have often reproduced in full the original passages on which they are based. I have, however, taken care to keep these passages out of the text of the work itself, instead relegating them to the notes.

Having set out the plan of this edition, it only remains for me to speak of

the criticisms of my first edition made by Mr. [James] Stuart, in an English book that contains a description of a number of buildings in Athens. My reply will be brief, both because I have already responded at length in my *Observations sur les édifices des anciens peuples* and because I discuss in the body of this work how much the author has been mistaken in his conjectures concerning the buildings of which the greatest ruins of Athens once formed part. Here, therefore, I shall merely answer the overall aims of his criticism, which call for no specific refutation.

The ruins of antiquity may be looked at in widely differing ways. In publishing them, one may undertake no more than a slavish record of their dimensions; and the most scrupulous accuracy in doing so is, in Mr. Stuart's opinion, almost the only merit that a book of this kind can possess. My journey, I confess, was undertaken with very different ends in view; I would never have traveled to Greece simply to observe the relations of the buildings and their component parts with the subdivisions of our foot. Such a claim to fame I gladly resign to anyone who desires it and aspires to nothing higher.

I measured the monuments of Greece primarily, as I have said, to find how they relate to one another or to those described by Vitruvius and to compare them with the edifices of the peoples that preceded or followed the Greeks in the knowledge of the arts. I dare state that I detailed them more fully and measured them far more precisely than needed to draw such observations from them;[2] and far from taking pride in filling my work with a multitude of plates of details—which, given the plan that I laid out, would have plunged it into confusion—I reduced such plates to the bare minimum. Often, I showed only those aspects that I considered the most mediocre, because their defects, palpable in these details, are lost to sight in a general view.

These pictorial representations in my work differ profoundly from those that Mr. Stuart has given of the same buildings, because they show them from other angles; they also differ very perceptibly in the way in which the ruins of the buildings are shown. In the views that I present, the ruins occupy a far greater part of the picture[3] than in those of Mr. Stuart; they make a livelier impression on the viewer and fill his mind with all the admiration that strikes us when we see the monuments themselves.

Le Roy's Notes

1. This work is entitled *Observations sur les édifices des anciens peuples*. This pamphlet, of which very few copies were printed, is now unobtainable—as is another pamphlet *Sur les temples des Chrétiens* [(*Histoire de la disposition et des formes différentes que les Chrétiens ont données à leurs temples*)], the substance of which is contained in the two essays, mentioned in this preface, on the history and the theory of architecture; however, each of these latter essays contains extensive passages that have never been published before. I would have been glad to assemble these additions in a supplement to be added to copies of the first edition of my book; but, as will be seen, they are of a nature that renders this impossible.

2. Buildings must of course be accurately surveyed; but to determine the proportions of a round temple, there is no need to measure all its diameters or those of each individual column, as [Antoine Babuty] Desgodets has done [in *Les édifices antiques de Rome, dessinés et mesurés très exactement*]. Such scrupulousness, which often entails thousands of measurements of undistinguished profiles, seems to me superfluous. Furthermore, it is almost inevitable that discrepancies will appear between measurements of the same profile made with different foot measures, sometimes on the building itself and sometimes on its fragments. For example, Mr. [Robert] Wood and his traveling companions spent only seventeen days at Palmyra [(Tudmur, Syria)] and Baalbek, and the buildings that they surveyed are almost all Corinthian and laden with countless ornaments and moldings. Does anyone suppose that if an architect were to undertake a second survey of the same buildings, he would have any difficulty in compiling long lists of discrepancies between his measurements and theirs? I think it very unlikely, but this does not detract in the slightest from my esteem for the work published by one of these English scholars.

As for the vast quantity of plates with which works of the present kind are sometimes laden, these often convey nothing to the public beyond the industry or the want of taste of those who have measured the monuments.

3. It is a recognized principle among painters, sculptors, and persons of taste that for an object in a picture to make a powerful impression on the beholder, it must not in any way be smothered by extraneous objects. Judge by this principle some of Mr. Stuart's drawings [in the first volume of *The Antiquities of Athens*] and my own. The foreground of his view of the ruins in the bazaar [(see his chap. 5, pl. 1)] offers only walls, unsightly roofs, and diminutive figures lost in a great, dark mass; only in the distance, across and above all this, do we glimpse the tops of the columns of the building. I took my view [(see vol. 2, pl. 6)] of this magnificent ruin from the foot of the building itself; I depicted its columns at their full height; I showed the street, which forms one side, roofed over in a highly picturesque manner. Finally, I conveyed an idea of the animated, present-day scene by showing the merchants who have their stalls there. My views of a Doric portico, of the Tower of the Winds, and of the Monument of Lysikrates [(see vol. 2, pls. 4, 3; vol. 1, pl. 10)] also differ from those of the author in question [(see his chap. 1, pl. 1; chap. 3, pl. 1; chap. 4, pl. 1)], both because I drew them from another angle and because the principal object occupies a larger portion of the picture.

Essay on the History of Architecture

The history of the arts offers us one spectacle that deserves the attention of all who love to trace their progress—namely, a view of how much the primitive original ideas of some creative geniuses have influenced the various works subsequently made by men. Their first attempts in architecture offer some striking instances. The stone set by the Phoenicians on the tomb of a famous man, imitated in other monuments of the same sort and rendered taller, more colossal, was the origin of the obelisk. The same stone represented instead by a piled mass of stones, wide at the foot and pointed at the apex, supplied the idea of the pyramid. These origins seem all the more believable to us because we know that pyramids were tombs and that obelisks were often set up to immortalize the memory of heroes or benefactors of humanity. Likewise, we find in the shape of the huts[a] built by different peoples, of which antiquity has left us a few traces, the prototype of the most ancient temples known to us.

Those earliest shelters, which necessity taught men to build, cannot have been much better than those that instinct leads the beasts to make to protect themselves from the weather; and no doubt they were equally varied. It would be vain to seek, amid the darkness of the first ages of the world, for the exact forms of those early efforts of the peoples of antiquity or to ask how many centuries passed before the various kinds of hut devised by men attained any degree of perfection. Far from penetrating into such remote ages, we cannot even detect, by the light of history alone, the series of events that brought one very celebrated people to espouse loftier ideas.

On reading the works of the ancient authors, we are struck first by the great undertakings of the Egyptians in architecture, though we remain none the wiser as to the source of their knowledge of this art. But if we travel to Egypt itself, and if we excavate its earliest ruins, we will discover, both in the entirety and in the details of these monuments, the simple ideas that governed the Egyptians' earliest steps in architecture. We see them enlarge and gradually embellish the forms of successive buildings of the same kind. We see them build columns in imitation of tree trunks, with only a round stone for the base and a square stone for the capital.[1] We see them carve the rocks to produce columns[2] that look like nothing so much as a number of slender tree trunks bound together.

This last idea, simple though it is, already bears the stamp of grandeur that

the Egyptians imparted to all their productions. It reveals that, as their trees were not stout enough to carry great loads alone, they joined several together to form thick piers and to build grand and colossal works. In their eagerness for great and awesome effects, the Egyptians never gave themselves time to perfect their architecture; content with any form of decoration for their columns, any kind of capital or entablature, they passed rapidly from their first efforts in architecture to the execution of the largest undertakings.

The Greeks, in contrast, matched their enterprises to their knowledge of the art of building. Slower than the Egyptians to reveal their genius, they advanced with surer steps toward perfection. They followed the laws of nature: starting with the simplest ideas and proceeding through successive discoveries to more ambitious undertakings, they finally produced the most sublime conceptions and gave their laws and rules to the whole world.

The monuments of the Egyptians and the Greeks; the buildings of other ancient peoples that resemble them, either in size or in disposition; the extraordinary boldness of those built by the peoples that participated in the renewal of the sciences and the arts in Europe—all these have been praised by various writers. And yet no one, it seems, has observed sufficiently either the marked affinities that link them or the striking differences that distinguish them. It is these differences, these affinities, these successive transitions from one perfection to another that we intend to demonstrate in the present essay. Constraints of space forbid discussion of the origins of each type of monument or the progress made by various peoples in the art of planning, constructing, and ornamenting them. We shall therefore confine ourselves principally to temples, those prodigious monuments in which these peoples have striven to surpass themselves, those monuments that are perhaps the most striking proof of the audacity and sublimity of the genius of man and of his great superiority over all the beings on the face of Earth.

From the vast area covered by its ruins, it is clear that the Temple of Jupiter at Thebes [(Temple of Amun at Karnak)], in Upper Egypt, was more than 1,400 feet long, 350 wide, and 3,500 all around, not including the immense porticoes that led to it.[3] Its columns were 7 feet in diameter; like the ceilings they supported, they were composed of prodigious blocks of granite and marble. The Temple of Belus [in Babylon],[4] Solomon's temple [in Jerusalem], the Temple of Jupiter [Olympius] in Athens, and the temples at Palmyra [(Tudmur)] and at Baalbek had within the walls of their enclosures more land than the largest of our city squares. The Basilica di San Pietro [in Vaticano (Saint Peter's)] in Rome and the circular colonnade that fronts it offer a yet more striking instance of the grandeur that may be achieved in human undertakings; altogether, they are 1,600 feet in length, with a perimeter of 4,000 feet.

These temples, the most magnificent ever built, are alike in their immensity, but their varied forms reveal differences that, if carefully examined, may cast some light on the history of the arts, inseparable as this is from the sum total of human knowledge. Barely discernible over the course of a few years,

these differences often become striking only after the passage of several centuries. Rarely does nature produce an inventive genius bold enough to overleap the barriers that custom and envy constantly set in the path of the finest new ideas.

The picture that we offer of the changing forms of temples among different peoples presents only general descriptions, with little detail. At any greater length, these descriptions would have broken the chain of our argument concerning the progress men have made in the art of planning such temples and yet left unsatisfied those readers who seek a thorough knowledge of the monuments themselves. A drawing, however small, gives at a glance a more precise idea than the clearest discourse. This has prompted me to have a series of these temples engraved in the order best suited to show their various degrees of growth and perfection. Below is the key to plate 1, in which they are illustrated. Each of the different figures that it contains is designated by a number.

Explanation of the first column of plate 1: The temples of the Egyptians, the Hebrews, and the Phoenicians.

1. Simple, detached hut of the Egyptians and the Phoenicians.

2. Hut of the Egyptians or the Phoenicians, perfected and surrounded with a hedge or a wall.

3. A very simple Egyptian building, whose resemblance in form to the three temples marked as figures 4, 5, and 6 suggests to us that this too was a temple, though [Richard] Pococke, who provides it, supposes it to have been an observatory. Its ruins may be seen at Syene [(Aswan)], in Upper Egypt.[b] See what Pococke has to say on the subject in his [*Description of the East*], vol. 1, p. 116. The porch of this temple has only one row of columns.

4. Temple at Esna [(Temple of Khnum at Isna)], now ruined, where the porch has two rows of columns and the interior has more divisions than the preceding. See the illustration given by Pococke, vol. 1, pl. 45, and his remarks on the subject on p. 111 of the same volume.

5. Temple at Edfu [(Temple of Horus at Idfu)], now ruined. This had three [four?] rows of columns in its porch. In addition, the porch was preceded by a court. The large space that was behind the porch and that formed the *naos* [(sanctuary)] was, I suspect, hypaethral, or roofless. See the illustration of this temple given by Pococke, [vol. 1,] pl. 46, and his remarks on the subject on p. 112.

6. Ruins of a building at Luxor [(Great Temple at Luxor)]. [Frederik Ludvig] Norden says [in his *Voyage d'Égypte et de Nubie*] that the part marked *C* was a covered temple. Pococke calls it *the Temple or the Sepulchre of Ozymandias.* Suffice it to say that we consider these to be the ruins of a temple of great splendor. As for Pococke's opinion that it was the work of Ozymandias, we cannot suppose that the Egyptians were so advanced in the arts as to build it in the reign of

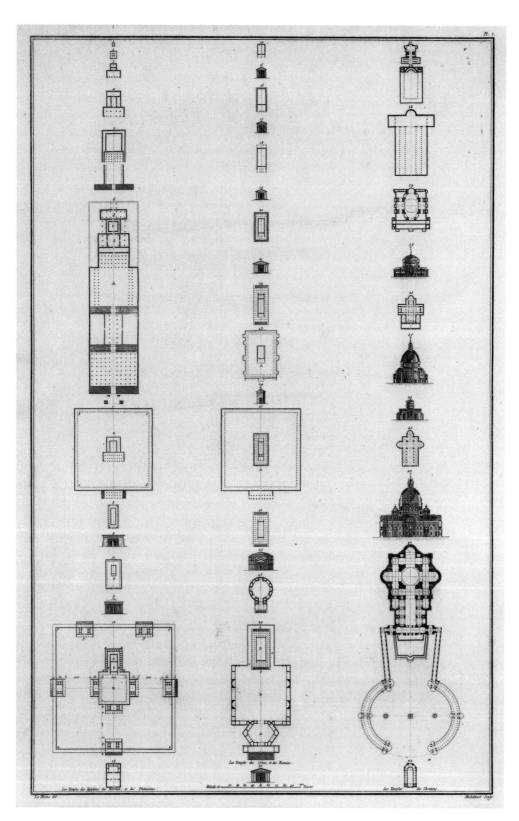

Pl. 1. Michelinot, after Le Moine

that prince, who lived, according to Diodorus [Siculus], about 2220 B.C.[c] We would ascribe its construction to a period more remote, when Sesostris, fresh from his conquests, built a large number of temples in Egypt.

This temple had a series of peristyles, through which one passes before entering the forecourt, marked A. The letter C was the point within the *naos* where the statue of the god probably stood; *b* was a hall that preceded this; and *d* was a vestibule. See the more detailed description of this building given by Pococke, vol. 1, p. 107.

7. The temple at Bubastis [(Tall Bastah)], which exemplifies the form of an Egyptian temple of another kind, is made up of a *naos*, A, and an enclosure, *b, c, d, e.* I have made this enclosure 4 stades around, in accordance with Herodotus's description, and have made the *naos* in the style of the Egyptian temples in figures 3 and 4. See the account given by Herodotus [(*History* 2.137–38)] of this temple, bk. 2, p. 143 in the edition of 1618.

8, 9. Plan and elevation of the Temple of the Serpent Knupis [(Temple of Khnum at Elephantine, near Aswan)], as given by Norden [in his *Voyage d'Égypte et de Nubie*, pl. 132]. It will be seen that its proportions were similar to those of the Greek temples and that it had a column in the center of its facade.

10, 11. Plan and elevation of the Tabernacle. The *naos, a,* of the Hebrews' temple was similar in its proportions to those of Greek temples. It had a column in the center of its facade. It was surrounded by an enclosure adorned with a peristyle, but the outside of this enclosure was formed only of cloth hangings.

12. Solomon's temple. The letters *n, o, p, q* demarcate the first court; *R,* the second court; *u, u,* the third court; *S, T,* the *naos* of the temple; *x, x, x, x,* the priests' chambers. The gateways that afforded access to the first court and from that court to the second court were each 50 cubits deep. The interval between the gates of the first court and those of the second was 100 cubits; and the second, square court, *R,* measured 100 cubits on each side; this is why the numbers 100 and 50 appear, placed between two letters. Thus, the depth of the four gateways [along the horizontal axis] totaled 200 cubits, and the three intervals between them totaled 300 cubits; which means that the total length or width of the area enclosed by the temple was 500 cubits, as related in the Bible [(Ezek. 42:16–20)].

13. Temple indicative of one type of Phoenician temple. It is shown in vol. 2 of Pococke, pl. 24.

Figures 3, 4, 5, 6, 9, 11, and 13 in this column and figure 24 in the second column, either because of the smallness of the original or to maintain the gradation in size, are not drawn to the scale of 100 toises[d] on which the plate is based, and which has been used for all the others.

Explanation of the figures in the second column of plate 1:
The temples of the Greeks and the Romans.

14. A type of hut so wide that the ceiling timbers must have required the support of a crosspiece held up by tree trunks; this first suggested the idea of columns.

15, 16. Elevation and plan of a temple *in antis* described by Vitruvius [(*De architectura* 3.2.2)].

17, 18. Elevation and plan of the Greek prostyle temple, assuming no columns on the rear elevation, and of the amphiprostyle, supposing them to be as shown [(see Vitruvius, *De architectura* 3.2.3–4)].

19, 20. Elevation and plan of the Greek peripteral temple [(see Vitruvius, *De architectura* 3.2.5)].

21, 22. Elevation and plan of the Greek dipteral temple [(see Vitruvius, *De architectura* 3.2.7)].

23. Plan of a Greek temple, drawn on the assumption that its enclosure was similar in shape and in dimensions to that of the ruins in the bazaar in Athens, of which we shall have occasion to speak.

24. Elevation of the Tower of the Winds in Athens. This is octagonal, each of its faces measuring only some 10 feet in length; as can be seen, it would have been impossible to draw it to the same scale as the other temples while making visible the shape of its roof, which it was essential to show.

25. Plan of the Temple of Jupiter Olympius in Athens, drawn after the descriptions given by Vitruvius [(*De architectura* 3.2.8)] and Pausanias [(*Description of Greece* 1.18.6–9)]. According to the latter, its enclosure was 4 stades[e] around, like that of the temple at Bubastis. The proportions of the *naos* have been modeled on those Greek temples that were more than twice as long as they were wide.

26. Roman dipteral temple, as described by Vitruvius [(*De architectura* 3.2.7)]. That author restricts the length of any temple to twice the width.

27, 28. Elevation and plan of the Pantheon built by [Marcus Vipsanius] Agrippa in Rome.

29. Plan of the temple at Baalbek: *A,* first court; *B,* second court; *C,* third court; *D, naos.* This temple has only nineteen columns on its sides in relation to the ten columns on its facades, which is in accordance with the Roman system. Note that its proportions are less than those of the Pantheon of Hadrian [(Temple of Zeus Olympios in Athens)], shown in [plate 23 of] the second volume of the present work.

30. Facade of the decastyle temple at Baalbek.

Explanation of the figures in the third column of plate 1:
The temples of the Christians.

31. An impression of the catacombs or underground caves in which the

early Christians concealed themselves and assembled; these are drawn in accordance with similar underground works to be found in Egypt and shown by Pococke in his *Description of the East* [(vol. 1, pls. 29–34)].

32. Ancient basilica shown in [Andrea] Palladio's book [(*I quattro libri dell'architettura*, bk. 1, chap. 19)].

33. The old Saint Peter's, Rome.

34, 35. Plan and section of Hagia Sophia, Constantinople.

36. Plan of San Marco, Venice.

37. Section of Santa Maria del Fiore, Florence.

38, 39. Section and plan of Sant'Agostino, Rome.

40. Section of Saint Peter's, Rome.

41. Plan of Saint Peter's, Rome, along with the colonnade that fronts it.

42. Plan of the chapel at Versailles.

Temples of the Egyptians, the Hebrews, and the Phoenicians

Of the peoples who claim to have first taught the world the rudiments of the arts, the Egyptians have the least implausible claim. At a time when almost every people on Earth was barbarian, they already had achieved such great things and were so well versed in the arts that one cannot deny them due credit for inventing a great many of those regarded as most useful, among which architecture holds a leading place.

According to Diodorus Siculus [(*Library of History* 1.43.4)], the earliest huts of the Egyptians were formed of interwoven reeds and canes. Built of the same materials as those of the Phoenicians, and no doubt alike in disposition, the huts of the inhabitants of the banks of the Nile were freestanding at first. Then an enclosure was added, either fixed before the entrance or surrounding the hut on all sides.[5] These first steps in their emergence from barbarism can still be traced in the remains of their buildings. There one sees clearly the replication of the three original forms of their first dwellings, and one can also distinguish a kind of temple strikingly different from those of other peoples.

The simplest of these buildings, its ruins still visible at Syene, has its porch adorned with one row of columns. There were two back chambers, one probably for the priests in attendance, the other for the altar of the deity worshiped there. As architects in Egypt grew more enlightened, they turned from the plan of this temple to the nobler disposition of that found at Esna. As will be seen, this has a porch made up of two rows of columns, and its interior has a larger number of divisions.

These two temples, like the simplest hut, of which they were partial imitations, were freestanding. The Egyptians then built others, of a more magnificent kind, on the model of a refined and enlarged hut preceded by a court. The Temple [of Horus] at Edfu offers us an image of this: the porch that led to the interior was adorned with four rows of columns and preceded by a forecourt of considerable size.

This celebrated people, embellishing this later idea, next built temples on a model designed with greater magnificence; one of these is still be seen in ruins at Luxor. On approaching it, the visitor was overawed by the sight of the two huge obelisks and the two colossal statues that flanked the first gateway. The building itself was entered through a hall of vast size, its ceiling supported by a forest of columns. From this, one passed on through a peristyle formed by other columns of prodigious girth and height, to emerge in an open forecourt, facing the porch of the temple itself, with double colonnades on either side. The porch was no less than four rows of columns deep, and there were more columns in the rooms that preceded and followed the most hidden and secret part of the building, where stood the statue of the god.

The Egyptians built still other temples of the kind that we have just described. The most important probably date from the period when Sesostris, having overrun parts of Asia, Europe, and Africa, returned in glory to his own dominions. It is known that he then ordered works to be built to protect the Egyptians' land both from the floods of the Nile and from the incursions of their enemies; but these useful monuments were far less magnificent than those that he erected to honor the gods and to perpetuate his own memory. He built, according to Diodorus Siculus [(*Library of History* 1.56.2)], a temple in every city in Egypt and dedicated it to the deity particularly revered there.

There are grounds for believing that Sesostris built the temple at Bubastis, in honor of the goddess from whom the city took its name. This was entirely different from those just described. An imitation of the hut made more perfect by the addition of an enclosure, it served as the model for the most celebrated sacred edifices built by the Hebrews, the Greeks, and the Romans. In Herodotus's time, it excelled in its beauty of disposition even the finest of the monuments that he saw elsewhere in Egypt.

There may, says this ancient author [(Herodotus, *History* 2.137)], speaking of the stately temple at Bubastis, be some sacred buildings that surpass it in size and in the immense sums spent in their construction; but none is so pleasing to the eye. It is reached by a path that forms a kind of island between two canals. Each of the latter is 100 feet wide. Lined and shaded by trees, they extend from the Nile to the front of the building.

The gates that close the first entrance are 10 *orguiai* in height.[6] The splendid figures that adorn them are 6 cubits tall. As the city has now been raised up on an embankment, while the temple has been left untouched in the center, the latter is so much sunken that walking around the outside, one can see into every part of it. The enclosure is bounded by a stone wall adorned with figures carved into its thickness. This encloses a sacred grove of tall trees planted around the *naos*,[7f] which contains the statue of the goddess. *Every side of the enclosure is 1 stade in length.* At the entrance is a road paved with stone; this is 3 stades long at most and leads across the public square toward the east. It is 400 feet [wide], with the Temple of Mercury at the far end, and it is lined on either side with trees so magnificent that their tops seem to lose themselves in the sky.[8]

The beautiful arrangement of the temple at Bubastis reappeared in the earliest edifice built by the Hebrews: the Tabernacle that they set up in the wilderness, like the Egyptian temple, was composed of a *naos* that was free-standing and some distance removed from its perimeter wall. The facade of the body of the temple itself was remarkable: it had a column in the center, a feature that is found only in a few, very ancient buildings and that would suffice — if proof were needed — to show that the Tabernacle was built at a very early date.

The enclosure of this building was nobly disposed and adorned; its interior was 100 cubits long and 50 cubits wide. The longer sides were each lined with twenty columns, and the shorter sides with ten. Cloth hangings, stretched behind the columns and supported by pilasters set far enough back to form a peristyle, encircled the temple; the space between the hangings and the columns was covered with other hangings or with skins. Finally, there were curtains to the right of the columns themselves, which could be drawn, so that the peristyle of the enclosure could be either open or closed.

The Temple of Solomon was another that bore an analogy to that at Bubastis; but in magnificence of design it surpassed even the most famous of sacred buildings. It united within itself all those individual beauties of disposition that characterized and made admirable other temples. The *naos*, or main body, of the temple, like that of the Tabernacle, was surrounded by a rectangular court and fronted a grand court, like those of some Egyptian temples. The *naos* and the two courts already mentioned were themselves freestanding in the center of a third, square court so immense that each side was 500 cubits long. For further details concerning this temple we refer the reader to what we have already said in explaining the plate in which we illustrate it; and to this we add a note, below, that gives the dimensions of the principal parts of the building.[9]

The extensive contact of the Egyptians and the Hebrews with the Phoenicians suggests that a close affinity must have existed between the forms of their temples. We cannot point by way of proof to any large building of the same kind built by the Phoenicians; but one temple, though very small, of which one may still see the ruins in Phoenicia[10] is close enough in disposition to some of those in Egypt and in Palestine to suggest to us that the same likeness was evident in other, much larger temples built by the Phoenicians.

The Temples of the Greeks and the Romans

When one considers that the Egyptians had already completed a great number of the monuments just described by the time that some of their heroes sailed to Greece and there instructed the inhabitants, then still a race of savages, in their laws and in the cult of their gods, one is tempted to suppose that the Greeks learned from the Egyptians the greater part of the discoveries in architecture to which the Greeks themselves later laid claim. But if we consider the numerous stages through which the Greeks passed, from simple huts (which necessity had forced them to build before ever they knew the Egyptians) to the

most magnificent temples, and if we observe that they devised a regular system based on the orders, where the Egyptians seem to have followed no system at all, then we are forced to acknowledge the Greeks as the people who, aside from a few ideas taken from the Egyptians, invented the art of building. And so, while allowing that the Egyptians were the first people distinguished by the grandeur and immensity of their monuments, we cannot deny the Greeks the honor of having invented the architecture that bears their name.

So auspicious were the Greeks' first steps in architecture that they never strayed from them; and this is perhaps their greatest claim to praise. All too often, reflection mars the simplicity of the first effusions of genius. They disposed their rude huts so wisely that they were able to maintain the same form in the grandest of their temples. Their richest entablatures sprang directly from the arrangement of ceiling and roof timbers that they saw on the sides of those huts; and the width of the joists determined the size of the module, a measure initially used only to give the parts of the building the relative dimensions needed for the building to be solidly constructed but subsequently employed to give those parts the shape and size needed to produce the effect most pleasing to the eye.

The use of columns seems to have established itself in Greek buildings not long after the discovery of the module.[11] As to their origin, we make the following conjecture. When the first Greek temples grew too small for the crowds who came to sacrifice there, the architects perhaps foresaw that if they built them larger, the excessive span of the ceiling beams would make the beams bend, and thus the new monuments would be greatly weakened. Or perhaps, as indeed seems more likely, they did not perceive the fault until the temples were built. To remedy it, they cut tree trunks and placed them upright, at equal intervals, beneath a beam that extended the entire length of the temple, so that it supported all the transverse joists of the ceiling at the center and thus relieved the entire structure.[12]

The novelty of the spectacle produced by these columns ranged at equal intervals within the temples seems to have caught the imagination of the inventors of the peristyle; they soon built others along the external elevations, and they or their successors eventually added porticoes of larger columns to both the outside and the inside of those monuments.

After this, the Greeks built a temple to Juno in the city of Árgos, and several others in various parts of the Peloponnese, and they also greatly perfected the disposition of these monuments; yet the proportions of their columns remained arbitrary and in general extremely short—probably less than six diameters.[13] The first rules of proportion they established were devised by those Athenians who crossed into Asia Minor under the leadership of Ion, son of Xuthus.[g] After their conquests, they built a number of temples to the gods, initially imitating those they had seen among the Dorians, and for this reason they called them *Doric*. They then introduced an additional refinement of their own: to make their columns resemble the strength and beauty of a man's body, they established a height of six diameters. This first step was undoubt-

edly the greatest discovery ever made in architectural decoration, and it was the foundation of all others of the same kind.

From imitating the proportions of a man's body in the massive columns with which they ornamented some of their temples, the Ionians easily passed to imitating the proportions of a woman's body in the lighter columns of other buildings. They called this new order *Ionic,* because they themselves were its inventors. They enriched its columns by adding bases, and they even imitated women's hair in the ornament of its capital. The Ionic was further distinguished from the Doric by its novel form of entablature. They made the frieze smooth, where in the Doric it was decorated with triglyphs,[14] and replaced the wide mutules of the Doric cornice with diminutive dentils. With these two discoveries, they gave themselves great scope for future invention, and they made rapid advances toward perfection.

Liberated from the strict rules of the Doric—which required them to place the columns directly beneath the triglyphs, forcing them to make their inter-columniations either too wide or too narrow—they devised for the Ionic order a variety of intercolumniations and adjusted the proportions of columns and entablatures accordingly.[15] And the Greeks did not content themselves with these general discoveries: in an attempt to enlist the Ionic in the service of their national history, they replaced its columns with *caryatids,* or statues of the women of the Caryae [(Karuai, in Laconia)], to punish that Greek state, which had treacherously allied itself with the Persians to make war on them.

There is every reason to believe that the Greeks made a profound study of optics. They observed that in a temple surrounded by a portico, the columns on the corners appeared the thinnest because there was the most air around them; and so they increased their bulk a little. We believe that observations of the same kind led them to reduce the bulk of the shafts in the second row of columns, which received less light and therefore appeared stouter. Finally, they enriched the columns of the Ionic order with fluting different from that of the Doric, and they added several beautiful moldings to its entablature.

From all this it will be clear that, in passing from Greece to Asia Minor, the Doric order attained perfection and indeed gave rise to a new order. It underwent a very different change when it was transported, in those far-off times, to Magna Graecia and to Tuscany. That which the Ionians had enriched, the Tuscans impoverished; they lacked the genius to make a new order, and their order has remained confounded with the Doric. It departs from it in some slight particulars only because—aside from making some changes to the proportions of the order—the Tuscans kept it unaltered; while the Doric proper, successively refined by the Greeks and enriched by the Romans, and thus much changed from its original form, appeared in Italy at the end of the Roman republic and under the emperors as an order quite distinct from the Tuscan.[16]

After the Greeks had by degrees devised two distinct orders, a number of beautiful dispositions for temples, and a variety of proportions to be observed

therein, it might have seemed that nothing of great architectural importance was left to be discovered, either in the forms of sacred buildings or in the orders themselves. But then Kallimachos, on seeing a basket covered with a tile, around which the leaves of an acanthus had happened to grow in such a way as to curl under the edges of the tile, created the admirable Corinthian capital. The Greeks were impressed only by grand things, however, and they refused to accept so slight an enrichment of capital and entablature as a new order in its own right. They never treated the Corinthian order as independent of the two others, barely distinguishing it from the Ionic, which in many ways it resembled; but they recognized its particular character and used it for those buildings where they aspired to the greatest magnificence.

Scaling new heights of sublimity and descending to the subtlest refinements, the Greeks later built Corinthian temples fronted by eight columns and adorned with even more perfect bas-reliefs or more elegant statues, sculpture having always closely followed the progress of architecture.

Such was the Greeks' knowledge of perspective[17] that they applied its rules even to the smallest component parts of their buildings. On the Temple of Minerva [(Parthenon)], which was built in Athens by order of Pericles, the metopes were made higher than they are wide, so that at a distance approximately equal to twice the height of the temple, they might appear square to the eye. In short, the Greeks discovered all that is beautiful and ingenious in architecture; and the Romans, who conquered Greece by force of arms, were obliged to recognize the Greeks as their superiors in intellect, as they themselves confess.

Always bear in mind, wrote Pliny [the Younger] to Maximus, speaking of Achaia [(the Roman province of Greece)], which the latter was to govern, that this is the land that gave us its laws and that has never taken its laws from any other people. It is to Athens that you go, and Lacedaemon [(Sparta)] that you must govern; and it would be inhuman and barbarous to divest them of the shadow and the name of liberty, which is all that remains to them.[18]

In giving laws to Italy, Greece also imposed her arts. Under their earliest kings, the Romans built only in the Tuscan manner, erecting buildings more notable for size than for beauty. We cannot be sure that they did not learn the art of building stout fortifications directly from the Egyptians; but it does seem certain that they derived the form of their temples, and their Tuscan order, from the Greeks. As is well known, they achieved perfection in the arts only after they entered into open communication with the Greeks.

So long as their republic lasted, the Romans were absorbed in the great enterprise of making themselves masters of the world and never sought to be admired for their architecture. Under their emperors, however, they made strenuous efforts to distinguish themselves in this respect. They engaged the most celebrated Greek architects to build monuments for them in Rome, Athens, Cyzicus,[19] Palmyra, Baalbek, and the other famous cities of their empire; and some of these still command admiration for their grandeur and for their fine — if perhaps unduly lavish — ornament. Hadrian, who built more

than any other emperor, prided himself on his knowledge of architecture and had a list of his buildings set up in his famous Pantheon in Athens. He was no less determined to excel in this art than Nero in music or Dionysius [the Elder], tyrant of Syracuse, in poetry. Just as Dionysius condemned the poet Philoxenus to the stone quarries for having a poor opinion of his verses, Hadrian had the cruelty to put the architect Apollodorus to death for his mockery of a temple of Venus that the emperor had designed.

All in all, it seems that the Romans lacked the prolific genius that led the Greeks to so many discoveries. In the orders, they invented nothing of consequence: the one to which they laid claim, known as the Composite, is no more than a somewhat imperfect mixture of the Ionic and the Corinthian; and by giving taller proportions to the Doric order and adding more moldings to its entablature, they may have deprived it of much of the masculine character that distinguished it in Greece.

It may be added that for as long as they remained pagan, the Romans never departed from the rectangular and round temple forms invented by the Greeks; and when the Romans embraced Christianity, it was once again the Greek architects who taught them to combine these two forms by suspending, as it were, round temples over the vast arches of their naves. Let us now determine the date and trace the progress of that great discovery.

The Temples of the Christians

The relative ease or difficulty with which different religions originally spread, the zeal with which powerful monarchs or entire peoples embraced them, and the resistance they encountered would seem to be the prime causes of the difference in internal capacity between edifices sacred to the true God and temples dedicated to the false deities of the pagans.

The various religions of those peoples most skilled in architecture established themselves, gradually and without opposition, within flourishing states. Their most solemn sacrifices were often performed in the open air, in front of the temples, in the midst of their cities or outside the walls, in full view of all the inhabitants. The temple interiors had only to accommodate the priests and the images of the deities worshiped there; and the peoples that built them could decorate their exteriors with great splendor without making them excessively large.

The Christian religion, by contrast, was persecuted from the outset and shunned the light of day. The earliest Christians long concealed themselves below ground, in the dismal catacombs that they shared with death itself; and there they celebrated the mysteries of our religion in secret. At length they were freed from those horrid retreats. Constantine the Great gathered them into some of those buildings in which the ancients administered justice and which they called *basilicas*.

In those vast, enclosed, and well-lighted monuments, they celebrated the mysteries of our faith, safe from the insults of a populace that had so long persecuted them; and when their fears were at an end, they imitated those

same buildings, distinguishing them by laying out the plan in the form of a cross.

We thus find that the first Christian temple of any size, which was built by Constantine,[20] was partly a copy of the ancient basilicas; and we see from its plan, which is illustrated in a number of books, that it took the approximate form of a cross. We may assume that the church that he built later at Constantinople, under the name of Hagia Sophia [(Holy Wisdom)], was similar in disposition. It did not stand for long. Constantius [II], Constantine's son, built a new church that fell prey to the most unfortunate accidents: destroyed in part and repaired under Arcadius, it was burned under Honorius and restored by Theodosius the Younger; finally, in Justinian's time, a violent insurrection reduced Hagia Sophia to ashes. Justinian aspired to immortalize his own name through new buildings in Europe, in Asia, and in several parts of Africa; and so, having quelled the insurrection, he sent for the ablest architects from every quarter.

Anthemios of Tralles and Isidorus of Miletus,[21] among all those whom Justinian summoned, appeared to be preeminent in skill. They undertook to build a temple far larger than any before and to protect it against fire by making no use of wood. In boldly attempting an entirely new system of construction, they had their trials, like all innovators. Their building suffered many unforeseen calamities, but they enjoyed the glory of completing it, and its disposition was considered so beautiful that it was later approved of and imitated by the most enlightened as well as the most barbarous peoples of Europe. On stepping into the interior of Hagia Sophia, one is struck with admiration for the grandeur and beauty of the whole; and it is no wonder that Justinian so gloried in it that he exclaimed in a transport of joy: *I have surpassed thee, Solomon!*

Whatever praise Hagia Sophia may deserve[22] for the invention of the immense vault that rises at the center of a cross, its circular plan reconciled with the square beneath and supported by pendentives,[23] we must acknowledge that there are some ages in which monarchs, however great and at whatever expense, can produce only imperfect works. The building in question is a striking example of this, for all the details of its architecture are highly defective.

The arts, which under Constantine's predecessors had already fallen from their former perfection, declined still further under this first Christian emperor and during the years that separated his reign from that of Justinian. Toward the end of the tenth century, the arts fell into such a barbarous state that the Venetians, who wisely copied in San Marco all that had succeeded in the disposition of Hagia Sophia, could think of nothing better than to imitate the bad taste of its interior decoration. In the tenth and eleventh centuries, all Europe derived her artistic laws from Constantinople, whose buildings now seem to us barely superior to those of the Goths.

So renowned were the Greek architects, even then, that the Italians summoned them to build their finest works: this is evident in a number of

historical instances, as it is in the resemblance between Hagia Sophia and San Marco. The disposition of San Marco would therefore seem to be Greek, but its plan was based on a more regular form of cross than had been used before. The vaults over the center and the arms of the cross are supported by pendentives and spanned by domes taller than those of the ancients; San Marco also embodies the idea, since imitated at Saint Peter's in Rome, of surrounding the central dome with smaller and lower domes, to create a pyramidal effect.

Before this point, we have been unable to discern the part taken by the Italians in the application of new architectual ideas, even in the buildings of their own cities; we now mark the date when they became indisputable creators.

In the arts, as in literature, those ages that bring forth the finest works are rooted in the obscure and arduous labors of previous ages. Fortunate insights allied with the most bizarre ideas, strokes of genius misjudged or little noticed in barbarous times and later taken up by great men, have given us those masterpieces that command our admiration while tempting us, perhaps, to overlook the sources on which their authors drew. The progress of architecture in Italy after the arts were first reborn in that country reflects the history of every branch of human knowledge. The ingenious ideas of the fifteenth century paved the way for the magnificence of the design conceived in the reign of Leo X for the largest building in the world. If Santa Maria del Fiore in Florence, begun in the Gothic style, had not been crowned with its present beautiful dome, and if a dome supported by pendentives had not been built in Sant'Agostino, the small and little-known church of the Augustinians in Rome, the shape of Saint Peter's might now be entirely different.

It was not the capture of Constantinople by Mehmet [II] in the year 1453, and the consequent flight of great men from the city, that spurred the Italians to regain the artistic preeminence that they had enjoyed under the earliest emperors. The first impulse sprang solely from their own genius. As early as 1407, a Florentine, [Filippo] Brunelleschi, revealed to them all the beauties that exquisite taste and profound study had enabled him to find in the ruins beneath their feet and in the precious monuments of ancient Rome. In those early years of the fifteenth century, attempts were made to decipher Vitruvius, the one, priceless work of the ancients on architecture that we possess; by the end of that century, the fine proportions of ancient buildings, and of their component parts, were public knowledge.

The immense dome over the sanctuary of the church of Santa Maria del Fiore in Florence was the earliest indication of this auspicious change, and one of the most striking. Begun in the Gothic style by the architect Arnolfo Lapi [(Arnolfo di Cambio)], it was intended to be completed under his direction; and on his death, the Florentines were at a loss to finish the main vault, which was wider than any ever attempted by the moderns.

Still unaware of the true ability of their own compatriot, Brunelleschi, the Florentines took his advice and summoned all the most noted architects in Europe to give their views on the completion of the church. In a general

assembly held in 1420, these men set forth their own projects for the building of the dome, all of which required an immense scaffold, as was the custom in those days. When Brunelleschi was consulted, he proposed that this scaffolding be reduced considerably, or even dispensed with altogether. On hearing so extraordinary and audacious a proposition, his rivals treated him as mediocrities commonly treat men of genius: they dismissed him as a madman. Brunelleschi was undaunted; well aware of the difficulty of persuading men during large and disorderly assemblies, he privately visited all the persons responsible for the building, and by speaking to them with a force and sagacity unknown in those who promote ill-considered projects, he convinced them. In a subsequent general assembly, they gave him the task of vaulting the dome, which he did with the greatest success.

Brunelleschi's boldness in constructing the dome of Santa Maria del Fiore in an entirely novel, sound, and inexpensive manner, to the general surprise of Italy and the embellishment of Florence, provoked Rome to emulation. One monument alone, so small that it has escaped the notice of writers on the buildings of Rome, shows us that after the death of Nicholas V [in 1455], the Romans attempted a new departure in the art of vaulting the sanctuaries of churches. From the Florentines' perfect dome, they took the further step of devising domes supported on the arches of the nave; it was the Romans who ventured to try this, and they were successful.

Sant'Agostino, where they first put this idea into practice, holds no place among the finest buildings of Italy; its only claim to our attention is its position in the train of ideas that has brought the crossings of our temples to their present perfection. Never before had the four arches of the crossing, with pendentives between, served to support a domical tower, that is, a cylindrical drum surmounted by a calotte.

The errors in the construction of this dome no doubt sprang from lack of experience. After I left Italy, it threatened to collapse and was demolished, after standing for no more than 380 years. The architect who built it had considerable structural difficulties to overcome: though the diameter was not very great, the supporting piers were far from substantial. It covered the sanctuary of a church built, according to an inscription on its facade,[24] on the orders of Guillaume d'Estouteville in 1483, during the reign of Pope Sixtus IV; this was some sixty years after Brunelleschi was employed to build the dome of Santa Maria del Fiore and twenty years before Julius II ordered plans to be made for the rebuilding of Saint Peter's.

Elected pope at the beginning of the sixteenth century, Julius embarked on the new basilica with all the zeal that betokens success for the greatest undertakings. We may imagine the exertions of those celebrated architects whom Fortune seemed to have brought to Rome expressly to compete for the undying distinction of being chosen to build that famous temple. [Domenico] Bramante had the glory of defeating all his rivals. His design was chosen; and, indeed, it was strikingly grand and beautiful. The interior, in the shape of a Latin cross, was very well conceived; the monument was vaster than any built

before; the principal nave was finely proportioned, and the adornments that marked the ends of the three other arms, consisting of peristyles of detached columns flanked by solid piers, were bound to produce a fine effect through the variety created by changes in the light. The interior of the Pantheon seems to have been Bramante's sole inspiration: such was his admiration for that temple that he planned to build another, exactly like it, over the crossing of Saint Peter's. It was Bramante, therefore—and not, as is supposed, Michelangelo—who had the idea of setting the Pantheon on the Temple of Peace.

Julius II laid the first stone, with the greatest solemnity, on 18 April 1506, some 1,180 years after the founding of the former basilica by Constantine the Great. After the praise that we have just lavished on the genius of the architect who devised its plan, we would prefer to draw a veil over his inadvertent faults: for such was his haste and lack of care in laying the foundations that, not long after his death (which was shortly followed by that of Julius II), the four completed arches designed to support the dome began to crack in several places.

Under Leo X, Adrian [VI], Clement VII, and Paul III, a succession of architects, the last of whom was Antonio da Sangallo [the Younger], were employed to remedy Bramante's errors, but in correcting them they made new ones. By considerably reducing the length of the principal arm of the cross and rendering it equal to the three others, they gave the interior of the church the form of a Greek cross.

Fortunately for Saint Peter's, and for the arts, Michelangelo was placed in charge of its construction. That great man, summoned from Florence to Rome by Paul III in 1[5]46, after Sangallo's death, set out to restore to the edifice the majestic decoration that Bramante had given it and of which Sangallo had deprived it.[25] His disinterestedness earned him the total confidence of Paul III, and he would have been at liberty to enlarge the basilica; but, in order to satisfy the pope's desire to have it finished, he decided to make it smaller.

Michelangelo left the nave and transepts in the Greek cross form and made few changes to their general ordonnance; but he changed the entire decoration of the exterior and, rightly rejecting Sangallo's notion of decorating the dome with two diminutive orders, he adorned it, like Bramante, with one. He also made its internal order taller than Sangallo had intended, and he lowered the vault that it was intended to support. He separated the vault into two thin vaults, one above the other, as had been done at Santa Maria del Fiore. For the outline of the dome, he traced a higher curve than had previously been intended; after his death, Giacomo della Porta and [Domenico] Fontana made it taller still by one-sixth.

As for Carlo Maderno, who completed the main body of the basilica, he merely restored the Latin cross form, as intended by Bramante, and built the present portico, which is very much inferior to that designed by Michelangelo. [Gian Lorenzo] Bernini subsequently added the magnificent piazza that now precedes Saint Peter's.

Michelangelo is therefore rightly regarded as the architect who contributed most to the perfection of Saint Peter's, though he had the direction of it for only seventeen years, after commencing work at the advanced age of seventy-two, forty years after Bramante had laid the foundations. The history just related shows that neither the general disposition of the building nor the idea of supporting the dome on the crossing arches was Michelangelo's, though he executed the latter idea with success — the merit of the artist who perfects being of a different order from that of the man of genius who invents.[26]

The general disposition of domes attained a new pitch of perfection, or at least acquired greater variety, when their supports were opened to afford free access to the side aisles of large churches. This was an English achievement; it was Sir [Christopher] Wren, so celebrated for his mathematical knowledge, who first put this happy idea into execution at Saint Paul's in London. This disposition was certainly a stroke of genius on the English architect's part; but the result is that the choir is too narrow and the nave and the transepts seem petty in relation to the vast extent of the dome. One need only look at the drawings to recognize that it is not the equal of Saint Peter's in beauty of form; and though the portico of the latter has its faults, it has only one order and is thus more nobly composed by far than that of Saint Paul's, which has two. Wren laid the foundations of that immense and admirable temple in 1676 and enjoyed the glory of completing it, in the space of some forty years, as he had first conceived it, whereas the ten or more architects who worked on Saint Peter's made considerable changes to Bramante's initial design.

There seemed to be no room for more improvements to the crossings of the largest churches when Louis XIV, at a time when Saint Paul's was under construction in London, engaged Jules Hardouin Mansart to build a rotunda at the Invalides. In this, Mansart proved the fertility of his genius. The constraints of the existing, very narrow nave, to which he was to add his dome, prevented him from devising as grand an ensemble as he might have done for a cathedral, but he found a way to improve the pendentive area, previously somewhat neglected. In the supporting pier of each pendentive, he made a central opening formed into a richly decorated chapel; he fronted each pier with a pair of columns, added steps reflecting the beautiful circular form of the cupola above, and designed his dome so that to stand at its center is to enjoy one of the most magnificent spectacles that architecture can afford.

Mansart also disposed the two vaults of his dome with consummate art. He made an opening in the lower vault and had the soffit of the upper vault covered with paintings, which are lit by windows in an attic. The light, entering between the two shells, strikes the curved surface of the upper vault in such a way that observers on the ground cannot see the windows or divine the source of the light; and this lends great éclat to the fine paintings with which the vault is adorned.

As we have shown, many centuries elapsed before Christians succeeded in perfecting the design of domed churches. In France, since the end of the age of

Louis XIV, a new tendency seems to have emerged in the planning and decoration of the interiors of such churches.[h] The earliest instance is the chapel at Versailles. In its lower part, Mansart maintained the frigid and weighty decoration of arches, which, variously enriched, form the ordonnance of most modern churches. In the upper part—where the king, surrounded by his court, attends divine service—Mansart deployed the full magnificence of Greek architecture. Imitating in this interior the audacious system used by Perrault in the peristyle of the Louvre, he outdid Perrault in audacity by making his columns sustain the thrust of the lofty vaults of his chapel and the immense weight of the roofs that cover them.[i]

Emboldened by this example, Monsieur [Nicolas Henri] Jardin, when summoned to Copenhagen to supply designs for the temple that is to be built there, made it circular in form and employed freestanding columns to support the vault.[j] But the first church building ever set in hand in which columns are employed throughout is undoubtedly that of Sainte-Geneviève,[k] which is being built to the designs of Monsieur [Jacques-Germain] Soufflot. The same system has since been followed at the Madeleine, a very different church, where the design under execution is by Monsieur [Pierre] Contant [d'Ivry].[l]

True, the buildings of antiquity supply some examples of this system, whereby columns mark all the divisions of a temple and form its principal decoration; but these internal colonnades were either in unroofed temples—and therefore no more difficult to build than the peristyles that adorned their exteriors—or in roofed buildings where they served as supports for great plain walls that rose perpendicularly above their entablatures and supported horizontal ceilings in the most natural manner, without having to sustain the thrust of a vault. It may be added that in the rare cases when vaults were carried on rows of columns, those vaults were of no great span and generally consisted, as in the chapel at Versailles, of a tunnel vault terminated by a half-dome.

Furthermore, the cross form gradually established and perfected in sacred buildings, and the massive piers required to support their central domes, seemed to have banished the use of columns forever, given the sheer impossibility of having those elements while using columns. We shall find that they reappear not only in the churches named here but also in those now or soon to be under construction in and around Paris; and we dare predict the generally pleasing effect that they will produce. Those architects who have done the most to establish this system seem to have found their way to it as follows.

A moment's reflection on the origin and progress of the arts suffices to show that men, given time, will make the best of what is around them. In the mountains that mark the confines of Egypt, the Egyptians discovered vast quarries of granite and marble, and from these they gradually contrived to extract blocks of prodigious size; to this day, travelers are amazed by this aspect of the ruins of their buildings, as well as by their obelisks, which adorn the squares of Rome.

The marbles that the Greeks found on Páros island, on Mount Pentelicus

[(Pendelikón)], and elsewhere yielded no such enormous blocks; but they still had resources enough in their own country to absolve them from any serious need to study the art of what architects call *stereotomy*. The Romans were similarly exempted by the excellence of the cement that served to form their vaults. It was left to the peoples of the north to investigate this art most deeply. The small stones used by the Goths, and the display of boldness that they favored in their buildings, earned them the distinction of carrying the art of stereotomy to a high degree of perfection.

This merit of Gothic buildings, long obscured by the bad taste that prevails in their architecture, has only lately been acknowledged: it was not until a few years ago that all the marvels of Gothic construction have been closely studied. The vaults in the naves of their churches are commonly somewhat lighter and somewhat taller than ours; and, having less thrust, they do not need such stout piers to sustain them. Thus, by following—in this respect alone—in the footsteps of the Goths, by searching for the strongest and at the same time lightest materials for the construction of vaults, and by placing extremely slender piers at the points where those vaults exert their greatest force, French architects might endeavor to make the interiors of their churches more unobstructed than was formerly thought possible, while gracing them with Greek orders used in the noblest and most comprehensive manner.

I shall not venture to pass judgment on any single church composed in accordance with the new system; but if it succeeds—and everything suggests that it will—it bids fair to raise our people to a considerable eminence in architecture. It is not likely that any monarch will ever undertake to build a church larger than Saint Peter's in Rome, but churches might yet be devised that would excel it in disposition or in decoration. These were the only means the Greeks employed to distinguish themselves from the peoples that had preceded them in the knowledge of the arts. In general, the buildings of the Greeks were smaller in extent than those of the Egyptians, and yet the Romans so admired the disposition and decoration of Greek temples that they imitated them, and their ornaments are still reproduced in our own buildings; in contrast, the design of Egyptian buildings and their ornaments are seen, at best, by a small band of curious amateurs, who consult the scarce books of a few travelers.

In speaking of the Egyptians at the beginning of this essay, we showed that, having imitated the trunks of trees in their earliest columns, they subsequently devised another, extraordinary and colossal form of column by binding small trees together. We showed how they gradually perfected temples or edifices of a type utterly different from those of all other peoples; and we also pointed out in some of their temples the initial ideas taken up in those of the Hebrews and the Phoenicians.

We then followed the Doric order from its birth in the wooden huts of Greece, as it perfected itself and grew in beauty. Like a tree frail at birth but in the course of time throwing out mighty limbs to a great distance from its trunk, it gave rise to the Ionic in Asia and to the Tuscan in Italy, and it grew in

height and in enrichment to produce the Corinthian order and, finally, the Composite. We also showed that the form of the temples of the Greeks is theirs and theirs alone, because it is the same as that of their huts; like the essential parts of their orders, it was a product of necessity.

In Egypt, where it seldom rains, temples had no roofs. The climate of Greece, mild though it was, did not allow roofs to be dispensed with, but it permitted them to be low; and this naturally suggested the appropriate shape for Greek temples. After initially following their example, the Romans eventually took into account the climate of their own country, with its occasional heavy rains, and made their roofs somewhat higher. And it seems that the form of Saint Peter's in Rome, which has been imitated all over Italy and in France, England, and Germany, is particularly suited to the countries of the north, because it unites the advantage of a high roof, which is necessary in cold climates, with the pleasing form of the cupola, which proclaims from every angle the magnificence of their cities.

From this it may be seen that the forms of buildings largely depend on climate and that the principles of architecture are not all so general that they do not sometimes give way before such influences. There are other considerations that cause some of those principles to vary from one people to another; and yet there are others on which all the peoples of Earth agree. We shall examine these varying degrees of certainty in the essay on the theory of architecture, which we have placed at the head of the second volume of this work.

Le Roy's Notes

1. See the drawing of these columns that [Richard] Pococke presents in his description of Egypt [(*A Description of the East, and Some Other Countries*)], vol. 1, pl. 67, as well as his remarks on p. 21 of the same volume.

2. See the form of these columns in Pococke's voyage to Egypt [(*Description of the East*)], vol. 1, pl. 47, as well as his remarks on p. 114 of the same volume.

3. See the drawing of this temple in Pococke's voyage to Egypt [(*Description of the East*)], vol. 1, pl. 28, as well as his remarks on p. 92 of the same volume.

4. This temple[—Esagila, the Temple of Marduk (Bel or Belus) at Babylon—]was the largest in all antiquity. According to Herodotus [(*History* 1.181)], its perimeter measured 8 stades, each side of its enclosure being 2 stades long. The body of the temple that was at the center[—the ziggurat Etemenanki, popularly known as the Tower of Babel—]was 1 stade long on every side and 1 stade in height. It was pyramidal, being composed of eight levels graduated in height. Another curious feature was that it had two *naoi* [(sanctuaries)], one at the apex of the pyramid and another, unroofed, in the lower part of the structure. See Herodotus, bk. 1, p. 75 (ed. of 1618).

5. See the fragment by Sanchuniathon, published by Eusebius [(*Preparation for the Gospel*, bk. 1, chap. 10, sec. 12)], for what he says on the huts of the Phoenicians. According to this fragment, the hut was perfected by *Agrus* and *Agronerus,* who placed it in a court. This court could either be before the hut or enclose it. We have reason to believe that huts were built of which some had the first disposition and the others the

second. The courts that fronted or surrounded the temples of the ancients are only an imitation of these, as we shall have occasion to show.

6. The *orguia* contained 6 feet. [The ὀργυιά (pl. ὄργυιαί), or fathom, was calculated as the stretch of both arms, or 6 feet.]

7. *Naos.* As we have already said, this was the main body of the temple; it was placed in the center of the ἱερὸν [(*hieron*, or enclosure)], whose dimensions Herodotus gives as follows: εὖρος δὲ καὶ μῆκος τοῦ ἱεροῦ, πάντη σταδίου ἐστί. "The breadth and the length of the sacred space of the ἱερὸν is one stade in every direction." From which one could believe that Herodotus, in specifying breadth and length, might be indicating a difference between them, that these two dimensions together made 1 stade; or that — correcting by the word πάντη the idea of inequality conveyed by the words εὖρος and μῆκος — the length was equal to the breadth, and that each was 1 stade. The magnificence of the building itself inclines me toward the latter. This is also the reading adopted by the Latin translator, who renders the passage thus: *longitudo Templi quoquo versus unius est stadii.* [Note that the Greek stade was initially calculated as the distance covered by one draft of the plow, or 600 feet; the Greek foot was not standard, however, for the Olympian foot measured 12.6 inches, the Pergamese foot 13 inches, and so on. Thus, like other measures, the stade was not fixed.]

8. See the description of this temple in Herod., bk. 2, p. 143.10 (ed. of 1618). [Herodotus, *History* 2.138.]

9. *Explanation of the disposition of the first temple at Jerusalem.*

In this explanation, we do no more than examine the disposition of a temple of great magnificence, as described in the most authentic work of antiquity that we possess: we do so in accordance with the account given by Ezekiel, who had seen it countless times and had officiated in it. To render this explanation as brief and as clear as possible, we shall not discuss the varying opinions that have been advanced as to the size of the temple. We shall say only that it is almost universally acknowledged that the *hieron*, the space bounded by the walls of the first and largest court, was a square, each side of which measured 100 cubits. Solomon's temple is indicated in plate 1 by the number 12. We assume that the side toward the bottom is the east, with the north on the right and the south on the left.

In chap. 40, v. 15, Ezekiel says: Καὶ τὸ αἴθριον τῆς πόλης ἔξωθεν, εἰς τὸ αἴθριον αἰλὰμ τῆς πόλης ἔσωθεν πηχῶν πεντήκοντα. "From the outer face of the gate to the inner face of the gate there were 50 cubits."

In verse 19, the prophet says: Καὶ διεμέτρησε τὸ πλάτος τῆς αὐλῆς ἀπὸ τοῦ αἰθρίου τῆς πόλης τῆς ἐξωτέρας ἔσωθεν ἐπὶ τὸ αἴθριον τῆς πόλης τῆς Βλεπούσης ἔξω, πήχεις ἑκατὸν τῆς Βλεπούσης κατὰ ἀνατολὰς καὶ ἤγαγε με ἐπὶ Βορρᾶν. "He measured," says the prophet, speaking of the angel who was his guide, "the breadth of the space from the face of the gate of the outer court up to the face of the gate of the inner court, and he found that there were 100 cubits on the east side; then he conducted me northward."

In quoting only these two verses, I have obviously omitted the minute scrutiny of all the measurements of details given in Ezekiel's description, seeking only to give an idea of the building as a whole. It will be seen from Ezekiel's verses that the depth of the east gate *lm* was 50 cubits, and that its distance *kb* from the corresponding gate of the second court was 100 cubits. The prophet concludes verse 19 by saying that the angel led

him northward. In the verses that follow, he gives all of the measurements of the north gate, and he also tells us that its depth *gh* was 50 cubits and its distance *gf* from the corresponding gate of the inner court was 100 cubits. At the beginning of verse 24, the prophet says that the angel brought him toward the south. He then gives the dimensions of the south gate of the first court; he says that its thickness *ab* was 50 cubits and its distance from the gate of the second court was 100 cubits.

From the description of the gates of the first court, the prophet passes on to that of the gates of the second court; and, first describing the south gate, which he has mentioned as one of the terms of the last-named dimension of 100 cubits, he tells us that, like that of the first court, it was 50 cubits in depth from *c* to *d*. He passes on to the east gate, which he tells us was also 50 cubits in depth from *l* to *k*; finally, he also says that the north gate was 50 cubits in depth from *c* to *f*.

After having described the gates of the first and second courts, Ezekiel gives the dimensions of the second court, *R*, in verse 47: Καὶ διεμέτρησε τῆς αὐλῆν, μῆκος πηχῶν ἑκατὸν, καὶ εὖρος πήχεις ἑκατὸν ἐπὶ τὰ τέσσαρα μέρη αὐτῆς, καὶ τὸ θυσιαστήριον ἀπέναντι τοῦ οἴκου. "He measured also," says Ezekiel, speaking of the angel who conducted him, "the court, which was 100 cubits long and 100 cubits broad, foursquare; and the altar that was before the temple."

Thus, taking all the individual measures given by Ezekiel for the parts of the temple from south to north, it will be seen that the depth of the gate *ab* was 50 cubits; the distance *bc* to the gate of the second court was 100 cubits; that the depth *cd* of the latter was 50 cubits; that the second court measured 100 cubits; and, finally, that the gates *cf* and *gk* were also each 50 cubits in depth and the space between them 100 cubits. These measures taken all together indicate that the total width of the temple was 500 cubits; which is the overall measurement on which the Jews and all those who have made a profound study of the temple are in agreement.

This perfect unanimity seems to us to justify our opinion concerning the general disposition of the temple. We may add that, since Ezekiel firmly states that the principal dimensions of the gates of the first court were the same as those of the second, and the latter court was 100 cubits across, if we accept either argument just given—that which shows each of the gates of the court to be 50 cubits deep, or that which shows the distance between them to be 100 cubits—the hypothesis is confirmed in either case. Since the width of the temple was only 500 cubits, the depth of the gates cannot be either increased or diminished without changing the distance between them; nor can this distance be increased or diminished without changing the depth of the gates. For the rest, we make no claim that our conjecture concerning the general disposition of the temple has any more than the degree of likelihood proper to such inquiries. [The cubit was not fixed, of course: the short cubit was the length from the elbow to the base of the fingers; the short cubit of Homer and Herodotus was the length from the elbow to the knuckles of a closed fist; the normal cubit was the length from the elbow to the fingertips.]

10. See figure 13, plate 1.

11. *Not long after the discovery of the module.* "The diameter of one column," says Vitruvius, bk. 2, chap. 2, "or the module of one triglyph, will give the size of a temple." He adds, in book 4: "The triglyph must contain one module, and the diameter of the column two." [Vitruvius, *De architectura* 3.3.7, 4.3.3–4, though these passages

do not match Le Roy's quotations exactly.] This passage quite clearly shows that the module was originally defined by the width of a triglyph, or by the width of the beam of which it formed the end; and that the Greek architects, wishing the column diameter to be in proportion with the building, first made it twice the width of the triglyph — whereas, if the principal measurement of the buildings had originally been taken from the foot of the column, they would have made the foot of the column one module and the width of a triglyph half a module. This makes it all the more probable that it was not until they came to invent the Ionic order — which has no triglyph in its frieze to define the module — that they took as their universal unit of measurement the foot of the column, or rather its diameter, which they counted as one module, not two.

12. I derived this conjecture from the way in which the columns were initially arranged in the Greek temples, as seen in two temples of the remotest antiquity. The one in Italy at [Pesto, or] Paestum, an ancient city of Magna Graecia, some 22 leagues from Naples, has a range of columns down the middle of the interior, just as we suppose the first columns were placed in buildings. The other, on Aegina, has five columns in the second rows of its front and rear elevations and consequently, again, a column in the center. Finally, my opinion seems to be confirmed by the etymology of the Latin word *columen*, which means *column*: it derived, says Vitruvius [(*De architectura* 4.2.1)], from a piece of wood called *culmen*, which it supported and which was placed under the ridge of a roof.

The public may form its own opinion as to the merits of this conjecture, partly deduced from the temples at Paestum. It has been to some extent confirmed in two books recently published on the ruins of that city: one by Mr. [Thomas] Major, the other by Monsieur [Gabriel-Pierre-Martin] Dumont. The chronology of the discovery of the temples by a Neapolitan painter, of the survey of them taken by Monsieur [Jacques-Germain] Soufflot, and of the various works published on them is given by Dumont in a note, pp. 8 and 9 [of his *Les ruines de Paestum, autrement Posidonia*].

13. *Less than six diameters.* We conjecture — from a temple at Corinth, of which we give drawings [in volume 2, pl. 17]; from another that we have discovered in Attica; and from those at Paestum, where the columns are far less than six diameters in height — that this extremely squat proportion was in use before there were any rules as to the ratio between the height and diameter of columns. We make no claim that the temples mentioned here predate the time when ratio was fixed at six diameters; only that they give an idea of that first manner of building, which persisted in use even long after the rules we are discussing had been established.

14. Vitruvius, bk. 4, chap. 1.

15. For the proofs of what I advance here, see Vitruvius, bk. 3, chap. 2 [Vitruvius, *De architectura* 3.3, 3.5.], or in the present work, part 2, "The Ionic Order."

16. *Distinct from the Tuscan.* See the parallel that I draw between this order and the earliest Dorics of Greece, at the beginning of part 2 of this work.

17. On the ancients' knowledge of perspective, see the work of the abbé [Claude] Sallier, *Mém. de l'Acad. des inscript.*, vol. 8, p. 97. By reference to a number of ancient texts, this author convincingly argues that the ancients were familiar with the rules of perspective, thus refuting Monsieur Perrault, who sought to prove the contrary by reference to Trajan's Column in Rome.

In view of their knowledge of perspective, the Greeks would seem the most likely source for the optical observations, mentioned above, regarding the apparent expansion or diminution of columns when surrounded by a large volume of air or dimly lighted. True, these observations come down to us from Vitruvius [(e.g., *De architectura* 3.3.11–13, 3.5.9)]; but we surmise that he took them from the books of the Greek architects, of which, by his own account, he made great use.

18. Pli., bk. 8, ltr. 24. [Pliny the Younger, *Epistulae* 8.24.4–5.]

19. See the fine description of a temple at Cyzicus [(Belkis, Turkey)], with columns of a surprising size, published by the comte de Caylus, in his erudite *Recueil d'antiquités égyptiennes, étrusques, grecques et romaines,* vol. 2, 250–52.

20. Constantine gave the order for the building of this temple, the old Saint Peter's, when he was in Rome to celebrate the twentieth year of his reign.

21. *Tralles and Miletus.* Two ancient cities in Asia Minor, near Smyrna [(İzmir, Turkey)]. They were counted among the cities of Greece. [Tralles is now called Aydin; Miletus is deserted.]

22. Being in Constantinople, I saw Hagia Sophia several times and even drew it to the best of my ability; and I speak of the construction of this mosque with a confidence derived from personal observation. [The readily available account of Constantinople and its chief buildings was Guillaume-Joseph Grelot, *Relation nouvelle d'un voyage de Constantinople: Enrichie de plans levez par l'auteur sur les lieux, et des figures de tout ce qu'il y a de plus remarquable dans cette ville* (Paris: la veuve de Damien Foucault, 1680), but there were accounts in various other travel books as well.]

23. *Pendentive* is a term of art, which it has proved impossible to avoid using frequently. It refers to the portion of the vault rising between the arches of a dome; its upper part advances to support the circular entablature that rests on the arches and supports the dome. At the Invalides, the curved surfaces of the pendentives are occupied by the four church fathers [(Saint Jerome, Saint Ambrose, Saint Augustine of Hippo, Pope Gregory the Great)].

Pendentives have also been given the name *panaches* [(plumes)], because of their shape: *panaches,* emerging from one extremely slender stalk, expand and advance as they rise, as do *pendentives.*

24. GUILLELMUS DE ESTOUTEVILLA, EPISCOPUS OSTIENSIS, CARD. ROTOMAG. S.R.E. CAMERARIUS, FECIT M. CCCC. LXXXIII. ["Guillaume d'Estouteville, bishop of Ostia, cardinal of Rouen, camerlengo of the Holy Roman Church, built this in 1483."]

25. On this topic, see the letter from Michelangelo to a friend, published in [Filippo] B[uo]nanni, chap. 14, page 75, which commences as follows: *Messer Bartolomeo amico caro. E non si può negare, che Bramante non fosse valente nell'Architettura, quanto ogn' altro, che sia stato degli antichi in quà,* etc. ["My dear Monsieur Bartolomeo, It is not to be denied that Bramante was as worthy a man in architecture as any other since the ancients."]

26. So little was known of the history of Saint Peter's, which is recorded only in voluminous and seldom-read works, that Monsieur de Montesquieu, in his *Essai sur le goût,* credited Michelangelo with the idea of supporting in midair a temple as large as the Pantheon; in fact, the idea was conceived by Bramante, forty years before Michelangelo ever worked on Saint Peter's.

Editorial Notes

a. Le Roy uses the word *cabanne*, which in the eighteenth century was rendered as *cabin* in English translations but has consistently been rendered as *hut* in twentieth-century translation, a practice followed here.

b. The "temple at Syene" is perhaps the ruined Ptolomaic temple in the town of Aswan, though the view in Pococke to which Le Roy refers depicts the ruins of the quays and walls of that town.

c. Diodorus Siculus discusses Ozymandias and his reign in the *Library of History* 1.47.1–1.49.6, but his text does not supply the date Le Roy cites.

d. According to Ronald Edward Zupko, *French Weights and Measures before the Revolution: A Dictionary of Provincial and Local Units* (Bloomington: Indiana Univ. Press, 1978), the standard linear measure in Paris in Le Roy's time was the *toise du Châtelet* (after 1688, known as the *toise du Pérou*) and 1 *toise* = 6 *pieds de roi* (feet); 1 *pied de roi* = 12 *pounces* (inches); 1 *pounce* = 12 *lignes* (lines); 1 *ligne* = 12 *points* (points). Or, converting to current metric and U.S. measures, 1 *point* = 0.188 mm; 1 *ligne* = 2.256 mm; 1 *pounce* = 2.707 cm (1 1/16 in.); 1 *pied de roi* = 32.483 cm (12 3/4 in.); 1 *toise* = 1.949 m (6 3/8 ft.).

e. According to Ronald Edward Zupko, *French Weights and Measures before the Revolution: A Dictionary of Provincial and Local Units* (Bloomington: Indiana Univ. Press, 1978), in Le Roy's time usually 1 *stade* = 125 *pas géometriques* = 1/8 *mille*, or, converting to metric and U.S. measures, 1 *stade* was about 180 m or about 590 feet. Thus, 1 *mille* = 1,000 *pas géometriques* = 8 *stades*, or, converting to metric and U.S. measures, 1 *mille* was about 1,440 m or about 4,725 feet or about 7/8 mile. Le Roy occasionally uses the *lieue* (league), which in Le Roy's time still varied in length but was generally between 2,000 and 3,000 *toises*. In his volume 2, Le Roy measures part of the plain of Sparta in *pas ordinaire*, which is half of a *pas géometrique*.

f. Le Roy's quotations of texts have not, in general, been modernized or corrected. In his Greek quotations, missing and misplaced accents and breathing marks, missing or added words, and punctutation marks have not been altered, except in the case of breathing marks at the beginning of words, which have been moved to appear as expected in modern usage. A few misspellings have been corrected; these changes appear enclosed in square brackets.

g. Traditionally accepted as the ancestor of the Ionians, Ion is usually identified as the son of Xuthus, a mythical figure, and Creusa, daughter of the Athenian king Erechtheus, though Ion was later to be identified by Euripides as the son of Apollo. See Timothy Gantz, *Early Greek Myth: A Guide to Literary and Artistic Sources* (Baltimore: Johns Hopkins Univ. Press, 1993).

h. On the interest in lightweight church design, related to an interest in Gothic construction, which emerges in France with the building of the chapel at Versailles, see Robin Middleton, "The Abbé de Cordemoy and the Graeco-Gothic Ideal: A Prelude to Romantic-Classicism," *Journal of the Warburg and Courtauld Institutes* 25 (1962): 278–320, 26 (1963): 90–123; and Wolfgang Hermann, *Laugier and Eighteenth Century French Theory* (London: A. Zwemmer, 1962).

i. On the iron reinforcements required, see Robin Middleton, "Architects as Engineers: The Iron Reinforcements of Entablatures in Eighteenth-Century France," *AA*

Files, no. 9 (1985): 54–64; and Robert W. Berger, *The Palace of the Sun: The Louvre of Louis XIV* (University Park: Pennsylvania State Univ. Press, 1993), esp. chap. 6, "Materials and Structure," in collaboration with Rowland J. Mainstone. On the French tradition of stereotomy, see Jean-Marie Pérouse de Montclos, *L'architecture à la française XVIe, XVIIe, XVIIIe siècles* (Paris: Picard, 1982).

j. See Nicolas Henri Jardin, *Plans, coupes et élévations de l'église royale de Fréderik V, à Copenhague: Monument de la piété de ce monarque* ([Paris?]: n.p., 1765); Christian Elling, ed., *Documents inédits concernant les projets de A.-J. Gabriel et N.-H. Jardin pour l'église Frédéric à Copenhague* (Copenhagen: Henrik Koppel, 1931); and Christian Elling and Kay Fisker, eds., *Danish Architectural Drawings, 1660–1920* (Copenhagen: Gyldendalske Boghandel, 1961), pls. 47–62.

k. On Sainte-Geneviève, see Jean Mondain-Monval, *Soufflot: Sa vie, son oeuvre, son esthétique (1713–1780)* (Paris: A. Lemerre, 1918); and Mae Mathieu, *Pierre Patte: Sa vie et son oeuvre* (Paris: Presses Universitaires de France, 1940), with many related studies to follow. The best summary history is Daniel Rabreau, "La basilique Sainte-Geneviève de Soufflot," in Barry Bergdoll, ed., *Le Panthéon, symbole des révolutions: De l'église de la nation au temple des grands hommes,* exh. cat. (Paris: Picard, 1989), 37–96.

l. For Contant d'Ivry's initial design for the Madeleine, see Pierre Patte, *Monumens érigés en France à la gloire de Louis XV...* (Paris: A. Guérinet, 1765). The most useful modern study is Gabrielle Joudion, "La Madeleine: Genèse de la construction," in *Chevotet, Contant, Chaussard: Un cabinet d'architectes au siècle des lumières* (Lyon: La Manufacture, 1987), 172–80.

The Ruins of the Monuments Erected by the Athenians before the End of the Age of Pericles, Historically Considered

Abridged Narrative of the Author's Journey from Rome to Athens

Having taken measures in Rome to make the journey to Greece a fruitful one, I traveled to Venice on 15 April 1754, there to await the departure of the cavaliere Donà, who had done me the honor of allowing me to accompany his embassy to the Sublime Porte. I soon had my wish, and on 5 May I received a message from the ambassador (known to the Venetians by the title *bailo*) that I should board the *Saint Charles*, a vessel of eighty guns,[1] that very day. In the evening he embarked with his entire suite, and we sailed overnight.

We first put in at Castelnuovo,[a] on the coast of Istria, a fortress where the warships that sail into or out of Venice unload or load their ordnance, on account of the shallow waters around that city. Taking advantage of the time required to arm our vessel at Castelnuovo, we—the marchese Spolverini of Verona; Signor Priuli, a noble Venetian; and I—went to see Pola [(Pula)], which is but forty miles distant.

Though of no size today, this city once was a celebrated republic. It even seems that the arts flourished there, judging from several monuments that are still extant, and particularly from two magnificent temples that are not far apart and entirely alike.[b] One is so ruinous, and so overwhelmed by a mass of hovels, that it escaped the notice of Messrs. [Jacob] Spon and [George] Wheler, those celebrated modern travelers; the other is almost intact. For beauty, this temple ranks among the most precious remnants of antiquity. The city of Pola erected it in honor of Rome and Augustus—from which it will be seen that it was built long after the age of Pericles. We have therefore placed the description, view, and details of it in the second volume of this work, which provides an entirely natural occasion for them.

The architecture of the other monuments[2] in the city is unremarkable, though they have some features that call for comment. The triumphal arch in honor of Gaius Sergius [(Arch of the Sergii)] is ornamented with coupled columns, like those on the facade of the Temple of the Sun at Palmyra;[3] these are the only instances known in all antiquity. The tiers of the arena were made of wood and were set up on public holidays to fill the space between two stone perimeter walls; it was thus intermediate between the earliest amphi-

theaters, which were made entirely of wood, and the later ones, built entirely of stone. Pompey was the first to erect one of the latter kind in Rome, and Tacitus [(*Annales* 14.20)] records that the Senate censured him for it.

Having satisfied our curiosity at Pola, we returned to Castelnuovo, whence we set sail with a following wind on 15 May. In two days we reached the Pelagosa, the Augusta, and the Pomo [(Palagruža Islands)], those three reefs in the middle of the Adriatic Sea that render it so difficult to navigate. Two constant currents add to the perils of this sea. One runs from its mouth along the coast of Albania, Dalmatia, and Istria to Venice; the other returns from Venice toward the mouth of the Adriatic, along the coast of Italy. After passing the three reefs of which I have spoken, we joined company near Cattaro [(Kotor)] with a frigate under orders to escort the ambassador's vessel as far as Tenedos [(Bozcaada)].

We were now following the coast of Greece, a country so much celebrated by the poets, and the scene of such momentous events, that the sight of the least island, the smallest cape, calls to mind some interesting fact of history. On the coast of Albania, we saw Durazzo [(Durrës)] and Polina, formerly celebrated under the names of Dyrrachium and Apollonia. It was there that Pompey and [Julius] Caesar landed: Pompey to fight in Greece for the expiring freedom of his own country; Caesar to destroy it, and to overthrow by an infamous crime the celebrated republic that had flourished so mightily for centuries past.

After Polina, having sailed out of the Adriatic Sea, we left on our port beam the Acroceraunian Mountains,[4] now known as the Mountains of the Chimera and inhabited by the descendants of the Macedonians. Availing themselves of the very advantageous situation of the place they occupy, these fearless ruffians have freed themselves from the sultan's rule and live as best they can by brigandry, selling Christians to the Turks and Turks to the Christians. Leaving those mountains behind us, we soon came to Corfu,[5] where we spent a fortnight in feasting and celebration. Hardly had we left that island when a favorable wind carried us close to the island of Santa Maura [(Levkás)], formerly Leucas, and to the ancient promontories of Actium and Nicopolis: the very spot where Mark Antony, yielding to fate and to love, fled before Octavian and followed Cleopatra. We would have liked to sail between Santa Maura and Cephalonia in order to see, if only through our spyglasses, that little rock of Ithaca that Homer made so famous; but our wish could not be satisfied. We rounded Cephalonia and called in at Zante [(Zákinthos)], and on the night of 23 June we left on our right the Strovadi or Strivalli. These islands, once known as the Strophades, are inhabited no longer by the Harpies, of whom the poets sang,[6] but by Greek monks.

At daybreak, holding to our course, we sighted at the mouth of the ancient harbor of Pylos, the island of Sphacteria, celebrated for an Athenian victory over the Spartans. Soon afterward the Cape of Sapience [(Ákra Akrítas)], where the ancient city of Methone once stood, came into view; at Methone

there was a temple to Minerva Anemotis, that is to say, Minerva who presides over the winds. Pausanias [(*Description of Greece* 4.35.8)] records that Diomedes dedicated it to the goddess in the hope that she would put an end to the violent winds that were inflicting great damage in the vicinity.[7] We, for our part, had no complaints; and if we had had any prayers to offer up, they would have been for the winds to continue to favor us. For after crossing in three hours from this cape to the ancient promontory of Taenarum [(Cape Matapan, or Ákra Taínaron)] and after sighting on the same day Cythera—an arid, desert island, unworthy to be, as the poets called it, the haunt of the goddess of beauty—we entered the Archipelago. The same wind held through the night, and on the next morning we sighted the Cyclades and the ruins of the Temple of Minerva Sunias, visible from a great distance, on the tip of Cape Colonna [(Cape Sunium, or Ákra Soúnion)]. Overjoyed, we expected to make landfall on Tenedos in two days, and at Constantinople soon after. But nothing is so unsure as plans laid at sea; and mariners are often no better prophets than the makers of almanacs. In spite of our hopes, and the assurances of our pilots, the wind veered from southwest to north and forced us to take shelter in a harbor on the coast of Attica, opposite the Long Island [(Makronísi)] and six miles to the north[east] of Cape Colonna.

We cast anchor off the shore of a plain ringed with hills, some eight or nine miles around; to the south, a mountain, somewhat taller than the hills, extended as far as the mouth of the Gulf of Aegina [(Saronic Gulf, or Saronikós Kólpos)], very close to Cape Colonna. We were in no doubt that this was Mount Laurium, which Pausanias [(*Description of Greece* 1.1.1)] saw after Cape Sunium, when he sailed from Rome to Athens; but with this difference, that as he entered the Saronic Gulf he saw it to the north, whereas we saw it to the south. Not content with this identification, we desired to know the ancient name of the place where we were; we sought it in Pausanias in vain, and Plutarch left us no wiser, though in his life of Themistocles [(4.1)] and life of Nicias [(4.2)] he mentions Mount Laurium and its silver mines. It was Xenophon, in his treatise on revenues, who gave us the name that these other writers had omitted. He says of the silver mines of Mount Laurium: "I take the view that they should not be abandoned in time of war; for those that open toward the south are defended by the fortress of Anaphlystos; the others, to the north, by that of Thoricus; and these two strongholds are no more than 60 stades apart."[8] The resemblance between the ancient name of this fortress and the name of Thorikos, which the modern Greeks still give to the port where we made landfall, seems enough to prove that the place in Attica whose name we sought was Thoricus.

Traversing the plain, we discovered fragments of columns, which aroused hopes of discovering some interesting work of architecture.[c] Such was my eagerness to know what these columns might be, that I decided to have felled the part of the thicket where I had glimpsed a considerable number of marble fragments and to have the standing columns excavated down to the foot of each shaft. The ambassador heartily approved of my idea, and he even had

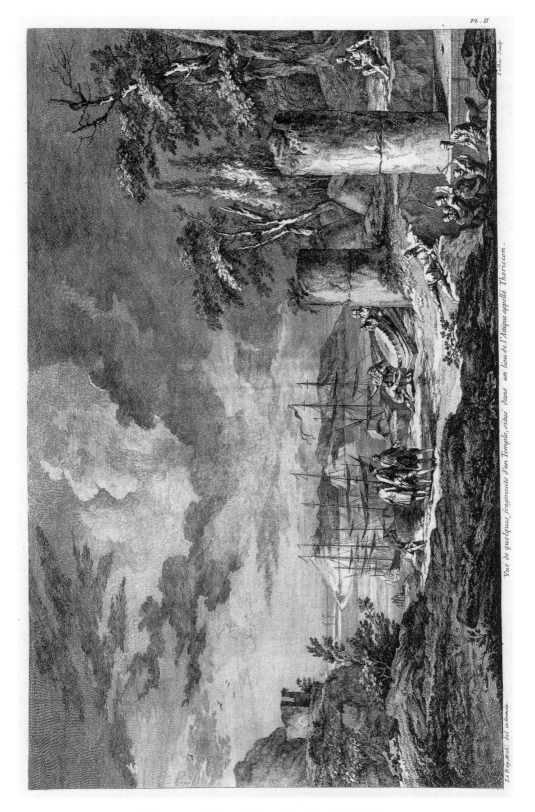

Pl. 2. Jacques-Philippe Le Bas, after Julien-David Le Roy
View of Some Fragments of a Temple, Located at a Site in Attica called Thoricus

the kindness to send with me a considerable number of his Slavonian soldiers, who brought all the tools necessary to carry out my plan.

Though this temple, or rather its few remnants, illustrated in plate 2, gives no indication that it ever was a beautiful building, I can attest that I took more pleasure in it than in many others more magnificent. I had begun my journey with the set purpose of discovering, if at all possible, the progress of architecture in Greece; and it seems that the very first monument that I happened upon in Attica was earlier than any of the same kind that I saw subsequently.

It stood to the north of Mount Laurium, on the plain already mentioned, and close to the spot where, according to Xenophon, the fortress of Thoricus stood. Its longer dimension, which I was unable to determine, ran north to south; its width was 36 feet 8 inches. The columns of this temple had no bases; they stood on a marble stylobate no wider than their lower diameter. I had holes dug on either side of the stylobate in various places, and for some distance into the interior of the temple, and I was surprised to find no indication that there ever had been a paved floor.

In those thickets it was no easy matter to determine the approximate height of one of the columns. I achieved this only by measuring its ruined capital and, in succession, all its drums, which had gotten slightly disarranged in their fall. In the remains of the temple, I found no inscription that might have indicated the date of its building. However, since I also failed to find any fragment of an architrave, frieze, or cornice; since the proportions of the columns were extremely short; and since a second, almost intact capital, which I found after more than a day's search, bears the imprint of the earliest notions of the inventors of the Doric, I judged, as I have said, that this temple was of a very early date. I fancied, even, that all the parts of its entablature might have been made of wood, as they were in the earliest ages of architecture.

What might further sustain this surmise is that, after having caused a joint to be levered apart to find how the stones of a column were held together, I found to my great surprise that they were joined by pegs of some red wood, quite hard and well preserved. The holes in each drum into which these pegs fitted were 3 inches wide and 4 inches deep. The marble of the temple was highly imperfect.

The Long Island, which is to be seen beyond our little fleet, is too celebrated to be passed over in silence. Strabo [(*Geography* 9.1.22)], Pliny [the Elder [(*Historia naturalis* 4.12.62)], and Pomponius Mela [(*De chorographia* 2.7.10)] call it Helena or Cranae. Pausanias as well, in his *Attica* [(*Description of Greece* 1.35.1)], calls it Helena, but places elsewhere the island that he calls Cranae,[9] that is, the island in Homer where Paris, after abducting Helen, enjoyed his conquest for the first time. Be this as it may, the Long Island is now totally uninhabited, as it already was in Strabo's day. [Joseph Pitton de] Tournefort, in his *Voyage du Levant* [(vol. 2, pp. 28–30)], rightly indicates Pliny's error in placing this island equidistant from Cape Colonna and the island of Zea [(Kéa)]: it is five miles from the cape, and twelve from Zea.

We sailed from Attica, fourteen days after our arrival there, and, after

lying at anchor for six days close to the southernmost cape of the island of Negropont [(Euboea)], in the area where the ancient city of Carystus [(Káristos)] once stood, we put to sea, and two days later we dropped anchor between the isle of Tenedos and the shores of Troy.

The baili of Venice are denied the privilege, enjoyed by the ambassadors from France and England, of taking their vessels into the harbor of Constantinople. Having wrested the loveliest isles of the Archipelago from the Venetians, and living still in constant fear of a surprise attack, the Turks send galleys to fetch the Venetian ambassador and all his retinue from the port of Tenedos; and so we found two galleys awaiting us there. Hardly were we aboard when the wind turned against us, seeming to favor some of us in our plan of visiting the ruins of Troy; but the ambassador, who had heard that there were brigands at large along that coast, refused his permission. We were unable even to visit the city of Tenedos, where we lay at anchor for a fortnight. There was a violent outbreak of plague, from which we were preserved only by a kind of miracle; for the Levantine crews of our galleys went into the city every day and then returned to mingle with us.

The wind having changed, we left those celebrated shores without regret and, setting our course northward, entered the famous straits of the Hellespont, or channel of the Dardanelles,[10] which separates Europe from Asia. We sailed between the two castles that mark the entrance, three miles from its mouth and eight miles apart. They fired salutes to us, as did two others that we passed twelve miles farther on; and we watched with some trepidation as the balls from the latter skimmed across the waves from Europe to Asia and from Asia to Europe, narrowly missing our galleys.[11] This second pair of castles, being only two miles apart, reduce the width of the channel and so much strengthen the current from the Black Sea that our galleys, which had hitherto made way into the wind by means of their oars, were compelled to wait until the wind dropped. We then continued on our way, with stops at several points along the channel, on the islands in the Sea of Marmara and at the port anciently known as Heraclea [(Marmaraereglisi)]. We finally reached Constantinople on 13 September 1754, after enduring great privations in the course of fifty-two days aboard the Turkish galleys.

Constantinople has the air of being the capital of the whole world. No city on Earth enjoys such a situation or is better placed to command a great part of this hemisphere. From afar it looks very fine, but within the walls it is highly disagreeable. Or so I found it, as I went around to see the antiquities, the royal mosques, a number of pavilions, the aqueducts, and so forth. During my stay in Constantinople, I also saw the magnificent festival of the Lesser Bairam [(Eid al-Fitr, marking the end of Ramadan)]; and the bailo did me the honor of including me in his party for his audience with the Grand Signior [(Mahmud I)].

On the day of the ceremony, the vizier conducted us to the Divan, where he dispensed justice in our presence. He then caused a dinner to be served to us in the same hall, from which we entered the second courtyard of the serai

[(Topkapı Palace)]. There we were dressed in caftans, and twelve of us, each supported — or rather gripped under the arms — by two *kapıcı başı* [(head gatekeepers], proceeded into the audience chamber of the Grand Signior. The sultan was seated on a magnificent throne; on his right stood the vizier, his hands most respectfully crossed across his stomach; on his left was the ambassador, standing like the vizier;[12] and we who had the honor to be in his suite were behind him. This arrangement meant that the ambassador did not see the Grand Signior face to face but only in profile. The profoundest silence reigned in the hall. When the dragoman interpreted the bailo's speech, he was pale and trembling. If these interpreters are bold enough not to be terrified when they address the Grand Signior, they take care to appear so, out of respect; several of them have lost their lives for one word out of place. Having heard the ambassador's compliments, the Grand Signior did no more than address a few worlds to the vizier, who made his answer for him. I shall not speak of all the diamonds, all the rubies, all the pearls on the throne or of the carpets woven with gold and silk that cover the paving of the hall and its vestibules; and I have only a word to say of Constantinople, where a stay of three months and the opportunities I had to witness the most magnificent ceremonies would furnish matter for numerous observations. But irksome though it may be for travelers who have been powerfully affected by places seen and by ceremonies witnessed to suppress the telling of them, it is no less irksome to read such accounts when they are out of place and prejudicial to the principal object of a work. I therefore pass on in haste to my departure from Constantinople.

The day when I left that magnificent capital was marked by one of those events that in Turkey can overturn the loftiest fortunes, often raising men from the vilest employments to the prime dignities of the empire. The Grand Signior had been confined to the serai by a persistent and dangerous ailment affecting one of his shoulders, and the people began to murmur — as they will, when he is not seen at the mosque on a Friday. Meanwhile, in the serai, every possible effort was made to convey a misleading impression of the prince's health. His pavilions, which are visible from some parts of the city, were opened, as if he had been there; the pretense was carried so far as to have a man who resembled him ride out along a terrace of the palace that overlooks the port. But the people continued to murmur, and the sultan resolved, sick though he was, to attend the mosque on Friday, 13 December. Hardly had he arrived when he was overcome by weakness; he was wrapped in a robe and carried to the serai, where he died around two o'clock in the afternoon. The news immediately spread through Constantinople and was confirmed by a general discharge of the artillery of the serai; a second and greater discharge soon afterward proclaimed the accession of Osman III to the throne. At the very moment when I embarked at the harbor of Tophane [(north of the serai, on the European shore of the Bosporus)], a crowd of Turks appeared, in the utmost excitement; and under our rail passed a great number of little boats laden with Greeks, Jews, and Armenians, who were retreating

to the country for fear of some revolution, their faces an image of anxiety and fear.

Such was the state of Constantinople when we weighed anchor and set sail for Smyrna [(İzmir)]. I spent little time there and, after visiting several islands in the Archipelago of little interest to my main concern, I traveled to Mykonos, whence I made frequent excursions to Delos, which is now known as Dhílos.

This island, the center of the Cyclades, Apollo's birthplace and believed by the Greeks to be his home, is now entirely desert and uncultivated. Its present barrenness is partly the result of its past magnificence, for marbles cover it on every side. But the famous temple that Erysichthon built in honor of Apollo,[13] or another built over its ruins, is conspicuous for the extent of ground occupied by its ruins. This was the most famous of all Apollo's temples, excepting only those at Delphi. On its facade was this inscription, well worthy of the notice of the most celebrated of Greek philosophers, who has passed it down to us:[14] *Of all things the most beautiful is justice, the most useful is health, and the most pleasing is the possession of what one loves.* It also bore a great number of inscriptions concerning the properties of plants and their medicinal uses for ailments of all kinds. Individuals and whole peoples, convinced that miracles frequently took place here, vied with one another in offering or sending notable sacrifices. The very Hyperboreans, whom the Greeks believed to be the northernmost peoples on Earth, sent their first fruits for the Athenians to offer them up in this temple.[15] In Athens the name *Sacred* was given to the boat that brought the offerings of the republic to Delos, and all sentences of death were stayed from the day it sailed until the day of its return; it was for this reason that the execution of Socrates was postponed for one month. The republic of Athens entrusted this important ceremony only to its most illustrious magistrates.

This temple, so much revered by the Greeks, stood as long as Delos was a flourishing and populous island, and even later: Pausanias tells us that in his day Delos would have been deserted without the garrison that the Athenians kept there to guard the temple.[16] At length, however, even the most notable buildings succumb to the laws of time or to the insults of barbarism; and the celebrated Temple of Apollo—the first, according to Vitruvius, in which the god's lyre was imitated by the ornament that later acquired the name *triglyph*—once among the masterpieces of Greece, is now no more than a mass of fragmentary columns, so confused that I was unable to make a view of it. A number of capitals are to be found there, but no fragments of an architrave, frieze, or cornice. However, one may still see the pedestal of the statue that was the gift—as Plutarch [(*Lives, Nicias* 3.5)] says, and as the inscription confirms—of the people of Naxos.[17] According to Plutarch [(*Lives, Nicias* 3.6)] again, a palm tree consecrated to the god by Nicias fell on the statue and overturned it; and so the statue that was broken up toward the end of the last century by an English sea captain who wished to carry off some part of it[18] was no doubt a substitute for that of the Naxiots. After completing my researches

on Delos, I left the island and returned with great joy to Attica. Landing at Porto Raphti early in February, I left at once for Athens.

On arriving in the city, I called first upon Monsieur [Etienne] Léoson, our consul, to whom I had such strong letters of recommendation that he insisted I should stay nowhere but in his own house. After I explained to him the purpose of my journey to Athens, we decided together that my first step should be to visit the disdar, or commandant of the citadel. He was then the most important officer in the city, the governor having been dismissed not long before as a result of an uprising that I shall describe in due course. Having presented me to the disdar, Monsieur Léoson sought permission for me to draw all the monuments of the citadel and of the city. The disdar entertained us favorably. Ordering coffee, sherbet, and perfumes to be brought to us, after the Turkish fashion, he told us that he held our people in such high esteem that he could deny us nothing, and that I was free to pursue whatever researches I pleased in Athens and to have ladders and whatever else I might require carried to any place where this might be necessary. The disdar showed me the consideration that revealed how much he esteemed the French: he told me that, the Turks and the Greeks being highly jealous of their wives, when I wished to climb to the top of the Temple of Minerva, I should let him know, so that he might have all women kept from walking within the little court-yards of the citadel, where I might be able to see them. To this order I was forced to subscribe or lose the liberty that he had given me. I had even to submit to a custom that seems strange and barbarous in the extreme to all travel-ers to Athens and that shows once more how jealous the Athenians are. When Turkish or Greek women pass by in a street in Athens, so our consul told me, it is polite to cross to the other side of the street and to turn one's back. Fully instructed, therefore, as to the conduct expected of me in the city, and escorted everywhere by the janissary assigned to me by Monsieur Léoson, I embarked on my examination of those monuments within the citadel that seemed to me most noteworthy. But any historical description of those monu-ments would seem to call for some prior reflection on the origins of Athens and on the history of its celebrated citadel.

On the Origins of Athens: Historical Description of the Citadel of the City, and of the Principal Monuments that Are to Be Seen Either in the Interior or on the Exterior of the Fortress

If we are to believe the Athenians' account of their own origins, they preceded all other peoples: they called themselves the *sons of Earth*, as ancient as the soil on which they lived,[19] born at the same instant as the Sun.[20]

Plato, in his *Timaeus* [(23e)], records that Solon, traveling in Egypt, found another Athens. There, in a temple, the priests kept authentic records to the effect that the Greek Athens was founded nine thousand years before the universal Deluge and one thousand years before their own Egyptian Athens.

Solon's account of the foundation of the city of Athens and the Athenians' version of their own origins must be counted among the most exaggerated

fables ever devised by any people; and yet there is no denying that Greece as a whole was inhabited before the arrival of the heroes who came there from Egypt and from Libya. The Athenians were thus not themselves Egyptian in origin; they have been in Attica since time immemorial. But, whatever fables they may have invented to impose on posterity, it is plain that they took from the Egyptians their first laws, their first ideas of the arts, and the cults of their most ancient gods.

It seems likely that, as several historians have declared, Ogyges was the first monarch to reign in Attica; but so vague and uncertain is their account of the very few events said to have taken place during the two hundred years that separated his reign from that of Cecrops, and so widely did the opinions of the people in the lesser towns of Attica diverge from those current in Athens,[21] that we may safely regard Cecrops as the founder of the city. Cecrops sailed to Attica from Egypt about 1582 B.C. and persuaded a small number of the inhabitants to join together to found a city and to build it on the high, elongated rock on the plain of Athens, which I have represented in plan, in its present state, in plate 3.

> *Explanation of this plan.*
> 1. Temple of Minerva [(Parthenon)].
> 2. *Pronaos,* or vestibule, of the Temple of Minerva.
> 3. Interior of the temple.
> 4. Mosque.
> 5. Temple of Erechtheus or, more probably, of Minerva Polias [(Erechtheion)].
> 6. Vestibule at the entrance to this temple.
> 7. Temple of Pandrosos [(north porch of the Erechtheion, including an altar to Poseidon)].
> 8. Small monument built against the wall of the Temple of Minerva Polias, with entablature supported by canephori or caryatids [(the Erechtheion's Porch of the Caryatids)].
> 9. Propylaia.
> 10. Central hall of the Propylaia; its ceiling was formerly composed of large marble slabs.
> 11, 11. Two vestibules that flanked the facade of the Propylaia; that on the right is in ruins and now serves as a prison.
> 12. Hall, which, I suspect, may have been the hall of paintings, adjoining the Propylaia, that Pausanias [(*Description of Greece* 1.22.6)] mentions.
> 13. Pedestal, which bore one of the two statues that fronted the Propylaia.
> 14. Theater [(Odeion of Herodes Atticus)].
> 15. Orchestra of the theater.
> 16. Stage.
> 17. Tiers.

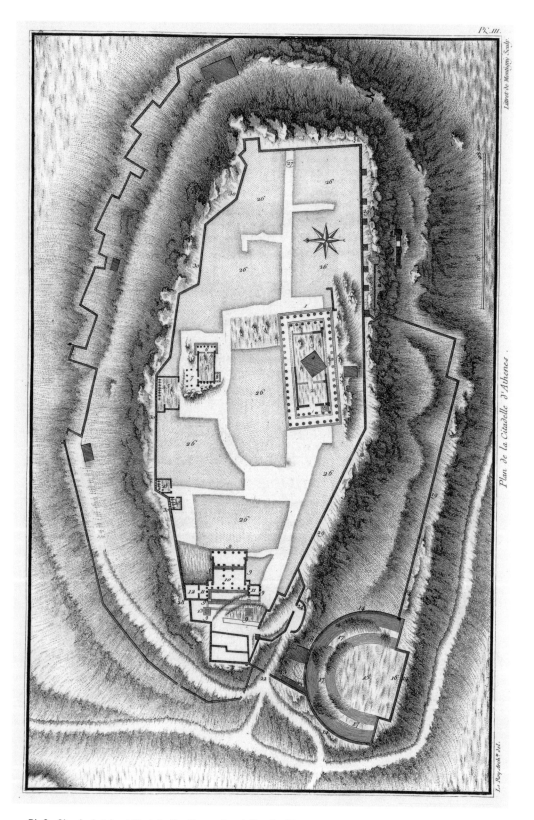

Pl. III.

Pl. 3. Claude-Antoine Littret de Montigny, after Julien-David Le Roy
Plan of the Citadel of Athens

18. Grotto, which is the probable site of the tripod on which Apollo and Diana were depicted slaying the children of Niobe.

19. Wall built over the arches of the Portico [(Stoa)] of Eumenes.

20. Monument erected by Thrasyllus to commemorate his victory in the theatrical contests; now the porch of a church called by the Greeks *Panagia Spiliotissa* [(Panayía Khrisospiliótissa, or Our Lady of the Golden Cave)].

21. Interior of the church of Panagia Spiliotissa.

22. Main gate of the citadel.

23. Way down to the theater.

24. Guardhouse of the citadel.

25. Gun batteries.

26. Areas of Turkish houses.

27. Ancient cistern of the citadel.

28. My suggestion of the site of the cave where, according to the Athenians, Apollo enjoyed [Creusa, daughter of] Erechtheus.

29. South wall, destroyed by the Persians and rebuilt by Cimon.

30. North wall, in which there are, opposite the Temple of Minerva Polias, fragments of a Doric order with the same profile as that of the Temple of Apollo on Delos, which suggests that they may stem from the first Temple of Minerva, destroyed by the Persians.

Cecrops named the city *Cecropia,* after himself. During his reign an olive tree and a spring of water suddenly appeared there. The people rushed to tell the king of this unprecedented happening, and he sent to Apollo's oracle at Delphi for an explanation. The reply came that the olive tree stood for Minerva and the water for Neptune and consequently the Cecropides were at liberty to name their native city after one or the other of these deities, who they would then make their principal object of worship. The inhabitants therefore assembled, and the men declared for Neptune; but the women, who were more numerous, invoked the protection of Minerva, and their vote prevailed. The inhabitants of Cecropia changed the name of their city to *Athens,* because Athena, in their language, is the name of Minerva. The poets, who clothe in fables the facts of history and the works of nature, have since said that Neptune and Minerva quarreled as to who should govern Athens and that Neptune struck the earth with his trident, calling forth a horse, and that Pallas or Minerva pierced the earth with her spear, immediately bringing forth an olive branch.

> ...Tuque, ô cui prima frementem
> Fudit equum magno tellus percussa tridenti,
> Neptune...
> Adsis, ô Tegeaee, favens; oleaeque, Minerva,
> Inventrix.
> —Virgil, *Georg[ics]* 1.12–14, 18–19

[And thou, O Neptune, to whom first the earth,

When struck by thy great trident, yielded forth

A champing horse . . .

Stand by us, O Tegaeus; and Minerva,

First finder of the olive.]

The rock on which Cecrops built his city was known to the Athenians as the Tritonium, because it was sacred to Minerva, the first deity whom they knew and revered, and whom they sometimes called *Tritonia* or *Tritogenia*.[22] The fortress itself was variously called *Glaucopion*,[23] *Parthenon, Cecropia,* or *Polis,* which means *city;* when Athens became powerful, this same fortress was called *Acropolis.* It was the most ancient and most venerated place in the city; on it stood several beautiful temples and a prodigious number of statues, precious both for their excellence of design and for the rich materials from which they were fashioned. Greek and Roman historians have vied with one another in their praise for the citadel of Athens, and it still deserves our admiration for the precious remains of antiquity that it holds. It must be understood, however, that the ruins now seen in Athens are no earlier in date than the Persian expedition to Greece. As is well known, after Xerxes had laid waste the lands of the Phocaeans and vainly ordered the sack of the temple at Delphi, he entered Attica, destroyed Athens, and consigned all its temples to the flames, without excepting that of Minerva, which was the most ancient monument in the city and the one held in most reverence by the Athenians. We may well regret the loss of the ruins of that temple, which would probably have cast much light on the origins of architecture in Greece; but we are compensated by the beauty of the Temple of Minerva that was built under Pericles by the celebrated Greek architects Iktinos and Kallikrates.[24]

This Temple of Minerva, known as the Parthenon, or Temple of the Virgin,[25] and also by the epithet *Hekatompedon*,[26] stands at the center of the rock of the citadel, which dominates by its height the entire plain of Athens. It is visible from afar, from any of the roads that lead to the city and from the sea as soon as one sails into the Gulf of Aegina. At first sight, the size of the building and the whiteness of its marble stir admiration; from closer by, the elegance of its proportions and the beauty of the bas-reliefs with which it is adorned give no less pleasure; and it is clearly evident that Iktinos and Kallikrates strove to their utmost to distinguish themselves in architecture by the building of a temple to Minerva, who invented this beautiful art. Plate 4 shows its ruins.

This temple forms a parallelogram according to the plan shared by almost all Greek and Roman temples. It is oriented east to west, and it is 221 feet long and 94 feet wide, without counting the steps that surround it. The order is Doric. It was peripteral, that is to say, surrounded by columns detached from the *cella,* or body, of the temple to form a portico all around; it was also octastyle, with eight frontal columns.

The great Doric columns that surround the outside of the temple are 5 feet

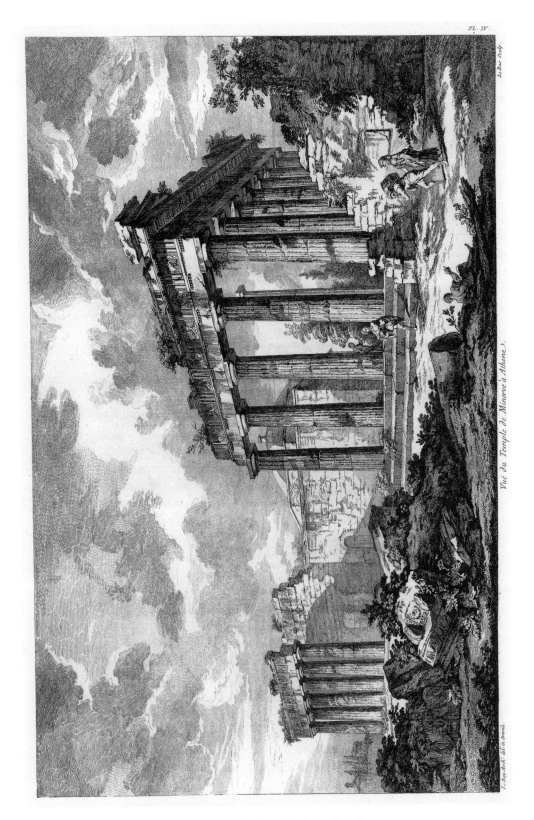

Pl. 4. Jacques-Philippe Le Bas, after Julien-David Le Roy
View of the Temple of Minerva in Athens

8 inches in diameter and 32 feet high. There were forty-six of these in all. They have no bases, but the extremely tall steps that almost touch the feet of the columns seem to serve this purpose. The columns carry a Doric entablature almost one-third as high as themselves; this is no less admirable for the beauty of the marbles with which it is adorned than for the masculine character that prevails in its moldings. The design of the interior was also rich and noble in the extreme: one crossed a spacious vestibule before entering, and this was decorated, according to Monsieur Spon, with two colonnades, now no longer extant; he says that they formed two galleries, one below, the other above.[27]

To make the temple worthy of the goddess who had given her name to Athens not only had the finest architecture been employed but also it was embellished by the masterpieces of the greatest sculptors. The statue of Minerva within was fashioned by Pheidias,[28] all in ivory and gold. Her massy golden ornaments amounted to a weight of more than forty talents.[29] The image of the Sphinx adorned the crest of her helmet; on either side of the helmet were griffins, with the bodies of lions and the wings and beaks of eagles. The sculptor represented the goddess standing, clad in a long robe that fell to her feet, and wearing on her breast the head of Medusa carved in ivory. Close by was a Victory, 4 cubits high, with a pike in her hand and a shield at her feet; next to her pike was a dragon, which according to Pausanias was the serpent of Erichthonios. The base of the pedestal of the statue was also adorned with a bas-relief representing the birth of Pandora.[30]

Outside the temple was a bronze Apollo, said to be the work of Pheidias. This figure bore the epithet *Parnopion*, because the Athenians said that when the country was ravaged by locusts, which in Greek are called *parnops*, Apollo promised to expel them and kept his promise. The vestibule contained a statue of Iphikrates, the general who served Athens with such renown. Standing alone in the interior of this splendid edifice was a figure of the emperor Hadrian.

The frieze that ran around the *cella*, or body, of the Temple of Minerva was adorned with bas-reliefs of which considerable fragments are still to be seen. A great number of them represented the glorious exploits of the Athenians. Between the time of Pericles and that of Attalus, these suffered some damage—or so Pausanias gives us reason to suppose. *On the south wall* of the temple, he says, *are statues that represent the legend of the war waged by the gods against those giants who once lived in the vicinity of Thrace and of the isthmus of Pallene [(Kassándra)]; also the Athenians' battle against the Amazons, their victory over the Medes at Marathon, and their massacre of the Gauls in Mysia. It was Attalus who restored to their places or repaired these bas-reliefs; each measures 2 cubits.*[31]

It seems to follow from Pausanias's narrative that the bas-reliefs of which he speaks were, as we have said, on the southern face of the frieze above this part of the *cella*, or body, of the temple. This frieze is 3 feet 1 inch 6 lines high; and the Greek or Athenian foot was—as we shall show in our disserta-

tion on its length—slightly shorter than ours. It will be recalled that a cubit was 1½ feet.

The portico of Doric columns that surrounded the temple had its own frieze of figures, stronger in relief than those just mentioned—which, in our view, is less a sign of a difference in date for these sculptures than it is an indication of the ingenuity of the sculptors, who carved the figures of the outer frieze in deeper relief because they were to be seen from greater distances. This latter frieze is 4 feet 1 inch 8 lines high; thus, as will be seen, it measured almost 3 Athenian cubits. This persuades us that it was the bas-reliefs on the inner frieze that were either restored to their places or repaired on the orders of Attalus. Many of those on the outer frieze, enclosed within those square spaces known to architects as *metopes,* represent the battle between the Athenians and the Centaurs.

The sculpture on the pediments was manifestly later in date than the building of the temple itself. These figures were carved in the round and life-size; in them, the sculptor represented the birth of Minerva.[32] The rear pediment has suffered most at the hands of time; we owe this information to Messrs. Spon [(*Voyage d'Italie,* vol. 2, p. 146)] and Wheler [(*A Journey into Greece,* p. 362)]. As they saw the temple before its ruin, they can also tell us of a highly curious circumstance concerning the first of these bas-reliefs that proves that it was made at the behest of Hadrian, namely, his statue and that of his empress, Sabina, appeared in it. There was also, says Monsieur Spon, a statue of Jupiter. He was naked, as the Greeks depict him, and set beneath the apex of the pediment. To his right was Minerva, more as the goddess of learning than of war, her chariot drawn by a team of horses led by a Victory. These horses, says Monsieur Spon, bear comparison with those of Pheidias and Praxiteles; their whole air conveys the fire and pride inspired by the presence of the goddess. Beyond the goddess's car was a seated woman with a child on her lap; and on the same side were the statues of the emperor Hadrian and the empress Sabina. Finally, on Jupiter's left were five or six figures whom the traveler took to represent the company of the gods, into which Jupiter desired to introduce Minerva.

The Athenians so gloried in the building of their temple to Minerva that they treated the beasts of burden employed there as sacred; as soon as it was finished, says Plutarch in his life of Pericles [(*Lives, Cato the Elder* 5.3)], they put them out to grass, and when one of them presented itself for work of its own accord and set itself at the head of all the other mules that were drawing loads toward the citadel, as if to encourage them, they ordered it to be fed at public expense as long as it lived.

The Athenians made solemn sacrifice to Minerva at her festivals, which were celebrated, according to some authors, every three years, every five years, according to others. On these occasions, old men bearing olive branches advanced into the sanctuary of the temple and lifted the goddess's veil, on which, so the people said, her heroic deeds were depicted. While Minerva's ox was being sacrificed, processions circled the temple; and, when the sacrifice

was complete, the sound of a trumpet and the voice of the *cursor* [(running messenger)] announced the start of the games, from which the women were excluded. It is well known that Minerva was the deity most honored by the Athenians and that the olive was sacred to her; they crowned her effigies with its branches, and a crown of olive was awarded to the victors in the Olympian Games.

This magnificent Temple of Minerva was long preserved in all its beauty, though Athens changed its masters. The Christians who took the city made this profane monument into a temple of the true God, and the Turks later changed it into a mosque. Messrs. Spon and Wheler, during their stay in Attica, had the good fortune to see it entire in 1676; but in 1677 the pro-veditore [Francesco] Morosini besieged Athens with eighty-eight hundred Venetian soldiers, and a bomb fell on the temple, igniting the supplies of gun-powder that the Turks had stored within and instantly reducing most of the building to ruins. Morosini, who sought to enrich his own country with the spoils of that superb monument, contributed still further to its ruin. He tried to remove from the pediment the statue of Minerva, her chariot, and her horses; but, to his own great regret and ours, he ruined the masterpiece with-out any profit to himself: part of the group fell to the ground and shattered. Inside the ruins of the temple, the Turks have since built a mosque with a low dome. We would complete our description by considering the reasons that might have led the ancients to call this temple the *Hekatompedon,* but that discussion inevitably runs to such length that we have relegated it to the end of this first part.

Minerva was so revered by the Athenians that they erected two temples to her in the citadel of their city: the one just described, and another, smaller one dedicated to Minerva Polias, or protectress of the city. In this stood a work that proclaimed the origins of sculpture in Greece and seemed to indicate the antiquity of the temple, namely, a wooden statue of the goddess dedicated to her by Cecrops. There was also a folding stool made by Daedalus; the body armor of Masistius, who commanded the enemy cavalry at the battle of Plataea; and a falchion that the Athenians believed to have belonged to that general. Among the other rare objects in the building was an olive tree to which the Athenians ascribed miraculous properties: they said that it was burned by the Medes when they took Athens and grew again, on the same day, to the height of 2 cubits.

By the Temple of Minerva Polias was the house of the canephori, so celebrated in antiquity, who were employed in the service of the goddess. Polykleitos and Skopas have represented them in statues that earned the praise of Cicero and Pliny, respectively.[33] They took their name *basket bear-ers,* which is the meaning of the word *canephoros,* from a rite of the greatest solemnity in which they were employed. On the eve of the feast of the god-dess, they went to her temple, where the priestess gave them baskets that they carried on their heads, though neither she nor they knew what they con-tained. These they deposited near to the Venus in the Gardens, in a natural

cave from which, with equal mystery, they brought back other baskets to the temple. The virgins, consecrated to the goddess for a fixed term, resigned their office on this day and were replaced by two new canephori.

Among Athenian women, the service of Minerva was so great an honor that the daughters of Cecrops offered themselves for it. It was said in Athens that the goddess entrusted them with a casket, which they were not to open, that contained the newborn Erichthonios. Herse and Aglauros disobeyed; only Pandrosos kept faith. The Athenians raised a temple in her honor, beside that of Athena Polias.[34] Within the citadel they also had a temple to Erechtheus, which had a number of peculiarities. Pausanias describes it as a double temple enclosing a well of saltwater;[35] when the wind blew from the south, the well made a sound like that of the sea.[36]

The ruin that is now to be seen, plate 5, clearly seems to represent the remains of one or other of the two temples just described, but we confess that it is hard to say which; for the combined temples of Minerva Polias and Pandrosos seem notably analogous to the Temple of Erechtheus, which was a double temple. I have therefore conveyed my doubts on the matter in the title to plate 5. I shall explain the reasons that incline me to believe, on closer scrutiny, that these are the ruins of the Temple of Minerva Polias, though I took a different view when I published my first edition.[37]

I first observe that, the ruins shown in plate 5 being to the north of the Parthenon, they are more likely to be those of the Temple of Minerva Polias than of the Temple of Erechtheus, because Pausanias [(*Description of Greece* 1.26.4–5)] describes the latter directly after the bas-reliefs on the south wall of the Parthenon, thus apparently implying that the Temple of Erechtheus lay south or roughly south of the Parthenon and that the Temple of Minerva Polias, of which he speaks later, was to the north. I would also say that the ruin shown in plate 5, when considered in conjunction with the plans and details in the second part of this volume, looks very much more like a small temple adjoining a larger one—the Temple of Pandrosos adjoining that of Minerva Polias—than like a double temple. Finally, we suspect that the small monument whose entablature is supported by statues of women was either the dwelling of the canephori, of whom Pausanias speaks [(*Description of Greece* 1.27.3)], or simply a building adorned with representations of those virgins, whom the Athenians so honored.

Having set forth our reasons for believing that the ruins represented in plate 5 are those of the Temple of Minerva Polias, we shall hazard some con-jectures regarding the date of the building. We suspect that it was built after the twenty-fifth year of the Peloponnesian War, for the following reason: Xenophon relates that in that year there was an eclipse of the Moon at Athens and that the former Temple of Minerva was burned.[38] Now, the Parthenon was built on the orders of Pericles, who died during that war; and con-sequently Xenophon would not have referred to it as the "former temple." We therefore believe that the temple burned in the twenty-fifth year of the Peloponnesian War was that of Minerva Polias, or protectress of the city,

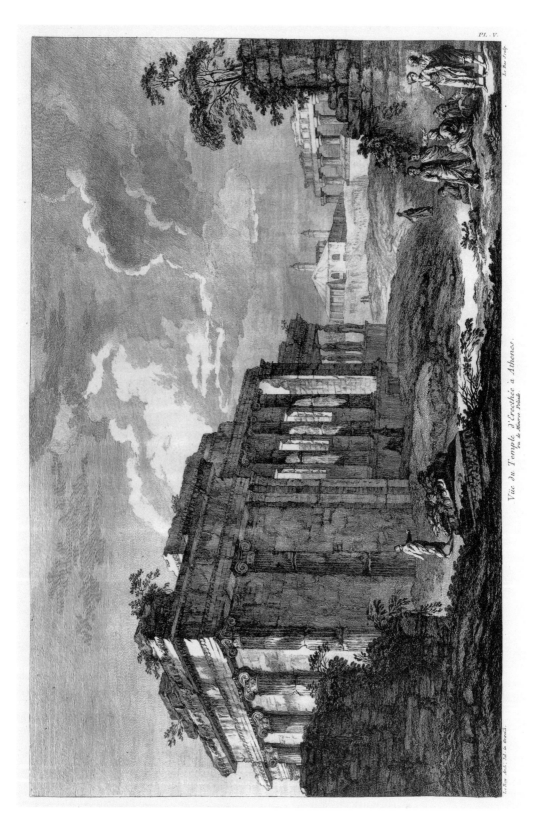

Pl. 5. Jacques-Philippe Le Bas, after Julien-David Le Roy
View of the Temple of Erechtheus or of Minerva Polias in Athens

which had been rebuilt around the time of the battle of Salamis; and that it was then rebuilt again, in the form suggested by the ruins shown in plate 5, either toward the end of the Peloponnesian War or in the interval between that war and the death of Alexander.

Of all the ancient authors, only Pausanias [(*Description of Greece* 1.27.1, 3)] has anything to say about the Temple of Minerva Polias; but almost all have praised the magnificence of the vestibules through which one passed on entering the citadel of Athens.[e] I have shown their ruins in plate 6. The Athenians, who had filled their city with the most glorious monuments, took particular pride in the Propylaia. They even said that Minerva herself signaled her divine approval by revealing to Pericles, in a dream, the remedy by which he cured a celebrated craftsman who had fallen from the top of the monument.[39] Designed by the famous Greek architect Mnesikles,[40] these magnificent vestibules were started under the archon Euthymenes, in the fourth year of the 85th Olympiad, and finished five years later, under the archon Pythodoros; they cost 2,012 talents to build.

Pausanias says that these vestibules had a ceiling of white marble, unsurpassed both for the size of the stones and for the moldings.[41] *As for the equestrian statues,* he says, *I cannot tell whether they are meant to represent the sons of Xenophon or whether they were set there solely for decoration.*

[Valerius] Harpocration, following Heliodoros, tells us of a feature of this monument that Pausanias has omitted, namely, that it was pierced by five doorways.[42] These features, mentioned by the ancient authors, are strikingly evident even in the present ruinous state of the Propylaia. It is astonishing that the modern travelers who have seen it—and in a less ruinous state than presented to me—have not recognized it. Spon [(*Voyage d'Italie,* vol. 2, p. 139)] thought it was a temple, because it had a pediment on its facade; [Francesco] Fanelli [(*Atene Attica,* p. 316)] follows the vulgar in calling it the Arsenal of Lycurgus. Of the three, Wheler [(*A Journey into Greece,* pp. 358–59)] seems to be nearest to the mark. After saying that it would be hard to tell whether this building was the Arsenal of Lycurgus, a temple, or some other edifice, he adds, Might it not be the Propylaia? But he offers no proof of his surmise; it seems, indeed, that he understood no more of the general form and disposition of this masterpiece of architecture than did Spon and Fanelli. Here is what I found in measuring it.

The facade as now seen consists of six Doric columns without an entablature, engaged in a ruinous wall and forming five intercolumniations, of which the one at the center is the widest, those at the ends the narrowest. In the wall opposite this facade, there are five doorways that correspond exactly to the intercolumniations of the facade. Each of these doorways is twice as high as it is wide: the largest is 12 feet 7 inches wide, the smaller two measure 8 feet 8 inches each, the smallest two are each 4 feet 4 inches. These last are more difficult to see than the other three, being buried up to the lintel; and I confess that I had some difficulty in distinguishing them.

The five doorways, which I was the first to discover in the ruins of this

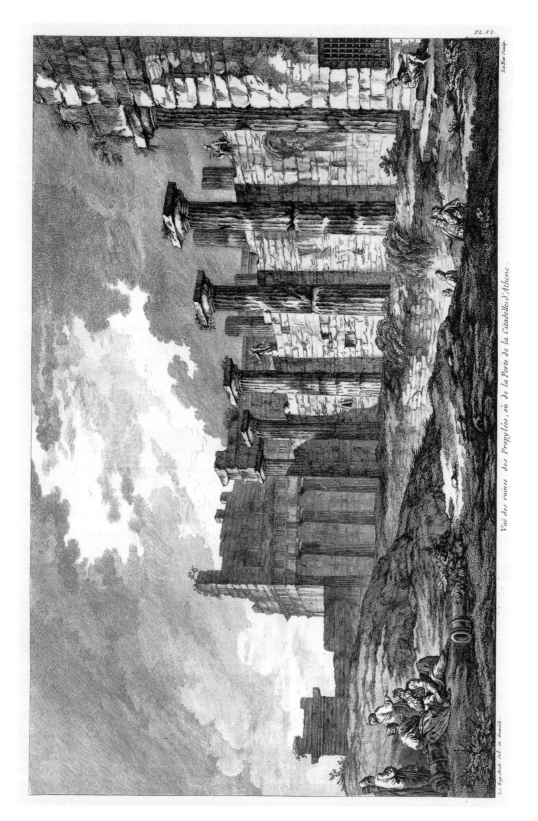

Pl. 6. Jacques-Philippe Le Bas, after Julien-David Le Roy
View of the Ruins of the Propylaia or of the Gate of the Citadel of Athens

building at the entrance to the citadel of Athens, seem to show that this was the Propylaia, as described in *Suidas* and Harpocration; and I found equally strong confirmation of Pausanias's statement as to the size of the stones that formed the ceiling. I measured the fragments of this, beneath the vaults that cover it. One of the principal marble lintels, broken at both ends, is more than 10 Paris feet in length; this formed part of one of nine similar beams that sustained the entire roof, each more than 16 Paris feet long. I measured another lintel, still intact, over the main doorway; it is nearly 22 feet long. No doubt Pausanias had the size of these pieces in mind when he praised the building, since the great lintel of the Temple of Diana [(Artemision)] at Ephesus, so heavy that the goddess herself was said to have put it in place, was only 30 Roman feet, or a little more than 27 Paris feet, in length.

I was finally convinced that this monument was the Propylaia when I found in front of it a very fine pedestal, together with another just like it, now ruinous. These two pedestals were separated by a distance a little greater than the width of the principal facade, from which they were distant 24 feet; a flight of steps occupied the intervening space. I could find no possible use for these two pedestals other than to support the equestrian statues mentioned by Pausanias; he never says in so many words that those statues were on pedestals, but neither does he say that they stood on the roof, as [Joannes] Meursius supposes. The abbé [Nicolas] Gedoyn has compounded this error. He says, misconstruing Pausanias, "I have been unable to determine what was meant by the equestrian statues *that were placed on these vestibules.* These last words are not in the text. The passage should be translated as I have done above: *As for the equestrian statues, I cannot tell whether they are meant to represent the sons of Xenophon or whether they were set there solely for decoration.*"[43]

It will be seen from this new and, we believe, more accurate translation that Pausanias indeed writes that these equestrian statues were a great ornament to the vestibules, but he did not state that they stood on top of them. I believe myself to be right in supposing that they stood on the great pedestals placed, most probably for that express purpose, in front of the main body of the monument. This supposition is reinforced by signs that the architect, in building these pedestals, had the shape of a horse in mind; for the sides parallel to the facade of the monument are shorter than the others — a strong indication, or so it would seem, that the statues faced the traveler as he arrived. The keys to the Propylaia were handed every day to the *epistatēs,* the archon who governed the city of Athens.

This monument thus matches all that the ancient authors tell us about the Propylaia; and this is sufficient proof that this was neither the Arsenal of Lycurgus nor a temple but rather the magnificent gateway to the citadel of Athens, the Propylaia built by Pericles. It would seem that the monument began to lose its shape after the Turks took possession of Athens. They turned the main structure into an arsenal and powder magazine and consequently had to wall up the five intercolumniations at the front and the five corresponding

gateways. Then, in 1656, lightning ignited the gunpowder in the magazine and blew up both the ceiling of the building and the lodging of Yusuf Aga, which was above. The Turk perished with his entire family, except for one daughter; and the Greeks regarded the event as a miracle, because on the very next day Yusuf Aga had intended to tear down one of their churches, known as Saint Dimitrios, which stood at the foot of the Mouseion hill. I have restored the Propylaia by reference to the relevant passages in the ancient authors, already cited, and to my own survey of the site; I give a perspective view in the second part of this volume, in plate 26.

After we had seen the interior of the citadel, Monsieur Léoson, Father Agathange, and I descended to the Theater of Bacchus [(Odeion of Herodes Atticus)], the position of which, relative to the fortress, is seen in plate 3. This may be regarded as one of the earliest structures still standing in Athens.[f] It incontestably predates the end of the age of Pericles and Alexander, since—as we shall have occasion to show—it was extant in the lifetime of the Macedonian hero's father, Philip [II]. We may even conjecture that Euripides and Sophocles, whose portraits were displayed in the Athenian theater, saw their tragedies performed there. They are known to have been Pericles' contemporaries; and the way in which Plutarch, in his life of Pericles [(13.56)], writes of the odeion built by that celebrated orator proves that Athens possessed another theater; this very probably was that of Bacchus. We initially concurred with a number of other authors[44] in supposing this theater to have been built by Philon [of Eleusis]; but on reflection it emerges that he lived too late to have built the whole of it. He is known to have been employed by Demetrius of Phaleron, which means that he can have done no more than repair or improve the building described here. Along with the portraits of the two celebrated poets mentioned above, the theater contained those of Menander, Aeschylus, and numerous obscure writers.[45]

On close inspection, this Athenian theater reveals both the origin of theaters and the principal improvements that they underwent subsequently,[g] for most of the tiers of the structure are not supported by vaults, as was done later, but are as if hewn out of the rock of the fortress of Athens, on which they rest. The theater at Sparta is designed in the same way, and I have seen one in the ancient kingdom of Árgos that came even closer to the origins of this species of monument: it was formed by simply arranging marble steps in a hollow of the mountainside, so that they naturally assumed the form of tiers.

The Greeks later greatly improved upon the primitive form of their theaters; but those of the Romans were larger, excelling in size even the theater at Megalpolis, the largest in Greece. There was also greater magnificence in the adornment of the Roman theaters. For all their opulence, however, they never approached the elegance and beauty of the theater at Epidauros; its architect was Polykleitos, whose work, as Pausanias says [(Description of Greece 2.27.5)], no other could ever rival. Its location, like those of the theaters in Athens and Sparta, strikingly suggests how the Greeks differed from the Romans in their opinion both of the plays performed there and of the proper

worth of the men employed in them. In Athens and in Sparta, the theater adjoined the citadel, occupying one of the most revered areas in these two cities so celebrated in Greece. And the site on which the Epidaurians built their theater seems to proclaim their high regard for the plays enacted there: it lies within the sacred enclosure of the Temple of Asklepios.[46]

What we have said of some of the Greek theaters suffices to show that they were not detached structures like those of the Romans. We have reason to suppose that they lacked those colonnades where Roman women could shelter from the Sun's rays and the rain to watch the performances; but they possessed the three essential features that mark all monuments of this kind and that embrace all the others: to wit, the place for the actors, which was generally called the *scene,* marked [16] on the plan, plate 3; that for the spectators, which they called the *theater* proper, marked [17]; and the *orchestra,* which among the Greeks was set aside for the mimes and dancers, designated by [the number 15].

The theater at Athens, of which I here give a drawing, is approximately 247 French feet at its greatest diameter.

The width of the scene itself, or the diameter of the orchestra, is approximately 104 feet; the rest is taken up by tiers of seats. The walls of the theater are 8 feet 3 inches thick; it is constructed entirely of white marble. For the form of the ancient theaters, see the detailed and extremely interesting report that Monsieur [Nicolas] Boindin has published in the first volume of the *Histoire de l'Académie* [*royale*] *des* [*inscriptions et*] *belles-lettres.*

Above the tiers of the Athenian theater, and close to the center, two niches are carved out of the rock, one on the right, the other on the left. One of these, probably the former [18], contained a tripod on which was depicted Apollo and Diana piercing the children of Niobe with arrows. The Athenians not only used this theater for the performance of their tragedies and comedies but also frequently assembled there to deliberate on their affairs. Diodorus Siculus relates that, on hearing that Philip [II], king of Macedon, had made an attack on the city, the people of Athens crowded into the theater without waiting, as was the custom, for the orders of the magistrate.[47]

After examining the interior of the theater, we viewed its exterior, from outside the citadel; and from this vantage I drew it. Plate 7, which shows that view, displays a part of the facade; for the portico that once fronted it has been reduced to ruins and nothing remains of it but a few broken stones. The temple above is that of Minerva. The arcades shown to the rear and to the right and crowned with a great, smooth wall are the remains of the Portico of Eumenes. This was used for rehearsals and was also one of the principal promenades of Athens. Not only did people resort to it for recreation and for fresh air, but it was also the meeting place for the philosophers. The sectaries of Aristotle were called *Peripatetics* because they walked to and fro beneath this portico as they debated. This same place was also the resort of the disciples of Zeno, and they derived their name *Stoics* from the Greek word *stoa,* which means *portico.*

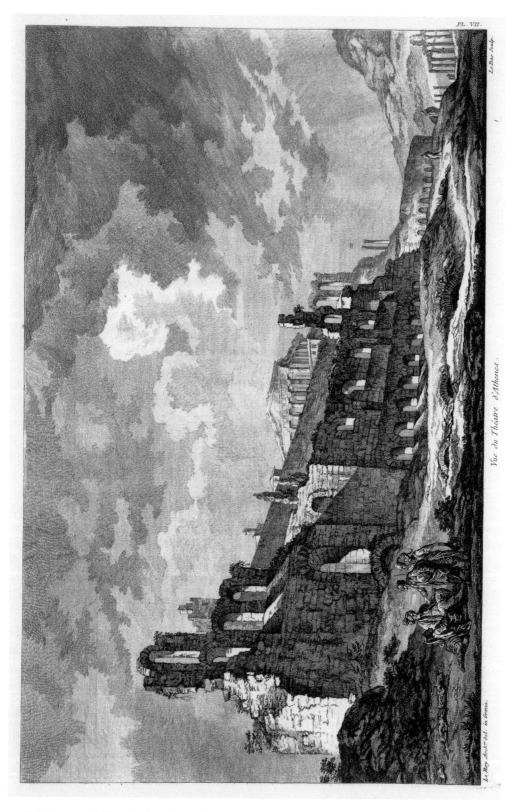

Pl. 7. Jacques-Philippe Le Bas, after Julien-David Le Roy
View of the Theater at Athens

The tall columns at the far right of the view are the remains of Hadrian's Pantheon [(Temple of Zeus Olympios)]. There are two other isolated columns, quite close together: these stand on the citadel rock, almost directly above a small and highly curious ancient building [(Monument of Thrasyllus)] that we shall describe in due course.

The Enlargement of Athens: Historical Description of the Earliest Monuments to Be Found around the Citadel of the City

Athens originally occupied a space no larger than the citadel; and this is so negligible, by comparison with its size when Theseus united it with the twelve cities founded in Attica by Cecrops, that Theseus is justly regarded as the second founder of Athens.[h] He divided the new city into five parts; one was the Athens of old, and around this he built the four others. One of these probably covered a part of the Mouseion hill; another extended toward Mount Anchesmus [(Lykabettos)], and a third toward the road to Thebes and Eleusis; the fourth faced the ports of Athens. I surmise, therefore, that the bounds of Theseus's new city enclosed the rock of the Areopagos, a part of the odeion hill [(Mouseion)], and the area that contains the celebrated temple to Theseus himself [(Hephaisteion)] and the Lantern of Demosthenes [(choragic Monument of Lysikrates)] — monuments whose situation we shall specify more closely in due course.

For all the enlargements decreed by its second founder, Athens was still far from the extent that Themistocles was to give it. That great man, says Plutarch [(*Lives, Themistocles* 3.3–4.2)], knew no rest after Miltiades' victory at Marathon; unlike all his fellow citizens, he believed that the Persians would soon return to devastate Greece. Judging that neither the walls of Athens nor its fortress would be any defense against the fury of those barbarians, he believed that the Athenians would never be safe without a good navy. To this alone he bent his mind; and, concealing his true intentions, he skillfully persuaded the Athenians to build a hundred galleys with the proceeds of their silver mines at Mount Laurium.

In the event, Themistocles' wisdom and foresight were vindicated. The Persians descended on Attica with an innumerable host, and most of the Athenians, on their general's advice, left the city and took refuge on the island of Salamis. Believing that the Greek fleet would be at an advantage if it engaged Xerxes' fleet in a confined space, Themistocles used false intelligence to mislead him into attacking the Greeks in the strait between the island and the mainland. The Persian king, who had one thousand ships in the harbor and quays of Phaleron, fell into the trap: he detached part of his fleet and sent it around the island of Salamis to station itself at the mouth of the straits toward Megara; then he himself entered the straits, with the rest of his ships, from the direction of Piraeus. Everyone knows the outcome of the battle: Themistocles won a glorious victory that saved the Greeks. It was a victory that emboldened the Athenians to equal and even surpass the most flourishing states in Greece.

Athens was considerably enlarged after the defeat of Xerxes, and Themistocles was as diligent in building its walls as he was skillful in circumventing the opposition of the Lacedaemonians. As maritime power was his sole concern, it seems likely that it was he who extended the city toward the sea. There is a passage in Plutarch that seems to favor this supposition:[48] *Themistocles, says that author, did not—as the poet Aristophanes said—add the harbor of Piraeus to the city of Athens, but rather he attached the city to Piraeus, and the land to the sea.* An inspection of the site confirms this view. On the way from Athens to Phaleron, beyond the Areopagos, the Mouseion hill, and the odeion [(Pnyx)], can be seen great square spaces, carved out of the face of the rock, that indicate the positions of buildings and even the distribution of their rooms.

In the days of its greatest prosperity, the city of Athens possessed eight gates. There was one in the east, known as the Gate of Aigeus; some way to the north of this was the Acharnian Gate, where there were good springs of water. In the same direction, farther to the east, was the Diochares Gate. The fourth was the Diomeian; the fifth, the Gate of the Sepulchers; the sixth, the [Sacred] Gate of Eleusis; and the last two were the Gate of Thrace and the Thriasian Gate, later called the Dipylon Gate. The circumference of Themistocles' walls made Athens one of the largest cities in Greece. The construction of Piraeus, and the Long Walls that Themistocles built to link the city with its harbors, raised it to the peak of greatness.

The city does not seem to have been greatly enlarged in Pericles' time, but during his time it took on an entirely new appearance. Before the rise of Pericles, Athens was already more powerful than Lacedaemon; when he became ruler of the republic, he adorned it with buildings of such beauty, grandeur, and nobility that it became the finest city in the world.

Pericles had given the Athenians a taste for the arts; and this still struck a few sparks in the century after his death. But fate had a great revolution in store. Alexander transformed the face of Greece and of all the parts of Asia and Africa that he conquered; and the arts, which follow in the train of glory and enhance its luster, departed with him to Alexandria. Athens now declined from her former superiority to occupy the second rank among celebrated cities. Opulence replaced the noble simplicity, the masculine and majestic character, of the buildings of Pheidias, Iktinos, Kallikrates, and Mnesikles. The Athenians, who in their jealous pride had refused to allow one of their greatest men to adorn the city with monuments at his own cost because he meant to set his own name on them, later allowed it to be restored by princes; and they proclaimed the fact in inscriptions that are visible to this day, as we shall show when we come to discuss the odeion. The striking difference between the monuments of successive ages in Athens persuades us to divide this work in this, its second edition, in a way that will better convey the superiority of the buildings erected before the end of the age of Pericles to those built later.

So much for the enlargement of Athens. Of the monuments now to be

discussed, the earliest in date is the Temple of Theseus [(Hephaisteion)]. Plutarch [(*Lives, Theseus* 23.3)] tells us that the Athenians raised a temple to Theseus in his own lifetime, after his return from Crete and his victory over the Minotaur. Theseus himself ordained that the cost for the upkeep of his temple and for the sacrifices performed there should be defrayed from the tribute formerly paid to King Minos, from which his valor had delivered them. To perform the rites, he appointed the Phytalids, who had welcomed him beside the river Kephissos when he first reached Athens and who had purified him at his request. Nor was this the only temple to Theseus to be founded in his own lifetime: the Athenians built many, but he kept only four for himself and caused all the rest to be rededicated to Herakles, out of gratitude to that hero for freeing him from the prison of Aidoneus, king of the Molossians; he changed their names from *Theseion,* from *Theseus,* to *Herakleion,* from *Herakles.*

Though there were temples to Theseus before the Persian invasion of Greece, the temple that we now see cannot have been constructed before the time of Cimon, son of Miltiades. After conquering the island of Skíros, that celebrated general searched there for the bones of Theseus, in accordance with the advice given to the Athenians by the oracle of Pythian Apollo. But the fierce temper of the inhabitants was not the only hindrance to his inquiries, for no one knew where on the island Theseus's tomb might be. According to Plutarch [(*Lives, Cimon* 8.5–6, sans the she-eagle)], Cimon was inspired by seeing a she-eagle strike the earth with her bill and scratch with her talons; he had his men dig at that spot, and they found the bones of a very tall man with a sword at his side. Not doubting that these were the bones of Theseus, Cimon had them loaded onto his galley, which he decorated richly, and shipped them to Athens nearly eight hundred years after Theseus had left it.

The honors with which the Athenians received Cimon on that occasion called for a magnificent gesture in return; and he erected the superb Temple of Theseus [(Hephaisteion)] that stands to this day. I have shown this temple, built ten years after the battle of Salamis, in plate 8.[49] It is a Doric building; and its plan, like those of nearly all Greek temples, is a parallelogram. It is adorned with a portico on all four sides, with six columns front and back and thirteen on either flank. In its architecture, it greatly resembles the Temple of Minerva; that temple partly imitates the Temple of Theseus, built a few years earlier.

The soffits of the portico of the Temple of Theseus are designed in a curious way: at the height of the cornice there appear to be great marble beams, which correspond almost exactly to each triglyph and which convey an impression of the arrangement of the wooden members that originally formed these ornaments. This construction is a strong argument for the antiquity of the temple, for it shows, in marble, those members that were originally made of wood.

The Temple of Theseus is enriched with fine sculptures, mentioned by Pausanias [(*Description of Greece* 1.17.2)]. They show the war between the Centaurs and the Lapiths and that between the Athenians and the Amazons.

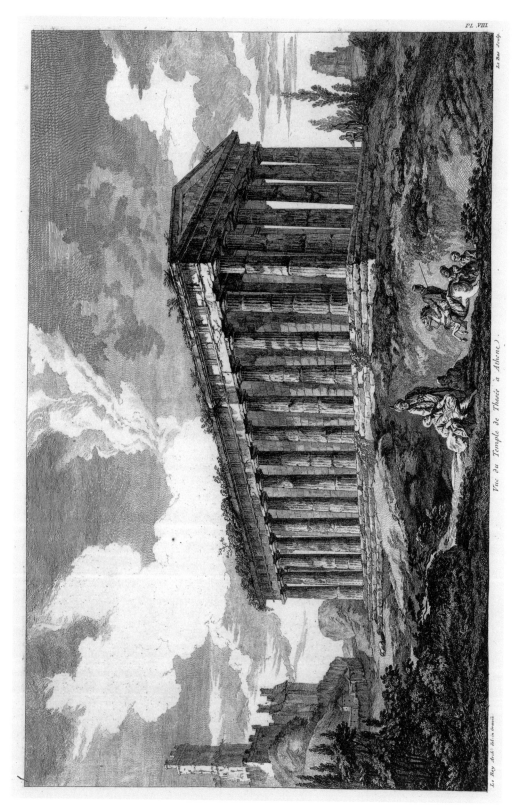

Pl. 8. Jacques-Philippe Le Bas, after Julien-David Le Roy
View of the Temple of Theseus in Athens

The common people of Athens took such pride in this latter war that it was also depicted on the shield at the Temple of Minerva and on the pedestal of the statue of Jupiter Olympius. These bas-reliefs are on the friezes at either end of the *cella*, or body, of the temple.[50]

On the rear face of the temple, and on the adjoining portions of the lateral faces, bas-reliefs may still be seen, enclosed within those square spaces that architects call *metopes*. There are grounds for believing that these are the work of Micon, the sculptor named by Pausanias, and that he intended to make similar ones all around the temple—or at least it would seem so from that ancient traveler's description of the bas-reliefs on the third wall of the Temple of Theseus.[51] Some of these bas-reliefs come strikingly close to our historical knowledge of the adventures of Theseus, but others seem more difficult to identify. We shall simply illustrate those that we have had engraved, from rather imperfect sketches, without attempting to explain them.

The interior of the Temple of Theseus is not adorned as the exterior is, but it contains one precious monument, which Monsieur Spon [(*Voyage d'Italie*, vol. 2, p. 184)] has already given in his voyage to Athens. This is a hollow cylinder bearing an inscription to the effect that the prytaneis [(presidents)] of the Pandionis tribe, to honor themselves and those who were entertained in the Prytaneion at public expense, recorded the name of the archon Ponticus in his eighth year of office as prytanis.[52] So profound was the Athenians' veneration for Theseus that they maintained his temple as an inviolable sanctuary where maltreated slaves could take refuge. The Greeks now use it as a church, despite the jealousy of the Turks, who envy them the possession of so fine a building. They have dedicated it to Saint George, who is much venerated in Athens.

The small monument seen on a hilltop to the right of the temple was built during Trajan's reign as a monument to Gaius [Julius Antiochus Epiphanes] Philopappos; I give a larger drawing of it in another view. The rock to the left of the temple, part of which is concealed behind the last column on that side, is the Areopagos; farther away, on the same side, is the entrance to the citadel of Athens in its present state, and exactly as I drew it in situ.

Not far from the Temple of Theseus, on the left as you go toward Piraeus, are the remains of the Odeion [of Pericles] [(Pnyx)],[i] shown in plate 9, between the Areopagos rock on the right and a mosque, overlooking a Turkish cemetery, on the left. The odeion was one of the finest monuments in the city of Athens. Its name, which derives from *ode*, indicates that it was a place devoted to song but seems to apply equally to a theater, where tragedies were performed, or to a place set aside for music. Plutarch [(*Lives, Pericles* 13.6)] leaves us in no doubt as to its function, however: he explains, most circumstantially, that it was used for musical contests.

Pericles, that passionate lover of all the arts, was the architect of this odeion. He had learned music from Damon and Pythokleides; and the beautiful disposition of the odeion suggests that he took lessons in architecture from the same celebrated artists whom he had employed for the Temple of Minerva

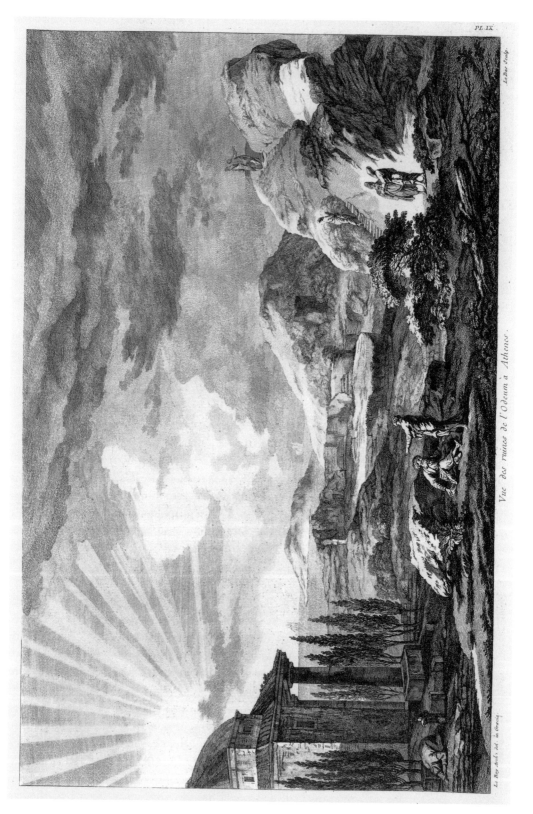

Pl. 9. Jacques-Philippe Le Bas, after Julien-David Le Roy
View of the Ruins of the Odeion at Athens

and the Propylaia. He designed this building as follows: he made it oval in form and build it, as one can see at the site, partly of rock and partly of large blocks of stone, 4 feet high by 8 feet wide, with diamond-faced rustication. The part of the monument that is lowest and foremost in the drawing formed a segment of a regular oval and was composed of the large blocks of which I have spoken. The part farther back is cut out of the rock; rather than forming a segment of an oval, it comprises three straight sides set at highly obtuse angles.

On this base Pericles set a stone colonnade,[53] and he designed the building to accommodate a large number of seats.[54] Plutarch, who reports this fact, and who also speaks of the columns of the odeion, gives the impression that the columns, like the seats, were in the interior of the odeion; so far as we can make out, however, it was walled only on the south side, to shelter the audience from the heat of the Sun. This monument was not remotely as large as the Theater of Bacchus, mentioned above, which rests against the citadel; and, since Pericles was famous for his eagerness to please the people, we believe that he left a number of intercolumniations open on the north side, so that those Athenian citizens for whom there were no seats or tiers within the building could still hear the musical concerts that were performed there and even catch sight of the musicians between the columns. No doubt to prevent the sounds from being lost in thin air, he broke with custom and gave the theater a roof. This was made from yards and masts captured from the Persians; it terminated in a point—in imitation, says Plutarch, of Xerxes' tent.

The poets had another word for the roof of the odeion, and thus mocked Pericles, whom they had named *Quinocephalus,*[55] that is, *squill-head,* a squill being a plant with an elongated bulb; and they likened his pointed head to the tall roof of the building.

This pleasantry on the Greek poets' part agrees, as will be seen, with what Plutarch tells us of the form of the roof of the odeion. For the rest, the building was designed in conformity with its use, so that, for the convenience of the Athenians, there were seats all around; some of these are still to be seen, hewn out of the rock.

Once completed, the disposition of the odeion so impressed the Athenians that they readily acceded to Pericles' proposal that they hold musical contests there during the Panathenaic festival. He was even elected rector of the games, and he presided over the awarding of prizes to singers and to players of the flute and of several other instruments. It seems that music made great strides in Athens during that period. By Pericles' time, musicians were no longer confounded with poets, as they had been when the arts were new in the city; but they had yet to be awarded prizes in their own right. For this they had Pericles to thank; and in all subsequent theatrical contests—as we see from the inscriptions on the monument commonly known as the Lantern of Demosthenes and on the porch of the small chapel in Athens known as Panagia Spiliotissa—the composer of the music was mentioned separately from the poet who had invented and versified the play.

Convenient in use, the odeion was no less pleasing to the eye. Plutarch [(*Lives, Pericles* 13.5–6)], Herodes Atticus, and Pausanias [(*Description of Greece* 7.20.6)] commended its beauty; and it must have greatly contributed to the praises that were heaped on Pericles for his improvement of the city of Athens. According to Plutarch [(*Lives, Pericles* 8.2)], some authors even derived his epithet, *the Olympian,* from the grandeur of the buildings that were built for him; others, however, gave other reasons.

The odeion stood complete, in all its beauty, until Athens was besieged by Sulla. Fearing that the Roman general might use it as a point from which to assail the citadel, Aristion burned the wooden roof structure. Vitruvius tells us that it was burned again during the Mithradatic War and subsequently restored by King Ariobarzanes;[56] but, since there were several princes of that name, we would remain in ignorance of its restorer's identity had not the abbé [Augustin] Belley enlightened us by publishing and elucidating an inscription that appears on the monument itself.[57]

From this, the abbé Belley demonstrates that the odeion was restored by Ariobarzanes Philopator and that this was the second king of that name, who reigned in Cappadocia from the year of Rome 690 until 703 [(circa 62 – circa 52 B.C.)]. He also notes that the inscription names the three architects entrusted with the restoration: Gaius and Marcus Stallius, sons of Gaius, both Romans; and Menalippos, whom he surmises to have been a Greek. The learned academician's paper also contains matter of great importance for the unraveling of the history of the kings of Cappadocia.

Several passages in the ancient authors make it clear that the odeion gave its name to the height on which it stood, with a view toward Piraeus. This hill was a natural stronghold from which to defend Athens on that side. According to Xenophon [(*Hellenica* 2.4.1–10)], when Thrasybulus expelled the Thirty Tyrants he first seized Piraeus, and the Thirty assembled at the odeion a force of three thousand men, horse and foot. This makes it sufficiently plain that the name *odeion* was sometimes used to mean the area where the musical theater was, rather than the theater itself, which was not large enough to contain so great a number of men. Another text confirms this. In the same war, says Xenophon [(*Hellenica* 2.4.10)], Spartan troops had seized half of the odeion — which cannot possibly refer to an oval theater of no great size, which the Spartans would either have seized in its entirety or been forced to vacate.

Xenophon says elsewhere [(*Hellenica* 2.4.24)]: "After the Thirty Tyrants had been expelled and ten magistrates appointed to govern the people and reconcile the two parties, the troops under their command spent every night in the odeion, with their horses and their shields; and, because they trusted no one, they kept watch along the walls from sundown, and in the morning they mounted their horses, for fear of being attacked by forces from Piraeus." This shows that the odeion, or its site, was such that one could contain and observe both the forces at Piraeus and those in the city and thus establishes the location of the odeion beyond possible error. Pausanias [(*Description of Greece* 1.8.6, 1.5.1, 1.14.6)] says that the monument was on the way from

Piraeus, after the Tholos and before the Temple of Theseus. The uses of the odeion at Athens, and of other buildings with the same name, and the etymology of the word *odeion,* are discussed in *Suidas* and by the Scholiast on Aristophanes, Eustathius, and other authors. Their opinions are cited in the commentary on Vitruvius, in the edition already cited, and I have inserted the gist of their commentary in a note.[58]

The view that I have made of this musical theater clarifies the preceding passages: it is drawn from the gate of the citadel of Athens. It shows that the odeion lay between the citadel and the sea. It also shows the outline of the rock on which the Areopagos was convened. The name in itself will suffice to recall to readers all that they have read of that court of justice, so celebrated for the integrity of its judges and the wisdom of its verdicts. The mosque is of no particular interest; according to Wheler [(*A Journey into Greece,* p. 383)], the cemetery in which it stands contains the spring that the ancients called the *Enneakrounos.* This view confirms Diodorus Siculus's statement that the mountains of Troezen [(some forty miles southwest across the Saronic Gulf, on the Peloponnese)] could be seen from the citadel: Diodorus says [(*Library of History* 4.62.2)] that Phaedra fell in love with Hippolytus when he came to Athens for the mysteries; when he had gone, she built a temple to Venus, close to the fortress, from which she could see Troezen.

After visiting the odeion, we turned to the northeast, passed along the southern wall of the citadel, and entered the city from that side. Almost at once, we came upon the small monument known as the Lantern of Demosthenes,[j] shown in plate 10. This is of great antiquity: the inscription on the face of the architrave informs us that it was built under Euainetos, who was archon in the second year of the 111th Olympiad, 335 B.C., the year of Rome 418. It is entirely built of marble, except for a part of the pedestal, which is stone; the entablature is supported by six columns equally spaced around the circumference. Of the six intercolumniations, some are open and the others are filled by marble slabs that are cut from one piece of stone, as are the columns; the upper parts of the slabs are decorated with tripods. The capitals of the columns are extraordinarily tall. In general, the proportions of the columns are slender, and the roof is extremely rich.

The Greeks today call this monument *to Phanari to Demosthenis,* the Lantern of Demosthenes. Here, they say, after he had several times been rebuffed by the people because of his labored delivery, the famous orator retired on the advice of Satyros, an accomplished comic actor, to school himself in adding grace of gesture and harmony of voice to the sublimity of his public speeches. But this tale of theirs seems unlikely, because the floor inside the monument is high above the level of the street, and Plutarch [(*Lives, Demosthenes* 7.3)] relates that the cabinet in which Demosthenes shut himself away for three months to instruct himself in eloquence was below ground— as seems all the more likely, given that he is known to have worked there by lamplight. Moreover, the interior of the building is less than 5 feet wide, and therefore unsuitable for the use to which the Greek orator is supposed to have

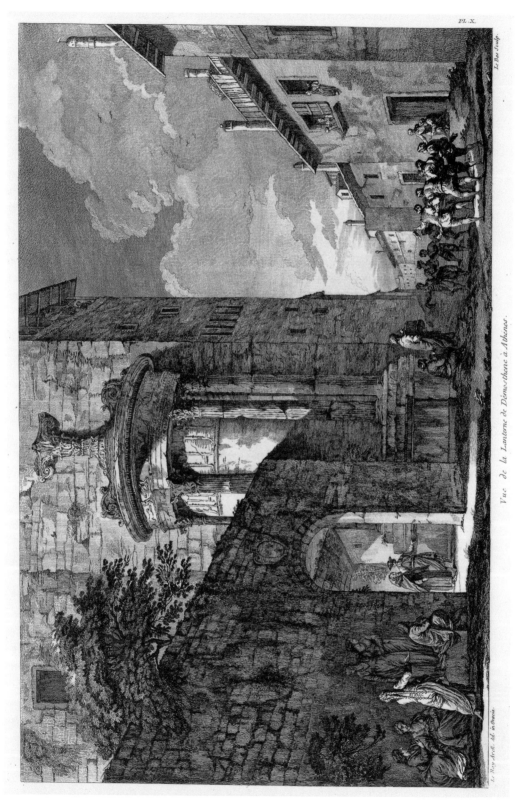

Pl. 10. Jacques-Philippe Le Bas, after Julien-David Le Roy
View of the Lantern of Demosthenes in Athens

put it. However, it was built after the death of Philip [II], early in the reign of Alexander, and in the period when Demosthenes' reputation was at its height; and so we might believe that it was built at his behest, as tradition has it — did not history plunge us into renewed uncertainty by informing us that at that precise time, Demosthenes fled from Athens.

On the frieze of the monument an inscription tells us that at contests presided over by Euainetos, who was probably the archon of that name,[59] the young men of the Akamantis tribe carried off the prize; but modern travelers are not agreed about the nature of the contests mentioned in the inscription. Wheler [(*A Journey into Greece,* pp. 398–99)] said that they were athletic games; Spon [(*Voyage d'Italie,* vol. 2, p. 174)] thought, on the contrary, that they were exercises of the mind rather than of the body. On mature consideration, as [Antonius] van Dale's dissertations on the ancient marbles had led me to suspect, and as I myself declared in my first edition,[60] I do not on the balance believe that Wheler's conjecture, which at first I embraced, is very likely.

Monsieur Spon's opinion on the Lantern of Demosthenes, which Mr. Stuart [(*Antiquities of Athens,* p. 27)] has followed, therefore seems to me to be the more plausible; and I have no doubt that this inscription, like all others of the same kind, refers to theatrical performances. This conjecture once accepted, the inscription on the architrave of the monument, which is dedicated to Lysikrates or raised in his honor, informs us that at contests presented by this Lysikrates, the youth of the Akamantis tribe carried off the prize. It also tells us that the Athenian Lysiades wrote the play, that Theon composed the music, and, finally, that Euainetos presided at the festival. We are led to suppose that the Athenians, among whom a talent for public oratory led its possessor to the highest public dignities, held contests in declamation for the youths of their tribes, so that from an early age, the desire to excel might teach them to speak with grace and animation. The people paid for these splendid contests, which were brilliant and costly, as were the prizes. In the commemorative inscriptions, the people accordingly assumed the title of choragus, because they had supplied the chorus or the festival themselves. On occasion, rich and respected private individuals were permitted to assume this burden; those who obtained this signal mark of favor were proud to show off their own greatness and were allowed to assume the title of choragus.

All the tribes of Attica were admitted to these contests. Each one, animated by the desire for victory, would engage a poet to compose the play that its youths were to learn; it also nominated the musician who was to accompany them in time with their declamation. These two choices were of the greatest importance: a happy choice of theme adopted by an able poet, to whom it offered the opportunity to present interesting situations on the stage, and the charm that a superior instrumentalist could add to the declamation were bound to contribute greatly to the victory of one tribe over another. And so we find the victorious and grateful tribe including the names of these men in the inscriptions that record its victory.

The names of the poet and the musician, which appear in these inscriptions,

yield a strong presumption that such festivals were contests in declamation; but, without the ample corroboration supplied by van Dale in the work cited above, this would not be proof positive, for the Greeks also used poetry and music in their athletic contests, albeit for very different purposes.

Most travelers who have visited Athens have surmised, as I did myself, that the contests presented by Euainetos formed the subject of the frieze of the building constructed for Lysikrates; but it is so easy to explain a bas-relief in different ways, especially when it contains a large number of figures, that I shall restrain myself in this respect and neither venture conjectures of my own nor adopt those of others.

The roof of this little building is very curious; we might suspect it of being a later addition, were it not that the ornament that composes it, the frieze on which the figures are carved, and the architrave with the inscription all appear to have been worked in the same period. Besides, the fourth book of Vitruvius [(De architectura 4.3.1)] contains a passage on round temples that leads me to suspect that this kind of roof was not so rare among the ancients as might be supposed. What I have to say on the subject will be found in the second volume of this work.

As will be seen, this monument is embedded in an inferior building, namely, the monastery of the Capuchin friars of Athens. The superior, while I was in the city, was the Reverend Father Agathange, from whom I received every sort of kindness. It was his distinction to be loved and respected by the Turks, by the Greeks, and by all those of our own people whose business took them to him.

The arched gateway in the wall, on the left in this view, is the entrance to the monastery; it is crowned with the arms of France, set there by Father Agathange, a good Frenchman. The houses on the right form the other side of the street. I thought that the reader might not be displeased if in representing the Lantern of Demosthenes, I also showed a very curious Greek dance that I saw at carnival time, when I was drawing this building. It is performed as follows: the dancers link arms, the coryphaeus (the one who leads the dance) holds a handkerchief, and they all wheel and turn, together, to the strains of a pipe and the sound of a drum, which one of their musicians beats at both ends. Seeing this dance, which is much performed in Greece, I recalled the dance that was performed, according to Plutarch [(Lives, Theseus 21.2)], around the altar known as the Keraton [(Altar of Horns)], on the island of Delos. This was the dance known to the Delians as the Crane [(geranos)], in which its deviser, Theseus, and his companions expressed through their evolutions the intricacies of the labyrinth. The striking analogy between this ancient dance and that which I have just described convinces me that the modern Greeks still imitate the dance invented by Theseus: perhaps the handkerchief in the coryphaeus's hand represents the thread that Ariadne gave to the hero. Who knows? Perhaps the Athenians danced before the Lantern of Demosthenes in the palmy days of their republic. It takes longer than one might suppose to destroy a custom that perpetuates itself from year to year.[61]

The formal dress of the Albanians, the poorest of the Greeks, also seemed to me to be very ancient; it resembles that of the heroes of Greece, of which we have an idea from medals and statues. The adornment of the women is singular and plainly derives from the remotest ages, when the use of jewels was unknown. Then, rich women could find no better way of displaying their wealth than to string gold and silver coins around their necks; and in Athens I have seen Albanian women who had such a vast quantity of piastres on their breasts that ours would regard such adornment as hard labor. The Albanian women allow their hair to hang down in braids behind; they cover the part of the braid nearest to the head with very large coins, and the remainder with smaller and smaller coins, down to the ends of the hair. Thus adorned, they can hardly be very agile in their movements, as may be imagined. I observed that the men move with great vigor when they dance alone, but that their dances with the women are performed with far more gravity. In these, the men stand in lines holding hands, with the women, all together, at the center; they dance while singing refrains in very slow time, and only kinsmen may hold the women's hands.

Before concluding our account of this building, we feel it necessary to examine Wheler's arguments concerning the nature of the games mentioned on the Monument of Lysikrates. Speaking of other inscriptions of the same kind, he says [(A Journey into Greece, p. 399)] that the persons named as victors must have won their prizes in athletic contests, because no prizes were awarded for tragedy or comedy. But his argument is unsound. Plato tells us that poets had held contests at Theseus's tomb since time immemorial. [Claudius] Aelianus [(Varia historia 13.25)] records that, around the 10th Olympiad, Pindar was defeated five times in such contests by the celebrated Corinna; and Pausanias, book 9, chapter 22, remarks that the portrait of that fair and learned lady was still to be seen on the exercise ground at Tanagra. She was represented, he says, with a ribbon around her head, to commemorate the prizes that she won for poetry against Pindar at Thebes.[62]

Voyage from Athens to Cape Sunium: Historical Description of the Temple of Minerva Sunias and of the Ports of Athens

Having completed my observations of the earliest monuments of Athens, I prepared to visit the ruins of the Temple of Minerva Sunias, which are no less ancient and no less beautiful than those whose history I have already recounted.[k] As I found it more convenient to travel by sea, I went to Piraeus to board one of those Greek vessels that ply throughout the Archipelago. Well formed to cut through the water, these craft normally have six or eight oars, as many oarsmen, and very large lateen sails; by this means they navigate very swiftly, even in a dead calm, or against contrary winds, provided these are not too strong; and, indeed, with a gentle breeze, we covered in three hours the 11 leagues that separate Piraeus from the cape of Attica known in antiquity as Sounion or Sunium, a distance that the ancients estimated to be 330 stades.[63]

At the foot of this cape, says Pausanias, there was a harbor; on its summit

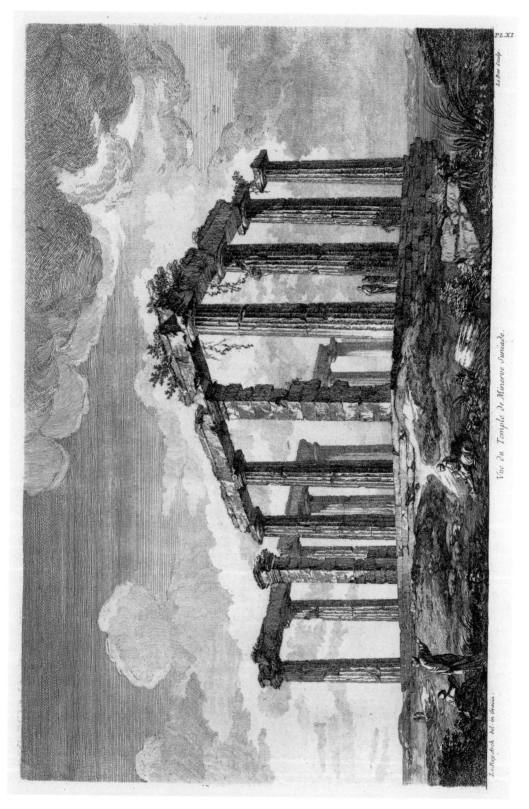

Pl. 11. Jacques-Philippe Le Bas, after Julien-David Le Roy
View of the Temple of Minerva Sunias

stood a temple sacred to Minerva Sunias.[64] There, as shown in plate 11, stand the ruins of a building, with seventeen columns standing, that clearly seems to occupy the same location as the Greek temple of which the ancient traveler speaks. These columns can be seen from so far off by those who sail the waters of the Archipelago that this ancient Attic promontory has acquired the modern name of Cape Colonna.

It would have been very desirable for the history of the arts if Pausanias had given us some clear indication of the position of the Temple of Minerva Sunias, the date of its building, and the reasons that led the inhabitants of Sunium to dedicate it to Minerva; but in these regards his writings tell us nothing. We found no more in the ruins of the building itself: there are no inscriptions, and any conjectures that one formed on the basis of the single bas-relief to be found there would be very shaky. *It represents,* says the abbé [Michel] Fourmont in the published narrative of his Greek travels,[65] *a woman seated with a child, who, like her, raises both arms and seems to watch with horror as a man hurls himself from the summit of a rock.*

Vitruvius appears to be the only ancient author with anything to teach us about the date and the appearance of the Temple of Minerva Sunias. He tells us that this and the Temple of Minerva in Athens were the prototypes for the Temple of Castor [and Pollux] near the Circus Flaminius in Rome.[66] This account in Vitruvius and a comparison of the architecture of the ruins in plate 11 with that of the temples of Minerva and of Theseus in Athens suggest that the Temple of Minerva Sunias was built before the death of Alexander; we consequently include it in this volume.

The temple was built, like all those in Athens, entirely of white marble. In general disposition it more closely resembled that of Theseus, just described, than that of Minerva, to which Vitruvius likens it;[67] for, like the former, it had a peristyle of columns that ran around it, with six frontal and thirteen return columns on each side. In its ruins I measured the triglyphs of its frieze and other ornaments of its cornice; these would have proved to me that it was of the Doric order, even if the form of its columns had left me in any doubt.

The relation that I found between the height of the bas-relief that I mentioned and that of the external frieze of the temple would have led me to suspect that the relief adorned some of the metopes, if only it had not been wider than it is high, which is incompatible with the square form of the metopes. This persuades me that it adorned the internal frieze of the front or rear portico of the monument, like the bas-reliefs at the Temple of Theseus, already mentioned, which represent battles between Centaurs and Lapiths and between Athenians and Amazons.

On the left, in the plate that represents this temple, is the island known to the ancients as Patroclus and to the moderns as Gaidarónisi [or Gaidaro Island]. On the right is the foot of Mount Laurium, where lay the silver mines that were one of the principal sources of the greatness of Athens. "The land of Attica," says Xenophon in his *Ways and Means* [(1.5)], "is not fit for tilling; but when excavated, it nourishes many more people than it ever could by

yielding good harvests; no doubt it is the bounty of the gods that has concealed mines of silver therein." Nicias employed as many as a thousand miners there and drew from it an income of one thousand obols a day.

After a day passed in measuring the Temple of Minerva Sunias, we embarked toward evening and spent the night on board, off Cape Colonna, for fear of those brigands who infest the Archipelago and who rob Greeks and Turks without distinction. On the following morning, we set sail and returned to Piraeus. As I was then without the necessary instruments for an accurate survey, I later paid a second visit to Piraeus, and I shall here record the observations that I made there and at the other harbors of Athens.

An exact knowledge of the size of these harbors, of their respective positions, and of their distances from Athens can cast great light on the history of the city and on its power during its heyday. I accordingly resolved to make a survey of them; and this I did with all the more scrupulousness because the comte de Caylus, as a zealous member of an academy widely known for its publications, had earnestly recommended that I do so through the intermediary of one of my brothers, who wrote to me frequently.

So that I might survey the harbors with greater accuracy, I prevailed upon Monsieur Léoson, our consul, to aid me in this task, and we went from Athens to Piraeus, where a sloop had been readied for us with compasses, leads, and all the instruments necessary to carry out our project. In the legends on plate 12,[1] the reader will find our observations on the extent and depth of those harbors and on the alignment of their moles. I shall say only a word or two about their history, for Meursius has written enough on this subject to make it plain that,[68] if treated at length, it would make a book in itself; and thus it could not be incorporated into the present work as an ancillary.

We first sailed from Piraeus to survey Phaleron, the most ancient of all the Athenian harbors. It was built, they said, by Phalerus, one of those who sailed to Colchis with Jason.[69] It was from Phaleron that Theseus set sail to fight the Minotaur in Crete and to free his country from the ignominious tribute levied each year by Minos.[70] In those remote times, the Athenians were so unskilled in seafaring that Sciros of Salamis gave Theseus a helmsman by the name of Nausithous to steer his ship and another mariner by the name of Phaiax to govern the prow. Sciros felt bound to do Theseus this service because Sciros's own nephew was one of the children chosen by lot for surrender to Minos. Theseus was so well pleased with the two pilots whom Sciros had given him that on his return he raised a chapel in their honor at Phaleron; and the festival named *Kybernesia,* that is, the Feast of the Master Mariners, was instituted in their honor.[71] It was also from this harbor that Menestheus sailed with his fleet to take part in the siege of Troy.[72]

Close to the port of Phaleron, says Pausanias [(*Description of Greece* 1.1.4)], were a temple in honor of Ceres and another dedicated to Minerva Sciras. There were also altars dedicated to the children of Phalerus, to the children of Theseus, and to various heroes; but the ancient traveler tells us that the altar with the simple inscription *To the Hero* was in honor of Androgeos.

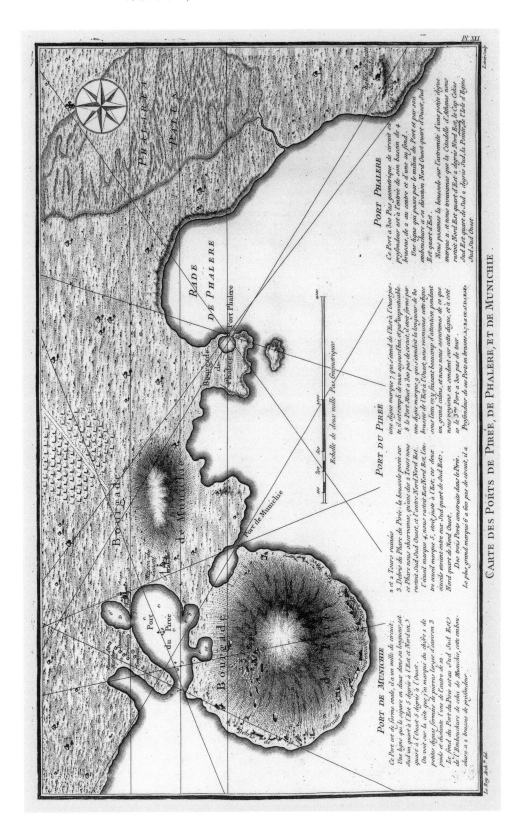

Pl. 12. Claude-Antoine Littret de Montigny, after Julien-David Le Roy
Map of the Ports of Piraeus, Phaleron, and Munychia

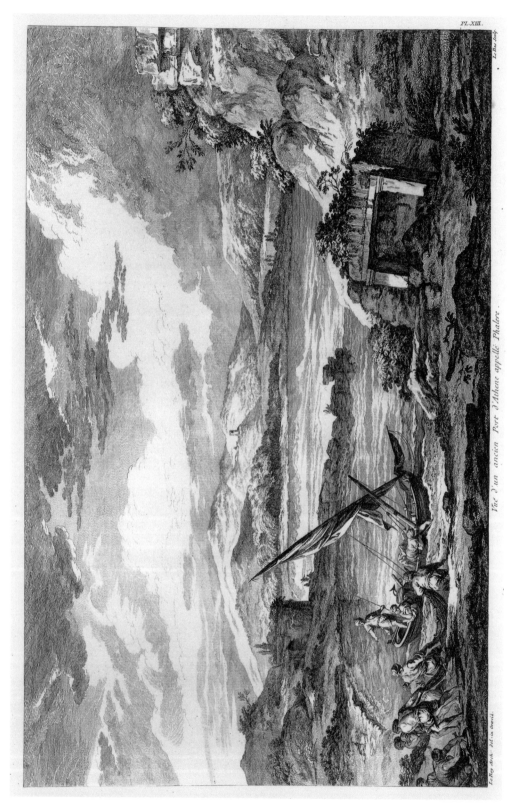

Pl. 13. Jacques-Philippe Le Bas, after Julien-David Le Roy
View of the Ancient Port of Athens Called Phaleron

The same author tells us that near Phaleron there were altars inscribed *To the Unknown Gods;*[73] and this is confirmed both by Philostratus [(*Life of Apollonius of Tyana* 6.3)] and in *Suidas*. Saint Paul obscurely alluded to these altars when, in the Acts of the Apostles,[74] he mentioned to the Athenians that he had seen among them an altar dedicated *To the Unknown God.* Saint Jerome clearly construed the inscription as Pausanias did—that is to say, *To All Unknown Gods,* not to one alone—for he corrected Saint Paul on this subject. There is every reason to believe that having raised altars to all the gods they knew, the Athenians dedicated others to those they did not know, for fear that these might do them harm. Meursius, in discussing the port of Phaleron in the essay cited above, enters into considerable detail concerning this inscription; we refer the reader to his remarks for this and for other details concerning the history of the port.

The port of Phaleron is now called simply *Porto.*[75] It is circular, and so shallow that only small boats can enter. It can be seen from the citadel of Athens, and the latter is visible from the viewpoint I adopted to show it in plate 13. The small bluff, on the right in my view, shelters it from the south. The land on the left is part of the mainland. In the center is a mole, and a little farther off is a roadstead where merchant vessels occasionally drop anchor; beyond this is a part of the Athenian forest. At the foot of the odeion hill is the citadel of that city, between the Mouseion hill on the [left], on which stands the triumphal monument of Gaius Philopappos, and Mount Anchesmus on the [right].[m] The taller mountains in the distance are Mount Hymettus on the right and the longer Mount Pentelicus on the left. The stone in the foreground is a massive block with something like two Tuscan pilasters, complete with an architrave, carved on one face of it. I could not see this block from the place where I sat to draw the harbor; it was some distance away, but I considered it remarkable enough to be added to the view.

As will be seen, Phaleron harbor was too small for so powerful a city as Athens; nevertheless, it remained the Athenians' only port until they turned their attention to seafaring. Let us say a word about the time when they began to do so with zest.

Having set Athens on a pinnacle of glory by winning the victory of Salamis, Themistocles desired to safeguard the city's power by constructing Piraeus, the largest and finest harbor in Greece; but because he suspected that the Lacedaemonians would never allow a project so conducive to the greatness of Athens to go unchallenged, he kept it secret. He told the assembled people that the undertaking he was about to propose was of such importance that it was unwise to make it public. He asked the people to nominate two persons on whose discretion he could rely, so that he could impart his intentions to them, and they could aid him in their execution; and they named Aristeides and Xanthippos. Themistocles confided in them; they certified to the people that the undertaking was grand, useful, and feasible; and the Senate, to which by the people's decision the secret was also entrusted, agreed with Aristeides and Xanthippos.

Empowered to do as he thought fit, Themistocles alleged no other reason for building a new harbor than the public good, which demanded, he said, the building of defenses to counter the designs of the Persians. But his principal concern, for the time being at least, was to distract the attention of the Spartans. And so he advised the Athenians to send him, with others, on an embassy to Lacedaemon, while the project was set in motion. The people worked with such zeal and diligence that the harbor was completed in a short time, to the great annoyance of the Lacedaemonians.[76]

Piraeus is some seven miles from the citadel of Athens, but the distance from the harbor to the outer walls of the city was very much shorter. According to Pausanias, Themistocles was the first to observe that three harbors could be made at Piraeus, and he had them built.[77] It can be seen from their small size, and from that of the harbors of Phaleron and Munychia, that the ships of the ancients were not very large; indeed, we should consider as a single harbor the great harbor of Piraeus and the three that were around it.

We recognized the largest of these harbors perfectly, but we were able to find the outline of one of the smaller ones only by taking soundings and examining the bed of the sea in calm weather. We discovered there the remains of an earthwork that ran from west to east to form the harbor. The harbor numbered 6 in the plan [(plate 12)] is the one referred to by Pausanias when he says, "Close to the largest of the three is the tomb of Themistocles."

I surmise that this tomb and that of Cimon, which was in the same area, were the two largest of the ruined towers that are still to be seen in that direction, for the ancients sometimes built their tombs in that form. I have not seen anything comparable in Greece, but the Romans, who imitated the Greeks in all kinds of architecture, have left us more than one example: such, in Italy, are the tower or tomb of Metellus [(tomb of Caecilia Metella in Rome)], that of Hadrian [(Castel Sant'Angelo)] in Rome, and so on. Also in the same direction, in the area where I have written on the plan *Ruins of a market*, is, I believe, the market of which Pausanias [(*Description of Greece* 1.1.3)] takes notice.

The mouth of the large basin [(plate 14)], around which the three harbors of Piraeus lay, was marked at the entrance by two circular stone towers [(each marked with the number 2 on plate 12)]. In the center of the channel was a lighthouse, marked with the number 3, which served to light ships on their way. Two small towers, a little farther on, probably served to hold the chain that closed the harbor. Two lions stand outside the gate of the Arsenal in Venice, with an inscription to the effect that they were removed from Piraeus by the proveditore Morosini in 1687. Messrs. Spon [(*Voyage d'Italie,* vol. 2, p. 231)] and Wheler [(*A Journey into Greece,* p. 418)], who traveled to Athens before the city was taken by Morosini, mention only one, which they saw at the far end of Piraeus. Perhaps this was one of those that the proveditore carried off, and perhaps he found a second that had escaped their notice. For my part, I saw none.

The most interesting part of Piraeus was incontestably the round area,

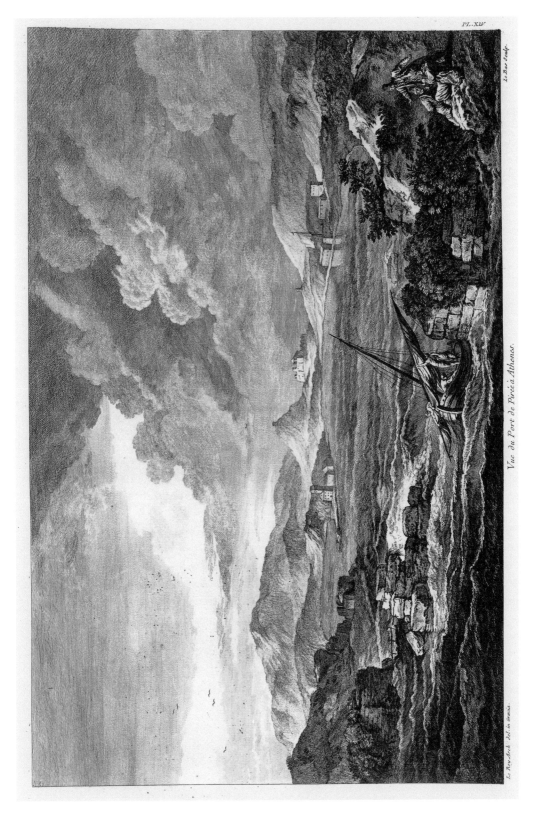

Pl. 14. Jacques-Philippe Le Bas, after Julien-David Le Roy
View of the Port of Piraeus at Athens

once entirely separate from the mainland[78] but since linked to it by an isthmus situated between the shoals of the harbor of Piraeus and those of Munychia.[n] There are grounds for believing that Themistocles was responsible for this linking and that he first made Piraeus into a peninsula and then fortified it.

Perhaps, too, Themistocles was responsible for the wall reinforced by towers, now ruined, which no doubt once encircled the Piraean peninsula, but it is possible that this was not built until after his time. In all events, Piraeus was a fortified place: a number of passages in the works of Greek historians tell us so. After Thrasybulus delivered Athens from the tyranny of the Thirty Tyrants, he promptly seized and defended the town of Piraeus—this must mean the place under discussion here, which is mentioned by several authors, including all those that make mention of generals who seized Piraeus and held out there.

The Piraean peninsula was 40 stades distant from the outer walls of Athens, as we learn from Strabo,[79] and this was also the length of the wall that joined the two.[o] The wall that ran from the city to Phaleron harbor was almost as long. The various names that the ancients gave to these two long walls, which converged toward the city and diverged toward the harbors of Phaleron and Piraeus, imply that they seemed to reach out to embrace the two ports of Athens;[80] their general appellation was *Macra teichè,* the Long Walls, as distinct from those that encircled the Piraean peninsula itself or the harbors of Munychia and Phaleron—or so the words of Diodorus [(*Library of History* 13.107.4)] lead us to suppose.[81]

First repaired by Cimon, almost entirely destroyed by Lysander, and largely reconstructed by Conon, the Long Walls were first completed by Kallikrates in the time of Pericles. They were wide enough for two chariots to race along them without colliding; their height was 40 cubits. They were solidly built of great ashlar stones jointed not with mortar but with iron and lead. All the ancient authors seem to agree that Philon was the architect of the Arsenal of Piraeus, which was regarded as an excellent work. It would seem to have consisted of a number of structures built around the three harbors of Piraeus to house ships or their tackle. These three harbors had names of their own: one was called *Kantharos,* another *Aphrodision,* and the third *Zea.*[p] The reader may refer to Meursius for the origins of these names, for his remarks on the subject, and for a number of passages from which we have derived the information just given.

The harbor of Munychia, which it remains for us to describe, was close to a township of the same name, which stood on the mainland. This township formed a triangle, with one side bounded by the sea; the two others were lined by the Long Walls, which extended from the harbors of Piraeus and Phaleron to converge close to the outer wall of the city of Athens. It was this advantageous situation that led a number of generals to hold out against the forces of Athens at Munychia, a place, says Diodorus Siculus [(*Library of History* 20.45.6)], no less fortified by art than by nature. Cornelius Nepos [(*De excellentibus ducibus exterarum gentium* 8.2.5)] relates that Thrasybulus fortified

Munychia; Plutarch [(*Lives, Demetrius* 8.3)] adds that there was a garrison there; Strabo says that by his time Munychia was no more than an eminence in the form of a peninsula.[82] Ptolemy locates the harbor of this township to the east, beyond the mouth of the Ilissos and ten miles from Piraeus — whereas it is no more than two rifleshots away. He is also mistaken, as Wheler [(*A Journey into Greece*, p. 418)] has observed, in placing Piraeus to the east of Phaleron, when it is really to the west.

The harbor of Munychia is oval in shape, with a narrow mouth. On the landward side, large ashlar stones can be seen beneath the water, apparently pointing toward the center of the oval. These stone walls, perhaps 3 feet thick and 11 or 12 feet apart, no doubt served to dock the galleys or smaller craft of the Athenians. This side of the harbor is all living rock, which seems in places to have been cut away at vast expense. By pulling in close to shore, on the side closest to Athens, one can see the foundations of houses and public buildings hewn out of the rock; in many places the rock contains small niches, possibly cut to house statues of the gods.

Greek Inscriptions Relative to Two Monuments of Which Drawings and a History Appear in the First Part of This First Volume

Inscription concerning the rebuilding of the odeion shown in plate 9. As mentioned above, this inscription has already been published in the *Mémoires de l'Académie* [*royale*] *des inscriptions* [*et belles-lettres*] and explained, by the abbé Belley.

ΒΑΣΙΛΕΑ ΑΡΙΟΒΑΡΖΑΝΗΝ ΦΙΛΟΠΑΤΟΡΑ ΤΟΝ ΕΚ ΒΑΣΙΛΕΩΣ
ΑΡΙΟΒΑΡΖΑΝΟΥ ΦΙΛΟΡΩΜΑΙΟΥ ΚΑΙ ΒΑΣΙΛΙΣΣΗΣ
ΑΘΗΝΑΙΔΟΣ ΦΙΛΟΣΤΟΡΓΟΥ ΟΙ ΚΑΤΑΣΤΑΘΕΝΤΕΣ
ΥΠ ΑΥΤΟΥ ΕΠΙ ΤΗΝ ΤΟΥ ΩΙΔΕΟΥ [*sic*] ΚΑΤΑΣΚΕΥΗΝ
ΓΑΙΟΣ ΚΑΙ ΜΑΡΚΟΣ ΣΤΑΛΛΙΟΙ ΓΑΙΟΥ ΥΙΟΙ ΚΑΙ
ΜΕΝΑΛΙΠΠΟΣ ΕΑΥΤΩΝ ΕΥΕΡΓΕΤΗΝ

That is, "Gaius and Marcus Stallius, sons of Gaius, and Menalippos" (have erected this monument) "to their benefactor King Ariobarzanes Philopator, son of King Ariobarzanes Philoromaios and Queen Athenais Philostorgos, having been entrusted by that monarch with the construction of the odeion."

At Athens, the Lantern of Demosthenes, shown in plate [34]:

ΛΥΣΙΚΡΑΤΗΣ ΛΥΣΙΘΕΙΔΟΥ ΚΙΚΥΝΝΕΥΣ ΕΧΟΡΗΓΕΙ
ΑΧΑΜΑΝΤΙΣ ΠΑΙΔΩΝ ΕΝΙΚΑ ΘΕΩΝ ΗΥΛΕΙ
ΛΙΣΙΑΔΗΣ ΑΘΗΝΑΙΟΣ ΕΔΙΔΑΣΚΕΝ ΕΥΑΙΝΕΤΟΣ ΗΡΧΕ[83]

"Lysikrates, son of Lysitheides of Kikyna, sponsored the games. The youth of the Akamantis tribe carried off the prize; Theon was in charge of the music, and Lysiades, an Athenian, of the recital; Euainetos presiding,[84] or then being archon."

Dissertation on the Length of the Greek Foot, with Some Inquiry into Ancient Estimates of Earth's Circumference; Read before the Académie [Royale] des Sciences, 31 August 1757

Knowledge of the measures used by the ancients seems so important for the light that it can cast on ancient history, on geography, and on astronomy that since the revival of the arts and sciences in Europe, most scholars have made it an object of inquiry.q To succeed in such an inquiry, however, it was first necessary to find either some extant points of reference or some of the ancient measures themselves; and in the sixteenth century this was done with respect to the Roman foot. Amid the ruins of Rome, three precisely equal foot measures were discovered, and Lucas Poetus proved beyond all doubt that these were ancient Roman feet. We have not hitherto had the same good fortune in respect to the Greek foot. For this, one point of reference, as mentioned above, is afforded by the base of the Great Pyramid, in Egypt. No doubt for this very reason, a number of scholars have traveled to Egypt to measure it; but the inconsistencies in the ancient accounts of its length have hitherto made it impossible to draw any certain conclusion as to the length of the Greek foot. As is known, Herodotus gives its length as 800 feet, Diodorus Siculus as 700, Strabo as less than 600, and Pliny [the Elder]—who has it by hearsay—as 883.r

These striking disparities in the ancient measurements of the length of the base have led many to despair of ever defining the Greek foot with any precision, for the Great Pyramid was believed to be the only extant monument of which the ancients had given us a precise measurement that we could compare with our own. However, one building that does offer such a measure is the celebrated Temple of Minerva, built at the behest of Pericles in the citadel of Athens, for this temple was so widely known to measure 100 feet that it was given the epithet *Hekatompedon.* But in which direction did the 100 feet run? The ancient authors neglect to tell us, and to date no modern traveler has found the answer. In this dissertation I hope to show that the dimension in question can only be the width of the temple and that, this once proved, there emerges a means of determining the length of the Greek foot that is more certain than any previously tried.

The great advantages of this new manner of determining the length of the Greek foot will appear once it is noted that the temple's facades still stand almost intact and that all possible care was lavished on the building of this temple in the very age when the sciences and the arts were at their greatest splendor in Athens, a city that surpassed in learning all others in Greece. If the foot of any ancient people is to be regarded as the true Greek foot, it must be that of the Athenians. I shall therefore not hesitate to refer to this as the Greek foot in the rest of this dissertation, which I shall divide into two articles.

In the first I will show that, as I have just said, the measurement of 100 feet assigned by the Greeks to the Temple of Minerva can apply only to its external width, which I have found, by an accurate survey of the site during my stay in Athens, to be 94 feet 10 inches of Paris measure.[85]

I shall show in the second that this length concurs with two mean measurements of the base of the Great Pyramid, one taken from all the ancients who measured it, the other from the most learned modern travelers. I shall also prove that the length that I propose for the Greek foot agrees not only with the general principle, established in several passages of the ancients, that it stood in the ratio of 25 to 24 to the Roman foot but also with a passage in Plutarch, who makes the Greek foot slightly larger than that proportion.

Article I

To understand the true meaning of the epithet *Hekatompedon* given to the Temple of Minerva, let us examine its various dimensions. A glance at the measurements marked on the plan and elevation, plate 7 of part 2 [(that is, plate 20)], suffices to show that they are all quite different: no more than one of them could ever have been precisely 100 feet. It is in this light that we should interpret the passage in Plutarch's life of Pericles[86] where he says that this temple was called *Hekatompedon* because it measured 100 feet. We should therefore regard as misinterpretations both the passage in the *Etymologicum magnum,*[87] which says that the temple was called *Hekatompedon* because it measured 100 feet on each of its sides, and the passage in Harpocration,[88] which says that the name was expressive of the temple's beauty rather than its size.

It was Spon [(*Voyage d'Italie*, vol. 2, p. 144)], that celebrated modern traveler, who first thought of using one dimension of the Temple of Minerva to determine the length of the Greek foot. He supposed 100 feet to represent the length of the interior of the temple, which he states to be 90 French feet. However, as it is well known that 90 of our feet are less than 100 Roman feet and that the Roman foot is shorter than the Greek foot, Spon very soon recognized that this dimension was too small. To make this dimension approximate 100 Greek feet, he added the thickness of the wall—which shows that he was forcing his explanation, for the temple would thus have had a dimension of 100 feet more palpable to the architect who built it than to the observers who viewed it. Though I find the internal dimension to be slightly longer than Monsieur Spon says, it remains too short to represent 100 Greek feet.

Since the name *Hekatompedon* cannot be applied to any of the internal dimensions of the temple, it must therefore refer to the exterior: the external dimensions were, after all, the most conspicuous, and when the ancients described a temple, they always mentioned these first. Pausanias, in his *Ilias* [(*Description of Greece* 5.10.3)], describing the Temple of Jupiter at Olympia, first tells us that it was 68 feet in height, 95 feet wide across the facade, and 230 feet in length. Pliny [the Elder (*Historia naturalis* 36.95)], similarly, tells us that the Temple of Diana at Ephesus was 440 feet long by 220 feet wide; he leaves us to infer the height of the temple from that of the columns.

Therefore, there is every reason to believe that the ancients had in mind an external dimension when they stated that the Temple of Minerva measured 100 feet; let us now consider which. It cannot have been either the length of the

temple, which is more than 200 French feet, or the height, which is only 65; from which it follows that it must have been the width. This is surely the dimension that the Greeks would have chosen as the most remarkable. It is known that the facade of such a building was its finest part; it was seen first on arrival, and the ancients depicted it on their medals; they described their temples as *octastyle, hexastyle,* or *tetrastyle,* from the number of columns that formed their frontispieces; they called them *pycnostyle, systyle,* or *diastyle,* according to the spacing between those columns. Why should they not have called the Temple of Minerva *Hekatompedon,* from the width of its facade?

The ancients regarded this dimension as so important that when they set out to build a temple, they established this dimension first and derived all the others from it.[89] If they intended to build an Ionic or a Corinthian temple, says Vitruvius, they began by determining the number of column diameters that were to be contained in the whole width of the front.[90] To build a Doric temple, they first settled the length of the frontal frieze in triglyph widths. This rule allowed them to define the relative proportions of every part of the temple, but it did not determine its size. To do that, it was still necessary, for example, in a Doric temple such as the one of which we are speaking, for the architects to settle the proportion between the width of one triglyph, or the total number of triglyph widths in the width of the facade, and one of their measures. This, in my opinion, is what Iktinos and Kallikrates, the architects of this temple, did when they equated the number of triglyph widths that constitute the total width of the frieze with 100 Greek feet, hence the epithet *Hekatompedon.*

To these arguments, which prove, from the manner in which the ancients set about building their temples, that it was the width of the Hekatompedon, and specifically of its frieze, that gave it its name, I shall add that the frieze and the architrave are the most conspicuous parts of the entablature, far exceeding all the others in height; that they are the parts to which the eye is naturally drawn; and, finally, that those parts are what the ancients enriched with bas-reliefs and engraved with inscriptions. For the rest, if we were to suppose that it was to the first step of the facade, which is 112 feet wide, that the Greeks assigned the width of 100 Greek feet, the resulting value for the Greek foot would be longer than that of Paris by one-ninth, which is enough to rule out this supposition. As for the width of the facade, this can be taken only at the foot of the columns, since the columns taper toward the top; what is more, this length, which is 95 feet 1 inch 10 lines, differs from that of the frieze only by 1 part in 227, which would produce no great difference between the length of the Greek foot derived from either measurement.

Having shown that the width of the Temple of Minerva, as determined by the length of the frieze on the facade, is the only dimension that could have given rise to the epithet *Hekatompedon* and that it consequently measured 100 Greek feet, we find — dividing by 100 the 94 feet 10 inches of Paris, which is the extent of that frieze as determined by our survey — the length of the

Greek foot to be 11 inches 4 lines $5\frac{3}{5}$ points of our foot; and our conclusion is confirmed by the fact that the length of this foot is the same, or very nearly so, as that found by two other means, which, albeit less certain, nevertheless creates the strongest presumption in favor of our measurement, as will be seen in the articles that follow.

Article II

To achieve the object that I have set myself in this article, let us begin by determining the true length of the base of the Great Pyramid in Egypt, according to the lengths given to us by the two most learned moderns who have measured it.

Father Fulgence of Tours, Capuchin and mathematician, assigns the greatest length to the base, making it 682 feet long.[5] This measurement was confirmed by a survey undertaken for Monsieur [Charles-François Olier, marquis] de Nointel, French ambassador to the Sublime Porte, and sent to the Académie [royale] des sciences; it was adopted by Monsieur [Jacques] Cassini in his *Traité de la grandeur et de la figure de la terre.*

Mr. [John] Greaves, in his *Pyramidographia* (1646, p. 68), gives the length of the base of the Great Pyramid as 693 English feet, approximately 650 of our feet. Mr. Greaves traveled to Egypt specifically to measure the base with all the accuracy at his command; and what ought to give great weight to his measurement is that Mr. Norden, a Dane, in his *Voyage d'Égypte*, which appeared some time ago, and which contains many critical remarks on Mr. Greaves's *Pyramidographia*, says that he has not touched on his measurements, because he found them to be correct.

I shall not choose between these two measurements. The former was preferred by the illustrious Monsieur Cassini, but we owe the second to a most able surveyor who seems to have taken such pains to avoid error that it is hard to withhold one's confidence. However, supposing both measurements to be equally uncertain, I shall take a mean between them, which yields a base measurement of 666 Paris feet; and this cannot, to all appearances, differ markedly from the true length.

If this is compared with Herodotus's 800 feet, Pliny's 883, and Strabo's 600, it follows that Herodotus and Pliny made the Greek foot shorter than the Roman foot, and that Strabo made it longer than the Paris foot—all of which is incompatible (as has been said) with what we know, in general, about the length of the Greek foot. This shows either that these authors were very much mistaken as to the length of the base in Greek feet or—as is far more likely—that they were using different measures. There is even some cause for believing that Strabo, who makes the base no more than 1 stade long, is speaking in terms of the Egyptian stade, which—as I shall show—was $684\frac{4}{5}$ Paris feet in length, very close to the mean value that we have calculated, which is 666 feet. This measurement of Strabo's,[91] like the other two mentioned, cannot, therefore, have been taken in Greek feet. Let us now examine the measurement given by Diodorus Siculus.

This author gives a length of 700 feet for the base of the Great Pyramid; by comparing this number with our mean value, we find that Diodorus was employing a Greek foot of 11 inches 5 lines. From which it is plain, first, that this length matches the idea that we have of the Greek foot in general, as being between the Roman foot and the Paris foot in length; second, that the resulting foot relates to the Roman foot in the ratio of 25 to 24, and even a little more than this, as we shall soon have occasion to show. Finally, if we suppose the length of the base given by Herodotus and by Strabo to share the same unit of measurement, that of Diodorus Siculus once more represents the mean between them. Moreover, this historian is known for the accuracy of his descriptions of the Egyptian monuments; we therefore have every reason to believe that he, of all the ancients, is most likely to give us the length of the base accurately in Greek feet. His foot bears the same relation to the Paris foot, with an error of 1 part in 300, as the foot that I deduced from a direct comparison between 94 feet 10 inches, the length of the frieze of the Temple of Minerva in Paris feet, and the length of 100 feet ascribed to it by the Greeks. This confirms my opinion concerning the ratio between the Greek foot and the Paris foot.

An approximate value for the length of the Greek foot is also given in two passages of the ancients, which I shall cite—and which, if other proofs had previously been advanced, would perhaps already have united all scholars in their judgment of the length of the Greek foot.

Suidas[92] states that the mile is a terrestrial measure, that 10 miles equal 80 stades, and that there are 600 feet in 1 stade and 4,800 in 1 mile. This passage in *Suidas* is of very great importance, since it shows us not only that the mile contained 8 stades but also that these were Greek stades; for the Greek stade, according to Herodotus [(*History* 2.149)], was 600 feet long, and the Roman stade is known to have measured 625 Roman feet.

In the third book of his *History*,[93] Polybius tells us that the Romans set marker stones on their roads every 8 stades, or every mile. It thus follows from the accounts in *Suidas* and Polybius that the Roman stade is (as several of the ancients stated) equal to the Greek stade, since each is contained eight times in a mile: 600 Greek feet are thus equal to 625 Roman feet, and the Greek foot is greater than the Roman foot by 1 part in 24 of the latter. The Roman foot being 1,306 points of the Paris foot,[94] it follows from these two sources that we have only to add 1 part in 24 to obtain the Greek foot, which is within a minute fraction of 1,360⅗ points. Now, the value that I deduced from the frieze of the Temple of Minerva is 1,365⅗ points of our foot; it therefore exceeds the other by only about 1 part in 273: the very factor by which 8 Greek stades deduced from my foot exceed 1 Roman mile or 8 Roman stades. This discrepancy is so small that it might easily have been overlooked or omitted by *Suidas* and by other authors, but it did not escape the notice of Plutarch,[95] who says in his life of Gaius [Sempronius] Gracchus that Gracchus caused the roads of Italy to be divided into miles, *each mile containing a little less than eight stades*. In this passage, he can only be referring to Greek stades,

not Roman stades; since, according to Polybius, the Romans counted exactly 8 stades to 1 mile. It follows that the passages of the ancients cited in this article confirm the opinion, previously held, that the Greek foot was longer than the Roman foot by 1 part in 24; the passage in Plutarch even proves that it exceeded it by a little more, as I have discovered.

It may be objected that if we were to calculate the Roman mile, as Monsieur Cassini has done in his book on the shape of Earth, by using the distances between Nîmes and Narbonne and between Bologna and Modena, which were given in miles by the ancients and measured, respectively, by himself and by Fathers [Giovanni Battista] Riccioli and [Francesco Maria] Grimaldi, we would obtain a Roman mile of 767 toises, and that the resulting Roman foot would be longer than that of Lucas Poetus by 1 part in 273, and, consequently, that the Greek foot would not, as I have asserted, exceed the Roman foot by more than 1 part in 24. This objection may seem a weighty one at first, but it is not incontrovertible. My answer is that no exact measurement of the mile can be obtained by this means, since the distances between towns were measured in miles, which was a fixed measure, and few of them will have contained a round number of miles. The itineraries themselves record this. At the head of each chapter, where these measurements are given, stand the letters *P. M.*, standing for *plus minus* and signifying *more or less,* which proves that the ancients made no claim to give the distances between cities with complete precision. Furthermore, it is far from certain that the moderns have measured the distances between these cities from the same points as the ancients.

Even if all these arguments did not contradict the definition of the ancient mile that Monsieur Cassini claims to have given us by this means, convincing proofs have been found that this mile was 10 toises shorter than Monsieur Cassini makes it. The marchese [Scipione] Maffei has found two miliary columns in Languedoc in situ and 756 toises apart. Monsieur [Louis] Astruc, the celebrated physician, measured two others, between Nîmes and Beaucaire, and found them to be 754 toises apart. Taking the mean between these two measurements, as Monsieur [Jean-Baptiste Bourguignon] d'Anville does,[96] we have a length of 755 toises for the Roman mile—the same as is found by assuming Lucas Poetus's Roman foot of 1,306 parts, which is the most generally accepted estimate.

I shall conclude this article with an argument in favor of my opinion that—though of less weight than the foregoing—nonetheless seems to me worthy of inclusion: this is that the stadium in Athens where the athletes ran their races, the ruins of which are still to be seen, measures 591 Paris feet from the place where I estimate that the gate stood to the lowest tier. The stade calculated from the frieze of the Temple of Minerva is just 22 feet shorter than this, a difference that probably corresponds to the distance between the far end of the arena and the turning post; on the course, the Greek stade of 600 feet was counted from the gate where the athletes started to the post where they turned when they ran a double stade.

On the Ancients' Computations of the Circumference of Earth

These reflections on the Greek foot and stade have led me to examine the values assigned by the ancients to the circumference of Earth. Monsieur Cassini singles out as the most accurate of their computations that of 180,000 stades: this sprang from the observation made by Posidonius, who found that there were seven and a half degrees between the cities of Alexandria and Rhodes; and from that of Eratosthenes, who, according to Strabo [(*Geography* 2.5.24)], measured with instruments the distance between those two cities and found it to be 3,750 stades. Several of the ancients adopted this circumference of 180,000 stades. It was accepted by Marinus of Tyre; and after Ptolemy had adopted it, it was attributed to him. But what was the length of those stades in relation to our measures? This has yet to be decided, and I propose to determine it.

To suppose that Eratosthenes employed the Greek stade is to suppose him grossly wrong in his survey; for if we multiply 180,000 by 94 toises 5 feet, which is the length of that stade, we have 17,036,666 toises for the circumference of Earth, which is too little by one-sixth, since, according to the moderns, whose observations are infinitely more accurate than those of the ancients, the circumference is 20,541,600 toises. Now, inaccurate as Eratosthenes may have been, it is not likely that he would have been so far wrong. Let us see, therefore, whether the difference between these two measurements might spring from Eratosthenes' use of not the Greek stade but the Egyptian or Phileterian stade — the stade, probably, of which Hesychius, a native of Alexandria, counts only 7 stades to a mile. Such are presumably the stades of which Herodotus speaks in his *Melpomene* [(*History* 2.149)], when he says that the Egyptian stades, like those of Asia, were 600 feet long — implying, in my view, that these stades were composed of feet different from those of the Greeks, since in his *Euterpe* [(*History* 2.168)], Herodotus says that the arure of the Samians was 100 cubits long, but adds that these were 100 Egyptian or Samian cubits, thus showing that these two cubits differed from Greek cubits, and therefore that the Egyptian and Samian foot differed from the Greek foot — for among the ancients, the foot was always two-thirds of a cubit.

Heron [of Alexandria] says in his book on rectilinear measurements [(*Geometrica* 23.7)] that the Phileterian foot was 4 palms or 16 digits long and that the Italian foot was only 13⅓ digits long. It seems beyond doubt, as Father [Bernard de] Montfaucon says, that Heron's Italian foot was the same as the ancient Roman foot discovered by Lucas Poetus. The Phileterian foot thus stood in a ratio of 6 to 5 to the Roman foot. The Roman foot has been found to be 1,306 points of the Paris foot; and so, if we add to the Roman foot one-fifth of its length, we have a Phileterian foot of 1,567 points of the Paris foot (and some fractions that I disregard) and a Phileterian stade of 652 Paris feet 11 inches — far longer, therefore, than the Greek stade, based on the Athenian foot.

The most authentic Egyptian measure that we now possess is their cubit. There were in Egypt a large number of Nilometers graduated in cubits;

of these, one alone has escaped destruction and is still to be seen in Cairo. Almost all scholars are agreed that the larger divisions of this Nilometer, which was rebuilt in the reign of Heraclius, are Egyptian cubits, copied precisely from the other Nilometers still extant in that emperor's time. Even the names that the Arabs give to the divisions of the Nilometer show that the largest of them were cubits and the smallest digits: they call the former *draas*, which means *elbow's length* or *cubit* in Arabic; and the latter *asbaa*, which means *finger* or *digit*. What is more, there are 24 of their asbaa in 1 draas, just as there were 24 digits in 1 cubit. Among the ancients, as is well known, the foot was made up of 16 digits, or two-thirds of a cubit; 16 digits of the Nilometer in Cairo are therefore equal to 1 Egyptian foot. But 1 cubit or draas of the Cairo Nilometer, most accurately measured by the English travelers and recorded by Jean Clérice, is 21.888 inches of the English foot, which corresponds to 20.544 inches, or 2,464.280 points, of the Paris foot.[97] Therefore 16 digits of the Egyptian cubit, that is, 1 Egyptian foot, will be 1,643.520 points of the Paris foot; and 1 Egyptian stade will be 684⅖ Paris feet. Here, then, is another ancient stade far longer than the Greek stade.

If we now remark that Eratosthenes took as his fixed points of measurement Alexandria, which is in Egypt, and Rhodes, which is in Asia and quite close to Samos, where Herodotus [(*History* 2.168)] tells us that the Egyptian measures were in use, it seems highly likely that Eratosthenes, in measuring the distance from Alexandria to Rhodes, used the Egyptian stade. What gives greater weight to this supposition is that by multiplying the 180,000 stades that Eratosthenes settled on as the circumference of Earth by 684⅖ feet, or rather by 114 toises ⅘ feet, we obtain a circumference of 20,534,740 toises, which differs only by 1 part in 2,994 from 20,541,600 toises, the circumference given by Monsieur Cassini; and an error in observation might easily have produced this small discrepancy. It thus appears that Eratosthenes employed the Egyptian stade, as I have suggested, and that this was the stade that the ancients had in mind when they set the circumference of Earth at 180,000 stades.

Le Roy's Notes

1. This vessel was already shipping water heavily in 1754, and it caused us some anxious moments in the Archipelago as we sailed to Constantinople; on its return voyage to Venice, it was nearly lost on the coast of Calabria [(Salentine Peninsula)]. The marchese Spolverini, who was aboard, later told me that for many days the entire ship's company, including the gentlemen of the bailo's suite, manned the pumps day and night. We were grieved to learn, from the *Gazette de France*, that the summer before last, 1768, it went down with all hands, some eight hundred men, [in the Adriatic Sea] off Senigallia.

2. These monuments were published by [Sebastiano] Serlio in his work entitled *De le antiquita, libro terzo*.

3. See the excellent work on the ruins of this city published in London by Mr. Robert Wood [and James Dawkins], in the year 1753, pls. 3, 16.

4. This name was given to them because their peaks were so high that they were frequently struck by lightning, ἄκρον [(akron)] signifying the peak of a mountain, and χεραὺνος [(keraunos)] a thunderbolt. Horace speaks of these mountains in his ode addressed to the vessel that carried Virgil to Athens:

Qui siccis oculis monstra natantia,
Qui vidit mare turgidum, et
Infames scopulos Acroceraunia?
[Who sees dry-eyed the monsters swimming, the swollen sea, the dread
Acroceraunian rocks? (Horace, *Carmina* 1.3.18–20).]

5. See the description of that island in the *Voyage* [...] *de Grece* of Spon [(vol. 1, p. 121)] and [in *A Journey into Greece*] of Wheler [(pp. 29–34)]. But here are some details about the fortifications of the capital, also called Corfu, of which they could not speak. This city stands on a promontory that extends into the sea. When those travelers saw it, in the last century, it was protected on the landward side only by a bastion called the Fortezza Nuova; and this fortress, like the city itself, was commanded by the heights of Mount Abraham and Mount San Salvador — a defect that the Turks, when they besieged Corfu in 1716, turned to account, bombarding the city and the Fortezza Nuova from batteries set up on both mountains. They even set scaling ladders against the fortress, but these proved too short. The Venetians received reinforcements and made a timely sortie under the command of Marshal [Johann Matthias von der] Schulenburg, destroying all the Turk's works and compelling them to raise the siege. The [Venetian] republic, in gratitude for the marshal's signal services on that occasion, set up his statue in the citadel of the city. It also ordered that the two mountains that commanded the city be reduced in height and fortified; this was done, and at present Corfu is one of the strongest places in Europe.

6. These are the words that Virgil has Aeneas speak when he relates his adventures to Dido:

Servatum ex undis Strophadum me littora primum
Accipiunt. Strophades Graio stant nomine dictae
Insulae Ionio in magno, quas dira Celaeno,
Harpiaeque colunt aliae.
　　　　　— V., *Aen.*, bk. 3, 209
[Saved from the deep, I first found refuge on the shores of the Strophades. These are islands in the great Ionian sea, home to dread Celaeno and the other Harpies (Virgil, *Aeneid* 3.207–10).]

7. Paus., bk. 4, p. 284 (ed. Syl[burg], Han[over], 1613). [Pausanius, *Description of Greece* 4.35.8.]

8. Λογίζομαι δ' ἔγωγε καὶ πολέμου γιγνομένου οἶόν τ' εἶναι μὴ ἐκλείπεσθαι τὰ ἀργυρεῖα· ἔστι μὲν γὰρ δήπου περὶ τὰ μέταλλα ἐν τῇ πρὸς μεσημβρίαν θαλάττῃ τεῖχος ἐν Ἀναφαύστω, ἔστι δ' ἐν τῇ πρὸς ἄρκτον τεῖχος ἐν Θορικῷ· ἀπέχει δὲ ταῦτα ἀπ' ἀλλήλων ἀμφὶ τὰ ἑξήκοντα στάδια. Xenophon, *De vectigalibus*, p. 733.20 (Bas[el], 1572).

"I think," says Xenophon in this passage, "that the silver mines ought not to be abandoned in time of war, because those close to the sea, in the south, are defended by

the fortress of Anaphlystos and those toward the north by the fortress of Thoricus; and these two fortresses are no more than 60 stades apart." [Xenophon, *Ways and Means* 4.43.]

9. Ἡ δὲ νῆσος ἡ Κραναὴ πρόκειται Γοθείου· καὶ Ὅμηρος Ἀλέξανδρον ἁρπάσαντα Ἑλένην, ἐν ταῦτα ἔφη συγγένεσται οἱ πρῶτον. Pausanias, *Lac[onia]*, p. 204.40 (ed. Sylb[urg]).

["The island of Cranae lies off Gythion; Homer says that after Paris carried Helen away, it was on this island he first slept with her." Pausanius, *Description of Greece* 3.22.1.]

10. See the fine description of this channel, and of the most remarkable sights to be seen there, in Tournefort, *Voyage du Levant* [(vol. 2, pp. 160–69)].

11. The Turks assert that several of the guns of the castles of the Dardanelles were cast by order of Mohammed II at the siege of Babylon. They are enormous; the bore at the mouth, which we measured, is more than 2 feet in diameter. This is what we observed: all these guns have chambers; they are made in two pieces of equal size, one toward the mouth, one toward the breech; at the join, the gun is circled by two cogwheels, each cast in one piece with half of the gun and exceeding its diameter by the depth of the cogs. This led me to suppose that half of the gun might be fashioned with a male screw, the other with a female screw, and that, by engaging these cogwheels in the teeth of a rack or wheel, and turning the pieces in opposite directions, the male screw was driven into the female screw until the pieces were firmly united.

12. In the first edition of this work I mistakenly said that the ambassador was seated.

13. The time when Erysichthon was alive, at least 1500 B.C., is so remote that we cannot be sure that the remains of the Temple of Apollo on Delos are those of the temple built by Erysichthon: I have accordingly refrained from making any positive assertion on the subject.

Some authors say that this Erysichthon was the son of Cecrops, king of Athens; others, that his father was Triopas, king of Thessaly. What seems certain is that he built the first Temple of Apollo on the island of Delos. After showing, on the authority of Athenaeus, book 9, that Erysichthon settled on Delos [(Athenaeus, *The Deipnosophists* 9.392d)], the abbé Sallier goes on to say: "Eusebius and Saint Jerome have added *that he built a temple to Apollo there*, ἱερὸν Ἀπόλλωνος ἱδρύνθη." *Mém. de lit.*, vol. 3, p. 388.

Pausanias confirms that Erysichthon took to Delos the worship and religion of his own country: Ἔστι δὲ μνῆμα ἐπὶ Πρασιαῖς Ἐρυσίχθονος, ὃς ἐκομίζετο ὀπίσω μετὰ τὴν θεωρίαν ἐκ Δήλου, γενομένης οἱ κατὰ τὸν πλοῦν τῆς τελευτῆς. Paus., *Att[ica]*, p. 59.20 (ed. Sylb[urg], Han[over], 1613). This means: "At Prasiae is the tomb of Erysichthon, who died at sea as he returned from Delos, to which he had transported the religion of his own country." [Pausanius, *Description of Greece* 1.31.2.]

14. This inscription is recorded by Aristotle, *Ethics*, bk. 1, chap. 9. It is cited in [Antoine Anselme, "Réflexions sur l'opinion des sages du paganisme, touchant la félicité de l'homme,"] *Mém. de lit.*, vol. 5, pp. 4–5, where it is translated as shown above.

15. Ἐν δὲ Πρασιεῦσιν Ἀπολλωνός ἐστι ναός· ἐνταῦθα τὰς Ὑπερβορέων ἀπαρχὰς ἱέναι λέγεται ... Ἀθηναίους δὲ εἶναι τοὺς ἐς Δῆλον ἄγοντας. Pausanias, *Att[ica]*,

p. 59.10 (ed. Sylb[urg]). This passage means: "The Prasians have a temple to Apollo, to which the first-fruits of the Hyperboreans are brought... and these the Athenians convey onward to Delos." [Pausanius, *Description of Greece* 1.31.2.]

16. Pausanias, *Arcad[ia]*. [Pausanius, *Description of Greece* 8.3.2.]

17. For the dimensions of this fragment, see plate XVI of the second part. [Le Roy shows the inscription he mentions, ΝΑΞΙΟΙ ΑΠΟΛΛΟΝΙ, meaning "People of Naxos to Apollo," on that plate.]

18. This fact is recorded by Mr. Wheler in his account of the island of Delos, in his *Journey into Greece* [(p. 56)].

19. The Athenians expressed the antiquity of their origins in a single word. They called themselves Αὐτόχθονες [(*autochthons*)]; but they were by no means agreed on the meaning that they attached to the word. The common people meant by it that the Athenians *had sprung from the bosom of the earth like the plants.* The philosophers meant simply that Attica was never peopled by colonists, its inhabitants having been born there since time immemorial. See Isokrates, *In Panaeg.* [*Panegyricus* 24–25]; Herod[otus, *History,*] bk. 7, [chap]. 161 (Q., 437.10) = [Louis Jouard de la Nauze, "Mémoire sur la différence des pélasges et des hellenes,"] *Acad. des inscript.,* vol. 23, M[*émoires*], p. 120. [For a modern account of the history of the Greeks, see Moses I. Finley, *The Ancient Greeks* (Harmondsworth, England: Penguin, 1963); and Ida Carleton Thallon Hill, *The Ancient City of Athens: Its Topography and Monuments* (Cambridge: Harvard Univ. Press, 1953; Chicago: Argonaut, 1969).]

20. Menander Rhetor, in *Rhetor. Graec. veter.* [See *Menander Rhetor,* ed. and trans. D. A. Russell and N. G. Wilson (Oxford: Clarendon, 1981), 49 (354.25–26).]

21. See what Pausanias says, in speaking of a temple to celestial Venus that the people of Athmonia built under the reign, or so they said, of Porphyrion, a king who ruled in Attica long before Actaeus: Δῆμος δὲ ἐστιν Ἀθηναίοις Ἀθμονέων, οἳ Πορφυρίωνα ἔτι πρότερον Ἀκταίου Βασιλεύσαντα τῆς Οὐρανίας φασὶ τὸ παρὰ σφίσιν ἱερὸν ἱδρύσασθαι· λέγουσι δὲ ἀνὰ τοῦς δήμους καὶ ἄλλα οὐδὲν ὁμοίως καὶ οἱ τὴν πόλιν ἔχοντες. Paus., *Attica*, chap. 14, p. 27.10.

"The Athmoneans," says Pausanias, "who live in a small town in Attica that bears their name, say that Porphyrion, who reigned before Actaeus, built a temple to Venus Urania in their town; and in other small towns they tell stories very different from those told by the inhabitants of Athens." [Pausanius, *Description of Greece* 1.14.7.]

22. *Tritogenia.* This name was given to her to express the extraordinary manner of her birth. Τριτόγενής *sic dictam volunt Minervam,* a capite, *quòd feratur nata ex capite Jovis. Atque* Τριτώ *Aeolice est caput.* Hesychius, Lug., s.v. Τριτόγενής. ["*Tritogenes.* They say Minerva is called thus, *from the head,* because she is said to have been born from Jupiter's head. And *tritos*, in Aeolian Greek, is *head.*"]

23. *Glaucopion.* This name was given to it from γλαυκῶπις, an epithet given to the goddess Minerva, to indicate that her eyes were the color of the sky. The origins of the other names of the fortress are too well known to need explanation.

24. Plutarch, *Vie de Périclès.* [Plutarch, *Lives, Pericles* 13.4.]

25. Ἐς δὲ τὸν ναὸν ὅν Παρθ[ε]νῶνα ὀνομάζουσιν. Paus., bk. 1, p. 43 (ed. Sylb[urg]). ["Those who go to the temple that the Athenians call the Parthenon" (Pausanius, *Description of Greece* 1.14.4–5).]

26. Plutarch, *Vie de Caton*. ["While the Athenians were building the *Hekatom-pedon*" (Plutarch, *Lives, Cato the Elder* 5.3).]

27. Spon, p. 153 (Lyon, 1678).

28. Pluta., *Per.*, p. 160 C (Par[is], 1624). [Plutarch, *Lives, Pericles* 13.9.]

29. Thucydides, bk. 2. [Thucydides, *History of the Peloponnesian War* 2.13.5.]

30. Pausanias, p. 59 (ed. Kühn, Leipzig, 1696). [Pausanius, *Description of Greece* 1.24.7.]

31. Πρὸς δὲ τῷ τείχει τῷ Νοτίῳ, Γιγάντων οἳ περὶ Θράκην ποτὲ, καὶ τὸν Ἰσθμὸν τῆς παλλήνης ᾤκησαν, τούτων τὸν λεγόμενον πόλεμον, καὶ μάχην πρὸς Ἀμαζόνας Ἀθηναίων, καὶ τὸ Μαραθῶνι πρὸς Μήδους ἔργον, καὶ Γαλατῶν τὴν ἐν Μυσίᾳ φθορὰν, ἀνέθηκεν Ἄτταλος, ὅσον γε δύο πηχῶν ἕκαστον. Paus., p. 59 (ed. Kühn). [Pausanius, *Description of Greece* 1.25.2.]

In this passage I have translated Πρὸς δὲ τῷ τείχει τῷ Νοτίῳ as Wheler [(*A Journey into Greece*, p. 361)] does, by "on the south wall of the temple," rather than, as the abbé Gedoyn has since done, by "on the south wall of the citadel," because Attalus would surely never have placed such precious bas-reliefs on the walls of the fortress, which are very low and seem never to have been decorated. And since the height of the frieze on the wall of the Temple of Minerva is the same as that given by Pausanias for these bas-reliefs, there is every reason to believe that this is the frieze of which he speaks.

In addition, I have rendered ἀνέθηκεν by "Attalus restored to their places" or "repaired these bas-reliefs," because the word ἀνατίθημι, from which ἀνέθηκεν is derived, can equally well mean *repono*, I replace, and *dedico*, I dedicate or consecrate; and since Plutarch [(*Lives, Pericles* 13.4.5)] says that Pericles completed the Temple of Minerva and that bas-reliefs of the same kind already existed in the vestibules of the Temple of Theseus, I take the view that the Temple of Minerva, being built with greater magnificence, had bas-reliefs all around it. Either Pericles did not finish the temple and Attalus consecrated these bas-reliefs, or Attalus simply had them repaired or restored to their places; be that as it may, there is every reason to believe that those on the other walls, facing north, east, and west, were set there by Pericles.

32. Ἐς δὲ τὸν ναὸν ὃν Παρθενῶνα ὀνομάζουσιν, ἐς τοῦτον ἐσιοῦσιν, ὁπόσα ἐν τοῖς καλουμένοις ἀετοῖς κεῖται, πάντα ἐς τὴν Ἀθηνᾶς ἔχει γένεσιν. Τὰ δὲ ὄπισθεν ἡ ποσειδῶνος πρὸς Ἀθηνᾶν ἐστιν ἔρις ὑπὲρ τῆς γῆς. Pausanias, p. 57 (ed. Kühn). [Pausanius, *Description of Greece* 1.24.5.] This passage may be literally translated as follows: "Those who go to the temple that the Athenians call *Parthenon* recognize that all that is represented in the eagles, or pediments, refers to the birth of Minerva; behind is the dispute between Neptune and this goddess over Attica." The natural sense of this, as may be seen from Pausanias's words and from our literal translation, is that the sculptures on the front and rear pediments were all concerned with the birth of Minerva; and when the ancient traveler says, "behind is the dispute between Neptune and Minerva over Attica," he seems to mean, "behind the pediments is the contest between Neptune and Minerva," rather than, "on the rear pediment, the artist has represented the quarrel that arose between Neptune and Minerva on the subject of Attica" — which is the rendering given by the abbé Gedoyn. His version seems to be corroborated by Messrs. Spon and Wheler, who saw the head of a seahorse on

the rear pediment; and, largely for this reason, I initially adopted it. But, on closer examination of the passage, I find the translation given by Messrs. Spon and Wheler and by the abbé Gedoyn to be so much at variance with the Greek text that I dare not endorse it.

33. Cicero praises the canephori of Polykleitos in his sixth oration against Verro [(*In Verrem* 4.3.5)]. This is what Pliny has to say of those by Skopas: *Scopae laus cum his certat: is fecit Venerem et Pothon et Phaethontem, qui Samothraciae sanctissimis caeremoniis coluntur: item Apollinem Palatium, Vestam sedentem laudatam in Servilianis hortis, duas chametaetas circa eam, quarum pars in Asinii monumentis sunt, ubi et Canephorus eiusdem.* Plin., bk. 36.

["Skopas's reputation is as high as theirs. A Venus, a Pothos, and a Phaethon he made are honored at Samothrace with the greatest ceremony. He made as well an Apollo Palatinus; a seated Vesta, much praised, for the Servilian gardens [in Rome], and two vestal virgins (*chametaetas*) in attendance on her, similar to those in the monument of Asinius [Bibliotheca Asinii Pollionis], where there is also a canephoros by the same artist" (Pliny the Elder, *Historia naturalis* 36.4.25–26).]

34. Τῷ ναῷ δὲ τῆς Ἀθηνᾶς Πανδρόσου ναὸς συνεχής ἐστι. "Adjacent to this Temple of Minerva is the Temple of Pandrosus." Paus., p. 64 (ed. Kühn, Leipzig, 1696). [Pausanius, *Description of Greece* 1.27.2.]

35. Καὶ διπλοῦν γὰρ ἐστι τὸ οἴκημα, καὶ ὕδωρ ἐστὶν ἔνδον θαλάσσιον ἐν φρέατι. "This building is double, and it has inside a well of saltwater." Paus., p. 62 (ed. Kühn). [Pausanius, *Description of Greece* 1.26.5.]

36. Ἀλλὰ τὸ δὲ φρέαρ ἐς συγγραφὴν παρέχεται κυμάτων ἦχον ἐπὶ νότῳ πνεύσαντι. Paus., ibid (ed. Kühn). "What is peculiar about this well is that when the south wind blows, the waters make a sound like that of the waves of the sea." [Pausanius, *Description of Greece* 1.26.5.]

37. What particularly moved me to adopt Messrs. Spon and Wheler's conjecture on the temple whose ruins are shown in plate 5 was the well mentioned in the preceding notes: for they were told that it still existed. They never saw it, however, and I was no more fortunate than they. It may be that I failed to discover it because of the marble slabs on the temple floor; but it is also entirely possible that no well ever existed in this temple, and I confess that any argument based solely on the story told by the Athenians to Messrs. Spon and Wheler is highly suspect.

38. Τῷ δ' ἐπιόντι ἔτει, ᾧ ἥ τε σελήνη ἐξέλιπεν ἑσπέρας, καὶ ὁ παλαιὸς τῆς Ἀθηνᾶς νεὼς ἐν ἀθήναις ἐνεπρήσθη. Xenoph., p. 345 (Basel, 1572). In this passage Xenophon says, "One day in the following year" (which was the twenty-fifth of the Peloponnesian War), "there was an evening eclipse of the Moon, and the old Temple of Minerva in Athens was burned." [Xenophon, *Hellenica* 4.5.5.]

39. Plut., *Vie de Pér.,* p. 160.13 (ed. Cruse[rius] and Xylander, Par[is], 1624). [Plutarch, *Lives, Pericles* 13.8.]

40. Τὰ δὲ προπύλαια τῆς ἀκροπόλεως ἐξειργάσ[θ]η μὲν ἐν πενταετίᾳ, Μνησικλέους ἀρχιτεκτονοῦντος. Plut., ibid. "The Propylaia of the Acropolis," says Plutarch, "were completed in five years; Mnesikles was the architect." [Plutarch, *Lives, Pericles* 13.7.]

41. Τὰ δὲ προπύλαια λίθου λευκοῦ τὴν ὀροφὴν ἔχει, καὶ κόσμῳ καὶ μεγέθει τῶν λίθων μέχρι γε καὶ ἐμοῦ προεῖχε. Pausanias, p. 51 (ed. Kühn). "The ceiling of the Propylaia,"

says Pausanias, "is of a white marble more beautiful than any seen to this day, both in workmanship and in the size of the stones." [Pausanius, *Description of Greece* 1.22.4.]

42. We shall quote the entire passage of Harpocration that contains this detail as well as the others that we have used in our description. Περὶ δὲ τῶν προπυλαίων τῆς ἀκροπόλεως ὡς ἐπὶ Εὐθυμένους ἄρ[χ]οντος οἰκοδομεῖν ἤρξαντο Ἀθηναῖοι, Μνησικλέους ἀρχιτεκτονοῦντος, ἄλλοί τε ἱστορήκασι, καὶ Φιλόχορος ἐν τῇ τετάρτῃ. Ἡλίοδωρος δ' ἐν πρώτῳ περὶ τῆς Ἀθήνησιν ἀκροπόλεως, μεθ' ἕτερα καὶ ταῦτά φησιν. Ἐν [ἔτεσι] μὲν πέντε παντελῶς ἐξεπιήθη, τάλαντα δὲ ἀνηλώθη δισχίλια δώδε[κα· πέντε δὲ πύλας ἐποίησαν, δι' ὧν εἰς τὴν ἀκρόπολιν εἰσίασιν. Harpocration, s.v. προπύλαια (trans. Blanc[ard], p. 302).

"The outer gates of the Acropolis," says Harpocration, "were begun by the Athenians under archon Euthymenes, the architect being Mnesikles, as a number of authors tell us. Philochorus tells us so in his fourth book; and Heliodorus, in his first, in which he treats of the citadel of Athens, adds to the other historians' accounts the following: the Propylaia were five years in the building; they cost 2,012 talents; and in them were five gateways, the entrances to the Acropolis."

43. Τὰς μὲν οὖν εἰκόνας τῶν ἱππέων οὐκ ἔχω σαφῶς εἰπεῖν, εἴτε οἱ παῖδές εἰσιν οἱ Ξενοφῶντος, εἴτε ἄλλως ἐς εὐπρέπειαν πεποιημέναι. Paus., p. 52 (ed. Kühn). "As for the equestrian statues," says Pausanias, "I cannot tell whether they are the sons of Xenophon or whether they were set there solely for decoration." [Pausanius, *Description of Greece* 1.22.4.]

44. Spon [(*Voyage d'Italie*, vol. 2, p. 164)]; also [Antoine Augustin Bruzen de] La Martinière, in his *Dictionnaire*.

45. Paus., p. 48 (ed. Kühn). [Pausanius, *Description of Greece* 1.21.1–2.]

46. Ἐπιδαύριος δέ ἐστι θέατρον, ἐν τῷ ἱερῷ, μάλιστα ἐμοὶ δοκεῖν θέας ἄξιον. τὰ μὲν γὰρ Ῥωμαίων, πολὺ δή τι καὶ ὑπερ[ῆρκε] τῶν πανταχοῦ τῷ κόσμῳ· μεγέθει δὲ Ἀρκάδων, τὸ ἐν Μεγάλῃ πόλει· ἁρμονίας δὲ ἢ κάλλους ἕνεκα, ἀρχιτέκτων ποῖος ἐς ἅμιλλαν Πολυκλείτῳ γένοιτ' ἂν ἀξιόχρεως Πολύκλειτος γὰρ καὶ θέατρον τοῦτο, καὶ οἴκημα τὸ περιφερὲς ὁ ποιήσας ἦν. Paus., *Corinth*, p. 174 (ed. Kühn).

"In the sacred enclosure of the Temple of Asklepios," says Pausanias, "the Epidaurians have a theater, which in my view richly deserves to be admired. For the theaters of the Romans excel all others in the magnificence and opulence of their ornament; they also surpass them in sheer size, with the single exception of that of Megalopolis; but for elegance and fine proportions what architect could ever compete with Polykleitos? It was Polykleitos who built the theater at Epidauros, as he did the rotunda mentioned above." [Pausanius, *Description of Greece* 2.27.5.]

47. Here is the passage mentioned, which proves the antiquity of the theater. Speaking of the fear that spread through Athens at the news of the approach of Philip, father of Alexander the Great, Diodorus Siculus says, ὁ δὲ δῆμος ἅπας ἅμ' ἡμέρᾳ συνέδραμεν εἰς τὸ θέατρον, πρὸ τοῦ συγκαλέσαι τοὺς ἄρχοντας, ὡς ἦν ἔθος. Dio., bk. 56, vol. 2, p. 147.15 (trans. Rhod[oman], Ams[terdam], 1747). This means: "Before daybreak the people ran to the theater to confer, without waiting, as was customary, for the order of the magistrate." [Diodorus Siculus, *Library of History* 16.84.3.]

48. Θεμιστοκλῆς δ' οὐχ, ὡς Ἀριστοφάνης ὁ κωμικὸς λέγει, τῇ πόλει τὸν Πειραιᾶ προσέμ[α]ξεν, ἀλλὰ τὴν πόλιν ἐξῆψε τοῦ Πειραιῶς, καὶ τὴν γῆν τῆς θαλάττης. Plutarch,

Thém., p. 121.F (Paris, 1624). The lines printed in italic in the text are the translation of this passage. [Plutarch, *Lives, Themistocles* 19.3–4.]

49. In making a fair copy of this drawing for the engraver, I put fourteen columns in the flank of the temple instead of the thirteen shown in my geometric plan of the building. I have invariably said, even in my first edition, that the flank of the temple contained only thirteen columns. I would have rectified this error, which I observed only a short time ago, and which very few persons have noticed, had I not feared that the view, which is very fine, might suffer. I shall therefore content myself with drawing the reader's attention to it here.

50. Γραφαὶ δέ εἰσι, πρὸς Ἀμαζόνας Ἀθηναῖοι μαχόμενοι· πεποίηται δὲ σφίσιν ὁ πόλεμος οὗτος καὶ τῆς Ἀθηνᾶς ἐπὶ τῇ ἀσπίδι, καὶ τοῦ Ὀλυμπίου Διὸς ἐπὶ τῷ βάθρῳ· γέγραπται δὲ ἐν τῷ τοῦ Θησέως ἱερῷ καὶ ἡ Κενταύρων καὶ ἡ Λαπιθῶν μάχη. Paus., pp. 39, 40 (ed. Kühn). "The battle between the Athenians and the Amazons," says Pausanias, "is represented *on the Temple of Theseus*; it has also been depicted on the shield of Minerva, and on the base of the pedestal of the statue of Jupiter Olympius. The bas-reliefs of that temple also show the battle between the Centaurs and the Lapiths." [Pausanius, *Description of Greece* 1.17.2.]

51. Τοῦ δὲ τρίτου τῶν τοίχων ἡ γραφὴ μὴ πυθομένοις ἃ λέγουσιν, οὐ σαφής ἐστιν· τὰ μέν που διὰ τὸν χρόνον, τὰ δὲ Μίκων οὐ τὸν πάντα ἔγραψε λόγον. Paus., ibid. "The subject shown on the third wall," Pausanias adds, "cannot readily be understood by those unversed in history: both because the sculptor Micon did not complete all the parts that were intended to compose it and because several pieces have been spoiled by time." [Pausanius, *Description of Greece* 1.17.2–3.]

52. On the prytaneis, see what Monsieur Blanchard has to say on the subject, *Hist. de l'Acad. des inscriptions*, vol. 7, p. 54.

53. *Et exeuntibus è theatro sinistro Odeum, quod Athenis Pericles columnis lapideis disposuit.* Vit., bk. 5, chap. 9 (ed. Laet, Ams[terdam], Elze[virum]).

["Also, for those who exit to the left, there is the odeion that Pericles surrounded with stone columns" (Vitruvius, *De architectura* 5.9.1), though modern texts attribute this deed to Themistocles, not Pericles.]

54. Τὸ δ' ᾠδεῖον, τῇ μὲν ἐντὸς διαθέσει πολύεδρον καὶ πολύστυλον, τῇ δ' ἐρέψει περικλινὲς καὶ κάταντες ἐκ μιᾶς κορυφῆς πεποιημένον, εἰκόνα λέγουσι γενέσθαι καὶ μίμημα τῆς Βασιλέως σκηνῆς, ἐπιστατοῦντος καὶ τούτῳ Περικλέους. Plut., p. 160 A (ed. Cruser[ius] and Xyland[er]). "The odeion," says Plutarch in this passage, "with its numerous interior benches and columns, and its roof that slopes to a point, is said to have been built on the model of Xerxes' tent; it was designed by Pericles." [Plutarch, *Lives, Pericles* 13.6.]

55. Plut., ibid. [Plutarch, *Lives, Pericles* 13.6.] Mr. Spon [(*Voyage d'Italie*, vol. 2, pp. 199–200)] believes that the building whose ruins we describe was not roofed; with little likelihood, he asserts that it was the Areopagos.

56. Vit., bk. 5, chap. 9 (ed. Laet). [Vitruvius, *De architectura* 5.9.1.]

57. *Mém. de litt.*, vol. 23, *Hist.*

58. In this commentary, which is entitled *De Significatione Vocabulorum, quibus Vitruvius Utitur,* we find the following information (p. 76). Odeum, bk. 5, chap. 9: *Et exeuntibus è Theatro, sinistra parte Odeum* [(Also, for those who exit to the left, there

is the odeion)]. Baldus: *De Odeo ita Suidas:* Ὠδεῖον Ἀθήνησιν ὥσπερ θέατρον, ὃ πεποίηκεν, ὥς φασι Περικλῆς, εἰς τὸ ἐπιδείκνυσθαι τοὺς μουσικοὺς, διὰ τοῦτο γὰρ καὶ ᾠδεῖον ἐκλήθη ἀπὸ τῆς ᾠδῆς· ἔστι δὲ ἐν αὐτῷ δικαστήριον τοῦ ἄρχοντος· διεμετρεῖτο καὶ ἄλφιτα ἐκεῖ. *Odeum Athenis instar theatri, quod Pericles, uti fertur, ad Musicorum ostentationem effecit, et propterea Odeum dictum est* ἀπὸ τῆς ᾠδῆς, *id est, a cantu. Ibidem est dicasterium, id est, praetorium judicis. Ubi etiam farinae metiebantur. De eodem Aristophanis Scholiastes, super illo versu,* οἱ δὲ ἐν ᾠδείῳ δικάζουσι, *locus erat in Theatri speciem, in quo de more poemata ostendebantur, antequam Theatro publicarentur, etc.*

["Baldi: *Suidas* writes of the odeion: 'The odeion at Athens is a place like a theater, which Pericles is said to have founded for performances by musicians; it was accordingly called the odeion, "after the ode." There too is the dikasterion, that is, the justices' court, where also flour was measured. On the same topic, the Scholiast on Aristophanes, on the verse οἱ δὲ ἐν ᾠδείῳ δικάζουσι, writes that it was a place like a theater, in which poems were customarily performed before being publicly shown in the theater."]

59. We suspect that the Euainetos who presided at these contests was an archon but cannot say so with absolute certainty. [As we wrote in our first edition (pt. 1, p. 56n):] "And if, as will be seen in our explanation of the inscriptions of the Lantern of Demosthenes and of the Monument of Thrasyllus, we have adopted the opinion of Messrs. Spon and Wheler and translated the word HPXE by *archon*, which suggests a very early date for both monuments, as we consider likely; we confess that some scholars are not of our opinion. Van Dale disagrees: he considers that the word HPXE does not mean archon. We shall leave the reader to draw his own conclusions."

60. On the inscriptions of this kind on two Athenian buildings, I wrote in my first edition [(pt. 1, p. 56n]: "The modern authors do not seem to agree as to the contests mentioned in these inscriptions; of the two travelers we have cited, Wheler considers that they were athletic contests, Spon that they were theatrical contests. The word *agonothete*, which we, along with a number of other authors, have interpreted as designating the official who presided at the athletic games, and the bas-reliefs of the Lantern of Demosthenes, which mostly represent combats, incline us toward the former; but on this general point we must confess that the latter has the support of van Dale. We consider the present note necessary to intimate that—since all that we have said on the meaning of these inscriptions rests on passages that bear more than one interpretation—we cannot positively affirm the truth of our conjectures."

61. So that readers can better judge the likelihood of this conjecture, we shall quote the passage from Plutarch; they will be able to compare it with the dance represented in my view of the Lantern of Demosthenes. Here it is: Ἐκ δὲ τῆς Κρήτης ἀποπλέων εἰς Δῆλον κατέσχε, καὶ τῷ θεῷ θύσας, καὶ ἀναθεὶς τὸ Ἀφροδίσιον ὃ παρὰ τῆς Ἀριάδνης ἔλαβεν, ἐχόρευσε μετὰ τῶν ἠϊθέων χορείαν ἣν ἔτι νῦν ἐπιτελεῖν Δηλίους λέγουσι, μίμημα τῶν ἐν τῷ Λαβυρίνθῳ περιόδων καὶ διεξόδων, ἔν τινι ῥυθμῷ παραλλάξεις καὶ ἀνελίξεις ἔχοντι· γιγνομένην· καλεῖται δὲ τὸ γένος τοῦτο τῆς χορείας ὑπὸ Δηλί[ω]ν γέρανος, ὡς ἱστορεῖ Δικαίαρχος. Plut., *Vie de Thés.*, p. 9D. "Sailing back from Crete," says Plutarch, "Theseus made landfall on Delos, where, having sacrificed to Apollo and dedicated to the god a statue given to him by Ariadne, he and his companions danced a

dance that the Delians still repeat; in this, by the rhythm and form of their evolutions, they imitate the twists and turns of the labyrinth. The dance is known as the Crane, according to Dicaearchus." [Plutarch, *Lives, Theseus* 21.1–2.]

62. Κορίννης δὲ ἢ μόνη δὴ ἐν Τανάγρᾳ ᾄσματα ἐποίησε, ταύτης ἐστὶ μὲν μνῆμα ἐν περιφανεῖ τῆς πόλεως· ἔστι δὲ ἐν τῷ γυμνασίῳ γραφὴ, ταινίᾳ τὴν κεφαλὴν ἡ Κόριννα ἀναδουμένη τῆς νίκης εἵνεκα, ἣ Πίνδαρον ᾄσματι ἐνίκησεν ἐν Θήβαις. Paus., bk. 9, chap. 22, p. 753, l. 4.

"Corinna," says Pausanias, "who was the only maker of odes at Tanagra, has her tomb in the most famous location in that city. Her portrait is also to be seen in the gymnasium, with her head bound with a ribbon as a mark of her victory at Thebes, where she carried off the prize for poetry in competition with Pindar." [Pausanias, *Description of Greece* 9.22.3.]

Mr. Stuart, as we have said, considers that the inscription on the building under discussion has to do with a theatrical contest; and in the work that he has published together with Mr. Revett, entitled *The Antiquities of Athens* (London, 1761), [p. 28,] he brings new arguments to bear in support of his opinion. Of these, one in particular, drawn from an inscription recorded by Plutarch in his life of Themistocles, has great force. The text may be found in that author, p. 114 C of the edition that I always cite: Θεμιστοκλῆς Φρεάριος ἐχορήγει, Φρυνίχος ἐδίδασκεν Ἀδείμαντος ἦρχεν. "Themistocles of the borough of Phrear was choragus; Phrynicos had trained the performers, and Adeimantos presided." [Plutarch, *Lives, Themistocles* 5.4.]

Having given Mr. Stuart his due, I feel entitled to complain of the lack of candor in his criticism of my description of the Monument of Lysikrates.

This author maintains that I was mistaken over the naming of several monuments, or over the purpose for which they were built; and in relation to the building commonly known as the Lantern of Demosthenes—which is the only monument described in the present volume that Mr. Stuart has also published—he seeks to prove that I was wrong to say, in my description, that it was erected in honor of the victors in athletic contests. This was the view taken by Wheler; whereas Mr. Stuart has followed that of Spon, who believed that the victory in question was theatrical. But when, within the bounds of a single work, an author who has subscribed to an opinion changes his mind and gives reasons for so doing, no reasonable blame would seem to attach to him.

These established laws of criticism, though observed by all those authors who pursue the truth in good faith, are not those to which Mr. Stuart subscribes. He is at pains to counter the opinion that I first advanced in my description of the monument but says not a word of the note in which I declared that I would not undertake to sustain it. This note is printed in the first edition of my work, at the end of the first part, at the foot of the leaf that contains the inscription of the monument known at Athens as the Lantern of Demosthenes; it is the note cited as a quotation above [(see note 60)].

63. Strabo estimates the distance between these two locations to be 330 stades; for he says, speaking of Piraeus, Διέχει γὰρ τοῦ μὲν Σχοινοῦντος τοῦ μετὰ τὸν ἰσθμὸν, περὶ τριακοσίους καὶ πεντήκοντα σταδίους· τοῦ δὲ Σουνίου τριάκοντα καὶ τριακοσίους. Strab., bk. 9, p. 599 B (Amst[erdam], 1707). In this passage Strabo says of Piraeus: "From Schoenus [(Schoinous)], which is on the isthmus, it is 350 stades, and from Sunium 330." [Strabo, *Geography* 9.1.2.] The 11 leagues to which we refer are maritime

leagues. If 1 league is computed as 2,500 toises, the distance is more than 12 leagues; and this is exactly the distance from Cape Colonna to Piraeus, as given by Monsieur d'Anville. This may be verified on one of the maps entitled *Graeciae antiquae*, and on another that bears the title *Les côtes de la Grèce et de l'Archipel*. These two maps, several parts of which I was able to verify against my own observations, seemed to me to be extremely accurate.

64. Pausanias, bk. 1, p. 1. [Pausanius, *Description of Greece* 1.1.1.]

65. *Acad. inscript.*, vol. 7, *Hist.*, p. 350.

66. Vitr., bk. 4, chap. 9. [Vitruvius, *De architectura* 4.8.4.]

67. Ibid.

68. See, in the works of Meursius, the part entitled *Piraeus, sive, De celeberrimo illo Athenarum portu, et antiquitatibus ejus.*

69. Paus., p. 4 (ed. Kühn). [Pausanius, *Description of Greece* 1.1.4.]

70. Paus., p. 3. [Pausanius, *Description of Greece* 1.1.2.]

71. Plut., *Vie de Thés.* [Plutarch, *Lives, Theseus* 17.6.]

72. Pausanias, p. 3. [Pausanius, *Description of Greece* 1.1.2.]

73. Βωμοὶ δὲ θεῶν τε ὀνομαζομένων ἀγνώστον καὶ ἡρώων καὶ παίδων τῶν Θησέως καὶ Φαληροῦ. Paus., p. 4 (ed. Kühn).

"At Phaleron," says Pausanias in this passage, "there are altars dedicated to the unknown gods, to the heroes, and to the children of Theseus and of Phalerus." [Pausanius, *Description of Greece* 1.1.4.]

74. Act., chap. 17. [Acts 17:25.]

75. Mr. Spon seems to us to be mistaken, when he says, p. 229 of vol. 2, that this harbor was very large and that it was more than 3 miles around. We believe that he has confused the port of Phaleron with the large bay, which is, in plate 12, between the harbors of Munychia and Phaleron. Both in its size and in its closeness to Athens, the open roadstead that Spon takes for Phaleron harbor seems to us to be far less similar to the ancients' accounts of the earliest and probably smallest of their ports than is the small, enclosed location that we have designated. Wheler [(*A Journey into Greece*, p. 418)] expresses himself in a way that suggests that he was not laboring under the same error as Spon on this subject.

76. For all these details, see the materials that Meursius has assembled on Piraeus, in the work just mentioned [in note 68].

77. Θεμιστοκλῆς δὲ ὡς ἦρξε (τοῖς τε γὰρ πλέουσιν ἐπιτηδειότερος ὁ Πειραιεὺς ἐφαίνετο οἱ προκεῖσθαι, καὶ λιμένας τρεῖς ἀνθ' ἑνὸς ἔχειν τοῦ Φαληροῖ) τοῦτο σφίσιν ἐπίνειον εἶναι κατεσκευάσατο· καὶ νεὼς καὶ ἐς ἐμὲ ἦσαν οἶκοι, καὶ πρὸς τῷ μεγίστῳ λιμένι τάφος Θεμιστοκλέους. Paus., p. 3 (ed. Kühn).

"When Themistocles governed Athens," says Pausanias, "since Piraeus seemed to him well sited to receive shipping, and since it could provide three harbors as against the one at Phaleron, he decided to build them; and down to my time there could still be seen at Piraeus ships and these three harbors to accommodate them. Next to the largest of the three was the tomb of Themistocles." [Pausanius, *Description of Greece* 1.1.2.]

Messrs. Spon [(*Voyage d'Italie*, vol. 2, p. 233)] and Wheler [(*A Journey into Greece*, p. 419)], who visited the port of Piraeus on their travels, give us only the vaguest notion of its shape, saying that they observed an inlet large enough to accommodate galleys;

but they did not observe the three distinct inlets that formed the three harbors of which Pausanias speaks, and which I am the first to have identified.

78. Τόν τε Πειραῖα νησιάζοντα πρότερον, καὶ πέραν τῆς Ἀκτῆς κείμενον, οὕτως Φασὶν ὀνομασθῆναι. Strab., bk. 1, pp. 101–2. "Piraeus," says Strabo, "was formerly an island separate from the coast of Attica; and that is the source of its name." [Strabo, *Geography* 1.3.18.]

Strabo's etymology of the name of Piraeus is entirely plausible, since πέραν [(*perān*)], from which it derives, means *trans*, beyond.

79. Ταῦτα δ' ἦν μακρὰ τείχη πρὸς τὸν πειραῖα, τεσσαράκοντα σταδίων. Strabo, bk. 9. "The Long Walls of Piraeus," says Strabo, "were 40 stades long." [Strabo, *Geography* 9.1.15.]

80. The Greeks called these walls Σκέλη or *crura*, the legs; the Latin authors sometimes called them the arms. Meursius, speaking of Piraeus, in his chap. 2, cites this passage: *Inter angustias semiruti muri, qui duobus brachiis Piraeum Athenis jungit.* Livy, bk. 35. ["In the narrow confines of the half-ruined wall that extends in two arms from Piraeus to Athens" (Livy, *Ab urbe condita* 31.26); Meursius, *Piraeeus*, chap. 2.]

81. Συνέθεντο τὴν εἰρήνην, ὥστε τὰ μακρὰ σκέλη, καὶ τὰ τείχη τοῦ πειραι[έ]ως, περιελεῖν. Diod., bk. 13; Meursius, chap. 2.

"They made peace," says Diodorus Siculus, "on the condition that the Long Walls and the walls of Piraeus should be dismantled." [Diodorus Siculus, *Library of History* 13.107.4; Meursius, *Piraeeus*, chap. 2.]

82. Λόφος δ' ἐστὶν ἡ Μουνυχία, χερρονησι[ά]ζων. Strabo, bk. 9.

"Munychia," says Strabo, "is an eminence in the form of a peninsula." [Strabo, *Geography* 9.1.15.]

83. Between the latter inscription reproduced here and that given by Mr. Stuart [(*Antiquities of Athens*, p. 28)] for the same structure, there are some discrepancies that make no difference whatever to the meaning. We shall nevertheless record this here. That author writes three of the words in the inscription as follows: Κικυνευς εχορηγη, εδιδασκε.

84. Euainetos is listed among the archons in the list printed in the *Universal History* published by a society of men of letters; his name is assigned to the year 355 B.C. I have adopted this date for that of the building of the Monument of Lysikrates. Mr. Stuart [(*Antiquities of Athens*, p. 2)] placed the date of building five years later, in 330 B.C. One might wish that he had given his reasons for rejecting the view taken by his compatriots. [It seems obvious that Le Roy meant 335 B.C. rather than 355 B.C. for the date of Euainetos. We would now translate the inscription as follows: "Lysikrates of Kikyna, son of Lysitheides, was choregos. The tribe of Akamantis won the victory with a chorus of boys. Theon played the flute. Lysiades of Athens trained the chorus. Euainetos was archon." The last reference dates the event to 335/334 B.C.]

85. I found the frieze of the Temple of Minerva to be 95 feet 4 inches long; but, having verified the foot-rule with which I took this measurement against another, highly accurate one, which had been supplied to me by Monsieur Canivet, that celebrated mathematical instrument maker, and calibrated against the standard foot at the Châtelet in Paris, I find my foot too short by a little over 7 points. This, multiplied by

95, gives approximately 700 points, or, as will be seen, very nearly 6 inches, which I have subtracted from my measurement.

86. Here is the passage: Πάντα δὲ διεῖπε καὶ πάντων ἐπίσκοπος ἦν αὐτῷ Φειδίας, καίτοι μεγάλους ἀρχιτέκτονας ἐχόντων καὶ τεχνίτας τῶν ἔργων· τὸν μὲν γὰρ ἑκατόμπεδον παρθενῶνα Καλλικράτης εἰργάζετο καὶ Ἴκτινος. Plut., *Vie de Péri.*, p. 159 E. "All this work," says Plutarch, "was supervised by Pheidias, who was in charge, though other masters were responsible for individual parts of it. Kallikrates and Iktinos worked on the Hekatompedon Parthenon." [Plutarch, *Lives, Pericles* 13.4.] The word *parthenon* means *dwelling of the virgins;* this is the name of the temple itself, and the word *hekatompedon* signifies that it measured 100 feet. In this passage, Plutarch does not say that the Temple of Minerva was known as the *Hekatompedon* because it measured 100 feet *in every direction;* the latter words are not in the text, and Monsieur Dacier had no reason to add them in his translation of Plutarch, entitled *Les* [*vies des*] *hommes illustres.* Following Monsieur Dacier, the abbé Gedoyn made the same error in his French translation of Pausanias, entitled *Voyage* [*historique*] *de* [*la*] *Grece.*

87. This passage is by the author of the *Etymologicum.* Joan. Meurs., *Athen. Atti. Cecropia,* chap. 14: Ἑκατόμπεδον, νεὼς ἐστι τῆς Ἀθηνᾶς ποδῶν ἑκατὸν ἐκ πάσης πλευρᾶς· διὰ τοῦτο γὰρ καὶ ὠνόμασται. *Hecatompedum Minervae Templum est ex unoquoque latere centum pedes habens: qua de re et nomen datum.*

["The Hekatompedon Temple of Minerva measures a hundred feet on every side; hence the name" (Meursius, *Cecropia,* chap. 14).]

88. Harpocration, s.v. Ἑκατόμπεδον = Jo. Meurs., *Athen. Atti. Cecropia,* chap. 14: Ὁ παρθενῶν ὑπό τινων Ἑκατόμπεδον ἐκαλεῖτο, διὰ κάλλος, καὶ εὐρυθμίαν· οὐ διὰ μέγεθος. *Parthenon à quibusdam Hecatompedum vocatur propter formam et concinnitatem ejus, non ob magnitudinem.*

["By some, the Parthenon was called *Hekatompedon,* on account of its beauty and harmony of proportion, not because of its size" (Meursius, *Cecropia,* chap. 14).]

89. *Frons aedis Doricae in loco, quo columnae constituuntur, dividatur, si tetrastylos erit, in partes XXVIII, si hexastylos, XLIIII: ex his pars una erit modulus, qui Graece* ἐμβάτης *dicitur, cujus moduli constitutione rationibus efficiuntur omnis operis distributiones.* Vitr., bk. 4, chap. 3, p. 66 (ed. Laet, Elze[virum], Ams[terdam]).

["Let the front of a Doric temple, where the columns are put up, be divided into 28 parts if it is to be tetrastyle, into 44 if hexastyle. One of these parts will be the module, which in Greek is called ἐμβάτης (*embatēr*); and, once this module has been determined, all the parts of the work are determined by calculations based upon it" (Vitruvius, *De architectura* 4.3.3).]

Some manuscripts read XXVII and XLII for the two numbers given above; and these are the readings preferred by [Guillaume] Philandrier and by Perrault. [And in the translation by Ingrid D. Rowland, published in 1999.]

90. *Reddenda nunc est Eustyli ratio, quae maximè probabilis, et ad usum et ad speciem, et ad firmitatem rationes habet explicatas:.... Hujus autem rei ratio explicabitur sic: Frons loci, quae in aede constituta fuerit, si tetrastylos facienda fuerit, dividatur in partes undecim semis, praeter crepidines et projecturas spirarum. Si sex erit columnarum, in partes decem et octo. Si octastylos constituetur, dividatur in XXIV et*

semissem. Item ex his partibus, sive tetrastyli, sive hexastyli, sive octastyli, una pars sumatur, eaque erit modulus, cujus moduli unius erit crassitudo columnarum. Vitr., bk. 3, chap. 2, p. 42.

["Now we will describe the system for the eustyle, the most praiseworthy class, which is arranged on principles developed with an eye to usefulness, beauty, and soundness....

The system for the eustyle may be set forth as follows. If a tetrastyle is to be built, let the width of the front, which shall have already have been determined for the temple, be divided into eleven and a half parts, not including the steps and the projections of the bases; if it is to be of six columns, divide it into into eighteen parts. If an octastyle is to be constructed, let the front be divided into twenty-four and a half parts. Then, whether the temple is to be tetrastyle, hexastyle, or octastyle, let one of these parts be taken, and it will be the module. The thickness of one column will be equal to one module" (Vitruvius, *De architectura* 3.3.6, 7).]

91. εἰσὶ γὰρ σταδιαῖαι τὸ ὕψος, τετράγωνοι τῷ σχήματι, τῆς πλευρᾶς ἑκάστης μικρῷ μείζον τὸ ὕψος ἔχουσαι. Strabo, bk. 17, p. 1161 C. "Each of them," says Strabo, speaking of the two largest of the pyramids, "is 1 stade in height; they are square in shape, and the sides are less than the height." [Strabo, *Geography* 17.1.33.]

92. *Suidas,* s.v. MILLE, Μίλιον. μέτρον γῆς. τὰ δέκα μίλια ἔχουσι στάδια π΄ ἄλλως. τὸ στάδιον ἔχει πόδας χ΄. τὸ δὲ μίλιον, πόδας δσ΄. "The mile," says *Suidas,* "is a terrestrial measure, 10 miles containing 80 stades; or, to put it differently, there are 600 feet to a stade and 4,200 to a mile." There is a manifest contradiction in this passage. Monsieur [Ottavio Antonio] Bayardi corrects this in the following manner, and I have adopted his correction: Μίλιον. μέτρον γῆς. τὰ δέκα μίλια ἔχουσι στάδια π΄ ἄλλως. τὸ στάδιον ἔχει πόδας χ΄. τὸ δὲ μίλιον, πόδας δω΄. "The mile is a terrestrial measure, 10 miles containing 80 stades; or, to put it differently, there are 600 feet to a stade and 4,800 to a mile." For this correction, see Bayardi, *Le antichità de Ercolano.*

93. Polybius, in the third book of his history, p. 193 A (Paris, 1609): ταῦτα γὰρ νῦν βεβημάτισται καὶ σεσημείωσται κατὰ σταδίους ὀκτὼ διὰ Ῥωμαίων ἐπιμελῶς. "The Romans," says Polybius, "divided their roads into lengths of 8 stades or 1 mile." [Polybius, *Histories* 3.39.8.]

94. *1,306.* When I read my dissertation to the Académie [royale] des sciences, I had adopted the estimate of the Roman foot given by the abbé [Diego] Revillas in the third volume by the Accademia [etrusca] of Cortona, namely 1,309 5/12 points of our Paris foot; but this Roman foot has since been measured at Rome by Father [François] Jacquier, the learned mathematician, and by the abbé [Jean-Jacques] Barthélemy, of the Académie [royale] des inscriptions; and Monsieur Barthélemy has proved convincingly, in a dissertation read to the Académie [royale] des [inscriptions et] belles-lettres, that the Roman foot was only 1,306 points in length, as many authors had previously estimated. I have now adopted this latter view.

95. Plutarch, *Vie de Caius Gracchus:* τὸ δὲ μίλιον ὀκτὼ σταδίων ὀλίγον ἀποδεῖ. "One mile," says Plutarch, "contains a little less than 8 stades." [Plutarch, *Lives, Gaius Gracchus* 7.2.] Monsieur Dacier, in his translation of Plutarch's *Hommes illustres,* has interpreted this passage as follows: "Each mile containing approximately 8 stades"; but his translation is not faithful, and it fails to render the meaning of the text, since one

cannot tell whether 8 stades were more than a mile, as clearly stated in the passage, or a mile more than 8 stades.

96. In his *Eclaircissements géographiques*.

97. In my calculation I have assumed the English foot to be $1,351\,^{66}/_{114}$ points of the Paris foot, in accordance with the ratio between the English and the Paris foot given to my brother, a member of the Académie royale des sciences, by Mr. Grames. That celebrated horologist, comparing the two feet with the greatest care, found that 36 inches of the Paris foot were equal to 38.355 inches of the English foot; the ratio between the Paris foot and the English foot was thus almost exactly 107 to 114. ["Grames" is presumably George Graham, the renowned English physicist and instrument maker, also well known in France.]

Editorial Notes

a. There is no Castelnuovo on the Istrian coast, as far as I can discover. Castelnuovo is the Italian name for Hercegnovi, the port on the Gulf of Kotor, on the coast of what is now Montenegro, Yugoslavia. In the eighteenth century, this port was the Venetians' great prize from their war with the Turks, and Le Roy was traveling with a Venetian bailo; however, it is some three hundred miles south of Istria and Pola. It may be that Le Roy meant the port of Cittanova, now called Novigrad, which is east of Venice, in what is now Croatia, on the western shore of the Istrian Peninsula and about thirty-five miles north of Pola.

b. See Thomas Allason, *Picturesque Views of the Antiquities of Pola, in Istria* (London: John Murray, 1819); and Stefan Mlakar, *Ancient Pula* (Pula: Archaeological Museum of Istria, 1958) or his *Das antike Pula* (Pula: Archäologisches Museum Istriens, 1972). See also Raymond Chevallier, "La découverte des antiquités de Pola par les voyageurs du XII^e au XIX^e siècle," in *Studi in memoria di Giuseppe Bovini* (Ravenna: Mario Lapucci, Edizione di Girasole, 1989), 147–59; and Günter Fischer, *Das römische Pola: Eine archäologische Stadtgeschichte* (Munich: Verlag der Bayerischen Akademie der Wissenschaften, 1996).

c. See Herman F. Mussche, *Thorikos: A Guide to the Excavations* (Brussels: Blandijneerg, 1974); John Travlos, *Bildlexikon zur Topographie des antiken Attika* (Tübingen: Wasmuth, 1988); and Herman F. Mussche, *Thorikos: A Mining Town in Ancient Attika* (Ghent: École Archéologique en Grèce, 1998).

d. On the buildings of the Acropolis and its surrounds, see Jeffrey Hurwit, *The Athenian Acropolis: History, Mythology, and Archaeology from the Neolithic Era to the Present* (Cambridge: Cambridge Univ. Press, 1999).

e. On the Propylaia, see Jens Andreas Bundgaard, *Mnesicles: A Greek Architect at Work* (Copenhagen: Gyldendal, 1957); Tasos Tanoulas, "The Propylaea of the Acropolis at Athens since the Seventeenth Century: Their Decay and Restoration," *Jahrbuch des Deutschen Archäologischen Instituts* 102 (1987): 413–83; Jos de Waele, *The Propylaia of the Akropolis in Athens: The Project of Mnesikles* (Amsterdam: J. C. Gieben, 1990); and Wolfram Hoepfner, "Propyläen und Nike-Tempel," in idem, ed., *Kult und Kultbauten auf der Akropolis* (Berlin: Archäologisches Seminar der Freien Universität Berlin, 1997), 160–77.

f. See Sir Arthur Wallace Pickard-Cambridge, *The Theatre of Dionysus in Athens*

(Oxford: Clarendon Press, 1946); and Luigi Polacco, *Il teatro di Dioniso Eleutereo ad Atene* (Rome: "L'Erma" di Bretschneider, 1990). Though Le Roy has misidentified the ruins of the Odeion of Herodes Atticus, which are farther west on the south face of the Acropolis, as the remains of the Theater of Dionysos, many of his comments regarding the latter are substantially correct.

g. See Magarete Bieber, *The History of the Greek and Roman Theatre*, 2d ed. (Princeton: Princeton Univ. Press, 1961).

h. For Greek architecture in general, see William Bell Dinsmoor, *The Architecture of Ancient Greece: An Account of Its Historic Development*, 3d ed. (London: B. T. Batsford, 1950); Gottfried Gruben, *Die Tempel der Griechen*, 4th ed. (Munich: Hirmer, 1986); and Arnold Walter Lawrence, *Greek Architecture*, 5th ed., rev. Richard Allan Tomlinson (New Haven: Yale Univ. Press, 1996). For the architecture of the town of Athens, see John Travlos, *Pictorial Dictionary of Ancient Athens* (London: Thames & Hudson, 1971); Richard Ernest Wycherley, *The Stones of Athens* (Princeton: Princeton Univ. Press, 1978); John McK. Camp, *The Athenian Agora: Excavations in the Heart of Classical Athens* (New York: Thames & Hudson, 1986); and *The Athenian Agora: A Guide to the Excavation and Museum*, 4th ed., rev. (Athens: American School of Classical Studies at Athens, 1990).

i. The scanty remains of the Odeion of Pericles are to the east of the Theater of Dionynos, on the south face of the Acropolis, not as Le Roy seems to think, on the Mouseion hill. Though Le Roy has misidentified the Pnyx as the Odeion of Pericles, many of his comments regarding the latter are substantially correct.

j. On the Monument of Lysikrates, see Heinrich Bauer, "Lysikratesdenkmal: Baubestand und Rekonstruktion," *Mitteilungen des Deutschen Archäologischen Instituts, Athenische Abteilung* 92 (1997): 197–227; and Wolfgang Erhardt, "Der Fries des Lysikratesmonuments," *Antike Plastik* 22 (1993): 6–67.

k. On Sunium, see William Bell Dinsmoor, *Sounion* (Athens: Lycabettus, 1971); John Travlos, *Bildlexikon zur Topographie des antiken Attika* (Tübingen: Wasmuth, 1988); Ulrich Sinn, "Sunion: Das befestigte Heiligtum der Athena und des Poseidon an der 'Heiligen Landspitze Attikas,'" *Antike Welt: Zeitschrift für Archäologie und Kulturgeschichte* 23 (1992): 175–90; and Hans R. Goette, "Studien zur historischen Landeskunde Attikas, I–III," *Mitteilungen des Deutschen Archäologischen Instituts, Athenische Abteilung* 110 (1995): 171–205.

l. On the harbors of Athens, see Robert Garland, *The Piraeus: From the Fifth to the First Century* B.C. (Ithaca: Cornell Univ. Press, 1987); and Wolfram Hoepfner and Ernst-Ludwig Schwandner, *Haus und Stadt im klassischen Griechenland*, 2d ed. (Munich: Deutscher Kunstverlag, 1994).

Le Roy is quite muddled about the harbors of Athens, which were not well identified until the twentieth century. Below is a translation of the legend to Le Roy's plate 12, *Map of the Ports of Piraeus, Phaleron, and Munychia.*

Port of Munychia

This port is oval in form and a mile in circumference. A line bisecting it lengthwise runs 5 degrees E of S by E to 5 degrees W of N by W.

On the coast I have marked with the number *1* the small seawalls made of large

stones measuring approximately 3 feet and placed 12 feet from one another.

The farside of the Port of Piraeus is to the SSE [NNW?] of the mouth of the Port of Munychia; this mouth is 2 fathoms in depth.

Port of Piraeus

2 and 2. Ruined towers.

3. Debris of the lighthouse of Piraeus: the compass positioned on this lighthouse indicated that one of the two towers was SSW of us and the other NNE. The reef marked *4* was ENE, the other reef, marked *5*, was nearly E, these two reefs were between SE by S and NW by N. Of the three ports built in Piraeus, the largest, marked *6*, is 600 *pas géométriques* in circumference; it has a seawall, marked *7*, that extends precisely EW; today it is full of silt and therefore impassable. Port Muet, marked *8*, is 300 paces in circumference; it is formed by a seawall, marked *9*, that extends EW the length of 80 fathoms; we discovered this seawall under water by paying close attention during a great calm, and we verified that this is what we saw by taking soundings of this seawall. At 10 is the third port, which is 300 paces in circumference.

The depth of these ports in fathoms: *A* 7, *B* 11, *CC* 15, *D* 1, *E* 1, *F* 1.

Port Phaleron

This port is 300 *pas géometriques* in circumference; its depth is 4 fathoms at the entry to its basin, 2 at the center, and 1 at the farside.

The line that passes through the center of the port and its mouth runs in the direction NW by W to SE by E.

We positioned the compass on the end of a small seawall, marked *11*, and found that the citadel of Athens stood 2 degrees NE of NE by E, Cape Colias [(Agios Kosmas)] 2 degrees S of SE by S, and the eastern point of the island of Aegina SSW.

According to Ronald Edward Zupko, *French Weights and Measures before the Revolution: A Dictionary of Provincial and Local Units* (Bloomington: Indiana Univ. Press, 1978), in Le Roy's time 1 *pas geometrique* = 1 *brasse* (fathom) = 5 *pieds* (feet), or, converting to metric and U.S. measures, 1.624 m or about 5⅜ U.S. ft.

m. In his original, Le Roy seems to have the Mouseion and Lykabettos hills reversed — from Piraeus, the Mouseion is to the left of the Acropolis, the Lykabettos to the right — so we have emended his text.

n. Actually Zea (now called Pasha Limani) adjoins the isthmus; Munychia (now called Mikrolimano) is a smaller harbor about a half mile farther east along the coast.

o. See David H. Conwell, *The Athenian Long Walls: Chronology, Topography, and Remains* (Ann Arbor, Mich: University Microfilms, 1992).

p. Le Roy's plate shows three harbors off the bay to the north of the Piraean peninsula and identifies them as Port Muet (Kophos Limen, or silent harbor) and two unnamed harbors; today the bay itself is identified as the Kantharos, and the harbor at the north is identified as the Kophos Limen; the other two harbors off the bay shown on Le Roy's map are unknown today. He identifies the modern Zea as the Munychia and does not mention the modern Munychia at all. Today the harbors of Piraeus would be identified as the Munychia, the Zea, and the Kantharos.

q. On some of the attempts of Le Roy's contemporaries to determine the length of the Greek foot, see p. 166 n. 167. For Greek measures of length and their relationship to the stadium, see Oskar Viedebantt, *Forschungen zur Metrologie des Altertums* (Leipzig: B. G. Teubner, 1917); Edward Norman Gardiner, *Athletics of the Ancient World* (Oxford: Clarendon, 1930); and David Gilman Romano, "Athletics and Mathematics in Archaic Corinth: The Origins of the Greek Stadion," *Memoirs of the American Philosophical Society* 206 (1993): 107–12.

In attempting to determine the length of the Greek foot, Le Roy made the two incorrect assumptions: that the epithet *Hekatompedon* referred to the Parthenon of Pericles and that the measurement related to the width of the temple rather than the length. Pericles's Parthenon might have been known as the Hekatompedon, but it contained no dimension of 100 feet. The width of the stylobate was only 94.5 Doric feet, the length of the east *cella* only 91.5 Doric feet. The name in fact commemorated an earlier temple, probably the H-temple, the oldest of the various Parthenons on the Acropolis. See William Bell Dinsmoor, "The Hekatompedon on the Athenian Acropolis," *American Journal of Archaeology* 51 (1947): 109–51, though this by no means represents the last word on the matter; see also Renate Tölle-Kastenbein, "Das Hekatompedon auf der Athener Akropolis," *Jahrbuch des Deutschen Archäologischen Instituts* 108 (1993): 43–81; and Manolis Korres, "Die Athena-Tempel auf der Akropolis," in Wolfram Hoepfner, ed., *Kult und Kultbauten auf der Akropolis* (Berlin: Archäologisches Seminar der Freien Universität Berlin, 1997), 218–43. See also Wolf Koenigs, "Maße und Proportionen in der griechischen Baukunst," in Herbert Beck, Peter C. Bol, and Maraike Bückling, eds., *Polyklet: Der Bildhauer der griechischen Klassi* (Mainz am Rhein: Philipp von Zabern, 1990), 121–34.

r. The modern measurement is 230 m or 755¾ U.S. ft. The passages Le Roy references are as follows: Herodotus, *History* 2.124; Diodorus Siculus, *Library of History* 1.63.4; Strabo, *Geography* 17.1.33; and Pliny the Elder *Historia naturalis* 36.17.80, though the Loeb edition gives Pliny's measurement as 783, rather than 883.

s. Father Fulgence's measurement is cited in Jacques Cassini's *Traite de la grandeur et de la figure de la terre* (Amsterdam: Pierre de Coup, 1723), 190. We have been unable to trace it to an earlier source or indeed to discover anything more about this mathematician.

The Ruins of the Monuments Erected by the Athenians before the End of the Age of Pericles and Alexander, Architecturally Considered

In the first part of this volume, we related the history of the earliest monuments erected by the Athenians. The present part will compare the proportions of those monuments, to show the relations among them and between them and certain Roman monuments and also to substantiate the views advanced in our remarks on the history of architecture regarding the changes effected in the Greek orders before the end of the age of Pericles, both in the places where they originated and in those where they were imitated.

The Doric Order

The Doric, first and oldest of the orders, is also the most altered in its principal proportions. We shall consider it in the three different states offered to us by the monuments we studied in Greece and represented in this work: the first, in which the columns were generally very short but had no set proportions; the second, in which the height of the columns was fixed at six diameters by those Greeks who, as Vitruvius [(De architectura 4.1.5–6)] tells us, migrated from Athens to Asia Minor under the leadership of Ion, son of Xuthus; and the last, marked by a more slender proportion, in excess of six diameters. We must say at the outset that columns of this last type will be found only in buildings erected since the death of Alexander; in accordance with the new plan that we have adopted, we shall postpone our description of them to the following volume.

The Doric Order Considered in Its Earliest State

It is an extraordinary fact that in Greece there are Doric temples still extant, albeit in ruins, in which the proportion of the columns is so short that they are less than six diameters in height. I have drawn two of this kind: one is ten leagues from Athens, at a place known as Thoricus; and the other is at Corinth.[1a] The columns of the former are smooth; those of the latter, like those of almost all temples extant in Greece, are fluted. Of these two types of column, the fluted seems to have been in more general use among the Greeks,

but the smooth is earlier: we have only to recall that columns were originally the trunks of trees, which bear no suggestion of fluting. We shall therefore discuss the temple in which the columns are smooth before turning to those in which they are fluted.

As I said in part 1, only eleven columns of this temple can now be located. My plan, figure 1 of plate 15, shows my hypothetical arrangement of the others, indicated in the engraving by a lighter tone. The columns stood on a stylobate made of the same marble as the columns and equal in width to the diameter of the columns at the foot of the shaft. I found no trace of the *cella*, the body of the temple. Perhaps it had none? I shall not venture to decide.

Figure 2 shows the dimensions of these columns: they were less than five diameters high. The width of the abacus is exactly equal to the diameter at the foot. It may also be seen, from the profile of the capital, figure 3, that the part that we call the echinus is not rounded, as the Greeks made it in perfecting their Doric, but simply chamfered; it is separated from the necking by three little cavetti. The necking is ornamented with very shallow flutes, such as the ancients employed for the Doric order and generally similar to those used by [Giovanni Niccolò] Servandoni for the columns of the portico of Saint-Sulpice [in Paris]. The necking of the capital rested on the shaft without an intervening astragal: it seems, in fact, from all the Doric orders found in Greece without astragals, that this ornament originated with the Ionic, on which, as I shall show, the Greeks placed an astragal. I suspect that the Romans were the first to apply it to the Doric order.

The close resemblance between the order of the Doric temple just described and the order of the Tuscan temple of which I show the facade and the profile of its capital in the same plate, figures 6 and 4, will emerge from the following comparison.

First, the Doric column is smooth; so is the Tuscan column.

Second, the width of the abacus of the Doric capital is exactly equal to the diameter of the foot of the column, as I said above; and Vitruvius [(*De architectura* 4.7.3)] lays down this same rule for the abacus of the Tuscan capital.[2]

Third, the abacus is smooth in both; the shape of the echinus is also the same, though in the Doric capital it is not rounded in profile as it is in the Tuscan, which shows that the latter is a developed form, farther from its origins. They also seem to differ in that the Doric capital has a fluted necking; Vitruvius mentions no such thing in his account of the Tuscan order. However, the only two monuments of the Tuscan order now to be seen in Rome (Trajan's Column, the profile of which I have shown in figure 5; and the Antonine Column [or Column of Marcus Aurelius]) have fluted neckings of exactly the same form as those in the Doric capital discussed above—a detail that leads me to surmise that fluted necking is another feature common to Tuscan and Doric capitals.

Fourth, the column has no astragal, and neither does Trajan's column, mentioned above. If it is certain, as Monsieur Perrault has conclusively shown,[3] that the astragal to which Vitruvius [(*De architectura* 4.7.3)] refers separated

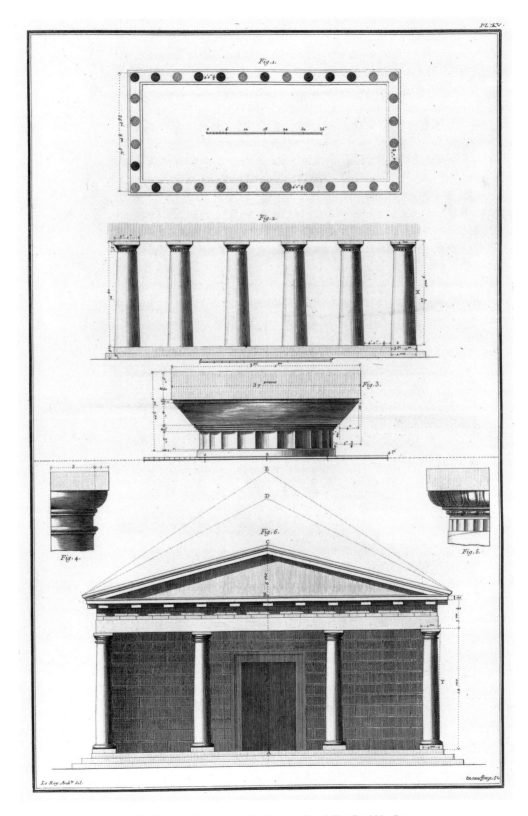

Pl. 15. Jean-François de Neufforge, after Julien-David Le Roy

the echinus from the necking, it is by no means so certain that the Tuscan column always had a second astragal separating the shaft from the necking. Vitruvius mentions no such thing; and, as we have said, there is no second astragal on Trajan's column.

Fifth, the columns taper markedly toward the top, both in the Doric order under discussion and in the Tuscan described by Vitruvius. The most notable difference to be observed between the two is that the columns of the temple just described are only five diameters in height, whereas Vitruvius's Tuscan column is seven. But the Tuscan was not always seven diameters high: Pliny [the Elder (*Historia naturalis* 36.56.178)] tells us in his book 36, chapter 23, that its height was only six diameters: "Columns," he says, "are of four kinds: namely, the Doric, the height of which is six times their thickness at the base; the Ionic, nine; the Tuscan, six; and the Corinthian, which are like the Ionic except for the capital, which is one diameter high in the Corinthian and only one-third of a diameter in the Ionic."

This comparison of the Doric order of the temple that we found some ten leagues from Athens and the Tuscan order described by Vitruvius reveals so much conformity between the two as to leave us no doubt but that they have the same origins. If we assume that the Tuscan order sprang from the Doric, rather than the Doric from the Tuscan, this is because the historians unanimously state that architecture began in Greece, rather than Italy, and because the Doric order that we have described, with its very short columns and its simple echinus and abacus, seems to stand closer to the origins of architecture. This seems to us all the more plausible in that this Doric order does not have a base and the Tuscan does. It will now be an easy matter for us to demonstrate that the Tuscan temple itself bears as close a resemblance to the Greek prostyle temple as its order does to the Doric with which we have compared it.

The Greek Prostyle Temple Compared with the Tuscan Temple
Both the prostyle temple and the Tuscan temple have columns only on the facade. In both, these columns are separated from the antae by a space equal to one intercolumniation.

Both temples also have columns between and in line with the antae.

Both also have a wall pierced by a doorway to separate the porch from the interior of the temple.

They differ only in the ratio of length to width and in the disposition of the interior.

But the greatest proof, perhaps, that the general form of the Tuscan temple was copied from the temples of Greece is that the ratio of the height of its pediment to the height of its facade is the same as that found in the temples of the Greeks: I shall demonstrate this, contra the view taken by Monsieur Perrault, who makes this pediment far too tall, because he has misunderstood the passage in which Vitruvius specifies the proportion.

Vitruvius first describes the Tuscan temple, as may be seen below, and

establishes that the height of the column must be equal to one-third of the width of the temple and that the height of the entablature must be one-quarter that of the column. He then adds, "the ridge, the rafters, and the purlins must be so disposed that the slope of the roof is equal to that of the pediment, which must form the *tertiarium*"—that is, together with the order that supports it, and of which it represents one-third, it must form a whole that he calls the *tertiarium*.[4] This is my explanation of the word, for which Monsieur Perrault employs the vague and inaccurate phrase, *which must be very high* [(*qui doit être fort éléve*)].

It is at once apparent that my interpretation of the word *tertiarium* in this passage precisely matches the definition given by Vitruvius himself in book 3, chapter 4; where, speaking of numbers, he says that if to the *asse*, or the number six, we add its third part, we then have the *tertiarium*.[5] My opinion is reinforced by the following arguments.

First, Vitruvius has established, as one can see in his description of the Tuscan temple given in our note, the height of the column in relation to the width of the temple, along with the proportion of the entablature in relation to the height of the column. It is therefore natural to expect him to determine the height of the pediment in relation to the entablature and the column—all the more so because, the Tuscan temple always being constructed in the same way, this proportion is invariable.

Second, my explanation states that proportion of the height of the Tuscan pediment is a constant and defined by one dimension of the temple, as seems to be required by Vitruvius's definition of the word *tertiarium*.

Third, the height of the pediment, added to that of the order, forms with this latter dimension a continuous line, just as one-third of six added to six makes the integer eight, to which Vitruvius give the name *tertiarium*.

Fourth, the explanation that I propose gives rise to a pediment of very beautiful proportions, of which the height, *BC*, in figure 6 of plate 15, is equal to that which is generally observed, with minor variations, in all the ancient temples in Greece and Italy. The height that I ascribe to the pediment of the Tuscan temple, *BD*, is very much less than Monsieur Perrault supposed. But I believe that the arguments set forth above are sufficient to give mine the preference—all the more so because that author offers no solid proof of his opinion and because the vague translation *très-élevés* that he provides for the word *tertiarium* gives the pediment only an arbitrary height, in conflict with Vitruvius's own definition of the word *tertiarium*, which represents, as I have said, a constant proportion.

Conscious of the inadequacy of his own explanation, Monsieur Perrault adds in his notes that he has followed [Adrianus] Turnebus in interpreting *tertiarium* as *a thing of which one part is one-third of the whole*. He ought to have said, more accurately, *a thing of which one part is one-third of another*, or *one-quarter of the whole*. But he does not pursue the idea. He assigns no exact proportion to the Tuscan pediment, and in his figure its height is neither one-half nor one-third of that of the order that supports it, and neither one-half nor

one-third of the width—proof that the author has no clear notion of the meaning of the passage in Vitruvius.

For the rest, if we were to suppose, in accordance with the latter hypothesis, that Vitruvius defined the height of the pediment as one-third of its width, and that these two dimensions together formed the *tertiarium,* we should be in error: first, because the height of the pediment is not added to its width, and these two dimensions together do not form a continuous line, as Vitruvius's definition of the word *tertiarium* seems to require; and, second, because this explanation makes the pediment so very tall, *BE,* that it verges on the Gothic and, as a result, is utterly remote not only from those of the ancient temples still to be found in Greece and in Italy, as we have said, but also from all those described by Vitruvius, which are very low.

In saying that the pediments of the temples described by Vitruvius are very low, we make no exception for that of the temple *in antis,* which Monsieur Perrault makes very high as a result of two errors. The first is that he models its proportions on those of the pediment of the Tuscan temple, though Vitruvius describes the latter only in his fourth book and though Vitruvius, in discussing the temple *in antis* in his third book, says explicitly that its pediment is to be proportioned according to the general rule laid down *in this book.*[6] These are his very words; the rule in question appears at the end of the third chapter of the third book. His second error is that, having misread this passage in Vitruvius, Monsieur Perrault also mistakes the proportions of the pediment of the temple that he has chosen as a model, supposing it to be very high when in reality it is very low, as we believe that we have demonstrated abundantly.

This likeness between the general form of the Tuscan temple and that of the Greek prostyle temple is palpable; but that between the Tuscan order and the Greek Doric orders of the remotest antiquity is no less striking, as we have shown, and this is also confirmed by the profiles of the columns of the Temple of Apollo [on Delos], to be seen in plate 16.

The Temple of Apollo is in so ruinous a state—with not a single column standing or even one drum set upon another—that I had great difficulty in determining the approximate proportions of the columns. This is how I went about it. Having observed that the drums of these columns were of different diameters, from the largest, which formed the foot of the column and was 2 feet 8 inches across at its foot, to the smallest, which was only 2 feet across at its top, I first made sure that I had surveyed all the drums, noticing that the top of the first drum, recognizable both by its diameter and by its fluting, corresponded exactly to the base of another drum, and so on, to the top of the capital. I found that, with the capital, the height of the column was 14½ feet, as shown in figure 1. The diameter at the foot being 2 feet 8 inches, it follows that the column was less than six diameters in height. The shaft is smooth, but there are twenty flutes at the foot and an equal number in the necking of the capital. These flutes are shallow.

A number of features show that the columns of the Temple of Apollo were

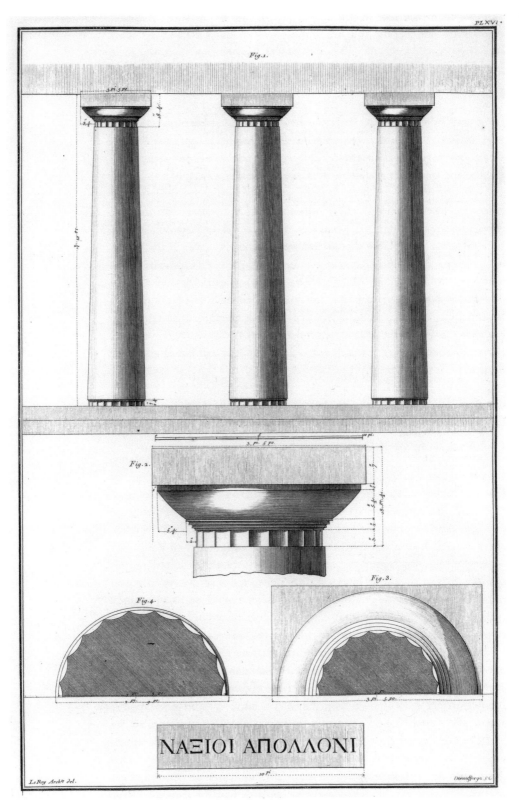

Pl. 16. Jean-François de Neufforge, after Julien-David Le Roy

more slender in their proportions than those of the temple previously described, for they have flutes at the foot, unlike those at Thoricus, and taper less markedly at the top. The capital, figures 2 and 3, is also more finely worked: the abacus has greater projection; and the echinus, though its curve is shallow in profile, is more than a plain chamfer. This capital, like that to which we are comparing it, has three little cavetti beneath the echinus, separated by tiny fillets; and its necking is similarly ornamented with shallow flutes. This last particular is all the more noteworthy because these flutes are repeated at the foot of the column, as will be seen in figures 1 and 4, and the body of the column is smooth.

As for the order in which the discoveries of the Greeks were made: as suggested by the two temples just described, we might surmise that they first capped all their columns with square pieces of wood or stone to form the rudest of capitals; that they then chamfered the portion of the capital known as the echinus, which would seem to be the simplest idea that could have presented itself to their minds; that they perfected this with the passage of time; and, finally, that they had the idea, the capital originally being detached from the column and worked separately, of ornamenting it by fluting first the necking, then the foot of the column, as at the Temple of Apollo, and eventually the whole column, as in the temple at Corinth already mentioned and in all those to be described later.

The Doric Order Considered in Its Second State

I have hitherto been able to write of the Doric order only in general terms; it has not been possible to give the precise heights of columns or the form of entablatures. Now, in discussing the Doric monuments of what may be called the second manner, I can speak more positively and offer my readers objects that are less defaced. The Temple of Theseus, which I am about to describe, is almost intact: all its columns are standing and little damaged; its entablature is very well preserved; and it lacks only some slabs in the soffits of the porticoes, which do not prevent us from conjecturing their design.

Built, as has been said, some ten years after the battle of Marathon, this temple is hexastyle and peripteral. Its architecture seems to have been imitated in the temples and the other most celebrated buildings erected subsequently in Athens, in the age of Pericles. I shall examine the most remarkable features of this monument, taking its plan, facade, soffits, and profiles in turn.

Plate 17 represents the plan and front elevation of the monument. The plan, figure 1, shows the temple to be more than twice as long as it is wide. The body of the temple, or *cella,* is completely surrounded by a portico; the porticoes of the flanks are shallow, that of the facade is a little deeper, and that of the rear is deepest of all. The front has a double portico, and the entrance itself is a very wide, single doorway. The interior forms a parallelogram more than two and a half times as long as it is wide. No pilasters adorn the interior; and the exterior of the *cella,* or body of the temple, has only four, placed at the corners and not corresponding to any of the columns of the

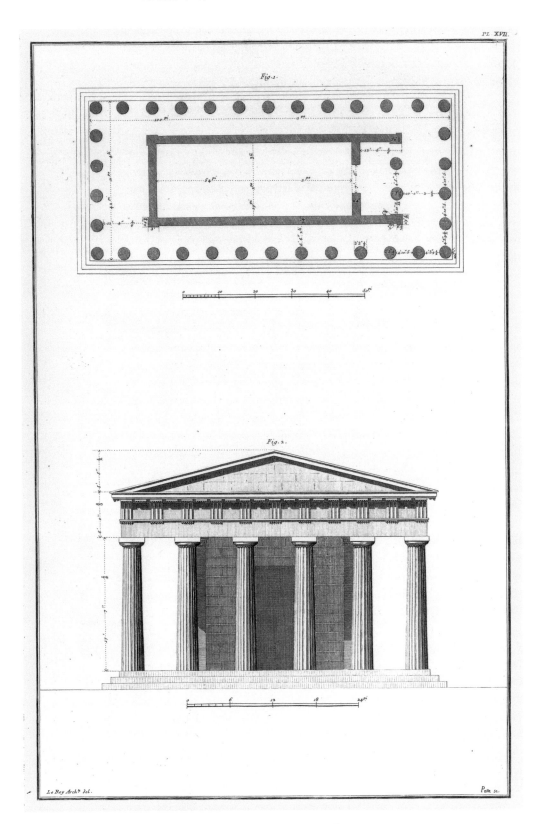

Pl. 17. Pierre Patte, after Julien-David Le Roy

front or flanks. It will be seen from this that the ancients, who wanted their facades made up of closely spaced columns, took no pride in having the pilasters at the corners of the *cella* correspond to a column in the elevation, because this would have made the side porticoes of the temple either too shallow or too deep. This liberty seems all the more pardonable because in practice it passes unnoticed.

The width of these pilasters is not equal to the diameter of the columns; they also differ in the form of their capitals; and it seems that the Greeks made no use of them as ornaments. It might be desirable that, without abandoning the use of pilasters altogether, they were not employed absolutely everywhere, and particularly not under peristyles, unless the order that governs them is colossal in the extreme; for in that position they compel the architect either to make his doors and windows small, with sorely disfigured cornices, or to make his intercolumniations too wide—a defect that the Greeks were at pains to avoid.

There is reason to believe that the Romans, like the Greeks, thought highly of close intercolumniations. Vitruvius praises Hermogenes' invention of the pseudodipteral plan, for the beauty of its outward appearance, for the spaciousness of the porticoes around the *cella,* and for the narrow spacing of the columns, and goes on to say, *One imagines that the arrangement of the* pteroma, *of those colonnades that surround a temple, was devised so that the severity of the intercolumniations might lend great majesty to their aspect.*[7] The ancients thus considered, in general, that the majesty of their temples was enhanced when they were surrounded by a large number of columns separated by narrow intercolumniations; but the Greeks were always stricter than the Romans in their observance of this rule—as becomes apparent when we compare the Temple of Theseus, the facade of which is seen in figure 2, with two Roman Doric temples described by Vitruvius[8] and given by Perrault in his translation, pages 114 and 115. These last two temples have very wide intercolumniations, which renders the ordonnance of their facades meager and ill-suited to the masculine character proper to a Doric building.

The Romans well knew that too wide an intercolumniation on the facade of a temple was a defect in ordonnance. Seeing that this vice sprang from their desire to see the doorway, however wide, unencumbered by columns, they built another kind of temple in which the central intercolumniation alone was very wide and the others were very narrow; but a glance at plate 27 of Perrault's translation of Vitruvius, which shows two temples of this sort, is enough to show the faulty nature of this composition; and undoubtedly one will greatly prefer the manner of the Greeks, who made the intercolumniations of their facades equal without giving a thought to the doorways or the antae behind them.

The truth is that the arrangement of the Doric frieze itself prevented the Greeks from ever making their intercolumniations perfectly equal when using the Doric order. They were forced to make the intercolumniation at the corner of a Doric temple slightly narrower than the others, because they

wanted the corners marked by triglyphs, not by half-metopes. This practice is observed in all the Doric monuments of Greece, even those built in Pericles' time; and the Romans seem to have been the first to think of leaving a half-metope, less one-half of the taper of the shaft, at the corner of Doric friezes, in order to make all the intercolumniations of their temples equal and to be able to place a triglyph directly over the axis of the corner columns, just as they were placed over all the other columns. That it was the Romans who thus perfected the Doric order seems to be proved by a temple, still standing in Rome in the fifteenth century, of which [Antonio] Labacco has left us drawings.[9] This was built in their earliest manner, in which they imitated the Greeks' manner—a faulty manner condemned by Vitruvius and by all modern architects.

The columns of the Temple of Theseus, like those of all those buildings erected in Athens during the time when the arts flourished in that city, are no more than six diameters high. The entablature measures one-third of the height of the columns, and the pediment over the facade is very low—lower even than it would be according to the rule given by Vitruvius for determining its height. We have already cited this rule in discussing the temple *in antis*.

The soffit of this temple is beautiful, simple, and very well preserved. Its marble joists, shown in figure 1 of plate 18, correspond, horizontally, to each triglyph, aside from a few slight variations that probably result from trifling faults in execution. This remarkable alignment of the joists with the triglyphs shows that the joists derive from the wooden members whose ends formed the triglyphs. However, because the joists of the soffit of the Temple of Theseus are raised to the height of the mutule, one might suppose them to indicate the origin of that ornament instead, did not Vitruvius [(*De architectura* 4.2.3)] tell us that the mutule imitates the projecting ends of the rafters. This is confirmed by a mutule of the Temple of Theseus: its face, with the guttae beneath, slopes at precisely the angle of the raking sides of the pediment. The disposition of the soffit in the porticoes of the Temple of Theseus, it seems to me, casts new light on the design of the soffit of the vestibule of the Tuscan temple, in which the wooden members were arranged, in my view, in just the same way as the marble joists of the Greek temple.[10] As will be seen from plate 15, I have followed this principle in arranging the mutules on the facade of the Tuscan temple. One also sees in Vitruvius's account of this temple and of the beams whose ends were visible on its facade that the faces of the mutules beneath the corona must be horizontal, not raked like the mutules of Doric temples.

The marble joists of the soffit of the Temple of Theseus, just mentioned, support slabs, each pierced with four holes. Figure 2 [of plate 18] shows a detail of these joists and slabs, as one would usually see them, from below. Figure 3 shows the same part as seen from above the temple. Figure 4 shows a section. Each hole in the slab was capped from above by a small, square piece of marble that could be removed and replaced; strange though this arrangement may seem, I have the impression that it was widely used and esteemed in Greece.

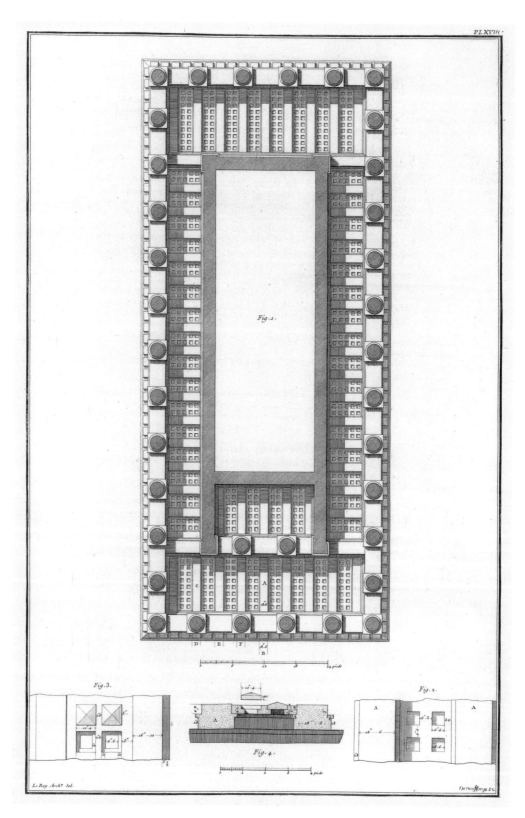

Pl. 18. Jean-François de Neufforge, after Julien-David Le Roy

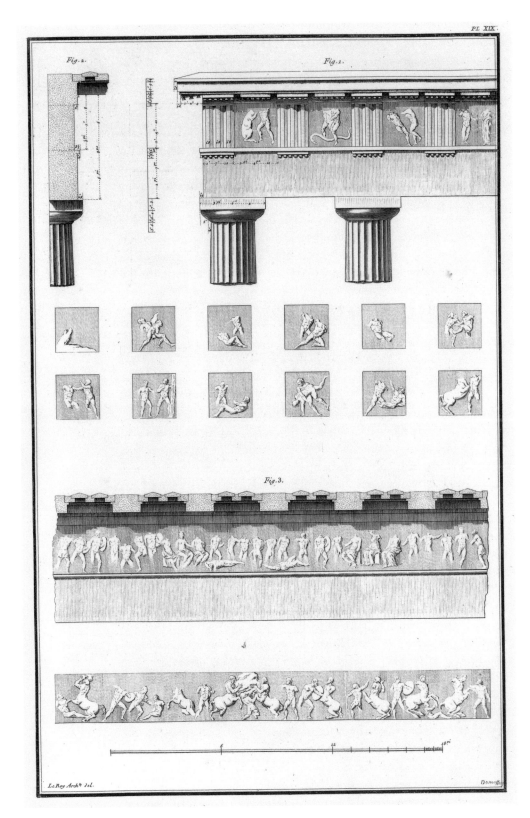

Pl. 19. Jean-François de Neufforge, after Julien-David Le Roy

The small pieces of marble, cut in the shape of tiles, that, according to Pausanias,[11] roofed the Temple of Jupiter at Olympia and were invented, according to the same author, by Byzes of Naxos may well have resembled those that I observed on the roof of the Temple of Theseus.

Plate 19 shows a number of the profiles of the temple drawn to a large scale. In figure 1, it will be seen that the architrave is rather high, as would be expected in a very early monument: this member was originally intended to support all the others and accordingly was made very high when copied in marble or other stone. The triglyphs are one-half a column diameter in width and three-quarters a column diameter in height. The metopes are square, and the mutules comparatively low. I have already spoken of their slope: I have a number of thoughts on this matter, as well as on the mutules, which lie over the centers of the metopes; but for all these details I refer the reader to the Temple of Minerva, which I shall describe later, for its profiles, which I have shown drawn to a very large scale, are the same — minute variations aside — as those of the Temple of Theseus.

Figures 2 and 3 present [longitudinal and latitudinal] sections of the porticoes at the front and the back of the temple; they contribute greatly to our understanding of the disposition of the soffits. As to the bas-reliefs seen in this plate, I have nothing to add here to the remarks I made in part 1 of this volume.

Remarks on the Temple of Minerva

The grandeur and beautiful disposition of the plan of the Temple of Minerva conveys an idea of its magnificence. In addition to the external portico, seen in figure 1 of plate 20, there were two in the interior, one above the other, each composed of twenty-two columns all around, as we remarked in part 1, following Messrs. Spon [(*Voyage d'Italie*, vol. 2, p. 155)] and Wheler [(*A Journey into Greece*, p. 360)]. This temple resembled, as the latter suggests, the type of temple that Vitruvius calls *hypaethral*, which had ten columns in its facade, and the Temple of Jupiter Olympius in Athens, which had only eight but which was adorned, according to the same author [(*De architectura* 3.2.8, 7.1.15)], with a portico of interior columns.

The proportion between the two principal dimensions of the Temple of Minerva is very remarkable. Each of its flanks had seventeen columns, and its facades only eight, which means that it was more than twice as long as it was wide. This proportion seems to have been generally observed by the Greeks: it is corroborated by the dimensions of the Temple of Theseus, which has six frontal and thirteen return columns; by those of the celebrated Temple of Jupiter at Olympia, which was, according to Pausanias [(*Description of Greece* 5.10.3)], 95 feet wide by 230 feet long; and, finally, by those of the temples of great antiquity that stand to this day in the ruins of Paestum [(Pesto)], an ancient city of Magna Graecia, some twenty-two or twenty-three leagues from Naples.

The overall proportions used in Greek temples seem to have been modified

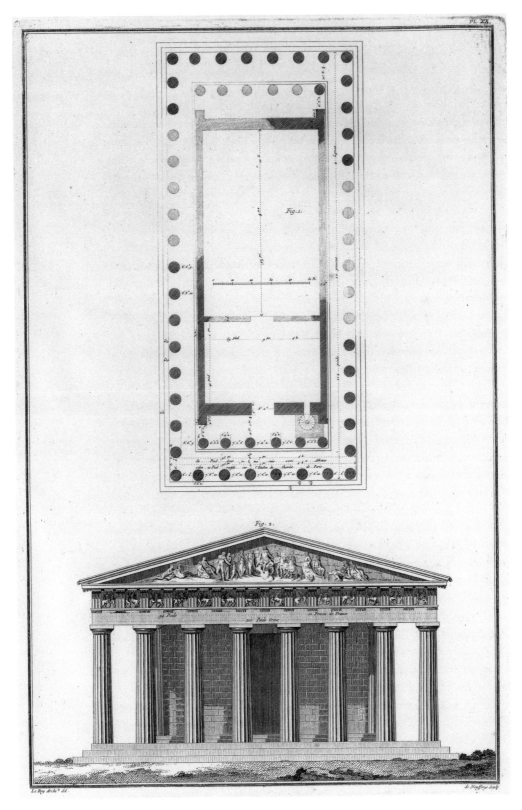

Pl. 20. Jean-François de Neufforge, after Julien-David Le Roy

by the Romans.[12] If Vitruvius is to be believed, they built their temples much shorter than those of the Greeks. Both [Guillaume] Philandrier and Perrault were unaware of this difference, and this has led them to misread their author. In book 3, chapter 1, where he gives rules for the disposition of the pseudo-dipteral temple, Vitruvius says that this has eight face and fifteen return columns, including those at the corners, which would make thirty-eight columns along the exterior perimeter of the temple and thirty-four in the second row of columns that one would include to make up the dipteron. He adds that there was no pseudodipteral temple of this kind in Rome but that there was one such in the city of Magnesia [ad Maeandrum], namely, the Temple of Diana by Hermogenes. It seems clear that he compares this last temple built by Hermogenes to the pseudodipteral of which he is defining the proportions solely for its general disposition and not, as Philandrier and Perrault both supposed, on account of any specific relation between the number of columns on the flanks and the number of columns on the facade: for, speaking as a historian in his book 2, Vitruvius says that Hermogenes invented the octastyle and the pseudodipteral style by eliminating from the dipteros the internal row of columns, of which there were thirty-eight in all,[13] which means that Hermogenes' pseudodipteros had forty-two columns on the exterior, with seventeen in the whole length of each flank. It follows that this is longer than that of Vitruvius by two columns and two intercolumniations.

The two commentators on Vitruvius just cited, comparing these two passages, asserted that the second was corrupt: since the octastyle dipteros, according to the proportions set down by Vitruvius, would contain only thirty-four columns on the inner row, Hermogenes would need to suppress only thirty-four columns to transform this into the pseudodipteros; therefore this number, not that before, was the correct reading of Vitruvius. But if they had known more of the proportions of Greek temples, they would have suspended judgment and avoided a misinterpretation. Hermogenes was a Greek architect; and Greek octastyle temples of various kinds probably had seventeen return columns, like the Temple of Minerva now being described, so Hermogenes had to eliminate thirty-eight columns of the dipteros to make it into the pseudodipteros. In view of the highly elongated proportions of the Greek temples, and—as I have shown above—the uniform reading of all the copies of Vitruvius for the passage in question, I therefore conclude that the author's text does not have to be altered in this place, as Philandrier and Perrault have wrongly asserted.

The facade of the Temple of Minerva, shown in figure 2 [of plate 20], is of a beautiful ordonnance and follows the Greek system of narrow intercolumniations. The eight columns of which it is composed stand on steps with a very high rise. In determining the rise of the steps that surrounded their temples, the Greeks appear to have been less concerned with making them easy to climb than with making them proportionate to the grandeur of the architecture. As may be seen, the entablature of the order is also very tall in proportion, and the pediment very low. Its tympanum was adorned with figures that are no

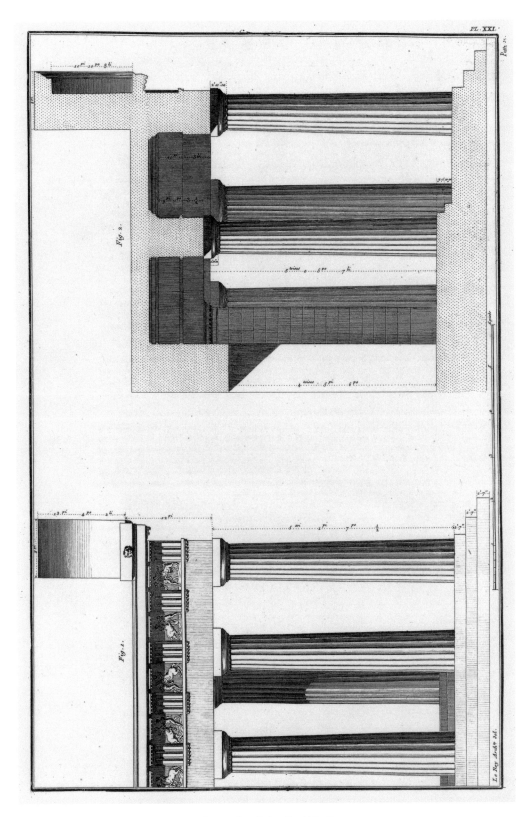

Pl. 21. Pierre Patte, after Julien-David Le Roy

longer extant. I have restored the bas-relief from the description of Messrs. Spon and Wheler, who saw it intact.

Behind the columns of the facade are two steps, which support the columns of the second portico. The bases of the latter thus stand higher than those of the former; their capitals are also higher, though the diameter and height of the shafts is less, as will be seen from the measurements on the plan and from the partial elevation and section of the temple porch shown in figures 1 and 2 of plate 21.

The entablature of this temple, drawn to a large scale in plate 22, is among the finest antique profiles that we possess. No admiration is too great for the wisdom of the architect who made this, and thus all the decoration of the temple, so masculine in form; for this building stands in the center of the citadel of Athens and is visible from all sides; the elements of its architecture had therefore to be grand and striking, and the profiles had to be made up of few elements, so that their general effect, unimpaired by diminutive moldings, would make a stronger impression on the beholder. The architrave and frieze of this entablature, beneath the corona, amount together to one-quarter of the height of the column. The capital is more masculine than those made by the Romans for this order. It has no astragal; perhaps the Greeks, who made their Doric columns only six diameters high, omitted this ornament because it would have made the shaft too short. This would seem to be confirmed by the fact that they made the echinus of their capital low but with a very marked projection. The abacus of the capital has no cyma; in so masculine an ordonnance as this, such a molding would have seemed petty.

The face of the triglyph is flush with that of the architrave: a rule that the Greeks observed at Athens, so far as I can discover, until the reign of Augustus, when they began to make the face of the triglyph project beyond the architrave; in this they were followed by the Romans. The two parts, the architrave and the frieze, which holds the face of the triglyph, project very markedly to align with the head of the column—as can be seen generally in all the monuments one finds in Greece. The width of the triglyphs is a little less than one-half of the half-diameter of the column, and their height is nearly three-quarters of the diameter. The metopes, as may be seen, are decorated with figures of men battling with Centaurs. Their height is 4 feet 2 inches 6 lines, and their width is only 4 feet 4 lines.

That the height of the metope exceeds the width gave me much pleasure to observe. It shows how scrupulous the Athenians of that time were in the design of their monuments; for there is no doubt that they made their metopes in this form so that the metopes might appear square when seen from a certain distance, in spite of the projecting taenia of the architrave. Perspective was already well known to the Greeks of that time. Vitruvius [(De architectura 7.pref.11)] informs us that Agatharchus learned the art of scenic design for tragedy from Aeschylus and that he wrote a book on the subject and taught what he knew to Democritus and Anaxagoras, each of whom then wrote a book of his own. Anaxagoras is known to have been a close friend

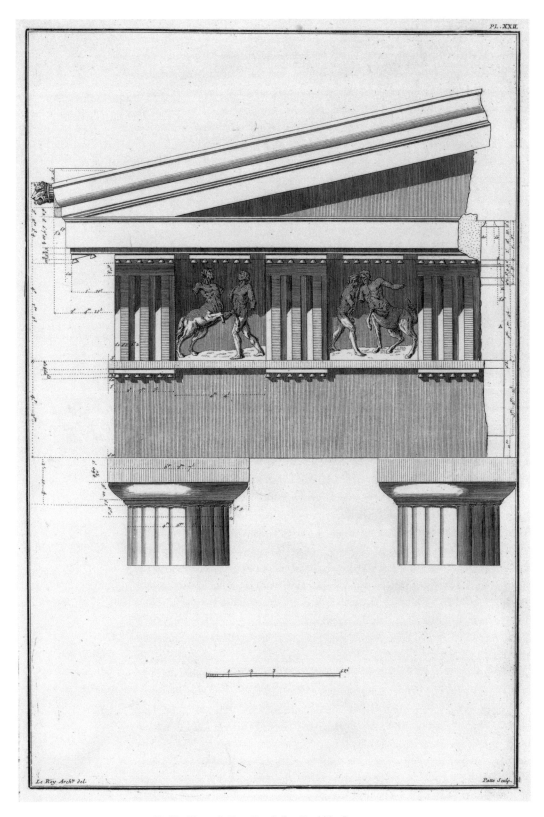

Le Roy Arch.ᵗ del.

Patte Sculp.

Pl. 22. Pierre Patte, after Julien-David Le Roy

of Pericles, at whose behest the Temple of Minerva was built; and it was probably on his advice that its architects, Iktinos and Kallikrates, made their metopes higher than they were wide, for the reason just given. Or perhaps perspective was already so well known that Iktinos and Kallikrates designed their metopes in this manner without Anaxagoras's help. The corona of this entablature is extremely tall and produces a very fine effect in its implementation.

The mutules are low and sloping, just as Vitruvius tells us that the ancients made them, to represent the slope of the rafters.[14]

Vitruvius's account of the origin of the mutule, which Perrault in his notes appears to doubt (2d ed., p. 3), is borne out by all the extant Doric monuments in Greece, without exception. In all, the mutules slope, just as Vitruvius says; but what confirms even more strongly that they were made thus to represent the ends of rafters is that their slope is exactly the same as the rake of the pediments, and consequently of the rafters. Palladio and [Jacopo da] Vignola, the two authors most respected for the purity of their profiles, have followed the letter of Vitruvius's text, and the mutules that they employ in their orders are sloping.

There are no mutules beneath the corona of the pediment. At each corner is a lion's head, which served to carry off any water; it also makes a rather beautiful effect at the top of the cornice. The profile, which is shown only in outline in this figure [(plate 22)], is the one that appeared above the smooth walls of the *cella* and the columns of the second portico. The frieze of that cornice approximately matches the height of the triglyph; it was adorned with very fine bas-reliefs. At the level of the corona, in this same profile, is the end of one of the marble beams that made up the soffit, as in the Temple of Theseus; it is shown exactly as it is, above the triglyph and level with the mutule.

I cannot tell why the ancients placed mutules above the centers of the metopes, as will be seen in this profile and in every Doric temple in Greece; and I am no less surprised that this method was taught by Vitruvius. The great [François] Blondel took the same view. "I know," says that celebrated architect [(*Cours d'architecture*, pt. 2, bk. 6, chap. 2)], speaking of Vitruvius's account of the Doric soffit, cited below,[15] "that some interpreters of Vitruvius have given drawings of this soffit very different from this one" (see figure 3 of plate 23). "But I fail to see that this brings them any closer to the author's text. Indeed, it seems that they have tried to reproduce the soffit supposed to have existed at the Theater of Marcellus, rather than the true meaning of Vitruvius."

In plate 23, figure 1 shows the Doric soffit of the Temple of Minerva; figure 2 shows that of Vitruvius, according to Perrault; figure 3 shows the latter according to the great Blondel; and, finally, figure 4 shows a fragment of Doric soffit that still existed some ten years ago at Hadrian's Villa, not far from Rome, on the terrace now belonging to conte [Giuseppe] Fede.[16] The analogy between this Doric fragment and the soffit of the Temple of Minerva, which may be treated as representative of all the temples in Greece, allows one to choose without a moment's hesitation between the views of the two

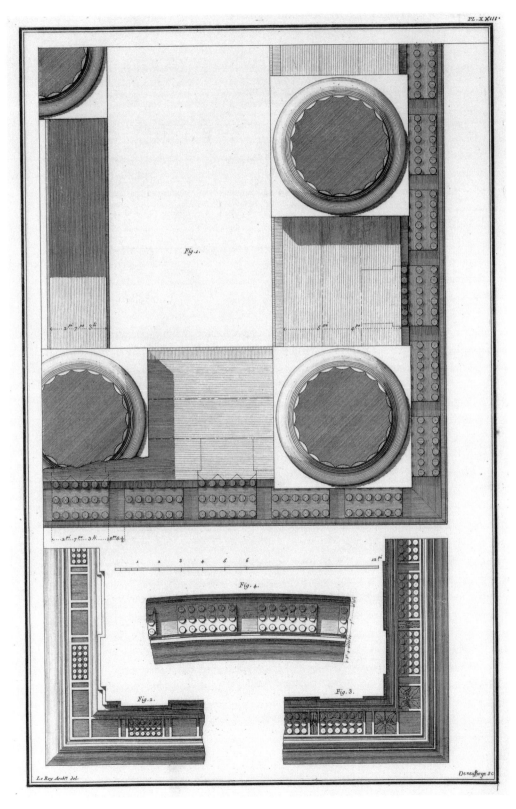

Pl. 23. Jean-François de Neufforge, after Julien-David Le Roy

modern authors just cited. Vitruvius's soffit as conceived by Perrault seems to me overly complicated, composed of diminutive parts, out of keeping with antiquity and with his author's text. I infinitely prefer that of the great Blondel; I only doubt whether he has correctly adjusted the corner, where I suspect that the three compartments shown, two with thunderbolts and one empty, would also have contained guttae. I believe that there would have been twenty-seven of these guttae [in all in the three compartments], and one would see six along the front, like on the mutule above each triglyph and below the center of each metope. Supposing the guttae to appear beneath the corona purely as an ornament, with no mutules, I find this arrangement tolerable; but I confess that a square mutule on the angle of the cornice, representing the end of a wooden member, would be absurd.

Description of the Propylaia

The ruins of a number of buildings in Rome, the medals of the ancients, and the writings of Vitruvius afford us some knowledge of the various kinds of monuments built by the Greeks; but up to now we have had no idea of how they designed their gateways when they wanted to make them magnificent in the extreme. Unknown before the publication of the present work, the monument surveyed here is all the more precious in that it is the only one of its kind that the ancients have left us; and the particular pride the Athenians took in it, and indeed in themselves for having it built at a time when the arts attained their highest degree of perfection in their city, makes it still more commendable.

The side of the monument facing outward from the citadel of Athens was composed of six columns, and so was that facing inward: this may be seen from the plan, plate 24. It will be seen that Mnesikles, who built it, wisely departed from the general rule that the Greeks had of making their intercolumniations narrow and made the central one extremely wide, to show clearly that this building was a gateway. The width of this intercolumniation from the axis of one column to that of the other was three triglyphs and three metopes. The intercolumniations on either side, marked CCCC, are monotriglyphic, as are those of the corners of both facades; but these last are narrower, because (as for the temples of Theseus and Minerva, discussed previously) there was one triglyph at the corner of the frieze, which made this necessary.

In the center of the structure are six Ionic columns, all set at the foot on square blocks, like that marked E, which I have indicated by dotted lines around one column. Another dotted line, at D, shows the width of the pieces of marble that supported the soffit. The five gateways that pierce the wall, KKKK, exactly correspond to the centers of the intercolumniations of the two facades. Five steps lead up to this wall, and in front of the building there are more steps, bounded by four low walls, two parallel and two perpendicular to the facade. Of the latter I could see only the one on the left; I assumed the presence of the former, because the steps below the columns of the facade return at right angles, and it seemed to me that such walls would have been

necessary. This great number of steps is indication enough in itself that the Propylaia stood on uneven ground, which made the composition a difficult one; but those difficulties, far from spoiling its disposition, inspired its architect to add new beauties; he skillfully took advantage of the unevenness of the terrain to enhance the nobility of the building. A glance at the section that I give, plate 25, will show how considerable was the ascent that one made on passing through it; in order to make this less evident, Mnesikles made the structure extremely deep, and artfully placed the greater part of his steps in front of its principal facade. Though I cannot claim to have discovered the exact arrangement of these steps, I believe that I am not far off; I made them slope at the same angle as those leading up to the wall marked *KK* on the plan.

Among the most singular features of this monument were the two pedestals crowned with statues set in front of its facade. True, antiquity does offer us a few examples of pedestals of this kind supporting statues in front of temples, but none of those known is as tall as these. Their height is within a few inches of that of the principal Doric columns of the building, and these no doubt determined the pedestals' proportions. This elevation shows the long side of one of the two pedestals, built, as I showed in part 1, to carry equestrian statues. Its profiles are rather fine; the courses of masonry are effectively varied, alternately large and small, the former twice the height of the latter.

The vestibules that flank the facade of the Propylaia, including the one seen frontally in the section drawing [in plate 25], show that the Greeks of Pericles' day were already combining large orders with small. The proportion between the order in these small vestibules and that in the facades of the same monument is admirable: it is the proportion most highly esteemed in our own day, the smaller order being approximately one-third the height of the larger.

The Ionic columns that supported the ceiling are, as I have just said, embedded in masses of stone that prevented me from studying their bases. The smallness of their diameter at the head of the shaft led me to conjecture that they stood on pedestals, but I cannot vouch for this. This is how I determined their total height above the floor of the hall, whether they had pedestals — as shown — or not. The least mutilated of the columns inside this hall still has its astragal at the top. Messrs. Spon [(*Voyage d'Italie*, vol. 2, p. 140)] and Wheler [(*A Journey into Greece*, p. 359)] inform us that the capitals of these columns, no longer to be seen, were Ionic; and I reached the same conclusion by measuring the vertical distance between the astragal of this one column and the little cornice that supported one end of the marble beams that formed the ceiling (the other end of these beams rested on the capitals of the columns in the hall). By adding to the Ionic column the height of its missing capital, I found that from the pavement of the building to the top of its capital, it measured 5 toises 1 foot 7 inches 10 lines; whereas the Doric columns that formed the facade of the same hall were only 4 toises 3 feet 1 inch 6 lines. It will be seen that the Ionic column was a little over one-sixth higher than the Doric.

The importance of this discovery, in my view, was that the disposition of the Ionic columns in this vestibule bears a close analogy to that of the Ionic or

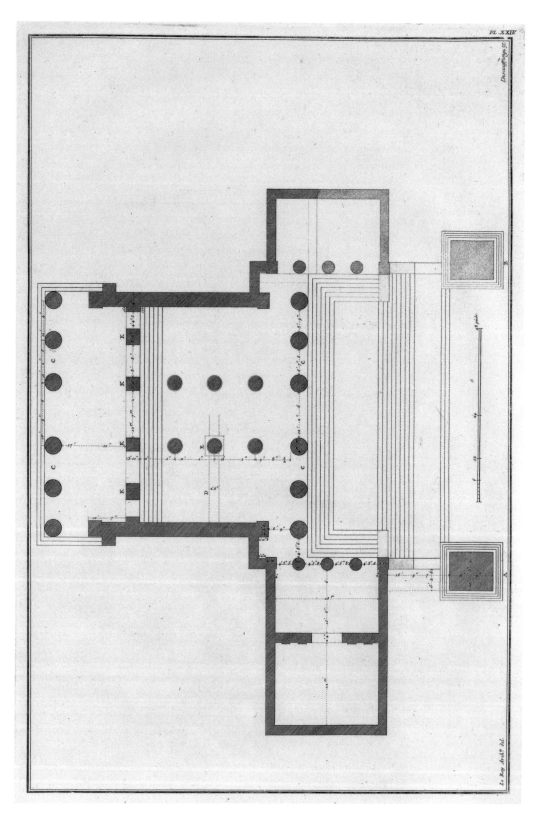

Pl. 24. Jean-François de Neufforge, after Julien-David Le Roy

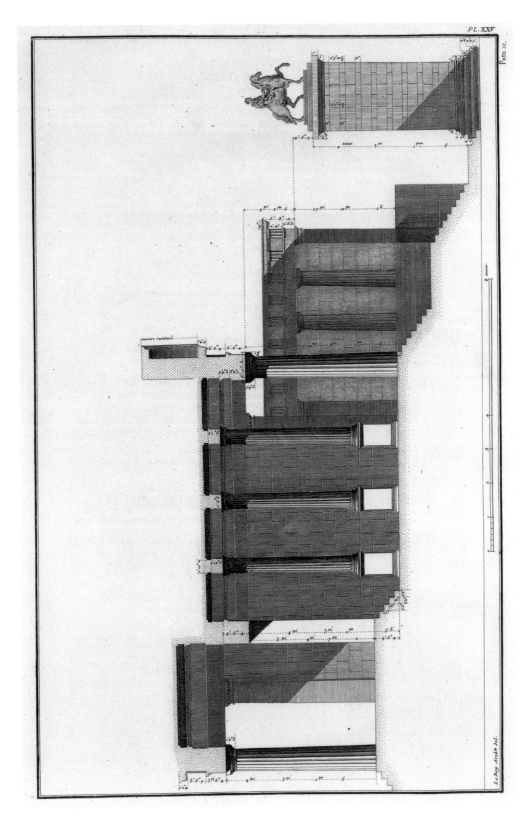

PL. XXV

Pl. 25. Pierre Patte, after Julien-David Le Roy

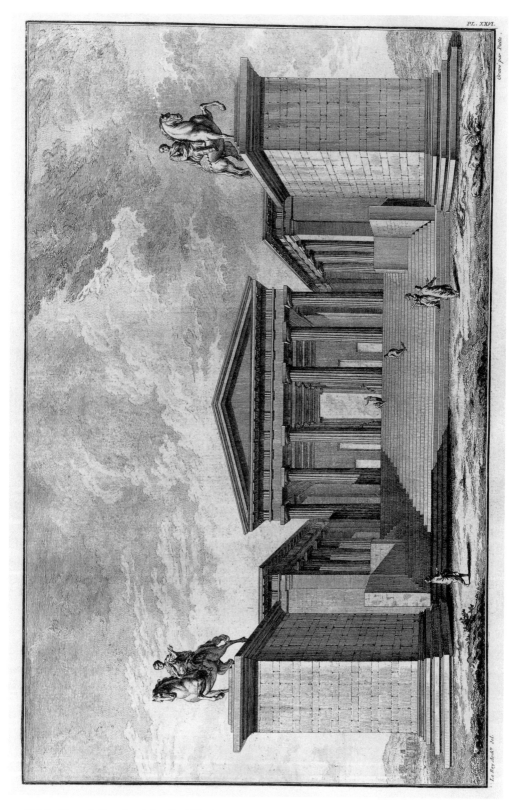

Pl. 26. Pierre Patte, after Julien-David Le Roy

Corinthian columns that stood, according to Vitruvius, in the centers of the porticoes that the ancients built behind the scenes of their theaters. Here is the passage, book 5, chapter 9:

"The porticoes and walks," says Vitruvius [(*De architectura* 5.9.2)], "adjacent to theaters are to be built in the following manner: they must be double and have Doric columns on the exterior, with architraves and ornaments carved with all the regularity of the proportions of that order. The width of the walks is to be set such that the height of the exterior columns gives the width of the walk between the bases of those columns to those in the middle and also of that between the middle columns to the walls that enclose the portico and its walks." *The columns of the middle row are to be one-fifth taller than those in the outer row; and they are to be built in the Ionic or Corinthian order.*

Monsieur Perrault suspects an error in this passage. "This one-fifth," he says, "is altogether excessive, for these columns must not exceed the others by any more than the height of the architrave, which, with a Doric column of fifteen modules, as in the present case, is only one-fifteenth of the column, because it is only the height of one module. It therefore seems that for 'one-fifth' we should read 'one-fifteenth' and take it that the X of the number fifteen was obliterated in the copy, leaving only the V."

I do not agree with Perrault's emendation, and the construction of the ceiling of the Propylaia bears me out on this. I believe that there is no error in Vitruvius's text and that the ancients used Ionic and Corinthian columns to support the centers of their ceilings because these, being more slender in their proportions, would be taller without taking up more room in diameter.[17] No doubt they placed architraves over these columns; but these architraves, like the marble beams that rested on the Ionic columns of the Propylaia, whose dimensions I marked in the cross section, bore no relation either in height or in width to the architraves that surmounted the exterior columns; they were simply made of a suitable size to support the load that they had to bear.

I shall conclude with some reflections on the Propylaia, which I have reconstructed, plate 26, in accordance with the various passages from Greek authors that I cited in part 1 of this volume and also with my own measurements. Its grandeur, the beauty of the white marble from which it was built, and its handsome disposition made this building a fitting entrance to the citadel of the celebrated city of Athens. The two great pedestals that stood in front of its facade; the number of steps on which it was raised; the porticoes that one saw to the right and to the left on arrival; and, most of all, the open central hall, which presented the spectacle of six fine Ionic columns supporting a ceiling remarkable for the size of its marble slabs; and, finally, the five doorways, through which could be seen the columns of the portico that faced the interior of the citadel—all these things must have combined to produce a magnificent spectacle, worthy of the praise of the Athenians and of which my drawing can give only the feeblest impression.

The Ionic Order

If the Doric order, just discussed, is worthy of praise because it gave birth to architecture in Greece, the Ionic order, which we are now to discuss, is no less so, for from it sprang the most felicitous discoveries in this art. As is known, the Ionians intended its slender columns to imitate the delicacy of the female form; the apt design of its entablature made it capable of the greatest variety, and the Greek architects took full advantage of the opportunities that it offered to vary the spacing of their columns at will. One of the most famous of them all, Hermogenes, who worked, says Vitruvius [(*De architectura* 3.3.1–6, 8, 10)], with an extraordinary subtlety of mind, devised five different manners of spacing columns. In one of these, called *pycnostyle,* in which the columns were separated by only one and one-half diameters, the height of the columns, according to Vitruvius, was ten diameters. In two other arrangements, the *diastyle* and the *eustyle,* in which the columns were, respectively, three diameters and two and one-quarter diameters apart, the columns were eight and one-half diameters high.[b] In a fourth system, the *systyle,* they were two diameters apart and nine and one-half diameters high. Finally, in the *araeostyle,* they were very widely spaced and only eight diameters high.

Vitruvius explains these proportions employed by the Greeks. "In an araeostyle," he says, "if the diameter of the columns were only a ninth or tenth part of their height, they would seem too slender, too frail, because the great volume of air contained in the width of the intercolumniations seems to swallow and diminish the shafts of the columns. Whereas, in the pycnostyle, if the [width] of the columns were to be one-eighth of their [height], the great number of narrow intercolumniations would make the shafts appear bloated and destroy all the grace of their outline."[18]

To Vitruvius's reason for avoiding very wide intercolumniations between slender columns, we may add another, based on the laws of mechanics. For example, if a given number of columns ten diameters high with pycnostyle spacing are strong enough to bear the load of the entablature that rests on them and then the same columns are moved farther apart, thus increasing the length of entablature that they support, until the spacing becomes araeostyle, in this latter case the building will not be so firm as before, unless the girth of the columns is also increased, because the same number of columns is supporting a considerably greater load; it will thus be necessary either to reduce the load or to increase the strength of the columns. It follows that if in the first case [(pycnostyle)] the entablature is proportionate to the height of the columns and if it cannot be reduced without too much loss of grace, we are compelled in the second case [(araeostyle)] to increase the girth of the columns, in order to keep the structure as solid with araeostyle spacing as it was with pycnostyle.

The other disposition condemned by Vitruvius, with narrow intercolumniations and squat columns, seems less defective. Nor does he avoid it slavishly: he gives us Doric temples with columns spaced pycnostyle, and the Greeks used only the pycnostyle in their temples of that order. But because the

arrangement of the Doric frieze disrupts the spacing of the columns in the Doric, it is not to the Doric that we must look for the true opinion of the ancients concerning intercolumniation but to the Ionic. This system does not seem to have been adequately understood until now. We shall therefore enlarge on it by some reflections on the passage of Vitruvius that is our source and by reference to a temple in Athens in which we see a number of different Ionic orders.

The moderns have adopted the orders of the Greeks as well as those of the Romans, and the most celebrated architects of the last two centuries have made every effort to give to each of the five orders now in use a particular character and a constant proportion. We have thus come to expect each class of column to display a constant proportion between height and diameter. A number of Vitruvius's commentators, relying on this principle and on the difference of two diameters in height that this ancient architect gave to the columns of a pycnostyle in relation to those of an araeostyle, have extended to all the orders the remarks that he makes on the Ionic and the Corinthian. They suppose that in discussing the various spacings of columns, imagined by Hermogenes, that one could employ in a building and the different heights that the columns would have to have to correspond to those spacings, he meant not just the two orders that we have just named but all five classes of column known to us — or at least the three Greek orders. But some architects thought differently; here are the reasons supporting this contrary opinion set out by the great Blondel.[19] He says, "That in this passage Vitruvius meant to speak only of the Ionic column, or of the Ionic and Corinthian at most: first, because he does not recognize a Composite order; second, because the interval of three diameters in the diastyle does not match the dimensions of the Doric metopes and triglyphs; third, because elsewhere, in discussing the spacing of Doric columns, he speaks of a different diastyle and systyle; and, finally, because, though pycnostyle intercolumniations may fit the monotriglyphic Doric, they are incompatible with the height that he gives for its columns."

One might add to the arguments adduced by this celebrated architect[20] to prove that Vitruvius was not referring to Doric temples in this passage, that the latter gives the height of eight diameters for the columns of the araeostyle and these are the shortest columns in any of the five systems of which he speaks; whereas the height of his Doric is only seven diameters, or seven and a half at most. Furthermore, in defining the various spacings of columns, he gives all the measurements in terms of the number of diameters, a measurement he always uses for Ionic or Corinthian buildings; whereas he invariably describes Doric facades in terms of the number of triglyphs contained in the full length of the frieze. But the way in which he concludes his third book seems to prove beyond dispute that he was speaking only of Ionic temples, since he says, "In this book I have dealt as accurately as I could with the ordonnance of Ionic temples; in the next I shall explain the proportions of the Doric and the Corinthian."[21]

Even if all this did not confirm what it is of the utmost importance for us

to know—that is, that the ancients varied the heights of their Ionic columns according to the greater or lesser intervals that they placed between them—the differing proportions of the Ionic columns on the temples of Minerva Polias and Pandrosos in the citadel of Athens would supply all the necessary proof, since in this respect they answer to the rules given by the Greek architect Hermogenes and handed down to us by Vitruvius.

Indeed, the three Ionic orders that adorn these two temples[c]—one on the front of the Temple of Minerva Polias, marked *A* in figure 1 of plate 27; another on its rear face, marked *B* on the same figure; and a third that formed the frontispiece of the small Temple of Pandrosos, marked *C*—all differ in the size and the proportions of their columns and intercolumniations. The front, shown in figure 2, has the narrowest intercolumniation, and its columns are taller in proportion than those of the other orders of the temple: their height is 19 feet 4 inches 11 lines, and their diameter 2 feet 1 inch 2½ lines; the intercolumniation is 4 feet 5 inches 2 lines—that is, an intercolumniation of approximately two and one-eighth diameters, and a column height of nine and one-quarter diameters. From this it will be seen that these columns are shorter in proportion, by one-quarter of one diameter, than Vitruvius's systyle of nine and one-half diameters; this, however, is in accordance with Vitruvius's own rule that columns should be a little shorter where the spacing is a little wider.

What suggests to me that the columns of this facade were intentionally made in this proportion is that the engaged Ionic columns at the opposite end of the building are a little more widely spaced. They are very close to the eustyle intercolumniation of two and one-quarter diameters, which the Athenians considered the most beautiful of all. Accordingly, the columns of this facade are a little shorter in proportion than those at the front, being nine and one-twelfth instead of nine and one-fourth diameters high.

Proof positive that the ancients used the spacing of a given order to determine the height of the columns within it is found on the facade of the Temple of Pandrosos, marked *C:* here, the spaces are very wide, almost three diameters, and the columns are very much shorter than those just mentioned, barely more than eight diameters high. This is of course shorter than the eight and one-half diameters that Vitruvius specifies for this intercolumniation; but this illustrates all the more clearly that his book 3, chapter 2, in which he discusses the five different intercolumniations and the corresponding proportions of columns, refers only to Ionic or, at most, to Ionic and Corinthian columns.

The heights of the columns of the Temple of Erechtheus thus correspond to their spacings, and to the general rules laid down by Vitruvius, though the spacings are never precisely the same as those that he prescribes; and this suggests to me that the Greeks followed some general rule whereby there was a column height for every possible spacing, from pycnostyle to diastyle.

The entablature of the Temple of Minerva Polias is less than one-quarter of the height of the columns. I shall discuss it at greater length when I show it drawn to a large scale, along with the bases and capitals of the columns. I can say nothing about the pediment or about the wall and doorway shown behind

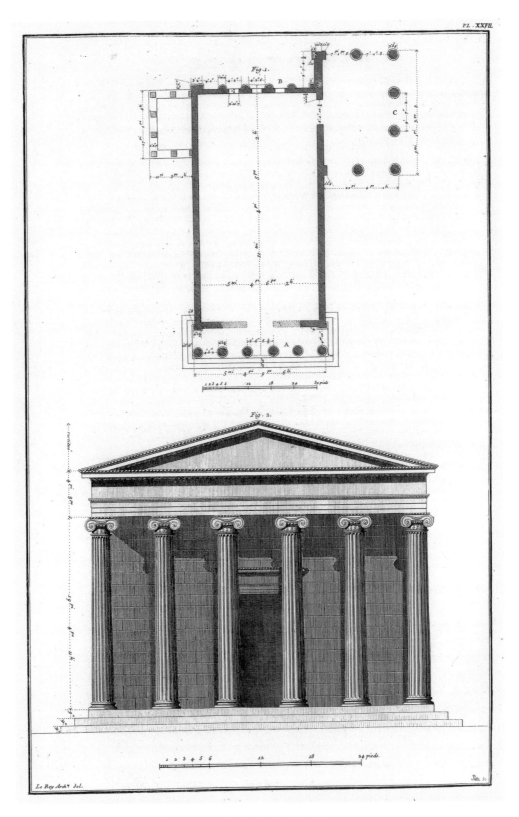

Fig. 1.

Fig. 2.

Le Roy Arch.t del.

Pl. 27. Pierre Patte, after Julien-David Le Roy

the columns, because these are no longer extant; I have added them only to grace the drawing and to give a more distinct idea of the facade of the temple.

The steps at the foot of this facade have a width of 1 foot 6 inches deep and a rise of 9 inches. They are in the proportions laid down for temple steps by Vitruvius in his book 3, chapter 3: *I consider,* he says, *that the rise of the steps should be no more than ten inches and no less than nine; if they are thus constructed, they will not be fatiguing to climb. Their width should be no less than one and a half feet in depth and no more than two. The steps all around the temple should be made in the same proportions.*[22]

Monsieur Perrault is wrong, in my view, to translate the phrase *retractiones graduum* as *les paliers de repos* [(landings)]: these words, as he himself says, signify the width of the steps, and I am at a loss to understand why he abandons the true meaning of his author's text and imagines that the width of, at most, 23 of our inches that Vitruvius assigns to the widest step is more suited to landings than to steps. There are no landings so narrow in all antiquity; on the contrary, the width of the steps of the Temple of Minerva in Athens is no less than 26 inches 2 lines, and the rise is 19 inches. No doubt it was this exorbitant proportion, or some other known to him, that led Vitruvius to say that steps should be restricted to 10 inches high, to make them easier to climb. As will be seen, the ancients made the steps in front of or around their temples very high. It seems that they regarded them as an important part of the decoration of the building and made them proportionate to its size; thus, the Temple of Minerva, an extremely large building, has steps that are almost twice as large as those of the Temple of Theseus, which is about half its size.

The general plan of this temple [to Minerva Polias] is marred by two smaller temples that have been built close to its rear face. I have shown this face in plate 28. On the right is the profile of a small building that I show elsewhere drawn to a larger scale; its entablature is supported by caryatids or canephori. On the left is another, larger structure that most probably was the Temple of Pandrosos.

The three windows that can be seen through the three central intercolumniations are exactly twice as high as they are wide. Their placing in the intercolumniations shows that the architect of the temple intended the light to enter from above, as is appropriate in buildings of this sort, and all the more so in that the window, without being too large and without impairing the grandeur of the order, more or less fills the intercolumniation: the bare wall is divided into upper and lower parts in such a way that neither part becomes too large and thus the architect has no need to fill them with tablets, garlands, or other trifling ornaments, which distract the eye and commonly destroy the beauty and simplicity of the ordonnance. I have shown one of these windows drawn to a larger scale in figure 1 of plate 29. Its frame has a beautiful profile; its width is more than one-sixth the width of the opening itself. One very singular feature is the presence of crossettes: proof that this ornament was in use at an early date, since the antiquity of the building itself is vouched for.

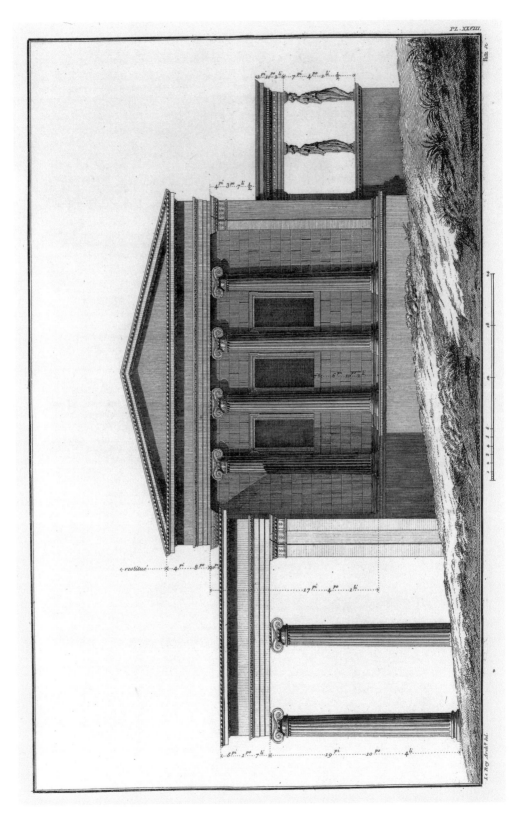

Pl. 28. Pierre Patte, after Julien-David Le Roy

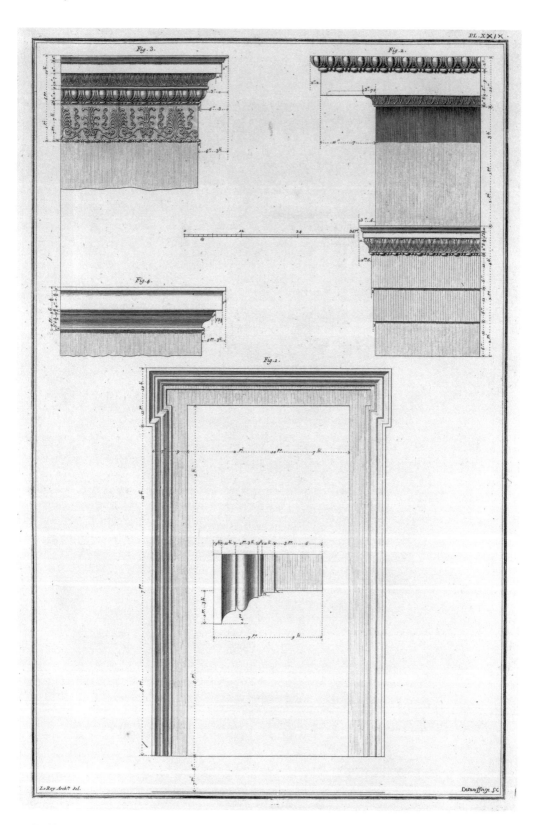

Pl. 29. Jean-François de Neufforge, after Julien-David Le Roy

The entablature on all sides of the body of the temple is of the same form as that of the Temple of Pandrosos. I have shown the latter drawn to a large scale in figure 2 of plate 29. Its architrave and frieze are proportionally very tall and its cornice very narrow, but because this last consists of very few moldings, it makes a correspondingly grand effect. The corona is large and makes a strong effect in this profile because it runs between two enriched moldings, the ovolo above it being decorated with egg and dart, and the cavetto below with water leaf. This entablature is exceptional in containing no dentils. The fasciae of its architrave are all equal—as are those on the small monument commonly known in Athens as the Lantern of Demosthenes and illustrated elsewhere in part 2. It may be that this was their original appearance, before they were made to diminish from top to bottom, as is the general custom, or from bottom to top, as in the temple at Pola in Istria.

The small cornice, figure 3, which surmounts the corner pilasters of the body of the temple and continues around the exterior below the entablature, is of a beautiful profile in general, though not without its faults; the ornaments on the bare part, between the astragal and the cornice, are very elegant. The cornice that is below this one, figure 4, is that of the continuous pedestal that supports the Ionic columns of the rear elevation; I consider that its profile deserves imitation. Undoubtedly, however, the most interesting feature of this building is its capital.

Persons versed in the arts, and in architecture in particular, who know the difficulty of devising new orders, and who are aware of the fruitless efforts made in the last century by celebrated architects spurred on by the prospect of reward, will be best placed to judge the importance for architecture of the discovery of an Ionic capital hitherto unknown.

This capital, which I have illustrated drawn to a large scale in figure 1 of plate 30, is, to my mind, an extremely beautiful one. It is superior in several respects to the finest capitals of the same order still to be seen on Roman monuments, and also to that of which Vitruvius gives us a description. I can say, therefore, that I have measured it with all the care that it deserves and that I have spared no pains in conveying its form and the relations between its minutest parts. I took my measurements from the corner capital of the Temple of Pandrosos, marked C in [figure 1 of] plate 27. The height of the capital overall, from the astragal to the top of the egg and dart that finishes it, is a little more than two-thirds of the diameter of the foot of the column; the capital's width, across the volutes, is a little less than one and two-thirds diameters. Its other proportions will be discovered by comparing the measurements on my drawings and sections.

I used no system in drawing the volute of this capital, for fear of choosing the wrong system and making a mistake; but with the greatest attention and the greatest care, I measured along its vertical and horizontal axes, placing, in each of these directions, a rule that passed exactly through the eye of the volute. Figure 2 shows all the measurements that can be taken by measuring the volute along the vertical line through the center of the eye; figure 3 all the

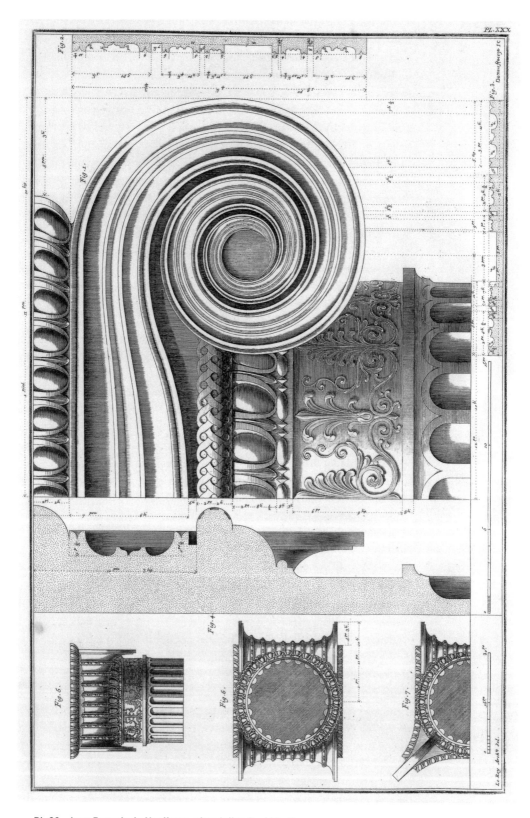

Pl. 30. Jean-François de Neufforge, after Julien-David Le Roy

measurements of the volute along a horizontal line, again through the center of the eye; and figure 4 all the measurements of the capital that can be taken along a vertical line following the axis of the column and of the capital. In figure 5 I show its profile, in figure 6 its plan, and in figure 7 half of the capital of one of the corner columns of the building.

This last figure demonstrates that the Greeks knew, as well as the Romans, what the moderns have since observed, namely, that the unaltered Ionic capital becomes highly defective at the corner of a building. In the temples of Minerva Polias and Pandrosos, they remedied this by twisting the corner volute around, as the Romans did in the temples of Fortuna Virilis and Concord in Rome, and as Michelangelo did in the capital that passes for his own invention — though it is no more than a slightly modified imitation of those just mentioned, which he could see in Rome, or perhaps of that of the Temple of Minerva Polias, which might have been known to him, since he sent pupils to draw the ruins of Greece. Having described this capital, we shall compare it with other, more modern Ionic capitals.

Figure 1 and figure 2 of plate 31 represent the capital and base of the columns of the Temple of Pandrosos; figures 3 and 4 are the profiles of the columns of the front and rear of the Temple of Minerva Polias. Figure 5 is a capital found in the ruins of the Temple of Ceres [(Telesterion)] at Eleusis; finally, figures 6 and 7 are, respectively, the capitals of the Theater of Marcellus and of the Temple of Fortuna Virilis in Rome.

Before turning my attention to the capitals of the two Greek buildings now under discussion, I have to say that the bases of the orders of these buildings do not stand on squared plinths; and I suspect that in Greece and in Italy the use of plinths at the bases goes back no further than Roman imperial times. The proof of this is that the various Corinthian bases found on the island of Delos as well as the bases of the Lantern of Demosthenes have no plinths; nor have the bases of the columns of the temples of Vesta at Tivoli or those that remain of the Temple of Concord in Rome; whereas all the monuments erected in Athens in Hadrian's time have plinths beneath the bases of their columns, as have all the later buildings in Rome.

The capital that forms the principal subject of this particular section is, as will be seen, extremely rich; it partly confirms Vitruvius's remark that the ancients made little distinction between the Ionic and the Corinthian orders. This attitude must have been even more general among the Greeks than among the Romans: in Greece, the Corinthian order quite commonly has an entablature with dentils only, as seen in Athens in the profile of the Lantern of Demosthenes; and the differences in their proportions and in the enrichment of their capitals, which is the principal distinction between the two orders, is less marked here than in Italy.

Indeed, the Ionic capital of the Temple of Minerva Polias has an astragal like that of the Corinthian; it is two-thirds of a diameter of its column, and thus it is only one-third of a diameter short of the height of a Corinthian capital. Just as the latter is adorned with leaves, the former has a necking

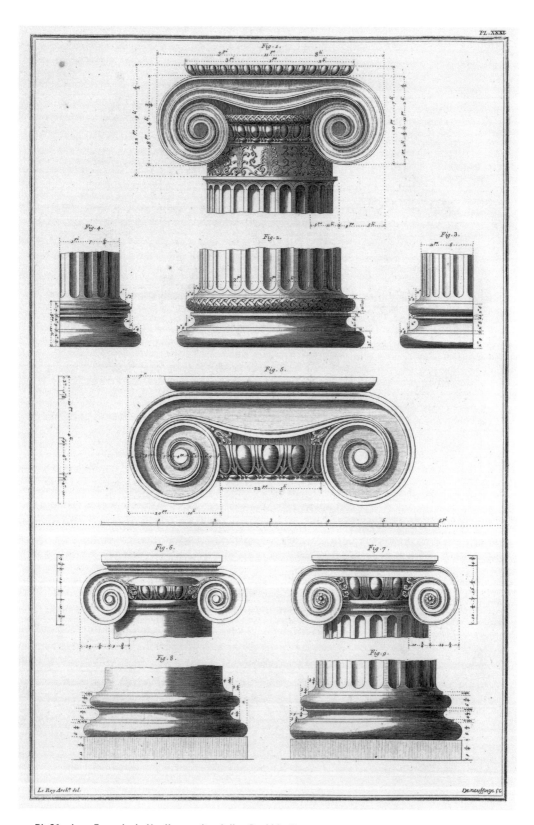

Pl. 31. Jean-François de Neufforge, after Julien-David Le Roy

enriched with a profusion of ornamental leaves and posies. This kind of orna-
ment is by no means confined exclusively to the Temple of Erechtheus: I have
seen it on capitals at Smyrna, in Asia Minor, in the house of Monsieur [Charles
de] Peyssonnel, the French consul. Furthermore, the capital from the Temple
of Minerva Polias has two ovolos enriched with egg and dart, and a finely
decorated torus. Its volute is extremely rich, the flutes of the shaft are the
same as those of the Corinthian order, and its base is one that the ancients
used indiscriminately for both orders. There is much grace in the central dip
of the volute, and this was its customary form in Greece: the capital shown in
figure 5, which I drew at Eleusis, is of the same shape, though simpler.

A glance at the two capitals at the foot of the same plate—one, marked
figure 6, from the Theater of Marcellus; the other, marked figure 7, from the
Temple of Fortuna Virilis; both traced from drawings published by [Antoine
Babuty] Desgodets—will suffice to show that they are far less rich than the
capital of the Temple of Minerva Polias. I prefer this last in many respects; but
because we are always partial toward those things that have cost much labor
to discover, I shall not positively declare that it is preferable to the others and
will pass on to remark on the small structure that adjoins the temple wall.

The Caryatid Order

The history of this order, on which we had a few words to say in our dis-
course on the history of architecture, is so curious that almost all authors have
spoken of it. We are well informed on its origins, but hitherto we have known
nothing of the proportions that the ancients observed in its use. Vitruvius
says not a word on the subject, there is no monument of this order in Rome,
and the example I give, which may well be the only one extant anywhere
in Europe, has hitherto remained unknown. We must even confess that
it is doubtful that the figures on the building in question are caryatids or
canephori. Be that as it may, there are grounds for believing that the pedestal
on which they stand and the entablature that they support are those proper to
the Caryatid order.

The structure on which the figures stand is represented to a smaller scale,
conjoined with the Temple of Minerva Polias, in the plan of that temple, fig-
ure 1 of plate 27, where it can be seen that there were six statues, equally
spaced. Four of these still adorn the front, and I have shown them to a larger
scale in figure 1 of plate 32. They are exactly alike, except that for symmetry's
sake the two on the right have the right leg advanced, and the two on the left
have the left leg advanced. These caryatids are crowned by capitals, shown
in figure 2.

The same figure shows the entablature of the order; the frieze is omitted, a
distinctive feature that may have been customary in this order among the
ancients. It is extremely tall, being more than one-third as tall as the statues
themselves. The great height of this entablature would be difficult to explain
were it not that a woman, dressed as these are, forms a mass closer in propor-
tion to a very short Doric column than to a slender Ionic column; the architect

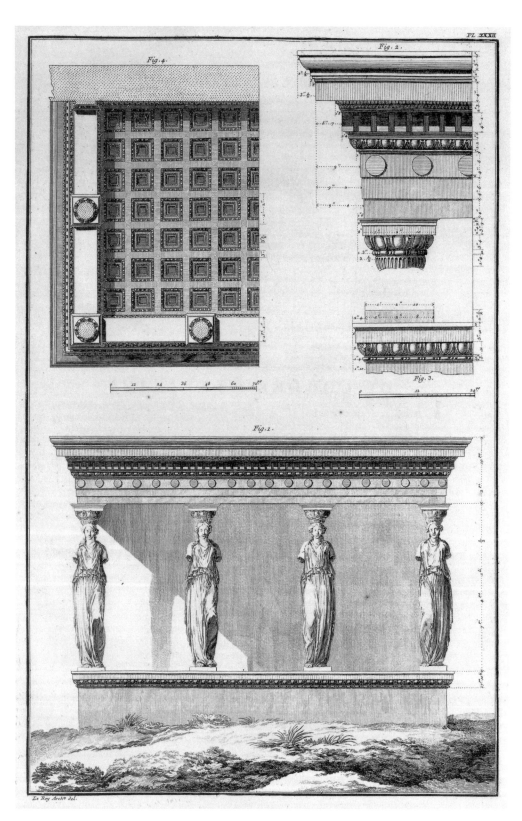

Pl. 32. After Julien-David Le Roy

of the building may well have apprehended that his entablature would appear too mean if he made it lower. Be that as it may, this entablature has a very fine profile. It has dentils in the cornice, which shows it to be Ionic; and it also has on one fascia of the architrave an ornament that creates a beautiful effect and is unknown in the other orders, namely, a regular succession of small roundels. The two upper fasciae of the architrave are equal in height, and the lowest is slightly narrower. The cornice of the great pedestal that supports the statues has a good profile. But the finest thing in this structure is undoubtedly the statues themselves. Only five of the six that must formerly have been present are still to be seen. They are of a beautiful design. Their drapery resembles that of the *Flora* that now stands in the Palazzo Farnese in Rome.[d]

The Corinthian Order

The Corinthian is the richest of the orders. The Greeks devised it last, and they always dedicated it to and employed it in those buildings that they wished to make of the greatest magnificence.

For the history of this order, as for that of the Caryatid order, the reader is referred to our essay on the history of architecture; but here we insert some remarks on the earliest monument of this order still extant in Athens. This is the monument dedicated to Lysikrates, commonly known in Athens as the Lantern of Demosthenes. In giving its history, we showed that it was built before the end of the age of Pericles; let us see what the Athenians then knew of this order, the last to be devised by the Greeks. The building is so laden with ornament as to suggest the decline of architecture rather than its impending perfection. Figure 1 of plate 33 shows its plan, taken at the level of the feet of the column shafts; figure 2 shows the design of the roof. Its elevation is shown in plate 34.

The columns are extremely slender in their proportions, being more than ten diameters high. The capital is also far taller than the common proportions of the Corinthian order. The entablature is barely more than one-fifth of the height of the column. What is most extraordinary is the crowning of the structure. Its form and its rich ornament have caused some architects, very understandably, to doubt its antiquity. I took the same view when I saw in Rome a drawing made in Athens for Lord Charlemont; but on examining and considering the monument at leisure, in the city where it stands, I changed my mind. I recognized that, beyond all doubt, the roof and the entire entablature of this edifice, including the architrave bearing an inscription that reveals that it was built in the time of Demosthenes, were fashioned at the same time.

Here I would say something about the ornament resembling a three-cornered capital that crowns the building—were it not that this discussion seems more appropriate to another place, where I shall speak of the roofs of the ancient round temples and enter into some detail concerning the Tower of the Winds. The section of the monument calls for little comment; the single slabs that fill its intercolumniations are of precisely the same height as the columns, base and capital included. In this section, I have marked the upper

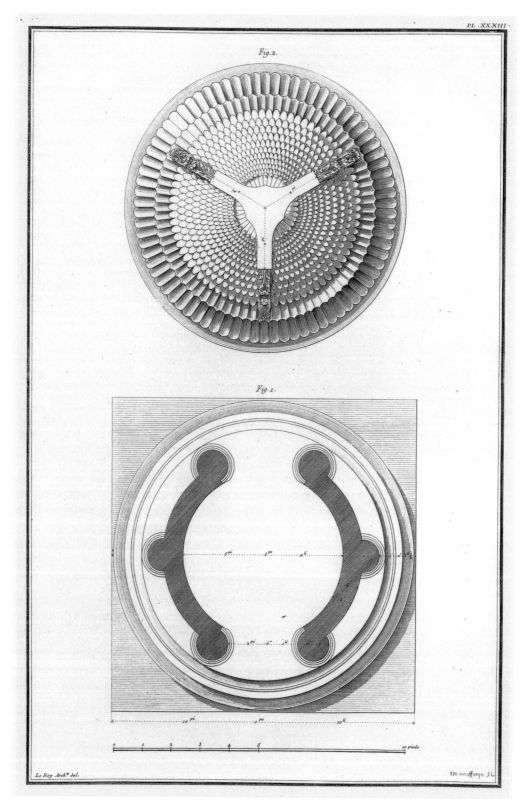

Pl. 33. Jean-François de Neufforge, after Julien-David Le Roy

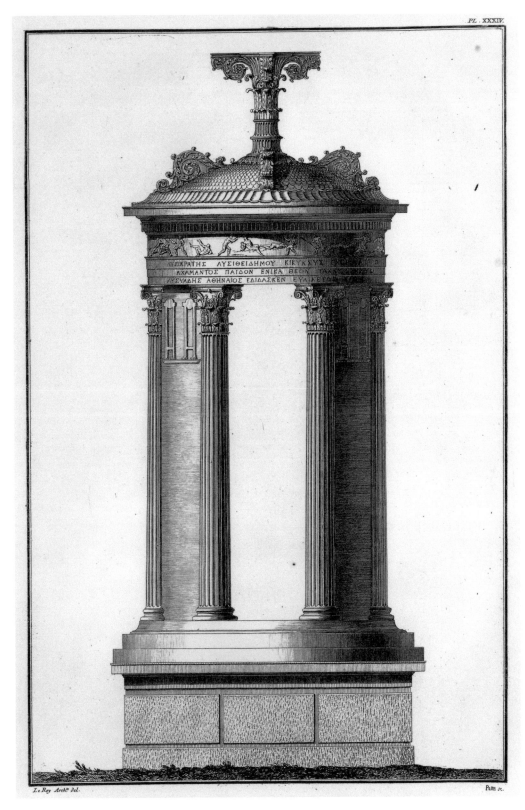

Le Roy Arch.^{te} del.

Patte sc.

Pl. 34. Pierre Patte, after Julien-David Le Roy

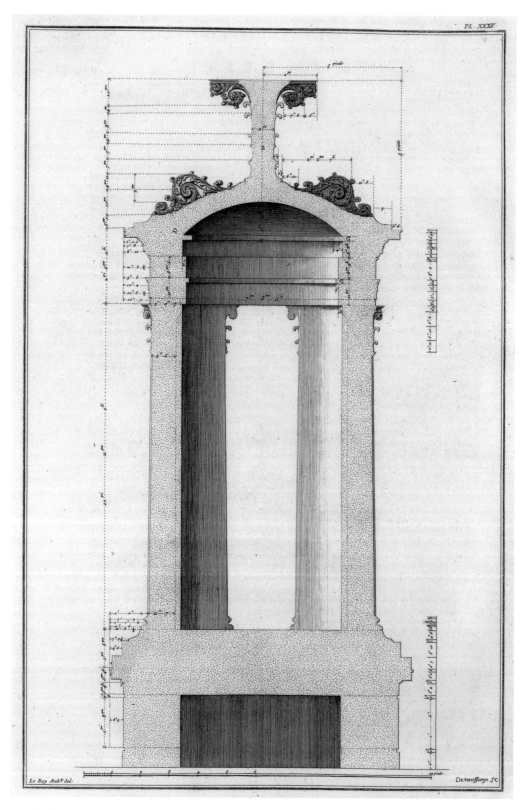

Pl. 35. Jean-François de Neufforge, after Julien-David Le Roy

and lower edges of these slabs with dotted lines, and I have also noted the dimensions of successive profiles. Both in this drawing and in the elevation, it may be seen that the cornice of the pedestal is extremely simple, that the step immediately above it projects markedly beyond the flat of the pedestal, that the column has an Attic base, and, finally, that there is no plinth, a feature already mentioned, which illustrates the antiquity of the monument.

As for the capital, I found this in too poor a state to attempt any restoration on a large scale; nothing remains of the caulicoles. Its proportions are very tall; and it is singular in that where ordinary capitals have four leaves to the half-circumference in the lower row, this capital has eight little leaves. These leaves are only half as high as those in the upper row. They also differ from the second row of leaves in that they are smooth, like water leaves, whereas those in the second row are jagged. There are four of these latter to a half-circumference, and they are separated by an ornament that I have never seen in any other capital — a kind of wheel, with seven or eight incised spokes or rays. These wheel-like objects may be seen in the capitals of the facade. The column shaft, as will have been seen, is fluted. The depth of the flutes is one-half their width. The capital is separated from the column not by an astragal but merely by a small channel.

The entablature is very light in proportion to the columns. The general division of its three parts seems to me very fine; the architrave has three precisely equal fasciae, and the whole is greatly enriched by the figures carved in the frieze. The cornice is adorned with dentils that are made very large because, though this is a Corinthian cornice, there are no modillions. The corona is fairly large, but there are several moldings between corona and dentils, and beneath the dentils, an arrangement of which architects may well disapprove. Plate 35, which shows a section of the monument, also contains the dimensions of its various profiles.

Le Roy's Notes

1. The second volume of this work offers a history and drawings [(pls. 11, 17)] of this temple.

2. *Abaci latitudo, quanta ima crassitudo columnae.* Vitr., bk. 4, chap. 7, p. 75 (ed. Laet).

"The width of the abacus," says Vitruvius, "will be equal to the diameter of the foot of the column." [Vitruvius, *De architectura* 4.7.3.]

3. In his notes on Vitruvius, bk. 4, [1st ed.,] p. 138 [n. 4].

4. Here is the passage in which, in our view, Vitruvius defines the height of the pediment: *Item, in eorum frontibus antepagmenta figantur, supraque ea tympanum fastigiis ex structura seu materia collocetur, supraque id fastigium, columen, cantherii. Templa ita collocanda, ut stillicidium tecti absoluti tertiario respondeat.* Vitr., bk. 4, chap. 7, pp. 75–76 ([ed. Laet,] Elze[virum]).

"On the beam ends that are seen on the facade of the building," says Vitruvius, "and that must be covered by revetments, raise the tympanum in masonry or in wood,

which supports the ridgepole, rafters, and purlins, in such a way that the slope of the roof is the same as that of the pediment, which must form the *tertiarium*." [Vitruvius, *De architectura* 4.7.5.]

[Many of the difficulties raised by Le Roy are avoided by translation; cf. *Vitruvius: Ten Books on Architecture*, trans. Ingrid D. Rowland (Cambridge: Cambridge Univ. Press, 1999), 61.]

5. *Mathematici verò contra disputantes, ea re perfectum esse dixerunt numerum, qui sex dicitur, quòd is numerus habet partitiones eorum rationibus sex numero convenientes: sic sextantem, unum: trientem, duo: semissem, tria: bessem quem* δίμοιρον *dicunt, quatuor: quintarium, quem* πεντάμοιρον *dicunt, quinque, perfectum sex. Cùm ad supputationem crescat, suprà sex adjecto asse,* ἔφεκτον: *cùm facta sunt octo, quod est tertia adjecta, tertiarium, qui* ἐπίτριτος *dicitur.* Vitr., bk. 3, chap. 1, p. 39.

"The mathematicians," says Vitruvius, "have maintained, contrary to Plato's opinion, that the perfect number is six, because the numbers that divide it, taken together, are equal to the number six. For the *sextans* [(one-sixth of six)] equals one; the *triens* [(one-third of six)] two; the *semissis* [(one-half of six)] three; the *bessis* [(two-thirds of six], which they call *dimoiros,* four; the *quintarius* [(five-sixths of six)], which they call *pentamoiros,* five; and the whole number six. If we continue the calculation, increasing the number, and add a sixth of the *asse* [(six)], we have the number known as *ephekton* [(seven)]. If we go as far as eight, adding one-third of the *asse,* we have the *tertiarium,* which is called *epitritos*." [Vitruvius, *De architectura* 3.1.6.]

The significance of the Greek word ἐπίτριτος [(*epitritos*)] seems to confirm our interpretation of *tertiarium,* which means in Latin what the former means in Greek: for ἐπίτριτος is made up of τρίτος [(*tritos*)], which means *third,* and ἐπί [(*epi*)], which means *on* or *over.* Thus, the word ἐπίτριτος means a number increased by one-third. One added to four, like two added to six, formed what Vitruvius called the *tertiarium.*

The marchese [Berardo] Galiani, in his Italian translation of Vitruvius, published in Naples in 1758 (which I was unable to mention in the first edition of the present work, which was published in the same year), gives a new explanation of the meaning of the word *tertiarium.* On p. 157 he says that Vitruvius meant by this that the roof of the Tuscan temple had three slopes for the water to run off, one to each side and the third at the back; but this clearly fails to convey the meaning of the word *tertiarium.* As we have shown, it does not simply mean a thing divided into three but a thing divided into three and augmented by a fourth part that is like the other three.

In our account of the Tuscan temple, we have adopted Monsieur Perrault's opinion as to the height of its entablature. Though the passage of Vitruvius in question appears to bear a different interpretation, it does seem utterly implausible that he could ever have meant the projection of the mutules in this order to be one-quarter of the height of the columns: we believe that he can only be referring to the height of the entablature.

The marchese Galiani proposes another explanation for the passage in question. On p. 156, he considers that for *quarta parte altitudinis columnae,* we should read *quarta parte latitudinis columnae;* and that Vitruvius is saying that the mutules should project one-quarter of the width of the column rather than one-quarter of its height. We do not favor this emendation: for the Latins never spoke, any more than we do, of the "width" of a cylinder, tree, or column. For this dimension of a solid they used the

term "thickness," *crassitudo,* as Vitruvius himself does six times in his account of the Tuscan temple alone. To adopt the marchese Galiani's conjecture, we should have to suppose that the copyists changed *crassitudinis* to *altitudinis,* a change so drastic as to be highly unlikely.

In saying this, I am very far from belittling the marchese Galiani's translation: on the contrary, I regard it as an excellent work—as indeed is that published in our own language by Monsieur Perrault. He has discovered some errors that had crept into the French author's work, and we shall point to a number of errors into which we believe that he himself has fallen. A perfect translation of Vitruvius can never be the work of one man alone; and it is often a greater labor to clear a piece of ground than to bring it into finished cultivation.

6. Of the proportions of the pediment of the temple *in antis,* Vitruvius has this to say: *In antis erit aedes, cùm habebit in fronte antas perietum, qui cellam circumcludunt, et inter antas in medio columnas duas, supraque fastigium symmetria ea collocatum, quae in hoc libro fuerit praescripta.* Vitr., bk. 3, chap. 1, p. 40 (ed. Laet).

"What characterizes a temple *in antis,*" says Vitruvius, "is that on its facade, it has pilasters at the ends of the walls that flank the *cella,* and in between the antae two columns that support a pediment made in the proportions given later in this book." [Vitruvius, *De architectura* 3.2.2.]

In the same book, Vitruvius does indeed go on to give the rule promised in his discussion of the temple *in antis.* This is what he says: *Tympani autem, quod est in fastigio, altitudo sic est facienda, ut frons coronae ab extremis cymatiis tota dimetiatur in partes novem, et ex eis una pars in medio cacumine tympani constituatur.* Vitr., bk. 3, chap. 3, pp. 57–58 (ed. Laet).

"The height of the tympanum of the pediment," says Vitruvius, "is to be determined thus: the length of the corona from one end of the cymatium to the other is divided into nine parts, and one of these is taken as the height of the tympanum." [Vitruvius, *De architectura* 3.5.12.]

It will be seen from these two passages, which sufficiently define the form of the temple *in antis* and the arrangement of the principal parts of its facade, that the corners of the facade were marked by two pilasters, or antae, which formed the ends of two walls that advanced to meet them; that between these antae, and on a line drawn from one to the other, there were two columns; and that the entire facade was crowned by a single pediment, the height of which was one-ninth of its width.

If we compare this idea of the temple *in antis,* which we consider to be exactly the idea given to us by Vitruvius, with the description and the drawings given by Monsieur Perrault in the second edition of his translation of Vitruvius, pp. 60–64, we find that he gives an entirely false idea of it, and a figure that, we venture to say, looks not so much like an antique temple as a Gothic building in the worst of taste.

First, he has set, p. 61, plate 8, the columns forward of the antae; whereas, according to the text, and in the opinion of Monsieur [François] Blondel, they should be in line with the antae. Without a shred of authority, he crowns them with two pediments, never seen in any ancient building; and, to justify the exorbitant height that he assigns to these, he translates *in hoc libro* by *ci-après* [(hereafter)]. He seeks the proportions of this pediment in the fourth book of Vitruvius, as will be seen from his explanation of

plate 8, p. 60; whereas, as we have seen, Vitruvius himself says that the explanation is in his third book. Finally, the pediment of the Tuscan temple, on which Monsieur Perrault models the proportions of his temple *in antis,* is not—as he alleges—tall in proportion but, as we have shown, extremely low.

The marchese Galiani has commented on Monsieur Perrault's temple *in antis* in very much the same terms as I; these remarks, which I have slightly amplified in the present edition, are such as might naturally occur to any attentive reader of Vitruvius. I would only wish that the Italian translator had not placed pedestals beneath the pilasters and columns of the temple *in antis,* as seen in figure 1 of plate 5 of his work, for pedestals are known to be a comparatively late invention. Vitruvius makes no mention of any in his temple *in antis,* and they seem inappropriate to the form of the simplest and most ancient temple that we know. On the contrary, if a characterization were desired, it seems to us that it should be figured with very short columns, with no bases and with shafts that are smooth, markedly tapering, and not separated from the capital by an astragal.

7. *Pteromatos enim ratio, et columnarum circum aedem dispositio ideò est inventa, ut aspectus propter asperitatem intercolumniorum haberet auctoritatem.* Vitr., bk. 3, chap. 2, p. 42 (ed. Laet). [Vitruvius, *De architectura* 3.3.9.]

Like most authors who have translated this passage, we render the word *asperitas* by *âpreté* [(harshness, severity)], because it seems to express quite well the striking effect of relief produced by a large number of columns ranged closely together; particularly when, in sunlight, a part of each shaft is brightly lit while the remainder is in shadow.

8. Bk. 4, chap. 3, p. 66 (ed. Laet). [Vitruvius, *De architectura* 4.3.3.] We have already cited the passage in which Vitruvius speaks of these temples, in our dissertation on the length of the Greek foot [(see p. 303 n. 89)].

9. These drawings may be seen in the work by this author entitled *Libro d'Antonio Labacco, appartenente à l'architettura, nel qual si figurano alcune notabili antiquità di Roma.* It is an early book; the edition that I cite was printed at Venice in 1576. The temple to which I refer is shown on pp. 21 and 23 of the work.

10. I call these members *marble joists*—an inappropriate term, but one that well and succinctly expresses their relation to the timbers mentioned.

11. Paus., bk. 5, chap. 10, p. 398 (ed. Kühn). [Pausanias, *Description of Greece* 5.10.3.]

12. To grasp what follows, see the figures of the pseudodipteros and dipteros shown on pp. 69 and 71, as well as a passage from Vitruvius halfway down p. 78, in Perrault's translation of Vitruvius, 2d ed.

13. *Eas autem symmetrias constituit Hermogenes, qui etiam primus octastylum pseudodipterive rationem invenit. Ex dipteri enim aedis symmetria sustulit interiores ordines columnarum XXXVIII.* Vitr., bk. 3, chap. 2, p. 42 (ed. Laet).

"Hermogenes," says Vitruvius of the intercolumniations that make the eustyle, "laid down these proportions, and he also devised the form of the pseudodipteral octastyle when he dispensed with the intermediate range of thirty-eight columns in the dipteral." [Vitruvius, *De architectura* 3.3.8.]

Monsieur Perrault translates this passage differently: "It was Hermogenes," he says,

"who discovered all these proportions, and who first devised the octastyle and the pseudodipteral manner, when he saw fit to remove from the dipteral the intermediate range of columns, which are thirty-four in number." Per[rault,] trans. of Vitr., 2d ed., p. 78.

Perrault (translation of Vitruvius, 2d ed., p. 68, in the note) supposes that in this passage the copyists put thirty-eight for the range of columns that Hermogenes eliminated from the dipteral to make the pseudodipteral, instead of thirty-four, which is what he, like Philandrier, thinks it should be. "It is not difficult to see," says he, "that this error might have been made when the scribe found in his original that the first I (of the four that follow thirty) was a little crooked, like this XXX\III, and he supposed that this I was one branch of a V, the other branch of which had been erased, and that he should write XXXVIII instead of XXXIIII."

The marchese Galiani has adopted Monsieur Perrault's conjecture on this passage, without acknowledging his indebtedness. This may be seen from the note in his work at the number 4, p. 106: *Leggesi in alcuni Codici 38. in altri 34. Pare chiaro che si abbia a leggere 34. Perchè tante, e non più sono le colonne, che formano l'ale interiori del Dittero; ed è facile il comprendere l'origine dell'errore scorso di 38. in luogo di 34. Imperciocchè scrivesi questo numero così XXXVIII. Ed ha forse potuto un imperito copista mettere un V ove era un \ com'è nel XXXIIII.* ["Some manuscripts read thirty-eight, others thirty-four. It seems clear that the true reading is thirty-four. For this, and no more, is the number of columns that form the inner ranks of the dipteral; and it is easy to understand the origin of the error of putting thirty-eight instead of thirty-four. This number is written like this: XXXVIII; and perhaps an unskillful copyist wrote a V where there was an \, as in XXX\III."]

The same author proposes another conjecture to reconcile Vitruvius's two statements: that the peripteral had fifteen return and eight face columns; and that in omitting the inner range of columns, Hermogenes removed thirty-eight. Ingenious though his conjecture is, it will be seen in figure 2 of plate 6 of the marchese Galiani's translation of Vitruvius that four columns are out of alignment with the thirty-four others. We therefore consider that our own explanation, derived from the difference we have pointed out between the lengths of the Greek and Roman temples, is simpler and should be preferred.

14. *Posteà alii in aliis operibus ad perpendiculum triglyphorum canterios prominentes projecerunt, eorumque prominentias sinuaverunt. Ex eo uti è tignorum dispositionibus triglyphi: ita è canteriorum projecturis mutulorum sub coronis ratio est inventa. Ita fere in operibus lapideis et marmoreis mutuli inclinati scalpturis deformantur quod imitatio est canteriorum. Etenim necessario propter stillicida proclinati collocantur. Ergo triglyphorum et mutulorum, in Doricis operibus, ratio ex ea imitatione est inventa.* Vitr., bk. 4, chap. 2, pp. 63–64 (ed. Laet).

Speaking of the builders who devised the various parts of the Doric entablature, Vitruvius says: "Later, in other buildings, others allowed the ends of the rafters to project, flush with the triglyphs, and they made them slope so that, the arrangement of the beams being the origin of the triglyphs, the mutules under the cornice derived from the projection of the rafters. This is why, in works of stone or marble, the mutules are carved at a slope, to imitate the slope of the rafters: a slope that is necessary if they are

to throw off the rain. Such is the origin of the triglyphs and mutules in Doric build-ings." [Vitruvius, *De architectura* 4.2.3.]

15. *Dividendae autem sunt in corona ima ad perpendiculum triglyphorum et ad medias metopas, viarum directiones, et guttarum distributiones, it uti guttae sex in lon-gitudinem, tres in latitudinem pateant: reliqua spatia, quòd longiores sunt metopae quàm triglyphi, pura reliquantur, aut fulmina scalpantur.* Vitr., bk. 4, chap. 3, p. 67 (ed. Laet).

We consider that this passage must be construed as follows: "On the underside of the cornice, viae are to be cut, perpendicular to the triglyphs and above the centers of the metopes, and the guttae are to be distributed in such a way that there are six in length and three in breadth; the remaining spaces, by which the width of the metopes exceeds that of the triglyphs, will be left bare, or else carved with thunderbolts." [Vitruvius, *De architectura* 4.3.6.]

16. This fragment was brought to my attention by Messrs. [Pierre-Louis] Moreau[-Desproux] and [Charles] de Wailly; they drew it while they were *pensionnaires du roi* in Rome [at the Académie de France], while making a particular study of Hadrian's Villa. Both are now members of the Académie [royale] d'architecture, and their work enjoys a high reputation. [The fragments drawn by *pensionnaires* Moreau-Desproux, de Wailly, and Marie-Joseph Peyre at conte Fede's villa, built on the ruins of Hadrian's Villa at Tivoli, are described in Joseph Jérôme Le François de Lalande's *Voyage d'un françois en Italie,* vol. 5, chap. 20.]

In his translation of Vitruvius, the marchese Galiani makes the same mistake as Monsieur Perrault: they fail to put mutules above the centers of the metopes, or at least guttae distributed in the place they should occupy, as Vitruvius's text demands. See what the Italian translator says in the notes to his p. 142 and see also figure 3 of his plate 11; it will be seen that he has placed thunderbolts where there ought to be guttae.

17. Here is the passage in which Vitruvius defines the height of these columns; the translation will be found two paragraphs back. *Circà theatra sunt porticus et ambula-tiones, quae videntur ita opportere collocari, uti duplices sint, habeantque exteriores columnas Doricas cum epistyliis et ornamentis, ex ratione modulationis Doricae per-fectas. Latitudines autem earum ita oportere fieri vedentur, uti quanta altitudine columnae fuerint exteriores, tantam latitudinem habeant ab inferiore parte colum-narum extremarum ad medias, et medianis ad parietes, qui circumcludant porticûs ambulationes. Medianae autem columnae quinta parte altiores sint, quàm exteriores, sed aut Ionico, aut Corinthio genere deformentur.* Vitr., bk. 5, chap. 9, p. 92 (ed. Laet). [Vitruvius, *De architectura* 5.9.2.]

It has been seen how Monsieur Perrault explains *Medianae autem columnae quinta parte altiores sint.* His emendation is adopted by the marchese Galiani, as is to be see in note 4 on p. 199 of his translation. But if he had possessed an intimate knowledge of the Propylaia, we have no doubt that he would have taken a different view and would have agreed with us that the text was not corrupt. On examining Vitruvius closely, and on comparing what he says with the buildings of the Greeks, I conclude that this author has been at least as badly corrupted by those commentators who have under-taken to correct him where no correction was necessary, as he has been by the copyists of his manuscript.

18. We shall give the text of this passage in its entirety: *Namque si in araeostylo nona aut decima pars crassitudinis fuerit, tenuis et exilis apparebit: ideò quod per latitudinem intercolumniorum aër consumit et imminuit aspectui scaporum crassitudinem. Contra verò pycnostylis si octava pars crassitudinis fuerit, propter crebritatem et angustias intercolumniorum, tumidam et invenustam efficiet speciem.* Vitr., bk. 3, chap. 2, p. 43 (ed. Laet). [Vitruvius, *De architectura* 3.3.11.]

19. The latter was the view taken by Perrault, in his figures depicting the various intercolumniations.

20. In his *Cours d'architecture* [(vol. 2, pp. 183–84; Le Roy has condensed a few paragraphs from pt. 3, bk. 1, chap. 2)]. There have been several architects of this name. The artist of whom we speak [(François Blondel)] was maréchal des camps et armées du roi [and a member] of the Académie royale des sciences and of the Académie royale d'architecture. He was deeply versed in literature, a very learned mathematician, and a very great architect. On several occasions, he was entrusted with negotiations at foreign courts. He has left us a learned treatise on the trajectory of bombs. His greatness as an architect is proved by the Porte Saint-Denis, a magnificent triumphal arch erected to glorify Louis XIV, in whose reign he lived. It is these combined talents, no doubt, that have led his fellow architects to give him the epithet *Grand*. It is his *Cours* that we have often cited, and will continue to cite, in the course of this work.

Monsieur [Jean-François] Blondel, architecte du roi and controlleur de l'École militaire, who died not long ago, was also highly esteemed; and Monsieur [Jacques-François] Blondel, his nephew, well known for a number of published books, is architecte du roi and professor at his Académie royale d'architecture.

[The Blondels to whom Le Roy refers are *François Blondel* (1617–86), first director of the Académie royale d'architecture, author of the *Cours d'architecture* first published in 1675 in two folio volumes, and architect of several of the gates of Paris, notably the Porte Saint-Denis, and the rope works at Rochefort-sur-mer; *Jean-François Blondel* (1683–1756), member of the Académie royale d'architecture from 1728 and architect of the communion chapel added to Saint-Jean en Grève in Paris, though his best-known works are a series of houses and villas in Geneva and its surrounds; and his nephew, Le Roy's mentor, *Jacques-François Blondel* (1705–74), professor of architecture at the school of the Académie royale d'architecture from 1762 until his death, author of a number of widely read books, in particular the *Cours d'architecture*, issued in six octavo volumes from 1771 to 1777 (the last two finished off by Pierre Patte), and designer of the Place d'Armes (Place Saint-Etienne) at Metz, but best remembered for his teaching. The first two are hopelessly muddled in the *Dictionnaire de biographie française*, edited by Jules Balteau, Marius Barroux, and Michel Prévost.]

21. *Aedium Ionicarum, quàm aptissimè potui, dispositiones hoc volumine descripsi, Doricarum autem, et Corinthiarum, quae sint proportiones, in sequenti libro explicabo.* Vitr., bk. 3, chap. 3, p. 58. [Vitruvius, *De architectura* 3.5.15.]

22. *Crassitudines autem eorum graduum ita finiendas censeo, ut neque crassiores dextante, neque tenuiores dodrante sint collocatae: sic enim durus non erit ascensus. Retractiones autem graduum, nec minus quàm sesquipedales, nec plus quàm bipedales faciendae videntur. Item si circà aedem gradus futuri sunt, ad eumdem modum fieri debent.* Vitr., bk. 3, chap. 3, p. 55 (ed. Laet). [Vitruvius, *De architectura* 3.4.4.]

Monsieur Perrault translates this passage as follows: "The thickness of the steps, in my opinion, must not be more than ten inches, or less than nine; for this height will make the climb an easy one. *The landings* must be neither narrower than a foot and half nor wider than two; and if steps be made all around the temple, they must be of the same width throughout." [Perrault,] trans. of Vitr., 2d ed., p. 86.

In his translation, Monsieur Perrault has failed to render the sense of the words *Item si circà aedem gradus futuri sunt, ad eumdem modum fieri debent.* Here, Vitruvius is saying that if steps be built all around the temples, they should not be less than [nine] or more than [ten] inches high; not less than a foot and a half or more than two feet wide — like those that lead up to the temples and are flanked by pedestals, those to which he seems to refer at the outset. Whereas, according to Monsieur Perrault's version, Vitruvius's last Latin sentence seems to say no more than that the steps that go all around a temple should all be of equal height.

In his translation, the marchese Galiani renders this passage with perfect accuracy; see p. 113 and notes 6 and 7 in his work.

Editorial Notes

a. See the series of publications on the excavations at Corinth issued, since 1929, by the American School of Classical Studies in Athens. On the Temple of Apollo, see E. Østby, "Corinto e l'architettura dorica dell'Occidente," in *Corinto e l'Occidente: Atti del trentaquattresimo convegno di studi sulla Magna Grecia* (Taranto: Istituto per la Storia e l'Archeologia della Magna Grecia, 1995), 211–27. For sources on Thoricus, see note c on p. 305.

b. In modern readings, the eustyle is nine and one-half diameters high, not eight and one-half; see *Vitruvius: Ten Books on Architecture,* trans. Ingrid D. Rowland (Cambridge: Cambridge Univ. Press, 1999), 50.

c. See Gorham Phillips Stevens and James Morton Paton, *The Erechtheum: Measured, Drawn, and Restored,* 2 vols. (Cambridge: Harvard Univ. Press, 1927); and Andreas Scholl, *Die Korenhalle des Erechtheion auf der Akropolis: Frauen für den Staat* (Frankfurt am Main: Fischer Taschenbuch, 1998).

d. The *Flora Farnese,* now at the Museo Archeologico Nazionale di Napoli, stood in the courtyard of the Palazzo Farnese until 1787. Evidence of it can be found in drawings of 1532 by Maerten van Heemskerck. Today it is thought to be the copy of a fourth century B.C. Roman Aphrodite. See Francis Haskell and Nicholas Penny, *Taste and the Antique: The Lure of Classical Sculpture, 1500–1900* (New Haven: Yale Univ. Press, 1981), 217–19.

List of what is contained in the first volume of this work

Volume Two

Which Contains the Ruins of the Monuments Erected by the Athenians after the End of the Age of Pericles and the Antiquities of Corinth and Sparta

With an Essay on the Theory of Architecture, and a Dissertation on the Length of the Course at Olympia

Essay on the Theory of Architecture

*The Different Categories to Which Architectural Principles May Be
Assigned, and the Degrees of Certainty Attached to Such Principles*
Principles in general are a small number of truths or of essential and fertile
notions that we either perceive in nature or derive from the sciences and arts
in which they serve as our guides. Their degree of certainty varies according to
the object of the science or art to which they belong; it varies, indeed, even
within a single science or art. This last is a truth of which writers on archi-
tecture seem to have been insufficiently aware: some, struck by the obvious-
ness of many of its principles, have treated all of them as certainties; while
others, with an eye to those least solidly established, have dismissed them all
as arbitrary.

The object of the present essay is to define, as far as possible, the true prin-
ciples of this art: to distinguish between those that are constant and incum-
bent on any artist who undertakes to build a structure worthy of public
approbation and those that may sometimes be relaxed. A proper understand-
ing of these principles would help us avoid two highly dangerous pitfalls in
architecture: that of accepting no rules and taking caprice as our sole guide in
the composition of monuments; and that of accepting too many, fettering the
architect's imagination and reducing this noble art to a kind of craft, confined
to the blind copying of a few ancient architects.

The principles of architecture may be divided into three classes: those that
all men admit without exception and that may be regarded as axioms; those
others that, though somewhat less certain, are nevertheless adopted either by
all peoples on Earth or solely by the most enlightened nations, past and pres-
ent; and, finally, those of a third, less general kind that are accepted only by
some peoples and that depend on the climates in which people live, the mate-
rials they possess, their power, their customs, and sometimes their caprices.

Among the axioms of architecture are the following principles: an edifice,
whatever its nature, must be well built; a dwelling must be situated in a healthy
place; a building must be constructed in the manner most appropriate to the
use for which it is intended. Then there are principles founded on the laws of
mechanics: in a building, the floors must be parallel to one another and to the
horizon; the loads must be uniformly distributed over the equivalent supports
bearing them; pillars that bear loads, whatever the material of which they are
made, must be perpendicular to the horizon; and so forth.

These principles have been accepted in all ages and by all peoples; they are accepted to this day and always will be; they are obvious enough to need no proof. This is not true of those in our second class, which constitute what we call beauty in architecture. These are less general and less certain. The principles of the first class contribute to our own preservation and welfare; those of the second pursue an end that is less essential, though still of the greatest interest to us: they tend to enhance our pleasures by agreeably affecting our organs of sight, the most precious of our senses. Let us therefore inquire into the nature of these principles. It seems that they may be reduced to the following: those that depend on the nature of the soul and of the sense of sight; those that pertain to our habitual response to the sight of the objects of nature; and, finally, those that seem to be connected with the general system of science and art, devised or perfected by the Greeks and adopted by all the enlightened nations of Europe.

Principles of Architecture That Depend on the Nature of Our Soul and of Our Sight; and First of All on the Beauty of Peristyles

Whatever the cause of the sensations that architecture inspires, it is undoubtedly the nature, force, or quantity of those sensations that prompts our judgment of those buildings that come to our attention. Often when the fine proportions of the parts of a building attract the eye, we traverse it from end to end, we observe all its parts and its details with a delight almost equal to that inspired by the most beautiful sights in nature. Sometimes, again, the grandeur of the divisions of the exterior or the interior of a building, the relief of its parts, the great space that it occupies, and its prodigious height produce a strong impression on the soul. Again, a multitude of small and disparate objects offered all at once to the eye affords us a multiplicity of mild sensations; while a small number of large objects presented from new aspects multiply the pleasing or strong sensations that we receive from the most beautiful decorations.

These three qualities—the pleasantness, the strength, and the variety of the sensations conveyed to us by architecture—though rarely combined in a single building, are the causes that make architecture beautiful. We shall show how they are to be found in peristyles in particular and how some peristyles reveal more of these qualities than others.

There are several ways of dividing surfaces in architecture. Round or square openings may be pierced through walls or left in the course of building but in such small numbers that our general impression of the surface differs little from that of a plain wall; or else these openings may be so large that the impression of the plain wall is greatly modified by that of the objects that we discover in or through the openings; or, finally, the surface divisions may be of an entirely different kind, giving no impression of holes pierced or left in the wall: this is the case when those divisions consist of rows of columns, together with the spaces between them. Let us consider which of these two different kinds of surface division conveys the more pleasurable sensations.

The earliest use of columns in architecture, as is well known, was to support lintels and ceilings; but it was not long before it was recognized how much they enhanced the appearance of the buildings for which they were so necessary. If the beauty of their effect had not been recognized from the remotest antiquity, why should the Egyptians have used columns to mark the grandest and finest divisions of their temples? And why should they have used them in such profusion? Whatever could have induced the Greeks and the Romans to adorn the exteriors, interiors, and enclosures of temples, squares, theaters, and other buildings with them? Why, again, do all the enlightened nations of Europe regard the orders as the source of the greatest beauties of architecture; and peristyles and columns as the class of decoration in which the orders are used in the greatest accord with their origins and with the most success? The peoples most celebrated for their architecture may sometimes have been induced by requirements of firmness or shelter or economy or by other causes to build porticoes; but it is nonetheless certain — it is nonetheless proved by the facts — that they have always preferred peristyles with these porticoes and that these, of all forms of decoration, afford us the most pleasing sensations.

This is not the only advantage of peristylar ornaments: almost infallibly, they supply the grandeur that alone can affect us powerfully and without which even the purest architecture commands but little of our attention.

All grand spectacles impress the human race. The immensity of the sky, the vast expanse of land or sea, which we discover from the peaks of mountains or from the middle of the ocean, seem to elevate our souls and expand our thoughts. The grandest of our own works impress us in the same way: on seeing them, we receive powerful sensations, far superior to those — pleasing, at best — that we receive from small buildings. This is not to say that the impression conveyed by a building is always proportionate to its size; it often depends as much on the divisions within its masses or its surfaces as on their dimensions.

Let us, for example, imagine the interior of the Roman Pantheon divided into a large number of chapels, only one of which can be seen at a time, and its frontispiece composed of several diminutive orders. The interior would give us nothing but a great number of feeble and successive sensations; the frontispiece, a great number of feeble and simultaneous sensations; whereas, in its present state, the entire scope of the interior of the building, which we discover in one glance, the height of the columns in the portico, their number, the number of intervals between them, and all that we see in the portico's depths make the strongest impression on us. This same impression is so much reinforced by the individual sensations that we receive from all the objects and from all the effects of light afforded by the depth of the portico that our souls are more strongly affected by the frontispiece of the Pantheon than by that of Saint Peter's, though there the columns of the porch are very much stouter and taller. These otherwise differ from those of the Pantheon only in one respect: being engaged in the wall, they give us none of the striking effects that arise from the depth of a peristyle. These two facades convey such

markedly different impressions that we have no hesitation in saying that the difference impresses itself on most of those who see them. This example, along with a great many others of the same nature, immediately demonstrates the ability of peristylar ornaments to endow buildings with the grandeur and the majesty that heightens their other perfections.

We have shown that too many divisions impair the beauty of a building; it remains to show the faults that arise from too few. Imagine the entire surface of the portico of the Pantheon[1] to be a smooth wall, without any decoration, and with only one diminutive door in the center; the sight of this smooth surface would certainly not affect us nearly as strongly as the sight of the same surface divided by eight columns and by all that is seen through the seven intervals between them—which seems to prove that the decoration of the frontispiece of the Pantheon would lose some of its beauty if the parts that compose it were made smaller and too numerous or if their number were very much diminished.

It will be seen from this that for any given surface, the number of divisions that will produce the greatest effects is confined within rather narrow limits and is equally remote from the two extremes that, while opposed, approach each other in effect: that in which, with no division indicated, there would be no decoration at all; and that in which the division would become infinite and thus escape our notice entirely. Taking division too far, as Monsieur [Charles-Louis de Secondat, baron] de Montesquieu astutely remarks, produces an effect contrary to that intended: the parts, diminished in direct proportion to their numbers, would produce weaker sensations; they would destroy one another, both by their sheer quantity and by the confusion that they would create, and we should remain unmoved.

This is the principle that leads painters to compose their pictures with a few figures that affect us strongly rather than multiplying the figures and sharing our attention out among a great many objects. A similar delicate observation of the span of attention of which most men are capable leads celebrated poets or musicians with a few hours at their disposal for a performance to seek to arouse a few emotions very strongly; those who lack taste vary too often the manner in which they affect us and never succeed in moving us at all.

The scale of the solids or surfaces generally allotted to the architect who is to decorate a building is a constraint of the same nature as the limitation of time imposed on the poets and musicians who work for the theater. They share also the impossibility of producing at first sight as many strong sensations as might be desired, for the soul itself is incapable of receiving very many at one time. The architect's art, like the poet's, lies in multiplying these sensations by making them successive—rather than in restricting them, as the painter does, to those that a picture can give in a single instant. As Monsieur [Jean-François] Marmontel says in his *Poétique [françoise]*, a poem that offers the imagination a succession of varied images interests us more than a picture that shows us only a single moment taken from nature; and perhaps it is

because poetry keeps the soul in motion—as it were—that we prefer it to painting.

On comparing architecture with these two arts, we find that often, like painting, it offers an image that does not change but sometimes, like poetry, it offers a varied succession of images. Consider, for example, two facades: one made up of columns that touch a wall, the other of columns that stand some way clear of it to form a colonnade; and suppose, also, that in both cases the intercolumniations are equal and decorated in the same way. The latter facade will possess a real beauty that the other will lack, namely, the varied and striking views that its columns present to the spectator as they jut out from the back wall of the colonnade. This property of multiplying, without enfeebling, the sensations that we receive at the sight of a building is one more notable advantage that is more evident in colonnades than in any other species of decoration. A comparison—a telling one, in our view—will make this apparent.

If you walk in a garden along and at some distance from a row of trees, regularly planted so that their trunks touch a wall pierced by arched openings, the apparent relation between trees and arches will change almost imperceptibly, and your soul will receive no new sensation, though you keep your eyes fixed on the trees and the openings in the wall and though you cover a considerable distance in a short time. But if the line of trees is set at a distance from the wall, you may walk in just the same way and enjoy a new view at every successive step as the trees mask a different section of the wall. At one moment, you will see the trees divide the arches into two equal parts; a moment later, they will divide them unequally or leave them entirely clear and mask only the intervals between them. As you move closer or farther away, the top of the wall will appear to rise level with the lowest branches or to intersect the trunks at widely differing heights. And so, though we have assumed the wall to be regularly decorated and the trees equally spaced, the former scheme will seem immobile, while the latter will come to life as the spectator moves, presenting him with a succession of highly varied views created by the infinity of possible combinations of the simple objects that he perceives.

These opposite effects, which arise solely from changing the position of a line of trees in relation to an arcaded wall, exemplify the contrast that we have sought to convey between the monotonous effect of columns touching a decorated wall and the rich variety produced by columns forming a colonnade. In the former case, suppose the intercolumniations to be adorned with niches, figures, and bas-reliefs: all the enrichment lavished on this decorative scheme—since it remains almost unchanged, whatever efforts we make to observe it from different angles—will soon lead us to turn our backs on a spectacle in which the soul, having seen everything at the first instant, looks in vain for something new with which to occupy itself. In the latter case, by contrast, the magnificence of the soffits, added to that of the back wall of the peristyle, will as it were renew itself at every instant: it will present a thousand different faces to the spectator and will richly compensate his efforts to find all the possible views of the colonnade by constantly offering him new beauties.

But to gain a better idea of the different effects produced by colonnades and of their superiority to the decorations that are composed merely of pilasters, let us seize the opportunity that Monsieur [Abel-François Poisson de Vandières,] marquis de Marigny, has afforded us of seeing, from every angle, the finest piece of architecture in Europe.[a] Run your eye along the full extent of the colonnade of the Louvre while walking the length of the row of houses opposite; stand back to take in the whole; then come close enough to discern the richness of its soffit, its niches, its medallions; catch the moment when the Sun's rays add the most striking effects by picking out certain parts while plunging others in shadow: how many enchanting views are supplied by the magnificence of the back wall of this colonnade combined in a thousand different ways with the pleasing outline of the columns in front of it and with the fall of the light! The rich variety of this spectacle appears to its greatest advantage when we compare it with the riverside elevation. Try to find new views in that array of pilasters, which are set at very much the same intervals as the columns of the peristyle; you will see, in contrast, only a kind of frigid and monotonous ornament that even sunlight, which brings all nature to life, can hardly change.

Even after several hours, the spectator will not exhaust the prospects afforded by the colonnade of the Louvre; indeed, new ones will appear at every hour of the day. Every new position of the Sun causes the shadows of the columns or of the soffit they support to fall on different parts of the wall; just as every change in its altitude will cause their shadows to rise or fall against the back of the colonnade.

This last-named source of variety in colonnades, born of the effects of light, is almost enough in itself, when they are well situated and built in good climates. There, lit by sunlight through almost every hour of the day, they have less need of richly decorated rear walls to hold the spectator's attention. In contrast, in those countries where the sky is always overcast, nature supplies less animation; and the architect must draw on other resources for the variety that will cause his colonnades to give constant pleasure. By enriching the walls behind them, he succeeds in overcoming the monotony that might arise when their decorations are uniformly lit.

To these general remarks on the beauty of the views that colonnades offer to the spectator who sees them from different angles, we shall add some important and detailed reflections concerning his perceptions on seeing them from a great distance, on drawing close, and on walking beneath them.

When we want to appreciate a colonnade as a whole, we are obliged to stand well back, in order to embrace the whole mass of it; then our movements make little apparent change in the positions of the discrete solids of which it is composed. As we come closer, our view alters. The mass of the building as a whole escapes us, but we are compensated by our closeness to the columns; as we change position, we create changes of view that are more striking, more rapid, and more varied. But if we enter beneath the colonnade itself, an entirely new spectacle offers itself to our eyes: every step we take

adds change and variety to the relation between the positions of the columns and the scene outside the colonnade, whether this be a landscape, or the picturesque disposition of the houses of a city, or the magnificence of an interior.

These two last classes of beauty, born of the spectator's closeness to the columns of the colonnade, are characteristic of the colonnade as it is used in interiors. Inside a temple or a church, however large, the spectator generally takes in almost the entire volume of the space at a glance; and, as he is always standing very close to a number of rows of columns, and as the walls that he sees beyond are commonly far richer and more complicated than those of external colonnades, his slightest movements produce the most striking changes in his view of the interior. In short, so universal is the beauty derived from such colonnades that it would remain apparent even if their constituent pillars were not superb Corinthian columns but mere trunks of trees, cut off above the roots and below the springing of the boughs; or if they were copied from those of the Egyptians or the Chinese; or even if they represented no more than a confused cluster of diminutive Gothic shafts or the massive, square piers of our porticoes.

The effect of these supports is indeed enhanced or diminished by their form, by the number of them within a set space, by their relationship to the intervals that separate them, by their varying distances from the backgrounds from which they project, and above all by the quantity of divisions created in the backgrounds. They compel us to vary the proportions of the principal parts of the interior according to the form and spacing of the pillars that mark its divisions; and their general effect, combined with other causes that we shall now examine, may tend to make those interiors seem either smaller or larger than they are.

That Errors Imposed by Our Manner of Seeing Cause Certain Interiors to Appear Larger or Smaller than They Are

Sight, the most precious of our senses, is not always the most faithful. In childhood we are very imperfect judges of the forms and sizes of objects. The man blind from birth to whom [William] Cheselden imparted the gift of sight at the very age at which our vision is at its most perfect began by almost invariably misjudging the forms that presented themselves to his gaze. A novice in the art of seeing, he frequently used the sense of touch to correct the errors into which he was led by sight. Whatever facility we may eventually acquire in judging the shapes, colors, and sizes of the objects that we see, at times our own judgments are no more certain than those of Cheselden's blind man. How often do we realize that our eyes deceive us! Why do the Sun and the Moon seem far larger on the horizon than they do at the zenith? What makes a place appear immense when its true extent is modest? And what is it that sometimes makes a very large place seem far smaller than it is?

It is easy to verify by experience how much we tend to fall into similar errors; but it is not so easy to discover why this is so. The most plausible conjectures yet proposed ascribe such errors to the comparisons that we draw

between one object and another. When we see the Moon or the Sun on the horizon, we compare it with the various terrestrial objects visible at the same time; and their smallness causes the Moon, Sun, and stars to seem very large. When we look at the same celestial bodies at the zenith, we have no points of comparison, and they appear smaller by comparison with the vastness of the sky. The error in such cases stems from our own judgment, not from any optical phenomenon, as is proved when we use a micrometer to measure the size of the Moon on the horizon as seen through a telescope. It then seems smaller than when it is measured through the same telescope at the zenith, which is as it should be, since at the zenith, it is closer to us by one-half of the diameter of Earth.

Our comparisons between objects seen at the same time thus exert a considerable influence on our assessment of their respective sizes. Let us see what we can learn from this much-confirmed observation in regard to the decoration of the interiors or exteriors of buildings.

In exterior decoration, three separate factors may affect our judgment of the same mass: the relationship between its different dimensions; the ways in which it is divided; and a comparison with the objects around it, such as houses, trees, men, or animals, the approximate size of which we know. Only two of these factors normally enter into our judgment of the size and principal dimensions of an indoor space: we compare dimensions with one another, and we compare them with the significant divisions effected there. Unless men or other beings of known size chance by, external objects have no bearing on our judgment, since we do not perceive them. And so, in judging the size of an interior without the aid of external objects, the mind often falls into very considerable error.

As nearly all travelers affirm, the Carthusian church[b] in Rome, like the Pantheon and Hagia Sophia in Constantinople, has the quality of appearing larger than it is. It is significant that its vaults are comparatively low in relation to their span or — which is the same thing — that their height is short in relation to their width. At Saint Peter's in Rome, the opposite effect is perceived: when we enter the basilica, it does not seem remotely as large as we discover it to be after contemplating its interior for some time. In general, its parts are very much taller in relation to their width than those of the three churches just mentioned. It would seem to follow from these two observations that in order to make the interior of a church appear very large, one should in general take care not to make the naves or other parts of the interior too high in relation to their width. However, these relations between height and width as a means of making an interior seem larger are not the same in all the systems of decoration that can be employed.

For instance, where a nave is formed by arched openings and the piers that separate the arches are very large in proportion to the openings, the nave ought certainly to be made lower than if it were decorated with more widely spaced columns: because, in the former case, the eye, blocked by the considerable masses that separate the arches, would, as it were, compare only the true

width of the nave with its height; in the latter case, the eye, passing through the wide intercolumniations to perceive the extensive spaces of the aisles, would compare all the space that it could see with the height of the nave, and the width would then seem very much greater in relation to the height. It is probably this comparison, involuntary on the spectator's part, between horizontal extent and vertical space, that causes Gothic naves—tall though they are—not to seem excessively so: being supported by columns whose diameter is slight in relation to the surrounding space, they allow us to see a great part of the extent or void of the aisles. No doubt for the same reason, the chapel at Versailles, which is lined with columns, does not appear so narrow as it really is, and indeed seems wider above than below; this is a consequence of the different decoration of the upper and lower parts, and thus goes to prove our contention.

No doubt the ratio between the size of parts such as columns, intercolumniations, piers, or arches, on one hand, and the dimensions of a nave or of the whole church, on the other, contributes considerably to making it seem larger or smaller than it is. But it is hard to determine accurately—or even approximately—those proportional relations between part and whole that would generally give an interior the appearance of great size. No precise statement can be ventured on this subject without the support of more observations than we could ever make. It may be that the interiors of Sainte-Geneviève and the Madeleine, which are of approximately the same size and are both decorated with columns but are fundamentally different in design, will cast some light for us upon this interesting branch of architecture.

The Greater or Lesser Dimensions of Objects Diminish at Different Rates in Accordance with Their Distance from the Spectator and with Their Color

There can be few who have not had occasion to observe that small objects are lost to view at a distance at which larger objects can still be seen. If an eagle and a lark soar aloft together until they seem to vanish into the clouds, the eagle will still be visible after the lark has gone out of sight. Its size is thus the cause that makes it disappear later than the smaller bird. Great masses are lost to view later and at greater distances than small masses. When seen far off, small masses diminish more rapidly than large masses; for there is no proportion, no relation of magnitude, between an object that one can no longer see at all and an object that one can simply see smaller.

If we apply to the extreme dimensions of a single solid what we have just found to be the case with separate solids, the same effects necessarily ensue. The largest dimensions will diminish less rapidly than the smallest; and this is just what we observe every day. The man whom we see far off, outlined against the sky, seems of a more slender shape than he truly is, because his height is a larger dimension than his width, and the latter dimension would, as it were, disappear while the former was still visible.

All painters know the optical phenomenon that we have just described,

namely, that men seen from a distance appear more slightly built. Any observant person will have been struck by it. If we were to make the same observations using other solid objects — for example, if we were to erect isolated columns of very slender proportions on a mountain peak — this optical phenomenon would be all the more striking, and it would be even more evident that at great distances small dimensions diminish more rapidly than large dimensions. Since nature does not proceed by leaps, this diminution must appear progressively, as the spectator moves from the closest to the farthest point of observation.

This extraordinary and yet well-attested phenomenon seems to shed some light on the cause of another optical phenomenon, no less surprising for being very common. A man seems more slender in the leg and waist when dressed in black than when dressed in white. Now, if black makes the girth of the body appear less, why does it not also seem to reduce the length? Why, if the leg seems less stout when clad in black, does it not also appear shorter? Is this not because — black being, of all colors, that which absorbs the most rays of light — a black object at a rather small distance away is almost like a remote object whose the greater dimension diminishes less rapidly than the lesser? For there is no explaining this phenomenon unless we find a cause that will make the various dimensions of the same object diminish at differing rates.

If various dimensions of solids diminish at different rates at great distances, if these same dimensions appear to vary in proportion to the quantity of rays of light that strike the solids or in proportion to the ability of the colors of their surfaces to reflect such rays, then this recognized and well-studied phenomenon undoubtedly could lead to a number of general principles widely applicable to the art of architecture. We shall not undertake here to examine these principles, which derive from the nature of our sensory organs. Having afforded a glimpse of them, we pass on to examine those principles that spring from habits contracted from the sight of the varied objects of nature.

Architectural Principles Derived from the Habits that Human Beings Contract on Seeing the Varied Objects of Nature

Kind nature has impressed on the human heart a fervent love for most of the objects that first presented themselves to our senses. We all love our place of birth, our close relatives, our neighbors, those with whom we lived as children. These were the objects that instilled in us the first ideas of our existence, that developed them, and that made us aware of all the faculties of our being; to be deprived of them causes a distress so palpable that we fall at times into the most atrocious lethargy. The presence of these same objects, by contrast, moves us so powerfully and so pleasurably — gives us on occasion so lively a sense of delight — that it recalls us to life.

This love that human beings feel for the places where they were born and for most of the objects that first caught their attention often comes as a great surprise to those who have not received either the same impressions or such frequent impressions of the same objects. With what surprise do we not hear,

in many well-authenticated instances, that if an inhabitant of the Guinea coast or a native of the polar regions is transported to Earth's fairest climes, the one will go back to view his burning fetishes and the other to admire his snowy mountains—unless the passage of time at length effaces their earliest impressions and gives them, in some sense, a new identity.

First impressions and impressions much repeated so powerfully influence our judgments that the Negro will boldly decide that the most beautiful figure is that of the Negro and that the most pleasing face is black, with a flat nose and thick lips. In matters of face and figure, the Lapp will be no less prejudiced in favor of the people of Lapland and indeed of all those beings that nature engenders there; and—with very few exceptions—the judgments of the Negro and the Lapp will be matched by those of the Chinese scholar or of the enlightened inhabitant of Europe. All will love best those things that remind them of the earliest or the often-repeated ideas received from things seen.

If the taste that guides us in our works or in our judgments is the fruit of impressions received from the objects around us, then to ensure that all men will have the same taste or shared ideas of taste, we must expose them all to the impressions best calculated to produce such taste or such ideas. Objects apt to produce such impressions must be so ubiquitous in nature as to exert a frequent and powerful effect on all the peoples of Earth.

Reflecting on the multitude of works that the magnificent spectacle of nature affords to us on every side, I seem to find in it two radically opposed general ideas, which it presents to us so frequently that we learn to love them by force of habit: these are the idea of symmetry, of perfect regularity in relation to our own perceptions; and the idea of conspicuous irregularity. The numberless stars scattered without order across the immensity of the sky, mountains, trees, plants, the irregular courses of rivers, the infinitely varied colors of the flowers that adorn the plains: these constantly afford us the spectacle of irregularity. The structure of animals, to the contrary, offers us symmetry; and since human beings confront these two opposing principles throughout their lives, sheer habit must necessarily lead to love. All human beings must consequently love both perfect regularity and striking irregularity. We shall show how these two sights are pleasing when presented clearly and unpleasing in those objects that present them only in a confused manner.

Nature often shows us the same kind of being in very different forms. We see there the living original of the enormously fat man whom the Chinese imitate in their curious figures; and we also—though perhaps more rarely—come across the man whose bodily proportions we regard as the best and who looks like the [*Dying*] *Gladiator*.[c] There is no comparison, for us, between these two forms in which the same being is presented: the latter seems infinitely preferable to the former. Even so, when in the palaces of the great we observe the most bizarre Chinese figures, they still please us, because they do not violate the general system of nature. Whatever the form of the figure's head, body, arms, or legs, the right eye matches the left eye and appears level with it. The right arm and leg are, so far as we can see, of the same length as the left arm

and leg; and, however outlandish this pagod may be, provided that its original is sometimes to be found in nature and that it is not disfigured by those accidents that produce monsters, it is merely singular, not disgusting.

From those variations of the human form that do not infringe the laws of nature, let us turn to those in which nature has manifestly been altered for the worse. Let us take a man whose figure resembles that of the *Gladiator* but whose right arm is longer than his left, whose mouth is crooked, and whose eyes are grossly unequal in size. Such a figure would certainly be displeasing to all peoples; it would displease the Hottentot,[d] who is the crudest specimen of mankind, just as it would the sculptor who is best acquainted with nature in all its beauty.

What, then, is the source of the feeling that we call taste and that makes one of these figures disgusting to us, whereas in the other we find no more than singularity—and, what is more, a singularity that amuses us? Used as we are from earliest youth to observing regularity in the eyes, arms, legs, and other parts of the human body, in the bird that soars aloft, in the fish that lurks beneath the waters, it can only be that all that seems to approximate that system and yet does not conform to it displeases us; whereas in general those forms that maintain it give us no such disagreeable feeling.

From animate entities, whose forms man cannot change, we pass on to those that he fashions and arranges to suit himself. Suppose that in a magnificent and regular garden, instead of making the principal walk perfectly straight and arranging the trees on each side at the same distance, some trees impinged on the walk and others, opposite, stood back from it. Despite this slight sinuosity, the path would remain more or less uniform in width; but it would be displeasing to the man of taste, and there is reason to suppose that even the most brutish of men, seeing the path so very nearly straight, would wish it completely so. And both men would prefer to this nearly regular path the picturesque and striking irregularity of those presented to us in the forests by the happy chances of nature.

The feeling we call taste, which causes us to find approximate regularity disagreeable and which leads us to prefer either symmetry or striking irregularity, makes itself felt in our judgments not only of the most sublime productions of the arts but also of those kinds of human handiwork that depend the least on taste and refinement, those whose forms are often chosen by the workman.

Consider, for example, the garments in which man clothes himself. You will observe that they fall into two classes: theatrical costumes, which we consider the most beautiful and which, like the draperies with which painters adorn their figures, convey to us the idea of disparity; and those that we wear, which remind us of the idea of symmetry and regularity. Confound these two ideas in a single garment, and it will be less pleasing to the eyes of people of taste. If the theatrical costume or the drapery of the painted figure falls into insufficiently varied folds, if one notices its symmetry, it will appear less agreeable. By contrast, if you destroy a little of the symmetry of the costume worn

by almost all the enlightened peoples of Europe, the costume will be less agreeable to look at. The cut of our clothes has frequently changed but never, to my knowledge, has one sleeve or one side of a coat been made longer than the other. Pockets have never been placed at unequal heights; or if so bizarre a fashion ever was devised, it certainly did not last.

In matters governed by fashion, which are those on which their tastes vary most, men thus seem to pursue the same two opposing systems, that of symmetry and that of striking disparity; and history shows us that every people on Earth has done so in every age. We shall conclude, therefore, that the principles derived from them are the first principles of taste in all the arts and in architecture above all. Indeed they seem to have in this art almost the same certainty as those principles that spring from the laws of mechanics or from the nature of our minds and senses. Through a constant succession of impressions conveyed to us by the works of nature, from the moment when we first open our eyes until we close them forever, these principles direct both the child who makes a bower for Corpus Christi and the man of taste who arranges his cabinet, the Frenchman who sets out his garden in a regular pattern and the Chinese or Englishman who seeks to evoke the disorder of nature.

We shall not undertake to determine how far one may depart from symmetry without disagreeably affecting the eye or how different forms being compared must be to avoid excessive symmetry; but we dare affirm that minor departures from either criterion will not trouble us, because we do not judge the works of nature on minute scrutiny. A form begins to offend the eye when the mind can no longer tell whether it was meant to be regular or irregular, whether the intention was to make its dimensions equal or unequal. These in-between forms are so displeasing to human beings that they almost never knowingly introduce them into their handiwork. So much so, indeed, that to discover which are the most agreeable forms, it might be enough to look at those in which nothing constrains the workman's decision—such as the most beautiful proportions for mirrors or for the sheets of paper, cards, or canvases that painters choose by preference.

If the habit that all the peoples of Earth unavoidably acquire from observing the infinite variety of nature makes them love both symmetrical and picturesque objects, it is the particular habits acquired by each people or by the inhabitants of each part of the world that make them love the forms that they know best. Different peoples will therefore have different ideas as to the beauty of human beings, animals, trees, or plants. But within each people taste will agree as to the forms preferred for these objects; since the models exist in nature, taste does not markedly vary within a single country. By contrast, if the model does not exist in nature, if it is formed by man, then taste will necessarily vary. The taste by which it is loved, or the taste that it forms, will be less general and less durable than the taste that we learn from the works of nature alone. Members of one people may thus find a thing beautiful at one time and not at another. They may love one species of architecture in one century only to abandon it in another: they may, for example, turn from

Gothic architecture to Greek architecture. Yet it seems virtually certain that once a people adopts in the other arts the general principles held by the most enlightened nations of antiquity, they will also adopt those that underlie their architecture. At least, this seems to be proved by a considerable number of examples, as we shall demonstrate.

Principles of Architecture Derived from Those of the Other Arts and Accepted by All the Enlightened Nations of Europe

Of all the systems of disposition or decoration ever devised to evoke notions of grandeur, nobility, majesty, and beauty, that of the Greeks seems generally to have been preferred by those authorities considered, in their own time or in ours, to be the most enlightened. It has not, however, been the universal preference of all men, for in architecture, they have sometimes preferred the Gothic to the Greek.

The beauty that we admire in Greek architecture cannot, therefore, be regarded as beauty of an essential kind; and the principles that tend to produce it cannot be regarded as axioms. And yet this architecture and its principles seem so consistent with the general system of science and art framed by the Greeks and since adopted by so many enlightened peoples, and they derive so much force therefrom, that, while it is debatable whether an American savage would prefer Greek architecture to Gothic, it seems certain that a man endowed with sound judgment and delicate organs of sense and instructed in the philosophical principles of the Greeks, in the order and division that they impose on the sciences, and in the general rules that they observe in the arts would be more agreeably affected by the monuments of Greek architecture than by those of any other kind. Examine the precepts contained in Horace's *Ars poetica,* those that Vitruvius has left us on architecture, those contained in [Charles-Alphonse] Dufresnoy's poem on painting, and finally those that [Jean-Philippe] Rameau has given us on music, and you will readily observe that the most general and most important of them are almost the same: "A building overloaded with divisions," says Monsieur Montesquieu, "is an enigma to the eye, as a confused poem is to the mind."[2]

To that great man's opinion we may add that the habit of judging by one of our senses greatly influences how we judge by the others; and we can be virtually sure that any people that changes its system in three of the fine arts will also change the fourth. For example, if a people were to accept that an epic poem or a tragedy is to be made up of a great number of distinct actions, with no main and predominant action, or that a picture or a bas-relief must represent a great number of subjects or ideas having nothing in common or that a piece of music must be no more than a succession of sounds without order or selection, such a people would infallibly go on to say that symmetry, aside from the requirements of firmness, is a tiresome thing in buildings; that one side of a facade, door, or window must not be decorated like the other; and that cartouches or other ornaments ought to be askew. Such a people, accustomed to regarding caprice as the sole arbiter of poetry, painting, and

music, would see beauty only in those monuments that, by their composition, appealed to its general taste.

We conclude from the foregoing that if we take from a certain people their general system of human knowledge, we ought also to take their system for a specific art, and that to combine, for example, the corpus of Greek learning with a taste for Chinese painting would be like finishing off the body of one animal with the leg of a totally dissimilar animal. And so we see that the Romans successively took from the Greeks their laws, their philosophy, and finally their precepts on the arts.

With the Roman empire overthrown, Greece laid waste, and ignorance prevailing all over Europe, no regular system was pursued any longer in the arts. But as soon as the light dawned once more in Italy and the books of the Greeks and Romans were studied again, and as soon as it became the custom, once more, to collect a certain number of ideas under general headings and to accept the universal system of human knowledge established by those two peoples, this acceptance was extended to their specific system of preference for one kind of architecture and their teachings concerning this art were studied both in the treatise of Vitruvius and in their monuments.

The same progression from general to particular took place subsequently in France, Germany, and England; it is taking place in our own time in the remotest regions of the north, and this form of architecture, which the Greeks invented and brought to the highest pitch of perfection, is spreading across the surface of Earth, as these peoples acquire the true taste in philosophy and literature with which it is associated. I believe that the concurrence of so many enlightened nations, so far apart in space and in time, in valuing one and the same kind of architecture entitles us to conclude that principles so generally accepted are as certain as principles founded on opinion can ever be. To expect more would be to fail to understand that certainty is always a matter of degree. Let us therefore see what those principles are; but let us try to include only those that are generally accepted, rather than the views of individual nations or architects.

In the earliest times, when the Greeks first turned to architecture, they, like the Egyptians, gave arbitrary proportions to their columns; or if they ever imitated in one building the proportions of another, this was merely a matter of habit, as with the Egyptians or the Chinese before them and the Goths after them. Then, no principle governed their proportions; but those that they went on to establish for their three orders at various times are all the more felicitous in that the orders can be can be made from various kinds of building materials available on Earth's surface. If they had modeled their columns on some natural object other than man, such as the tall and slender trunk of a particular kind of tree, they could have built them only in very hard materials, such as granite and marble, and countries lacking such materials would never have been able to adopt the order.

No doubt it was the ease with which the orders of the Greeks could be executed anywhere and the nobility of the creature on which they chose to

model them that gained universal acceptance for their principle that *the three manners of building may be derived from the general imitation of the different proportions of the body of a man, a woman, and a girl.* The Greeks and their followers may differ in their ways of pursuing the same object: some, imitating the robust and masculine proportions of a Herakles, have made their columns six diameters high; while others, taking a leaner man such as the *Gladiator* as their model, have made theirs seven diameters high; and still others, perhaps intending to imitate the body of a young man, have made their Doric columns eight diameters high and modified the proportions of their Ionic and Corinthian columns accordingly. Nevertheless, all have maintained the principle that the columns resemble the sturdy or delicate proportions of the body of a man, a woman, or a girl: a principle universally adopted by the most enlightened peoples on Earth, and one that we consider to be as certain as any that is founded on opinion. Some peoples, it seems, have sought to express the varying proportions of the bodies of men or women at different ages; but these belong to that class of less general principles—whether connected with the orders or with the form of each class of building—that apply only to the peoples concerned and that we find applauded in one century and condemned in the centuries that follow, adopted by some architects and rejected by others.

Another general principle, and one that follows from the foregoing, is that the masses and individual parts of a building should imitate the object that has served as the model for one of its parts. So, if the proportions of the columns are those of a man, the masses and all the other parts of the building must convey the idea of strength. This rule appears to have its foundation in nature: strong men and large animals have stout limbs and prominent muscles; tall trees have stout branches. And so this principle, like the foregoing, is accepted by all the enlightened peoples of Europe; and we include it among the principles that belong to the second class. By observing it in a building, we produce the happy agreement between the whole and its parts that generates what is called *harmony* in architecture.

The next principle, acknowledged as axiomatic, *that firmness is the first of all the perfections that a monument can possess,* leads us to another essential principle established by the Greeks, who took it as the foundation of a highly important aspect of their orders, namely, that the firmness of a building must be evident and manifest. This principle has its origins in the following observation. The Greeks admired their earliest temples, both because they were firmly built and because the walls, whether of stone or another material, were roofed with a wooden frame whose construction they could see, giving them visible signs of this firmness. When they came to build more splendid buildings in marble, they imitated what they had initially seen only in wood. This was the origin of architraves, friezes, cornices, mutules, triglyphs, modillions, and dentils: all the arrangements that reflect this origin are pleasing, and those that depart from it are bizarre.

This rule seemed so excellent that it was adopted by the Romans and by

the most enlightened peoples on Earth, all of whom accept the Greek orders in which it is rigorously observed. We therefore class it among the best of the architectural principles founded on opinion; we cannot place it in the first category, because the Goths thought differently, because the Egyptians appear to have had no more than a glimpse of it, and because if any examples were ever to be found in Chinese architecture,[3] we have reason to believe that these would be the result of coincidence, not of any established system.

Principles of Architecture Peculiar to Certain Peoples and that We Assign to the Third Class

Knowledge of these general principles—accepted by so many enlightened peoples and constituting the foundation and basis of Greek architecture—does not suffice to produce perfect buildings. Several peoples, while accepting them, have differed as to the more specific principles that result from differences in the climates in which they live, in the materials that they possess, in their power, and in their customs. They have also differed as to the principles that establish the relative proportions of the parts of a building to one another and to the whole. This appears in different countries in relation to the shape, disposition, and construction of buildings; it is also observed in the different systems of orders employed by one people at different times and by different peoples at one time. We do not profess to review and discuss all these here: that would be a task for a substantial treatise on architecture, not for an essay on the theory of the art. We shall, nonetheless, consider the degrees of certainty that attach to the best regarded of the systems of orders.

All such systems may be reduced to these: the orders given to us by Vitruvius, partly from the Greek authors and partly from the works that he valued most highly and that the Romans imitated in his day; those founded on the precise dimensions of the ruins of ancient buildings now to be seen in Italy; those formed by the most eminent architects in accordance with the antiquities of Italy and with the writings of Vitruvius; and, finally, those that might be extracted solely from the dimensions of the buildings still extant in Greece.

The principles handed down by Vitruvius should not satisfy us: for even in the event that his judgment was indeed so exquisite as to enable him to make the best possible choice among the various proportions available in his own day for the orders and their parts, he could not have done so, because his knowledge of them was imperfect. He himself, in the preface to his seventh book, tells us that he derived most of his principles from the Greek writers on architecture. But he ought to have had a perfect knowledge of the buildings themselves and to have drawn and measured them with the greatest attention, and this he did not do. Furthermore, the drawings with which he illustrated his book are lost; deprived of the light that these would have cast on his text, his commentators have construed him in different ways. We conclude that the orders as given by Vitruvius are not for general imitation, because he did not have all the materials necessary to arrive at the best choice, and also because we do not really know his true teaching.

If the proportions of the orders cannot be fully known from the principles laid down by Vitruvius, can we expect to find them in the ruins of Roman monuments? This method, also, I venture to regard as highly imperfect: for though the Romans took their architecture from the Greeks, it is possible that they did not put into their own monuments all the perfections that they found in those of the Greeks; and even if we could be sure that they had done so, there are so few monuments left in Italy of all those that once adorned the country that the most precious have possibly escaped us. Examine without preconceptions what remains to us of the Doric order in Roman monuments, and you will find only one example; and that one, to be found at the Theater of Marcellus, is condemned by Vitruvius [(De architectura 4.4.5)] on account of the dentils in the cornice. And the Ionic capitals to be found in Rome appear impoverished and defective.

The shortcomings in these two ways of determining the best proportions of the orders were perfectly evident to the architects who contributed to the revival of the arts in Italy; and since neither the orders that adorn the ancient monuments of Rome nor the precepts handed down by Vitruvius entirely satisfied them, they attempted to put both to use by making corrections and even by adding something of their own invention.

Some of these systems of orders, devised by the most celebrated architects, have enjoyed great success; several peoples have adopted them in preference to the pure examples of antiquity or the precepts of Vitruvius. But by this method different authors arrive at such different proportional systems that it is difficult to subscribe exclusively to one rather than another: some seem to have the best Doric, others the best Ionic or Corinthian.

Knowledge of Greek monuments, which those authors lacked, affords us a new opportunity to make our own choice. Are we to imitate them slavishly? To demand that would smack of favoritism. The buildings of the Greeks are in the same plight as those of the Romans; and though in the city of Athens alone we can see several examples of all the orders and even some of the buildings built for Pericles, all the others have been so completely destroyed that we do not even know where they stood.

No people has ever attained perfection in the Greek orders. Perhaps the only way that we have to reach that point is to look at the ruins of ancient buildings to be found in Europe, Asia, and Africa and at the opinions of the most celebrated ancient and modern architects concerning the proportions of the component parts of the orders as so many elements that we can draw on to compose the best orders possible, according to all these data. The more comparisons we can draw, the more certainties we shall acquire; and there is every reason to suppose that the great architects of whom we have spoken, those who brought about the rebirth of the arts in Italy, would have given us more finished works if only they had enjoyed the sight of Rome in the reign of Hadrian or Athens in the age of Pericles or Greece in their own day—or even of Greece as it is now, its magnificent ruins offering vast scope for their reflections.

This path of conciliation is perhaps the surest that we can follow in choosing among the differing opinions of peoples or architects concerning the architectural principles of my third category. Only those ignorant of the depth of research that architecture demands can be excused for regarding the orders of Vignola or those of others as perfect without having taken the trouble to consider the sources from which those architects derived their principles and whether they chose rightly from the materials available to them. It might greatly assist the progress of architecture if the best architects in Europe were to work on the orders once again. Productions unworthy of imitation would soon be forgotten; and those of great men would do credit to our own age and pass down to posterity.

Le Roy's Notes

1. The Pantheon, the most magnificent temple of antiquity that remains extant at Rome, has a portico made up of eight colossal columns, which support a pediment; the decoration of this portico is among the grandest and most majestic known to us.

2. *Dictionnaire encyclopédique,* s.v. "Goust." [See Denis Diderot and Jean Le Rond d'Alembert, eds., *Encyclopédie; ou, Dictionnaire raisonné des sciences, des arts et des métiers ... par une société de gens de lettres* (Paris: Briasson, 1751–80), 7:763–64: "Un bâtiment d'ordre gothique est une espece d'énigme pour l'oeil qui le voit; et l'ame est embarrassée, comme quand on lui présente un poëme obscur."]

3. On Chinese architecture, see a curious little book published in England by Mr. [William] Chambers, architect to His Majesty, the king of Great Britain. When I found that, in general, the ideas of the Chinese about the peristyle were not far removed from those of the Egyptians and the Greeks, and that several of their vases were of antique forms, my surprise was all the greater, because I knew the author well at Rome and have no doubt that his drawings are highly accurate. This connection between Chinese and Egyptian architecture seems to prove that, as Monsieur [Joseph] de Guignes has suggested, the Chinese are no more than an Egyptian colony.

Editorial Notes

a. See Marianne Roland-Michel, "Soufflot urbaniste et le dégagement de la colonnade du Louvre," in *Soufflot et l'architecture des lumières* (Paris: Ministère de l'Environnement et du Cadre de Vie, Direction de l'Architecture/Centre National de la Recherche Scientifique, 1980), 54–67. The east front of the Palais du Louvre was greatly admired in France throughout the eighteenth century; see Robert W. Berger, *The Palace of the Sun: The Louvre of Louis XIV* (University Park: Pennsylvania State Univ. Press, 1993), 120–217, to which might be added the note from Robin Middleton's review of Berger's book, *Burlington Magazine* 135 (1993): 702 n. 1.

b. Santa Maria degli Angeli, which was built in the remains of the Baths of Diocletian by orders of Pope Pius IV. Michelangelo designed the church and started the work in 1563 but died in 1564; his design was completed by one of his pupils. Major alterations were carried out by Luigi Vanvitelli in 1749.

c. The *Dying Gladiator* is now in the Museo Capitoline, Rome, for which it was

acquired, before 1737, by Clement XII. See Francis Haskell and Nicholas Penny, *Taste and the Antique: The Lure of Classical Sculpture, 1500–1900* (New Haven: Yale Univ. Press, 1981), 224–27; and Marina Mattei, *Il Galata Capitolino: Uno splendido dono di Attalo* (Rome: "L'Erma" di Bretschneider, 1987).

 d. Southern Africa was designated on several eighteenth-century maps as "Hottentot country."

The Ruins of the Monuments Erected by the Athenians after the End of the Age of Pericles, Historically Considered; with the Antiquities of Corinth and Sparta

The State of Athens from the End of the Age of Pericles to the Enlargement of the City under Hadrian

Description of Some Monuments Built There between Those Two Ages

The Athenians, whose power Philip [II] had curtailed, nevertheless retained some part of their pride and their valor until the end of the age of Pericles. They resisted Alexander with great firmness, and, apparently fearing to have them as enemies when he left Greece, he did not march against them after the ruin of Thebes. He even gave them a signal mark of his esteem: he asked them to watch over the affairs of the people while he was absent in Asia; it was his intention that Athens should rule over Greece if he should perish in the execution of his vast designs.[1]

Their courageous conduct toward that hero was one of the Athenians' last efforts to maintain their liberty. Those hardy republicans made no secret of their horror at the sack of Thebes, and they fearlessly opened their gates to those Thebans who had escaped the Macedonian sword; but after Alexander's death they delivered up Demosthenes,[2] who had so long been their defender against enslavement, to the wrath of Antipater. Pursued by the minions of Antipater and condemned to death by his fellow citizens, he withdrew to the island of Cratera [(Kalauria, or Póros)], where he took his own life at the foot of the altar of Neptune.

The Athenians were also cowards enough to permit Antipater to change the form of their government, in which the common people, always jealous of the city's independence, held too much power. They allowed him to lay fetters on them, as it were, by posting a Macedonian garrison at Munychia; and—sufficient sign of their loss of the noble pride that had inflamed them in the palmy days of their republic—only Xenocrates among their envoys long refused to accept Antipater's terms, which the others thought lenient and humane: *Antipater,* said he, *treats us very well for slaves but very harshly for free men.*[3]

Though imminent peril had blinded them to the harshness of Antipater's terms, the Athenians later felt their humiliation keenly. Plutarch gives an affecting account of this in his life of Phocion. What made them still more wretched, he says [(*Lives, Phocion* 28.1)], was that the very instant of their enslavement, the entry of the Macedonian garrison into Munychia, coincided with the most solemn day of the festival of Ceres at Eleusis.

While Lysimachus, Seleucus [Nicator], Ptolemy [Ceraunus], and Sosthenes were alternately contending for and ruling the Macedonian state, Athens appeared to enjoy its liberty, and its inhabitants gave proof of their former valor in fighting off the Gauls led by Brennus; but Antigonus Gonatas, son of Demetrius [Poliorcetes], soon afterward forced them to receive his troops, and they were numbered among his subjects. They subsequently made one last effort to shake off their chains: imploring Aratus to come to their aid, they redeemed themselves from slavery, as it were, and lived independently for a time with Achaean support.

Despite these repeated efforts, Athens never had the good fortune to recapture its former glory. Hardly had the Romans set foot in Greece when the city was left with nothing but the shadow and the name of a republic, nursing an impotent hatred of tyrants that it sometimes concealed beneath a veil of base flattery. Athens declared for Pompey against [Julius] Caesar; it raised statues to Brutus and Cassius; but it gave Augustus the title of god, in the inscription on a monument in his honor; we shall give its history later in this section.

As is well known, the miserable death of Demosthenes, just mentioned, is by no means the only example of the Athenians' ingratitude. We must convey some idea of their genius and their customs after the age of Pericles, and this necessity forces us to relate other facts that we would prefer to expunge from the history of a people formerly so great. They insulted Demetrius Poliorcetes, who had freed them from the sway of Cassander and whom they had addressed in terms of the vilest flattery. They garlanded themselves with flowers to pay court to Philip [V] at the first rumor of the death of Aratus,[4] that sworn enemy of tyrants who had several times promised to deliver them from the Macedonian king, that same Aratus who, appearing before the walls of Athens with an army to punish them, was magnanimous enough not only to overlook their base ingratitude but also to do them a great service; sick though he was, says Plutarch [(*Lives, Aratus* 34.4)], Aratus had himself carried into the city to free them from a foreign yoke and redeemed them at the sacrifice of twenty talents from his own fortune.

After a century or so of inaction, the Athenians once more had the imprudence to show themselves ungrateful to a powerful state. The Romans had set foot in Greece for the second time solely in answer to the pleas of the Athenian ambassadors, in order to defend them against Philip [V], and had left them their liberty after the destruction of Corinth and of the Achaeans. And yet, as inept as they were ungrateful, they declared for Mithradates [VI Eupator Dionysus] against Rome. Sulla exacted a cruel penance.

Though afflicted by two centuries of misfortune, Athens had lost none of

its extent, and the city and its harbors were still united by the Long Walls. It was Sulla who broke the connection. And if we did not know already, from several authors, that Athens and Piraeus were distinct strongholds and could be defended separately, Sulla's siege of the city would enlighten us. Advancing to the walls of Athens, he surrounded the city proper with one part of his forces and attempted to take the citadel of Piraeus by storm with the other; having failed to do so, he withdrew with his army to prepare his siege engines in a camp close to Eleusis. He then returned, cut the lines of communication between the city and Piraeus, laid siege to that fortress a second time, was repulsed again, and turned back to Athens itself, which he ultimately took by surprise and sacked in the most barbarous fashion. Plutarch's account of this massacre is horrific to read [(*Lives, Sulla* 14.3–4)]. He relates, however, that Sulla, sated with revenge and touched by the pleas of Meidias, Kalliphon, and some of the senators, finally spoke these words: *I forgive the greater number for the sake of the lesser, and I spare the living for the sake of the dead.*[5] A glance at the map of the plain of Athens, shown in plate 1, and at the explanation that I have given, will convey still more clearly all the maneuvers that Sulla performed to seize that famous city.

Sulla's words, just quoted, have also been ascribed to Caesar; and indeed they seem to suit him better, for he was as merciful in victory as Sulla was barbarous. Caesar had all the more right to be incensed with the Athenians, because they had declared themselves his personal enemies by taking the part of Pompey, the Senate, and liberty. When fortune favored him, Athens, which feared his rigor, experienced his kindness. He was too great a man to make a crime out of having embraced a cause that seemed to all the world—and perhaps to him—most just and to destroy the native city of those orators whom he would have equaled had he not chosen to occupy instead the first position among warriors.

After Caesar's death, the Athenians—more jealous of their liberty than capable of winning it by their courage, and always unfortunate in their choices—raised statues of Brutus and Cassius alongside those of the heroes who had delivered their country from the tyranny of the Pisistratids; shortly afterward, they declared for Mark Antony. He showed them great favor, but they soon lost it under Augustus. From Germanicus they obtained the privilege of employing a lictor, and this mark of sovereignty was maintained by Tiberius and his successors. Finally, Vespasian reduced Attica and the rest of Greece to a Roman province. We shall see in the following section how Athens grew and changed its form under Hadrian.

Having surveyed the state of Athens from the end of the age of Pericles to the reign of Hadrian, we shall indicate the shapes and positions of the principal districts that composed the city during this period, as well as the respective situations of the monuments embellishing the city. Plate 1 is a general map of the entire plain on which Athens stood, the mountains that surrounded the city, its harbors, and the island of Salamis with its celebrated strait. The explanation of this plate indicates the area and the different

perimeters of Athens, from the foundation of the city to the reign of Hadrian, as well as the locations of the monuments already described or described in this section.

Explanation of the areas indicated by numbers in plate 1, representing the plain of Athens.

1. Athens as founded by Cecrops.
2. Perimeter of Athens as enlarged by Theseus.
3. Perimeter of Athens as enlarged by Themistocles.
4. The Long Walls built by Themistocles to enclose the townships of Piraeus, Phaleron, and Munychia and to connect them with the city of Athens.
5. Perimeter of the new city of Athens, built by Hadrian.
6. Present perimeter of Athens.

The monuments of Athens situated outside the citadel.

7. Magnificent ruins of a building [(Hadrian's Library)] to be seen in the bazaar at Athens.
8. Temple of Theseus [(Hephaisteion)].
9. Odeion [(Pnyx)], the theater for music built on hill of the same name.
10. Monument in honor of Lysikrates, commonly known in Athens as the Lantern of Demosthenes.
11. Tower of the Winds.
12. Ruins of a Doric portico [(Gate of Athena Archegetis)].
13. Triumphal monument to Gaius Philopappos on the summit of the Mouseion hill.
14. Arch of Theseus [(Arch of Hadrian)] built by Hadrian.
15. Decastyle hypaethral temple [(Temple of Zeus Olympios)] erected by Hadrian.
16. Stadium [of Herodes Atticus].
17. Ruins of a building [(cistern)] begun by Hadrian and completed by Antoninus [Pius] at the foot of Mount Anchesmus [(Lykabettos)].

We shall attempt to justify the position assigned to each monument through a detailed exposition of the path taken by Pausanias as he traversed Athens.[a] Arriving at Piraeus by sea, he begins his account thus: Traveling from Piraeus to the city, you see the ruins of the wall that Conon built after his naval victory at Cnidus. The road is lined with the tombs of illustrious persons, among them that of Menander and the cenotaph of Euripides; close to the gate is another tomb, on which stands an equestrian statue of a warrior.

Hardly are you inside the city walls when you discover a building in which all the necessary preparations are made for the celebration of the Panathenaia; nearby are a temple of Ceres and the porticoes that run as far as the Kerameikos. Among those that adorn the Kerameikos itself, the first on the right is the Royal Portico [(Stoa Basileios)]; behind this is another on which are

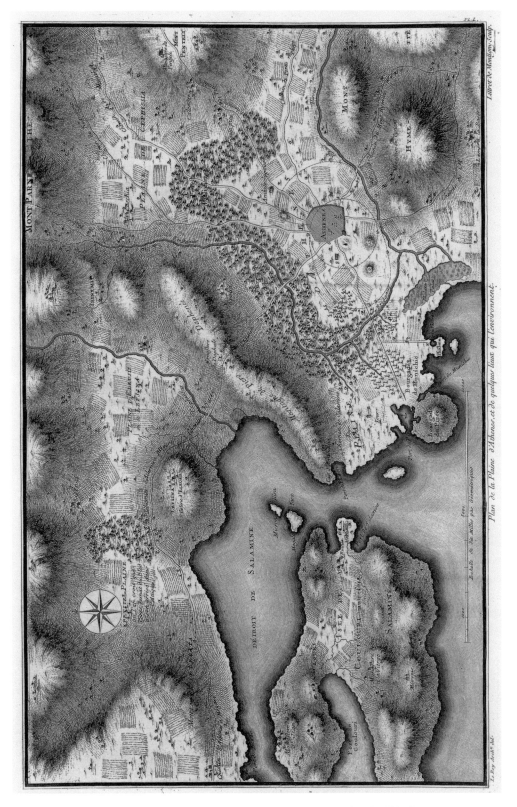

Pl. 1. Claude-Antoine Littret de Montigny, after Julien-David Le Roy
Plan of the Plain of Athens and Some Nearby Sites

paintings of the Twelve Gods by Euphranor. The Temple of the Mother of the Gods, the Council Chamber of the Five Hundred, and the Tholos are in the same place. Nearby are some statues greatly reverenced by the Athenians; these are the heroes from whom the Athenian tribes take their names. The statue of Amphiaraus, that of Peace [(Eirēné)], and another representing Demosthenes are not far from those just mentioned. After giving this account, Pausanias goes on to speak of the theater known as the odeion, set aside for musical contests.

The details of Pausanias's itinerary from Piraeus to the odeion, which we have just reviewed, and those more essential details of the same nature that we are about to give, seem to us a necessary addition to the present edition of this work. These details, disengaged from the long digressions in which they are embedded in the ancient traveler's narrative, seem to us well suited to place, so to speak, the ancient state of Athens before the reader's eyes. We have also found it desirable, in giving the details that follow, to print Pausanias's text in a note, for by following the order in which he names the monuments, by giving due weight to the value of the terms he employs to indicate their respective distances and situations, and by comparing them with the present state of the ruins of Athens, we shall make it easier to judge the likelihood of our conjectures on the subject.

Pausanias's route from Piraeus to the odeion gives us no occasion to reflect on any of the ruins still extant at Athens, because he encountered on this route none of the monuments that we discuss. But we shall examine minutely the two paths that he subsequently traced: the first from the odeion to the Temple of Theseus, two buildings whose ruins we have given and whose functions are well known; and the second from the Temple of Theseus to the city of Hadrian, the location of which is still marked in the clearest possible manner by the ruins of several monuments.

Here is the order in which Pausanias names the notable buildings that he saw on the way from the odeion to the Temple of Theseus [(*Description of Greece* 1.14.1–1.17.3)]. He speaks of the Enneakrounos, or fountain of nine spouts; of two temples, one to Ceres and the other to Proserpina; of the temples to Eukleia [(Glory)] and to Venus Urania; of a Mercury with the epithet *Agoraios*, or patron of the markets; of the Poikilē [(Painted Stoa)], an edifice named for the variety of the paintings of its interior; and then of the public marketplace, the Gymnasium of Ptolemy, and the Temple of Theseus,[6] which is situated at the number *8* in plate 1.

Pausanias, in whose footsteps we follow, advances from the Temple of Theseus to the new city of Hadrian, the perimeter of which we have marked in plate 1 by the figures *5, 5, 5, 5*. After the Temple of Theseus, he names that to the Dioscuri; a chapel dedicated to Aglauros; the Prytaneion; the Temple of Serapis, where Theseus and Peirithoos resolved to go to Sparta together; the Temple of [Juno] Lucina [(Temple of Eileithyia)]; and that of Jupiter Olympius [(Pausanias, *Description of Greece* 1.18.1–1.19.1)]. He then goes on to speak of so many buildings erected by Hadrian that we are obliged to conclude that he has reached the new city built by that emperor.[7]

On the first of the two routes followed by Pausanias, which we have just described, we have only one remark to make: there are grounds for believing that the buildings that he names after the odeion and before the Temple of Theseus should be sought approximately within the space that separates the two. His second route is more difficult to identify. Since the citadel of Athens stands directly between the Temple of Theseus and the new city of Hadrian, we cannot be certain whether the ancient traveler, as he followed this route, left the fortress on his left or on his right, whether he skirted its south or its north face. We take the view that it was the north face; and we shall show good reasons for this supposition.

This once allowed, we shall seek to extract from Pausanias's route some guidance as to two of the five monuments that we give in this section, the others being known to us either by their inscriptions or by their forms. Those that we shall attempt to identify are a Doric building, marked *12* on plate 1, and a enclosure, marked *7* on the same plate, with a magnificent facade that gives on the bazaar at Athens. Both undoubtedly stand on the route that Pausanias took from the Temple of Theseus to the new city of Hadrian, if—as we believe—he went along the north side of the citadel. It follows that our author either neglected to mention these buildings or included them among those that he did mention or describe. We shall consider this question in due course, when we come to discuss their history, which must be preceded by that of two older monuments, that erected in honor of Thrasyllus and the Tower of the Winds.

The first of these, the Monument of Thrasyllus, is shown in plate 2; as may be seen, it is built against the rock of the citadel. Its entablature—which seems Doric in character, though it lacks some of the parts that characterize that order—is supported by three pilasters; the spaces between these are filled with marbles that were not originally part of the building. The interior is a niche hollowed out of the rock, which now forms a little church, called by the Greeks *Panayía* [*Khriso*]*spiliótissa*. Messrs. Spon [(*Voyage d'Italie*, vol. 2, pp. 167–68)] and Wheler [(*A Journey into Greece*, p. 369)] rightly contradict La Guilletière, who supposed this to be the cave in which, according to the Athenians, Apollo enjoyed the daughter of Erechtheus; this is readily enough disproved by the information that the ancients give us as to the location of that cave. However, the three inscriptions that appear on the monument do not so readily yield all the historical information that we might desire.

The surest information that they contain concerns the age of the structure. The earliest inscription tells us that it is of great antiquity. There is reason to believe, nevertheless, that it does not date back as far as the age of Pericles: for the name of Neaichmos appears among the archons of Athens only in the 115th Olympiad, three years after the death of Alexander and 320 years before our era; and, even if the year when he presided at the contests mentioned in the inscription was not that in which he was the eponymous archon, that is, the one who gave his name to the year, it is not likely to have been very much earlier or later.[8]

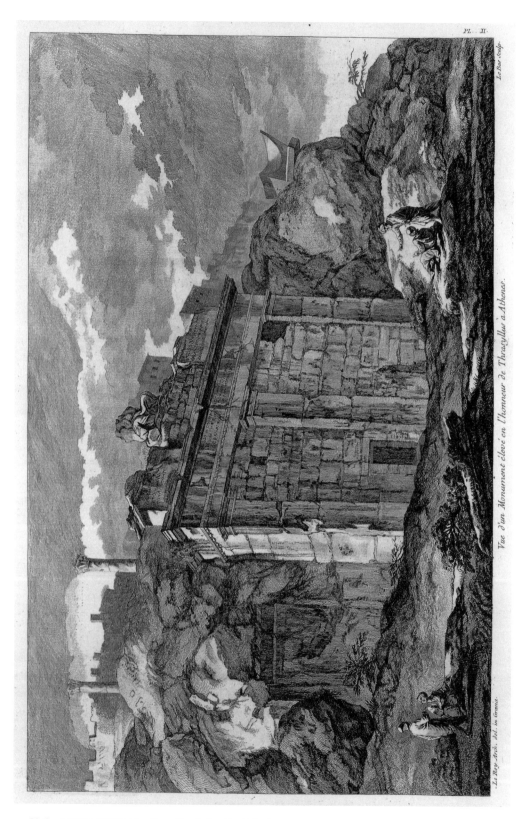

Pl. 2. Jacques-Philippe Le Bas, after Julien-David Le Roy
View of a Monument Erected in Athens in Honor of Thrasyllus

If this structure is not, as we have shown, so early as those given previously, it must surely rank as the earliest of those that we are about to give, and it seems well suited to justify and illustrate the historical distinction on which we have established the division of our book. Our first volume ends with the Monument of Lysikrates, which—as we have shown from the inscription on its frieze—is only a few years earlier than the end of the age of Pericles; and the Monument of Thrasyllus, with which this volume begins, was built only a short time after the death of Alexander, which marked the end of that age.

The other inscriptions on the same monument are not so early. There is every reason to believe that they refer to contests of the same kind as those at which Neaichmos had presided a half-century before. Pytharatos, named in the latest of these inscriptions, was the eponymous archon forty-nine years after Neaichmos: it follows that these later contests were held no more than 271 years before our era.

There seem to be only slight differences among the inscriptions of this kind still extant. The earliest of those on Thrasyllus's monument tells us that he dedicated it after winning the contests with the Hippothontis tribe. It also names the magistrate who presided, and the *didaskalos* who trained the chorus. Finally, there is the name of the musician who accompanied the declamation with the strains of his flute. This account of the inscription is enough to show that it bore the most striking resemblance to that of the Monument of Lysikrates, which we gave in the first volume of this work.

Bacchus was the principal subject of the hymns that were performed in these contests. But there are grounds for believing that the Sun and Apollo were also honored there, for the Athenians regarded these as a single deity and accordingly chose a tripod as the prize awarded to the victors in these contests.

The contests were commonly held every year. As soon as the prize giving brought the old year to an end, the tribes hastened to nominate the choragi who were to preside at the contests prepared for the following year's festival. Abstentions were rare, because the Athenians thought very ill of any tribe that failed to enter. This is proved by the reproaches that they addressed to the Pandionis tribe, which let three years pass without naming a choragus. The tribe redeemed itself only through the generosity of Demosthenes, who nominated himself as the choragus of his tribe and undertook to bear the expense of schooling its chorus for the forthcoming contests.[9]

So celebrated were these ancient contests by Themistocles' time that, as the victorious choragus in a tragic contest, he sought to leave an authentic monument to posterity, with an inscription that Plutarch [(*Lives, Themistocles* 5.4)] has preserved for us. As it omits certain details that appear in other, later inscriptions, van Dale[10] suspects that Plutarch did not record it entire. However, perhaps it is so simple because of its early date; when Themistocles won his victory, contests of this kind might well have been less complicated than they later became. In these festivals of Bacchus, the Athenians took great care to set the competing tribes on an equal footing, but there are grounds for believing that this was not always so. Initially, each tribe seems to have been

free to choose its own *didaskalos* and its own flutist; this custom no longer existed in Demosthenes' day. Instead, the choragi drew lots as to who should have first choice of these two men who did so much to ensure the victory of the tribe. The luck of the draw favored Demosthenes in the year when he voluntarily declared himself choragus of his own tribe, and he was able to choose the best of the musicians.[11]

Having spoken about the earliest of the three inscriptions, we will attempt to draw some enlightenment from the others. These differ from their predecessors in that, in them, the choragus was no longer an individual but rather the citizens themselves. There was also an *agonothete;* van Dale suggests that this was the person who performed the functions of the choragus for the contests. The other details furnished by these inscriptions may be seen at the end of part 1, where they are printed along with translations. Here we shall say only that Lysippus, named in one of these inscriptions, seems to have been the poet named in *Suidas* and Athenaeus [(*The Deipnosophists* 8.344e)] as the author of certain tragedies; and we are encouraged in this belief by the fact that the hymns to Bacchus that were sung at these festivals, along with those addressed to Apollo and other gods, were the origin of tragedy.[12]

We shall not attempt to explain the form of these hymns, or how the music combined with the poetry, or what measure was employed in their versification. These matters have been learnedly and exhaustively discussed in the *Mémoires* of the Académie [royale] des [inscriptions et] belles-lettres; and we particularly invite our readers to consult the fifth volume for three Greek hymns addressed, respectively, to Kalliope, Apollo, and Nemesis.[b] In our plate, to the left of the monument just described are the upper parts of two columns, the lower parts of which were hidden from me by the rocks. These are curious in that each has an abacus with only three faces. On the same side, lower down, a square niche has been hewn out of the rock; I was unable to determine its purpose. The walls behind the columns are those of the citadel of Athens.

The marble sundial on the right, which stands on the tip of a rock, is highly curious. It recalls Vitruvius's description of the hemicycle [(hemispherical sundial)] invented by Berosus the Chaldean, which *was cut out of a square and inclined.*[13] The upper surface of that at Athens, as of all sundials of this type, is parallel to the horizon. The inclined face that intersects this surface is in the plane of the equator. This, no doubt, is what Vitruvius meant in saying vaguely that this sundial was *inclined*. In the sundial invented by Berosus, and in the earliest sundials that took it as a model, there is every reason to believe that the tip of the pointer corresponded to the center of the hemicycle, or rather to the center of the portion of the sphere of the sundial that stood for the center of the world. This is the natural idea that seems to have presented itself to the first makers of sundials. In these, no doubt, the intersection of the inclined and horizontal faces was contrived so as to mark the twelve hours of the longest days of the year. Lines could then be traced on the concavity of the dial to indicate the declinations of the Sun. This is how we imagine the sun-

dial invented by the Chaldean astronomer. Those of this kind that have been discovered in Italy by the learned Father [Ruggiero Giuseppe] Boscovich[c] differ slightly in form: he observes that in them the pointer does not correspond to the center of the hemicycle or to that portion of a sphere. I suspect that the dial at Athens resembled them in this respect; however, since I spent little time on examining it, I dare not affirm this as a fact.[14]

The sundial just described is not the only monument that shows that in the earliest times the Athenians already had a knowledge of gnomonics; more proofs of this are to be found in the Tower of the Winds,[d] the ancient building that served as a clock tower for the city of Athens. This tower, shown in plate 3, had another use: it served to show the inhabitants of that maritime city the direction of the wind. As may be imagined, they wanted to be informed of the winds, whether favorable or adverse, that affected their health, their agriculture, and the movements of their many ships at sea. Let us therefore first examine what light this monument can shed on the number of winds that the Greeks counted in the entire circle of the horizon.

Of those who have considered the number of winds, says Vitruvius [(*De architectura* 1.6.4)] in chapter 6 of his first book, some have held that there are only four: Solanus in the equinoctial east; Auster in the south; Favonius in the equinoctial west; and Septentrio in the north. But more careful investigators have counted eight; in particular, Andronicus Cyrrhestes has given us a notable example in building the octagonal marble tower at Athens. On each face of the octagon, he caused to be carved the image of the appropriate wind, each facing the point from which it blows. He also surmounted the tower with a marble pyramid, on which he set a bronze Triton with a rod in his outstretched right hand; and the machinery was adjusted so that the Triton always turned to face into the wind that was blowing, directly above its image, to which he pointed with his rod. Vitruvius arranges the four winds added by Andronicus Cyrrhestes in the angles between the first four, as follows: Eurus between Solanus and Auster; Africus between Auster and Favonius; Caurus between Favonius and Septentrio; and Aquilo between Septentrio and Solanus. He concludes by saying that in addition to these eight winds, which he regards as the principal ones, there were others besides. In accordance with the division used by the Romans, he divides the circle of the horizon into twenty-four; as is well known, the moderns have increased this number to thirty-two.

Though Vitruvius does not say that the Greeks divided their *schema*[15] in the same way as the Romans, and though the modern travelers who have visited Athens have drawn no such conclusion from their examination of the building itself, on reflection, all the indications are that the Greeks, like the Romans after them, counted twenty-four winds in the circle of the horizon. There is even reason to believe that they did not neglect to recognize them in the buildings or machines that they set up to indicate the direction of the wind, for the roof of the Tower of the Winds is made up of twenty-four identical pieces of marble, with their lower ends resting on the body of the tower and their upper ends converging at the apex of the roof. On examining this

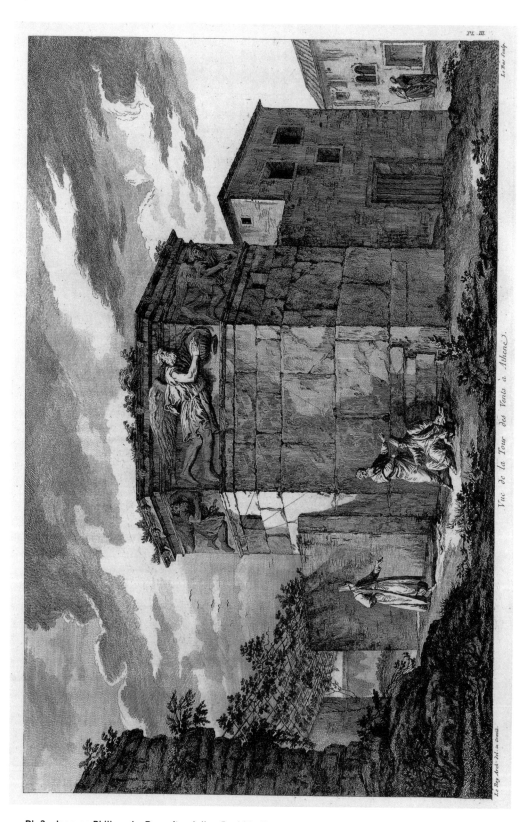

Le Roy

Pl. 3. Jacques-Philippe Le Bas, after Julien-David Le Roy
View of the Tower of the Winds in Athens

construction, I guessed at once that Andronicus, who contrived the Tower of the Winds with such genius and such art, did not use this number of stones by chance. Recalling that the Romans divided the compass into twenty-four points, I surmised that these conspicuous divisions at the top of the tower might indicate the twenty-four winds. This seemed to me even more likely when I noticed that the division into twenty-four equal parts is marked on the cornice by an ornamental head,[16] each of which corresponds to the corner of one of the stones of the roof.

Not content with giving a striking indication of the positions of the eight principal winds, Andronicus placed the image of each wind, as Vitruvius says, on the side facing the point from which it blows and furnished some of them with particular symbolic attributes. I shall make no attempt to explain these attributes — or rather I shall refrain from retailing the opinions expressed, before publication of my work, by two of the most learned travelers who have been to Athens. These explanations — in which one supposes that one of the winds facing the north, like the northwest, is pouring ashes and fire out of the urn he carries because the ancients had urns that contained fire, and one chooses the prevailing summer wind because the prevailing winter wind fails to support this conjecture — are, as can be seen, extremely rash. I shall therefore make no attempt to explain these attributes but merely say a word on the figures that they characterize.

Skiron, or the northwest wind, who faces the viewer in this plate, is shown holding an overturned vase. Zephuros, who is to his left, is a young man, almost naked, who carries flowers in his cloak; he blows from the west. The sculptor has represented Boreas as a venerable figure who holds a conch shell in his right hand and one corner of his cloak in his left. The northeast wind, Kaikias, also shown as an old man, holds a shield in both hands and scatters on the ground the hailstones or the olives that it contains. In a fold of his cloak, Apeliotes carries the most precious productions of nature: ears of grain, honey, and fruits. He blows from the east, and is followed by Euros, the southeast wind, who has no symbol but who seems more completely covered than the others by his cloak. Finally, Notos, the south wind, carries a vase like Skiron but its shape differs; and Lips, from the southwest, holds in his hands a ship's prow with which he seems to cleave the waters of the sea. All these have wings, and six of them wear boots of some kind on their legs. Only Lips and Zephuros are barefoot; the latter, as we have said, is almost entirely naked.

This monument had an additional purpose: it served as a clock tower for the city of Athens, for it had eight dials, the lines of which are still to be seen on each of its faces. Each pointer was at the intersection of the radiating lines that formed each dial. Thus, all these dials together marked all the hours of the day, though individually each served to mark only a few of them. A number of transverse lines, cutting across those that emanate from the pointer, are also to be seen. These served to mark the changing altitude of the Sun throughout the year and also, most probably, the solstices and the equinoxes, as Mr. Stuart [(*Antiquities of Athens*, p. 20)] believes. If, as a passage in Varro

suggests,[17] the principal use of this monument—or one of its principal uses—was to serve as a clock tower for the city of Athens, this clearly indicates that the dials are as old as the building itself; on the strength of this, we shall attempt to determine the approximate date of its construction.

The Greeks of Pericles' day, enlightened though they were in the arts, seem to have known little of those sciences that depend on geometry; they were late-comers to astronomy and gnomonics. They acquired from the Babylonians, says Herodotus, their knowledge of the pole, the gnomen, and the division of the day into twelve equal parts;[18] but they made their first sundials only in the time of Anaximander (according to Diogenes Laertius [(*Lives of Eminent Philosophers* 2.1.1)]) or that of his disciple Anaximenes (according to Pliny [the Elder (*Naturalis historia* 2.78.187)]).[19] It was therefore not until some five hundred years before our era that the Greeks acquired the rudiments of gnomonics.

So slow was their initial progress in this science and in astronomy that, two hundred years later, in the time of Demetrius of Phaleron, they still divided the year into 360 days—though Plato, Eudoxus, and Thales had long since learned that the Egyptians divided the year into 365 days and approximately 6 hours. The Greeks' particular manner of dividing the months, which they made mostly of 30 days and sometimes of 29, is another proof of the slowness with which they perfected their knowledge of astronomy. They divided each month into three parts, each of 10 days; and it was not until several centuries after the end of the age of Pericles that they divided the week into 7 days.

As we have seen, the construction of these dials seems to indicate that the Athenians, when they made them, were already well versed in gnomonics. This being so, we believe that the Tower of the Winds was built after the age of Pericles; and the nature of its architecture seems to confirm our conjecture. The bad taste that prevails in its profiles, in which the moldings are many and minute, clearly suggests that it was built at a time when architecture in Athens was beginning to decline from the perfection it had achieved, rather than before it reached that state. Finally, I cannot refrain from repeating that, as I have already said, the sculpture of the figures on this building is decidedly mediocre and far inferior to that of the bas-reliefs on the buildings of Pericles' day.

This monument stands between two streets. Below it, I have shown some Turkish religious, known as whirlers,[e] who were watching me as I drew. The name *whirlers* was given to them for a somewhat singular religious practice of theirs that I witnessed in Athens at the Tower of the Winds, which they use for this purpose. Their chief places himself at the center of the building, and, after uttering some prayers, he begins to whirl on his feet, without moving from that spot, to the strains of a kind of flute that the Greeks call *naye;* the religious gather around their chief at a certain distance, whirling on their feet and, at the same time, around him. This ceremony, which I find most curious, seems to represent the system of the universe: perhaps, if one might conjecture, it was invented by the Egyptian or Chaldean priests whom we believe to

have been the inventors of astronomy, and they meant it to express the motion of the Sun, which is at the center of the planetary system and turns on its axis, and that of the planets, which, while turning on themselves, make circuits around that celestial body. At Constantinople, however, I gleaned the following information on the subject of this ceremony among the Turks: their religious maintain that in order to think of God with greater tranquility, one must detach oneself completely from all thoughts of this world, and the dizziness that they inflict on themselves by whirling in this manner puts them into such an ecstasy that they absurdly imagine themselves to be in communion with the Creator.

Having related the history of the monuments built by the Athenians before they were subdued by the Romans, I now turn to those that they built or restored while Athens was subject to Rome.[f] Of these, the earliest is the building of which the portico shown in plate 4 formed a part. This portico, as one can seen, consists of four Doric columns supporting an entablature topped with a pediment. It stands on a street in Athens, and those who pass along the street must go through the central intercolumniation. I have not shown this portico from the front but from one side, so as to lose none of the form and the beauty of this portico; to draw it from this angle, I stepped into an alley that separates the house of the French consul, seen on the left, from another house, to the right.[20] The gateway directly ahead is the entrance to the street from this alley. Beyond the gateway may be seen the street in which this monument stands and one of the antique Ionic columns that have been used, without symmetry, to form a doorway. The part of the portico that is on that side is engaged in a small church dedicated to the Savior.

The architrave of the portico bears a long Greek inscription, which I did not give in the first edition of this work. Messrs. Spon and Wheler, who published it, omitted the first line; but it has since been given in its entirety,[21] and we shall make use of it in the historical description that we will give of this monument and of several others that depend on it.

The first line of the inscription tells us that the building of which this portico formed a part was dedicated by the Athenians to Minerva, by the generosity of Caesar and Augustus; but from other inscriptions there and from the great number of statues erected in honor of members of Augustus's family, one sees clearly that in effect it was consecrated to Augustus himself; such was their base flattery of those princes. We have sufficiently demonstrated their capacity for this in speaking of Demetrius of Phaleron; and Plutarch, in his life of this prince [(*Lives, Demetrius* 10.3–4ff.)], gives so many instances as to make it impossible to deny that they carried the vice of flattery to the utmost degree. Looking at this monument, we see that the facade is crowned by a pediment, the apex of which supports a low pedestal, on the face of which we read in Greek characters: *The People to Lucius Caesar, Son of Augustus Caesar God.* In another inscription, carved on the pedestal of a statue representing Julia, they extend the title of goddess to her.

As the first of these inscription shows,[22] such was the Athenians' zeal to

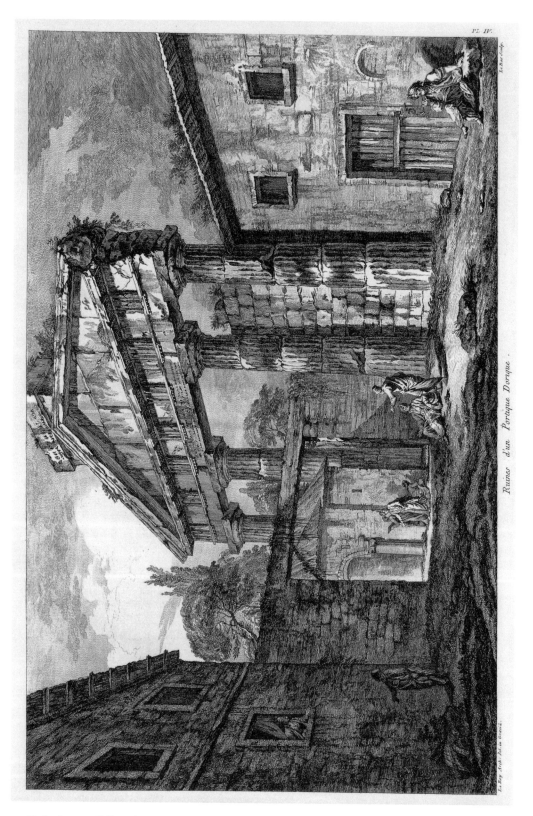

Pl. 4. Jacques-Philippe Le Bas, after Julien-David Le Roy
Ruins of a Doric Portico

flatter Augustus that they not only erected a statue to his adoptive son Lucius [Julius] Caesar but also bestowed on the emperor himself the title of god. They also gave his daughter Julia the title of goddess on the base of the pedestal that supported her statue in the same portico.[23]

This was not the first time that the Athenians had bestowed this exalted title on their rulers: long before, they honored Antigonus [Monophthalmos] and his son Demetrius Poliorcetes in the same way. So abject was their flattery that, as Plutarch tells us in his life of Demetrius, it rendered both monarchs objects of loathing to the whole of Greece.

To what we have already said about the historical value of the monuments that we describe and the inscriptions carved thereon, we have the following to add. The inscription on the architrave tells us that Herodes, charged with overseeing the progress of the building, was compelled to absent himself for an embassy and his duties were assumed by his son, Eucles of Marathon.[g]

Such, in general, is the tenor of the inscriptions carved on this portico; one might wish for some information as to the form of the building to which it belonged, whether a temple or some other structure; but unfortunately on this point they leave us none the wiser, and the present state of the ruins affords no clarification. Since we lack authorities, we shall hazard some conjectures of our own, or at least examine those that have been advanced. We shall examine whether it is likely that this portico is the remains of one of Athens's two agoras, or marketplaces, as Mr. Stuart [(*Antiquities of Athens*, p. 3)] supposes.

In all likelihood, one of those markets, the one known as the old agora, was situated, as the English author I cited believes, in the Kerameikos, within the city walls and close to the Dipylon Gate. Pausanias would have traversed this old agora on his way from Piraeus to the odeion. Thus, as Mr. Stuart says, it is unlikely that the Doric portico in question ever formed part of it.

The other agora, later in date, is the one to which the English traveler assigns the ruin shown in plate 4. This agora could only be the one mentioned by Pausanias on the way from the odeion to the Temple of Theseus, as may be verified by checking the details of his route, to be found [in note 6] of this part. It is therefore clear, given the position of the later agora, that it cannot have incorporated the Doric portico described here, for the portico is located at number *12* in plate 1, and consequently Pausanias passed it on his way from the Temple of Theseus to the new city of Hadrian, not before he reached the Temple of Theseus.

This argument against Mr. Stuart's conjecture seems to us to be controverted neither by the evidence that he produces, namely, the mention of two market overseers in the inscription on the pedestal of Julia's statue, nor even by the decree of Hadrian on the subject of oils, inscribed on the doorjamb of the building, for this might have been placed just as fittingly at the entrance to some court of law. Nor would it have been as misplaced as one might suppose if inscribed at the entrance to the Temple of Minerva, the goddess to whom the olive tree was sacred, especially if this were the entrance not to the *cella* of

the temple itself, its most sacred part, but to its forecourt or surrounding enclosure.

Since by this reasoning the Doric portico in question cannot be the entrance to either of the agoras of Athens, we think that it may be either the facade of the enclosure[24] of a temple erected by the Athenians in honor of Minerva and Augustus and his family or, more probably, the entrance to one of the law courts of the city. It is, in fact, far more likely to be that of the Prytaneion than that of either of the two agoras.

It is apparent from the profiles of this Doric portico that the building was inferior as a work of architecture to those built previously by the Athenians. After attaining its peak at Athens in the time of Pericles, this noble art degenerated in the reign of Augustus. To be persuaded of this, it is enough to compare the details of this portico, given in part 2 of this volume, with those of the temples of Minerva and Theseus, in the preceding volume. The columns of this portico are taller in proportion than the columns of those others: a change entirely comprehensible, if the reader will but remember that the Doric order consistently grew taller among both the Greeks and the Romans. Since this building suggests no further grounds for historical reflection, I shall say no more of it here and pass on to discuss the other Athenian buildings contained in this section. The earliest of these, after the one just described, seems to be the monument erected to Gaius Philopappos, which stands at the top of the ancient hill known as the Mouseion.

Leaving the Doric portico behind us, we traversed part of the city on the way to the Mouseion. Passing along the south side of the citadel of Athens, we climbed the hill in question, which rises to the southwest of the fortress. This was the place where Musaeus of Eleusis, son of Antiophemus, chanted his poems. This celebrated poet, from whom the hill took its name, was a disciple of Orpheus and lived in the time of Cecrops II. He composed a number of works, in particular a great number of verses addressed to his son, Eumolpus.[25] His works were already rarities by Pausanias's time; all that remained, says that author, was a hymn to Ceres, composed for the Lycomids,[26] a celebrated Athenian family that enjoyed the sole right of singing the pieces of this kind written by the ancient poets in honor of Love and the great goddesses.[27]

Musaeus died of old age on the hill that bears his name. He was so revered by the Athenians that they kept his portrait in a hall at the entrance to the citadel of their city, together with those of a great number of other distinguished Athenians. Most of these paintings were by Polygnotus and Timaenetus. The ancient Athenian poets held that Boreas had given Musaeus the power of flight.[28] Pausanias [(*Description of Greece* 1.25.8)] says that his tomb was to be seen on the Mouseion; but an inscription mentioned by Mr. Spon [(*Voyage d'Italie*, vol. 2, p. 204)] indicates that his tomb was at the harbor of Phaleron. The hill itself affords no confirmation of Pausanias's statement; but the monument to a Syrian, which he mentions, is still standing: he was named Gaius Julius Antiochus Philopappos. This monument, shown in plate 5, formed in its plan a segment of a circle. There were three niches in

the facade, of which only two remain. The central niche contains a statue of Philopappos himself, and one can read on its pedestal *Philopappos, Son of Epiphanes of Bisa* (or rather *Besa*). The statue on the left, in a similar niche, has on its plinth this inscription: *King Antiochus, Son of King Antiochus.*

This latter inscription led Mr. Spon [(*Voyage d'Italie*, vol. 2, p. 205)] to conjecture — most plausibly — that the figure above is that of one of Philopappos's illustrious ancestors, because Philopappos himself is given the name of Antiochus in the large inscription on the face of one pilaster of this monument.[29] The same author also took the view that Philopappos, the subject of the monument, was of Syrian origins, though the inscription states that he was born in the small town of Besa. Mr. Spon also conjectures that it was Philopappos's Syrian royal ancestry that led the Athenians to erect a monument to him: it is known that the state of Athens gave the name of these princes to one of its tribes, and these princes did much to improve the city by repairing or completing certain buildings.

The inscription carved on the pilaster, just mentioned, begins with the name of Philopappos, who is honored with the title of consul.[30] The placement of his statue, in the center of the monument, seems to show clearly enough that it is his triumph that is commemorated in the bas-reliefs on the lower part of the structure. There is reason to believe that when he won the victory that earned him triumphal honors, Philopappos was in command of Roman troops entrusted to him by Trajan, since the same inscription names that emperor, with all the praise that he deserved for his virtues and for his conquests among the Dacians and the Germans. From the same inscription we learn that Philopappos was one of the Arval Brethern and that Trajan had enrolled him among the praetorians. The mention in the inscription of Trajan's victory over the Dacians leads us to the conclusion that this monument was built between that victory by the emperor and the end of his reign. As for Philopappos's victory, nothing is known of it now, and there seems to be nothing in the bas-relief of his triumph to enlighten us. In it, we see a man in Roman dress standing in a chariot drawn by four horses; the hero is preceded and followed by a splendid procession. The sculpture on the monument seemed to me to have some merit, but its architecture is mediocre in the extreme. The recessed panel in the remaining pilaster is sufficient indication of the bad taste of the profiles.

This monument stands on an eminence. To draw it, I chose the most pleasing vantage, that from which one can see Piraeus and the sea. Some *Franks* have called it the Arch of Trajan, but it is obvious at a glance, as Messrs. Spon [(*Voyage d'Italie*, vol. 2, p. 205)] and Wheler [(*A Journey into Greece*, p. 380)] quite rightly remark, that it has never had the form of an arch; and the inscriptions show that it was never dedicated to Trajan, though that emperor's name is to be found on it.

The hill on which it stands has changed its name: in Athens, it is now called *to Seggio*. It is often mentioned in Greek history, because it offered a strong position from which to subdue part of the city. When the king Demetrius

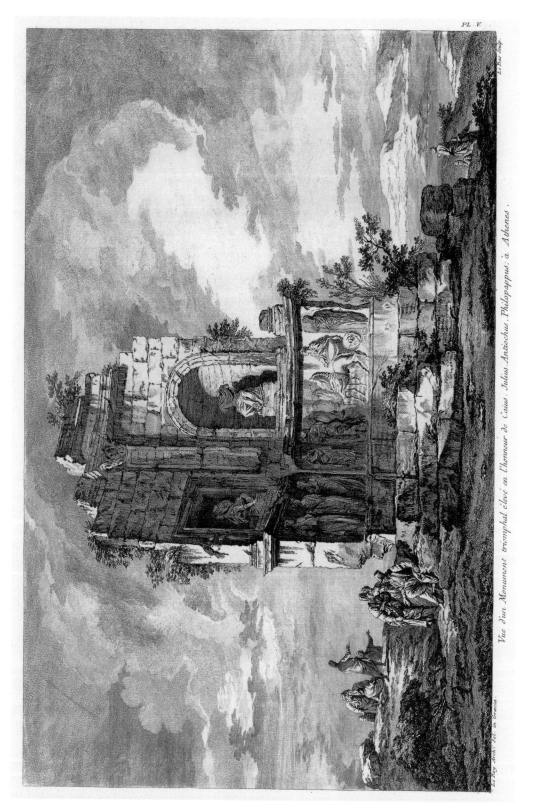

PL. V.

Le Bas sculp.

Vue d'un Monument triomphal élevé en l'honneur de Caius. Julius Antiochus. Philopappus: à Athenes.

Le Roy Arch.t del. in Græcia

Pl. 5. Jacques-Philippe Le Bas, after Julien-David Le Roy
View of a Triumphal Monument Erected in Athens in Honor of Gaius Julius Antiochus Philopappos

[Poliorcetes], having delivered Athens from its tyrants, desired to become a tyrant himself, he did not rest content with a lengthy occupation of Piraeus but seized the Mouseion, fortified it, and held it until Olympiodorus, at the head of the Athenian forces, expelled him and delivered the people from tyranny. Pausanias includes this hill within the old city, but by this he seems to mean the city built by Theseus, as discussed in our account of the successive city walls of Athens under Cecrops, Theseus, and Themistocles.

On the way from the Mouseion to the most populous part of the city, and passing some distance away from the north side of the citadel, we find the Doric portico of which we spoke before we gave the history of the Monument of Philopappos. Continuing the same way into the lowest part of the city, to the north of the citadel, we find a magnificent ruin whose situation is indicated by the number 7 in plate 1. By common consent of the most enlightened travelers who have visited Athens in the past half-century, this is the lowest-lying part of Athens[31] and also the unhealthiest.[32] Having clearly indicated the position of the ruin, let us go on to study what time has preserved of the building of which it once formed part.

At a glance, the ruins of this building convey some idea of what it formerly was. The view that I have shown of it, plate 6, shows only half of the facade. The anterior part and the columns crowned with projecting entablatures seem to indicate that this was not the main body of the building but rather part of the walls of the enclosure. Mr. Spon [(*Voyage d'Italie*, vol. 2, p. 186)] made the surprising error of regarding this facade and its corresponding wings not as enclosing walls but as the exterior of the *cella* of a temple. His traveling companion, Wheler [(*A Journey into Greece*, pp. 392–93)], understood the composition better: here is how he laid it out.[33] The three fluted columns on the right-hand side of the street formed part of the central vestibule; the smooth ones with the projecting entablatures adorned the walls that were to each side. The smooth entablature seen at the far end of the ruin, facing the observer's viewpoint, surmounted a wall that broke forward, with a pilaster at its end. Its principal function, in my view, was to separate two different schemes of decoration: that of the walls of the enclosure, which was quite simple; and that of the facade of the enclosure, which was adorned with great opulence and magnificence.

The enclosure wall, a large part of which is still extant, is some 1,400 feet in perimeter. A column still standing within the enclosure as far from the wall as the depth of a portico has prompted the supposition that there was such a portico all around it. Also in the middle of the enclosure, in terms of width, are the remains a building that occupied nearly one-quarter of the enclosure's width. It is much closer to the far end of the enclosure than to the entrance; and the enclosure itself forms a rectangle whose length to width is approximately 3 to 2. Thus the monument in question was probably composed as follows: it had a large enclosure bounded by a wall lined on the interior on all sides with a portico; and within the enclosure was a building, the plan of which, like that of the enclosure itself, probably formed a parallelogram.

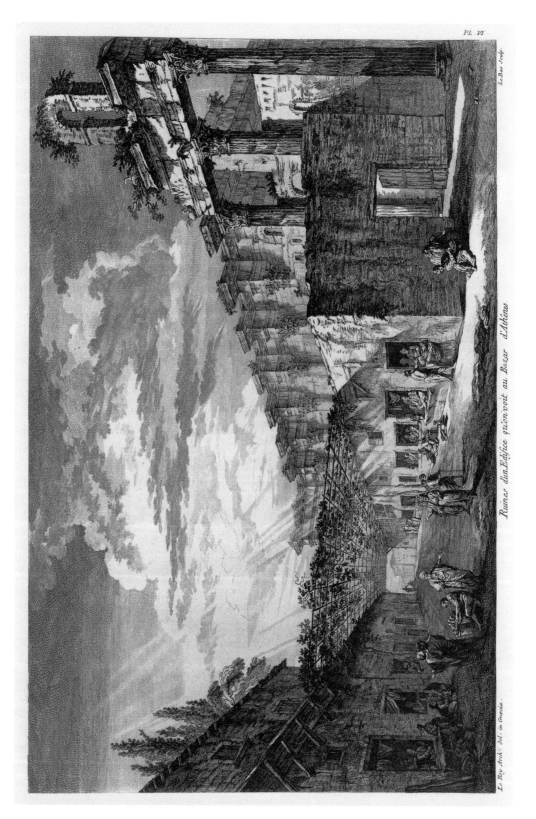

Pl. 6. Jacques-Philippe Le Bas, after Julien-David Le Roy
Ruins of an Edifice to Be Seen in the Bazaar in Athens

The ruins now seen at the center of the enclosure suggest two distinct ideas. Some of their parts seem late in date and irregular, with nothing of the antique about them; others, including three columns and one pilaster equally spaced and ranged parallel to the sides of the enclosure, seem to proclaim the remains of an ancient and regular building. After giving a general idea of all the parts of this handsome ruin, we shall inquire into the nature of the building of which it probably formed a part.

The modern travelers fall into two schools of conjecture on the subject of these ruins. Messrs. Spon and Wheler, whose view I initially shared, believed them to be the remains of the Temple of Jupiter Olympius; Messrs. Stuart and Revett took the other view, which is that they were part of the Poikilē, a portico named for the varied paintings that it contained. We shall examine these two conjectures in turn.

In this inquiry, Pausanias will be our guide, and we invite those of our readers who desire to follow him with us to refer to the details of his route from the odeion to the Temple of Theseus [given in note 6], and the map of the plain of Athens [(plate 1)]. As will be seen, our author names only four temples and two places of note between the odeion and the Poikilē; and he then names an agora or a marketplace, the Gymnasium of Ptolemy, and the Temple of Theseus. Thus, if Pausanias held a steady course, the Poikilē must have been situated more or less between the number 9, which marks the site of the odeion, and the number 8, which marks location of the Temple of Theseus — but rather closer to the latter than to the former. It follows that Pausanias would have come to the Poikilē well before the building at 7, the ruins that Mr. Stuart [(*Antiquities of Athens*, pp. 40–41)] supposes to be the Poikilē.

In determining the location of this portico, the English author cannot, therefore, be relying on Pausanias's steady progress but on his vagueness after referring to the Temple of Venus Urania: *Going toward the portico known as Poikilē...you come to a bronze Mercury.*[34] Let us see what these words amount to. If we accept that they are vague, it follows that the building could have been located on any radius of a circle centered on the Temple of Venus Urania; which tells us nothing of the location of the Poikilē. If we suppose them to have a precise meaning, it will be necessary to indicate the points through which the line from the Temple of Venus Urania passed to terminate at the Poikilē. Mr. Stuart claims to have defined those points. He professes to have found the spot where stood the bronze Mercury, with the epithet *Agoraios*, of which Pausanias speaks, but he supplies no proof of this; and we shall demonstrate how many implausible suppositions he is obliged to make in order to sustain his conjecture.

Pausanias's path from the odeion to the Temple of Theseus does not, in truth, seem very regular. Mr. Stuart interprets this irregularity in his own favor; but I shall show that, on the contrary, it disables his conjecture. Pausanias implies that the Temple of Vulcan and that of Venus Urania, which he mentions on the way from the odeion to the Temple of Theseus, were close to the Royal Portico,[35] which was the first portico on the right as you went from the

gate of Athens where the road from Piraeus ended to the Kerameikos. From this it follows that the Kerameikos, which was inside the city, was close to its westward-facing walls, as Mr. Spon observes;[36] and, since the temples of Vulcan and Venus Urania were close to the Kerameikos, that of Venus Urania must have been farther away than the odeion from those ruins in the bazaar that Mr. Stuart takes for the Poikilē; from which it will be seen that the erratic path followed by Pausanias is unfavorable rather than favorable to the English traveler's conjecture.

Another argument against Mr. Stuart's thesis is the enormous distance that would have separated the Temple of Venus Urania, which stood close to the western wall of Athens, from the Poikilē—if, as he says, its ruins are those in the bazaar. It seems wholly unlikely that if Pausanias had half of the city to traverse on his way from the temple to the portico, he would have failed to name a single building of any consequence, or indeed anything else beyond a Mercury, who presided over the markets and was therefore called *Agoraios*, and a triumphal arch that was nearby.

Still another objection to Mr. Stuart's view derives from the statements of Pausanias and the modern travelers as to the lowest part of the whole city. That is the point where Pausanias locates the Temple of Serapis.[37] Messrs. Spon[38] and Wheler believe that the lowest place in Athens is precisely where the ruin identified by Mr. Stuart as the Poikilē is situated; and, as I have already said, the Athenians still regard this as the lowest and unhealthiest part of the whole city. If Mr. Stuart is right, it follows that the Temple of Serapis must have been close to the Poikilē. But Pausanias suggests nothing of the sort; for between them he names the public square, the Gymnasium of Ptolemy, the Temple of Theseus, the Temple of the Dioscuri, and the Prytaneion. And so, between two buildings that would appear to be neighbors, Pausanias names five of the greatest monuments at Athens; whereas, in the vast space between the Temple of Venus Urania and the ruins that Mr. Stuart identifies as the Poikilē, the ancient author names only a statue of Mercury and a triumphal arch. We say "in the vast space" between the two because Pausanias's detailed account of the contents of the temple's interior leaves us in no doubt but that he went to see it and that he set out from it to go to the Poikilē; he informs us that this Temple of Venus Urania contained a statue of the goddess by Pheidias.[39]

I shall not pause to refute Mr. Stuart's arguments based on the present state of the ruins in the bazaar. I shall say only that those arguments, while they forcibly suggest that these were not the ruins of the Temple of Jupiter Olympius, do nothing to prove that they were not part of some other temple, and still less to prove that they were part of the Poikilē. Mr. Stuart's error concerning this ruin and—I will freely admit—my own error in mistaking it for the remains of the Temple of Jupiter Olympius ought to inhibit my putting forward any new conjectures on the subject; but since conjectures with any claim to credence are few in number and since in inquiries of this kind there are no other ways to discover the truth, I shall hazard the new ideas that have

occurred to me on the subject of these ruins. I do so with that much less diffidence because the facts on which we rely in solving problems of this sort are usually so imprecise that it is no disgrace to admit an error.

In this new inquiry, we shall follow as closely as possible in Pausanias's footsteps. As we have seen, in going from the odeion to the Temple of Theseus, he had the citadel on his right. All his subsequent remarks seem to prove that his progress was consistent in this respect and that, passing around the fortress, he kept it on his right and passed close to its northern face. This is the simplest and most natural idea offered by his narrative, and we dare affirm that it is the most likely.

Setting out from the Temple of Theseus, our author first names the Temple of the Dioscuri; and, probably intending to show that he was close to that part of the north wall of the citadel from which Aglauros sprang to escape the wrath of Minerva,[40] he says, *Above the Temple of the Dioscuri is the sacred grove of Aglauros, and nearby is the Prytaneion.* Continuing his account, our author adds, *Leaving the Prytaneion to go into the lower part of the city, you come to the Temple of Serapis; not far off is a place where Theseus and Peirithoos jointly swore an oath to go to Lacedaemon; and nearby is the Temple of Eileithyia.*[41] In retailing these passages from Pausanias, we have used, as far as possible, his very words; and it seems that he was at pains to distinguish, by the terms that he uses, between the slightly elevated places and localities that were close to the fortress and those that were close together and in the low part of the city.

It seems likely that Pausanias and modern travelers are in agreement as to the lowest point in the city of Athens; if so, it follows that the Temple of Serapis and that of Eileithyia, which were in that lowest spot, must have been very close to the place where the bazaar now is; or even that one or the other of them was the building whose remains we now see alongside that market. And if the reader will join us in supposing that Pausanias would hardly pass over in silence a monument whose ruins are so magnificent, we shall soon demonstrate that these can be none other than the ruins of the Temple of Eileithyia. According to Pausanias, the cult of Serapis was brought to Athens by Ptolemy; and so we have every reason to believe that it was in his lifetime that the Athenians built their temple to that god. The look of the ruin shown in plate 6, the breaks in its entablatures, the pedestals on which its columns stand, clearly show it to be later than Ptolemy. By contrast, if we compare this ruin with that shown in plate 7, which is a work of Hadrian's—an arch on which his name is inscribed—we cannot but recognize a great degree of similarity between the two structures. On both, the entablatures break outward above the columns; and the columns on the lower part of the arch formerly stood on pedestals like those that decorate the walls of the ruin in the bazaar.

The architecture of these ruins thus indicates that the building of which they once formed part was not built in the time of Ptolemy, and hence that these are not the ruins of the Temple of Serapis. It therefore seems likely that these are the ruins of the Temple of Eileithyia, or Juno Lucina.[42] This

Le Roy

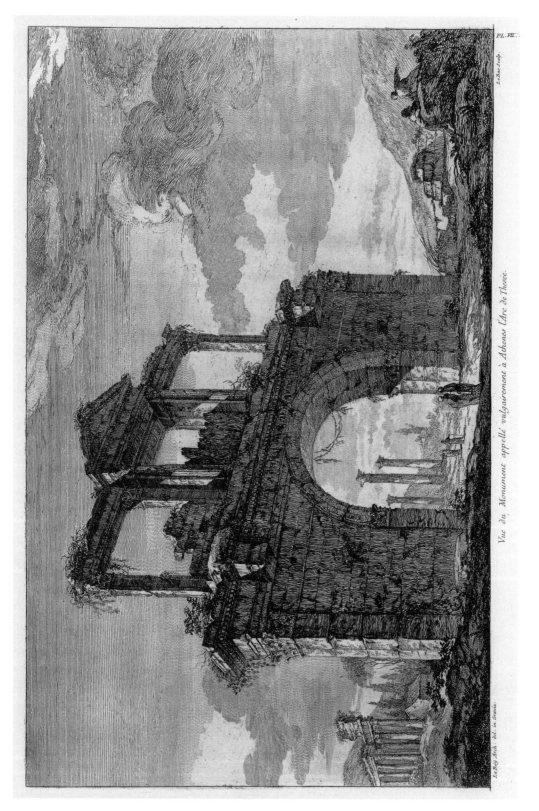

Pl. 7. Jacques-Philippe Le Bas, after Julien-David Le Roy
View of a Monument Commonly Known in Athens as the Arch of Theseus

likelihood comes close to a certainty if — having shown on architectural grounds that this was a work of Hadrian's time — we can additionally show that Hadrian built a temple to Juno; and this is just what Pausanias says, in the clearest terms. After speaking of the Temple of Jupiter Olympius and vaunting its magnificence, he says, *But Hadrian erected still other buildings for the Athenians; he built the Temple of Juno, etc.*[43] It seems to us highly likely that Pausanias is simply telling us that the same Temple of Juno or Eileithyia that he has just mentioned[44] was the work of Hadrian.

The similarity between the general proportions of the enclosure of this Temple of Juno and that of the great temple built by Hadrian, of which seventeen columns still stand, seems to add likelihood to our conjecture, for the width of each of the two enclosures is approximately two-thirds of its length. And if in the few ruins commingled with modern structures in the center of this enclosure in the bazaar, one cannot clearly recognize the minute parts of a temple, one can at least recognize that they have both the position and the mass of the rear facade of a *naos*.

The location of the Temple of Eileithyia determines that of the Prytaneion, and we have every reason to suppose that this accounts for the remains of the Doric portico, given above. This clearly also shows that Mr. Stuart was wrong in his identification of the ruins that he regards as the remains of an agora, of those that he believes to have formed part of the Poikilē, and of those that he holds to be the remains of the Gymnasium of Ptolemy. As for the Temple of Serapis, since this was close to that of Juno, the very large ruin that is to be seen close to the ruins in the bazaar would seem to be its remains; but, its location being the only evidence that we have, we should not venture to affirm it to be so.

Having shown the probable identity of the building of which the ruin, shown in plate 6, once formed part, I am prompted to say a word about the street where that monument stands. One of the principal streets of Athens, it is the place where the Turks hold their market; they sit before their booths, as may be seen in the drawing. The first part of the street is wider than the rest; this is where fruit and vegetables are sold. To shade themselves from the heat of the Sun, the vendors have planted a grapevine, whose shoots intertwine and are supported by battens that span the width of the street. The magnificence of the ruin, the picturesque effect produced by the variety of houses that line it, and the greenery that covers them, enhanced by the masses of shadow and light that the Sun creates, render this street an enchanting sight in summer. This is not the only street in the city that is shaded in this manner; I noticed several others with similar shelters.

The State of Athens from the Reign of Hadrian to the Present: Description of Some of the Buildings in the Hadrianopolis, or New Athens, Built by That Emperor

It was natural that Hadrian, who spoke Greek as well as he did his native language and who passionately craved the applause of the Athenians for his own

works, should have loved the city where he had borne the title of archon before ever he became emperor. And so, in the course of his grand tour of all the provinces dependent upon the empire, he did not rest content with passing through Athens; he returned there on his way home and spent an entire winter there. During his stay in the city, he heaped gifts upon the Athenians. He attended the greatest of the festivals that they celebrated in honor of Bacchus, and he there showed all the zeal of a citizen, to the point of assuming, to please the Athenians, the dress that his office of first magistrate of the city entitled him to wear. It was then that he applied himself with a will to the enlargement and the improvement of Athens. So many buildings were built for him in one part of the city that it became known as Hadrianopolis, or the city of Hadrian.

The ruins shown in plate 7, of a monument still extant in Athens, marked the division between the city built by Hadrian and that built by Theseus. The inscriptions on the faces of the monument furnish incontestable proof of this. On the side that faces the citadel we read, *This is the city of Theseus;* and on the other: *This is the city of Hadrian, and not that of Theseus.* It is apparent at a glance that this cannot be the Arch of Theseus, as the Athenians commonly call it, for in that hero's day the Greeks had barely invented the Doric, the first and most ancient of their orders; and it is well known that Kallimachos did not invent the Corinthian until many centuries after Theseus's time. The structure itself, which bears Hadrian's name, has all the marks of those built by that emperor or in his reign, as we shall have occasion to illustrate when we give details of it in part 2 of this volume.

From these few remarks, which are all we have to say on the history of this structure, let us go on to consider the area occupied at Athens by Hadrianopolis. As will be seen, the arch just described marks a point on its perimeter. This perimeter is defined, in our opinion, by the numbers 5, 5, 5, to be seen on plate 1.

The inland location of Hadrianopolis is sufficient indication that Hadrian was more concerned to beautify Athens than to restore its former strength. He had, it is true, its harbors repaired; but he seems to have been reluctant to put the city in a condition to defend itself. Though he gave the Athenians so many tokens of his goodwill, it seems that he never gave them leave to rebuild the walls that had formerly secured the connection between the city and Piraeus, Phaleron, and Munychia: the walls that Conon built and Sulla dismantled. The proof of this lies in Pausanias's statement that while traveling from Piraeus to Athens, he saw the walls' ruins on either side of the road the entire way.[45]

After Hadrian's death, the Athenians enjoyed the favor of Antoninus Pius and of Marcus Aurelius. [Lucius Septimus] Severus treated them with rigor; but under Valerian they finally obtained the liberty to secure their city by rebuilding the walls just mentioned. These did not, however, preserve them from the fury of the Goths, who seized Athens during the reign of Claudius [II Gothicus]. The Athenians later enjoyed the particular favor of Constantine [the Great] and of his son Constantius [II]; but the Goths took the city a second time and reduced its finest buildings to a heap of ruins.

After that time, Athens passed into the hands of a number of petty princes; the Turks finally seized it, and it has remained in their possession, though the Venetians have several times wrested it from them. At length, the city that once gave laws to the whole of Greece, and commanded the respect of Asia and Africa, had sunk so low that, even in the last century, it trembled at the sight of a corsair. This fear caused the houses nearest to the sea to be abandoned, and those now inhabited are within reach of the defenses of the citadel. I have marked with dark shading and the numbers 6, 6, the space that Athens presently occupies.

On the plan, I have marked, by the same means, the position of the citadel, which is very much neglected at present. The walls that enclose it are flimsy: embedded in them are fragments of columns and entablatures, which shows that they have been overthrown several times and hastily rebuilt. This fortress has only a score of cannon, in a very poor state, most having no carriages. It is defended by a considerable force of troops, known in Turkish as *neferât* and *askeriye*, and in modern Greek as *castriani*. They are commanded by the disdar, or governor of the castle, who lodges there, as do his troops, which defend it. I have not thought fit to detail the positions of the hovels of the city, which are devoid of interest; and I shall have only a word to say of the religion and customs of the inhabitants, several travelers having already spoken on the subject. The consuls and merchants, who have lived longer in the city, are better able than I to give a full account of it.

Athens is an archdiocese under the patriarch of Constantinople. It contains more than a hundred churches, of which the principal ones are dedicated to the Savior, to the Virgin, and to Saint George. In general, the city has more inhabitants that it had in the last century, when Messrs. Spon and Wheler went there, and it is growing every day. It now has some fourteen or fifteen thousand inhabitants. The Turks make up barely a tenth of that number; nevertheless, the smaller group wields the power and oppresses the other. When I was at Athens, the only Catholics whom I found were six or seven persons in the family of Monsieur Gaspari, the former French consul; Monsieur Léoson; Father Agathange; and a number of children whom the good monk was raising in our religion. It is surprising to find that there are no Jews in Athens and that they are not tolerated in that city, though they are scattered over the whole face of Earth. I asked an Athenian for the reason; he told me, laughing, that the Jews could not stay at Athens because cunning though they are in trade, the Athenians are more so. It is true enough that the latter, though very affable and polite to strangers, are extremely astute in pursuing their own ends.

The only language spoken at Athens is demotic Greek, which is closer to ancient Greek there than anywhere else in Greece. The Turkish tongue is little used. The Athenians are a handsome people in general; they have most lively faces. We were struck by this when we first set foot in Attica, in the train of the Venetian ambassador. We were met by peasants who introduced themselves with a very good grace and spoke to the ambassador with much wit

and freedom. The Athenians are robust and long-lived; this stems, perhaps, from the situation of the city, where the air is so pure that plague is less common there than in other parts of the Levant. However, the city now stands in the worst position relative to the citadel, where it can least readily be refreshed by the east wind. What I say is founded on an experiment conducted there: meat was exposed at the monastery of the Capuchins, which is close to the Portico of Eumenes and the east face of the citadel, and it kept well; meat was exposed at the same time in the heart of the city, which is low-lying and receives little air, and this promptly spoiled.

The Athenians' fondness for honey may also contribute to their good health. The honey of Athens, and of Mount Hymettus in particular, is truly delicious. It was praised, of course, by Ovid [(*Ars amatoria* 2.420)] and by Martial [(*Epigrammata* 13.104)].

The Athenians, like many another people, have been the victims of the ambition of a more powerful people. They languish today beneath the oppression of the Turks; they do not kiss their chains but rather keenly feel their weight. If in ancient times they expelled tyrants from their country, in the year 1754 they gave new proof of the impatience with which they bear the Turkish yoke. When the governor of the city sought to impose an unjust tax, they took up arms, rushed to the castle, and expelled him. His brother was killed in the rising, and a large number of Greeks and Turks met their death as well. Athens was in a state of great confusion for several weeks. The governor was afraid to show his face. A man from the lowest section of the people, but born with the spirit and boldness needed to impress and command the multitude, placed himself at the head of the rebels; he conducted this petty war with much guile, and he employed a number of stratagems to take his enemies unawares. To keep the rebels up in arms and to give them hope, he showed them letters purporting to be from Corinth, Napoli di Romania [(Nauplia, or Návplion)], Patras, and other cities; he pretended that conspiracies to support the revolt at Athens were afoot in those places and that they were on the point of rising; he promised no less than the liberation of Greece. But troops were dispatched to Athens, the rebels took refuge in concealment or flight, and the conspiracy was dissolved.

It would be unjust to blame the Athenians in general for the destruction of a considerable number of the fine buildings that adorned their city and that would have stood for many years to come had not barbarism hastened their ruin. The blame for this attaches solely to those who profess the Muslim religion, and not to the Christians: for the former, on a point of religious principle, mutilate all the figures that fall into their hands; whereas the latter, out of respect for their antiquities, do all that is in their power to conserve them. The houses of the Greeks may be recognized by the bas-reliefs that commonly appear above their doors. The Christians of Athens take the conservation of their monuments so much to heart that they permit the Capuchins to lodge in the monastery that they possess in the city, and in which the Lantern of Demosthenes is embedded, only on the condition that

they enroll as citizens of Athens, to ensure that they carefully conserve that curious building.

One part of the city of Athens still extant today is within the enclosure formed around the citadel by Theseus to enlarge the city; and it is within the area chosen by that hero that we find the ancient monuments of which we have already given the history. We shall complete our account of those that remain to be described in the present section by describing the buildings that stand within or near to the new city of Hadrian.

The tall columns visible through the opening of the Arch of Hadrian seem incontestably to be the remains of a temple raised by that emperor, or during his reign: their relative positions and the proportions customarily given to their temples by the Greeks plainly show that the temple of which they formed a part must have had ten columns on its facade; and we have no grounds for believing that any temple of this kind—which, as we shall show, was unknown in Athens in Vitruvius's day—was built there before the time of Hadrian. Therefore the only buildings of which these ruins could possibly have been a part appear to be the temple that Hadrian erected to all the gods, or the Pantheon; or the temple that the Greeks built to honor Hadrian himself under the name of Panhellenic Jupiter, or protector of all Greece. We shall give our reasons for believing that these are the ruins of the first of these temples.

Pausanias, speaking of the monuments that Hadrian built at Athens, says: "He built the Temple of Juno, that of Panhellenic Jupiter, and the Pantheon." He adds that the latter is most notable for its 120 columns of Phrygian marble. The walls of the porticoes *of the enclosure* are of the same marble. Niches are cut therein. They are adorned with statues and paintings; and gold and alabaster shine in their soffits.[46]

So magnificent a temple, in which Hadrian took great pride, undoubtedly embellished Hadrianopolis and must have been its most beautiful ornament; and as the ruins represented in plate 8 would seem to be those of the most splendid building in Hadrian's city, we consider that they must be the remains of his Pantheon. We are confirmed in this by the 120 most remarkable columns that were to be seen in that building, which is precisely the same number as those in the temple whose ruins are still extant.

Fine though the Temple of Panhellenic Jupiter may have been, we have fewer grounds for supposing these ruins to be its remains. Pausanias states that Hadrian built it, yet Cassius Dio [(*Roman History* 49.16.1–2)] records merely that Hadrian gave the Greeks leave to build it and to dedicate it to him. And so, since it is uncertain that Hadrian built this temple, and since Pausanias, who gives so glowing a description of the Pantheon, has only a word to say about the Temple of Panhellenic Jupiter, we may suspect that the latter did not stand within the Hadrianopolis—or, at least, that it was not that area's principal ornament, that the temple to all the gods surpassed it in size and beauty, and, in short, that the majestic ruins shown in plate 8 are the remains of the Pantheon.

Inside the Pantheon of Hadrian stood a monument that proved both his

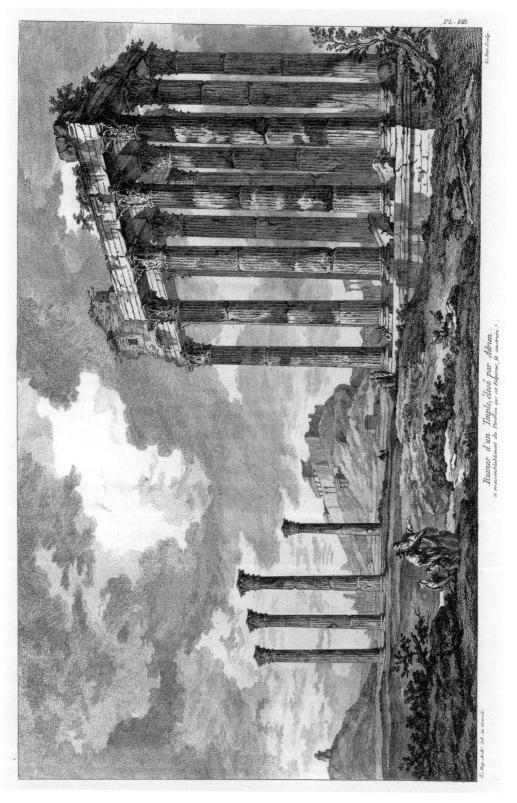

Pl. 8. Jacques-Philippe Le Bas, after Julien-David Le Roy
Ruins of a Temple Erected by Hadrian, Probably the Pantheon that This Emperor Had Built

love of the fine arts and his extraordinary passion for architecture. This was a list of all the temples that he had built, of those he had decorated or enriched with donations, of the countless gifts with which he had honored Greek cities, and of similar favors that he had bestowed on the barbarians. The interior must also have contained a prodigious number of statues, since it was consecrated to all the gods.

Temples of this kind were the largest and most magnificent of all those that the ancients built. They differed in shape but were all alike in being hypaethral, or unroofed. Such was the Pantheon built by Agrippa in Rome, which still stands; and such was the Pantheon of Hadrian, now under consideration. In accordance with the account Vitruvius [(*De architectura* 3.2.1)] gives of unroofed temples, the latter would have had two internal colonnades, one above the other, as did the inside of the Temple of Jupiter Olympius at Athens. Hadrian's Pantheon resembled this in one other respect: a vast enclosure surrounded its *naos*, as may be seen from some existing fragments of boundary wall. Close attention to the extant literature will show that this arrangement was frequent in ancient times.

The columns of the Pantheon of Hadrian, or the ruin described here, are fluted and closely spaced—an arrangement that, while increasing the firmness of the building, rendered its aspect richer and more lively by the multitude of columns that were seen all at once. These columns are crowned with capitals containing sharply acute angles. Of the entablature nothing remains except the architrave, which supports, in places, some comparatively large masses of brickwork. This has led some modern travelers, and the Athenian people themselves, to suppose that Hadrian's palace was built over these columns: an idea plainly too absurd to warrant refutation. We feel bound, however, to examine some others less implausible.

I shall not labor the error of Mr. Spon [(*Voyage d'Italie*, vol. 2, p. 169)], who takes these columns for the 120 of which Pausanias speaks in discussing the Pantheon, and who says that there were six rows of twenty columns each. I shall only say that those that remain are not arranged in the way ascribed to them by that traveler. Mr. Wheler [(*A Journey into Greece*, p. 371)], who commits the same error as Mr. Spon in this respect, and who makes the supposition that the Temple of Jupiter Olympius was elsewhere, nevertheless seems to have harbored some suspicion that these columns of Hadrian's were the remains of the Temple of Jupiter Olympius. This suspicion has become a certainty for Mr. Stuart [(*Antiquities of Athens,* p. 38)], who asserts that it is impossible to imagine these ruins to be the remains of another temple. We shall see whether he is right in making this supposition.

The Temple of Jupiter Olympius, says Pausanias, was of great antiquity, and this is borne out by the list he gives of its contents. According to this author, it contained a very ancient Temple of Saturn and Rhea, the tomb of Deucalion, a statue of Isokrates, and the statues, in Phrygian marble, of Persians supporting a tripod.[47] History tells us that the building was first consecrated by Peisistratos and that Cossutius, a Roman citizen, was appointed

by Antiochus [Epiphanes] to work on its completion. The details Vitruvius provides about the work this Roman architect did on the temple shows that Cossutius, if he did not complete the body of the temple or *naos,* at least carried it far forward.

Assuming that these are the ruins of the Temple of Jupiter Olympius, if we look at the ancient accounts of the Temple of Jupiter Olympius in association with the ruins in plate 8, only two conclusions are possible: either these formed part of the *naos*[48] on which Cossutius worked and which Vitruvius describes; or they are the remains of a new *naos* built by Hadrian in place of that on which Cossutius worked. By quoting Vitruvius's references to the shape of the Temple of Jupiter Olympius,[49] and by arguing that the ancients' descriptions of that monument conform to the arrangement or the location of the remains under consideration,[50] Mr. Stuart shows that he favors the former supposition, since Vitruvius could not have spoken of a temple built by Hadrian. We shall therefore first examine the English author's conjecture.

One feature of the Temple of Jupiter Olympius of which Vitruvius tells us in a passage cited by Mr. Stuart himself, and given here in a note, proves incontestably that the ruins shown in plate 8 cannot have formed part of it: Vitruvius says that it had only eight frontal columns, and the ruins under discussion clearly show that the *naos* of the temple to which they belonged had ten, since its flanks had twenty. This proof is decisive, clear, direct; and there is no likelihood, from the known proportions of the Greek and Roman temples, that one with twenty columns on its flanks could have had only eight in its facades.

This objection against Mr. Stuart's conjecture is so strong that he can counter it only by proving either that the passage in which Vitruvius says that the Temple of Jupiter Olympius had only eight columns is corrupt; or that all the translators of Vitruvius have been wrong in rendering it as they have done; or that the Temple of Jupiter Olympius, described by Vitruvius in the preface to his seventh book as one of the four finest in Greece, suffered from an absurd disproportion between width and length. By its nature, this objection shows that we could dispense with the other authorities invoked by Mr. Stuart in support of his conjecture. Nevertheless, to show that we do not seek to evade them, we shall include them in the discussion.

The ruins shown in plate 8, commonly known in Athens as the Columns of Hadrian, were incontestably the remains of the *naos* of a temple; and this temple was surrounded by an enclosure. Mr. [Francis] Vernon, who traveled to Athens when that enclosure was perhaps more complete than it now is, found it to be 1,000 feet long by 680 wide,[51] which gives a perimeter of more than five stades. This shows that, in Mr. Vernon's opinion, it was more than one-fifth larger than Pausanias's estimate of the perimeter of the Temple of Jupiter Olympius, which was some four stades. True, Mr. Stuart says only that the enclosure approximates the dimensions given by Pausanias; but since Pausanias's measurement tallies better with his conjecture, and since the enclosure, of which only a part is to be seen above ground, is poorly defined,

it is entirely possible that Stuart was mistaken. It is, at least, certain that it supplies him with no corroboration that could ever balance the direct proofs that we have adduced, and that show its unlikelihood.

According to a passage in Hierocles that Mr. Stuart [(*Antiquities of Athens*, p. 39 n. *a*)] cites, the Enneakrounos fountain was close to the Temple of Jupiter; and he maintains that this fountain was close to the Columns of Hadrian. In this he is clearly mistaken, since Pausanias [(*Description of Greece* 1.14.1)] locates it close to the odeion, which is far away from Hadrian's new city, where the columns to which he has given his name are located. This may be seen from plate 1, and the explanation of the parts shown therein. The position of the odeion being established, as is that of the Enneakrounos fountain, which was close by, the passage in Hierocles thus tends to disprove rather than to favor Mr. Stuart's conjecture. Besides, in the passage cited by Mr. Stuart, Hierocles does not say that—as Mr. Stuart renders it—the fountain was close to the Temple of Jupiter Olympius but simply that it was close to the Temple of Jupiter.[52] There were two such temples at Athens when Hierocles wrote: that of Jupiter Olympius and that of Panhellenic Jupiter.

What Thucydides [(*History of the Peloponnesian War* 2.15.4)] says of the location of the Temple of Jupiter Olympius furnishes Mr. Stuart [(*Antiquities of Athens*, p. 38)] with a new argument. The Greek historian relates that it was in the southern part of the city. I shall not consider whether his translator, [Lorenzo] Valla, was right to correct Thucydides' text and place in the north what he places in the south; I shall merely say that the Columns of Hadrian are not to the south of the citadel of Athens but to the southeast and that the southern part of the city is large enough to include both the Temple of Jupiter Olympius and Hadrian's Pantheon.

Mr. Stuart [(*Antiquities of Athens*, pp. 38–39)] says further that since the Columns of Hadrian reveal by their arrangement that they are the remains of a hypaethral edifice, this proves them to be the remains of the Temple of Jupiter Olympius, which Vitruvius mentions as hypaethral, or unroofed. This last argument will be no more difficult to refute than the others: as we have shown, the hypaethral building of which Vitruvius speaks was octastyle, and that of which the Columns of Hadrian formed a part was decastyle. Besides, the great size of pantheons, their purpose, and the example of that which Agrippa built in Rome are incontestable proofs that temples of this kind were unroofed. Finally, since the number and arrangement of the columns of these ruins proclaim that they once formed part of a temple with precisely 120 columns, and since Pausanias says that there were 120 notable columns in Hadrian's Pantheon, there is every reason to believe that these are the remains of that magnificent building. It would be extraordinary to find that this similarity was the product of sheer coincidence; and this last proof seems to us so certain that we believe that it cannot be shaken by the trifling differences alleged by Mr. Stuart [(*Antiquities of Athens*, p. 39)] between the Phrygian marble of which Pausanias says that the columns of the Pantheon were built and the marble of the columns that we believe to have belonged to that building.

There is, as we have said, a second hypothesis consistent with the proposition that the Columns of Hadrian are the remains of the Temple of Jupiter Olympius; and this one is less implausible than the first. If we consider that the ruins shown in plate 8 formed part of the *naos* of the Temple of Jupiter Olympius as rebuilt by Hadrian, it might well be believed that this temple had ten columns in its facade, and the strongest objection against the second hypothesis would be removed; but new objections would take its place, because the ancient authors do not say that Hadrian ever rebuilt the temple. Cassius Dio says only that he completed it,[53] and Pausanias that he consecrated it;[54] or such is the construction that a celebrated academy seems to place on those authors' words, when it says in its *Histoire* that Hadrian *had the honor of consecrating this temple, after having put the final touches on it.*[55] Indeed, to suppose that Hadrian rebuilt the whole or even just the *naos* of the Temple of Jupiter Olympius would compel us to suppose that he had demolished the *naos* built by Cossutius, which Vitruvius praises so highly.

I shall conclude my remarks on the building of which this beautiful ruin formed a part by observing—as I have already done in another work—how difficult it is to get to the truth in inquiries of this kind; and how readily authors who differ in their opinions persuade themselves that they have found it. Mr. Stuart says, in the passage in his book that we have cited, that it is not easy to conceive how anyone ever could have imagined that these were not the remains of the Temple of Jupiter Olympius; and I can truthfully affirm that, for my own part, I have no less difficulty in imagining how Mr. Stuart ever came to suppose that they were.

The rock that may be seen through the widest opening in the temple is that of the citadel of Athens, viewed from its southern side. There may be discerned the respective positions of the Temple of Minerva, the Monument of Thrasyllus, and the theater. This last is behind the three columns on the left; the Mouseion, surmounted by the triumphal monument erected to Gaius Philopappos, is on the far left. The Arch of Hadrian is visible through one of the intercolumniations; this is the side of the arch that faces the Pantheon and bears the inscription that reads, *This is the city of Hadrian, and not that of Theseus.*

The architecture of the Pantheon is greatly superior to that of the Arch of Hadrian. Its capitals are very fine, so far as can be judged by looking up at them from below, for I was unable to measure them, given the prodigious height of the columns and the impossibility of getting in Athens any ladders tall enough. The ruins of this monument include neither frieze nor cornice.

In his new Athens, Hadrian built a road from the Pantheon along the course of the Ilissos. Proceeding upstream, the road led to a bridge, beyond which lay the stadium. "The history of the stadium of Athens," says Pausanias, "is not so interesting as that of some other buildings at Athens; but it is impossible to see it without being struck with amazement. It is all white marble. Some idea of its size may be formed if I say that, beginning upstream of the hill beyond the Ilissos, it extends from the point where it forms a crescent

down to the river. Its direction is in a straight line, and it is double. It was built by Herodes [Atticus], an Athenian, and it used most of the marble of the quarry on Mount Pentelicus."[56]

The stadium, of which Pausanias gives us so grand an impression, is now very far from the beauty that it possessed when that author visited Athens. The tiers are no longer to be seen, though the general shape is still discernible. The part that constituted the facade is visible at the center of the view, plate 9; to make this view more interesting, I thought it best to include both the bridge to my left, which one crosses to reach the monument, and the part of the river Ilissos that lay before me. This class of monument, which the ancients called *stadia,* was built for footraces. Its general shape was that of a much-elongated horseshoe. It had tiers on either side, flanking the enclosure in which the races were run; the start was at the gate at the entrance to the stadium, and the finish was sometimes at the post close to the far end. In some of these monuments, the space between this post and the gate was 600 feet by the Greek measure and 625 by the Roman measure.

The stadium race was the most ancient of the exercises that were held at Olympia and imitated, in whole or in part, at various places in Greece, and at Athens in particular. Animal fights were also held there sometimes: in the stadium described here, Hadrian presented a show in which a thousand ferocious beasts fought on one day.

When we contemplate the immensity of this monument, which was entirely faced with marble, we are astonished that a private individual was able to build it at his own expense; and indeed Herodes [Atticus], who did so, was the richest citizen of Athens. Philostratus [(*Lives of the Sophists* 2.1.547–48)] and others tell us of the good fortune that was the source of his prodigious wealth, of which he made such good use in improving Athens. Some historians also tell us that, rich though he was, Herodes was also greatly learned; a disciple of the celebrated Favorinus, he instructed Marcus Aurelius and Lucius Verus in rhetoric. Respect for his rare qualities won him the dignity of consul. At his death he left ten crowns to each Athenian, and in gratitude they buried him in the stadium, though he had left instructions that he was to be buried in the township of Marathon, his birthplace.

This would be the place to speak of the size of Greek stadia and of the connections among them; but I have treated this topic in a dissertation on the length of the course at Olympia, which will be found at the end of this first part. Here I shall say only that the length of the stadium at Athens, from the entrance to the foot of the lowest tier at the far end, is some 22 feet more than the stadium considered as a unit of measure, which we have calculated to be 569 [Paris] feet. In the plate, I have shown the Ilissos, a river celebrated in history but so small that it runs dry in hot weather: when I went to Athens, there was very little water in its bed.

As I was drawing the stadium from some distance away, I saw some Turkish women washing their clothes in the river. I surreptitiously included them in my view, doing everything in my power to remain unobserved. They noticed

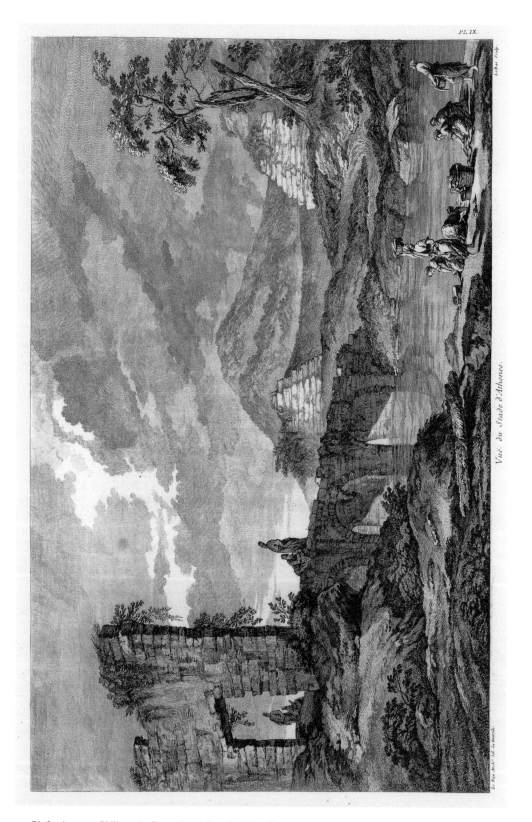

Pl. 9. Jacques-Philippe Le Bas, after Julien-David Le Roy
View of the Stadium at Athens

me nevertheless, seemed highly puzzled, and signed to me to withdraw; which I did, to conform with the established custom of Athens.

A little way from the stadium, and likewise across the Ilissos, stand the scanty remains of a very small temple. I did not draw it; but I shall say a word on Diana Agrotera, or the huntress, to whom it was dedicated. The Athenians gave out that she came from Delos to live in a part of Attica near Mount Hymettus, which abounded in game. To propitiate the goddess, who abhorred marriage, young wives resorted to her temple and offered sacrifices; and as soon as they were with child, they went there to present their girdles to the goddess, and they hung them in her temple, never to wear them again.

On leaving the stadium I followed the Ilissos upstream [(northward)] and, turning away to the left, came to Mount Anchesmus, which overlooks the citadel of Athens, the Mouseion, and the Areopagos. It is a stiff climb to the peak of this little mountain, but the reward is one of the finest views in the world. From there, one sees not only the entire plain of Athens, laid out like a map, but also a great part of the Gulf of Aegina and of the coasts bordering it. It is a delight to survey that beautiful landscape while reading the history of Greece and recalling to mind the extraordinary events for which so many places are famous. If the mind is satisfied, the eyes are no less so, as one surveys the plain of Athens, watered by many streams and planted with olives, vineyards, oranges, and lemons.

At the foot of Mount Anchesmus stands an Ionic monument of mediocre design, shown in plate 9, on which we read that in this place Hadrian built an aqueduct to carry water to the city of Athens. From the design of the monument, I do not believe that it formed part of the aqueduct itself, with the water flowing over it. The Latin inscription,[57] from which we derive this information, is incomplete; Mr. Spon found the missing portion of the text in a manuscript at Zara. I too have found the lost portion of the inscription, in Rome, in a manuscript that Messrs. Spon and Wheler mention only in another context. The manuscript in question is in the Barberini library, where, thanks to the intervention of Cardinal [Domenico] Passionei, I was favored with a sight of this little-known work. In it, the ruin at the aqueduct is depicted, albeit somewhat imperfectly; this drawing differs from my own, made at Athens, in showing not only the two columns with their architrave, frieze, and cornice but also a piece of entablature, lying at the foot of the columns, on which the other part of the inscription is to be seen. I thought it best to correct my own drawing with reference to this and to give the monument as it was before Messrs. Spon and Wheler visited Athens, before the pieces on the ground were carried away or destroyed. The inscription assembled by combining the two parts, plate 10, tells us that the emperor Antoninus [Pius], consul for the third time, completed and dedicated this aqueduct, which had been commenced by his father Hadrian in new Athens.

The manuscript in Rome, just mentioned, is by Giuliano Giamberti da Sangallo[h] and bears the date 1465. It shows several of the antiquities of Athens, including the facade of the Temple of Minerva, which seems to have

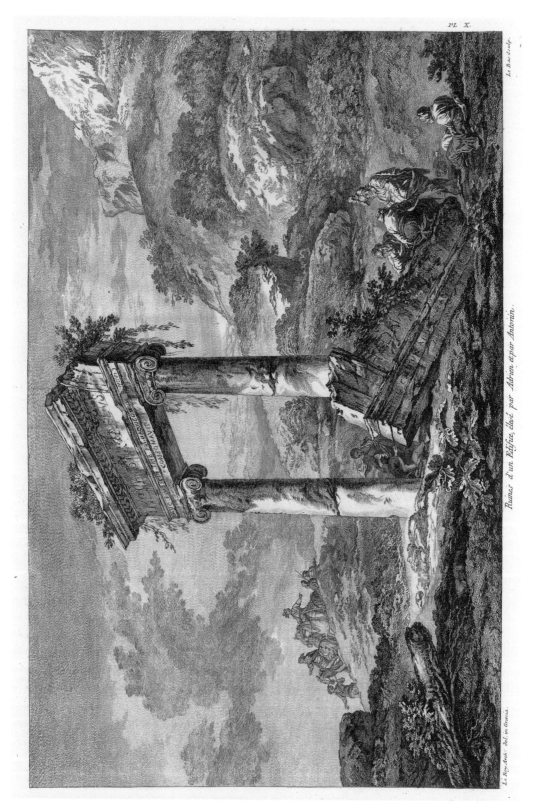

Pl. 10. Jacques-Philippe Le Bas, after Julien-David Le Roy
Ruins of an Edifice Erected by Hadrian and by Antoninus

been drawn from a description in some ancient author that Giamberti misconstrued, since he shows the Centaurs in an attic story and the order as Ionic instead of Doric. The same manuscript contains a plan of a round temple at Athens that the author says was identified by a Greek informant as a temple to Apollo; but, as I have said, the Temple of Minerva has been so imperfectly restored that I am compelled to have my doubts about that of Apollo as shown in this manuscript and about many of the Roman monuments that are also shown and are somewhat oddly reconstructed.

Journey from Athens to Sparta: The Ruins of Cities and Monuments that Are Still to Be Found along the Way

Having seen Athens, having measured and drawn the architectural monuments that still stand, I felt that I ought to go to Sparta, though I was assured that there were few ruins there, so as to compare the present states of these two cities so celebrated in history and so famous for their rivalry. I was strengthened in this resolve by the fact that the journey would take me by way of ancient Eleusis (now Lefsina), Megara, Corinth, Árgos, and, finally, the most interesting localities of the Morea, or the Peloponnese. But, since Sparta is close to Maina, a part of Greece infested with brigands, I thought it necessary to take measures for my own safety, and I accepted with pleasure the consul's offer of his janissary, whom he offered as my escort; I hired another for myself and also took with me an Albanian groom and my own servant.

We thus left Athens well armed; and, taking the precaution of furnishing ourselves with all we deemed necessary to alleviate the expected discomfort of bad lodgings, we set out northward, leaving the Temple of Theseus on our left. After a half-hour's march we came to the beautiful forest of olive trees that partly surrounds the city of Athens, as was seen in plate 1.

The celebrated Academy, where Plato taught his philosophy, was in this forest, between our road and the road to Thebes, which lay to our right. Cicero simultaneously informs us of its location and its fame.[58] Ever since, it has given its name to all those places where the arts and sciences are cultivated. There are no traces of it now, but the fertility of the area where it was situated makes it easy to believe what the ancients said of the beauty of the place, and particularly of the wood of the Eumenides, which was close by. In this wood, which is watered by streams, we saw laurels, ivy, a vine, and other plants, and numerous birds of many kinds. We spent nearly an hour in traversing this beautiful forest, and afterward we soon arrived at the mountain of Pikrodaphne, so called by the modern Greeks because of its many bitter laurels.

This mountain is divided into two parts, between which we passed. The one that we left on our right extends as far as the road from Athens to Thebes; Thucydides [(History of the Peloponnesian War 2.19.2)] calls it Aigaleos. The ancients called the other Korydallos; and they gave the name Amphiale to the headland that it forms where it reaches the sea, opposite the site of the ancient city of Salamis. The mountain reveals no trace of the ancient city of

Korydallos; there is only a roadside spring and an abandoned monastery named after the mountain itself.

On entering the plain of Eleusis, we discovered two watercourses running into the sea. They would be taken for two rivers, says Pausanias [(*Description of Greece* 1.38.1)], if the water were not salt. It is believed that they come from the Evripos strait at Khalkis and that they are sacred to Ceres and Proserpina; only the ministers of those deities are permitted to fish therein. Beyond these creeks we crossed the river Kephissos, now named *Nero is to palaeo milo,* the water of the old mill. On its banks, says Pausanias [(*Description of Greece* 1.37.3)], was the statue of Mnesimache and that of her son, who made an offering of his hair to this river. Between this crossing and Lefsina are the ruins of several temples and a length of paved road of great antiquity; this formed part of the Sacred Way to Eleusis.

As is well known, the city of Eleusis, now Lefsina, once was one of the most famous in Greece, as its ruins show even now. Still to be seen are the remains of a number of fine marble temples, great aqueducts, and other traces of its former splendor. After first examining the traces of the Temple of Diana Propylaia and of a number of other temples, I concentrated my attention on the extant remains of the Temple of Ceres [(Telesterion)].

Once so celebrated and so revered by every people that it was spared even by Xerxes, that sworn enemy of the gods of Greece and destroyer of their temples, this monument is now entirely formless, like that of Apollo on Delos; it is so ruinous that I found it impossible to draw a view of it. It is nevertheless easily identified from its extent and the beauty of its fragments, which include some very fine Doric and Ionic capitals. Vitruvius numbers it among the four temples in Greece whose disposition was imitated by the most celebrated architects, as we have said.[59] Iktinos built it, in the Doric order, of extraordinary size and without external columns, to leave more space for the sacrificial rites. Later, Demetrius of Phaleron, when he was governor of Athens, made it prostyle by placing columns before it, both to enhance the dignity of the building by decorating its facade and to make room for those not yet admitted to the mysteries of the goddess.

In the sanctuary of this temple stood a beautiful statue of Ceres in white marble. This was colossal: the size of its bust, still to be found in the ruins of the temple, shows that it must have been more than fifteen feet tall. The goddess was shown carrying a basket on her head, around which ears of wheat, well known to be her attribute, can still be seen; on her breast she has two ribbons crossed diagonally, with a head of Medusa at the point where they intersect. The draperies in which she was dressed seemed to me to be in the best of taste and in the manner of the caryatids of the Temple of Pandrosos at Athens or of the *Flora* in the Palazzo Farnese in Rome. The statue's face is entirely disfigured; but her hair, tied up with a ribbon and falling onto her left shoulder, is still very fine and fairly well preserved.

The Temple of Ceres was one of the most ancient in Greece; her cult arose in Attica very shortly after that of Minerva. According to Diodorus Siculus

[(*Library of History* 1.1.29.1–4)], Erechtheus introduced it to the Athenians. He delivered the people from a cruel famine by bringing them wheat from Egypt; and after ordering it to be sown in the plains of Eleusis, which he had conquered, he made laws to govern agriculture in Attica and instructed its inhabitants in the cult of Isis, under the name of Ceres. The Athenians accordingly related the myth of Ceres and Proserpina in a form that bore all the features of that of Isis and Osiris; but since they wished to be known as the oldest people on Earth, they attempted to draw an impenetrable veil over the source of their knowledge. Not only did they give out that Ceres had honored Attica with her presence and that she herself had taught them agriculture and given them their laws but they also inscribed this event, in which they so gloried, on a number of their monuments. One of these is still to be seen in Paris: it is a sarcophagus, recovered from the ruins of Athens, on which Monsieur [Claude Gros] de Boze has written a learned dissertation.[60]

As for the goddess, it would be pointless to rehearse here all that the scholars have to tell us concerning her or their additions to the work of Meursius, who was at pains to collect all that relates to her mysteries. Suffice it to say that those mysteries, to which initially only Athenians were admitted, became so celebrated that in time foreigners also desired to take part. Of these the first to be initiated was Herakles; it is even supposed that the Lesser Mysteries were instituted for his benefit. The Athenians subsequently admitted Castor and Pollux, Asklepios, and Hippocrates. Eventually the Romans, after they had conquered the Greeks, were admitted to the Temple of Ceres, and before long it was thrown open to all peoples.[61]

So celebrated in antiquity, Eleusis now fails to merit even the name of village. In the ruins of that ancient city I saw only a few hovels; but it was clear to me that the surrounding plain, and particularly the section between the city and Mount Gerania, is still, as the ancients said, the most fertile part of Attica. This area is some four or five miles around: it is bounded to the east by a small forest and by the hill on which one part of Eleusis stood; to the north by the mountains that separate Attica from the land of the Plataeans; to the west by Gerania, just mentioned; and to the south by the sea. Here, having taken on mortal shape to seek her daughter Proserpina, Ceres was overcome by weariness and seated herself on a stone that has been known ever since as the Sad Stone, from the grief that afflicted the goddess as she rested there.

After resuming our journey and crossing this plain, we traversed Mount Gerania along a narrow and precipitous coastal road and arrived at Megara toward evening.

This town is twenty-six miles from Athens by the road that we took; but the Athenians say that a league or so may be gained by traveling to the ancient Cape of Amphiale [(Pérama)], crossing to the island of Salamis, and crossing, again, from the point on the island where stands a monastery dedicated to Saint John to the former site of Nisaea, the port of the Megarians, two miles from their city.

As history relates, and as the remnants of its walls still show, Megara was

once a flourishing city, one that fought so long and so fiercely against Athens for the possession of the island of Salamis that the Athenians passed a law expressly to punish with death any person who should propose to conquer it, a law later repealed at the behest of Solon. Megara is now reduced to a state of abject misery. When it grew powerful, it transformed its huts into palaces; penury has reversed the process, and the most splendid buildings have reverted to the huts from which they originally sprang, for no other name can be given to houses that have only one story, with walls of sun-dried clay and roofs of the same material.

No ancient monuments, and very few fragments of architecture or sculpture, can be seen at Megara. There are numerous inscriptions, which have been published in part by Messrs. Spon [(*Voyage d'Italie,* vol. 2, pp. 288–91)] and Wheler [(*A Journey into Greece,* pp. 432–35)] and were collected at greater length in the year 1730 by the abbé Fourmont and his nephew [Claude-Louis Fourmont], who traveled in Greece for this purpose at the king's command. Death having carried off the abbé Fourmont, his collection was deposited at the Bibliothèque du roi, where it may now be seen.

We left Megara and passed, on the way to Corinth, over the mountain that Diodorus Siculus [(*Library of History* 4.59.4–5)] calls *Chelone* and other authors *Skironia Saxa:* it derived this latter name from Skiron, a famous brigand of the locality, slain by Theseus. He forced all passing travelers to wash his feet at the brink of a precipice; then he gave them a kick, and they tumbled to the foot of the cliff. This pass is so bad and so difficult to negotiate that in one place a kind of bridge had to be made by laying long planks on boughs wedged into fissures in the rock. This precarious bridge is only three feet wide and has no handrail. Crossing it, one sees the sea beneath one's feet, more than thirty toises down; all travelers dismount at this point. So dangerous is this part of the mountain that the present-day Greeks have given it the name *Kaki Skala,* or evil steps. Between this mountain and Corinth, where I arrived at nightfall of the day on which I had left Megara, I saw nothing of note.

According to the Greek poets and historians, Corinth was founded by Ephyra, daughter of Ocean, and initially bore the name of its foundress. Later, under the name of Corinth, which it retains to this day, it became one of the most flourishing cities in Greece. Its power was no doubt greatly enhanced by its favorable situation: it stands on the isthmus that separates the Morea, or the Peloponnese, from the rest of Greece. Diodorus Siculus [(*Library of History* 11.16.3)] says that this isthmus is forty stades wide from the headland of Kenchreai to Lechaion; I estimated its width to be some five miles, which agrees with the ancient author's information.

Acrocorinth, the castle of the city, stands on the isthmus, at the entry to the Morea: it is set on a mountain so tall and so well fortified by nature that the poets said it had been built by the Cyclopes. As history shows, all the peoples of Greece were eager to ally themselves with the state of Corinth. Powerful by sea and on land, it could prevent the inhabitants of the Peloponnese from leaving their own country and stop other peoples from entering

that part of Greece. It had fleets in the Gulf of Corinth and in the Saronic Gulf. Its situation was, as it still is, so strong that Philip [V] of Macedon, who aspired to subjugate all the Greeks, called it the key and the shackles of Greece. Corinth was also famous for the ease with which the peoples of Greece could make their way to the Isthmian Games, which took place there. These games were very ancient; the brigands who ravaged the isthmus put a stop to them for a time, but Theseus took pride in having restored them, as Herakles did in having founded the Olympian Games. The second founder of Athens even induced the Corinthians to agree that the Athenians should have a place of honor at the games, separate from all other peoples, and that this space would be as wide as the sail of the vessel on which they arrived.

It was at these games, whose magnificence several ancient authors have described, as well as at those of Olympia, that the various states of Greece and their individual citizens were rewarded for their prowess by receiving the acclaim of the entire people. When T[itus] Q[uinctius] Flamininus arrived at the Isthmian Games, where almost the whole of Greece had gathered to learn the consequences of his victory over Philip of Macedon, and had his herald proclaim, in the name of the Roman republic, the restoration of liberty to the peoples of Greece oppressed by that prince, what a reward he reaped!

If Corinth was commendable by virtue of all that we have related, it was no less so for the monuments that adorned it. Of these, some were the precious remnants of a greater number that had stood before the sack of the city by [Lucius] Mummius; others were built after its refounding, as it began to flourish again. Pausanias [(*Description of Greece* 2.1.7, 2.1.4)] tells us of two temples to Neptune, of temples to Diana, to Apollo, and to Jupiter, of the tomb of the celebrated Lais, and of many other monuments. But only one temple has escaped the general destruction, thanks perhaps to the girth and firmness of its columns. It seems to have been built to last through the ages. I saw it on the way from Athens to Sparta and again on returning from Sparta to Athens, each time with the greatest pleasure.

The eight columns shown in a row and almost frontally in plate 11 were those of the temple's facade; those behind—some crowned by an architrave, others only by their capitals—were those of the temple's flanks. I was surprised by the extraordinarily squat proportions of these columns, a sure sign of great antiquity. They are only 22½ feet high but 6 feet in diameter, which gives less than four diameters for the height of each column, including the capital. The space between one column and the next is one diameter; to judge by the architrave, the entablature must have been prodigiously tall. I counted fourteen columns of this temple still standing, though Messrs. Spon [(*Voyage d'Italie*, vol. 2, p. 296)] and Wheler [(*A Journey into Greece*, p. 440)] record that there were only eleven. The one internal column to be seen, which stood at the corner of the inner peristyle, lacks a capital, and the view reveals that it was taller than those of the facade: this is commonly seen in very ancient temples. This one is entirely built in stone, unlike those of Athens, which are entirely of marble. Its columns are made up of multiple drums and show a

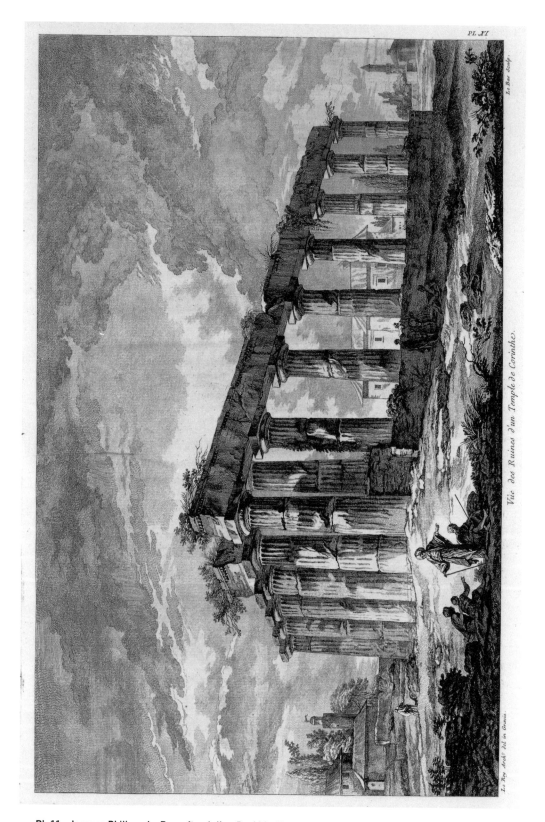

Pl. 11. Jacques-Philippe Le Bas, after Julien-David Le Roy
View of the Ruins of a Temple at Corinth

very marked taper. As there is no inscription on this temple, there is no telling when, or by whom, it was built. The form of its architecture is the sole proof of its antiquity that we have.

Corinth is so ruinous that this monument cannot be identified from its position relative to any object known from the accounts of the ancient writers. I observed, nevertheless, that it stands on a small hill, a mile from the sea, on the side facing the Gulf of Patras. It stands to the north of the citadel, and in relation to the modern city of Corinth, it is close to the bazaar, the place where most houses are clustered together; for Corinth — proud Corinth — is now in so wretched a state that it numbers only some five hundred houses scattered and separated by gardens and plowed fields. The citadel is occupied only by the troops that guard it. At the base of the mountain on which it stands can be seen the marks of an undertaking on which four Roman emperors embarked: that of cutting through the Isthmus [of Corinth]. So difficult did this seem to the Greeks that they made it into a proverb: among them, *to undertake to cut through the isthmus* was to attempt the impossible.

Having drawn and measured the temple just described, I left the city and took the road to Sparta. On leaving Corinth, we had its citadel on our left, and after a westward march of three to four hours along a winding road, much interrupted by ravines, we came to a fertile little plain, approximately a league and a half long from north to south. Here stood the small city of Kleonai; its ruins are still to be seen. Pausanias [(*Description of Greece* 2.15.1)] tells us of its position and mentions a temple to Minerva that stood there, the remains of which I saw. It contained, he says, a statue of the goddess by Scyllis and Dipoenus, disciples or perhaps sons of Daedalus. Pliny [the Elder (*Historia naturalis* 36.4.9)] tells us that these two were among the first Greek statuaries to work in marble. The temple was Doric; its columns were no more than a foot in diameter, and there were dentils in the entablature, a remarkable feature. Nearby I saw some other ruins that I suspect were those of the tomb of Eurytus and Cteatus, slain by Herakles as they passed from Elis to Corinth on their way to the Isthmian Games. We then traversed a gorge by a narrow, difficult, and dangerous track that is permanently guarded by *dervins,* a kind of Turkish irregulars, ill paid and ill equipped. These guards are almost naked; they have a rifle as their only weapon; they offer travelers water to refresh themselves and fire to light their pipes. They will escort the traveler from one guardhouse to the other for a few paras, a small silver coin worth about six of our liards.

The city and forest of Nemea were reached by a road that was on our right as we passed through the gorge. Monsieur Cairac, a merchant at Napoli di Romania, told me that once, having lost his way in this place, he found himself, after advancing for about a league, in a deserted spot where he saw five or six fine standing columns; these were probably the ruins of the magnificent Temple of Jupiter Nemeus.

On emerging from the gorge, we found ourselves in the plain of Árgos; this is so broad and fertile that it comes as no surprise to find that the first settlers

to reach Greece from Egypt founded their colonies there and that the kingdom of Árgos, though created after that of Sikyon, soon exceeded the latter in power. From this gorge to the Gulf of Argolis, the plain of Árgos is five or six leagues in extent; it is watered by several streams and produces an abundance of wheat. Árgos stood not far from the sea; its citadel was on a large and fairly high rock, which appeared to our right as we crossed the plain. The Gulf of Argolis was ahead of us, and Napoli di Romania on our left. This last-named city, where I spent only one day at the house of our consul, Monsieur Bocher,[i] is one of the strongest places in the entire Morea. Still to be seen there are fine fortifications, which were built by the Venetians and on which I saw the Lion of San Marco. But since there are no antiquities at Napoli di Romania, and at Árgos nothing but a few boustrophedonic inscriptions that have been published by Monsieur Fourmont [in his "Remarques sur trois inscriptions,"] I halted at neither of these cities.

Setting out at once on the road to Sparta, we followed the coast and left on our right the castle of Árgos, the marsh of Alcyone, and the fortress of Temenion. The road from Árgos to Sparta is extremely bad; almost all the way, it clings to the flanks of the mountains and borders on a precipice. The hardships of the road are compounded by the poor lodgings; and so I made the journey in two days, though it normally takes three. Like most travelers in Greece, I almost invariably ate in the open air; fourteen miles from Napoli di Romania, I found myself dining in the same place as two agas from that city. We made each other's acquaintance; they sent their slaves over to me with coffee and another liquor that I expected to be sherbet. In this I was mistaken: these worthy Turks were not punctilious in their observance of the law of Muhammad. They followed a proverb that is current among them in the lingua franca: *Real Turks eat pork and drink wine.* The liquor that they offered me was quite good wine, and they accepted with pleasure that which I gave them in return.

Continuing on my way, I saw a small plain, some twenty miles from Árgos, in a location that suggested to me the place, of which Pausanias [(*Description of Greece* 2.38.5)] speaks, where three hundred Spartans fought for this patch of ground against an equal force of Athenians, and a common tomb was erected; but I found no monument there to confirm my opinion. We then crossed the mountain known to the ancients as Parnon and entered the plain of Trípolis. This plain lies high above the level of the sea; it is traversed by streams that rise in the surrounding hills, lose themselves in sinkholes below, and reappear later. On this plain, as on the highest mountains, it is cold in every season. Overtaken by a downpour of rain, we took shelter in a village at the far end of the plain toward Sparta, where, had it not been for my janissaries and the respect with which they are treated everywhere in Greece, I would never have found lodging.

The house or rather hut in which we lodged, like all those in the villages of Greece, was rectangular in plan, with only one story; the pitch of the roof closely resembled that of the Greek temples. It housed a family and all its live-

stock, and I was much surprised, after we settled ourselves there, to find oxen, kids, and sheep passing in front of us and peaceably going to their allotted resting places.

We left the place at dawn and crossed mountains so tall that in places we saw the clouds beneath us. Finally we came to the part of Mount Thornax that overlooks the plain of Sparta. This extensive plain, watered by the Eurotas and by several streams, is surrounded, except on the side nearest to the sea, by lofty mountains. It was the most beautiful part of the Lacedaemonians' territory. They gave out that Lelex, son of Earth, had been their first king, and that they had initially been known, after him, as Leleges; that their state was later successively ruled by Myles, Eurotas, and Lacedaemon; and that the last-named built their city, giving it the name of Sparta after Spartē, Eurotas's daughter, whom he had married.

The Present State of Sparta and the Position of the City in Relation to the Eurotas, to the Stream Knakion, and to Mistra

Description of the Plain on Which It Stands and of the Ruins Still to Be Seen There

Sparta—so celebrated for the laws established by Lycurgus and for the courage of its inhabitants—is now so ruinous, with so few buildings left there, that we feel no necessity to write the history of its former state.[j] From Mount Thornax, which dominates the city, it is visible only if its position is known beforehand, though Pausanias said that it was obvious to all those who descended from that mountain. Since I had brought with me from Rome the works of almost all the ancient and modern authors who have written of it, I easily found the ruins; but, with night falling, I did not examine them closely. I crossed the Eurotas at the foot of Thornax and left the ruins on my left as I traversed the plain to Mistra, where I lodged at the house of one Anastasius, a Greek, who is commissioner for the French people, for in that city we have neither consul nor vice-consul.

Mistra is not built on the ruins of ancient Sparta[k]—as may be understood from plate 12, which shows Sparta located on the plain and Mistra's position as well. Mr. Vernon, an English gentleman who went to Greece in the year 1675, was the first traveler to remark upon this;[62] he confirms La Guilletière, who had published the same opinion, and his view has since been corroborated by the accounts given to Messrs. Spon [(*Voyage d'Italie*, vol. 2, p. 180)] and Wheler [(*A Journey into Greece*, p. 397)] at Athens and reported in their writings, as well as by Monsieur Fourmont's "Relation abrégée du voyage littéraire."[63] But the position of ancient Sparta in relation to the Eurotas and to Mistra has yet to be clearly elucidated; indeed, I discovered that Monsieur Fourmont himself was in error on this point. His great abilities, the trust rightly placed in the work in which the relation of his journey is printed, and the conclusions that could be drawn adverse to my own views on the position of the city oblige me to point out a few instances in which he is mistaken.

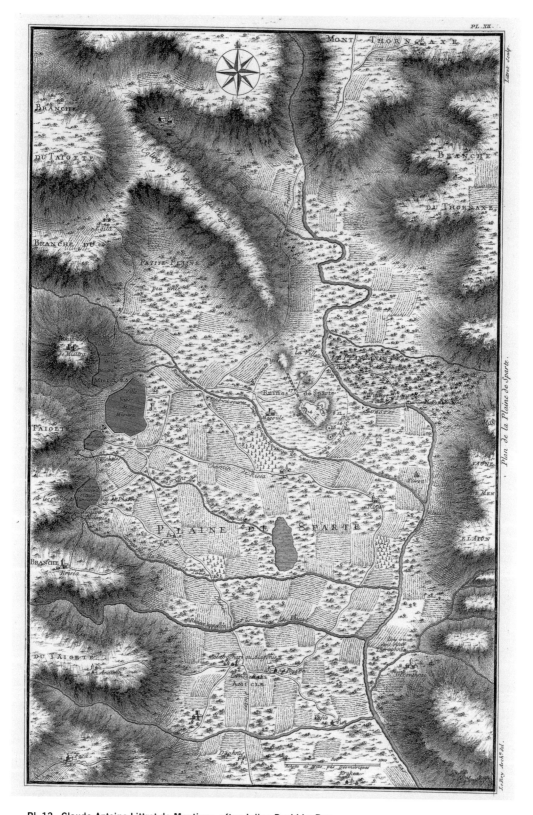

Pl. 12. Claude-Antoine Littret de Montigny, after Julien-David Le Roy
Plan of the Plain of Sparta

Here are the words of the academy's historian: "When the principal citizens of Mistra learned that Monsieur Fourmont had arrived in their city, they came to see him, and they assured him that there was no less a harvest to be had at Mistra and ancient Sparta than at Athens. They made an appointment to go to Sparta; all the *gerontes* [(elders)] resolved to accompany Monsieur Fourmont and to examine it with him, Pausanias in hand. Having crossed the bridge over the Eurotas, Pausanias enters the *platanistous* [(grove of plane trees)] on the right bank of the river, which is still to be seen; he then goes up into the town, etc." If we are to suppose that the academy's historian has understood the traveler's narrative aright, then Monsieur Fourmont and all the *gerontes* of Mistra, Pausanias in hand, were very much mistaken. They cannot have crossed the Eurotas, as the narrative alleges, on the way from Mistra to ancient Sparta: for Pausanias arrived in Sparta from Mount Thornax, to the north of the city, and Monsieur Fourmont set out from Mistra, which is to the west. Even if the ancient author were to say—which he does not—that he crossed the Eurotas, it would not follow either that Monsieur Fourmont, who came from a different direction, must also have crossed it or that the little stream that he did cross was the river Eurotas. Monsieur Fourmont's error as to the relative positions of Sparta and the Eurotas is compounded by his implication that this river, which he situates between Mistra and Sparta, is to the west of the latter, whereas it is to the east according to Polybius [(*Histories* 5.22.2)], a most accurate historian.

Monsieur Fourmont was also mistaken as to the position of the *platanistous* in relation to Sparta. Pausanias [(*Description of Greece* 3.14.8)] says that the way from Sparta to the *platanistous* was across two bridges; he thus places the Eurotas between the *platanistous* and the city of Sparta, and not on the same side, as Monsieur Fourmont asserts. The *platanistous* is not on the road from Mistra to Sparta but is reached only after traversing the ruins of the latter city. Polybius's description of the location of Sparta in relation to the Eurotas and to the various places of which we shall soon have occasion to speak will make Monsieur Fourmont's error still plainer.

Sparta, as I saw in the course of my several visits to Mistra, is two miles distant from that city. To go from Mistra to Sparta, one crosses a little stream that the Greeks nowadays call *Triti*, from the name of a little town where it arises, some two leagues from Mistra, in the mountains of the Máni. Two miles from Mistra, beyond the stream, on the right-hand side, is a hamlet or rather a scattering of huts to which the Greeks give the name of Magula: it is here that the ruins of Sparta begin. The city has been entirely destroyed, but because very few huts have been built over its ruins, the barren space occupied by its remains makes its extent more easily discernible than that of Athens.

The famous city of Sparta was partly built on a number of slight elevations at the foot of a mountain of Messenia which, forming a kind of curve, dwindles to a point facing south by east. The plain, which is hemmed in as well as divided by this mountain or hill, begins to widen out at Sparta, where it is perhaps a league and a half in width and six or seven in length, in the direction of

the sea. The general course of the Eurotas across the plain of Sparta lies to the east of the city, but the section of it that flows between Sparta and the *platanistous* is to its northeast. Sparta was bounded to the southwest by the little river Triti [(Magoula)], which the ancients called the Knakion stream: at the point where it meets the ruins of Sparta, this stream runs some two miles from the mountain chain that borders Messenia. The space between the Eurotas and the mountains east of Sparta, on one of which stood the fort known as the Menelaion, is no more than a quarter of a mile. Finally, the city, which I discovered to be round in shape, just as Polybius says, was no more than six miles in circumference, which corresponds to the forty-eight stades assigned to it by that author.

As is well known, Sparta had no walls until its inhabitants declined from the valor of their ancestors, nor did it have an elevated citadel, like those of Athens or Árgos; but it did enclose within its limits one piece of high ground that dominated the city and took the place of such a fortress. On this stood the most notable buildings, as Pausanias [(*Description of Greece* 3.17.1)] tells us and as I recognized from the theater and the *dromos* [(racecourse)], the remains of which are still to be seen. This eminence rises some thirty to forty feet above the plain: its greatest extent is from east to west, and it may measure 250 geometric paces by 150 from north to south. The city also enclosed four other small rises, two to the northwest and two to the east of the greater one. These little hills formed a kind of chain from east to west. The section of the city between them and the Eurotas measured 600 ordinary paces; the other section, which faced southwest, was far larger.

This description of Sparta derives to some extent from the one supplied by Polybius,[64] but because that historian's account of the position of the city was given solely for the better understanding of two battles won by Philip [V], one beneath its walls and the other within sight of the city, he omitted, as will be seen, a number of features that I find it necessary to include. Nevertheless, what he says of these two battles fought by Philip close to Lacedaemon confirms the truth of my plan, just as this plan, prepared on the spot, may cast new light on the disposition and the movements of Philip's army and the army of the Lacedaemonians. Here is what Polybius has to say on the subject:

"After having ravaged a great part of Laconia, Philip arrived before Amyklae" (which stood, as I shall show, at the site now occupied by the little village of Sklavókhori, marked on plate 12). "Lycurgus came out to meet him, crossed the Eurotas, and took up his position on the mountains of the Menelaion, ordering the troops left in Sparta to be ready to make a sally at once at a signal from him. Philip had to pass the defile that is between the Eurotas and the mountain on which the Menelaion stood: he had the Eurotas and Lycurgus on his right, the city and the Lacedaemonians ready for battle on his left. He took the risk of crossing the river in order to dislodge Lycurgus from the mountain of the Menelaion, and in this he succeeded. While the action was in progress, the phalanx commanded by Aratus arrived from Amyklae and made for Sparta. The garrison of the city came out to engage Aratus, but

Philip quickly recrossed the Eurotas in support of Aratus's phalanx and drove the enemy back to the gates of Sparta; then, having got the phalanx that he had relieved back across the river, he himself followed it, and emerged from the defile glorious and unopposed."

This outline of these two interesting battles, of which the details are to be found in Polybius [(*Histories* 5.20.12–5.23.10)], confirms my account of the situation of Sparta. I suspect, from a large number of observations on the site, that its perimeter was approximately as marked by the dotted circle in plate 12. Within this circle, toward the Eurotas, is the highest part of the city, which according to Pausanias, and as I have said, served the Lacedaemonians as a citadel.

In identifying a number of other localities in the vicinity of Sparta, I shall draw upon Plutarch's account of the city and its form of government. "The oracle of Apollo," he [(*Lives, Lycurgus* 6.1–2)] says, "commanded Lycurgus the legislator first to build temples to Sylanian Jupiter and Sylanian Minerva; then to divide the city into tribes and institute a senate of thirty counselors, including the two kings; and afterward to assemble the people in the public square, between the Babyca[65] and the river Knakion: this was to be the place where the senators would have the right to hold and dismiss assemblies but the common people would have no right to make speeches." This passage positively determines the location of the river Knakion, which was the stream that flows on the southwestern side of the ruins of Sparta and is known to the Greeks of Mistra as the river Triti, since the public square lay, as may be seen in the plan, on the high ground that indeed stands between this river and the ruined bridge across the Eurotas, marked *21*, which was probably designated by the oracle. A little way downstream stood the other bridge over the Eurotas, marked *22*, where its ruins are still to be seen; this was probably not yet built, and its position does not correspond to that of the bridge mentioned by the oracle.

These two bridges served as crossings from Sparta into the *platanistous*, a little plain that drew its name from the great number of those handsome trees known as planes that grew there; this seems to be proved because at its southern extremity, there is still a village called *Platanos*. Here is the gist of Pausanias's account of the place:[66] "When you enter the *dromos*, on the side toward the tomb of the Agiadai, you see the *platanistous* on your right. This grove forms a kind of island, bounded by the Eurotas. It is entered from Sparta across two bridges; on one stands a statue of Herakles and on the other a statue of Lycurgus." This passage shows that the *platanistous* occupied the location that I have marked on the plan. Pausanias also has an interesting description of the fights held there by the young Spartans; content with having indicated its position in relation to Sparta, I shall indicate that of several monuments in that city.

The monuments of Sparta are of two kinds. Some, like the theater and the *dromos*, are still recognizable by their shape; the others, mostly Doric and decidedly mediocre in their architecture, are so ruinous that they present no

more than a confused mass of columns, capitals, and cornices. I was able to find their positions only by reading, on the spot, some extracts from Pausanias that I had made for that purpose and from which I had removed all the superfluous digressions, the better to follow the author's progress. With the more ruinous buildings, I have contented myself with marking their locations on the map of the plain of Sparta by numbers, with the key below.

Explanation of the numbers marked on plate 12.

1. Theater.
2. *Dromos.*
3. Tomb of the king Pausanias.
4. Cenotaph of Brasidas.
5. Highest ground in the city of Sparta, where stood the Temple of Sylanian Minerva [Chalkioikos].
6. The public square at Sparta; it was adorned with a portico, known as the Persian Portico; two temples, one dedicated to Caesar and the other to Augustus; and several fine statues.
7. Street of Limnaion, in which there was a temple dedicated to Diana Orthia, under the epithet *Lygodesma.*
8. Temple of Agnitas, an epithet conferred on Asklepios, because of the wood of which his statue is made.
9. Trophy of Pollux.
10. Heroic monument of Alkon.
11. Temple of Neptune, under the epithet *Domatites.*
12. Temple sacred to Minerva Axiopoenos, or the avenger.
13. Another temple of Minerva, consecrated by Theras.
14. Temple of Hipposthenes.
15. Hill on the summit of which stood a temple to Venus.
16. High ground, known as Kolona, on which there was a temple to Bacchus Kolonatas.
17. Aqueduct.
18. Hill.
19. Another hill.
20. Modern bridge.
21. Ruins of an ancient bridge.
22. Ruins of another ancient bridge.
23. Former site of the school for the Spartan youth.

I made drawings of the theater and the *dromos,* however, and of these I shall now furnish a description.

Pausanias [(*Description of Greece* 3.14.1)] says that the finest building in Sparta was the theater, shown in plate 13; but he does not tell us when it was built. It may still easily be recognized by its shape and size: its widest opening was 250 ordinary paces; its seats were of a grayish white marble and its external walls of a beautiful stone cut in rustication.

This theater was constructed more or less on the model of that of Bacchus at Athens. The spectators' seats have a feature that I have not noticed in any other monument of this kind: the part on which the spectators would sit is rounded and hollowed out such that the front of the row is a little lower than the back. This building is remarkable not so much for its architecture as for one interesting historical fact.

It was here that the Lacedaemonians gave shining proof of their constancy in the face of disaster. When news of the loss of the battle of Leuktra reached Sparta, the rumor spread that all was lost; but the *ephors* [(civil magistrates)] then presenting a festival at the theater, far from betraying any trace of emotion, ordered the games and dances to continue, and each man tried hard to distinguish himself and to win the prizes. After that, they sent the list of the dead all around the city.

In front of the theater is a mass of brickwork with parts of two standing columns, which probably represents the remains of the tomb of the king Pausanias; it was situated here, as was the famous column inscribed with the names of those brave Spartans who withstood the Persian onslaught at Thermopylae.

Also close to this theater was the Cenotaph of Brasidas, the famous Lacedaemonian general. Pausanias mentions it on the way out of the square to the west. The cenotaph was octagonal in shape, as can still be seen; but it was so unprepossessing that I saw no need to draw it. I have a word to say on the subject of the *dromos*.

The *dromos* was a kind of stadium where the young Spartans ran races; it is now extremely ruinous. On one side, toward the Eurotas, is a large number of pedestals covered with inscriptions that tell us the names of those who won prizes at these games. I shall not give these inscriptions; they were copied by Monsieur Fourmont and deposited, with many others, in the Bibliothèque du roi, where they may be seen. But in my view of the *dromos*, plate 14, I have shown the form of one of these pedestals.

To draw this monument, I placed myself on slightly raised ground, so that I could show the Eurotas and its position between the *dromos* and the mountain on the right, on which the Menelaion fort once stood. The other mountain, on the left, is Thornax.

Having examined the ruins of Sparta, I set out to locate a number of other famous cities in the neighboring parts of Laconia. Starting from ancient Sparta in search of the site of Amyklae, I was soon successful. Its position, which Pausanias [(*Description of Greece* 3.18.6)] indicated as being beyond the river Tiasa; its distance of 20 stades from Sparta, noted by Polybius and by Pausanias himself; the fertility of the area where it was built; and the fine trees that surrounded it were the signs that confirmed for me that, as abbé Fourmont has said, it stood on the site now occupied by the village of Sklavókhori.

Amyklae lay in ruins long before Sparta; by Pausanias's time it was no more than a village. One of its finest monuments was the Temple of Alexandra, whom the Amyklaeans identified with Kassandra, daughter of Priam, and

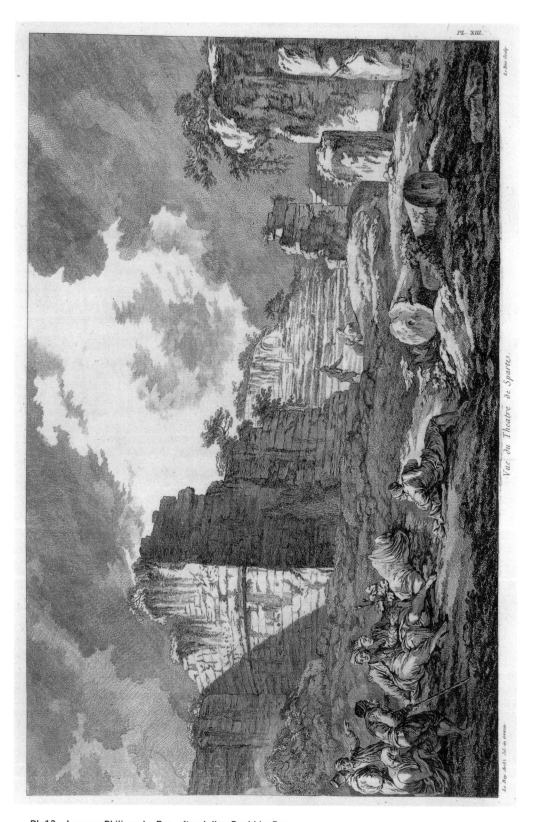

Pl. 13. Jacques-Philippe Le Bas, after Julien-David Le Roy
View of the Theater at Sparta

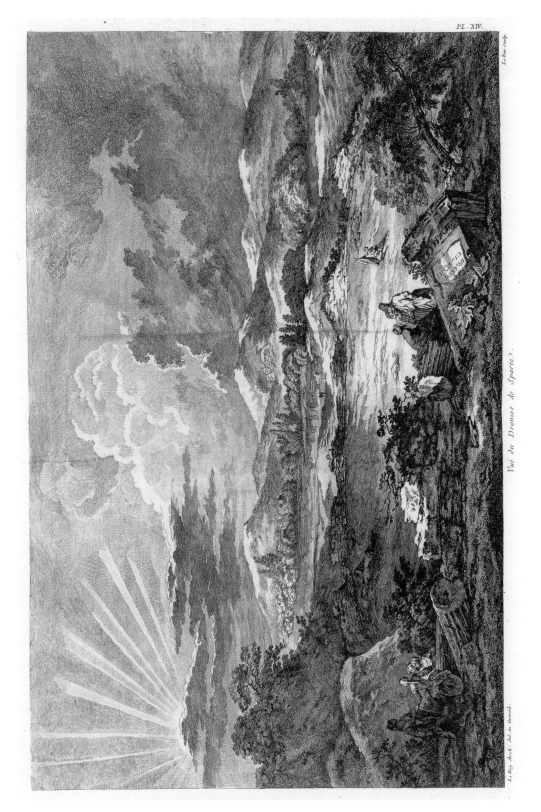

Pl. 14. Jacques-Philippe Le Bas, after Julien-David Le Roy
View of the Dromos at Sparta

whom they held in particular reverence. The *Mémoires* of the Académie [royale] des inscriptions [et belles-lettres, vol. 15,] contain an excellent dissertation by Monsieur Fourmont on an inscription that he found in this temple. I did not see it; it has been broken or removed, or else it eluded me.

On his way from Amyklae to Therapne, Pausanias [(*Description of Greece* 3.19.6–7)] crossed the Eurotas; but he does not say that he crossed the Tiasa again, which leads me to the conclusion that this town was situated more or less as I have marked it. Therapne took its name from a daughter of Lelex. Menelaos had a temple there, in which, according to the inhabitants, he and Helen were buried. On the road from Sparta to Therapne, on the right, was the fountain of Polydeucea, or of Pollux; the college of the Spartan youths was near there, separate from Sparta itself. Pausanias [(*Description of Greece* 3.20.3)] describes Pharis as being situated on the road from Therapne to Mount Taíyetos; and so Monsieur Fourmont's opinion [in his "Relation abrégée du voyage littéraire," p. 356,] that Pharis was on the site currently occupied by the suburb of Sparta called *Pharori* seems to agree perfectly with our ancient author. The suburb of Pharori is one of three possessed by the city of Mistra; the two others are called *Enochorion* and *Exochorion*.

For the rest, Mistra stands higher than its suburbs; as has been said, it does not occupy the site of ancient Sparta. The inhabitants of that city were forced to abandon it altogether because the Turks had broken its aqueducts; they built Mistra, or new Sparta, on the slope of a high rock, of which it occupies the entire eastward- and northward-facing part. This city is dominated by its castle, which stands on the summit of the rock, and the castle is dominated in turn by the mountains of Máni or Messenia, peaks of tremendous height, covered with snow. The citadel of Mistra stands west by south of the piece of high ground that took the place of a citadel in Sparta.

There are ten thousand souls at Mistra, among them very few Turks and no Catholics. All the land dependent on the city pays to the sultan eight thousand *caratch*. The *caratch* is a poll tax that the sultan raises in his domains. Women and children do not pay it. When I was in Greece it was normally four, five, six, or seven piasters. In general, this tax is very moderate; but wealthy Greeks are sometimes made to pay, on some slight pretext, a kind of arbitrary impost, the *avania,* which is extremely onerous.

The principal trade of the inhabitants of Mistra is in silk; they also harvest cotton and oil. They ship these goods from Helos, and this trade is conducted, at the point of a sword, as it were, for the factors who travel to Helos on behalf of French merchants go escorted by twenty well-armed men, to deter attacks from the brigands who infest this stretch of coast.

While I was at Mistra, I witnessed a most agreeable fair on the plain of the *platanistous,* which is bounded by the Eurotas, beside the bridge that leads to it; it was an image of the public feasting of the ancient Spartans. The people gather there often; some dine alfresco, while others dance and make merry to the sound of a drum.

They have one singular superstition. On the plain of the *platanistous* is

the ruin of a monument with a fallen column that bears a long and badly weathered inscription. To this they bring cottonseeds and rub them on the column; after this mysterious operation, they say that they are sure of an abundant crop.

After satisfying my curiosity about the remaining monuments of ancient Sparta and about the position of the city in relation to all the interesting sites that surround it, I set out once more for Napoli di Romania, where I met a merchant of our own people who suggested that I return with him to Corinth by way of Lessa. I accepted with pleasure, notably because Pausanias [(*Description of Greece* 2.25.10–2.26.1)] mentions a town of that name as the last town in the state of Árgos, on the border with Epidauros. We therefore left on our left hand the road that one normally takes from Napoli di Romania to Corinth, and, proceeding toward the sea, we came to Lessa. There I saw a number of ruins that satisfied my curiosity yet did not appear important enough to merit drawing. I therefore set out once more for Corinth and Athens. I saw the last-named city with renewed satisfaction, and, having spent three more weeks there, I left at the end of April. I went with Monsieur Léoson, the French consul, to Oropos [(Skála Oropoú)], where I embarked for Italy, there to revisit the ruins of the monuments of antiquity and compare them with those of the buildings that I had examined in Greece.

Greek Inscriptions Still to Be Found on Those Monuments of Which Drawings and Histories Are Given in the First Part of This Volume

Inscription on the frieze of the monument erected in honor of Thrasyllus:

ΘΡΑΣΥΛΛΟΣ ΘΡΑΣΥΛΛΟΥ ΔΕΚΕΛΕΥΣ ΑΝΕΘΗΚΕΝ
ΧΟΡΗΓΩΝ ΝΙΧΗΣΑΣ ΑΝΔΡΑΣΙΝ ΙΠΠΟΘΟΩΝΤΙΔΙ ΦΥΛΗΙ
ΕΥΙΟΣ ΧΑΛΚΙΔΕΥΣ ΗΥΛΕΙ ΝΕΑΙΧΜΟΣ ΗΡΧΕΝ
ΚΑΡΚΙΔΑΜΟΣ ΣΩΤΟΣ ΕΔΙΔΑΣΚΕΝ

"Thrasyllus, son of Thrasyllus, of Dekeleia, dedicated this, having been the victor while presenting the games, with the men of the Hippothontis tribe. Euios of Khalkis supplied the musical accompaniment, Neaichmos being archon or having presided. Karkidamos Sotos directed the recital."

Inscription on the plinth on the left, above the entablature of the same monument:

Ο ΔΥΜΟΣ ΕΧΟΡΗΓΕΙ ΠΥΘΑΡΑΤΟΣ ΗΡΧΕΝ
ΑΓΩΝΟΘΕΤΗΣ ΘΡΑΣΥΚΛΗΣ ΘΡΑΣΥΛΛΟΥ ΔΕΚΕΛΕΥΣ
ΙΠΠΟΘΟΩΝΤΙΣ ΠΑΙΔΩΝ ΕΝΙΚΑ
ΘΕΩΝ ΘΗΒΑΙΟΣ ΗΥΛΕΝ
ΠΡΟΝΟΜΟΣ ΘΗΒΑΙΟΣ ΕΔΙΔΑΣΚΕΝ

"The people presented the games, Pytharatos being archon or having presided, and Thrasykles, son of Thrasyllus, of Dekeleia, being agonothete.

The victory went to the youth of the Hippothontis tribe; Theon of Thebes had charge of the music; Pronomos of Thebes directed the recital."

Inscription on the plinth on the right above the entablature of the same monument:

Ο ΔΗΜΟΣ ΕΧΟΡΗΓΕΙ ΠΥΘΑΡΑΤΟΣ ΗΡΧΕΝ
ΑΓΟΝΟΘΕΤΗΣ ΘΡΑΣΥΚΛΗΣ ΘΡΑΣΥΛΛΟΥ ΔΕΚΕΛΕΥΣ
ΠΑΝΔΙΟΝΙΣ ΑΝΔΡΩΝ ΕΝΙΚΑ
ΝΙΚΟΚΛΗΣ ΑΜΒΡΑΚΙΩΤΗΣ ΗΥΛΕΙ
ΛΥΣΙΠΠΟΣ ΑΡΚΑΣ ΕΔΙΔΑΣΚΕΝ

"The people presented the games, Pytharatos being archon or having presided, and Thrasykles, son of Thrasyllus, of Dekeleia, being agonothete. The victory went to the men of the Pandionis tribe; Nicocles of Ambracia had charge of the music; Lysippus, an Arcadian, directed the recital."

Inscriptions on the monument erected in honor of Gaius Philopappos:

C. IVLIVS C. F.
FAB. ANTIO
CHVS PHILO
PAPPVS COS.
FRATER AR
VALIS SVLLE
CTVS INTER
PRAETORI
OS AB IMP.
CAESARE
NERVA
TRAIANO
OPTVMO
GERMANICO
DACICO

"Gaius Julius Antiochus Philopappos, son of Gaius, of the Fabian tribe, consul, Arval brother, admitted to the ranks of the praetorians by the most excellent emperor Caesar Nerva Trajan, victor over the Germans and Dacians."

On a plinth of the same monument:

ΦΙΛΟΠΑΠΠΟΣ ΕΠΙΦΑΝΟΥΣ ΒΗΣΑΙΕΥΣ
"Philopappos, son of Epiphanes of Besa."

On a plinth of the same monument:

ΒΑΣΙΛΕΥΣ ΑΝΤΙΟΧΟΣ ΒΑΣΙΛΕΩΣ ΑΝΤΙΟΧΟΥ
"The king Antiochus, son of the king Antiochus."

Inscriptions on the faces of the arch set up by Hadrian:

ΑΙ Δ ΕΙΣ ΑΘΗΝΑΙ ΘΗΣΕΩΣ Η ΠΡΙΝ ΠΟΛΙΣ
"This is Athens, which began as Theseus's city."

ΑΙ Δ ΕΙΣ ΑΔΡΙΑΝΟΥ ΚΟΥΧΙ ΘΗΣΕΩΣ ΠΟΛΙΣ
"This is Hadrian's city, not Theseus's."

Dissertation on the Length of the Course at Olympia; on the Way in Which It Was Traversed by the Athletes; and on the Relations between the Olympian, Italian, and Pythian Stades; Presented to the Académie [Royale] des Inscriptions et Belles-Lettres at the Beginning of the Year 1767

As is well known, we owe the origins of the stadium to Herakles,[67] who first traced it at Olympia. There he paced out a course for the footrace and made it 600 feet, or 1 stade. The athlete who ran those 600 feet once, with all possible speed, was running the single stade. There was also a double stade, known as the diaulos, which covered the full length twice; and the dolichos, or 12 stades, which covered it twelve times in succession. But how were these different courses run? Was the course of 600 feet set by Herakles at Olympia, which formed the single stade, in a straight line? Did he pace it out without changing direction? Or did he simply go 300 feet in one direction, from a fixed point to the finishing post, and 300 feet back to the place from which he started? This is what has yet to be determined.

Since this question is of the utmost importance in understanding both the dimensions of the stadium and the specific circumstances of the race, we propose to examine it in this dissertation. We shall thus consider first the conditions of the race in general, then the length of the course at Olympia and of some other courses in Greece, and then how the athletes ran them.

Conditions of the Race

The first men ever to exercise themselves by running races may well have set only one condition: that, starting from the same place and running together, they would seek to outrun one other. But a man who begins very fast soon exhausts his strength and becomes unable to sustain the race for long, and so there are grounds for believing that those who perfected the footrace in classical times added another condition: that, of two men who set out from the same place at the same moment, the one who arrived first at a certain goal would carry off the prize for the race. Finally, to complicate the race, to make it more difficult and try the skill of the participants, they added a third condition: that, of two athletes who set out at the same time from the same place to touch or to run around a post, the prize should go to the one who returned to the start first.

Of all the authors who have written on the single stade race, none has failed to regard the first two conditions I identified as being essential to it—

namely, a start and a finish to the race or to the course. But they have not regarded the third condition—namely, touching or turning around a goal or post and then returning to the start—as essential to the single stade race in remotest antiquity; and here, in my view, they are mistaken.

From the description given by Homer of the chariot races held by Achilles at the funeral of Patroklos, it is evident that the condition of rounding a post was the principal difficulty of this sort of race; this can be seen from the advice that Nestor gives to his son Antilochos as to ways of avoiding a fall.[68] Homer thus supposes, and informs us, that Nestor knew of this condition in the chariot race, which greatly increased its difficulty; and, even if this complication did not exist at the time of the Trojan War, the date of Homer proves that it formed part of the chariot race more than a century before the revival of the Olympian Games.[69]

Not only does Homer tell us in the clearest manner that there was a turning post in chariot races but he [(*Iliad* 23.758)] also mentions a post in his account of the footrace for which, again, Achilles offered the prize. The authorities have differed as to the use of that post in the footrace described by Homer: some regard it as marking the start or the finish of the course, others as a turning post.[70] At Olympia, however, it seems certain from a large number of passages—though it has not hitherto been remarked on—that the runners turned the post and returned to the start not only in the longest races but also in the shortest, those that were only a single stade long.

On the Length of the Course at Olympia, and the Way in Which the Athletes Traversed It

Monsieur [Pierre-Jean] Burette, who has so learnedly investigated the races of the ancients, has in our view adopted some opinions that he might well have contested. He says "that the stadium chosen as the place for the race—the lists or the course—was commonly formed by a bank or a kind of terrace."[71] Such, he says, was the stadium at Olympia, as described by Pausanias. He adds a little later: "The length of the stadium varied from place to place; that at Olympia was 600 feet." All that he says then, while dealing successively with the beginning, middle, and end of the stadium, serves to confirm that in his opinion the place that served as the course was 600 feet in length. The far end of the stadium, he says,[72] was known by a variety of names: some defined the end of the course as the post where the race of the *stadiodromoi*, or runners of footraces, ended; whereas in both chariot races and horse races, the contestants ran around this post, to return to the end from which they had started. From which it ensues, says this author, that the finishing post reached by the *stadiodromoi* in running the single stade, the course of 600 feet, was different from the finishing post for the diaulos, the chariot races, and the horse races.

It seems to us that Monsieur Burette's description of the stadium allows of only one conception of the course, namely, that having run 300 feet (or *AB* in figure 1 of plate 15) from the start, one reached the center of the stadium,

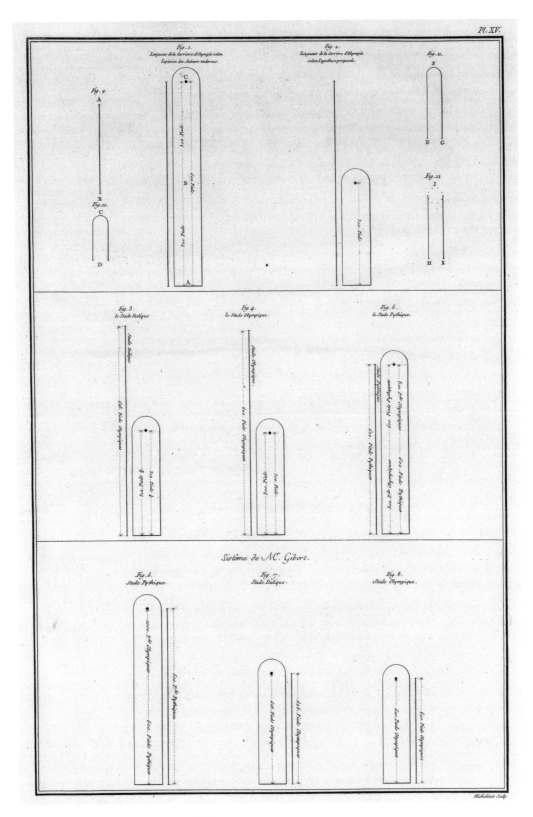

Pl. 15. Michelinot

where the prizes were set out; then, after continuing in a straight line for an additional 300 feet, one came to the end of the course, C, that is, the place where the post was. In his account of the matter, this plan applies to the stadium at Olympia and to all other stadia. But here is my own view as to the way in which that stadium was laid out.

The course at Olympia was 600 feet long, but while Monsieur Burette believed this to be a straight line, we consider that the 600 feet were arranged as in figure 2, such that the outward leg, from gate to post, was 300 feet and the return leg, from post to gate, was another 300 feet. So our hypothesis is that in the course run by the *stadiodromoi*, the post was not the finish, as Monsieur Burette maintains, but the halfway mark; and the finish, instead of being the post, as he also says, was on precisely the same transverse line as the start.

Though the distance that we give from gate to post in the stadium at Olympia is only half that given by Monsieur Burette and by all those who have written on stadia, we nevertheless hope to prove that it was that and no more. To this end, we shall show:

1. That if the single stade race had ended at the post, it would have lacked one important condition.
2. That by supposing the distance from gate to post to be no more than 300 feet, we explain more naturally than hitherto the ancient authors' most important references to the topic of stadia.
3. That this hypothesis also explains more plausibly than hitherto the famous passage in Censorinus [(*De die natali* 13.23)] on the relation between the Olympian, Italian, and Pythian stades.

Item 1

If the *stadiodromoi*—those who ran the single stade—had run the distance of 600 feet in a single straight line, then the victorious athletes would have owed their triumph almost entirely to nature, which makes some stronger or more agile than others: the distance being inconsiderable, the art of husbanding one's strength at the start of the race could not have contributed much to the victory. But suppose that there was a turning post at the midpoint of the course, 300 feet from the starting line: then the art of coming very close to that post and rounding it quickly might have gone far to make the contest an equal one. One man, for example, might reach it ahead of all his rivals but then round it slowly or fall clumsily and thus find himself outstripped by them; and this must have greatly increased the interest and the pleasure that the spectators took in races of this kind. It also considerably assisted the judges whose duty it was to preside and to crown the victor, for they were able to judge, all together, both the moment of the start and that of the finish; whereas, under the alternative supposition, some judges would have had to be at the start and others at the far end of the stadium.

Item 2

The different parts of the stadium had different names, which Monsieur Burette has collected and explained, and for this reason we shall not speak of them here; we shall merely give those names that can cast some light on the distance between the gate and the post and on the length and direction of the course traversed by the athletes during the race: namely, the words that serve to designate the beginning of the course or the race and also to mark the end, such as *balbis* and *grammē*. Both were used to designate the start of the race,[73] but both were used to designate the finish as well; it is in this sense that Pindar uses the term *grammē*, which signifies *line*. This poet [(*Pythian Odes* 9.117–20)] relates that Antheus, king of Irase in Libya, offered his daughter Barcea to her suitors as the prize in a footrace; he placed her on the finishing line and declared that the man who first touched her veil might take her and carry her off.[74] Now it is difficult to imagine that Pindar, in describing this athletic contest, would have used the same word to denote the finish and the start, if the start and the finish had not been on the same line. He commemorates a race that both started and finished at the same line, known as the *grammē*, and the athletes performed a complete circuit of the stadium and rounded the post once.

This post was so important, it so increased the difficulty of the race, that it was given an epithet derived from the longest race that was run in the stadium: Pindar calls it *dodecagnampton*,[75] which means that it was rounded twelve times. In the horse races, the same poet gives the horses the epithet *dodecadromoi*, to show that they ran the same course twelve times.

How long, then, was the course in which horses made twelve circuits and in which the post was rounded twelve times? As is well known, this was the dolichos; and though *Suidas* describes it as 24 stades long, Heron [of Alexandria] and most of the ancient commentators made it only 12: from which it follows that, if there were only 12 stades in the whole course of the dolichos and if the runners rounded the post twelve times, the post must be only 300 feet, or half a stade, from the gate: which is precisely what we propose.

It will thus be seen how easy it is, under our hypothesis, to explain why the end of the course was given the same name as the start and why the contestants rounded the post twelve times in running only 12 stades in the race. Let us see whether, on the supposition of a distance of 600 feet between the gate and the post, the same passages submit to an equally natural explanation.

First, according to this hypothesis, the single-stade race, that of the *stadiodromoi,* would finish at the post; they would not have rounded it, and the race would have lacked this important provision. It would also have been more difficult and less convenient to judge, for it requires posting some judges at the entrance to the stadium, the athletes' starting point, and other judges at the finish.

Second, in this race, the finish could never have been given the same name as the start. Since they would have been at opposite ends of the stadium, 600 feet apart, the finish and the start could never have been identified or confounded with each other.

Third, those who ran the dolichos, or 12 stades, would have completed only six full circuits; and, in that case, the epithet *dodecagnampton,* assigned to the post by Pindar, and that of *dodecadromoi,* which the same poet assigned to the horses, would no longer have applied.

Some authors, it is true, have sought to reconcile these two ideas. Monsieur [Louis-François-Joseph] de La Barre, who agrees with Monsieur Burette in supposing the distance from the post to the gate to be one full stade, thus giving only six complete circuits of the stadium for the dolichos, says, "It will be seen that runners made not twelve but six revolutions round the post, at which, if I may so put it, they veered twelve times, half as they turned to run behind it and half as they turned back into the straight" ([p. 392 in] *Mém. de litt.*). But it is all too evident, from the very manner in which Monsieur de La Barre expresses himself, that he feels the precarious nature of his explanation of Pindar's epithets for the post and the horses. Before him, the abbé Gedoyn had proposed another explanation: he suggested that there were twelve distinct divisions of the course, twelve consecutive spaces through which the runners passed. He says, "Perhaps, too, they described twelve concentric circles around the post, coming closer at every turn, so that on the last revolution they were so close that they seemed to touch it."[76] These ideas of the abbé Gedoyn's on the races are very far removed, as will be seen, from those of all other writers on the subject; and since it seems to me that he has not demolished the explanation of Pindar's epithets previously offered by Monsieur Burette and adopted by me, I hope to be excused if—in the cause of rendering this dissertation as brief as possible—I forbear contesting this scholar's opinion.

Finally, what seems to prove in the most irrefutable manner that the single course, such as that at Olympia and the most ancient ones in Greece, measured only 300 feet from gate to post is that the ancients gave the name *double* to those courses that measured twice this distance from gate to post, or 600 feet; for Pausanias says, in so many words, that the stadium at Athens was double;[77] and it is clear from what remains of it, as has been seen in this first part, that it measured just 600 feet from gate to post. The passage of that author, cited in note [77], clearly proves what we claim.

Item 3: That the Hypothesis Proposed Allows a Very Natural Explanation for a Significant Passage by Censorinus on Stades

Censorinus, speaking of the Italian, Olympian, and Pythian stades, says that the first is 625 feet, the second 600, and the third 1,000.[78] Of all the discussions of the Greek measures that we find in the ancients, this passage by Censorinus undoubtedly appears the hardest to explain; indeed, it seems at first to contradict all that we gather in general from their writings. It should be no surprise, therefore, to find that some authors, including Monsieur d'Anville in his *Eclaircissements geographiques,* have regarded this passage as inexplicable. How can we believe that the Pythian stade contained 1,000 feet, as Censorinus states? It could not contain 1,000 Pythian feet, since all Greek stades were divided into 600 feet; and if we were to suppose that 600 Pythian

feet corresponded to 1,000 Olympian feet, it would follow—the Olympian foot being, by common consent among the Greeks, the exact length of Herakles' foot—that the Pythian stade was unconscionably long. Alternatively, if the Pythian stade were not to be longer than any other known to us, it could remain equivalent to 1,000 Olympian feet only if the Olympian foot became so short that it could never square with the length of Herakles' foot.

The shortness of the Olympian foot that follows from Monsieur [Joseph-Balthasar] Gibert's highly ingenious explanation of this passage[79] is perhaps the sole objection that can be made to his hypothesis; for he remarks, with considerable justice, that if we are to assume that Censorinus meant to make a true and rational statement, we must believe that he assessed the three stades, Italian, Pythian, and Olympian, by the same measure. To this remark of Monsieur Gibert's, which I have taken into account in my proposed explanation, I shall add another: that Censorinus has applied a single measure—one and the same foot, for example—to things of the same nature, which he compares with one another.

These things of the same nature that Censorinus has compared may possibly be the values of the linear measures known as stades considered in the abstract, with no reference to the place known as a stadium from which, according to some authors, they take their origin; or else he may have had in mind the distances run in those races that supplied the Greeks with their measures. Construed in the former sense, and in the most direct manner, the passage seems so contrary to all we know about these Greek measures that we believe that it can be understood in another manner.

We consider, therefore, that Censorinus meant to say of the Italian stadium that its length, the entire extent of the race, was 625 feet. This we explain (pl. 15, fig. 3) as follows: the runners ran 312½ feet from gate to post and 312½ feet back from post to gate. Similarly, we believe him to have meant that the Olympian stadium (fig. 4) measured 600 feet over the whole length of the course and that the course at the Pythian stadium measured 1,000 feet (fig. 5), which the runners covered by making one circuit.

From which it will be seen that a complete circuit of the Italian or Olympian stadium would have been exactly equal to the length of that stadium considered as a stade or measure; and that a complete circuit of the Pythian stadium would, as Censorinus failed to explain, have measured 1,000 Olympian feet, equal to 1,200 Pythian feet or 2 Pythian stadia taken as a unit of measure.

Obviously we have taken the Olympian foot as a common measure, as does Monsieur Gibert. We felt impelled to do so because the Olympian stadium is alone in preserving the division intrinsic to the Greek stade, into 600 feet, and it seems natural to suppose that the elementary foot of this stadium served as Censorinus's common measure to gauge the length of the others.

From this it follows that the distance run for the prize was 2 stades at Delphi, while at Olympia it was only 1. This makes it easy to understand the differing remarks of *Suidas* and Heron on the dolichos: for Heron, who

describes it as 12 stades long,[80] must be referring to the Olympian course, or to any of those that measured only half a stade from the gate to the post; whereas *Suidas,* who gives its length as 24,[81] must mean the Pythian course, or others like it.

These differing ideas that *Suidas* and Heron give us of the dolichos compel us either to reject the opinion of *Suidas* on this race; or to reject what Heron tells us, namely, that it was only 12 stades long; or to admit, as we do, that there were two kinds of course: one with a circuit that measured 2 stades in all, so that twelve complete circuits equaled 24 stades; the other with a circuit that measured only 1 stade, so that twelve circuits measured 12 stades — with the proviso that since the post at Olympia was given the epithet *dodeca-gnampton* and the horses at Delphi that of *dodecadromoi,* the simplest race in either stadium seems to have consisted of a single circuit, that is to say, 1 Olympian stade at Olympia, and 2 Pythian stades at Delphi.

Which proves most clearly that the single stade was not run in a straight line on all the Greek courses, and that there were some, like that at Olympia, where the athletes who ran it made a circuit, a period; for this reason, *Suidas* calls the diaulos the *great period.*[82] He would never have used the adjective *great* if the diaulos had been the shortest of all courses — as it would have been, if the single stade had always been run in a straight line. Thus, if *Suidas* gives the name of long circuit, *great period,* to the race in which the athletes covered the double stade or diaulos, then this can only be in relation to the short circuit that they performed in running the single stade.

This explanation of the epithet that *Suidas* applies to the diaulos seems to me all the more necessary because it constitutes one of the objections advanced by a very learned critic to my account of the length of the course at Olympia. These objections may be seen in the notes,[83] where I felt it incumbent on me to place them.

Not only does our hypothesis seem to supply a natural explanation for the different lengths given by the ancients for the dolichos but it also yields measures for the Olympian and Pythian foot that seem to tally with their general statements on the subject. Under our proposed interpretation, 1,000 Olympian feet are equal to 1,200 Pythian feet; and so the Olympian foot emerges as one-sixth longer that the Pythian foot, and it can plausibly be regarded as the longest foot in Greece and as that derived — as it is known to have been — from the foot of Herakles.

We make bold to say that previous conjectures as to the lengths of the Olympian foot and stade have not by any means the same advantages as those that we propose. In the twenty-fourth volume of the Académie [royale] des [inscriptions et] belles-lettres, on page 505 of the *Mémoires,* according to the table of ancient measures given by Monsieur [Nicolas] Fréret, the Olympian foot would have been no more than 9 inches 6/10 lines of our foot. Now, such an Olympian foot — the longest of the Greek feet, derived from the foot of Herakles himself — would have been shorter than that Greek foot that we know to have exceeded the Roman foot by 1 part in 25; it would also have

been shorter than the Athenian foot, as determined from our discussion of the Hekatompedon or Temple of Minerva. From which we feel justified in concluding that Monsieur Fréret's conjecture, along with all those that fail to treat the Olympian foot as the longest of all the Greek feet, is lacking in plausibility.

We shall say only a word on the Italian stade. Censorinus describes this stade as only 25 feet longer than the Olympian stade; so that — as we have said — 625 Italian feet must have been the entire length of the course of a stadium of this kind; from gate to post will have been only 312½ feet.

Our inquiry into the two principal subjects announced in the title of this dissertation leads to the following conclusions: that the course at Olympia instead of measuring 600 feet from gate to post, as has been supposed, must have been only half that distance; and that the three stades of which Censorinus speaks, rather than representing, under Monsieur Gibert's system (plate 15), 1,000 Olympian feet for the Pythian, 625 for the Italian, and 600 for the Olympian, should be as follows: the Italian 625, the Olympian 600, and the Pythian 500.

Le Roy's Notes

1. These are Plutarch's words on the subject, in his life of Alexander: ἀλλ' εἴτε μεστὸς ὢν ἤδη τὸν θυμὸν, ὥσπερ οἱ λέοντες, εἴτε ἐπιεικὲς ἔργον ὠμοτάτῳ καὶ σκυθρωποτάτῳ παραβαλεῖν βουλόμενος, οὐ μόνον ἀφῆκεν αἰτίας πάσης, ἀλλὰ καὶ προσέχειν ἐκέλευσε τοῖς πράγμασι τὸν νοῦν τὴν πόλιν, ὡς, εἴτι συμβαίη περὶ αὐτὸν, ἄρξουσαν τῆς Ἑλλάδος. Plut., *Vie d'Alex.*, p. 671 B.

"Whether," says Plutarch of Alexander, "he had sated his wrath, as lions do, or he wished to set an example of clemency, after inspiring terror by his severity, he overlooked all the grievances that he had against the Athenians; he even called upon their city to watch over the affairs of the people: the governance of Greece should fall to them, if some accident should befall him." [Plutarch, *Lives, Alexander* 13.2.]

2. Plut., *Vie de Démosthene.* [Plutarch, *Lives, Demosthenes* 27.1–29.5.]

3. Οἱ μὲν οὖν ἄλλοι πρέσβεις ἠγάπησαν ὡς φιλανθρώπους τὰς διαλύσεις, πλὴν τοῦ Ξενοκράτους· ἔφη γὰρ, ὡς μὲν δούλοις, μετρίως κεχρῆσθαι τὸν Ἀντίπατρον· ὡς δὲ ἐλευθέροις, βαρέως. Plut., *Vie de Pho.*, p. 753 F.

"The other envoys," says Plutarch, "were well content with these terms and considered them merciful and humane; the exception was Xenocrates. 'For slaves,' said the philosopher, 'Antipater treats us with forbearance; but for free men, he treats us harshly.'" [Plutarch, *Lives, Phocion* 27.6.]

4. Πᾶσαν δὲ Ἀθηναῖοι κουφότητα κολακείας τῆς πρὸς Μακεδόνας ὑπερβαλλόντες, ἐστεφανηφόρησαν, ὅτε πρῶτον ἠγγέλθη τεθνηκώς. Plutar., *Vie d'Arat.*, p. 1047 A.

"The Athenians," says Plutarch, "carried their adulation of the Macedonians to such a pitch that they donned chaplets of flowers at the first rumor of the death of Aratus." [Plutarch, *Lives, Aratus* 34.3.]

5. Ἔφη χαρίζεσθαι πολλοὺς μὲν ὀλίγοις, ζῶντας δὲ τεθνηκόσιν. Plut., *Vie de Syll.*, p. 460 F.

"I forgive," said Sulla, speaking to those who asked him to show mercy to the Athenians, "the greater number for the sake of the lesser, and I spare the living for the sake of the dead." [Plutarch, *Lives, Sulla* 14.5.]

6. *Pausanias's route from the odeion to the Temple of Theseus:*

Τοῦ θεάτρου δὲ ὃ καλοῦσιν ᾠδεῖον, ἀνδριάντες πρὸ τῆς ἐ[σ]όδου βασιλέων εἰσὶν Αἰγυπτίων. P[ausanias], ch. 8, p. 20.

"In front of the vestibule of the theater known as the odeion are the statues of the kings of Egypt." [Pausanius, *Description of Greece* 1.8.6.]

Ἐς δὲ τὸ Ἀθήνησιν εἰσελθοῦσιν ᾠδεῖον, ἄλλα τε καὶ Διόνυσος κεῖται θέας ἄξιος· πλησίον δέ ἐστι κρήνη, καλοῦσι δὲ αὐτὴν Ἐννεάκρουνον...ναοὶ δὲ ὑπὲρ τὴν κρήνην, ὁ μὲν Δήμητρος πεποίηται καὶ Κόρης· ἐν δὲ τῷ Τριπτολέμου κείμενόν ἐστιν ἄγαλμα. P. 34.

"Among the remarkable sights inside the odeion, one of the most admirable is the statue of Bacchus. Nearby is a fountain called *Enneakrounos,* or with nine spouts.... Above this are two temples, one to Ceres, the other to Proserpina. Inside the latter is a statue of Triptolemus." [Pausanius, *Description of Greece* 1.14.1.]

Πρὸ τοῦ ναοῦ τοῦδε, ἔνθα καὶ τοῦ Τριπτολέμου τὸ ἄγαλμα, ἔστι βοῦς χαλκοῦς οἷα ἐς θυσίαν ἀγόμενος· πεποίηται δὲ καθήμενος Ἐπιμενίδης Κνώσιος. P. 35.

"In front of the temple where this image of Triptolemus stands, you see a bronze cow, adorned like a victim that is dragged to the altar; in the same place you see Epimenides, seated." [Pausanius, *Description of Greece* 1.14.4.]

Ἔτι δὲ ἀπωτέρω ναὸς Εὐκλείας.

"Not far off is the Temple of Eukleia." [Pausanius, *Description of Greece* 1.14.5.]

Ὑπὲρ δὲ τὸν Κεραμεικὸν καὶ στοὰν τὴν καλουμένην Βασίλειον, ναός ἐστιν Ἡφαίστου...πλησίον δὲ ἱερόν ἐστιν Ἀφροδίτης Οὐρανίας. P. 36.

"Above the Kerameikos and the portico called the *Royal Portico,* there is a temple of Vulcan.... Near this temple is that of Venus Urania." [Pausanius, *Description of Greece* 1.14.6.]

Ἰοῦσι δὲ πρὸς τὴν στοὰν, ἣν Ποικίλην ὀνομάζουσιν ἀπὸ τῶν γραφῶν, ἔστιν Ἑρμῆς χαλκοῦς καλούμενος Ἀγοραῖος, καὶ πύλη πλησίον· ἔπεστι δὲ οἱ τρόπαιον Ἀθηναίων ἱππομαχίᾳ κρατησάντων Πλείσταρχον. P. 36.

"Going to the portico called *Poikilē,* on account of the variety of its paintings, you come upon a bronze Mercury, under the epithet *Agoraios,* and a gate close by him. On this gate is a trophy raised by the Athenians, who defeated Pleistarchus in a cavalry engagement." [Pausanius, *Description of Greece* 1.15.1.]

Ἀθηναίοις δὲ ἐν τῇ ἀγορᾷ καὶ ἄλλα ἐστὶν οὐκ ἐς ἅπαντας ἐπίσημα, καὶ Ἐλέου βωμός. P. 39.

"In the marketplace, there are things that are not known to everyone, and notably an altar to Pity." [Pausanius, *Description of Greece* 1.17.1.]

Ἐν δὲ τῷ γυμνασίῳ τῆς ἀγορᾶς ἀπέχοντι οὐ πολύ, Πτολεμαίο[υ] δὲ ἀπὸ τοῦ κατεσκευασμένου καλουμένῳ, λίθοι τέ εἰσιν Ἑρμαῖ, θέας ἄξιοι, καὶ εἰκὼν Πτολεμαίου χαλκῆ, καὶ ὅ τε Λίβυς Ἰόβας ἐνταῦθα κεῖται καὶ Χρύσιππος ὁ Σολεύς· πρὸς δὲ τῷ γυμνασίῳ Θησέως ἐστὶν ἱερόν. P. 39.

"In the gymnasium that is not far from the marketplace and that is called *Pto-lemeion* after its founder, there are some stones called *Hermes,* which are worth seeing, and a bronze statue of Ptolemy; in the same place are seen the statues of Juba the

Libyan and Chrysippus of Soli. The Temple of Theseus is not far away." [Pausanius, *Description of Greece* 1.17.2.]

7. *Pausanias's route from the Temple of Theseus to the new city of Hadrian:*

Πρὸς δὲ τῷ γυμνασίῳ Θησέ[ω]ς ἐστὶν ἱερὸν. P. 39.

"Close to the gymnasium is the Temple of Theseus." [Pausanius, *Description of Greece* 1.17.2.]

Τὸ δὲ ἱερὸν τῶν Διοσκούρων ἐστὶν ἀρχαῖον, αὐτοί τε ἑστῶτες καὶ οἱ παῖδες καθήμενοι σφίσιν ἐφ' ἵππων. P. 41.

"The Temple of the Dioscuri is ancient; they are represented standing, and their children seated on horses." [Pausanius, *Description of Greece* 1.18.1.]

Ὑπὲρ δὲ τῶν Διοσκούρων τὸ ἱερὸν, Ἀγλαύρου τέμένος ἐστὶν. P. 41.

"Above the Temple of the Dioscuri is the sacred grove of Aglauros." [Pausanius, *Description of Greece* 1.18.2.]

Πλησίον δὲ Πρυτανεῖόν ἐστιν, ἐν ᾧ νόμοι τε οἱ Σόλωνός εἰσι γεγραμμένοι. P. 41.

"Nearby is the Prytaneion, where the laws of Solon are graven." [Pausanius, *Description of Greece* 1.18.3.]

Ἐντεῦθεν ἰοῦσιν ἐς τὰ κάτω τῆς πόλεως, Σαράπιδός ἐστιν ἱερὸν, ὃν' Ἀθηναῖοι παρὰ Πτολεμαῖου θεον ἐσήγαγοντο. P. 42.

"Leaving there to go to the lower part of the city, you find the Temple of Serapis, whose cult the Athenians acquired from Ptolemy." [Pausanius, *Description of Greece* 1.18.4.]

Τοῦ δὲ ἱεροῦ τοῦ Σαράπιδος οὐ πόρρω χωρίον ἐστὶν, ἔνθα Πειρίθοῦν καὶ Θησέα συνθέμενους ἐς Λακεδαίμονα καὶ ὕστερον ἐς Θεσπρωτοὺς σταλῆναι λέγουσι. P. 42.

"Not far from the Temple of Serapis is a place where Peirithoos and Theseus are said to have joined forces to travel to Lacedaemon and to Thesprotia." [Pausanius, *Description of Greece* 1.18.4.]

Πλησίον δὲ ᾠκοδόμητο ναὸς Εἰλειθύιας. P. 42.

"Nearby is the temple of Eileithyia or Juno Lucina." [Pausanius, *Description of Greece* 1.18.5.]

Πρὶν δὲ ἐς τὸ ἱερὸν ἰέναι τοῦ Διὸς τοῦ Ὀλυμπίου, Ἀδριανὸς ὁ Ῥωμαίων Βασιλεὺς τόν τε ναὸν ἀνέθηκε, καὶ τὸ ἄγαλμα θέας ἄξιον. P. 42.

"Before entering the *hieron* [(sacred enclosure)] of the Temple of Jupiter Olympius, we must point out that the emperor Hadrian consecrated both its *naos* and a very fine statue." [Pausanius, *Description of Greece* 1.18.6.]

Ἀδριανὸς δὲ κατεσκευάσατο μὲν καὶ ἄλλα Ἀθηναιοῖς ναὸν Ἥρας, καὶ Διὸς Πανελληνίου, καὶ θεοῖς τοῖς πᾶσιν ἱερὸν κοινόν.

"Hadrian built other edifices in Athens. He constructed the *naos* of the Temple of Juno and that of the Temple of Panhellenic Jupiter. He also built the temple consecrated to all the gods, etc." [Pausanius, *Description of Greece* 1.18.9.]

From Pausanias's subsequent account of a number of buildings pertaining to Hadrian, it is clear that he has now entered the new city that Hadrian had built and where all the buildings that bear his name are to be found. When we come to describe this city, we will speak of these various edifices.

8. In 320 B.C., Neaichmos was the principal archon, as we learn from the historical record of those magistrates; but it does not follow that these contests were held during

that year, because it is not proved that it was the Ἐπώνυμος, the archon who gave his name to the year, who presided on those occasions. Neaichmos might well have presided in his capacity as one of the nine archons who governed the city in any given year, or even at a time when he was not an archon at all: the word HPXE simply indicates who commands and is not restricted to the principal archon or to one of the other archons.

Van Dale's doubts on this subject are set out in his book entitled *Dissertationes IX, Antiquitatibus Quin et Marmoribus* (Amsterdam, 1753), p. 690. He believes that the word HPXE does not refer to the the the archon Ἐπώνυμος exclusively. I have already stated his view on the subject in general in my first edition, and in the present one, on p. [299 n. 59] of the first volume, but I have found it necessary to repeat it here, more correctly expressed.

9. Van Dale, *Diss. VIII*, ch. 5.

10. Van Dale, ibid.

11. Ἐπειδὴ γὰρ οὐ καθεστηκότος χορηγοῦ τῇ Πανδιόνιδι φυλῇ τρίτον ἔτος τουτὶ, παρούσης δὲ τῆς ἐκκλησίας, ἐν ᾗ τὸν ἄρχοντα ἐπικληροῦν ὁ νόμος τοῖς χοροῖς τοὺς αὐλητὰς κελεύει, λόγων καὶ λοιδορίας γενομένης, καὶ κατηγοροῦντος τοῦ μὲν ἄρχοντος τῶν ἐπιμελητῶν τῆς φυλῆς, τῶν δὲ ἐπιμελητῶν του ἄρχοντος, παρελθὼν ὑπεσχόμην ἐγὼ χορηγήσειν ἐθελοντής· καὶ κληρουμένων, πρῶτος αἱρεῖσθαι τὸν αὐλητὴν ἔλαχον. Van Dale, *Diss. VIII*, ch. 5, p. 676.

"Seeing," says Demosthenes in his oration *Against Meidias* [(13)], "that for three years there had been no choragus named by the Pandionis tribe and that the day of the assembly had come, when the archon is required by law to draw lots for the flute players for the choruses, and hearing complaints that the archon blamed the curators of the tribe, while they in turn blamed the archon—I came forward and offered myself as choragus; and when lots were drawn for *auletes*" — or flute players — "I was fortunate enough to have first choice of musicians."

Concerning our contention as to the *didaskalos*, see van Dale, *Diss. VIII*, ch. 5.

12. [René Vatry, "Dissertation où l'on traite des avantages que la tragédie ancienne retiroit de ses choeurs,"] *Mém. de littér.*, vol. 8, p. 199.

13. Vitruvius, bk. 9, ch. 9 ([ed. Joannes de] Laet, p. 199). [Vitruvius, *De architectura* 9.8.1.]

14. I have corrected the remarks I made in my first edition on this sundial in the light of the account of such dials given by Father Boscovich, which he was courteous enough to send to me at my request. This account is in a periodical that I was unable to find in Paris. It is entitled *Giornale de' letterati*; see the volume for 1746, art. 14.

Among other interesting observations in this account, Father Boscovich remarks that the intervals that mark the first and last hour of the day are not so wide as those for the other hours, which are all equal; this leads him to surmise that the ancients counted some part of the twilight as part of the twelve hours that composed their day. They did not, however, incorporate one hour of twilight in the twelve, contrary to Monsieur de Lalande's assertion in his *Voyage d'Italie,* vol. 4, p. 210.

While this remark of Monsieur de Lalande's is incorrect, I owe him for another, entirely judicious one, concerning Posidonius's measurement in degrees of the distance between the cities of Alexandria and Rhodes, which has been found to be an overesti-

mate, as Father Riccioli demonstrates (*Astronomia reformata*, p. 145). It follows that the measurement of 180,000 stades that the ancients assigned to the circumference of Earth cannot be deduced from Posidonius's observation; but it remains true, as Monsieur Cassini says, that this has been regarded as the most accurate of those given to us by the ancients; and this in itself suffices to justify the conclusions that I have drawn. I would have appended this information to my dissertation [in the first volume] on the ancient estimates of Earth's circumference, but that volume was already printed when Monsieur de Lalande sent me his observation.

15. The word *schema* corresponds to the word *boussole* [(compass)], which would make the sense clearer; but it cannot be used, as that invention was totally unknown to the ancients.

16. Mr. Stuart is the traveler who supposes one of the northerly winds—Skiron, the northwest—to be strewing fire. On p. 23 of his work [(*Antiquities of Athens*, vol. 1)], he has this to say of the figure's upturned urn: "His vase is curiously wrought, and probably represents a brazen Fire-Pot; from whence he may be supposed to scatter Ashes and burning Coals, expressive of the drying and scorching Quality of this wind, and of the frequent Lightnings which attend it."

This wind, which Mr. Stuart supposes to be dry and scorching, blows at Athens in a line drawn from the vicinity of Iceland across Germany and along the shores of the Adriatic Gulf. It can therefore hardly acquire the qualities that he ascribes to it; I always supposed that the dry and scorching winds of Athens came from Africa.

If we are to believe Mr. Stuart, the south wind, Notos—the wind that must come from Africa—"is very sultry and very wet in Athens"; and this, he says, is why the sculptor represents him upturning a vase of water. And so this ingenious sculptor, according to Mr. Stuart, showed the northerly winds scattering fire and the south wind bringing rain. Is it not more plausible to suppose that, these winds being harmful either by the excessive heat or by the excessive cold that they brought to the city, the sculptor showed them upturning vases full of various kinds of oil or wine, because of the harm done by Skiron and Notos to the olive trees or grape vines? For the rest, I have corrected my descriptions of the figures of the winds with the aid of the drawings that Mr. Stuart has had engraved to a very large scale.

17. *In eodem Hemisphaerio medio, circum cardinem, est orbius ventorum octo, ut Athenis in Horologio quod fecit Cyrrhestes.* Var., *De re rus.*, bk. 3, ch. 5.

"In the center of the same hemisphere," says he, "around the axis, is seen the circle of the eight winds, as on the horologe in Athens made by Cyrrhestes." [Varro, *Rerum rusticarum* 3.5.17.]

Mr. Stuart adduces this passage to prove that the building under discussion marked not only the hours of the day, by its sundials, but also the hours of the night and those of days without sunshine: in short, that this building was a clepsydra.

We find Mr. Stuart's conjecture by no means implausible; but, as he himself remarks, Vitruvius seems to furnish a strong argument against his view by speaking of the building only as an indicator of the winds. When Vitruvius does discuss water clocks—that is to say, clepsydrae—he seems positively to contradict Mr. Stuart's opinion, since he describes them as instruments exposed to public view in the open air, and neither as buildings nor as machines housed behind closed doors within buildings, such

as the Tower of the Winds. [Vitruvius, *De architectura* 1.6.4; Vitruvius discusses water clocks in 9.9, but he makes no mention of whether they are enclosed (Le Roy may have been thinking of 1.6.6).]

Pliny, speaking in his book 7 of one of these clepsydrae, that set up by [Publius Cornelius] Scipio Nasica [Corculum] in Rome, admittedly says that it was roofed over; but he does not say that it was inside, behind closed doors. [Pliny the Elder, *Naturalis historia* 7.60.215.] Furthermore, the remains of the Tower of the Winds reveal no sign of an external dial or of perpendicular divisions such as might suggest that, though the machine itself was inside, it showed the time on the outside.

Finally, whatever conclusions may be drawn, as Mr. Stuart does, from the presence of channels under the pavement of the building and of a conduit not far away in the city and from the authors who state that there was a clepsydra at Athens, though not that it was either a building or an instrument enclosed in a building, all these conclusions are very far from being proofs. We shall therefore regard the Tower of the Winds as a timepiece simply by virtue of its sundials, which were more accurate than clepsydrae and which—in a fine climate such as that of Attica—rarely failed to mark the hour.

18. Πολόν μὲν γὰρ καὶ γνώμονα, καὶ τὰ δυώδεκα μέρεα τῆς ἡμέρης παρὰ Βαβυλωνίων ἔμαθον Ἕλληνες. Herod., *Euterp.* = [Etienne de Canaye, "Recherches sur Anaximandre,"] *Mém. de litt.*, vol. 10, p. 26.

"The Greeks," says Herodotus, "are said to have learned from the Babylonians how to find the pole, the use of the gnomon, and the division of the day into twelve parts." [Herodotus, *History* 2.109.]

19. See [Canaye,] *Mém. de lit.*, vol. 10, pp. 26, 27.

20. In engraving this view [(pl. 4)], the objects have been reversed; so that, in order to gain an idea of the present state of the site, the view must be looked at in a mirror; or everything that appears on the left must be supposed to be on the right, and everything on the right, on the left.

21. Mr. Stuart [(pp. 1–2)] has given this inscription and the others pertaining to the same building.

22. Ο ΔΗΜΟΣ ΛΟΥΚΙΟΝ ΚΑΙΣΑΡΑ ΑΥΤΟΚΡΑΤΟΡΟΣ ΘΕΟΥ ΥΟΥ (or ΤΟΥ) ΣΕΒΑΣΤΟΥ ΚΑΙΣΑΡΟΣ ΥΟΝ.

This inscription may be read in two ways. In the reading adopted by Mr. Stuart, the meaning is this: *The people* (honor by this statue) *Lucius Caesar, son to Caesar Augustus, emperor, son of god.* The other reading is as follows: *The people honor* (by this statue) *Lucius Caesar, son* (by adoption) *to the emperor Augustus, god.*

It will be seen that our proposed emendation consists in reading Τ in place of Υ; these capital letters are so alike that, in an inscription whose characters are quite small and much disfigured by time, we believe that they might easily have been confused.

Here are the reasons that lead us to prefer the latter translation, in which Augustus is called *god*. First, the Athenians would hardly have given his daughter Julia the title of goddess without giving Augustus that of god. To bestow it was to court his favor and to shed additional luster on his son. Furthermore, as is well known, they had already given the title of god to other princes less powerful than Augustus. In their citadel they had a temple to Rome and Augustus, in which—as may be seen from an inscription

recorded by Gruterus—he bore the title of savior. Finally, it was so customary to give Augustus the title of god that he was known as such by almost every people subject to the Roman Empire.

The inhabitants of Pola gave him this title in their Temple of Rome and Augustus; the Romans themselves called him that as well. In his first *Eclogue*, Virgil gives thanks to Augustus, who had restored the poet's father to his estates at Andes, in the following words:

O Meliboee, Deus nobis haec otia fecit.

Namque erit ille mihi semper Deus: illius aram

Saepe tener nostris ab ovilibus imbuet agnus.

["O Meliboeus, a god gave me this leisure. To me he will always be a god; his altar shall often be bloodied by a tender lamb from my fold" (Virgil, *Eclogues* 1.6–8).]

23. This inscription begins as follows: ΙΟΥΛΙΑΝ ΘΕΑΝ ΣΕΒΑΣΤΗΝ, where the word ΘΕΑΝ ought incontestably to be translated by the word *goddess*, not, as Mr. Stuart [(*Antiquities of Athens*, p. 2)] does, by the word *divine*.

24. In my first edition, I judged that this portico was the entrance to the temple itself; but Mr. Stuart [(*Antiquities of Athens*, p. 4)] says that he has found walls extending to the left and right of the antae of this portico. I will confess that, though I measured one of the latter (that on the right), I found no trace of such walls. But, even supposing that they ever existed, the objection that one could make to my view that this portico was a temple entrance falls away as soon as we regard it as the portico of a temple enclosure; nor is there any virtue in the argument that Mr. Stuart derives from the slightness of its columns, which he attributes to the nature of the building instead of to the age in which it was built.

25. *Suidas*, s.v. Μουσαῖος.

26. Paus., bk. 1, ch. 22. [Pausanias, *Description of Greece* 1.22.7.]

27. See Hesychius, s.v. Λυκομίδαι.

28. Paus., bk. 1, ch. 22. [Pausanias, *Description of Greece* 1.22.7.]

29. For this inscription, see the end of this first part [(p. 446)].

30. Philopappos does not appear on the list of consuls. Monsieur Spon suggests that he may have been *consul suffectus*, that is, one of those deputed to replace a consul who died before the end of his year.

31. Monsieur Spon, vol. 2, p. 185, speaks of this building as follows: "In my view, this was the Temple of Jupiter Olympius, for several reasons. These are that the front was built in the manner of a temple, with a vestibule and a pediment; *that it is in the lowest part of the city.*" Whether or not Monsieur Spon was mistaken in this conjecture, it is nonetheless true that he attests to the fact that the building, or the ruin in the bazaar, is *in the lowest part of the city;* and Wheler, his traveling companion, says exactly the same thing in discussing this ruin.

32. See what I have said on the subject in my first edition, p. 18 of part 1; and what I shall shortly say in the present one, in discussing the state of Athens from Hadrian to the present day.

33. I describe the building partly from the detailed drawings that Mr. Stuart [(*Antiquities of Athens*, chap. 1)] has given of all its parts.

34. Ἰοῦσι δὲ πρὸς τὴν στοὰν, ἣν Ποικίλην ὀνομάζουσιν ἀπὸ τῶν γραφῶν, ἔστιν Ἑρμῆς χαλκοῦς καλούμενος Ἀγοραῖος. "On the way," Pausanias says, "to the portico called *Poikilē,* for the variety of its paintings, you come upon a bronze Mercury, under the epithet *Agoraios."* [Pausanias, *Description of Greece* 1.15.1.]

35. Στοαὶ δέ εἰσιν ἀπὸ τῶν πυλῶν ἐς τὸν Κεραμεικὸν....πρώτη δέ ἐστιν ἐν δεξιᾷ καλουμένη στοὰ Βασίλειος. Paus., bk. 1, pp. 6, 8.

"There are porticoes," says Pausanias, "from the city gate to the Kerameikos.... The first of these, on the right-hand side, is the Royal Portico." [Pausanias, *Description of Greece* 1.2.4, 1.3.1.]

Ὑπὲρ δὲ τὸν Κεραμεικὸν καὶ στοὰν τὴν καλουμένην Βασιλειὸν, ναός ἐστιν Ἡφαίστου...Πλησίον δὲ ἱερόν ἐστιν Ἀφροδίτης Οὐρανίας. Pausanias, bk. 1, p. 36.

"Above the Kerameikos and the portico called the *Royal Portico,* there is a temple of Vulcan....Nearby is the Temple of Venus Urania." [Pausanias, *Description of Greece* 1.14.5, 6.]

It emerges from these passages, and from the route taken by Pausanias, that, having set out from the odeion and returning toward the places that he had left behind, he says—after naming the fountain Enneakrounos and the Temple of Ceres, that of Proserpina, and that of Eukleia—that the Temple of Vulcan was seen above the Royal Portico; and that close to this temple was that of Venus Urania. From which it follows that, as the Royal Portico was the first on the right, on the way from the city gate to the Kerameikos, this portico and the temples to Vulcan and Venus Urania were not far from the gate through which Pausanias entered Athens from Piraeus—or, in other words, that these buildings were not far from the intersection, plate 1, of the city limits defined by Themistocles, marked *3, 3,* and the road from Piraeus to the city. And yet, in the enormous distance between this intersection and the point marked *12* in the plate, Pausanias names, under Mr. Stuart's conjecture, only one statue of Mercury and one triumphal arch. However Mr. Stuart may seek to minimize the distance in question, this will always make his conjecture seem unlikely.

36. "The inner Kerameikos," says Monsieur Spon, vol. 2, p. 181, "was to the west of Athens, near the Dipylon Gate, which was also known as Porta Kerameiko; just as the ancient marketplace was not far from the Temple of Theseus." He speaks of the "inner Kerameikos" because there were two. See Harpocration, *Suidas,* and Hesychius.

37. See the route from the Temple of Theseus to the new city of Hadrian, p. [457], note [7], in this volume.

38. See Spon, vol. 2, p. 185; or see note [31], on p. [461] of this volume.

39. Paus., bk. 1, p. 36. [Pausanias, *Description of Greece* 1.14.6–7.]

40. *From which Aglauros sprang to escape the wrath of Minerva.* Pausanias, bk. 1, ch. 18, p. 41. [Pausanias, *Description of Greece* 1.18.2.] There is reason to suppose that the grove sacred to Aglauros was at the foot of the citadel, at the very spot where she fell after throwing herself from the top of the fortress; and, since Pausanias walked down from the grove to the lowest part of the city, which is to the north, it follows that the side of the citadel from which Aglauros made her leap was also to the north.

41. See the route from the [Temple of Theseus] to the [new city of Hadrian], p. [457], note [7], in this volume.

42. Εἰλειθυίας· Ἥρα ἐν Ἄργει. Hesy[chius, *Lexicon*], s.vv. Ilithiye, Junon, Lucine.

43. Ἀδριανὸς δὲ κατεσκευάσατο μὲν καὶ ἄλλα Ἀθηναίοις, ναὸν Ἥρας. Paus., bk. 1, p. 43.

"But Hadrian," says Pausanias, "built other edifices for the Athenians: he built the temple of Juno." [Pausanias, *Description of Greece* 1.18.9.]

44. As has been seen, Pausanias says of a place not far from the Temple of Serapis, Πλησίον δὲ ᾠκοδόμητο ναὸς Εἰλειθύιας. Paus., bk. 1, p. 42. "Nearby is the Temple of Eileithyia or Juno Lucina." [Pausanius, *Description of Greece* 1.18.5.]

One sees from the two passages above that Εἰλειθυίας and Ἥρας are simply two different names for Juno; and thus there is every reason to believe that Pausanias speaks of one and the same temple in both passages.

45. Ἀνιόντων δὲ ἐκ Πειραιῶς, ἐρείπια τῶν τειχῶν ἐστιν, ἃ Κόνων ὕστερον τῆς πρὸς Κνίδον ναυμαχίας ἀνέστησε. Paus., bk. 1, pp. 5–6.

"On the road from Piraeus to the city," says Pausanias, "stand the ruins of those walls that Conon had rebuilt after fighting the naval battle of Cnidus." It clearly follows from this passage that these walls, dismantled by Sulla, had not been rebuilt by Hadrian's time. [Pausanius, *Description of Greece* 1.2.2.]

46. Ἀδριανὸς δὲ κατεσκευάσατο μὲν καὶ ἄλλα Ἀθηναίοις, ναὸν Ἥρας, καὶ Διὸς Πανελληνίου, καὶ θεοῖς τοῖς πᾶσιν ἱερὸν κοινόν· τὰ δὲ ἐπιφανέστατα, ἑκατὸν εἴκοσι κίονες Φρυγίου λίθου. Πεποίηνται δὲ καὶ ταῖς στοαῖς κατὰ τὰ αὐτὰ οἱ τοῖχοι· καὶ οἰκήματα ἐνταῦθα ἐστιν ὀρόφῳ τε ἐπιχρύσῳ καὶ ἀλαβάστρῳ λίθῳ, πρὸς δὲ, ἀγάλμασι κεκόσμημένα καὶ γραφαῖς. Paus., bk. 1, ch. [1]8, p. 43.

"Hadrian," says Pausanius, "built other several other edifices for the Athenians: he built the Temple of Juno, that of Panhellenic Jupiter, and a temple to all the gods together. What was most notable about the latter was its 120 columns of Phrygian marble. He built the walls of the porticoes in the same material. The recesses that are found there are decorated with statues and paintings; and their soffits are resplendent with both gold and alabaster." [Pausanius, *Description of Greece* 1.18.9.]

We conjecture that the walls of which Pausanias speaks here were those of the temple enclosure. The recesses to be found there particularly support us in this supposition. There were similar recesses in niches, or exedrae, in the court of the temple at Baalbek, which was built at very much the same time. Sometimes these recesses were circular in plan, sometimes square; they had several different uses.

47. Paus., bk. 1, ch. 18, p. 43. [Pausanius, *Description of Greece* 1.18.7–8.]

48. The *naos* was the body of the temple, which stood in the center of the court that surrounded it. It is indisputable, from the details that Vitruvius [(*De architectura* 7.*pref*.15, 17)] gives about Cossutius's work at the Temple of Jupiter Olympius, that Cossutius worked on the *naos*.

49. Here are the passages that he cites on p. 39 of his work, in notes b and c; I have rendered [...] the English translations that he gives.

In Astu verò Jovem Olympium amplo modulorum comparatu, Corinthiis symmetriis et proportionibus, Architectandum Cossutius suscepisse memoratur.

"In the City of Athens we are told that Cossutius undertook the building of the Temple of Jupiter Olympius on a scale of great dimensions, and of the Corinthian Order." Vitruvius, proem to his seventh book. [Vitruvius, *De architectura* 7.*pref*.17.]

Hypaethros verò decastylos est in pronao et postico. Reliqua omnia eadem habet,

quae dipteros, etc. Hujus autem exemplar Romae non est, sed Athenis octastylos in Templo Jovis Olympii.

"The Hypaethros is decastyle both in the Portico and in the back Front. In all other respects it is the same with the Dipteros. There is no example of it at Rome, but at Athens the Temple of Jupiter Olympius tho' an octastyle is of this species." Vitruvius, bk. 3, ch. 1. [Vitruvius, *De architectura* 3.2.8.]

50. Here is Mr. Stuart's passage in full. Having spoken of the columns commonly known as the Columns of Hadrian, of which we speak here, he says: "In reality, these last mentioned Ruins agree in so many other particulars, besides their situation, with the descriptions of that sumptuous Temple which are still extant, that it is not easy to conceive, how any other Building could ever be mistaken for it. For we find, that the columns of Adrian, as they are called, stand in the South Part of the City, and they are near to the Fountain Enneacrunos, or Callirrhoe, as was before observed; to which may be added, that they are of very extraordinary dimensions, being near sixty Feet high, and about six Feet in Diameter; they are the remains of Dipteros and Hypaethros, of the Corinthian Order; and the Peribolus or Enclosure in which they stood, was nearly if not quite a circuit of four stadia. Now these are exactly the particulars which the Ancients have left us concerning the Temple of Jupiter Olympius at Athens, as may be seen by the Authorities, cited in the Notes." Stuart, pp. 38–39.

51. See the English journal entitled *Philosophical Transactions*, no. 124, 24 April 1676, p. 575. See also [Jacob Spon,] *Réponse a la critique publiée par M. Guillet sur le Voyage de Grece de Jacob Spon* (Lyon, 1679), p. 294. Mr. Vernon expresses himself as follows: "I have measured the enclosure of the building to which [the Columns of Hadrian] belonged, as accurately as I could, and found it to be some 1,000 feet long and 680 wide." [Le Roy inserted "(ces colonnes d'Adrien)" in quoting Vernon's original.]

52. Ταραντῖνος δὲ ἱστορεῖ τὸν τοῦ Διὸς νεὼν κατασκευάζοντας Ἀθηναίους Ἐννεακρούνου πλησίον, etc.

"Tarentinus relates, that when the Athenians were building the Temple of Jupiter Olympius, near the Fountain Enneakrounos." Hierocles in the preface to his *Hippiatrics*, cited by Meursius in his *Cecropia*, p. 32. [(*Hippiatrica berolinensia* 1.13.9)]

The Greek text simply reads as follows: "Tarentinus relates that when the Athenians were building the Temple of Jupiter." The epithet *Olympius* bestowed on the god has been added by Mr. Stuart in his translation.

53. Ἀδριανὸς δὲ, τό τε Ὀλύμπιον τὸ ἐν ταῖς Ἀθήναις, ἐν ᾧ καὶ αὐτὸς ἵδρυται, ἐξεποίησε, etc. Joannes Xiphilinus's *Epitome Dionis Romanae historiae*, in *Scriptores Graeci Minores* (Frankfurt, 1590), p. 358.10.

"Hadrian," says Cassius Dio, "finished at Athens the Temple of Jupiter Olympius, in which he himself has a statue." [Cassius Dio, *Roman History* 69.16.1.]

54. Πρὶν δὲ ἐς τὸ ἱερὸν ἱέναι τοῦ Διὸς τοῦ Ὀλυμπίου, Ἀδριανὸς ὁ Ῥωμαίων Βασιλεὺς τόν τε ναὸν ἀνέθηκε. Pausanias, bk. 1, ch. 18, p. 42.

"Before we go to" — or we enter — "the *hieron* of the Temple of Jupiter Olympius," says Pausanias, "I must inform you that it was consecrated by Hadrian, emperor of the Romans." [Pausanias, *Description of Greece* 1.18.6.] In this, the second translation that we give of this passage, we have rendered the beginning in two ways: "Before entering"

or "Before going to the *hieron* of the Temple of Jupiter Olympius." And indeed, on closer scrutiny, this latter rendering seems more in keeping with the distance between this temple and that of Eileithyia—if, that is, the passage in which Thucydides [(*History of the Peloponnesian War* 2.15.4)] speaks of its situation is not corrupt. It also seems to us more in keeping with the usual simplicity of Pausanias's language, for there is every reason to believe that if he had meant to say "before entering the temple," he would have written εἰσίεναι, instead of ἴεναι, with the preposition and its complement.

55. [Marc Oudinet, "Réflexions sur les médailles d'Athènes,"] *Mém. lit.*, vol. 1, *Hist.*, p. 221.

56. Paus., bk. 1, ch. 19, pp. 45–46. [Pausanias, *Description of Greece* 1.19.6.]

57. IMP. CAESAR T. AELIUS

AUG. P. COS. III. T. P. II. P. P. AQUAEDUCTUM. IN NOVIS

CONSUMMAVIT

HADRIANUS ANTONINUS

ATHENIS. COEPTUM. A. DIVO HADRIANO. PATRE. SUO.

DEDICAVITQUE

58. *Sex illa à Dipylo Stadia confecimus: cùm autem venissemus in Academiae non sine causâ nobilitata spatia*, etc. Cicero, *De fini.*, bk. 5, § 1.

"Leaving the Dipylon Gate," says Cicero, "we covered six stades and arrived at the Academy, so justly celebrated." [Cicero, *De finibus bonorum et malorum* 5.1.1.]

59. Vit., bk. 7 (ed. Laet, p. 125). [Vitruvius, *De architectura* 7.pref.16.]

60. See this description [and the engraving] in [Claude Gros de Boze, "Description d'un tombeau de marbre antique,"] *Mémoires de la Académie [royale] des inscriptions et belles-lettres*, vol. 4, 648 ff. [Intended as a gift for Cardinal Richelieu, this sarcophagus was in the hands of one Monsieur Foucault, conseiller d'Etat, when Claude Gros de Boze described it thus: "Ce qui est représenté sur la première face du monument, et qui attire d'abord toute l'attention, c'est l'histoire de Cérès, son arrivée à Éleusis, et l'institution de ses mystères dans cette ville ou bourgade de l'Attique" (Represented on the principal face of the monument, and initially absorbing all one's attention, is the story of Ceres, her arrival at Eleusis, and the institution of her mysteries in this city or village in Greece) (p. 649).]

61. Cicero, *De nat. deorum*, bk. 1, ch. 42. [Cicero, *De natura deorum* 1.42.]

62. In a letter [by Vernon] dated 10 January 1676, printed in the *Philos. Trans.*, no. 124, p. 575.

63. [Michel Fourmont, "Relation abrégée d'un voyage littéraire que M. l'abbé Fourmont a fait dans le Levant par ordre du roy, dans les années 1729 et 1730,"] *Académie [royale] des inscriptions et belles-lettres*, vol. 7, *Hist.*, p. 357.

64. Τῆς γὰρ Σπάρτης, τῷ μὲν καθόλου σχήματι περιφεροῦς ὑπαρχούσης, καὶ κειμένης ἐν τόποις ἐπιπέδοις, κατὰ μέρος δὲ περιεχούσης ἐν αὐτῇ διαφόρους ἀνωμάλους, καὶ βουνώδεις τόπους· τοῦ δὲ ποταμοῦ παραρρέοντος ἐκ τῶν πρὸς ἀνατολὰς αὐτῆς μερῶν, ὃς καλεῖται μὲν Εὐρώτας, γίνεται δὲ τὸν πλείω χρόνον ἄβατος διὰ τὸ μέγεθος· συμβαίνει τοὺς βουνοὺς ἐφ' ὧν τὸ Μενελάιον ἐστι, πέραν μὲν εἶναι τοῦ ποταμοῦ κεῖσθαι δὲ τῆς πόλεως κατὰ χειμερινὰς ἀνατολὰς, ὄντας τραχεῖς, καὶ δυσβάτους, καὶ

διαφερόντως ὑψηλούς· ἐπικεῖσθαι δὲ τῷ πρὸς τὴν πόλιν τοῦ ποταμοῦ διαστήματι κυρίως· δὶ οὗ φέρεται μὲν ὁ προειρημένο[ς] ποταμὸς παρ᾽ αὐτὴν τὴν τοῦ λόφου ῥίζαν· ἔστι δ᾽ οὐ πλεῖον τὸ πᾶν διάστημα, τριῶν ἡμισταδίων. Polyb., bk. 5 (Par[is], 1509, p. 370).

"Here," says Polybius, "is the nature of the locality under discussion. Sparta is of a round shape in general, and the space that surrounds it is a plain; but within the city there are irregular and differently sited parts and high ground. The river Eurotas, which flows to the east of the city, is too wide to be crossed for most of the year. The mountain escarpments on which the Menelaion stands are close to the river and situated in the quarter where the Sun rises in winter at Sparta. They are difficult to climb, prodigiously high, and entirely dominate the land that lies between the river and the city. It is along this land, close to the mountains, that the river Eurotas runs; its distance from the city is no more than three half-stades." [Polybius, *Histories* 5.22.]

Polybius here speaks of the general course of the river and seems not to mention the curve that it traced around the *platanistous,* approaching the city near its wall.

65. *Babyca:* Amyot supposed this to be a stream [in his translation of Plutarch], but I prefer to accept the authority of Hesychius, who glosses Βαβύκα as Γέφυρα, a bridge.

66. Pausanias, bk. 3, ch. 14, pp. 241–42. [Pausanius, *Description of Greece* 3.14.6–10.]

67. Paus., bk. 5, ch. 7. [Pausanius, *Description of Greece* 5.7.7–9, though he makes no mention of a stadium, either as a place or measure of a distance.]

68. *Iliad,* bk. 23. [Homer, *Iliad* 23.300–350.]

69. See [Nicolas Fréret, "Réflexions sur l'étude des anciennes histoires, et sur le dégré de certitude de leurs preuves,"] *Mém. de lit.,* vol. 6, p. 161: "It is computed that the works of Homer, which Herodotus states to be older than his by four hundred years, were written 884 years before Christ; and the revival of the Olympian Games is generally supposed to have taken place in 776 B.C., more than a century after Homer."

70. Madame Dacier supposes that in this footrace, described by Homer, the athletes rounded the post. Other authors believe that it served only to mark one of the ends of the course. Both parties have sought confirmation of their opposing views in this passage by the Greek poet: Τοῖσι δ᾽ ἀπὸ νύσσης τέτατο δρόμος· ὧκα δὲ ἔπειτα ἔκφερ᾽ Ὀϊλιάδης. *Il.,* bk. 23. [Homer, *Iliad* 23.758.]

Madame Dacier renders this passage as follows: "Achilles gives them the finish of their course, which was the double stade, for from the post they were to retrace their steps." Monsieur Burette endorses Madame Dacier's translation of the passage when he writes, "Achilles gave them the finish of their course, which was to extend or was prolonged from the post." [See Burette, "Mémoire pour servir à l'histoire de la course des anciens,"] *Ac. des insc.,* vol. 3, *Mém.,* p. 310. M. de La Barre, who believes that the course was run in a single direction, supposes, to the contrary, that the post, which was at the far end of the stadium, was the starting point from which the athletes ran to finish at the place where the judges were stationed. See [Louis-François-Joseph de La Barre, "Dissertation sur les places destinées aux jeux publics dans la Grèce, et sur les courses qu'on faisoit dans ces places,"] *Mém. de litt.,* vol. 9, pp. 388–89.

71. [Burette, "Mémoire,"] *Acadèm. des inscript.,* vol. 3, *Mém.,* p. 290.

72. [Burette, "Mémoire,"] *Acadèm. des inscript.,* vol. 3, *Mém.,* pp. 294–95.

73. Γραμμή...ἡ ἀρχὴ, ἡ ἀφετηρία, ἡ βαλβίς. Γραμμή...*Principium, carceres, et locus, unde cursores ad cursum emittebantur.* ["The beginning, the start, the place from which the runners were dispatched for the race."] *Suidas.*

74. This is what Pindar says in speaking of the spot where the king of Libya placed his daughter in the area set aside for the race:

. ποτὶ γραμ-
μᾷ μὲν αὐτὰν στᾶσε κοσμή-
σαις, τέλος ἔμμεν ἄκρον.
Εἶπε δ᾽ ἐν μέσσοις, ἀπάγε-
σθαι, ὅς ἂν πρῶτος θορὼν
Ἀμφί οἱ ψαύσειε πέπλοις.
ΠΙΝΔ. ΠΥΘ. ΕΙΔ. Θ.

After he had her arraying, says Pindar, "he placed her on the line, that she might herself be the finish of the race; and he said that the first of her suitors to touch her veil might carry her off." Pind., 9th *Ode des Pythio,* last strophe. [Pindar, *Pythian Odes* 9.117–20.]

As will be seen, the competitors in this race returned to the start; and yet there is every reason to believe that the course was one of the shortest ever known, since the title of Pindar's ode tells us that this was the race invented by the Greeks, in the 60th Olympiad, where the athletes ran in full armor.

We have shown, by reference to *Suidas,* that the line was at the entrance to the course and at the beginning of the race. To eliminate any remaining doubt as to its also being the finish, we append two passages cited by Monsieur Burette, *Mém. de lit.,* vol. 3. He writes [(p. 292)], "It is thus that Euripides [(frag. 169 Nauck)] says figuratively, Ἐπ ἄκραν ἥκομ[ε]ν γραμμὴν κακῶν, 'we have arrived at the last line,' that is, 'at the acme of misfortune'; and this is also the point of the proverb μὴ κινεῖ γραμμὴν, 'do not move the line,' that is, 'do not shift the goal.'"

75. Τῷ νιν γλυκὺς ἵμερος ἔσχε
δωδεκάγναμπτον περὶ τέρμα δρόμου
ἵππων φυτεῦσαι. Oly. 3.

In this ode, Pindar relates that the beauty of the trees that Herakles saw in Elis so delighted him that "the fancy took him to plant some of them in the place set aside for the horse race, around the post that was rounded twelve times." Pind., *Olymp.* 3, v. 58. [Pindar, *Olympian Odes* 3.31–34.]

The same poet also tells us (by stating in the fifth of his *Pythian Odes,* ποδακέων δυωδεκαδρόμων τέμενος) that the race at Delphi consisted of twelve circuits of the course—or of the Temple of Apollo, which served as a turning post. [Pindar, *Pythian Odes* 5.33.]

76. [Nicolas Gedoyn, "Recherches sur les courses de chevaux et les courses de chars aux jeux olympiques,"] *Acad. des inscript.,* vol. 9, M., p. 369.

77. He has this to say of this stadium: Ἄνωθεν ὄρους ὑπὲρ τὸν Εἰλισσὸν ἀρχόμενον ἐκ μηνοειδοῦς καθήκει τοῦ ποταμοῦ πρὸς τὴν ὄχθην, εὐθύ τε καὶ διπλοῦν. Paus., bk. 1, ch. 19, pp. 45–46.

"This stadium," says Pausanias, "begins at the mountain above the Ilissos, where it forms a crescent; it extends from there to the river bank; it is straight and double." [Pausanias, *Description of Greece* 1.19.6.]

[Friedrich] Sylburg, [Joachim] Kühn, and the abbé Gedoyn have said [in their editions of Pausanias's work] that it ended at the river with a double wall; but it is clear from Pausanias's text that he makes no mention of any wall.

It seems, in fact, that our knowledge of the length of this stadium derived from modern travelers and the hitherto prevalent view that stadia, even the simplest, measured 600 feet from gate to post have together induced the abbé Gedoyn to misconstrue this passage entirely.

78. *Stadium autem in hâc mundi mensurâ id potissimùm intelligendum est quod Italicum vocant, pedum sexcentorum viginti quinque. Nam sunt praetereà et alia longitudine discrepantia, ut Olympicum quod est pedum sexcentorum, item Pythicum pedum mille.* ["The stade most likely to be implied in this measurement of the world is that which they call the Italian, of 625 feet. But there are other variations in length: the Olympian is 600 feet, and the Pythian is 1,000 feet." (Censorinus, *De die natali* 13.23).]

79. For this explanation, and for Monsieur Gibert's research concerning the length of the ancient pace, see [Joseph-Balthasar Gibert, "Observations sur les mesures anciennes,"] *Acad. des belles-lett.*, vol. 28, M[*émoires*, 212–24].

80. στάδιον κατὰ μῆκος ἔχει πόδας χ΄, δίαυλος αΒ΄, μίλιον η΄, δόλιχος στάδια ιΒ΄. Heron of Alexandria, in *Isagoge* [(Introduction)].

"The length of the stade," says Heron in this passage, "is 600 feet; that of the diaulos is 1,200; there are 8 stades to the mile, and 12 stades to the dolichos."

81. ἔστι δὲ ὁ δόλιχος κδ΄ στάδια. *Suidas*, s.v. Δόλιχος.

"The dolichos," says *Suidas*, "is 24 stades long." *Suidas* has given other measurements for the dolichos; but this tallies best with the accounts given by other authors.

82. Δίαυλος…. ἡ μακρὰ περίοδος. *Suidas*, s.v. Δίαυλος.

"The diaulos," says *Suidas*, "is the long period."

83. Objections *that have been raised to the proposed system concerning the length of the course at Olympia.*

In the author's system, the diaulos would have consisted in covering the entire course twice, turning the post twice and returning twice to the gate: this is contrary to the idea of the diaulos given to us by all the ancients:

1. Eustathius, explaining the metaphorical use of the word, says that it is used to express anything that goes and returns. [See Eustathius, *Commentarii ad Homeri Iliadem pertinentes…*, ed. Marchinus van der Valk (Leiden: Brill, 1971–87), 4:57.]

2. *Suidas* calls it μακρὰ περίοδος; he would otherwise have said διπλῆ περίοδος.

3. To express the motion of the waves as they advance and retreat again, one says δίαυλοι κῦματων.

4. Philo [of Alexandria], speaking of a thing that having advanced to a limit, returns in the opposite direction to the point from which it started, calls it *diaulos.*

The etymology of *diaulos* in itself shows that it was the way there and back; and, furthermore, that the 600 feet of the stadium or stade are to be understood as lying in a straight line. The word comes from δὶς, *twice,* and αὐλὸς. Now, αὐλὸς means *flute;* and, by analogy, anything that extends in a straight line like a flute, such as the stadium

or stade. The diaulos thus consisted in covering the length of the stadium twice, in tra-
versing twice (as in figure 9 of plate 15), not in traversing the course as marked twice
(see figure 10).

As for the dolichos, all that we know of this from the ancients tends to demolish
rather than sustain the system.

The footrace consisted of covering the course once; the chariot race covered it twice,
turning the post, because there was skill in coming close to the post without breaking
the axle. The footrace was the stade; the chariot race, the diaulos; this is what emerges
from Homer [(*Iliad* 23.287 ff.)] and from Virgil [(*Aeneid* 5.114 ff.)], where the boat
contest stands for the chariot race.

These objections to my hypothesis, raised by a very learned critic, do not appear to
me to be unanswerable, and I shall reply to them.

"The etymology of the word δίαυλος — composed of δìς, *twice*, and αὐλòς, *flute* —
indicates," he says, "that this was the way there and back; and also that the way there
and the way back were in one straight line, because," he adds, "αὐλòς means *flute*, and,
by analogy, anything that extends in a straight line." This interpretation of the meaning
of the word δίαυλος is no doubt an entirely natural one; but it is not exclusive, and I
believe that it can be interpreted, with equal plausibility, in a different way.

1. The ancients are known to have had flutes in varying shapes.

2. When the diaulos was run on the course at Olympia, it is true that the runners
ran twice over a course that resembled a straight flute, on raised ground extending
from gate to post; but the ratio between the width of this raised ground and its length
was not so small as to be discounted altogether. The width of this embankment must
have been fairly great, since on the course at Delphi it was terminated by a temple of
Apollo, which served as a post. The ancients are therefore just as likely to have meant
that a lap was run on this figure that resembled a flute as that the runners covered only
its length. The line of the run may thus have been either straight, like *AB* in figure 9, or
curved, like *AB* in figure 10.

Thus, what Eustathius says of the δίαυλος, namely, that its general meaning was
anything that goes and returns; the use of it to express the movement of the waves as
they advance and recede, δίαυλοι κῦματων; Philo's use of the word δίαυλος for a thing
that having advanced to a limit, returns in the opposite direction to the point from
which it started: all this applies equally well to the diaulos, whether we consider each of
the 2 stades that composed its full length as a curved line or as a straight line, always
provided that in covering the second stade the athlete retraces his own footsteps. The
advancing and receding motion of the waves would suggest that the runner goes for-
ward and back in one straight line; but the alternative supposition more precisely con-
veys that he returns to his starting place, retracing all of his own steps.

If the athlete had gone, in figure 11, from *E* to *F* and from *F* to *G* in running the first
stade, and if he had returned from *G* to *F* and from *F* to *E* in covering the second, dur-
ing the second stade he would have trodden in exactly the same steps he covered in the
first. He would have arrived at the exact point from which he had started. Whereas if,
on the alternative supposition, as shown in figure 12, he had gone from *H* to *I* in run-
ning the first stade and from *I* to *K* in running the second, he would not have retraced
all the steps covered in the first. He would certainly have returned to the line *HK* from

which he had set out; but he would not have returned to *H*, the point from which he had started.

I believe that I have shown that analogies drawn from the diaulos are equally applicable to the case in which each stade was covered in a straight line and to the case in which each stade was covered along a curve. I shall now show that, even if I had not disposed of the objections to my account of the diaulos at Olympia, this would still not undermine my system; for I feel bound to point out that the objectors appear to have extended to all stadia what I apply only to some.

I did not assert that the distance from gate to post was only 300 feet on all Greek courses. On the contrary, I said in my dissertation that on the course at Delphi the distance from gate to post was 600 feet. I said that the Greeks had courses of two kinds: some, like that at Olympia, measured only 300 feet from gate to post; others, like that at Delphi, measured 600 feet. It is on this difference that I base my explanation of the passage in Censorinus. From which I conclude that, since all authors are agreed that the diaulos was never more than two stades, at Olympia the post was rounded twice, and then every stade covered by the athlete was along a curve; at Delphi, the post was rounded once, and then every stade covered by the athlete was in a straight line, or virtually so. The former case also applied on those courses where the twelve laps (the dolichos) were just 12 stades, and in the latter case where the twelve laps (the dolichos) were 24 stades, as stated by *Suidas*.

Thus, the name that *Suidas* gives to the diaulos, when he calls it μακρὰ περίοδος, far from militating against my hypothesis, entirely favors it, as I have shown; and the argument that he does not call the diaulos διπλῆ περίοδος does not invalidate my argument, since the very same *Suidas* assigns 24 stades to the dolichos, which was covered in twelve laps, and one lap of which measured 2 stades and was called μακρὰ περίοδος, *the long period*, to distinguish it from the single stade run by the athletes, which was only half the length. The epithet μακρὰ, applied to the diaulos, would argue against my system only if it had been used by Heron, or by any other author who made the dolichos only 12 stades, for then they, as the author of the objections rightly says, ought to have written διπλῆ περίοδος.

The author of the objections says that "The footrace consisted of one length of the stadium," in a straight line. This is true of that described by Virgil, but numerous passages prove that in Greece the runners, even if armed, rounded a post. "On the course named Δίαυλος," says Monsieur Burette, *Mém. de litt.*, vol. 3, p. 309, "the athletes known as Διαυλόδρομοι covered the length of the stadium twice; that is to say, having reached the end, they returned to the gate." He adds, *Mém.*, p. 311, "The athletes who ran the diaulos on foot were often armed. I find proof of this in [lines 291–92 of] the *Birds* of Aristophanes, where one character asks, 'But why do these birds have crests on their heads? Are they about to run the diaulos?' On which the Scholiast [on Aristophanes] remarks, 'Those who ran the diaulos ran it in armor, with crests.' This is confirmed by Pausanias [(*Description of Greece* 10.34.5)], who cites among the victories gained by the athlete Mnesibulus at Olympia, 'that of the stade and that of the diaulos with the shield.'"

It will be seen from the passages cited by Monsieur Burette that the athletes rounded a post in running the Δίαυλος; and we have proved to our own satisfaction

that they also rounded a post when they ran the single stade. We shall conclude our reply by saying that arguments drawn from the etymology of a word, and from the metaphorical senses in which the ancients used it, do not seem so strong as those founded on the following simple calculation: since some sources say that in the dolichos the runners covered only 12 stades, and since Pindar tells us that they rounded the post twelve times, on those courses the post can have been only half a stade from the gate; however, on those courses where the dolichos measured 24 stades, it was 1 stade from the gate.

This would be the place to show that the ancients used very small stadia; but this topic has been discussed, at length and with great clarity, by Messrs. d'Anville and Gibert, and I refer the reader to what they have written in the *Mémoires de l'Académie [royale] des belles-lettres*.

Editorial Notes

a. In these two paragraphs, Le Roy provides a much-abbreviated version of the first part of Pausanius's itinerary; see Pausanius, *Description of Greece* 1.2.2–4, 1.3.1–4, 1.5, 1.8.3–4, 1.14. Note that Pausanius's odeion is the Odeion of Agrippa, to the east of the Hephaisteion, not the Pnyx, to the southwest of the Hephaisteion, as Le Roy seems to think. Note also that Le Roy identifies the Pnyx as the Odeion of Pericles. On the long-term struggle to understand Pausanias's route through Athens, see p. 152 n. 58. A good source on the sites in Greece discussed by Le Roy is Hans Rupprecht Goette, *Athens, Attica, and the Megarid: An Archaeological Guide* (London: Routledge, 2001).

b. Pierre-Jean Burette, "Dissertation sur la mélopée de l'ancienne musique" (read 12 November 1720), *HistMemBL* 5 (1729): *Mémoires*, 185–99, pls. 2–4 after p. 192.

c. On Ruggiero Giuseppe Boscovich, see M. Bossi and Pasquale Tucci, eds., *Bicentennial Commemoration of R. G. Boscovich, Milano, September 15–18, 1987: Proceedings* (Milan: Unicopli, 1988). Joseph Jérôme Le François de Lalande, in his *Voyage d'un françois en Italie, fait dans les années 1765 et 1766* (Venice: Desaint, 1769), 4:210, noted that Le Roy had misunderstood Boscovich's description in the article in the *Giornale de' letterati*.

d. On the Tower of the Winds, see Joachim von Freeden, *Oikia Kyrrestou: Studien zum sogenannten Turm der Winde in Athen* (Rome: G. Bretschneider, 1983); Hermann J. Kienast, "Untersuchungen am Turm der Winde," *Archaeologischer Anzeiger* (1993): 271–75; and Hermann J. Kienast, "Antike Zeitmessung auf der Agora: Neue Forschungen am Turm der Winde in Athen," *Antike Welt: Zeitschrift für Archäologie und Kulturgeschichte* 28 (1997): 113–15.

e. On dervish lodges and *tekkes*, see Raymond Lifchez, ed., *The Dervish Lodge: Architecture, Art, and Sufism in Ottoman Turkey* (Berkeley: Univ. of California Press, 1992), though the Athens lodge is not mentioned therein.

f. On Hadrianic Athens in particular, see Dietrich Willers, *Hadrians panhellenisches Programm: Archäologische Beiträge zur Neugestaltung Athens durch Hadrian* (Basel: Vereinigung der Freunde Antiker Kunst, Archäologisches Seminar der Universität, 1990); Renate Tölle-Kastenbein, *Das Olympieion in Athen* (Cologne: Böhlau, 1994); and Christian Habicht, *Athen: Die Geschichte der Stadt in hellenistischer Zeit* (Munich: Beck, 1995).

g. Herodes was archon in 60/59 B.C., and his son Eucles of Marathon in 46/45 B.C.

h. See Luigi Beschi, "I disegni ateniesi di Ciriaco: Analisi di una tradizione," in Gianfranco Paci and Sergio Sconocchia, eds., *Ciriaco d'Ancona e la cultura antiquaria dell'umanismo: Atti del convegno internazionale di studio, Ancona, 6–9 febbraio 1992* (Reggio Emilia: Edizioni Diabasis, 1998), 83–94; and Christian Hulsen, *Il libro di Guiliano da Sangallo: Codice Vaticano Barbariniano latino 4424,* 2 vols. (Leipzig: O. Harrassowitz, 1910; reprint, Vatican City: Biblioteca Apostolica Vaticano, 1984). The drawing by Ciriaco d'Ancona (see this volume, fig. 6) from which Sangello's version of the Parthenon was derived is in the Staatsbibliothek zu Berlin (MS Hamilton 254, fol. 85r).

i. Bocher is not listed as a consul at Corinth in Anne Mézin, *Les consuls de France au siècle des lumières (1715–1792)* (Paris: Ministère des Affaires Étrangères, Direction des Archives et de la Documentation, 1998).

j. On the history of Sparta, see Paul Cartledge, *Sparta and Lakonia: A Regional History, 1300–362 B.C.* (London: Routledge & Kegan Paul, 1979); and Paul Cartledge and Anthony Spawforth, *Hellenistic and Roman Sparta: A Tale of Two Cities* (London: Routledge, 1989).

k. On Mistra, see Gabriel Millet, *Monuments byzantins de Mistra . . .* (Paris: E. Leroux, 1910); and Manoles Chazedakes, *Mystras: The Medieval City and the Castle: A Complete Guide to the Churches, Palaces, and the Castle,* trans. Alison Frantz-Louise Turner (Athens: Ekdotike Athenon, 1981).

PART 2

The Ruins of the Monuments Erected by the Athenians after the End of the Age of Pericles, Architecturally Considered; with a Description of Two Temples, One at Pola, the Other at Corinth

Introduction

At the beginning of the first volume of this work, we set out the reasons that have induced us to place in this second volume our description and drawings of the Temple of Rome and Augustus consecrated by the little republic of Pola. Maintaining the order followed in our previous descriptions of other buildings, we shall simply collect here what history relates concerning this temple and then, in the course of this second part, insert the remarks of a different kind suggested to us by the details of the monument.

The temple at Pola, shown in plate 16, is so beautiful as to be among the most precious relics of antiquity. The inscription on its frieze tells us that it was dedicated to Rome and Augustus;[1] it also tells us, by the epithets *Divine* and *Father of His Country* which are given to that prince, that this building dates from the latter part of his reign, when the Senate had conferred these titles upon him. As we have said elsewhere, they carried flattery to such lengths as to call him a god.

It is clear, from the magnificence of this temple, that the city of Pola must have erected it in gratitude for some signal favor; and, though the inscription does not record its nature, the location of the monument allows us to guess. The ancients had the custom of locating the temples of their gods according to the favors supposedly conferred by the gods in question.[2] We therefore have reason to suppose that the inhabitants of Pola set up a temple to Augustus in their public square—a place sacred to Mercury, Isis, and Serapis, the patrons of trade and industry—to extend to him the same honors as those gods because he had granted them some notable privileges in commerce.

This temple is admirable for the beauty of its plan, for the fine proportions of its principal masses and component parts, and for its ornament. It is of the Corinthian order and of the type that Vitruvius calls prostyle, that is, it has columns only on its facade. Its builders gave it majesty by raising it on a

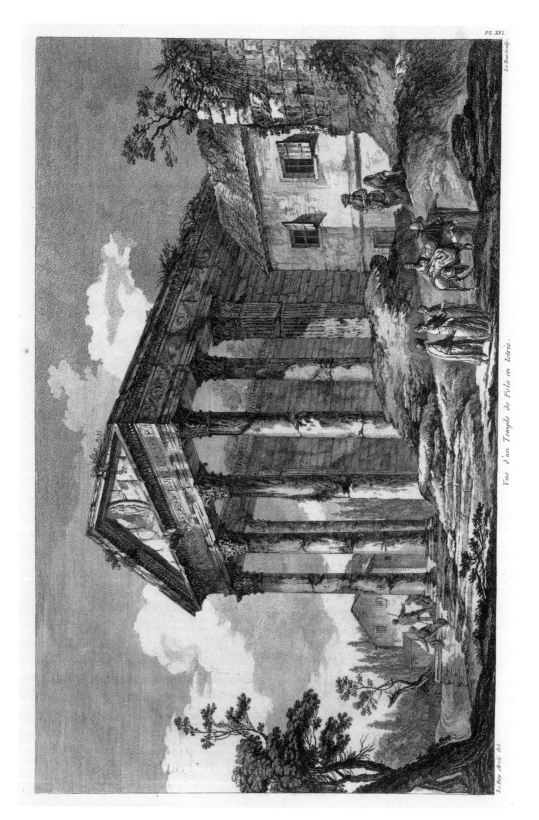

Pl. 16. Jacques-Philippe Le Bas, after Julien-David Le Roy
View of a Temple at Pola in Istria

number of steps, and the variety of the marbles of which it is built still pleases the eye. The marble of the columns, in particular, is very fine; it is red speckled with white. These columns are smooth, but their capitals are adorned with oak and olive leaves.

This employment of two kinds of leaves in a single capital is highly unusual, and perhaps it was not done without purpose: the Romans are known to have awarded Augustus a crown of laurel for bestowing peace on the world and another of oak for protecting the citizens of the republic. The entablature of the order is rich, and its profiles most elegant. Nothing could be in better taste, or better executed, than the ornament on the frieze of the flanks of this temple. The medallion in the pediment is oval, but the sculpture is so much damaged that I was unable to determine the subject. I pass over the details of interest to architects, which I shall give later in this second part, when I come to discuss the Corinthian order.

Monuments of the Doric Order

Description of the Ruins of a Temple at Corinth

The Doric temple whose ruins are still to be seen at Corinth, and whose plan I have shown in plate 17, is incontestably one of the most noteworthy in Greece for the light that it can shed on the history of architecture. Its columns, figure 2, are shorter in proportion than any others known; they are less than four diameters in height, their diameter being 6 feet and their height approximately 22½ feet. I say approximately because at Corinth, unlike Athens, I was unable to procure ladders to measure the precise height of the columns. I had some poles joined together, which I lifted up under the architrave, and by this means I succeeded in gaining an approximate notion of the proportions of the columns and the mass of their capitals. As for the profile of the capitals, shown in figure 3, I can certify that it is a very close approximation, having devoted the greatest attention to drawing it in situ.

As will be seen, these columns are of the same type as those of the two Greek temples given at the beginning of the second part of the previous volume. They differ slightly in that the columns at Corinth are shorter and fluted, whereas the others are not; and also in that the echinus or *quart de rond* of the capital is much more rounded. The first of these differences would seem to suggest that the temple at Corinth is earlier than any other known in Greece; but I confess that the flutes and the well-rounded form of the echinus of the capital make me doubt that the columns are of such great antiquity.

To determine the approximate date of the ruins of a temple, I consider it necessary to examine not only the general proportions of its columns but also the taper of the shaft, the form of the capital, and the details of the profiles and entablature. Even columns less than six diameters high may well be so elaborate in their detailing that they cannot possibly antedate the time when — according to Vitruvius [(*De architectura* 4.1.5–6)] — the Greek colonies founded in Asia Minor by Ion, son of Xuthus, first had the idea of making their Doric

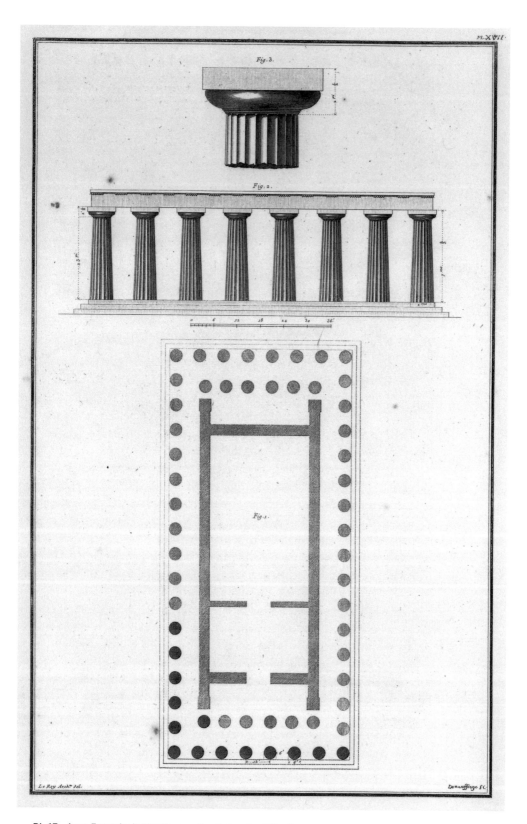

Pl. 17. Jean-François de Neufforge, after Julien-David Le Roy

columns six diameters high. And so, more cautious than those who, in a work published in Italy, have sought to assign to the temples of Paestum[3] a date earlier than that given by Vitruvius for the invention of the Doric, we shall say only that the temple at Corinth is of great antiquity and that it was probably built before the age of Pericles.

The Doric Order Considered in Its Third State

The building sacred to Minerva and Augustus whose ruins are still to be seen at Athens, and whose facade I show in plate 18, figure 1, is notable because its Doric order is more slender in its proportions than the Doric of the other, earlier monuments that we have given. Since it is the only example of this kind to be found at Athens, and since the Romans were already well versed in architecture by Augustus's time, we cannot be sure whether the Greeks, having made their Doric columns more slender, were imitated by the Romans or the Romans, having altered the Greek Doric order, insisted that monuments in Greece built for or dedicated to Romans should observe their own customary proportions for the Doric. Be that as it may, this portico indicates the source of all the changes made by the Romans to the Doric proportions that had been current in Greece in Pericles' time.

The column of this portico tapers less than that of the Doric temples given previously: its capital, figure 2, takes a different shape, the echinus being far more rounded; and there are three annulets between the echinus and the shaft, whereas in the Temple of Minerva there are four little cavetti. Furthermore, the entablature is less tall in relation to the column, with less projection over the head of the shaft, and the cornice projects much farther than in the other temples of the same order at Athens; the cornice also contains more moldings.

It may also be noticed that in this entablature the triglyph projects less from the frieze than in the Doric profiles of the earlier temples of Greece; and where in the temples of Minerva and Theseus its face is flush with the architrave, in that of Augustus the face of the triglyph projects, as indicated by the measurements on the figure.[4] The flange that surmounts the corona of this entablature is a molding more suited to joinery than to marble construction; and in general, if I may speak my mind on this entablature and on that of the Temple of Minerva, I find the latter infinitely the more beautiful and the more masculine of the two. It may also be observed that the proportion of the pediment of this Doric portico seems taller than those of the temples given previously.

Greatly though the Doric of the monument to Minerva and Augustus differs from that of the temples of Minerva and Theseus, far greater changes, and perhaps more of a decline, may be seen in the Doric monuments of the Romans. Vitruvius [(*De architectura* 4.3.4)] tells us that Doric columns are to be seven diameters high. He makes the architrave of the order low, contrary to the origin of this member, which ought to imply the strength to support all the other parts of the entablature; his frieze is too tall, at the expense of the architrave; and his cornice is made up of too many moldings

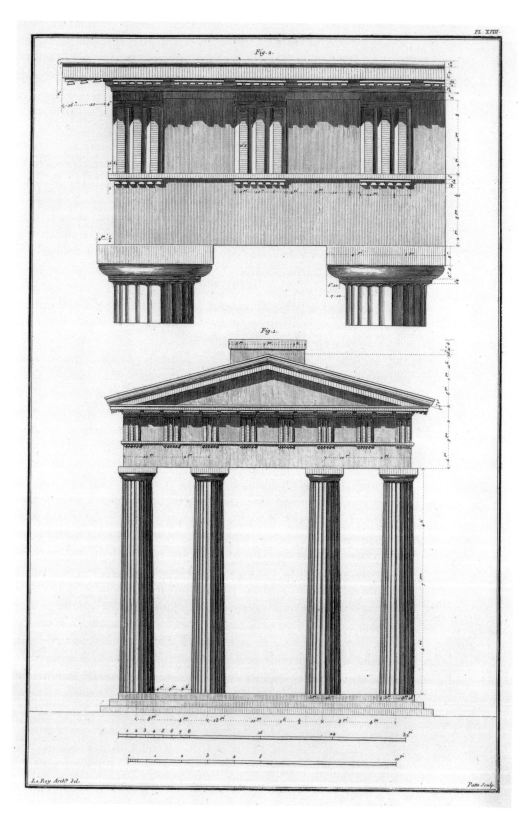

Pl. 18. Pierre Patte, after Julien-David Le Roy

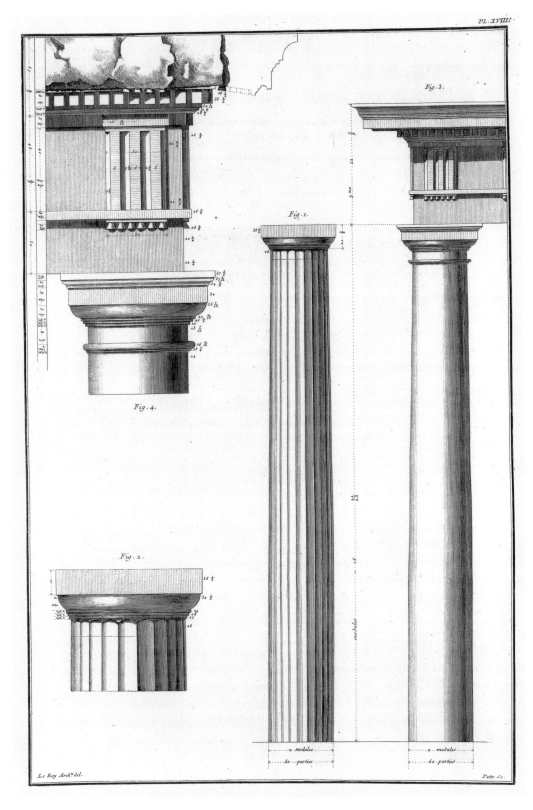

Fig. 3.

Fig. 1.

Fig. 4.

Fig. 2.

Le Roy Arch.ᵗ del.

Patte Sc.

Pl. 19. Pierre Patte, after Julien-David Le Roy

and consequently not likely to make a grand effect in the execution. In venturing my own view of Vitruvius's Doric, I have in my favor the authority of several able architects, and indeed of modern opinion in general, for this order is rarely built in the form given by that ancient author.

The Doric of the Theater of Marcellus, shown in plate 19, figures 3 and 4, seems to me to show imperfections of the same kind in its entablature: in general it seems to have too many moldings; its dentils are condemned by Vitruvius and by most modern architects, because this ornament is contrary to the origins of the Doric order. Its column is very much taller in proportion than Vitruvius prescribes, since it is nearly eight diameters high. It seems, from those that have been erected in the nave of San Pietro in Vincoli in Rome,[a] shown in figures 1 and 2, that the Romans built more than one Doric monument with columns of these proportions.

I drew these columns on my return from Greece to Rome, and I confess that I had not previously paid them the attention that they deserved. They have no bases; their flutes are the same in form as those of the Doric buildings of Athens; the abacus of the capital is not surmounted by an ogee; and there is neither necking nor astragal beneath the capital itself. These columns therefore appeared to me, in several details, to bear a strong resemblance to the Doric of the Greeks and to give clear proof of the transfer of their architecture into Italy; and this prompted me to illustrate them in plate 19. I have since found further evidence to support my conjecture: I saw capitals of the same kind at Naples, and Monsieur [Marie-Joseph] Peyre, whom I have already mentioned, tells me that he has found similar ones in the vicinity of Rome.

The comparisons just drawn between the Doric order as built at Athens in Pericles' time and the Doric built there during the reign of Augustus, and particularly as built by the Romans, show that the latter considerably increased the height of the column. In consequence of this, as the columns became more slender in proportion, more moldings were added to the capitals and entablatures. Were these changes wholly for the better? I think not. However, the question can be resolved only by the unanimous decision of several peoples enlightened in the fine arts. I shall await and accept their verdict.

Among the monuments whose history is given in this volume, Athens offers no Ionic building of particular note; we shall therefore speak of those built in the richest of the orders that the Greeks devised, to be seen both in that city and at Pola.

Monuments of the Corinthian Order

The two temples whose ruins are seen at Pola in Istria — and whose plans and positions, together with the facade of the less ruinous of the two, are shown in plate 20 — are of the class that Vitruvius called *prostyle*. Their intercolumniations are systyle, being two diameters wide, except for that in the center, which is wider than those flanking it. I was able to confirm Palladio's statement that a pedestal runs around their facades, with its top level with the paved floor of the temple, which is reached by means of steps placed as

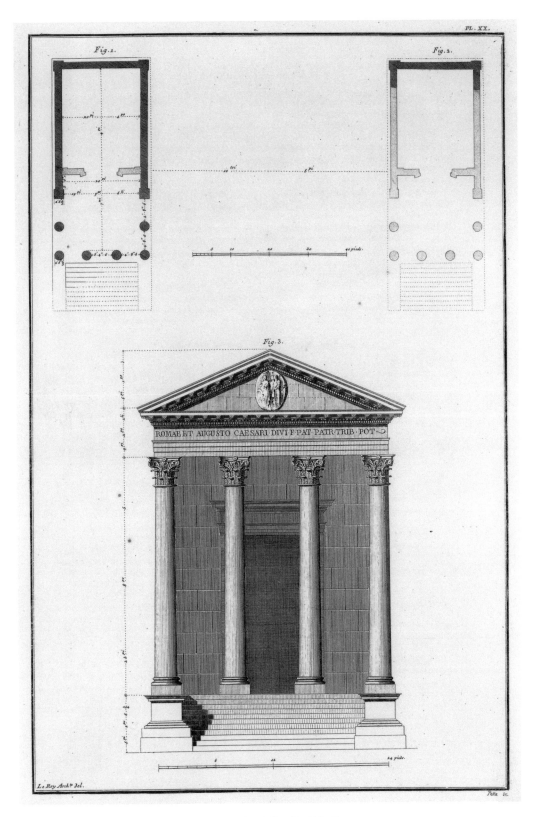

Fig. 1.

Fig. 2.

Fig. 3.

ROMAE ET AUGUSTO CAESARI DIVI F PAT PATR TRIB POT

Le Roy Arch.^{te} del.

Patte Sc.

Pl. 20. Pierre Patte, after Julien-David Le Roy

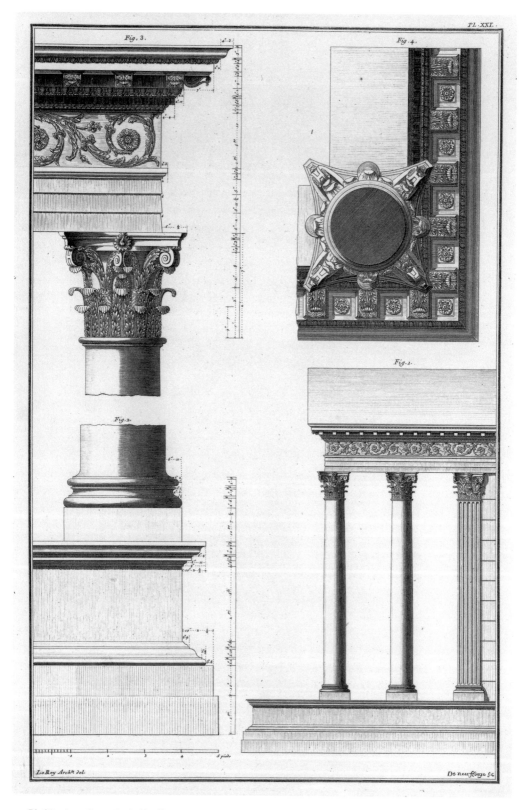

Pl. XXI.

Fig. 3.

Fig. 4.

Fig. 1.

Fig. 2.

Le Roy Arch.t del.

De neufforge Sc.

Pl. 21. Jean-François de Neufforge, after Julien-David Le Roy

he indicates. I also found, as that author says, that the plinth occupies half of the whole height of the base; that the capitals are adorned with olive leaves and their caulicoles covered with oak leaves; that the fasciae of the architrave decrease in width from bottom to top, and they are not vertical but battered.

The pediment of the facade contains a medallion, which Palladio does not mention, and there is another, similar one in the pediment of the rear elevation. The latter face is much simpler than that of the front, being merely terminated at the corners by two fluted pilasters and having an entablature without inscriptions or ornaments in the frieze.

Figure 1 of plate 21 represents part of the profile of the temple on the porch side. The smooth portion, not seen at its full length, is pierced by a small window, the band of which almost touches the entablature. The ornament in the frieze of this flank is very fine. The pilaster seen here has only five flutes on each face, though there are seven in Palladio's drawings. Figures 2, 3, and 4 show the profiles of the parts of the column, pedestal, entablature, and soffit of the order of this monument, on a larger scale.[5] The architect who built it was unaware of the rule laid down by Vitruvius that there should be no dentils in Corinthian cornices adorned with modillions; or, at any event, he did not observe it. But it appears that he has skillfully avoided a clash between these two members by making his modillions large within the mass of the cornice and the dentils contrastingly small.

The beauty of the profiles of the Temple of Rome and Augustus, as just given, proves that the Corinthian order was close to, though not yet at, the peak of its perfection in the ancient world. By Hadrian's reign, that moment of felicity lay in the past. The portion of the magnificent ruin of an enclosure to be seen near the bazaar at Athens gives striking proof of this. I have shown its plan, elevation, and details in the first four figures of plate 22, and I will take this occasion to add here a few remarks to those I made on this ruin in the first part of this volume. Figure 1 shows part of its plan.

Figure 2 shows the least damaged part of the facade of the enclosure. It will be seen that the freestanding columns of the frontispiece to the central vestibule, which formed the entrance to the enclosure, were fluted and ornamented with fillets, and therefore far more ornate than those along the walls, which have smooth shafts. The latter are surmounted by an entablature that breaks forward for each column: a decoration that proves what we have advanced, which is that this part was rebuilt by Hadrian, such projections being unknown in the monuments of early antiquity. The capital is ordinary in composition and highly mediocre in execution. The entablature, shown on a larger scale in figure 3, is less than a quarter of the height of the column. It is rather fine; like that of Nero's frontispiece,[b] so well known and so highly esteemed, it has two fasciae on its architrave and double modillions whose ends stop well short of the corona. The modillions are paneled beneath, as will be seen from the soffit view of the same entablature, figure 4; and between the modillions are regular square panels with rosettes. As the measurements

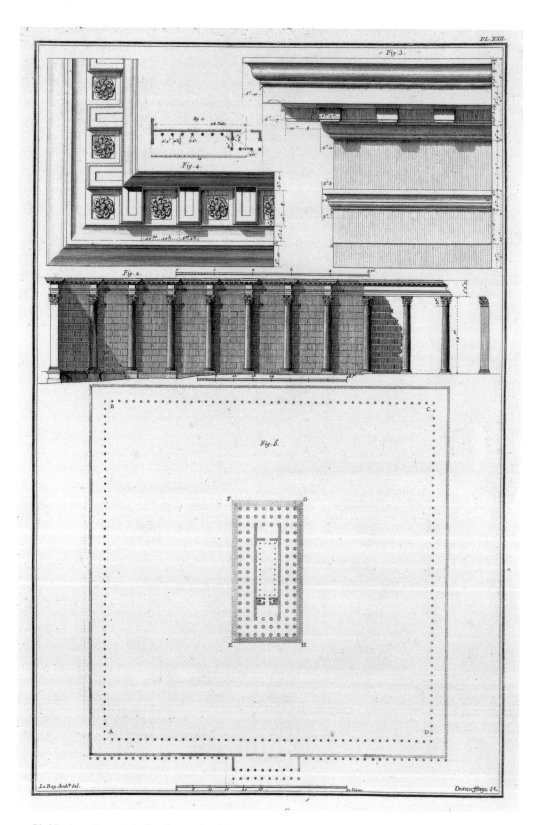

Pl. 22. Jean-François de Neufforge, after Julien-David Le Roy

on these figures suffice to show the proportions between each part and the whole, I will say no more on the subject here.

The magnificence of this enclosure permits us to judge the beauty of the building that it contained; we have given elsewhere the reasons that lead us to suppose that it formed part of the Temple of Eileithyia, built by Hadrian. The walls of the enclosure lent such grandeur and nobility to the temples that they surrounded that we cannot conceive how Vitruvius, who discussed all branches of architecture with such thoroughness, omitted to speak of them. This has led us to show on a larger scale, plate 22, figure 5, the plan of the *naos* or body of the Temple of Jupiter Olympius and of the enclosure that surrounded it. True, we have reason to suppose that nothing remains of this celebrated temple; but since Vitruvius gives a precise description of its *naos*, and since Pausanias tells us the extent of its enclosure, we believe that the plan that we have traced is not far from the truth.

Here are Vitruvius's [(*De architectura* 3.2.8)] words: "The hypaethral is decastyle, front and rear. Otherwise it resembles the dipteral, except that inside it has two orders of columns, one above the other, and set away from the wall to form porticoes, as in peristyles. The center is unroofed, and there are doors in the front and back walls. We have no examples of this kind at Rome, but there is one at Athens, in the Temple of Jupiter Olympius, which is only *octastyle.*" Since this translation of Monsieur Perrault's seems to us accurate, we give it unaltered.

Following Vitruvius, I have shown eight columns in the facade of the temple; but he does not specify the number on the flanks, and so I have made them seventeen, in accordance with the proportions observed by the Greeks. I decided the space that it occupied within its enclosure by following that occupied in a similar enclosure by the magnificent Temple of the Sun at Palmyra. The colonnade that lines the latter enclosure has led me to essay a similar one, *ABCD*, for the Temple of Jupiter Olympius; and I have followed Pausanias in making the length of its perimeter 4 stades. At the same time, I have no authority for making it square in shape, for, admittedly, Pausanias's description would suit any other rectangular figure equally well.

We attach more importance to the details of the disposition of the Temple of Jupiter Olympius because there seems to be no doubt but that it served as the model for the larger temple built by Hadrian, which, as we have said, most probably was the Pantheon or temple that he dedicated to all the gods. Messrs. Spon [(*Voyage d'Italie*, vol. 2, p. 169)] and Wheler [(*A Journey into Greece*, p. 371)] supposed the seventeen extant columns of this temple to be the remains of a portico of six rows of twenty columns each, which tallies neither with what Pausanias tells us nor with the intervals between the seventeen columns that remain of this temple, shown bolder than the others in the plan, plate 23. Here are my conjectures on the disposition of this monument. It was, in my view, the complete hypaethral of which Vitruvius speaks, and of which no perfect example was to be found in that author's lifetime at Rome or at Athens, for this Pantheon was built long after the reign of Augustus,

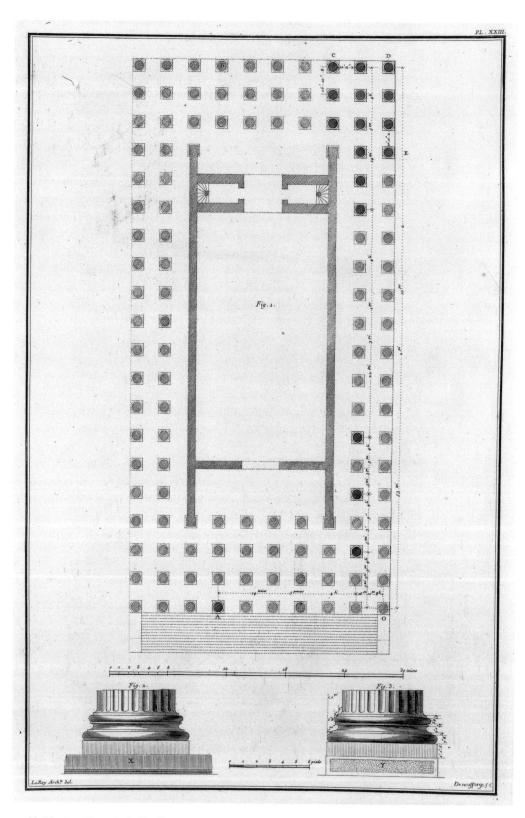

Pl. 23. Jean-François de Neufforge, after Julien-David Le Roy

during which Vitruvius lived. I have arranged the missing 103 columns in the way shown in the plan in order to arrive at the number of 120 that Pausanias assigns to this monument. According to my hypothesis, it would have had four rows of columns forming a triple portico on the entrance side, three more rows at the rear, and two on each flank. This arrangement seems to be authorized by that of the Temple of Minerva at Athens, which, as has been seen, has two rows of columns forming double porticoes front and rear, though there is only one row of columns and a single portico on either flank.

I have supposed that in Hadrian's Pantheon, according to the rule laid down by Vitruvius for the internal arrangement of temples, the body of the temple, known as the *cella,* and its vestibule together amounted to approximately twice the external width of the *cella.*[6]

This temple, like the hypaethral and the Temple of Jupiter Olympius, probably had two colonnades in the interior, one above the other, just as I proposed in part 1; but it particularly resembled the latter in being set in the center of a vast enclosure, of which some of the foundations are still to be seen, though we have found nothing to indicate the nature of its decoration.

The columns of this monument are nearly 6 feet in diameter, and I estimate that they were more than 55 feet high. I cannot give a precise measurement because I found no ladders in Athens tall enough for the purpose; so I shall give no drawing. As for the former general appearance of the monument, some idea may be gained by looking at the facade of the hypaethral temple as given in book 3 of Monsieur Perrault's translation of Vitruvius, which in my view is perfectly in the antique taste, saving a few minor cavils as to the design of the steps and plinth.

Figures 2 and 3 reveal that in Hadrian's Pantheon the bases of the columns, which were Attic, stood on plinths—which goes to show, as we have said more than once, that this is not a building of the greatest antiquity. Beneath one of these bases can be seen the profile of the pedestal that ran around the peristyle; beneath the other is a support of which the pecked part was joined to the other marbles that formed the pavement of the temple. The difference between the members that support the plinths of each of these two bases was of great assistance to me in distinguishing the external columns from the others.

In a sense, the natural order that we have observed herein would require us to follow our account of Hadrian's buildings with that of his arch, of which plate 24 represents the plan, elevation, and details. However, since these details are in very poor taste, we thought it best to relegate to a note[7] the comparatively minor points we have occasion to make about the monument. Rather than break the thread of the far more important remarks that we have to make concerning temples, to our detailed comments in the present work we will add other, more general reflections on the differences in mass between the square and round temples of the ancients, as shown together in plate 25; on their varying roofs; and on the variations of proportion likely for each of these two kinds of temples.

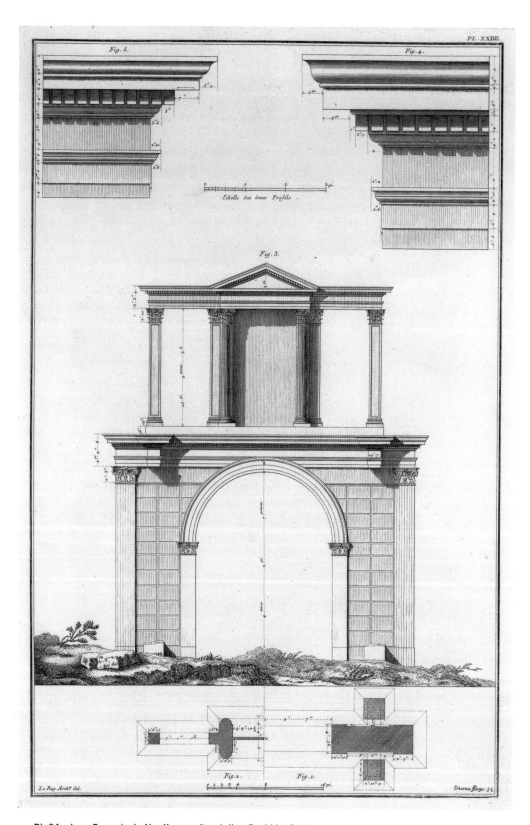

Pl. 24. Jean-François de Neufforge, after Julien-David Le Roy

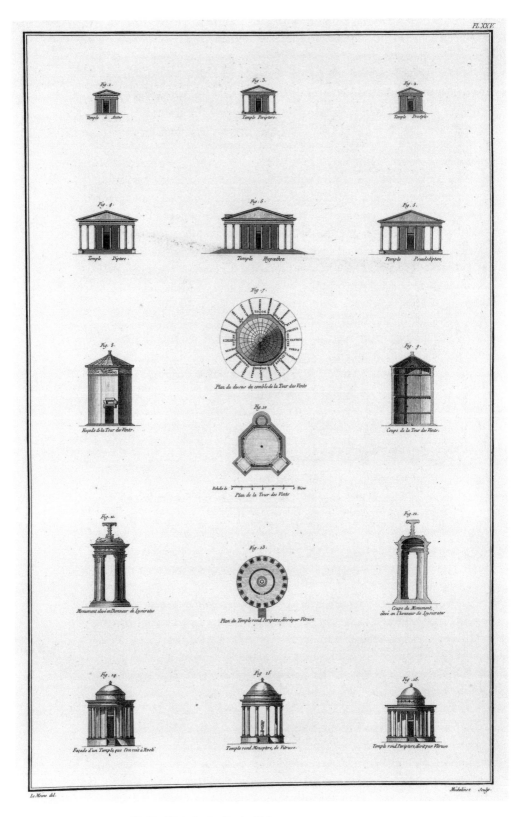

Pl. 25. Michelinot, after Le Moine

The first six figures in this plate show the appearance of the rectangular Greek temples; the reader will recognize at a glance the facades of the temple *in antis,* prostyle, amphiprostyle, dipteral, pseudodipteral, and hypaethral. Since Vitruvius [(*De architectura* 3.2)] has described each of these separately, we refer the reader to what he has to say on the subject; we must observe, however, that his words must be weighed with great care and must be compared with the antique examples that we still possess if we are not to regard all temples of the same type — prostyle, for instance, or peripteral — as more similar than they really were.

If we therefore examine the writings of Vitruvius and consider the temples still extant in Greece, Magna Graecia, and various parts of Asia, we shall find that every type of temple could vary widely in its forms without ever passing into a different class. The proportions of the facades might differ according to the number of columns, the kind of columns, the proportions given to these by the architect, the width of their spacing, and, finally, the design of the steps that served, in a sense, as the foundations of the building.

Vitruvius defines, it is true, the number of columns that every kind of temple should have on its facade, but there are still many examples in Greece to prove that the architects of that people did not slavishly observe the rules. The Temple of Minerva at Athens, for instance, is peripteral; yet it has eight columns in its facade, though Vitruvius speaks of this type of temple as having only six. That of Minerva Polias, in the same city, has six frontal columns; but by Vitruvius's rules, since it is prostyle, it should have only four. Finally, the Temple of Jupiter Olympius at Athens, which had only eight columns in its facade, was hypaethral, though Vitruvius lays down that such a temple should have ten.

Not only did the Greeks not feel obliged to use a fixed number of columns in the facade of each particular type of temple but they employed different orders as well; and since they built their Doric columns only six diameters high and their Corinthian sometimes more than ten, this prodigious disparity of proportion must also have produced striking differences in form and character for the facades of temples of the same type, according to the order employed.

Differences in the proportions that the Greeks gave to columns of the same order, and the concomitant variations in spacing, were another source of variety when they constructed their temples. Finally, the steps that led up to the temple could either continue all around the building or be terminated by pedestals at the corners of the facades; and this, again, caused the masses to vary. In the former case, the steps added little to the height; in the latter case, they increased it considerably.

It follows that the ancient rectangular temples of any one type were far more varied in their forms and in the proportions of their facades than could ever have been supposed until we became familiar with the ruins of Greece, Magna Graecia, and various cities in Asia. From this analysis we pass to some remarks on round temples and on their roofs.

Among the buildings whose ruins are still to be seen at Athens, the Monument of Lysikrates and the Tower of the Winds are the only ones that can cast any light on the round temples of antiquity. For the better understanding of what I have to say on this subject, which is as important as it is little known, I have had engraved in plate 25 the geometrical designs of these two buildings, of a round temple whose remains are still to be seen at Tivoli, near Rome, and of the round temples described by Vitruvius. What we learn from the former buildings will add to our understanding of what this ancient author tells us about round temples.

It may be seen from the elevation and section of the Tower of the Winds, figures 8 and 9, that the roof of the building is low, like those of rectangular Greek temples, and that it rises in a pyramid. It was terminated in a remarkable way, with a capital.

The small calotte that surmounts the Monument of Lysikrates is also very low, as is seen in figures 11 and 12. It is not exactly pyramidal, but the curve that it forms is not very marked; again, it is important to note that this little monument was surmounted by a triangular capital.

The calotte that crowns the temple at Tivoli, figure 14, bears a close analogy to those of the two Greek buildings just named. It is low, and its curvature is not very pronounced. We do not know how it terminated at its peak, but it is certain that the ancients did not make the finials of their round temples quite so masculine as we now suppose; for, according to Labacco, the Mole of Hadrian [(Castel Sant'Angelo)] was terminated by the bronze pinecone still to be seen at Rome, in the Belvedere.

Our observations concerning the roofs of ancient round temples lead us to conclude that these were originally pyramidal and either resembled the roof of the Tower of the Winds or consisted of a kind of steps such as still appear at the base of the calotte of the Rotunda [(Pantheon)]. Originally pyramidal, the roofs of circular buildings then acquired a subtle curvature, perhaps like that of the calottes of the temple at Tivoli and of the Rotunda [in Rome]; furthermore, we believe that this slight curve did not prevent the ancients, in Vitruvius's time, from regarding them as pyramids. Finally, the capitals that surmounted the Tower of the Winds and the Monument of Lysikrates and the flower that terminated the Mole of Hadrian suggest to us that the ancients initially topped their round temples with capitals similar in height to those of the columns; and that they subsequently replaced these with flowers, giving rise to Vitruvius's rule that the flower crowning a round temple is to be of the same height as the capitals of the columns.

Not only does Vitruvius tell us of the finial of a round temple and its proper height but he also to some extent determines the elevation of the cupola, by saying that its height, excluding the flower, should be half its diameter;[8] and his account leads us to give the small cupola of the round temples described by him, in figures 15 and 16, a curvature very different from that given by Monsieur Perrault and by the marchese [Berardo] Galiani, who, in our view, make these cupolas far more like those of modern than of antique temples.

We have hitherto discussed the Tower of the Winds only in terms of the light that it sheds on the history of round temples; we have more to say in a different connection. Figures 8, 9, and 10 show its elevation, section, and plan. As will be seen, this monument is not as distinguished in its detailing as it is curious in other respects; this is why I have dispensed with its profiles. But I have shown the plan of its roof, figure 7; and there I have marked, in addition to the positions of the eight principal winds shown on the faces of the building, the twenty-four stone slabs and the twenty-four heads that most probably corresponded — as we said in discussing this monument in the historical part of this book — to the twenty-four winds known to the Greeks. As I have been unable to discover the Greek names for sixteen of these winds, and we know only the eight principal ones, I have called the others by the names given to them by the Latins.

The roof of the building rises in the shape of a pyramid, as Vitruvius says; its division into twenty-four parts is visible on the inside as well as from the outside. At one end, the stones that constitute the vault rest on the walls of the tower; at the other, the stones taper to meet the round stone at the center that serves as a keystone. On this keystone, no doubt, stood the Triton who, according to Vitruvius [(*De architectura* 1.6.4)], pointed with his rod to the wind that blew.

There is little decoration on the inside of the tower. The two cornices low down on interior[9] are of a very poor design; the intermediate cornice has modillions entirely devoid of ornament. The little columns up above are cantilevered on a circular band inscribed in the octagon of the tower; it touches each of the eight faces and leaves a little space at each angle for the eight columns, which are Doric. As will be seen, these are very short in proportion and surmounted merely by an architrave, on which rest the twenty-four stone slabs of the roof.

Remarks on Some Fragments of Columns that I Found on the Island of Delos

I was struck by the singularity of the oval columns that Tournefort [(*Voyage du Levant*, vol. 1, pp. 359–63)] saw and admired on Delos,[c] in which each drum, figures 1, 2, 3, and 4 of plate 26, consisted in plan of two semicircles separated by two flat surfaces. I examined these with the greatest attention and measured them very precisely.

My curiosity drove me to seek, close to the place where the drums of these columns are found, for their bases and capitals. I was momentarily deceived by seeing a very fine Corinthian base, figures 5 and 6, with flutes on the shaft of the column very similar to those of the oval columns. This fragment was lying on its side and half-buried. In uncovering it, I expected to find it the same shape as the drums of the oval columns, but I was deceived, for on closer examination of the column and the base of this fragment, I found both to be perfectly round.

However, as this base is very fine, I measured it accurately; and not far

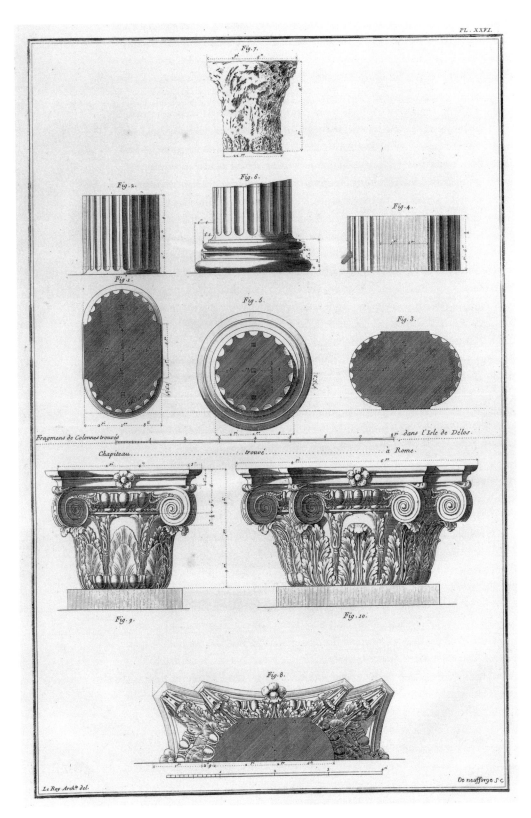

Pl. 26. Jean-François de Neufforge, after Julien-David Le Roy

from the place where it lay, I found a Corinthian capital, figure 7, of which only two leaves of the lowest row and the drum were visible: it was so completely ruined that there were no second tier of leaves, no caulicoles, and no abacus; all that could be clearly discerned was the height of the capital and the diameter of its base. Upon measuring these two dimensions, I easily recognized it as the capital of the base that I had just found; and having returned from Delos to Mykonos, when I came to review and compare the measurements that I had taken on Delos, it occurred to me that the Corinthian base that I had found and its capital might have formed part of the columns of the same building in which the oval columns had also been used. I therefore went back to Delos, and, comparing the measurements of all these fragments, I found that the larger diameter of the round Corinthian column corresponded exactly to the lesser diameter of the oval columns. I also ascertained that the flutes were of the same width; combining this with the proximity of the two different types of column, I was confirmed in my opinion that they had been used in the same building.

Reflecting further on these columns, I called to mind a curious capital found in Rome,[d] shown in figures 8, 9, and 10, to which I had paid insufficient attention during my stay in that city, before my journey to Greece. It is at Trinità dei Monti, on the pedestal of one flight of the steps that lead upward to the church of the Minims. This capital, which I drew on my return from Greece to Italy, has the upper surface of the abacus in the shape of a parallelogram and the lower part, which rested on the shaft of the column, more or less oval, as will be seen from the plan. It seems a perfect match for columns similar to those on Delos; for its longer sides present four volutes each: two in the middle, which probably surmounted the flat faces that separated the two rounded ends of these curious columns, and two at the extremities, which surmounted those same round parts. I was confirmed in my supposition that Delos was not the only place where columns of this shape had been used; I even surmised that the architect who had employed them, probably together with round columns in the same building, had not done so without good cause, but for the sake of firmness. My conjectures on the subject were as follows.

Having noticed, more than once, that the columns that stood at the corners of the peristyles with which they surrounded their temples were more subject to collapse than the others, the ancients naturally had the idea of making them stouter. Vitruvius [(De architectura 3.3.11)] tells us that they did this for optical reasons; but the firmness of the building is likely to have been one of the main reasons for the increase in diameter. We therefore think it probable that architects, seeking some means of solving the problem without spoiling the decorative effect of a facade, had the idea of making one column at each corner oval in plan and related to another, round column as the drum in figure 1 is related to the drum in figure 5. By this means, they would have reinforced the corner of the building more than they could ever have done by making the column stouter yet maintaining the round shape; for if it had been

too much larger than the others, it would have become absurd. They would have, in addition, the advantage of reinforcing the corner without spoiling in any way the facade of the building, for its appearance was essentially the same whether there was an oval column placed as we suppose or a round. What is more, their architraves, all of one piece, would have been placed naturally on the capitals, without being distorted at the ends, as they are when they rest on angle columns.

The relation between the drum in figure 5 and that in figure 3 represents another, more imperfect fashion of arranging columns of these kinds, because, if the corner column were to display its longer side to the front, it would look absurd combined in a single facade with round columns of a smaller diameter.

These two ways of arranging oval columns in relation to round columns represent more or less all that can be imagined. I do not think that there is much use to be made of columns of this type; round ones are infinitely preferable; but perhaps the reader will not be displeased to know that the ancients used them, and in exceptional cases this recourse might serve.

Le Roy's Notes

1. *ROMAE ET AUGUSTO CAESARI DIV. F. PAT. PATR. TRIB. POT.*

2. *Aedibus verò sacris, quorum Deorum maximè in tutela civitas videtur esse, et Jovi et Junoni et Minervae, in excelsissimo loco, unde moenium maxima pars conspiciatur, areae distribuantur. Mercurio autem in foro, aut etiam uti Isidi et Serapi, in emporio: Apollini patrique Libero, secundùm Theatrum: Herculi, in quibus civitatibus non sunt Gymnasia neque Amphitheatra, ad Circum: Marti extra urbem, sed ad campum: itemque Veneri ad portam.* Vitruvius, bk. 1, ch. 7.

"Sacred buildings, and notably the temples of the tutelary deities, such as those of Jupiter, Juno, and Minerva, are to be built at the highest point of the city, from which the greater part of its walls should be visible. That of Mercury must be in the forum, or else in the marketplace, as must those of Isis and Serapis. The temples of Apollo and Bacchus are sited close to the theater; that of Hercules, next to the circus, if the city possesses no gymnasium or amphitheater. Finally, the temples of Mars and the goddess of beauty are to be outside the city: that of Venus close to the gates; that of the war god adjoining the field that is sacred to him." [Vitruvius, *De architectura* 1.7.1.]

3. See these temples as published by Messrs. Dumont [(*Les ruines de Paestum*)] and Major [(*The Ruins of Paestum*)].

4. In my first edition, there were a number of considerable errors among the measurements, which became apparent if they were compared with one another. I have corrected these by reference to my original drawings. The most considerable error was in the diameter of the column, which was insufficiently stout.

5. Since the ambassador, with whom I had the honor of traveling from Venice to Constantinople, allowed us — namely, the marchese Spolverini, a Venetian nobleman by the name of Signor Priuli, and myself — very little time to visit Pola, I was unable to take all the detailed measurements of this temple; and I would be wanting in veracity if I neglected to inform the public that, not wishing to deprive it of the details of this

monument, I have taken most of my measurements from Palladio's work, converting from the Venetian foot to our foot.

6. Vitruvius, bk. 4, ch. 4: *Distribuitur autem longitudo aedis, uti latitudo sit longitudinis dimidiae partis.* "The proportions of the body of a temple are to be such that its width is half of its length." [Vitruvius, *De architectura* 4.4.1.] "It is clear," as Perrault says in his notes on this passage, "that by 'temple' Vitruvius here means only the walls that compose the *cella*, or interior of the temple, and the *pronaos*, or porch." For this very reason, I have translated *aedes* as "the body of the temple"; but it is equally true that the entire chapter in question concerns only this part of the temple. Monsieur Perrault seems to be mistaken when he adds, in the same note, "Square temples were of two kinds. The one had no columns or had only those columns that were enclosed between the walls of the porch; these are the temples of which he speaks here. The other had columns outside." In chapter 4, Vitruvius is not speaking of any particular kind of temple but rather, as the title of the chapter clearly indicates, of the internal arrangement of temples (*De interiore cellarum et pronai distributione*). As he has already announced at the end of chapter 3, *Quoniam exterior species symmetriarum, et Corinthiorum, et Doricorum, et Ionicorum est perscripta, necesse est etiam interiores cellarum pronaique distributiones explicare.*

"Having described the form and external proportions of Corinthian, Doric, and Ionic temples, it is necessary also to explain the internal arrangement of their *cellae* and their porches." [Vitruvius, *De architectura* 4.4.before 1.]

The end of this third chapter, the title of the fourth, and all contained therein appear so precise to me, that I am surprised at Monsieur Perrault for failing to recognize, despite all the indicators, that Vitruvius—having determined in his third book and in the first part of the fourth the external ordonnance of temples and the arrangement of their various columnar porticoes—proceeds in the fourth chapter of the fourth book to determine how the parts of the interiors of those same temples should be ornamented and arranged. I dare maintain that if we read Vitruvius's original text under the assumption that he speaks only of temple interiors and that he takes for granted the presence of columnar porticoes around the parts that he describes—an assumption that would take too long to explain in detail—we shall find him perfectly clear. In contrast, he becomes obscure in the extreme if we suppose, as does Monsieur Perrault, that he has in mind a specific kind of temple built all of a piece, with no columns around it.

7. Part of the plan in plate 24, figure 1, is the plan of the ground floor; the other part shows the upper story of the structure. It may be observed that the small columns of the upper order, which support the pediment, overhang the face of the wall below, through which the gateway is pierced; this is a basic fault. Furthermore, the pilasters of the lower order are surmounted by capitals that look more Gothic than antique, as do those of the pilasters that support the arch. A further defect in this monument is that the archivolt of the arch cuts into the architrave of the order.

It will be seen from the two parts of the entablature of the lower order that break forward, and from the presence of pedestals directly below them, that these were the positions of two detached columns, since destroyed or removed. These projecting entablatures above columns usually make a poor effect in facades. They are out of keeping with the true beauty of antiquity, as we have already observed in discussing the

frontispiece of the enclosure of the Temple of Eileithyia; and they prove that both monuments were built by Hadrian. I have given the inscriptions on the friezes of either face of the structure. There was a marble tablet that filled the intercolumniation beneath the pediment. It will be seen that the corner pilasters of this upper part, beneath which the missing columns formerly stood, are very poorly designed, their faces being inset, and the inset panels being ornamented with an ogee all round; this makes the pilasters meager and more appropriate to a work of joinery than to a structure built in marble.

The pilasters of the triumphal monument of Gaius Philopappos, on the Mouseion at Athens, a view of which I have given, are of the same kind. I feel at liberty to dispense with the details of this structure because they lack any feature of note and are even worse designed than those of the Arch of Theseus or Hadrian. As for the entablatures of both orders of this arch, which I have represented in figures 3 and 4, it will be seen that the architrave and frieze are very weak and the cornice, by contrast, is very strong, and that there are only dentils on this Corinthian monument, as on the small monument commonly known in Athens as the Lantern of Demosthenes, though really it was built in honor of Lysikrates.

8. *In medio tecti ratio ita habeatur, uti quanta diametros totius operis erit futura, dimidia altitudo fiat Tholi praeter florem.* Vit., bk. 4, ch. 7.

Speaking of the circular variety of temple, Vitruvius says, "In the center, the roof must be raised to a height equal to half of the diameter of the whole part of the temple covered by the roof, not including the flower." [Vitruvius, *De architectura* 4.8.3.]

It will be seen from our translation that we understand this to mean that the height of the cupola was only half of the diameter of the entire body of the temple covered by the roof, without including, in the case of the peripteral temple, the columns that encircled it. What leads us to adopt this interpretation is that the temple at Tivoli, which is peripteral, is precisely in this proportion; and that the calotte or cupola that results from this interpretation is very low, as were all those of the ancients. Whereas, if we make the height of the cupola—as the text seems to demand and as Monsieur Perrault and the marchese Galiani have done—half of the width, peristyle included, of the peripteral round temple, the result is a very tall dome and entirely out of keeping with the surviving examples of the round temples of the ancients.

9. I have added the lowest of these cornices, which is small and in as poor taste as the others, from the drawings published in the English work on Athens of which I have often spoken; and I have corrected my own drawings in several minor respects by reference to the same work. [Stuart and Revett, *The Antiquities of Athens*, vol. 1, chap. 3.]

Editorial Notes

a. On San Pietro in Vincoli in Rome, see Gabriele Bartolozzi Casti and Giuliana Zandri, *San Pietro in Vincoli* (Rome: Istituto Nazionale di Studi Romani, 1999).

b. The considerable remains of a great temple, the so-called frontispiece of Nero, stood in the gardens of the Palazzo Colonna until completely destroyed about 1630. The building stood on the edge of the Quirinal, on the west side of the present Via della Consulta. Numerous drawings and plans of these ruins by architects and artists are extant, including those in Sangallo (*Codice Vaticano Barbariniano latino 4424*, 63v, 65r, 65v, 86v), Andrea Palladio's *I quattro libri dell'architettura* (Venice: Dominico de'

Franceschi, 1570), bk. 4, chap. 12, pp. 41–47; and Antoine Babuty Desgodets, *Les édi-
fices antiques de Rome, dessinés et mesurés très exactement* (Paris: Jean Baptiste Coig-
nard, 1682), 147–51.

c. For a modern account, see René Vallois, *Les constructions antiques de Délos*
(Paris: E. de Boccard, 1953); and René Vallois, *L'architecture hellénique et hellénistique
à Délos...*, 2 vols. (Paris: E. de Boccard, 1944–78). See also Philippe Bruneau and Jean
Ducat, *Guide de Délos,* 3d ed. (Paris: École Française d'Athènes, 1983).

d. The capital was published first in Richard Pococke's *A Description of the East
and Some Other Countries* (London: W. Bowyer, 1745), vol. 2, pt. 2, p. 56, pl. 52.
Pococke compared the capital with those he saw at Magnesia ad Maeandrum; the
drawings he used for his plan and three elevations were "procured by the learned and
accurate abbot [Diego] Revillas of Rome."

List of what is contained in the second volume of this work

Works by Le Roy

1756

Prospectus for *Les ruines des plus beaux monumens de la Grece; ou, Recueil de desseins et de vues de ces monumens; avec leur histoire, et des reflexions sur les progrés de l'architecture*. Paris: H. L. Guérin & L. F. Delatour, [before March 1756].
Summarized:
L'année littéraire, April 1756, 22–31.
Journal encyclopédique, April 1756, 54–57.
Mémoires de Trévoux, April 1756, 1133–38.
Journal des sçavans, May 1756, 319–20.

1758

Les ruines des plus beaux monuments de la Grece: Ouvrage divisé en deux parties, où l'on considère, dans la première, ces monuments du côté de l'histoire, et dans la seconde, du côté de l'architecture. Paris: H. L. Guérin & L. F. Delatour, 1758.
Announced:
Journal encyclopédique, October 1758, 142–43.
Reviewed:
Mémoires de Trévoux, October 1758, 2615–48; November 1758, 2773–97; December 1758, 2885–909.
L'année littéraire, November 1758, 100–124.
Mercure de France, November 1758, 192–98.
Bibliothek der schönen Wissenschaften und der freyen Künste 5, pt. 1 (1759): 181–85.
Nova Acta Eruditorum, April 1760, 193–211.
Summarized:
Mercure de France, December 1758, 130–40; January 1759, 128–33; February 1759, 105–11; March 1759, 106–15.
The Royal Magazine; or, Gentleman's Monthly Companion 2 (1760): 364–67; 3 (1760): 95–96, 187–91, 245–48, with 3 plates.
Bibliothek der schönen Wissenschaften und der freyen Künste 10, pt. 1 (1763): 1–8.

1764

Histoire de la disposition et des formes différentes que les chrétiens ont données à leurs temples, depuis le règne de Constantin le Grand, jusqu'à nous. Paris: Desaint & Saillant, 1764.

Announced:

Catalogue hébdomadaire; ou, Liste, 15 September 1764, Livres étrangers, art. 5; 19 January 1765, Livres nationaux, art. 12.

Gazette littéraire de l'Europe, 26 September 1764, 62–64.

Journal oeconomique, January 1765, 8.

Reviewed:

L'année littéraire, September 1764, 104–22.

Mémoires de Trévoux, October 1764, 936–38.

Mercure de France, October 1764, pt. 2, 116–17.

1767

Observations sur les édifices des anciens peuples, précédées de Réflexions préliminaires sur la critique des Ruines de la Grèce, publiée dans un ouvrage anglois, intitulé Les antiquités d'Athènes, et suivies de Recherches sur les mesures anciennes. Amsterdam: n.p., 1767.

Announced:

Catalogue hébdomadaire; ou, Liste, 6 February 1768, Livres étrangers, art. 17.

Mercure de France, March 1768, 108.

Journal oeconomique, January 1769, 23.

Reviewed:

L'année littéraire, January 1768, 193–204.

L'avant coureur, 8 February 1768, 82–84.

Journal encyclopédique, April 1768, 77–88.

Journal des sçavans, Paris ed., June 1768, 435–37; Amsterdam ed., August 1768, 3–10.

1770

Les ruines des plus beaux monuments de la Grece, considérées du côté de l'histoire et du côté de l'architecture. 2d ed. 2 vols. Paris: Imprimerie de Louis-François Delatour, 1770.

Announced:

Catalogue hébdomadaire; ou, Liste, 25 November 1769, Livres nationaux, art. 2.

Journal oeconomique, January 1771, 21.

Reviewed:

L'avant coureur, 11 December 1769, 785–87.

Mercure de France, January 1770, pt. 1, 176–79.

Journal encyclopédique, March 1770, 195–209, 354–67.

1777

"Premier mémoire sur la marine des anciens" (read 23 February 1770). *Histoire de l'Académie royale des inscriptions et belles-lettres; avec les Mémoires de littérature tirez des registres de cette académie 38 (1777): Mémoires, 542–58.*

"Second mémoire: Sur la marine des Grecs" (read 28 August 1770). *Histoire de l'Académie royale des inscriptions et belles-lettres; avec les Mémoires de littérature tirez des registres de cette académie 38 (1777): Mémoires, 559–81.*

"Troisième mémoire: Sur la marine des Egyptiens sous les Ptolémées." *Histoire de l'Académie royale des inscriptions et belles-lettres; avec les Mémoires de littérature tirez des registres de cette académie 38 (1777): Mémoires, 582–97, with 4 plates.*

La marine des anciens peuples, expliquée et considérée par rapport aux lumieres qu'on en peut tirer pour perfectionner la marine moderne; avec des figures représentant les vaisseaux de guerre de ces peuple. Paris: Nyon aîné & Stoupe, 1777.

1783

Les navires des anciens, considérés par rapport à leurs voiles, et à l'usage qu'on en pourroit faire dans notre marine; ouvrage servant de suite à celui qui a pour titre La marines des anciens peuples. Paris: Nyon aîné, 1783.

1785

Recherches sur le vaisseau long des anciens, sur les voiles latines, et sur les moyens de diminuer les dangers qui courent les navigateurs. Paris: Stoupe, 1785.

1786

Nouvelles recherches sur le vaisseau long des anciens, sur les voiles latines, et sur les moyens de diminuer les dangers qui courent les navigateurs; lues à l'Académie des belles-lettres, à la rentrée publique de Pâques, année 1786; servant de suite à l'ouvrage qui a pour titre Les navires des anciens, etc. Paris: n.p., 1786.

1787

Lettre à M. Franklin sur les navires des anciens, sur ceux des modernes et sur les moyens de perfectionner la navigation en general et particulière-ment celles des fleuves, en se rapprochant de la forme des premiers et en faisant usage de leurs voiles. Paris: Nyon, 1787. Read by Dacier, as censor, 6 March 1787.

"Lettre de M. Benjamin Franklin, à M. David Le Roy, membre de plusiers académies: Contenant différentes observations sur la marine; en mer ... au mois d'août 1785" (first part of letter). *Journal de physique, de chimie, d'histoire naturelle et des arts,* September 1787, 224–31. Together with

the next two items, this is a translation by Julien-David Le Roy, along with some observations, of "A Letter from Dr. Benjamin Franklin, to Mr. Alphonsus Le Roy, Member of Several Academies, at Paris: Containing Sundry Maritime Observations; at Sea . . . August 1785" (read 2 December 1785), *Transactions of the American Philosophical Society, held at Philadelphia, for Promoting Useful Knowledge* 2 (1786): 294–329.

"Suite de la lettre de M. Benjamin Franklin à M. David Le Roy, membre de plusiers académies: Contenant différentes observations sur la marine." *Journal de physique, de chimie, d'histoire naturelle et les arts,* October 1787, 254–64.

"Suite de la lettre de M. Benjamin Franklin à M. David Le Roy, membre de plusiers académies: Contenant différentes observations sur la marine." *Journal de physique, de chimie, d'histoire naturelle et les arts,* December 1787, 456–68.

Suite de la lettre adressée par M. David Le Roy à M. Benjamin Franklin sur les moyens de perfectionner la navigation des fleuves. Rouen: Imprimerie de veuve L. Dumesnil, 1787.

1788

"Lettres de M. David Le Roy à M. Franklin, sur la marine, et particulièrement sur les moyens de perfectionner la navigation des fleuves: Première lettre: Sur les navires des anciens, sur ceux des modernes, et sur les moyens de perfectionner la navigation en général, et particulièrement celle des fleuves, en se rapprochant de la forme des premiers, et en faisant usage de leurs voiles." *Journal de physique, de chimie, d'histoire naturelle et des arts,* March 1788, 209–22.

"Seconde lettre de M. David Le Roy, à M. Franklin: Sur la marine et particulièrement sur les moyens de perfectionner la navigation des fleuves." *Journal de physique, de chimie, d'histoire naturelle et des arts,* April 1788, 288–301.

"Troisième lettre de M. David Le Roy, à M. Franklin: Sur la marine et particulièrement sur les moyens de perfectionner la navigation des fleuves." *Journal de physique, de chimie, d'histoire naturelle et les arts,* August 1788, 136–44.

1789

"Observations sur les moyens de prévenir à Paris la disette des grains, adressées au Comité des subsistances de l'Assemblée nationale." *Journal de physique, de chimie, d'histoire naturelle et les arts,* August 1789, 84–95.

Observations sur les moyens de prévenir à Paris la disette des grains, adressées au Comité des subsistances de l'Assemblée nationale, servant de suite à diverses lettres écrites à M. Franklin sur la marine. N.p., n.d. Based on items published in the *Journal de physique, de chimie, d'histoire naturelle et des arts,* 1787–89.

1790

Lettres à M. Franklin, sur la marine, et particulièrement sur la possibilité de rendre Paris port; précédées de recherches sur les moyens d'y prévenir la disette des grains. 2d ed. Paris: L'auteur [&] Barrois, 1790. Based on the items published in the *Journal de physique, de chimie, d'histoire naturelle et des arts*, 1787–89.

"Notice sur Franklin." In Claude Fauchet, *Éloge civique de Benjamin Franklin prononcé le 21 juillet 1790, dans la rotonde, au nom de la Commune de Paris*, 38–50. Paris: J. R. Lottin, 1790.

1791

Bossut, Charles, and Julien-David Le Roy. *Canal de Paris*. Paris: Imprimerie du Canal de Paris, [signed 1 June 1791]. Report on a revised project by Jean-Pierre Brullée for a canal linking the Seine at the Paris Arsenal, via the Hôpital Saint-Louis, to the river at Saint-Denis, signed by Bossut and Le Roy and addressed to the Académie royale des sciences. Extract from the procès-verbal de l'inspection des travaux.

Canaux de la Manche proposés, année 1791, pour ouvrir à l'intérieur de l'empire deux débouchés à la mer et pour employer aussi les hommes désoeuvrés qui le surchargent, ou suite des lettres à M. Franklin sur la marine. Paris: Dupain-Triel, 1791.

1792

Nouvelle voilure proposée pour les vaisseaux de toutes grandeur; écrit servant de suite et de complément à ceux qu'il a publiés sur la marine ancienne et à ses lettres à Franklin sur la marine moderne. Paris: L'auteur, 1792.

1793

Extraits de quelques écrits de David Le Roy, membre de la Commune des arts, professeur d'architecture au museum. Paris: n.p., [after May 1793].

1795

Bossut, Charles, and Julien-David Le Roy. *Examen des projets de canaux de navigation, entre la rivière d'Oise, et la Seine au bastion de l'Arsenal à Paris; fait par ordre du Comité des travaux publics de la Convention nationale*. Paris: Imprimerie de la République, prairial, An III [May/June 1795].

1796

Plume de voyage; ou, Description d'une plume nouvelle, adressée au citoyen Guinguené. N.p.: n.p., [5 nivôse, An V (25 December 1796)].

1797

Nouvion, Julien-David Le Roy, and J.-F. Normand. *Projet du Point-central des arts et métiers pour la restauration de dôme du Panthéon*. Paris: Imprimerie de J.-F. Sobry, [signed 14 prairial, An V (2 June 1797)]. Extract from the procès-verbal de la Société de Point-central des arts et métiers.

1798–1799

Nouvelle voilure proposée pour les vaisseaux de toutes grandeurs, et particulièrement pour ceux qui seroient employés au commerce, précédée d'un écrit sur la marine ancienne. Paris: Jansen, An VII [1798–99].

1800–1801

Canaux de la Manche, indiqué pour ouvrir à Paris deux débouchés à la mer. 2d ed. Paris: [Imprimerie de Stoupe], An IX [1800–1801].
Précis d'une dissertation sur les mesures des anciens. Paris: Stoupe, An IX [1800–1801].
Précis d'une dissertation sur les mesures des anciens: Seconde dissertation sur les mesures des anciens, et dans laquelle on prouve que la carrière d'Olympie n'avoit de longueur qu'un demi-stade. Paris: Imprimerie de Stoupe, An IX [1800–1801].

1801–1802

Mémoire sur le Moeris. Paris: Imprimerie de Stoupe, An X [1801–2].
Des navires employés par les anciens et l'usage qu'on en pourroit faire dans notre marine. Paris: L'auteur, An X [1801–2].

Works Cited by Le Roy

Classical texts, several editions of which were available to Le Roy, are in most cases listed under their modern titles, which are given in Latin for works written in Latin, in English for works written in Greek, with a citation for the edition used by Le Roy when that has been specified or can be guessed or can be inferred from the contents of Camille Falconet's library, a collection of some fifty thousand volumes that Le Roy is known to have used, as cataloged in [Jacques-Marie Barrois, ed.,] *Catalogue de la bibliotheque de feu M. Falconet*, 2 vols. (Paris: Barrois, 1763). All references to classical texts added to the translation of Le Roy's work are to the Loeb editions, where available, save for *De architectura*, for which the editorial references are to *Vitruvius: Ten Books on Architecture*, trans. Ingrid D. Rowland (Cambridge: Cambridge Univ. Press, 1999).

The title of the journal *Histoire de l'Académie royale des inscriptions et belles-lettres; avec les Mémoires de littérature tirez des registres de cette académie* is abbreviated throughout as *HistMemBL*.

Classical and Medieval Sources

Aelian (Claudius Aelianus). *Historical Miscellany*. Le Roy may have used Bouchaud de Bussy, *La milice des Grecs; ou, Tactique d'Élien*, 2 vols. (Paris: C. A. Jombert, 1757). Barrois (nos. 12622–25) lists six editions of this work, the most recent of which was an en face Greek and Latin edition, *Variae historiae*, trans. Justus Vultejus, ed. Abraham Gronovius (Leiden: S. Luchtmans & J. A. Langerak, 1731).

Aristophanes. *The Birds*. Le Roy may have used *Oedipe, tragédie de Sophocle; et Les oiseaux, comédie d'Aristophane*, trans. Jean Boivin (Paris: Jean-Luc Nyon, 1729). Barrois (no. 10730) lists one en face Greek and Latin edition that includes scholia: *Aristophanis comoediae undecim, Graece et Latine, ex codd. mss. emendatae; cum scholiis antiquis...*, ed. Ludolf Kuster (Amsterdam: sumtibus Thomae Fritsch, 1710).

Aristotle. *Nichomachean Ethics*. Barrois (no. 2370) lists a Greek edition of Aristotle's works, *Opera*, ed. Desiderius Erasmus, 2 vols. in 1 (Basil: per Io. Beb. & Mich. Ising., 1550).

Athenaeus of Naucratis. *The Deipnosophists*. Barrois (no. 12349) lists an en face Greek and Latin edition, *Athenaei Deipnosophistarum libri quindecim*, trans. Jacques Dalechamps, ed. Isaac Casaubon, new ed., 2 vols. in 1

(Leiden: sumptibus Ioannis Antonii Huguetan & Marci Antonii Rauaud, 1657–64).

Cassius Dio. *Epitome Romanae historiae Dionis Nicaei* (Roman history). Translated by Guillaume LeBlanc. Edited by Joannes Xiphilinus the Younger. In Friedrich Sylburg, ed., *Romanae Historiae Scriptores Graeci Minores*, 3:137–452. Frankfurt: Andreae Wecheli heredes, Claudium Marnium & Ioann. Aubrium, 1590. This is an en face Greek and Latin edition.

Censorinus. *De die natali* (On the birthday). Edited by Louis Carrion. New ed. Paris: Aegidium Beysium, 1583. This edition is listed in Barrois (no. 12359).

Cicero. *De finibus bonorum et malorum* (On the limits of good and evil).

———. *De natura deorum* (On the nature of the gods).

———. *In Verrem* (Against Verres).

Cornelius Nepos. *De excellentibus ducibus exterarum gentium* (On great generals of foreign nations).

Diodorus Siculus. *Bibliothecae historicae libri qui supersunt* (Library of history). Translated by Lorenz Rhodoman. Edited by Petrus Wesseling. 2 vols. Amsterdam: sumptibus Jacobi Wetstenii, 1746. This en face Greek and Latin edition, for which Le Roy gives the publication date as 1747, is listed in Barrois (no. 14440).

Diogenes Laertius. *Lives of Eminent Philosophers*.

Etymologicum magnum; seu, Magnum grammaticae penu.... Heidelberg: Typographeio Hieronymi Commelini, 1594. Originally compiled between 1100 and 1250; editorship has been attributed to Markos Mousouros, who wrote the preface to the first printed edition (Venice, 1499), and to Zacharias Kallierges, its printer.

Eusebius of Caesarea. *Preparation for the Gospel*. Editions of this work — which preserves all that we have of Sanchuniathon's history, written prior to the Trojan War — were published from 1470 on; in Le Roy's time, the most recent publication was *Sanchoniatho's Phoenician History Translated from the First Book of Eusebius De Praeparatione Evangelica...*, trans. Richard Cumberland (London: printed by W. B., for R. Wilkin, 1720). Barrois (no. 640) lists *Evangelicae praeparationis lib. XV* (Paris: Rob. Stephani, 1544), in which the text is in Greek.

Eustathius. *Commentary on Homer's Iliad*. Barrois (no. 10610) lists *In Homeri Iliadis et Odysseae libros parekbolai*, ed. Nicolaus Majoranus, 3 vols. (Basil: [Hieronymus Froben], 1560), in which the text and the commentary are in Greek.

Harpocration, Valerius. *Harpocrationis Lexicon decem oratorum* (Lexicon of the ten orators). Translated by Nicolas Blancard. Commentary by Philippe Jacques de Maussac. Edited by Henri de Valois. Leiden: J. A. Gelder incepit, J. A. de la Font perfecit, 1683. This en face Greek and Latin edition is listed in Barrois (no. 9581).

Herodes Atticus (Tiberius Claudius Atticus Herodes). Of his writings only a

Latin translation of a *fabula* survives, but he is the centerpiece of
Philostratus's *Lives of the Sophists*.

Herodotus. *Herodoti Halicarnassei Historiarum libri IX*... (History).
Translated by Lorenzo Valla. Edited by Henri Estienne and Friedrich
Sylburg. Geneva: Oliva Pauli Stephani, 1618. This is an en face Greek and
Latin edition that seems to appear in Barrois (no. 14420).

Heron of Alexandria. *Geometrica*.

Hesychius of Alexandria. *Alphabetical Collection of All Words*. Barrois
(nos. 9585, 9586) lists both the editions of this work published in Leiden,
that is, Lugduni Batavorum or "Lug." as Le Roy notes without specifying
an editor or a publication date: *Hesychiou lexikon, cum variis doctorum
virorum notis*..., ed. Cornelis Schrevel (Leiden and Rotterdam: ex
officina Hackiana, 1688); and *Hesychii Lexicon, cum notis doctorum
virorum integris*..., ed. Johannes Alberti and David Ruhnkenius, 2 vols.
(Leiden: Samuelem Luchtmans & Filium, 1746–66).

Hierocles. All that remains of his writings are the three chapters from a work
on veterinary medicine (*Hippiatrics*, to use Le Roy's title) preserved in
book 16 of *Geoponica*, compiled in the tenth century by Cassianus
Bassus.

Homer. *Iliad*. Barrois (no. 10625) lists *L'Iliade d'Homere,* trans. Anne
Dacier, 3 vols. (Paris: Rigaud, 1711), but the revised editions of this
prose translation certainly would have been available to Le Roy as well.

Horace. *Ars poetica* (Art of poetry). Barrois (no. 12478) lists *Ars poetica
Horatii*..., ed. János Zsámboki (Ioannes Sambucus) (Antwerp: ex
officina Christophori Plantini, 1564).

———. *Carmina* (Odes).

Isokrates. *Panegyricus*. Barrois (no. 10253) lists an en face Greek and Latin
edition, *Panegyrica oratio: Helenae laudatio et Busiridis item laudatio;
tres ex orationibus Isocratis selectissimae,* trans. Hieronymus Wolf (Paris:
F. Pelicanum, 1633).

Livy. *Ab urbe condita* (From the foundation of the city).

Martial. *Epigrammata* (Epigrams).

Menander of Laodicea (Menander Rhetor). *Menandri Rhetoris Divisio
causarum in genere demonstrativo* (Division of causes in demonstrative
classes). In Aldo Manuzio, ed., *Rhetores in hoc volumine habentur hi* ...
[*Rhetores graeci*], 1:594–641. Venice: in aedibus Aldi, 1508. Barrois (no.
10185) lists *De genere demonstratiuo libri duo* (Venice: Petrum Bosellum,
1558), but Le Roy references *Rhetores graeci,* which likewise appears in
Barrois (no. 10187).

Ovid. *Ars amatoria* (Art of love).

Pausanias. *Description of Greece*. Le Roy cites three editions: *Pausaniae
accurata Graeciae descriptio,* trans. Romolo Quirino Amaseo, ed. Wilhelm
Xylander and Friedrich Sylburg (Hannover: Typis Wechelianis, apud
haeredes Claudii Marnii, 1613); *Pausaniae Graeciae descriptio accurata,*
trans. Romolo Quirino Amaseo, ed. Wilhelm Xylander, Friedrich Sylburg,

and Joachim Kühn (Leipzig: Thomam Fritch, 1696); and *Pausanias; ou, Voyage historique de la Grece*, trans. and ed. Nicolas Gedoyn, 2 vols. (Paris: F. G. Quillau, 1731). The first two are en face Greek and Latin editions; only the second is listed in Barrois (no. 14410).

Philo of Alexandria (Philo Judaeus). *On the Creation.*

Philostratus the Athenian. *Lives of the Sophists.*

Pindar. *Odes.*

Plato. *Timaeus.*

Pliny the Elder. *Naturalis historia* (Natural history).

Pliny the Younger. *Epistulae* (Letters).

Plutarch. *Lives.* Le Roy cites three different translations, two of which would have have been available in various editions. Barrois (no. 19309) lists one edition of Jacques Amyot's translation, *Les vies des hommes illustres grecs et romains, comparées l'une avec l'autre*, 2d ed., 2 vols. (Paris: Michel de Vascosan, 1565). The most recent version of André Dacier's translation available to Le Roy was *Les vies des hommes illustres de Plutarque*, new ed., 10 vols. (Amsterdam: Zacharie Chatelain, 1735). The other edition that Le Roy references is *Plutarchi Chaeronensis Omnium quae exstant operum: Tomus primus, continens Vitas parallelas...*, trans. Hermannus Cruserius and Wilhelm Xylander, and Philippe Jacques de Maussac, 2 vols. (Paris: Typis Regiis, apud Societatem Graecarum Editionum, 1624); this last is an en face Greek and Latin edition that is listed in Barrois (no. 19307).

Polybius. *Polybii Lycortae F. Megalopolitani Historiarum libri qui supersunt* (Histories). Translated and edited by Isaac Casaubon. Paris: Hieronymum Drovardum, 1609. This en face Greek and Latin edition is listed in Barrois (no. 14561).

Pomponius Mela. *De chorographia* (On geography).

Ptolemy. *Geography.* Barrois (no. 13473) lists the first edition of the Greek text, *De geographia libri octo* (Basil: [Hieronymus Frobenius & Nicolaus Episcopius], 1533).

Sanchuniathon. *Phoenician History. See* Eusebius of Caesarea.

Strabo. *Strabonis Rerum geographicarum libri XVI* (Geography). Translated by Isaac Casaubon. Edited by Theodoor Jansson van Almeloveen. 2 vols. in 1. Amsterdam: Joannem Wolters, 1707. This is an en face Greek and Latin edition.

Suidas. Barrois (no. 9589) lists one Greek and Latin edition: *Suidae lexicon, graece et latine*, trans. Ludolf Kuster, ed. Aemilius Portus (Cambridge: Typis Academicis, 1705).

Thucydides. *History of the Peloponnesian War.* Barrois (no. 14424) lists one edition of Valla's translation, which first appeared in 1452: *Thucydidis De bello Peloponnesiaco libri VIII*, trans. Lorenzo Valla, ed. Henri Estienne, 2d ed. ([Geneva]: Henricus Stephanus, 1588). This is an en face Greek and Latin edition.

Varro. *Rerum rusticarum* (On agriculture).

Virgil. *Aeneid.*

———. *Eclogues.*

———. *Georgics.*

Vitruvius. *De architectura* (On architecture). Le Roy cites four editions, counting both editions of Perrault's translation: *M. Vitruuii Pollionis De architectura libri decem; cum notis, castigationibus et observationibus Guilielmi Philandri integris; Danielis Barbari excerptis, et Clavdii Salmasii passim insertis...*, ed. Joannes de Laet (Amsterdam: Ludovicum Elzevirum, 1649); *Les dix livres d'architecture de Vitruve*, trans. Claude Perrault (Paris: J.-B. Coignard, 1673; 2d ed., Paris: J.-B. Coignard, 1684); and *L'architettura di M. Vitruvio Pollione*, trans. Berardo Galiani (Naples: Stamperia Simoniana, 1758). The first—which is listed in Barrois (no. 9152), as is the second edition of Perrault's translation (no. 9153)— includes the commentary of Guillaume Philandrier, first published in 1552, and of Daniel Barbaro, among others; the last is an en face Latin and Italian edition.

Xenophon. *Xenophontis et imperatoris et philosophi clarissimi omnia, quae extant, opera.* Translated by Johannes Leunclavius. 2d ed. Basel: per Thomam Guarinum, 1572. This is an en face Greek and Latin edition. Le Roy cites from *Ways and Means.*

Later Sources

Anselme, Antoine. "Réflexions sur l'opinion des sages du paganisme, touchant la félicité de l'homme" (read 25 May 1723). *HistMemBL* 5 (1729): *Mémoires*, 1–14, esp. 4–5, recording Aristotle's remarks on an inscription on Delos.

Anville, Jean-Baptiste Bourguignon d'. *Eclaircissemens géographiques sur l'ancienne Gaule, precedés d'un traité des mesures itinéraires des romains, et de la lieue gauloise.* Paris: la veuve Estienne, 1741.

———. *Traité des mesures itinéraires anciennes et modernes.* Paris: Imprimerie Royale, 1769.

Baldi, Bernardino. *De Verborum Vitruvianorum Significatione; sive, Perpetuus in M. Vitruvium Pollionem Commentarius.* Augsburg: ad insigne pinus, 1612. Reprinted in Vitruvius, *M. Vitruuii Pollionis De architectura libri decem...*, ed. Joannes de Laet (Amsterdam: Ludovicum Elzevirum, 1649).

Barthélemy, Jean-Jacques. "Mémoire sur les anciens monuments de Rome" (read 15 November 1757). *HistMemBL* 28 (1761): *Mémoires*, 579–610, esp. 607–10, his discussion on the antique foot.

Bayardi, Ottavio Antonio, ed. *Le antichità de Ercolano.* Naples: Regia Stamperia, 1757.

Belley, Augustin. "Explication d'une inscription antique sur le rétablissement de l'odeum d'Athènes, par un roi de Cappadoce." *HistMemBL* 23 (1756): *Histoire*, 189–200.

Blanchard, Elie. "Sur l'origine et les fonctions des prytanes et sur les

prytanées" (read 1729). *HistMemBL* 7 (1733): *Histoire*, 57–67.

Blondel, François. *Cours d'architecture enseigné dans l'Académie royale d'architecture.* 5 pts. in 2 vols. Paris: Lambert Roulland [etc.], 1675–83.

Boindin, Nicolas. "Discours sur la forme et la construction du théatre des anciens, où l'on examine la situation, les proportions, et les usages de toutes ses parties." *HistMemBL* 1 (1736): *Mémoires*, 136–53.

Boscovich, Ruggiero Giuseppe. "D'una antica villa scoperta sul dosso del Tuscolo: D'un antico orlogio a sole, e di alcune altre rarità, che ci sono tra le rovine della medesima ritrovate; Luogo di Vitruvia illustrato." *Giornale de' letterati* (Rome: Fratelli Pagliarini) (1746): 115–34, with plate. Luigi Vanvitelli was in charge of both the renovation of the villa, known as Rufinella and located east of Rome, near Frascati, and the concomitant excavations, in consultation with not only Boscovich but also the marchese Giovanni Poleni and the Jesuits Archangelo Contuccio de Contucci and Niccolò Galeotti.

Boze, Claude Gros de. "Description d'un tombeau de marbre antique" (read 13 November 1716). *HistMemBL* 4 (1746): *Mémoires*, 648–64.

Bruzen de La Martinière, Antoine Augustin. *Le grand dictionnaire géographique et critique.* 9 vols. in 10. The Hague: P. Gosse [etc.], 1726–39. This edition is listed in Barrois (no. 13586), though several other editions, including two enlarged editions (Dijon: Arnauld-Jean-Baptiste Auge, 1739–41; Paris: Libraires Associés, 1768) and an abridged version (Paris: Le Mercier, 1759) would have been available to Le Roy as well.

Buonanni, Filippo. *Numismata Summorum Pontificum Templi Vaticani Fabricam Indicantia, Chronologica Ejusdem Fabricae Narratione, ac Multiplici Eruditione.* Rome: Felicis Caesaretti & Paribeni, 1696.

Burette, Pierre-Jean. "Addition à la dissertation sur la mélopée" (read 2 September 1721). *HistMemBL* 5 (1729): *Mémoires*, 200–206.

———. "Dissertation, où l'on fait voir que les merveilleux effets attribués à la musique des anciens, ne prouvent point qu'elle fût aussi parfaite que la nôtre" (read 28 July 1718). *HistMemBL* 5 (1729): *Mémoires*, 133–51.

———. "Dissertation sur la mélopée de l'ancienne musique" (read 12 November 1720). *HistMemBL* 5 (1729): *Mémoires*, 160–99.

———. "Dissertation sur le rhythme de l'ancienne musique" (read 22 August 1719). *HistMemBL* 5 (1729): *Mémoires*, 152–68.

———. "Mémoire pour servir à l'histoire de la course des anciens" (read 7 July 1713). *HistMemBL* 3 (1746): *Mémoires*, 280–318.

Canaye, Etienne de. "Recherches sur Anaximandre" (read 22 April 1732). *HistMemBL* 10 (1736): *Mémoires*, 21–35, esp. 26–27, on sundials.

Cassini, Jacques. *Traité de la grandeur et de la figure de la terre.* Amsterdam: Pierre de Coup, 1723.

Caylus, Anne-Claude-Philippe de Tubières, comte de. *Recueil d'antiquités égyptiennes, étrusques, grecques et romaines.* 7 vols. Vols. 1, 3: Paris: Desaint & Saillant, 1752, 1759; vol. 2: Paris: Duchesne, 1756; vols. 4–7:

Paris: N. M. Tilliard, 1761–67. Vols. 3–7 have the title *Recueil d'antiqui-tés égyptiennes, étrusques, grecques, romaines et gauloises.*

Chambers, William. *Designs of Chinese Buildings, Furniture, Dresses, Machines, and Utensils ... to which Is Annexed a Description of Their Temples, Houses, Gardens, etc.* London: published for the author, 1757. Simultaneously published in French as *Desseins des édifices, meubles, habits, machines, et ustenciles des Chinois ... auxquels est ajoutée une description de leurs temples, de leurs maisons, de leurs jardins, etc.* (London: J. Haberkorn, 1757).

Dale, Antonius van. *Dissertationes IX, Antiquitatibus Quin et Marmoribus.* Amsterdam: Salomonem Schouten, 1743. Le Roy gives the publication date as 1753.

Desgodets, Antoine Babuty. *Les édifices antiques de Rome, dessinés et mesurés très exactement.* Paris: Jean Baptiste Coignard, 1682.

Dufresnoy, Charles-Alphonse. *L'art de peinture.* Translated and annotated by Roger de Piles. Paris: Nicolas l'Anglois, 1668. Includes Latin original, *De arte graphica liber,* and an en face French translation.

[Dumont, Gabriel-Pierre-Martin.] *Les ruines de Paestum, autrement Posidonia ... : Ouvrage contenant l'histoire ancienne et moderne de cette ville; la description et les vues de ses antiquités; ses inscriptions, etc.* [Translated by Jacques de Varenne.] London: n.p., 1769. This includes a free translation of the text of a book originally published in English in London in 1767 and attributed to John Berkenhout or, more recently, John Longfield; as well as eighteen plates after designs by Gabriel-Pierre-Martin Dumont, whose last name is appended to the prefatory letter dedicating the volume to the marquis de Marigny.

Fanelli, Francesco. *Atene Attica, descritta da suoi principii fino all'acquisto fatto dell'armi veneti nel 1687.* Venice: Antonio Bortoli, 1707.

Fourmont, Michel. "Relation abrégée du voyage littéraire que M. l'abbé Fourmont a fait dans le Levant par ordre du roy, dans les années 1729 et 1730." *HistMemBL* 7 (1733): *Histoire,* 344–58.

———. "Remarques sur trois inscriptions trouvée dans la Grece" (read 15 November 1740). *HistMemBL* 15 (1743): *Mémoires,* 395–419.

Fréret, Nicolas. "Essai sur les mesures longues des anciens" (read 1723). *HistMemBL* 24 (1756): *Mémoires,* 432–547.

———. "Observations sur le rapport des mesures grecques et des mesures romaines." *HistMemBL* 24 (1756): *Mémoires,* 548–68.

———. "Réflexions sur l'étude des anciennes histoires, et sur le dégré de certitude de leurs preuves" (read 17 March 1724). *HistMemBL* 6 (1729): *Mémoires,* 146–89, esp. 161, on Homer.

Gedoyn, Nicolas. "Recherches sur les courses de chevaux et les courses de chars aux jeux olympiques" (read 19 February 1732). *HistMemBL* 9 (1736): *Mémoires,* 360–75.

Gibert, Joseph-Balthasar. "Observations sur les mesures anciennes" (read 20 August 1756). *HistMemBL* 28 (1761): *Mémoires,* 212–24.

Greaves, John. *Pyramidographia; or, A Description of the Pyramids in Aegypt.* London: printed for George Badger, 1646. At least four editions were issued between 1704 and 1744. Translated as *Description des pyramides d'Egypte,* in Melchisédec Thévenot, ed., *Relations de divers voyages curieux, qui n'ont point esté publiées, ou qui ont esté traduites...* (Paris: G. Meturas, 1663), a collection that is listed in Barrois (no. 17731); but Le Roy refers to Greaves's work by its English title.

Gruterus, Janus, ed. *Inscriptiones Antiquae Totius Orbis Romani.* Heidelberg: ex officina Commeliniana, 1602. Barrois (nos. 18185, 18186) lists two editions of this work: *Inscriptionum Romanarum Corpus Absolutissimum* (Heidelberg: in bibliopolio Commeliniano, 1616); and *Inscriptiones Antiquae Totius Orbis Romani,* 2 vols. (Amsterdam: excudit Franciscus Halma, 1707).

Guignes, Joseph de. "Mémoire dans lequel après avoir examiné l'origine des lettres phéniciennes, hébraïques, etc., on essaye d'établir que le caractère épistolique, hiéroglyphique et symbolique des egyptiens se retrouve dans les caractères des chinois et que la nation chinoise est une colonie egyptienne" (read 18 April 1758). *HistMemBL* 29 (1764): *Mémoires,* 1–26.

———. *Mémoire dans lequel on prouve, que les chinois sont une colonie égyptienne, lû dans l'assembée publique de l'Académie royale des inscriptions et belles-lettres, le 14. novembre 1758; avec un précis du mémoire de M. l'abbé Barthelemy, sur les lettres phéniciennes, lû ... le 12. avril 1758.* Paris: Desaint & Saillant, 1759.

Histoire universelle: Traduite de l'anglois d'une société de gens de lettres contenant l'histoire moderne de tous le empires, royaumes, etats, republiques, etc. Amsterdam: Arkstée & Merkus, 1762.

Jouard de la Nauze, Louis. "Mémoire sur la différence des pélasges et des hellenes" (read 19 August 1751). *HistMemBL* 23 (1774): *Mémoires,* 115–28.

Labacco, Antonio. *Libro d'Antonio Labacco, appartenente à l'architettura, nel qual si figurano alcune notabili antiquità di Roma.* Venice: Girolamo Porro, 1576.

La Barre, Louis-François-Joseph de. "Dissertation sur les places destinées aux jeux publics dans la Grece, et sur les courses qu'on faisoit dans ces places" (read 2 May 1732). *HistMemBL* 9 (1736): *Mémoires,* 376–96.

———. "Essai sur les mesures géographiques des anciens: Avant propos." *HistMemBL* 19 (1753): *Mémoires,* 512–14.

———. "Premier mémoire: Sur le stade des grecs, où l'on établit qu'ils ont employé deux stades différens." *HistMemBL* 19 (1753): *Mémoires,* 514–32.

———. "Quatrième mémoire: De l'usage du grand stade chez les grecs." *HistMemBL* 19 (1753): *Mémoires,* 562–76.

———. "Second mémoire: De l'usage que les grecs ont fait du petit stade." *HistMemBL* 19 (1753): *Mémoires,* 533–46.

———. "Troisième mémoire: Du schène des égyptiens et du parasange des Sertes." *HistMemBL* 19 (1753): *Mémoires,* 547–62.

La Guilletière (Georges Guillet de Saint-Georges). *Athenes ancienne et nouvelle, et l'estat present de l'empire des Turcs*. Paris: Estienne Michallet, 1675.

Lalande, Joseph Jérôme Le François de. *Voyage d'un françois en Italie, fait dans les années 1765 et 1766*. 8 vols. Venice and Paris: Desaint, 1769.

Maffei, Scipione. "Epistola VII" (letter to Nicola Garelli, 4 December 1732). In idem, *Galliae Antiquitates Quaedam Selectae atque in Plures Epistolas Distributae*, 31–37. Paris: Caroli Osmont, 1733.

Major, Thomas. *The Ruins of Paestum, Otherwise Posidonia, in Magna Graecia*. London: T. Major, 1768. Simultaneously published in French as *Les ruines de Paestum, ou de Posidonie, dans la Grande Grèce*, [trans. Jacques de Varenne] (London: T. Major, 1768).

Marmontel, Jean-François. *Poétique françoise*. 2 vols. Paris: Lesclapart, 1763.

Meursius, Joannes (Johannes van Meurs). *Athenae Atticae, sive, De Praecipuis Athenarum Antiquitatibus Libri III*. Leiden: Commelines fratres, 1624. Listed in Barrois (no. 14474).

———. *Cecropia; sive, De Athenarum Arce, et Ejusdem Antiquitatibus Liber Singularis*. Leiden: Elzeviriana, 1622. Listed in Barrois (no. 14468), though Le Roy may be citing from Meursius's *Opera Omnia*, in which *Cecropia* appears in vol. 1, cols. 401–58.

———. *De Regno Laconico Libri II: De Piraeeo Liber Singularis; et in Helladii Chrestomathiam Animadversiones*. Utrecht: Guiljelmum vande Water, 1687. Listed in Barrois (no. 14477), though Le Roy may be citing from Meursius's *Opera Omnia*, in which *Piraeeus, sive, De Celeberrimo illo Athenarum Portu, et Antiquitatibus Eius* appears in vol. 1, cols. 541–76.

———. *Ioannis Meursi Opera Omnia in Plures Tomos Distributa*. Edited by Giovanni Lami. 12 vols. in 8. Florence: Tartinium & Franchium [etc.], 1741–63.

Montesquieu, Charles-Louis de Secondat, baron de. *Essai sur le goût*. In Denis Diderot and Jean Le Rond d'Alembert, eds., *Encyclopédie; ou, Dictionnaire raisonné des sciences, des arts et des métiers...par une société de gens de lettres*, 7:766–70. Paris: Briasson, 1757. Also published in Montesquieu's *Considérations sur les causes de la grandeur des romains, et de leur décadence; nouvelle édition, à laquelle on à joint... l'Essai sur le goût, fragment* (Amsterdam: Arkstee & Merkus, 1759).

Montfaucon, Bernard de. *L'antiquité expliquée et représentée en figures*. 5 vols. in 10. Paris: Florentin Delaulne [etc.], 1719.

———. *Supplement au livre de L'antiquité expliquée et représentée en figures*. 5 vols. Paris: la veuve Delaulne [etc.], 1724.

Norden, Frederik Ludvig. *Voyage d'Égypte et de Nubie*. Translated by J. B. des Roches de Parthenay. Edited by the Kongelike Danske Videnskabers Selskab. 2 vols. Copenhagen: Imprimerie de la Maison Royale des Orphelins, 1755. Includes "Remarques sur la pyramidographie de Mr. John Greaves," pp. [90]–101.

Oudinet, Marc. "Reflexions sur les médailles d'Athènes" (read circa 1705). *HistMemBL* 1 (1736): *Histoire*, 219–27, esp. 221, on Hadrian's contribution.

Palladio, Andrea. "Dei disegni di alcuni tempii, che sono fuori d'Italia, e prima de' due tempii di Pola." In idem, *I quattro libri dell'architettura*, 4:105–8. Venice: Dominico de' Franceschi, 1570.

Philandrier, Guillaume. *See* Vitruvius.

Pococke, Richard. *A Description of the East and Some Other Countries.* 2 vols. London: W. Bowyer, 1743–45.

Rameau, Jean-Philippe. Le Roy could have read any number of Rameau's publications, from articles (such as "Source où, vraisemblablement, on a dû puiser la premiere idée des proportions, aussi bien que du nombre des termes dont elles sont composées, par conséquent des progressions qui en sont une suite, et surtout du plus ou moins de perfection dans les différens rapports," *Mercure de France*, April 1761, pt. 2, 129–33) to longer works, of which the following four appear in Barrois (nos. 8828–31): *Generation harmonique; ou, Traité de musique theorique et pratique* (Paris: Prault fils, 1737); *Démonstration du principe de l'harmonie...* (Paris: Durand, 1750); *Observations sur notre instinct pour la musique, et sur son principe...* (Paris: Prault fils, 1754); and *Code de musique pratique... avec de nouvelles réflexions sur le principe sonore* (Paris: Imprimerie Royale, 1760).

Revillas, Diego. "Dissertazione IV: Sopra l'antico piede romano, e sopra alcuni stromenti scolpiti in antico marmo sepolcrale." In *Saggi di dissertazioni accademiche pubblicamente lette nella nobile Accademia etrusca dell'antichissima città di Cortona*, 3:111–39. Rome: Tommaso & Niccolò Pagliarini, 1741.

Riccioli, Giovanni Battista. *Astronomiae Reformatae Tomi Duo: Quorum Prior Observationes, Hypotheses, et Fundamenta Tabularum... et Ipsas Tabulas Astronomicas CII Continet.* 2 vols. in 1. Bologna: haeredis Vittorio Benazzi, 1665.

Sallier, Claude. "Discours sur la perspective de l'ancienne peinture ou sculpture" (read 6 April 1728). *HistMemBL* 8 (1733): *Mémoires*, 97–107.

———. "Histoire de l'isle de Délos" (read 20 April 1717). *HistMemBL* 3 (1746): *Mémoires*, 376–91.

Serlio, Sebastiano. *Il terzo libro: Nel qual si figurano, e descrivono le antiquita di Roma, e le altre che sono in Italia e fuori d'Italia....* Venice: Francesco Marcolino da Forli, 1540. Translated into French as *Des antiquites, le troisiesme livre translaté d'italien en franchois* (Antwerp: Imprime pour Pierre Coeck d'Alost, par Gil. van Diest, 1550).

Sévin, François. "Recherches sur la vie et les ouvrages de Phylarque" (read 29 November 1726). *HistMemBL* 8 (1733): *Mémoires*, 118–26. This is one of the sources for Le Roy's references to Athenaeus of Naucratis and *Suidas*.

Spon, Jacob. *Réponse a la critique publiée par M. Guillet sur le Voyage de Grece de Jacob Spon; avec quatre lettres sur le mesme sujet, le Journal d'Angleterre du sieur Vernon, et la liste des erreurs commises par M. Guillet dans son Athenes ancienne et nouvelle.* Lyon: Thomas Amaulri, 1679.

———. *Voyage d'Italie, de Dalmatie, de Grece, et du Levant, fait és années 1675 et 1676.* 3 vols. Lyon: Antoine Cellier le fils, 1678.

Stuart, James, and Nicholas Revett. *The Antiquities of Athens.* Vol. 1. London: printed by John Haberkorn, 1762.

Tournefort, Joseph Pitton de. *Relation d'un voyage du Levant, fait par ordre du roy; contenant l'histoire ancienne et moderne de plusieurs isles de l'archipel, de Constantinople....* 3 vols. Lyon: Anisson & Posuel, 1717. Under "Pitton de Tournefort," Barrois (no. 17716) lists the two-volume edition published in Paris by the Imprimerie Royale in 1717.

Van Dale. *See* Dale, Antonius van.

Vatry, René. "Dissertation, où l'on traite des avantages que la tragédie ancienne retiroit de ses choeurs" (read 16 July 1728). *HistMemBL* 8 (1733): *Mémoires,* 199–210.

Vernon, Francis. "Mr. Francis Vernons Letter, Written to the Publisher Januar. 10th. 1675/6 Giving a Short Account of Some of His Observations in His Travels from Venice through Istria, Dalmatia, Greece, and the Archipelago, to Smyrna, Where This Letter Was Written." *Philosophical Transactions* 11, no. 124 (1676): 575–82.

Wheler, George. *A Journey into Greece.* London: William Cademan, 1682.

Wood, Robert, and James Dawkins. *The Ruins of Balbec, Otherwise Heliopolis, in Coelosyria.* London: n.p., 1757. Simultaneously published in French as *Les ruines de Balbec, autrement dite Heliopolis, dans la Coelosyrie* (London: n.p., 1757).

———. *The Ruins of Palmyra, Otherwise Tedmor, in the Desart.* London: n.p., 1753. Simultaneously published in French as *Les ruines de Palmyre, autrement dite Tedmor, au désert.* London: A. Millar, 1753.

Zatta, Antonio. *L'augusta ducale basilica dell'evangelista San Marco nell'inclita dominante di Venezia colle notizie.* Venice: Antonio Zatta, 1761.

[1]

LES RUINES
DES PLUS BEAUX MONUMENS
DE LA GRECE;
O U
RECUEIL DE DESSEINS ET DE VUES
DE CES MONUMENS;
AVEC LEUR HISTOIRE, ET DES REFLEXIONS
SUR LES PROGRÈS DE L'ARCHITECTURE.

Par M. LE ROY, Architecte, ancien Pensionnaire du Roi
à Rome, & de l'Institut de Bologne.

ON ne peut se former une idée précise de l'état des Monumens de la
Grece, qui subsistent encore, ni sur les Écrits des Anciens, ni sur ceux des
Modernes. Une grande partie des Edifices dont Pausanias nous a donné des
descriptions si magnifiques, sont détruits; & Spon, Wheeler, Fanelly & la
Guilletiere ne nous donnent qu'une idée très-imparfaite de ceux qui ont échappé
au temps & à la barbarie. Cependant, malgré les ravages que la Grece a
essuyés, on reconnoît encore qu'elle a été le centre du goût & des beaux Arts.
C'est en effet ce qu'annoncent les magnifiques ruines, qui la couvrent de toutes
parts, & plusieurs monumens entiers ou peu altérés, qui excitent l'admiration,
par leur grandeur, par l'élégance de leurs proportions, & par la beauté des
marbres dont ils sont construits. On remarque en général dans l'Architecture
de ces Edifices, un caractere plus mâle, plus de variété, &, si l'on peut se
servir de ce terme, plus d'esprit que dans les Monumens Romains. On y
découvre la source de toutes les perfections que nous connoissons dans les Ordres,
& on y apperçoit des beautés, dont on ne trouve aucunes traces dans les Auteurs
anciens ou modernes, ni dans les Monumens antiques de l'Italie. Enfin on y
voit, pour ainsi dire, l'Architecture naître, s'élever, toucher à la perfection,
& laisser ainsi que la Sculpture, des chefs-d'œuvres auxquels les Romains n'ont
pu atteindre, & qui feront à jamais l'admiration de la postérité.

CE tableau ne présente qu'une foible esquisse des Monumens que l'on trouve
encore dans la Grece, & qui font le sujet de cet Ouvrage. Pour y répandre
plus de clarté, & le traiter avec plus de précision, on le divisera en deux
parties. Dans la première, on envisagera les Monumens principalement du côté

historique ; dans la seconde ; on les considérera du côté de l'Architecture, c'est-à-dire, par rapport à leurs proportions, leurs mesures, &c. On se procurera par cette division deux avantages : les détails d'Architecture étant séparés de la partie historique, celle-ci deviendra moins languissante ; & ces détails rapprochés les uns des autres dans la seconde partie, & comme réunis sous un seul point de vuë, rendront les comparaisons plus faciles à faire.

PREMIERE PARTIE.

On donnera dans cette partie le plan de Sparte & de la plaine qui l'environne; lequel comprendra la nouvelle ville de Misitra, une partie du fleuve Eurotas, les ruisseaux de Gnacion & de Babyca, & dans lequel seront marquées les positions des anciennes villes d'Amyclée & de Therapnée. Le plan d'Athènes & de toute la plaine, qui s'étend depuis les montagnes de Corydalies & de Pentilicus jusqu'à la mer, entrera de même dans cette partie, ainsi que le plan particulier de sa Citadelle, & une carte des ports de Pirée, de Phalere, de Munychie, & du fameux détroit de Salamines.

On rapportera les extraits des Ouvrages de Pausanias, qui ont servi de guide dans la construction de ces plans & de cette carte ; par-là le lecteur pourra suivre avec plus de facilité les recherches que l'on a faites, & admettre ou rejetter les conjectures de l'Auteur, selon qu'elles lui paroîtront bien ou mal fondées.

Cette partie contiendra de plus les Vuës des Monumens qui subsistent encore en différens lieux de la Grece, leur histoire, leurs inscriptions, les passages des Auteurs anciens qui y ont rapport, & des remarques sur la situation de quelques Villes anciennes de ce pays, sur son état actuel, & sur la maniere d'y voyager.

On n'oubliera pas de relever les erreurs dans lesquelles sont tombés les Voyageurs modernes déja cités ; on fera voir à quel point la Guilletiere s'est trompé sur la situation de Sparte; Spon, Wheeler & Fanelly * sur la dénomination & les particularités de quelques Monumens d'Athènes fort célebres : erreurs, au reste, bien pardonnables à ces derniers, qui, plus versés dans les Sciences que dans les beaux Arts, n'avoient pas fait une étude profonde de l'Architecture.

On ne décidera pas des avantages que cette partie peut avoir pour l'Histoire; c'est aux gens de Lettres & aux Savans qu'il appartient d'en juger. Mais on se flatte au moins, qu'elle pourra les intéresser par le plaisir de retrouver encore dans les deux plus fameuses Villes de la Grece (Athènes & Sparte) ces Places, ces Théatres, ces Portiques, si illustrés par les Orateurs, les Poëtes & les Philosophes.

SECONDE PARTIE.

On rassemblera dans cette partie les plans géométraux, les façades & les profils des édifices avec toutes leurs mesures. On ne les détaillera pas également, parce qu'il semble qu'il n'y a que deux raisons, qui puissent rendre les détails nécessaires ; la premiere, qu'ils soient assez beaux pour être imités par les Artistes ; la seconde, qu'ils puissent servir à l'histoire de l'Art. Les membres d'Architecture qui auront rapport aux deux objets de curiosité ou d'utilité dont on vient de parler, seront développés fort en grand, les autres ne le seront pas avec la même étendue.

* La Guilletiere a publié une Description de Sparte, où il étoit en 1669 ; Wheeler Anglois & Spon Antiquaire & Médecin de Lyon, allerent à Athènes en 1676, & ont donné au Public la relation de leur voyage ; Fanelly Vénitien qui étoit avec le provéditeur Morosini en 1687, dans le temps qu'il s'empara d'Athènes a donné une description de cette Ville, intitulée : Athènes antique & moderne.

[3]

AFIN de rendre cette partie plus intéressante, on y joindra les profils des Colonnes doriques antiques de l'Eglise de S. Pierre aux liens à Rome, ceux des Colonnes & de l'entablement du Théatre de Marcellus dans la même Ville, & quelques parties des Temples de Pæstum au Royaume de Naples. Ces monumens curieux comparés avec les ordres Grecs, prouveront d'une maniere sensible & décisive ce que l'Histoire ne nous apprend qu'en général sur le passage de l'Architecture grecque en Italie.

LES Desseins des Monumens avec leurs mesures seront rangés de suite, selon l'ordre de leur antiquité, dans chacune des classes suivantes ; la premiere renfermera les ordres Doriques, la seconde les ordres Ioniques, & la derniere les Corinthiens.

C'EST d'après ces précieux restes des Edifices antiques élevés en différens temps, que l'on tâchera, autant que les objets pourront le permettre, de tracer ou de faire reconnoître la suite des progrès de l'Architecture en Grece. On verra les premiers Architectes Grecs faire leurs colonnes lisses, d'une proportion courte, sans base, les chapiteaux sans moulures & les entablemens fort lourds. On verra leurs successeurs donner plus de légéreté à leurs colonnes, les orner de cannelures, enrichir les chapiteaux de moulures, en ajouter un plus grand nombre aux entablemens ; enfin donner à leurs Edifices la plus grande magnificence, en les embellissant d'ornemens & de figures.

C'EST encore par le parallèle que les Architectes pourront faire des plus beaux Monumens Grecs, dont cette partie contient les Desseins géométraux, avec ceux qui ont été le plus admirés chez les Romains, qu'ils seront en état de se former une idée plus précise du goût de chacun de ces Peuples, & de comparer leur connoissance en Architecture avec les nôtres, afin d'en tirer de nouvelles lumieres sur cet Art. Car quelques systèmes que l'on nous ait donné sur les principes du beau en Architecture, on ne peut s'empêcher de reconnoître que ce n'est point dans la nature seule qu'il les faut chercher ; mais dans ces monumens qui sont les fruits heureux d'un nombre infini de tentatives, & qui ont enfin obtenu le suffrage & l'éloge de tous les gens de goût. L'exemple des plus grands Architectes Italiens & François, paroît prouver ce que l'on avance : on sait assez que Michel Ange, Palladio, Vignole, Perrault, ne se sont rendus si habiles & si célebres que par une étude profonde des Monumens antiques. La route qu'ils nous ont tracée paroît être la plus sûre pour parvenir à exceller dans la grande Architecture, c'est-à-dire, dans celle qui a pour objet, les Temples, les Palais, les Places, les Théatres, enfin tous ces Monumens publics qui montrent aux Etrangers la grandeur d'une Nation, & font admirer à la postérité son goût & sa magnificence.

LA premiere partie de cet Ouvrage sera précédée d'un Discours sur l'histoire de l'Architecture ; la seconde, d'un autre sur les principes de cet Art.

UNE suite d'Ouvrages faits dans les vûës de celui-ci, sur l'Egypte, sur l'Italie, sur la France, nous mettroit peut-être en état de faire l'histoire générale de ces efforts de génie, par lesquels les hommes ont créé pour ainsi dire l'Architecture, & sont parvenus à élever après tant de siecles, ces chefs-d'œuvres de l'Art qui étonnent l'esprit humain.

ON vient d'exposer les différens objets que l'on a en vue en donnant au Public *les Ruines des plus beaux Monumens de la Grece*, & l'ordre dans lequel on a dessein de les traiter : le projet est sans doute fort étendu, & on ne se dissimule pas tout ce qu'il exige pour être bien rempli ; aussi l'Auteur n'entreprend-il cet Ouvrage qu'après y avoir été encouragé par les conseils, il ose dire même, par les suffrages de Savans illustres, & de personnes fort éclairées dans les beaux Arts : il fera tous ses efforts pour le rendre aussi intéressant qu'utile, & il assure

[4]

qu'il a employé tout le temps & tous les soins néceffaires ; pour mefurer & deffiner les Monumens avec toute l'exactitude qui lui a été poffible : ayant eu en cela toutes fortes de facilités , par la protection des Miniftres de Sa Majefté dans le Levant. Il faifit avec empreffement cette occafion de leur en témoigner publiquement fa reconnoiffance, en attendant qu'il puiffe le faire plus amplement dans fon Ouvrage.

DÉTAIL DES PLANCHES
CONTENUES DANS CET OUVRAGE.

DANS LA PREMIERE PARTIE,

Trois Plans généraux { de Sparte , d'Athènes ; de la Citadelle d'Athènes.

Une Carte des Ports d'Athènes.

Vingt-cinq Vûes de Monumens particuliers ,

MONUMENS d'Athènes. { du Temple de Jupiter Olympien , de la Tour des Vents , de la Lanterne de Démofthène , de l'Arc de Philopappus , du Portique de Théfée , du Panthéon d'Adrien , de l'Aqueduc d'Adrien ; du Temple d'Augufte , du Stade , de l'Aréopage & de l'Odéon , du Temple de Minerve Suniade , du Temple de Théfée , d'un Temple de la Bourgade de Zoter.

VUES des MONUMENS de la Citadelle & des Ports d'Athènes. { des Propylées ; du Temple de Minerve ; du Temple d'Erechtée , du Théatre , du Gymnafe , du Pirée , de Phalère ;

De Sparte. { du Théatre ; du Dromos ,

VUES. { du Théatre de Délos ; d'un Temple de Corinthe ; d'un Temple à Pola en Iftrie dédié à Augufte.

DANS LA SECONDE PARTIE,

Trente-deux Planches de différens détails , plans , coupes & profils des Monumens ci-deffus.

Toutes ces Planches auront onze pouces de haut fur dix-fept de large.

Le Papier fera du grand Colombier ; & le tout formera un volume *in-folio* de la même grandeur que le Livre des RUINES DE PALMYRE.

CONDITIONS DE LA SOUSCRIPTION.

Chaque exemplaire en feuilles fera payé par les Soufcripteurs fur le pied de *Cinquante-quatre livres*, en un feul paiement ; & le prix pour ceux qui n'auront pas foufcrit , fera de *Soixante & douze livres*.

On recevra les Soufcriptions jufques à la fin du mois de Juillet, & l'Ouvrage fera délivré à la fin de la préfente année 1756.

Les Soufcriptions fe délivrent à Paris chez H. L. GUERIN *&* L. F. DELATOUR, *Libraires-Imprimeurs , rue Saint Jacques.*

Comparison of Editions

This is a summary attempt to indicate the transposition into the 1770 edition of the *Ruines* of parts of earlier texts, mainly from the 1758 edition but also from Le Roy's *Histoire de la disposition et des formes differentes que les chrétiens ont données à leurs temples* of 1764 and his *Observations sur les édifices des anciens peuples* and *Recherches sur les mesures anciennes*, the last two published together in one volume in 1767. There are minor amendments and changes of grammar and spelling throughout the 1770 edition, but these are not noted here. The paragraph numbers for the 1770 edition are counted from one main heading to the next. The paragraph numbers for the 1758 edition are counted between these same headings when continuous, clearly corresponding sections of text were taken into the 1770 edition; when shorter runs of text were reused, the paragraph numbers for the 1758 edition refer to those on the page cited. Most of the notes in the 1770 edition are new; the exceptions are listed herein.

The transposition of the plates from the 1758 edition of the *Ruines* into the 1770 edition is summarized on pp. 528–29.

Volume One, Which Contains the Ruins of Those Monuments Erected by the Athenians before the End of the Age of Pericles

Preface
(1770 *Ruines*, Vol. 1, pp. iii–vi = Translation, pp. 205–8, paras. 1–12 = 1758 *Ruines*, Vol. 1, pp. v–viii, paras. 1–11)
Paras. 1–2 = new
Paras. 3–4 = 1758 Vol. 1, para. 7, in the main
Para. 5 = new
Para. 6, first two lines of para. 7 = 1758 Vol. 1, para. 8
Para. 7 remainder, paras. 8–9 = new
Paras. 10–11 = *Observations*, "Réflexions préliminaires," pp. 6–8, in the main
Para. 12 = new
Notes 2–3 derive from *Observations*, "Réflexions préliminaires," pp. 8–9, 11–12

Essay on the History of Architecture
(1770 *Ruines,* Vol. 1, pp. vii–xxiv = Translation, pp. 209–33, paras. 1–78 =
1758 *Ruines,* Vol. 1, pp. ix–xiv, paras. 1–19)
Para. 1 compiled from *Observations,* pp. 3–4
Paras. 2–6 = 1758 Vol. 1, paras. 1–3, though partly paraphrased
Paras. 7–8 = *Histoire,* pp. 2–3
Paras. 9–14, beginning of para. 15, Explanation of plate 1 = new
Para. 15 end = *Observations,* p. 8
Para. 16 = new
Paras. 17–21 = *Observations,* pp. 9–10, 12–13
Para. 22 = new
Paras. 23–38 = 1758 Vol. 1, paras. 4–15, though Pliny's letter to Maximus is
 cited more correctly and references to Major's and Dumont's publications
 are added to note 12
Paras. 39–42 = *Histoire,* pp. 7–8, with amendments
Paras. 43–45 = 1758 Vol. 1, paras. 16–17, 18 in part
Paras. 46–47, 49–66, first sentence of para. 67 = *Histoire,* pp. 16–44, with
 some compression, some omissions, and minor additions
Para. 48 = new
Para. 67 remainder, paras. 69–72, part of para. 73, para. 74 = *Histoire,*
 pp. 73, 75, 77–78, 80–82, 88, not necessarily in order and in part
 compiled, with the reference to Jardin
Para. 68, most of para. 73, para. 75 = new
Paras. 76–78 = 1758 Vol. 1, paras. 19–20
Notes 6–7 = *Observations,* pp. 9–10
Notes 11–17 = 1758 Vol. 1, pp. x–xii
Notes 21–22 = 1758 Vol. 1, p. xiii
Notes 24–26 = *Histoire,* pp. 28, 35, 31

**Part 1. The Ruins of the Monuments Erected by the Athenians before
the End of the Age of Pericles, Historically Considered**
(1770 *Ruines,* Vol. 1, pp. 1–27 = Translation, pp. 236–305, paras. 1–25,
1–41, 1–39, 1–27 = 1758 *Ruines,* Vol. 1, pp. 1–31, 49–56)

*Abridged Narrative of the Author's Journey from Rome to Athens
(pp. 236–44)*
Paras. 1–25 = 1758 Vol. 1, paras. 1–3, 6–25, with minimal additions
Notes 5, 10–11, 17 = 1758 Vol. 1, pp. 3, 5, 6

On the Origins of Athens (pp. 244–61)
Paras. 1–7, first part of para. 8 = 1758 Vol. 1, paras. 1–6, first four lines of
 para. 7
Para. 8 remainder, paras. 9–13, first half of para. 14 = new
Para. 14 second half = 1758 Vol. 1, para. 7 in part

Para. 15 = new

Paras. 16–17 = 1758 Vol. 1, paras. 8–9

Paras. 18–24 = new

Paras. 25–32, first sentence of para. 33 = 1758 Vol. 1, paras. 11–17

Para. 33 remainder, paras. 34–35, first sentence of para. 36 = new

Para. 36 remainder, paras. 37–41 = 1758 Vol. 1, second half of para. 18, paras. 19–23

Note 41 = 1758 Vol. 1, p. 11n, expanded

The Enlargement of Athens (pp. 261–73)

Paras. 1–5 = 1758 Vol. 1, paras. 1–2, first two sentences of para. 3; the lines on Themistocles are rewritten

Paras. 6–7 = new

Paras. 8–11 = 1758 Vol. 1, para. 23, first third of para. 24

Paras. 12–13 = new

Paras. 14–29 = 1758 Vol. 1, paras. 25–38

Paras. 30–34 = new

Paras. 35–38 = 1758 Vol. 1, paras. 40–43

Para. 39 = new

Notes 52, 57, 59–60 = 1758 Vol. 1, pp. 22–23, 56

Voyage from Athens to Cape Sunium (pp. 273–83)

Para. 1 = 1758 Vol. 1, para. 1, minus the last sentence

Paras. 2–5 = new, apart from the quotation from Fourmont

Paras. 6–23 = 1758 Vol. 1, paras. 4–7, 9–14, with some omissions and some rewriting

Paras. 24–25 = new

Paras. 26–27 = 1758 Vol. 1, paras. 16–17

Notes 65, 74 = 1758 Vol. 1, pp. 28 revised, 29

Greek Inscriptions (p. 283)

1770 Vol. 1, p. 28 = 1758 Vol. 1, p. 56

Dissertation on the Length of the Greek Foot (pp. 284–91)

1770 Vol. 1, pp. 29–34 = 1758 Vol. 1, pp. 49–55 = *Recherches*, pp. 21–46

Notes 85–88, 92–97 = 1758 Vol. 1, pp. 49–50, 52–54

Notes 89–90 = 1758 Vol. 1, p. 51, in French translation only

Note 91 = 1758 Vol. 1, p. 52, rewritten

Part 2. The Ruins of the Monuments Erected by the Athenians before the End of the Age of Pericles and Alexander, Architecturally Considered (1770 *Ruines*, Vol. 1, pp. 35–53 = Translation, pp. 309–60, paras. 1–104 = 1758 *Ruines*, Vol. 2, pp. 1–19, parts of pp. 22–23, paras. 1–99)

Paras. 1–99 = 1758 Vol. 2, paras. 1–28, 31–63, 68–85, first sentence of para. 86.
Several paragraphs in the 1770 *Ruines* are amended or considerably

revised versions of the text in the 1758 *Ruines:* para. 2 has an additional sentence; para. 13 is rewritten; para. 35 is largely rewritten, with particular reference to notes 7–8, as is para. 37; paras. 65, 70, 81 provide new translations from Vitruvius; para. 96 has an additional sentence

Para. 100 = new

Paras. 101–4 = 1758 Vol. 2, para. 97 in part, paras. 98–99

Notes 3, 10, 12, 19–20 = 1758 Vol. 2, pp. 2, 7–8, 15, with the end of note 20 changed

Notes 6, 13, 16 incorporate quotations or remarks from 1758 Vol. 2, pp. 5, 9, 11

Volume Two, Which Contains the Ruins of the Monuments Erected by the Athenians after the End of the Age of Pericles and the Antiquities of Corinth and Sparta

Essay on the Theory of Architecture
(1770 *Ruines,* pp. iii–xx = Translation, pp. 367–85, paras. 1–72 = 1758 *Ruines,* Vol. 2, pp. i–vi, paras. 1–20; *Histoire,* pp. 46–71)

Paras. 1–4, all but the last sentence of para. 5 = 1758 Vol. 2, paras. 1–3

Para. 5 last sentence = new

Paras. 6–33 = *Histoire,* pp. 46–71, minus part of the final sentence and the deletion of the word "metaphysique"

Paras. 34–52 = new

Paras. 53–72 = 1758 Vol. 2, paras. 4–20, though minor rewriting occurs at the beginning of para. 62, with more extensive rewriting and the removal of sentences in paras. 70–71 and note 2, and the notable addition of the remark "No nation has ever attained perfection in the Greek orders"

Note 1 = *Histoire,* p. 52

Notes 2–3 = 1758 Vol. 2, pp. ii, iv

Part 1. The Ruins of the Monuments Erected by the Athenians after the End of the Age of Pericles, Historically Considered
(1770 *Ruines,* Vol. 2, pp. 1–17, 36–42 = Translation, pp. 387–471, paras. 1–77, 1–43, 1–58 = 1758 *Ruines,* Vol. 1, pp. 14, 17–18, 20, 26, 27, 32–33, 35–48)

The State of Athens from the End of the Age of Pericles to the Enlargement of the City under Hadrian (pp. 387–413)

This section is almost entirely newly composed, though much of the matter concerning Pausanias's route and the buildings encountered, all directly related to Le Roy's dispute with Stuart, appeared in his initial response, in *Observations,* pp. 22–48; descriptions of individual monuments, or parts thereof, have been incorporated from the earlier edition of *Ruines*

Paras. 1–20, 22–32, 38–40, 43–52, 60, 62–77 = 1758 Vol. 1, pp. 14, 20, 26, 27, 32–33

Para. 21 derives from 1758 Vol. 1, p. 14, para. 2

Paras. 33–37 and note 15 derive from 1758 Vol. 1, p. 26, paras. 2–4

Para. 41 = 1758 Vol. 1, p. 27, para. 3

Para. 42 = 1758 Vol. 1, p. 32, para. 1, with alterations

Paras. 53–59 = 1758 Vol. 1, p. 33, with omissions and additions

Para. 61 = 1758 Vol. 1, p. 20, para. 2, with some alteration

Explanation of plate 1 = 1758 Vol. 1, p. 15

The State of Athens from the Reign of Hadrian to the Present (pp. 413–27)

Paras. 1–5 = new

Paras. 6–12, first part of para. 13 = 1758 Vol. 1, p. 17, paras. 4–6, with the
first sentence rewritten; p. 18

Para. 13 remainder, paras. 14–31 = new, though based on information and
comment in *Observations* (e.g., para. 20 = p. 40 in part) and 1758 *Ruines*
(e.g., 1770 Vol. 2, paras. 14–15, 20–21 vs. 1758 Vol. 1, p. 35, para. 3;
p. 36, paras. 1–2)

Paras. 32–39 = 1758 Vol. 1, p. 36, with a new translation of Pausanias in
para. 34 and a lengthy insertion in para. 37

Para. 40 = new

Paras. 41–43 = 1758 Vol. 1, p. 37, paras. 3–5; p. 38, para. 1 in part; three
lines are added in para. 43

Note 57 = 1758 Vol. 1, p. 37

Journey from Athens to Sparta and *Present State of Sparta (pp. 427–45)*

Paras. 1–58 = 1758 Vol. 1, paras. 1–33, 35–58, with a sentence removed in
para. 4; quotations removed in paras. 10 and 19; a sentence on the
caratch added in para. 54; a sentence added in para. 58

Explanation of plate 12 = 1758 Vol. 1, p. 46

Notes 58, 60–63, 65 = 1758 Vol. 1, pp. 38, 39–40, 44, 46

Greek Inscriptions (pp. 445–47)

1770 Vol. 2, p. 35 = 1758 Vol. 1, pp. 55–56

The Arch of Theseus is described now as the Arch of Hadrian

Dissertation on the Length of the Course at Olympia (pp. 447–55)

1770 Vol. 2, pp. 36–42, paras. 1–4, 7–19, 21–28, 33–34 = *Recherches*,
pp. 1–20, 47–54

Para. 5 largely rewritten

Para. 6 = new, in the main

Paras. 20, 29–32 = new

Notes 67–69, 71–72 = *Recherches*, pp. 1, 4, 5–6

Notes 74–75 = *Recherches*, pp. 10n, 11n, both greatly expanded

Notes 76, 78 = *Recherches*, pp. 13, 20

Note 83 = *Recherches*, pp. 47–54, with a major addition near the end
relating to the opinions of Burette

Part 2. The Ruins of the Monuments Erected by the Athenians after the End of the Age of Pericles, Architecturally Considered
(1770 *Ruines,* Vol. 2, pp. 43–52 = Translation, pp. 473–97, paras. 1–52 = 1758 *Ruines,* Vol. 1, p. 1; Vol. 2, pp. 5–6, 13–14, 20–21, 23–25)

Para. 1 = new

Paras. 2–5 = 1758 Vol. 1, p. 1, para. 4; p. 2, paras. 1–2

Paras. 6–7 = 1758 Vol. 2, p. 5, para. 6; p. 6, paras. 1–2, this last rewritten

Para. 8 = new

Paras. 9–15 = 1758 Vol. 2, p. 13, paras. 3–5; p. 14, paras. 1–2, with some rewriting

Para. 16 = new

Paras. 17–19 = 1758 Vol. 2, p. 23, paras. 5–6; p. 24, para. 1

Para. 20 = new

Para. 21 = 1758 Vol. 2, p. 20, para. 5

Para. 22 = new

Paras. 23–24 = 1758 Vol. 2, p. 20, paras. 3–4, with an addition to the final sentence

Para. 25 = 1758 Vol. 2, p. 20, para. 6; p. 21, para. 1, with additions to the first sentence

Paras. 26–29 = 1758 Vol. 2, p. 21, paras. 2–5

Paras. 30–42 = new

Paras. 43–45 = 1758 Vol. 2, p. 23, paras. 2–4, with alterations to the first sentence and final paragraph

Paras. 46–52 = 1758 Vol. 2, p. 24, para. 4; p. 25, with minor changes

Note 1 = 1758 Vol. 1, p. 1n

Note 7 = 1758 Vol. 2, p. 24, para. 2

PLATES

The first edition of the *Ruines* included sixty plates. Twenty-four were views, all signed "Le Roy Arch. Del in Graecia" (with the exception of that of the temple at Pola, which was signed "Le Roy Arch. Del"), all engraved by the celebrated Jacques-Philippe Le Bas (French, 1707–83). There were as well thirty-two plates of measured drawings of the buildings, all drawn by Le Roy, nineteen engraved by Jean-François de Neufforge (French, 1714–91), twelve by Pierre Patte (French, 1723–1814), one unsigned. In addition there were four maps, all drawn by Le Roy, all engraved by Claude-Antoine Littret de Montigny (French, 1735–75). With the exception of the two plates of the plans, section, and elevation of the Tower of the Winds (one each by de Neufforge and Patte), all the plates from the first edition of 1758 were to be included, though much rearranged, in the second edition of 1770. Three new plates were added: plate 1 in volume 1 is a thoroughly revised version of the comparative plans of temples and churches from Le Roy's *Histoire de la disposition et des forms differentes que les chrétiens ont données à leurs temples* of 1764; plate 15 in volume 2 is a new engraving of the diagram of antique stadia prepared for a dissertation on that subject that Le Roy presented at the Académie royale des inscriptions et belles-lettres early in 1767 and published in the same year in his *Recherches sur les mesures anciennes;* plate 25 in volume 2 is yet another assemblage of temple fronts and circular and octagonal buildings (with the Tower of the Winds included here); two of these plates were drawn by Le Moine (that of the stadia was unsigned), all three were engraved by Michelinot.

With the rearrangement of plates in the second edition, almost all were renumbered (though not vol. 1, pls. 2–7, and vol. 2, pls. 22, 23); captions too, as a result of the disputes with Stuart, had to be changed on four plates. *Vue du temple d'Auguste à Athènes* became *Ruines d'un portique dorique* (vol. 2, pl. 4); *Vue du temple de Jupiter Olimpien à Athènes* became *Ruines d'un edifice qu'on voit au bazar d'Athènes* (vol. 2, pl. 6); *Vue des ruines du Panthéon bâti par Adrien à Athènes* became *Ruines d'un temple, élevé par Adrien et vraisemblement du Panthéon que cet empereur fit construire* (vol. 2, pl. 8); and *Vue des ruines de l'aqueduc d'Adrien* became *Ruines d'un edifice, élevé par Adrien et par Antoni* (vol. 2, pl. 10). The dimension at the base of the column of the Doric portico (the west gate of the agora) was changed from 3 ft. 10 in. to 3 ft. 8 in. 10 lines (vol. 2, pl. 18), though Le Roy claimed to have found that the column was stouter than he had first shown it. Only one plate required readjustment: the three porticoes that had been shown on the plan of the so-called ruins in the bazaar were reduced to one (vol. 2, pl. 22). Otherwise the plates appeared as they had in the first edition.

The platemarks of the sixty-three engravings measure an average of 46.2 × 30.5 cm (18¼ × 12 in.). The plates of the 1758 edition are printed on pages measuring approximately 55 × 40.5 cm (21⅝ × 16 in.); the deckle-edge pages of the 1770 edition are slightly larger, measuring approximately 58.5 × 42.5 cm (23 × 16¾ in.).

Volume 1
1770 vs. 1758

Pl. 1 = new
Pl. 2 = Vol. 1, pl. 2
Pl. 3 = Vol. 1, pl. 3
Pl. 4 = Vol. 1, pl. 4
Pl. 5 = Vol. 1, pl. 5
Pl. 6 = Vol. 1, pl. 6
Pl. 7 = Vol. 1, pl. 7
Pl. 8 = Vol. 1, pl. 11
Pl. 9 = Vol. 1, pl. 12
Pl. 10 = Vol. 1, pl. 13
Pl. 11 = Vol. 1, pl. 15
Pl. 12 = Vol. 1, pl. 16
Pl. 13 = Vol. 1, pl. 17
Pl. 14 = Vol. 1, pl. 18
Pl. 15 = Vol. 2, pl. 1
Pl. 16 = Vol. 2, pl. 2
Pl. 17 = Vol. 2, pl. 4
Pl. 18 = Vol. 2, pl. 5
Pl. 19 = Vol. 2, pl. 6
Pl. 20 = Vol. 2, pl. 7
Pl. 21 = Vol. 2, pl. 8
Pl. 22 = Vol. 2, pl. 9
Pl. 23 = Vol. 2, pl. 10
Pl. 24 = Vol. 2, pl. 11
Pl. 25 = Vol. 2, pl. 12
Pl. 26 = Vol. 2, pl. 13
Pl. 27 = Vol. 2, pl. 16
Pl. 28 = Vol. 2, pl. 17
Pl. 29 = Vol. 2, pl. 18
Pl. 30 = Vol. 2, pl. 19
Pl. 31 = Vol. 2, pl. 20
Pl. 32 = Vol. 2, pl. 21
Pl. 33 = Vol. 2, pl. 24
Pl. 34 = Vol. 2, pl. 25
Pl. 35 = Vol. 2, pl. 26

Volume 2
1770 vs. 1758

Pl. 1 = Vol. 1, pl. 9
Pl. 2 = Vol. 1, pl. 8
Pl. 3 = Vol. 1, pl. 14
Pl. 4 = Vol. 1, pl. 19
Pl. 5 = Vol. 1, pl. 20
Pl. 6 = Vol. 1, pl. 10
Pl. 7 = Vol. 1, pl. 21
Pl. 8 = Vol. 1, pl. 22
Pl. 9 = Vol. 1, pl. 23
Pl. 10 = Vol. 1, pl. 24
Pl. 11 = Vol. 1, pl. 25
Pl. 12 = Vol. 1, pl. 26
Pl. 13 = Vol. 1, pl. 27
Pl. 14 = Vol. 1, pl. 28
Pl. 15 = new
Pl. 16 = Vol. 1, pl. 1
Pl. 17 = Vol. 2, pl. 3
Pl. 18 = Vol. 2, pl. 14
Pl. 19 = Vol. 2, pl. 15
Pl. 20 = Vol. 2, pl. 29
Pl. 21 = Vol. 2, pl. 30
Pl. 22 = Vol. 2, pl. 22
Pl. 23 = Vol. 2, pl. 23
Pl. 24 = Vol. 2, pl. 31
Pl. 25 = new
Pl. 26 = Vol. 2, pl. 32

1758 Vol. 2, pls. 27, 28 omitted

Illustration Credits

All photographs of illustrations from Julien-David Le Roy, *Les ruines des plus beaux monuments de la Grèce, considérées du côté de l'histoire et du côté de l'architecture,* 2d ed., 2 vols. (Paris: Imprimerie de Louis-François Delatour, 1770), are courtesy the Getty Research Institute, Research Library, ID no. 86-B5414. © 2004 The J. Paul Getty Trust. The following sources have granted permission to reproduce the illustrations in the introduction to this book:

Figs. 1, 2	Photo: Service Photographique, École Nationale Supérieure des Beaux-Arts
Figs. 3, 4	Photo: Getty Research Institute, Research Library, ID no. 85-B23048; © 2004 The J. Paul Getty Trust
Fig. 5	Photo: Getty Research Institute, Research Library, ID no. 85-B3279; © 2004 The J. Paul Getty Trust
Fig. 6	Photo: Staatsbibliothek zu Berlin—Preussischer Kulturbesitz, Handschriftenabteilung
Fig. 7	Photo: Cliché Bibliothèque Nationale de France, Paris, Fc 3a Réserve
Fig. 8	Jacques Carrey, *Réception du marquis de Nointel à Athènes,* inv. 4383. Courtesy Dépôt du Musée des beaux-arts de Chartres, France. Photo: Courtesy National Art Gallery and Alexandros Soutzos Museum, Athens
Fig. 9	Photo: James Ford Bell Library, Minneapolis
Figs. 10, 11	Photo: Getty Research Institute, Research Library, ID no. 84-B7359; © 2004 The J. Paul Getty Trust
Fig. 12	Photo: Cliché Bibliothèque Nationale de France, Paris
Figs. 13–17	Photo: Getty Research Institute, Research Library, ID no. 86-S1733; © 2004 The J. Paul Getty Trust
Fig. 18	Photo: The State Hermitage Museum, Saint Petersburg
Figs. 19–21	Photo: Getty Research Institute, Research Library, ID no. 86-S1733; © 2004 The J. Paul Getty Trust
Figs. 22, 23	Photo: Getty Research Institute, Research Library, ID no. 90-B18303; © 2004 The J. Paul Getty Trust
Fig. 24	Photo: Collection Centre Canadien d'Architecture/Canadian Centre for Architecture, Montreal, ID 94-B1806 Cage

Index

The Ruins of the Most Beautiful Monuments of Greece
Julien-David Le Roy
Introduction by Robin Middleton
Translation by David Britt

Robin Middleton is professor of art history at Columbia University, where he has been a member of the faculty since 1987. He was technical editor of *Architectural Design* from 1964 to 1972; and head of general studies at the Architectural Association, London, and librarian and lecturer in the Faculty of Architecture and Art History at Cambridge University from 1972 to 1987. In addition to numerous articles on French and English architecture of the eighteenth and nineteenth centuries, Dr. Middleton is the author of the introduction to David Britt's translation of Nicolas Le Camus de Mézières's *The Genius of Architecture; or, The Analogy of That Art with Our Sensations* (1992) and coauthor of *Architettura moderna* (with David J. Watkin, 1977), which has been published in English, French, and German.

David Britt graduated from Cambridge University with a degree in French and German in 1961. He was an editor of art books at Thames and Hudson in London for more than twenty years and a full-time freelance translator from 1987 until his death in January 2002. His translations in the Getty Research Institute's Texts & Documents series include volumes by Nicolas Le Camus de Mézières, Carl Gustav Carus, Jean-Nicolas-Louis Durand, Friedrich Gilly, Giovanni Battista Piranesi, and Aby Warburg.

Texts & Documents

A Series of the Getty Research Institute Publications Program

In Print

Otto Wagner, *Modern Architecture: A Guidebook for His Students to This Field of Art* (1902)
Introduction by Harry Francis Mallgrave
ISBN 0-226-86938-5 (hardcover), ISBN 0-226-86939-3 (paper)

Heinrich Hübsch, Rudolf Wiegmann, Carl Albert Rosenthal, Johann Heinrich Wolff, and Carl Gottlieb Wilhelm Bötticher, *In What Style Should We Build? The German Debate on Architectural Style* (1828–47)
Introduction by Wolfgang Herrmann
ISBN 0-89236-199-9 (hardcover), ISBN 0-89236-198-0 (paper)

Nicolas Le Camus de Mézières, *The Genius of Architecture; or, The Analogy of That Art with Our Sensations* (1780)
Introduction by Robin Middleton
ISBN 0-89236-234-0 (hardcover), ISBN 0-89236-235-9 (paper)

Claude Perrault, *Ordonnance for the Five Kinds of Columns after the Method of the Ancients* (1683)
Introduction by Alberto Pérez-Gómez
ISBN 0-89236-232-4 (hardcover), ISBN 0-89236-233-2 (paper)

Robert Vischer, Conrad Fiedler, Heinrich Wölfflin, Adolf Göller, Adolf Hildebrand, and August Schmarsow, *Empathy, Form, and Space: Problems in German Aesthetics, 1873–1893*
Introduction by Harry Francis Mallgrave and Eleftherios Ikonomou
ISBN 0-89236-260-X (hardcover), ISBN 0-89236-259-6 (paper)

Friedrich Gilly: Essays on Architecture, 1796–1799
Introduction by Fritz Neumeyer
ISBN 0-89236-280-4 (hardcover), ISBN 0-89236-281-2 (paper)

Hermann Muthesius, *Style-Architecture and Building-Art: Transformations of Architecture in the Nineteenth Century and Its Present Condition* (1902)
Introduction by Stanford Anderson
ISBN 0-89236-282-0 (hardcover), ISBN 0-89236-283-9 (paper)

Sigfried Giedion, *Building in France, Building in Iron, Building in Ferroconcrete* (1928)
Introduction by Sokratis Georgiadis
ISBN 0-89236-319-3 (hardcover), ISBN 0-89236-320-7 (paper)

Hendrik Petrus Berlage: Thoughts on Style, 1886–1909
Introduction by Iain Boyd Whyte
ISBN 0-89236-333-9 (hardcover), ISBN 0-89236-334-7 (paper)

Adolf Behne, *The Modern Functional Building* (1926)
Introduction by Rosemarie Haag Bletter
ISBN 0-89236-363-0 (hardcover), ISBN 0-89236-364-9 (paper)

Aby Warburg, *The Renewal of Pagan Antiquity: Contributions to the
Cultural History of the European Renaissance* (1932)
Introduction by Kurt W. Forster
ISBN 0-89236-537-4 (hardcover)

Alois Riegl, *The Group Portraiture of Holland* (1902)
Introduction by Wolfgang Kemp
ISBN 0-89236-548-X (paper)

Walter Curt Behrendt, *The Victory of the New Building Style* (1927)
Introduction by Detlef Mertins
ISBN 0-89236-563-3 (paper)

Jean-Nicolas-Louis Durand, *Précis of the Lectures on Architecture* (1802–5)
with *Graphic Portion of the Lectures on Architecture* (1821)
Introduction by Antoine Picon
ISBN 0-89236-580-3 (paper)

Karel Teige, *Modern Architecture in Czechoslovakia and Other Writings*
(1923–30)
Introduction by Jean-Louis Cohen
ISBN 0-89236-596-X (paper)

Carl Gustav Carus, *Nine Letters on Landscape Painting, Written in the Years
1815–1824; with a Letter from Goethe by Way of Introduction* (1831)
Introduction by Oskar Bätschmann
ISBN 0-89236-674-5 (paper)

Giovanni Battista Piranesi, *Observations on the Letter of Monsieur Mariette;
with Opinions on Architecture, and a Preface to a New Treatise on the
Introduction and Progress of the Fine Arts in Europe in Ancient Times* (1765)
Introduction by John Wilton-Ely
ISBN 0-89236-636-2 (paper)

Carol Armstrong, *Odd Man Out: Readings of the Work and Reputation of
Edgar Degas* (1991, reprint)
ISBN 0-89236-728-8 (paper)

Hollis Clayson, *Painted Love: Prostitution in French Art of the Impressionist Era* (1991, reprint)
ISBN 0-89236-729-6 (paper)

In Preparation

Gottfried Semper, *Style in the Technical and Tectonic Arts; or, Practical Aesthetics* (1860–63)
Introduction by Harry Francis Mallgrave
ISBN 0-89236-597-8 (hardcover)

Jacob Burckhardt, *Italian Renaissance Painting According to Genres* (1885–93)
Introduction by Maurizio Ghelardi
ISBN 0-89236-736-9 (paper)

Johann Joachim Winckelmann, *History of the Art of Antiquity* (1764)
Introduction by Alex Potts
ISBN 0-89236-668-0 (paper)

Designed by Bruce Mau Design Inc.,
Bruce Mau with Chris Rowat and Daiva Villa
Coordinated by Stacy Miyagawa
Type composed by Archetype in Sabon and News Gothic
Printed and bound by Transcontinental, Litho Acme, Montreal,
on Cougar Opaque

Texts & Documents
Series designed by Bruce Mau Design Inc., Toronto, Canada